BORN TO BE
POSTHUMOUS

BORN TO BE POSTHUMOUS

The Eccentric Life and Mysterious Genius of Edward Gorey

MARK DERY

WILLIAM
COLLINS

William Collins
An imprint of HarperCollins *Publishers*
1 London Bridge Street
London SE1 9GF

www.WilliamCollinsBooks.com

First published in Great Britain by William Collins in 2018

1

Book designed by Marie Mundaca

A catalogue record for this book is
available from the British Library

ISBN 978-0-00-832981-5

Printed and bound in Great Britain by
CPI Group (UK) Ltd, Croydon

MIX
Paper from
responsible sources
FSC
www.fsc.org
FSC˚ C007454

This book is produced from independently certified FSC paper
to ensure responsible forest management.

For more information visit: www.harpercollins.co.uk/green

For Margot Mifflin, whose wild surmise— "What about a Gorey biography?"—begat this book. Without her unwavering support, generous beyond measure, it would have remained just that: a gleam in her eye. I owe her this—and more than tongue can tell.

CONTENTS

Contents

BORN TO BE POSTHUMOUS

INTRODUCTION

A GOOD MYSTERY

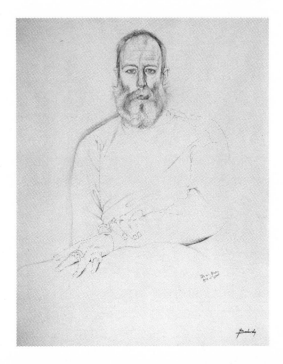

Don Bachardy, *Portrait of Edward Gorey* (1974), graphite on paper. *(Don Bachardy and Craig Krull Gallery, Santa Monica, California. Image provided by the National Portrait Gallery, Smithsonian Institution.)*

EDWARD GOREY WAS BORN to be posthumous. After he died, struck down by a heart attack in 2000, a joke made the rounds among his fans: During his lifetime, most people assumed he was British, Victorian, and dead. Finally, at least one of the above was true.

In fact, he was born in Chicago in 1925. And although he was an ardent Anglophile, he never traveled in England, despite passing through the place on his one trip across the pond. He was, however, intrigued by death; it was his enduring theme. He returned to it time and again in his little picture books, deadpan accounts of murder, disaster, and

discreet depravity with suitably disquieting titles: *The Fatal Lozenge, The Evil Garden, The Hapless Child*. Children are victims, more often than not, in Gorey stories: at its christening, a baby is drowned in the baptismal font; one hollow-eyed tyke dies of ennui; another is devoured by mice. The setting is unmistakably British, an atmosphere heightened by Gorey's insistence on British spelling; the time is vaguely Victorian, Edwardian, and Jazz Age all at once. Cars start with cranks, music squawks out of gramophones, and boater-hatted men in Eton collars knock croquet balls around the lawn while sloe-eyed vamps look on.

Gorey wrote in verse, for the most part, in a style suggestive of a weirder Edward Lear or a curiouser Lewis Carroll. His point of view is comically jaundiced; his tone a kind of high-camp macabre. And those illustrations! Drawn in the six-by-seven-inch format of the published page, they're a marvel of pen-and-ink draftsmanship: minutely detailed renderings of cobblestoned streets, no two cobbles alike; Victorian wallpaper writhing with serpentine patterns. Gorey's machinelike cross-hatching would have been the envy of the nineteenth-century printmaker Gustave Doré or John Tenniel, illustrator of Lewis Carroll's *Alice* books. Hand-drawn antique engravings is what they are.

Gorey first blipped across the cultural radar in 1959, when the literary critic Edmund Wilson introduced *New Yorker* readers to his work. "I find that I cannot remember to have seen a single printed word about the books of Edward Gorey," Wilson wrote, noting that the artist "has been working quite perversely to please himself, and has created a whole little world, equally amusing and somber, nostalgic and claustrophobic, at the same time poetic and poisoned."[1]

That "little world" has won itself a mainstream cult (to put it oxymoronically). Millions know Gorey's work without knowing it. Whether they noticed his name in the credits or not, Boomers and Gen-Xers who grew up with the PBS series *Mystery!* remember the dark whimsy of Gorey's animated intro: the lady fainting dead away with a melodramatic wail; the sleuths tiptoeing through pea-soup fog; cocktail partiers feigning obliviousness while a stiff subsides in a lake. Then, too, every Tim Burton fan is a Gorey fan at heart. Burton

owes Gorey a considerable debt, most obviously in his animated movies *The Nightmare Before Christmas* and *Corpse Bride*. Likewise, the millions of kids who devoured A Series of Unfortunate Events, the young-adult mystery novels by Lemony Snicket, were seduced by a narrator whose arch persona was consciously modeled on Gorey's. Daniel Handler—the man behind the nom de plume—calls it "the flâneur." "When I was first writing A Series of Unfortunate Events," he says, "I was wandering around everywhere saying, 'I am a complete rip-off of Edward Gorey,' and everyone said, 'Who's that?' " That was in 1999. "Now, everyone says, 'That's right, you *are* a complete rip-off of Edward Gorey!' "

Neil Gaiman's dark-fantasy novella *Coraline* bears Gorey's stamp, too. A devout fan since childhood, when he fell for Gorey's illustrations in *The Shrinking of Treehorn* by Florence Parry Heide, Gaiman has an original Gorey hanging on his bedroom wall, a drawing of "children gathered around a sick bed."[2] Gaiman's wife, the dark-cabaret singer Amanda Palmer, references Gorey's book *The Doubtful Guest* in her song "Girl Anachronism": "I don't necessarily believe there is a cure for this / So I might join your century but only as a doubtful guest."[3]

His influence is percolating out of the goth, neo-Victorian, and dark-fantasy subcultures into pop culture at large. The market for Gorey books, calendars, and gift cards is insatiable, buoying indie publishers like Pomegranate, which is resurrecting his out-of-print titles. Since his death, his work has inspired a half dozen ballets, an avant-garde jazz album, and a loosely biographical play, *Gorey: The Secret Lives of Edward Gorey* (2016). Of course, there's no surer sign that you've arrived than a *Simpsons* homage. Narrated in verse, in a toffee-nosed English accent, and rendered in Gorey's gloomy palette and spidery line, the goofy-creepy playlet "A *Simpsons* 'Show's Too Short' Story" (2012) indicates just how deeply his work has seeped into the pop unconscious.

But the leading indicator of Gorey's influence is his transformation into an adjective. Among critics and trend-story reporters, "Goreyesque" has become shorthand for a postmodern twist on the gothic—anything

that shakes it up with a shot of black comedy, a jigger of irony, and a dash of high camp to produce something droll, disquieting, and morbidly funny.

But is that all we're talking about when we talk about Gorey? An aesthetic? A style? The way we wear our bowler hats?

Truth to tell, we hardly know him.

Gorey's work offers an amusingly ironic, fatalistic way of viewing the human comedy as well as a code for signaling a conscientious objection to the present. Handler attributes Gorey's enduring appeal to the sophisticated understatement and wit of his hand-cranked world, dark though it may be—a sensibility that stands in sharp contrast to the Trumpian vulgarity of our times. The Gorey "worldview—that a well-timed scathing remark might shame an uncouth person into acting better—seems worthy to me," says Handler.

Like Handler, the steampunks and goths with Gorey tattoos who flock to the annual Edwardian Ball, "an elegant and whimsical celebration" inspired by Gorey's work, dream of stepping into the gaslit, sepia-toned world of his stories.[4] Justin Katz, who cofounded the Ball, believes revelers, many of whom come dressed in Victorian or Edwardian attire, are drawn by the promise of escape from our "Age of Anxiety," a "chaotic time" of "accelerated media" that is "stressful and rootless" for many.

Gorey, it should be noted, groaned at being typecast as the granddaddy of the goths and would have shrunk from the embrace of neo-Victorians. "I *hate* being characterized," he said. "I don't like to read about the 'Gorey details' and that kind of thing."[5] There was more—much more—to the man than charming anachronisms and morbid obsessions.

Only now are art critics, scholars of children's literature, historians of book-cover design and commercial illustration, and chroniclers of the gay experience in postwar America waking up to the fact that Gorey is a critically neglected genius. His consummately original vision—expressed in virtuosic illustrations and poetic texts but articulated with equal verve in book-jacket design, verse plays, puppet

shows, and costumes and sets for ballets and Broadway productions—
has earned him a place in the history of American art and letters.

Gorey was a seminal figure in the postwar revolution in children's
literature that reshaped American ideas about children and childhood.
Author-illustrators such as Maurice Sendak, Tomi Ungerer, and Shel
Silverstein spearheaded the movement away from the bland *Fun with
Dick and Jane* fare of the Wonder Bread '50s toward a more authentic
representation of the hopes, anxieties, terrors, and wonders of
childhood—childhood as children live it, not as the angelic age of in-
nocence adults imagine it to be, a sentimental chromo handed down
from the Victorians. Gorey was never a mass-market children's author
for the simple reason that publishers, despite his urgings, refused to mar-
ket his books to children. They were squeamish about the darkness of
his subject matter, not to mention the absence of anything resembling a
moral in his absurdist parables.

Nonetheless, the Wednesday and Pugsley Addamses of America *did*
read Gorey. In a nice twist, Boomer and Gen-X fans raised their chil-
dren on *The Gashlycrumb Tinies*, turning a mock-moralistic ABC that
plays the deaths of little innocents for laughs ("A is for Amy who fell
down the stairs / B is for Basil assaulted by bears…") into a bona
fide children's book. Some of those kids grew up to be cultural shak-
ers and movers. The graphic novelist Alison Bechdel, whose scarifying
tales of her childhood earned her a MacArthur "genius grant," is a
careful student of Gorey's "illustrated masterpieces," as she calls them;
the Gorey anthology *Amphigorey* is among her ten favorite books.[6] Fol-
lowing Gorey's lead, she and others have turned traditionally juvenile
genres—the comic book, the stop-motion animated movie, the young-
adult novel—to adult ends, opening the door to a new honesty about
the moral complexity of childhood. Bechdel's graphic memoir *Fun
Home*, an unflinching exploration of growing up lesbian in the shadow
of her abusive father, is only one of a host of examples.

The contemporary turn toward an aesthetic, in children's and YA
media, that is darker, more ironic, and self-consciously metatextual (that
is, aware of, and often parodying, genre conventions and retro styles)

would be unthinkable without Gorey. *Miss Peregrine's Home for Peculiar Children* (2011), a bestselling YA novel by Ransom Riggs, is typical of the genre. Unsurprisingly, it was inspired by the "Edward Gorey–like Victorian weirdness" of the antique photos Riggs collected, "haunting images of peculiar children."[7] He told the *Los Angeles Times*, "I was thinking maybe they could be a book, like *The Gashlycrumb Tinies*. Rhyming couplets about kids who had drowned. That kind of thing."[8]

Gorey's art—and highly aestheticized persona—foreshadowed some of the most influential trends of his time. His work as a cover designer and illustrator for Anchor Books in the 1950s put him at the forefront of the paperback revolution, a shift in American reading habits that, along with TV, rock 'n' roll, the transistor radio, and the movies, helped midwife postwar pop culture. Before the Beats, before the hippies, before the Williamsburg hipster with his vest and man bun, Gorey was part of a charmed circle of gay literati at Harvard that included the poets Frank O'Hara and John Ashbery; O'Hara's biographer calls Gorey's college clique "an early and elitist" premonition of countercultures to come, at a time—the late '40s—when there *was* no counterculture beyond the gay demimonde.[9] Though he'd shudder to hear it, Gorey was the original hipster, a truism underscored by the uncannily Goreyesque bohemians swanning around Brooklyn today in their Edwardian beards and close-cropped hairstyles—the very look Gorey sported in the '50s.

Before retro took up permanent residence in our cultural consciousness; before the embrace, in the '80s, of irony as a way of viewing the world; before postmodernism made it safe to like high and low culture (and to borrow, as an artist, from both); before the blurring of the distinction between kids' media and adult media; before the mainstreaming of the gay sensibility (in the pre-Stonewall sense of a Wildean wit crossed with a tendency to treat life as art), Gorey led the way, not only in his art but in his life as well.

Yet during his lifetime the art world and literary mandarins barely deigned to notice him or, when they did, dismissed him as a minor talent. His books are little, about the size of a Pop-Tart, and rarely more than thirty pages—mere trifles, obviously, undeserving of serious

scrutiny. He worked in a children's genre, the picture book, and wrote in nonsense verse. Even more damningly, his books are funny, often wickedly so. (Tastemakers take a dim view of humor.)

But the nail in Gorey's coffin, as far as high-culture gatekeepers were concerned, was his status as an illustrator. For much of his lifetime, critics and curators patrolled the cordon sanitaire between serious art, epitomized by abstract expressionism, and commercial art, that wasteland of kitsch and schlock. Clement Greenberg, the high priest of postwar art criticism, dismissed *all* representational art as kitsch; illustration, it went without saying, was beneath contempt. Decades after abstract expressionism's heyday, the art world was still doubling down on its disdain for the genre: a 1989 article in the *Christian Science Monitor* noted that prominent museums were "reluctant to display or even collect" illustration art, an observation that holds true to this day.[10] By the same token, graduate programs discourage dissertations on the subject because, as a source quoted in the *Monitor* informed, "If you choose to get involved in a secondary art form, which is where American illustration fits in, you are regarded as a secondary art historian."

Gorey didn't help matters by standing the logic of the critical establishment on its head. He had zero tolerance for intellectual pretension and seemed to regard gravitas as dead weight, a millstone for the mind. Like the baroque music he loved, he had an exquisite lightness of touch, both in his inked line and in his conversation, which sparkled with quips and aperçus. He pooh-poohed the search for meaning in his work ("When people are finding meaning in things—beware," he warned) and championed as aesthetic virtues (with tongue only partly in cheek) the inconsequential, the inconclusive, and the nonchalant.[11]

Those virtues, as well as Gorey's persona—a pose that incorporated elements of the aesthete, the idler, the dandy, the wit, the connoisseur of gossip, and the puckish ironist, wryly amused by life's absurdities—were steeped in the aestheticism of Oscar Wilde and in the ennui-stricken social satire of '20s and '30s English novelists such as Ronald Firbank and Ivy Compton-Burnett, both of whom, like Wilde, were gay.

Gorey's own sexuality was famously inscrutable. He showed little

interest in the question, claiming, when interviewers pressed the question, to be asexual, by which he meant "reasonably undersexed or something," a state of affairs he deemed "fortunate," though why that should be fortunate only he knew.[12] To nearly everyone who met him, however, his sexuality was a secret hidden in plain sight. There was the bitchy wit. The fluttery hand gestures. The flamboyant dress: floor-sweeping fur coats, pierced ears, beringed fingers, and pendants and necklaces, the more the better, jingling and jangling. And that campy delivery, plunging into sepulchral tones, then swooping into near falsetto. "Gorey's conversation is speckled with whoops and giggles and noisy, theatrical sighs," wrote Stephen Schiff in a *New Yorker* profile. "He can sustain a girlish falsetto for a very long time and then dip into a tone of clogged-sinus skepticism that's worthy of Eve Arden."[13] Many of his intellectual passions—ballet, opera, theater, silent movies, Marlene Dietrich, Bette Davis, Gilbert and Sullivan, English novelists like E. F. Benson and Saki—were stereotypically gay. Nearly everyone who met him pegged him as such.

Viewing Gorey's art through the lens of gay history and queer studies reveals fascinating subtexts in his work and argues persuasively for his place in gay history, situating him in an artistic continuum whose influence on American culture has been profound.

"At the heart of all of Gorey, everything is about something else," his friend Peter Neumeyer, the literary critic, once observed.[14] In his life as well as his art, he embraced opposites and straddled extremes. His tastes ranged from highbrow (Balthus, Beckett) to middlebrow (*Golden Girls*, *Buffy the Vampire Slayer*) to lowbrow (true-crime potboilers, Star Trek novelizations, the Friday the 13th franchise). He was equally unpredictable in his critical verdicts, pitilessly skewering dancers in George Balanchine's ballets yet zealously defending, with a perfectly straight face, William Shatner's animatronic acting. Allowing that his work might hark back "to the Victorian and Edwardian periods,"

he pulled an abrupt about-face, asserting, "Basically I am absolutely contemporary because there is no way not to be. You've *got* to be contemporary."[15]

What you saw wasn't always what you got. Take his name. It was too perfect. *Edward* fits like a dream because his neo-Victorian nonsense verse is modeled, unapologetically, on that of Edward Lear (of "The Owl and the Pussycat" fame). His mock-moralistic tales are set, more often than not, in Edwardian times. Moreover, Gorey was an eternal Anglophile, and Edward is one of the most English of English names, a hardy survivor of the Norman Conquest that dates back to Anglo-Saxon times, when it was *Ēadweard*—"Ed Weird" to modern eyes unfamiliar with Old English, an apt sobriquet for a legendary eccentric. (Did I mention that he lived, in his later years, in a ramshackle nineteenth-century house that he shared with a family of raccoons and a poison-ivy vine creeping through a crack in the living-room wall? Gorey was benignly tolerant of both infestations—for a while.)

As for *Gorey*, well, the thing speaks for itself: his characters often meet messy ends. The novelist and essayist Alexander Theroux, a member of Gorey's social circle on Cape Cod, thinks "he felt obliged to be gory-esque, G-O-R-Y, because of that name." "Nominative determinism," the British writer Will Self calls it.[16] No doubt, the body count is high in Gorey's oeuvre. In his first published book, *The Unstrung Harp*, persons unknown may have drowned in the pond at Disshiver Cottage; in *The Headless Bust*, the last title published during his lifetime, "crocheted gloves and knitted socks" are found on the ominously named Stranglegurgle Rocks, leading the missing person's relatives to suspect the worst.*

Bookended by this pair of fatalities, the deaths in Gorey's hundred or so books include homicides, suicides, parricides, the dispatching of a big

*Publishers, dates of publication, and related details can be found, with a few exceptions, in "A Gorey Bibliography" at the end of this book. Quoted matter isn't cited in endnotes for the simple reason that nearly all Gorey's books are unpaginated; even so, readers shouldn't have much trouble tracking down quotations, since few Gorey titles are longer than thirty pages.

black bug with an even bigger rock, murder with malice aforethought, vehicular manslaughter, crimes of passion, a pious infant carried off by illness, a witch spirited away by the Devil, at least one instance of serial killing, and a ritual sacrifice (to an insect deity worshipped by man-size mantids, no less). In keeping with the author's unshakable fatalism, there are Acts of God: in *The Hapless Child*, a luckless uncle is brained by falling masonry; in *The Willowdale Handcar*, Wobbling Rock flattens a picnicking family.

And, of course, infanticides abound: children, in Gorey stories, are an endangered species, beaten by drug fiends, catapulted into stagnant ponds, throttled by thugs, fated to die in Dickensian squalor, or swallowed whole by the Wuggly Ump, a galumphing creature with a crocodilian grin.

To relieve the tedium between murders, there are random acts of senseless violence and whimsical mishaps:

There was a young woman named Plunnery
Who rejoiced in the practice of gunnery,
Till one day unobservant,
She blew up a servant,
And was forced to retire to a nunnery.[17]

Only rarely, though, does Gorey stoop to slasher-movie clichés, and then only in early works such as *The Fatal Lozenge*, an abecedarium whose grim limericks cross nonsense verse with the Victorian true-crime gazette. Graphic violence is the exception in Gorey's stories. He embraced an aesthetic of knowing glances furtively exchanged or of eyes averted altogether; of banal objects that, as clues at the scene of a crime, suddenly phosphoresce with meaning; of empty rooms noisy with psychic echoes, reverberations of things that happened there, which the house remembers even if its residents do not; of rustlings in the corridor late at night and conspiratorial whispers behind cocktail napkins—an aesthetic of the inscrutable, the ambiguous, the evasive, the oblique, the insinuated, the understated, the unspoken.

12

Gorey believed that the deepest, most mysterious things in life are ineffable, too slippery for the crude snares of word or image. To manage the Zen-like trick of expressing the inexpressible, he suggests, we must use poetry or, better yet, silence (and its visual equivalent, empty space) to step outside language or to allude to a world beyond it. With sinister tact, he leaves the gory details to our imaginations. For Gorey, discretion is the better part of horror.

The gory details: how he detested the phrase, not least because, year after dreary year, editors repurposed that shopworn pun as a headline for profiles but chiefly because it cast his sensibility as splatter-film shtick when in fact it was just the opposite—Victorian in its repression, British in its restraint, surrealist in its dream logic, gay in its arch wit, Asian in its attention to social undercurrents and its understanding of the eloquence of the unsaid.

Gorey was an ardent admirer of Chinese and Japanese aesthetics. "Classical Japanese literature concerns very much what is left out," he noted, adding elsewhere that he liked "to work in that way, leaving things out, being very brief."[18] His use of haikulike compression—he thought of his little books as "Victorian novels all scrunched up"[19]—had partly to do with a philosophical critique of the limits of language, at once Taoist and Derridean. Taoist because the opening lines of the *Tao Te Ching* echo his thoughts on language: "The name that can be named / is not the eternal Name. / The unnamable is the eternally real."[20] Derridean because Gorey would have agreed, intuitively, with the French philosopher Jacques Derrida's observations on the slipperiness of language and the indeterminacy of meaning.

Gorey believed in the mutability and the inscrutability of things and in the deceptiveness of appearances. "You are a noted macabre, of sorts," an interviewer observed, prompting Gorey to reply, "It sort of annoys me to be stuck with that. I don't think that's what I do exactly. I know I do it, but what I'm really doing is something else entirely. It just looks like I'm doing that."[21] Pressed to explain what, exactly, he *was* doing, Gorey was characteristically evasive: "I don't know what it is I'm doing; but it's not that, despite all evidence to the contrary."[22]

It's the closest thing to a skeleton key he ever gave us. Apply it to his work, and you can hear the tumblers click. Take death, his all-consuming obsession. Or is it? Despite the lugubrious atmosphere and morbid wit of his art and writing, Gorey uses death to talk about its opposite, life. In his determinedly frivolous way, he's asking deep questions: What's the meaning of existence? Is there an order to things in a godless cosmos? Do we really have free will? Gorey once observed that his "mission in life" was "to make everybody as uneasy as possible, because that's what the world is like"—as succinct a definition of the philosopher's role as ever there was.[23]

Gorey inclined naturally toward the Taoist view that philosophical dualisms hang in interdependent, yin-yang balance. And while his innate suspicion of anything resembling cant and pretension would undoubtedly have produced a pained "Oh, *gawd!*" if he'd dipped into one of Derrida's notoriously impenetrable books, he had more in common with the French philosopher than he knew. Derrida, too, questioned the notion of hierarchical oppositions, using the analytical method he called deconstruction to expose the fact that, within the closed system of language, the "superior" term in such philosophical pairs exists only in contrast to its "inferior" opposite, not in any absolute sense. Or, as the *Tao Te Ching* puts it, "When people see some things as beautiful, / other things become ugly. / When people see some things as good, / other things become bad."[24] Better yet, as Gorey put it: "I admire work that is neither one thing nor the other, really."[25]

Revealingly, there's an almost word-for-word echo, here, of the dismissive quip he tossed at the interviewer who asked him, point-blank, what his sexual preference was: "I'm neither one thing nor the other particularly."[26] The close harmony of these two answers invites the speculation that his aesthetic preference for things that aren't either/or but rather both/and—as well as his fondness for ambiguity and indirection, puns and pseudonyms, and, most of all, mysteries—may have had personal roots.

"What I'm trying to say," he told the journalist who pressed him on the question of his sexuality, "is that I am a person before I am any-

thing else."[27] In the end, isn't it a hobgoblin of little minds, this attempt to skewer a mercurial intelligence like Gorey's on the pin of language? "Explaining something makes it go away," he maintained. "Ideally, if anything were any good, it would be indescribable."[28]

The paradoxical, yin-yang nature of the man and his art bedeviled critics' attempts to sum up his sensibility in a glib one-liner, a point underscored by the train of oxymoronic catchphrases that trails behind Gorey. Writers trying to transfix that elusive thing, the Goreyesque, reach instinctively for phrases that conjoin like and unlike, describing his work as embodying "[the] comic macabre," "morbid whimsy," "the elusive whimsy of children's nonsense…with the discreet charm of black comedy," and "[the] whimsically macabre."[29] (Where would we be without the long-suffering "whimsy"?)

Gorey didn't fit neatly into philosophical binaries: goth or *Golden Girls* fan? "Genuine eccentric" or (his words) "a bit of a put-on"?[30] Unaffectedly who he was or, as he once confided, "not real at all, just a fake persona"?[31] Commercial illustrator or fine artist? Children's book author or confirmed pedophobe who found children "quite frequently not terribly likeable"?[32]

We can even see the quintessential Gorey look—Harvard scarf, immense fur coat, sneakers, and jeans, accessorized with a Victorian beard and a profusion of jewelry—as a sly rejoinder to black-or-white binaries, resolving Wildean aesthete and Harvardian, New York balletomane and Cape Cod beachcomber in an unnamable style that one journalist called "half bongo-drum beatnik, half fin-de-siècle dandy."[33] The effect, as the eye moves from the flowing white beard of a nineteenth-century litterateur to the elegant fur coat to land, anticlimactically, on scuffed white Keds, is a kind of sight gag—a goofy plunge from highbrow to low, with the sneakers as punch line.

Goths who knocked on Gorey's door, in his semiretired final decade on Cape Cod, were crestfallen to be greeted not by a palely loitering Victorian in a Wildean fur coat but by an avuncular gent in a polo shirt and, during the summer, those mortifying short shorts old guys insist on wearing. Gorey refused to play to type: in his driveway, where you'd ex-

pect to find a decommissioned hearse, sat a cheery yellow Volkswagen Beetle and, later, a shockingly suburban Volkswagen Golf (though it was black, at least). Not for him the sinister suavity of Vincent Price or the open-casket affect of Morticia Addams; Gorey alternated between the languorous air of the aesthete, all world-weary sighs and theatrically aghast "Oh, *dear*"s, and a Midwestern affability born of his Chicago roots, most evident in the bobby-soxer slang that peppered his speech ("zippy," "zingy," "goody," "jeepers").

For an auteur of crosshatched horrors who collected postmortem photographs of Victorian children, Gorey was disappointingly normal. "His work and his personality [were] enormously separate from one another," says Ken Morton, his first cousin once removed. "His day-to-day life was fairly frivolous and lazy and laid-back. It was watching *Buffy the Vampire Slayer* with a bunch of cats hanging on his shoulders and maybe reading a book at the same time or doing a crossword puzzle."[34]

As Morton points out, Gorey's everyday life wasn't terribly Goreyesque. When he wasn't hunched over his drawing board, he was cycling through routines so ritualized they verged on the obsessive. His virtually unbroken record of attendance at the New York City Ballet, from 1956 to 1979, is only the best known of his compulsions. "I'm a terrible creature of habit," he admitted.[35] "I do the same thing over and over and over and over. I tend to go to pieces if my routine is broken."[36]

The routines that filled his days added up to an existence that, by his own avowal, was essentially "featureless."[37] Gorey was a bookworm. Waiting in line, killing time before the curtain went up at the ballet, even walking down the street, he went through life with his nose in a book. (His library, at the time of his death, comprised more than twenty-one thousand volumes.) He was a movie junkie, taking in as many as a thousand films a year. Of course, he spent countless hours lost in George Balanchine's dances.

Not exactly the stuff of pulse-racing biography. This, after all, is the

man who, when asked what his favorite journey was, replied, "Looking out the window"; who "never could understand why people always feel they love to climb up Mount Everest when you know it's quite dangerous getting out of bed."[38] And if his uneventful life makes him an unlikely biographical subject, his tendency to snap shut, oyster-tight, when interviewers probed too deep makes him an especially uncooperative one. An only child, he was solitary by nature and single by choice. He had good friends, but whether he had any *close* friends is an open question. With rare exception, he was silent as a tomb on personal matters—his childhood, his parents, his love life. Even those who'd known him for decades doubted they truly knew him.

Gorey was inscrutable because he didn't *want* to be scruted. He was a master of misdirection, adroit at dodging the direct question (about his art, his sexuality). His theatrical persona was part of that strategy of concealment. (Freddy English, a member of his Harvard circle, always felt that behind the Victorian beard, the flowing coats, and "the millions of rings," Ted, as Gorey was known to his friends, was "a nice Midwestern boy" who "got himself done up in this drag.")

In 1983, I came face-to-face with that persona. I was twenty-three, fresh out of college and newly arrived in New York, working as a clerk at the Gotham Book Mart. The store's owner, Andreas Brown, was the architect of Gorey's ascent to mainstream-cult status, publishing his books, mounting exhibitions of his illustrations, inking deals for merchandise based on his characters. Now and then, Gorey dropped by, usually to sign a limited edition of a newly published title. I was running down a book for a customer when a tall man with a beard worthy of Walt Whitman swept down the aisle. He was chattering away in a stage voice of almost self-parodic campiness, and his costume was equally outlandish, a traffic-stopping getup of Keds, rings on each finger, and clanking amulets, topped off with a floor-length fur coat dyed the radioactive yellow of Easter Peeps. Taking in this improbable apparition, I wondered who was inside the disguise.

This book is the answer to that question.

Gorey is grist for the biographer's mill after all, not only because

he was an artist of uncommon gifts but because he was a world-class eccentric to boot. If his life looked, from the outside, like an exercise in well-rutted routines, its inner truth recalls the universe as characterized by the biologist J. B. S. Haldane: not only queerer than we suppose but queerer than we *can* suppose.[39] To be sure, he lived much of his life on the page, in the worlds he conjured up with pen and ink, and did most of his adventuring between his ears. In large part, the art *is* the life. But Gorey's work also gives us a spyhole into his mind (as does his conversation and his correspondence).

And what a mind: poetic, playful, darkly nonsensical à la Lewis Carroll, exuberantly silly as Edward Lear, generally nonchalant but prone to melancholy in the sleepless watches of insomniac nights, surrealist, Taoist, Dadaist, mysterious, mercurial, giddy with leaps of logic and free-associated connections, rich in spontaneous insights, childlike in the unselfconsciousness of his pet peeves, hilarious in the self-contradicting capriciousness of his likes and dislikes. Gorey charms us by virtue of his inimitable Goreyness—the million little idiosyncrasies that made him who he was. And he was *always* who he was—utterly, unaffectedly himself; a species of one, like his character Figbash, or the Zote in *The Utter Zoo*, or better yet the Doubtful Guest, his enigmatic alter ego in the book of the same name, a furry, sneaker-shod enfant terrible who turns an Edwardian household upside down.

That's as good a personification as any. Gorey was a dubious character, particularly in the eyes of children's book publishers and Comstockian guardians of childhood innocence. But he was also doubtful in the sense that he was fraught with doubts: about his art ("To take my work seriously would be the height of folly"[40]), his fellow Homo sapiens ("I just don't think humanity is the ultimate end"[41]), free will ("You never really choose anything. It's all presented to you, and then you have alternatives"[42]), God, romantic love, language, the Meaning of Life, you name it. On occasion, he even doubted his own existence: "I've always had a rather strong sense of unreality. I feel other people exist in a way that I don't."[43]

Then, too, Gorey was a Doubtful Guest in the sense that he seemed

as if he'd been born in the wrong time, maybe even on the wrong planet. By all accounts, he regarded the human condition with a kind of wry, anthropologist-from-Mars mixture of amusement and bemusement. "In one way I've never related to people or understood why they behave the way they do," he confessed.[44]

How to get to the bottom of a man whose mind was intricate as Chinese boxes? In the pages to come, we'll use the tools of psychobiography to make sense of Gorey's relationships with his absent father and smothering mother and of the lifelong effects of growing up an only child with a prodigious intellect (as measured by the numerous IQ tests he endured). Gay history, queer theory, and critical analyses of Wildean aestheticism and the sensibility of camp will be indispensable, too, in unraveling his tangled feelings about his sexuality, his stance vis-à-vis gay culture, and the "queerness" (or not) of his work. A familiarity with the ideas underpinning surrealism will help us unpack his art, and a close study of nonsense (as a literary genre) will shed light on his writing. An understanding of Balanchine, Borges, and Beckett will come in handy, as will an appreciation of Asian art and philosophy (especially Taoism), the visual eloquence of silent film, the mind-set of the Anglophile, and the psychology of the obsessive collector (not just of objects but of ideas and images, too).

Yet no matter how carefully we prowl the lawn for footprints or scour the Persian rug for bloodstains, like the sleuths in the Agatha Christie whodunits he loved so much, the Mystery of Edward St. John Gorey is, ultimately, uncrackable. "Each Gorey drawing and each Gorey tale is a mystery that ends—meaningfully—with the absence of meaning," Thomas Curwen observed in the *Los Angeles Times*. "He would never presume to know, and if he did, he would never tell."[45] "Always be circumspect. Disdain explanation," wrote Gorey in a postcard to Andreas Brown.[46] The deeper we go into the hedge maze, the more stealthily we try the doorknobs in the rambling manor's abandoned west wing, the more elusive he seems. Not that it matters: with Gorey, never getting there is half the fun.

CHAPTER 1

A SUSPICIOUSLY NORMAL CHILDHOOD

Chicago, 1925–44

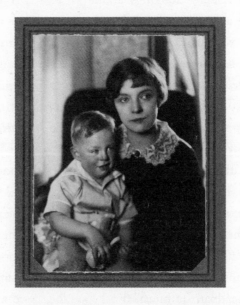

Ted Gorey, age two, with his mother, Helen Garvey Gorey, 1927.
(Elizabeth Morton, private collection)

HIS WAS "A PERFECTLY ordinary childhood," Gorey always insisted.[1] "The facts of my life are so few, tedious, and irrelevant to anything else," he once told an interviewer—no doubt with one of the full-body sighs he used as a melodramatic flourish—"there is no point in going into them."[2]

The facts: Edward St. John Gorey was born on February 22, 1925, at St. Luke's Hospital, Chicago. Father: Edward Leo Gorey, twenty-seven, newspaperman. Got his start as a police reporter, covering local crime. From 1920 to 1933, worked the politics beat for Hearst's *Chicago*

Evening American, climbing by '31 to the position of political editor. Later, publicist; still later, aide to an alderman, as Chicago calls the powerful ward representatives who sit on its city council. Mother: Helen Garvey Gorey, thirty-two, stay-at-home mom. Both parents were of Irish descent, though the Garveys—moneyed, Republican, Episcopalian—were the lace-curtain variety, several rungs up the socioeconomic ladder from the working-class, Democrat, devoutly Catholic Goreys. (Disapproving noises were heard, on the Garvey side, when they married—cluckings about Helen marrying beneath her station.) Ted—as the younger Edward was known—was a bright kid, well adjusted, well liked. Bookworm, culture vulture, aspiring artist. Attended high school at Francis W. Parker, a progressive private school founded on Deweyite principles. Drafted into the army in '44. Off to Harvard in '46.

Even Gorey seemed regretful that his origins didn't live up to his myth, lamenting that he "did not grow up in a large Victorian house" and noting, with half joking dismay, that his childhood was "happier than I imagine. I look back and think, 'Oh poetic me,' but it simply was not true. I was out playing Kick-the-Can along with everybody else."[3]

Of course, he was adroit at throwing sleuths off the scent. When an interviewer sniffed around the subject of his childhood, he led his interlocutor off into the tall grass of a digression or swatted the question aside with a deadpan quip: asked what he was like as a child, Gorey replied, "Small."[4] When all else failed, he pled amnesia. "What's past is past," he declared, closing the door on the subject.[5]

But the past is *never* past, not in the dark room of the subconscious, where our childhood memories become *more* vivid, not less, with age, and certainly not in gothic fiction, where the past we've repressed always comes back to haunt us. And much of Gorey's fiction, whatever else it is—existentialist, absurdist, surrealist—is inescapably gothic. It's *all about* the past, from its period settings to its archaic language to the obvious fact that Gorey uses obsolete genres (the Puritan primer, the Dickensian tearjerker, the silent-movie melodrama) to tell his stories.

Gorey's own story, it turns out, is as full of unsolved riddles and

buried secrets as any good mystery, though his childhood looks suspiciously normal at first glance.

It wasn't.

How normal is teaching yourself to read at the age of three and a half, then cutting your eyeteeth on Victorian novels? Gorey lived up to the myth of the precocious only child, plowing through *Dracula* and Lewis Carroll's *Alice in Wonderland* and *Through the Looking-Glass*—in the same *month*, even—between the ages of five and seven, with *Frankenstein* close on their heels. *Dracula* scared him to death, he said. By the age of eight, he'd read the collected works of Victor Hugo, he claimed, a herculean labor that perplexed even Gorey himself, retrospectively. "Chloroform!" was his adult verdict. "But I can still remember a Hugo being forcefully removed from my tiny hands when I was about eight so I could eat my supper."[6]

Gorey's infatuation with *Dracula* and *Frankenstein* at an age when most of us are struggling with *Charlotte's Web* was an augury: the gothic sensibility is deeply embossed on his work. His encounter with *Dracula* was especially prophetic, not only because the bat-winged shadow of the gothic would flap across his aesthetic but also because he would owe the sanguinary count his greatest commercial success. Gorey's costume and set design for the Broadway production of the play based on Bram Stoker's novel made him the toast of Manhattan theater circles in 1977 and bought him a house on Cape Cod.

No less important for a budding visual intelligence were the illustrations in the books he read as a child. "We [had] a wonderful horrid thing called *Child Stories from Dickens*, which was illustrated with chromolithographs," he recalled. "It was all the deaths: Little Nell, [Smike] from *Nicholas Nickleby*. I remember it with horror."[7]

He fell in love with Ernest Shepard's wry, fine-lined drawings for A. A. Milne's *Winnie-the-Pooh* and the sharp-nibbed precision of Tenniel's illustrations for the *Alice* books. Little wonder, then, that he

grew up to be the sort of artist who is all about line. "Line drawing is where my talent lies," he said in a 1978 interview.[8] What strikes the eye before anything else, in Gorey's work, is his mesmerizing pen-and-ink technique. Look close, and you can almost see the pullulation of a million little strokes. You've seen this texture somewhere before, the tight mesh of crisscrossed lines. And then it hits you: the man is doing *hand-drawn engraving*. What you're looking at, in all that impossibly uniform stippling and cross-hatching, is the fastidious mimicry, by hand, of effects usually achieved with engravers' tools: gravers, rockers, roulettes, burnishers. Gorey is a counterfeiter of sorts, fooling us into thinking his drawings are engravings, obviously of Victorian or Edwardian vintage, undoubtedly by an Englishman long dead.

According to Gorey, "the Victorian and Edwardian aspect" of his work had its origins in "all those 19th-century novels I've read and [in] 19th-century wood engraving and illustration."[9] But there was a more elusive quality that seduced him as well, "the strange overtone" nineteenth-century illustrations have taken on over time.[10] The Victorian era bore witness to the birth of the mass media, inundating British society with a flood of mass-produced images. Many of those images are still floating around, in one form or another, and Gorey was drawn to the uncanniness of all those transmissions from a dead world—specifically, to their unsettling combination of coziness and creepiness, which Freud called the *unheimlich* (literally, "unhomelike").

It was that same quality, he thought, that seduced the surrealist artist Max Ernst, who with the aid of scissors and paste conjured up dreamlike vignettes from Victorian and Edwardian scientific journals, natural-history magazines, mail-order catalogs, and pulp literature. Gorey was profoundly influenced by Ernst's wordless, plotless "collage novels," of which *Une Semaine de Bonté* (A week of kindness, 1934) is the best known. Seamlessly assembled from black-and-white engravings, Ernst's images look like scenes from silent movies shot on some back lot of the unconscious: a bat-winged woman weeps on a divan, oblivious to the sea monster beside her; a tiger-headed man brandishes a severed head, fresh from the guillotine. "I was very much taken with

[nineteenth-century illustrations], in the same way that I presume Max Ernst was," said Gorey. "I mean, all those things that Ernst used in his collages *can't* have looked that sinister to people in the 19th century who were just leafing through ladies' magazines and catalogues. And, of course, now they look nothing but sinister, no matter what. Even the most innocuous Christmas annual is filled with the most lugubrious, sinister engravings."[11]

Gorey started drawing even earlier than he started reading, at the age of one and a half.[12] "My first drawing was of the trains that used to pass by my grandparents' house," he remembered.[13] Benjamin St. John Garvey and Prue (as Ted's stepgrandmother, Helen Greene Garvey, was known to the family) lived in Winthrop Harbor, an affluent suburb north of Chicago on the shores of Lake Michigan. Their house was on a bluff, overlooking the Chicago and North Western railroad tracks. Describing his infant effort, he recalled, "The composition was of various sausage shapes. There was a sausage for the railway car, sausages for the wheels, and little sausages for the windows."[14]

Gorey, who saw much more of his mother's side of the family than he did his father's, seems to have had fond memories of his visits to Winthrop Harbor: family photos show him squatting by an ornamental pond, peering at a flotilla of lily pads; trotting alongside his grandfather as he mows the lawn.

All of which has the makings of what Gorey assured interviewers was a disappointingly "typical sort of Middle-Western childhood."[15] Before his birth, however, his grandparents starred in a gothic set piece—a messy divorce—that must have scandalized the Garvey clan, especially since the Chicago papers gave it front-page play. (Benjamin was vice president of the Illinois Bell Telephone Company, and his marital melodrama made good copy.) Whether any sense of things hushed up crept into the corners of Gorey's consciousness, we don't know, though it's tempting to locate the sense of things repressed that pervades his

work—the furtive glances, the averted gazes—in the grown-ups' whisperings about scenes played out behind closed doors.

Gorey's grandmother Mary Ellis Blocksom Garvey had divorced his grandfather in 1915; it was the unhappy denouement of a marriage buffeted by accusations of madness and counteraccusations of forced stays in sanitariums, where Gorey's grandmother was restrained in a straitjacket and left to languish in solitary confinement, she claimed. "TRIED TO DRIVE ME INSANE," WIFE ASSERTS IN SUIT, the *Chicago Examiner* blared. PHONE MAN KEPT HER IN SANITARIUM UNTIL REASON FLED, SHE DECLARES.[16]

The divorce sowed discord among the Garvey children. Ted's cousin Elizabeth Morton (known by her nickname Skee*) remembers him talking about his mother and her siblings fighting. Skee's sister, Eleanor Garvey, thinks "it was a fairly volatile family."

Asked by an interviewer if he was an only child, Gorey said, "Yes. And in childhood I loved reading 19th-century novels in which the families had 12 kids."[17] Then, in the next breath: "I think it's just as well, though, that I didn't have any brothers or sisters. I saw in my own family that my mother and her two brothers and two sisters were always fighting. There were so many ambivalent feelings. And then my grandmother would go insane and disappear for long periods of time." (Madness and madhouses recur throughout Gorey's work: an asylum broods on a desolate hill in *The Object-Lesson*; the protagonists of *The Willowdale Handcar* spy a mysterious personage who may or may not be the missing Nellie Flim "walking in the grounds of the Weedhaven Laughing Academy"; Madame Trepidovska, the ballet teacher in *The Gilded Bat*, loses her reason and "must be removed to a private lunatic asylum"; Jasper Ankle, the unhinged opera fan who stalks Madame Caviglia in *The Blue Aspic*, is "committed to an asylum where no gramophone [is] available"; Miss D. Awdrey-Gore, the reclusive mystery writer memorialized in *The Awdrey-Gore Legacy*, may or may not have gone to ground in "a private lunatic asylum"; and on and on.)

*After Skeezix, the foundling left on a doorstep in the long-running newspaper strip *Gasoline Alley*.

In later life, Gorey adopted Eleanor and Skee as surrogate siblings. "I felt as if I were his little sister," says Skee. "Since we never had a brother, and he never had any siblings..." She trails off, the depth of feeling in her voice unmistakable. "I think that's why he liked being here, 'cause it was like having sisters," she decides. (By "here," she means Cape Cod, where Gorey spent summers with his Garvey cousins from 1948 on, moving there for good in 1983.) Cousins are the most frequent familial relations in Gorey's stories; make of that what you will.

The childhood Gorey insisted was "happier than I imagine" was troubled by tensions in his parents' marriage, too. Class frictions between the Garveys' aspirational WASPiness and the Goreys' cloth-cap Irishness complicated things. Who knows how Ted negotiated the transition from his well-heeled grandparents' suburban idyll, in Winthrop Harbor, to the corner-pub world of his Gorey relatives?

Unsurprisingly, the group psychology of families—relations between husbands and wives, the interactions of parents and children—is fraught in Goreyland. Parents are absent or hilariously absentminded, like Drusilla's parents in *The Remembered Visit*, who, "for some reason or other, went on an excursion without her" one morning and never returned. Of course, neglectful parents are vastly preferable to the heartless type, a more plentiful species in Gorey stories. In *The Listing Attic*, we meet the "headstrong young woman in Ealing" who "threw her two weeks' old child at the ceiling...to be rid of a strange, overpowering feeling"; the Duke of Daguerrodargue, who orders the servants to dispose of the puny pink newborn that nearly killed his wife in childbirth; and the "Edwardian father named Udgeon, / whose offspring provoked him to dudgeon," so much so that he'd "chase them around with a bludgeon."

Kids growing up in households where adults are inscrutable and unpredictable learn that keeping their mouths shut and their expressions blank is the shortest route to self-preservation. (Burying your nose in a book is another way of making yourself invisible.) Gorey's people are almost entirely expressionless, their mouths tight-lipped little dashes; they barely make eye contact and shrink from displays of affection. Conver-

sation consists mostly of non sequiturs; awkward silences hang in the air. Alienation and flattened affect are the norm.

The only truly happy relationships in Gorey's books are between people and animals: Emblus Fingby and his feathered friend in *The Osbick Bird*, Hamish and his lions in *The Lost Lions*, Mr. and Mrs. Fibley and the dog they regard as a surrogate child when their infant disappears from her cradle in *The Retrieved Locket*. None of which is at all surprising: Gorey's fondness for his cats was at least as deep as his affection for his closest human friends, probably deeper. Asked by *Vanity Fair*, "What or who is the greatest love of your life?" he replied, "Cats."[18] Perhaps the warmest bonds are between animals, as in *The Bug Book*, the only Gorey title with an unequivocally happy ending. In it, a pair of blue bugs who live in a teacup with a chip in the rim are "on the friendliest possible terms" with some red bugs and yellow bugs, calling on each other constantly and throwing delightful parties. They're all cousins, of course.

In 1931, another not entirely ordinary incident ruffled the placid surface of Gorey's "perfectly ordinary" childhood. He was six, but his precociousness enabled him to skip first grade and enroll as a second grader. The school in question was a parochial school; Gorey had been baptized Catholic. Saint Whatever-It-Was (no one knows which of Chicago's parochial schools he attended) was loathe at first sight. "I hated going to church and I do remember I threw up once in church," he recalled. "I didn't make my First Communion because I got chicken pox or measles or something and that sort of ended my bout with the Catholic church."[19]

The temptation to see Gorey's suspiciously well-timed illness as a verdict on the faith is tempting, especially in light of his terse response to the question, "Are you a religious man?": "No."[20] His brief spell in Catholic school didn't leave him with the usual psychological stigmata, he claimed—"I'm not a 'lapsed Catholic' like so many people I know who apparently were influenced forever by it"—but it does seem to have put him off organized religion for good.[21]

A subtle anticlerical strain runs through Gorey's work: cocaine-addled curates beat children to death, nuns are possessed by demons, unfortunate things happen to vicars. In Goreyland, immoderate religiosity is soundly punished: Little Henry Clump, the "pious infant" of Gorey's 1966 book of the same name, is pelted by giant hailstones, succumbs to a fatal cold, and lies moldering in his grave, all of which make the narrator's assurance that Henry has gone to his reward sound like a laugh line for atheists. *Saint Melissa the Mottled*, a book Gorey wrote in 1949 but never got around to illustrating (Bloomsbury published it posthumously, with images filched from his other books), is a gothic hagiography about a nun noted not for good works but for Miracles of Destruction. Given to dark designs involving blowgun darts, Melissa graduates, in time, to "supernatural triflings" such as the withering of the Duke of Dimgreen's arm and a seagull attack on two young girls. In death, she becomes the patron saint of ruinous randomness. She's just the sort of saint you'd dream up if you believed, as Gorey did, that "life is intrinsically, well, boring and dangerous at the same time. At any given moment the floor may open up. Of course, it almost never does; that's what makes it so boring."[22]

In fact, the floor *was* always opening up in Gorey's early years.

For example, after his less-than-successful year in parochial school, his parents sent him to Bradenton, Florida, a small city between Tampa and Sarasota, to live with his Garvey grandparents for the following year.

Why? It is, as they say in Catholic theology, a Mystery.

In the fall of '32, he entered third grade in Bradenton, at Ballard Elementary. He seems to have landed on his feet, catlike, in alien surroundings: he made new friends, had a dog named Mits, was a devoted reader of the newspaper strips ("I get all the Sunday funnies, but I want you to send down the everyday ones," he wrote his mother), and earned high marks on his schoolwork.[23]

But a December 1932 photo of him with his grandfather Benjamin Garvey tells another story. Sitting in a rocker on what must have been

the Garveys' porch or patio, the old man gazes benignly, through wire-rimmed glasses, at the dog on his lap, petting him; Mits—it must be Mits—arches his back in an excess of contentment. Ted stands behind him, a proprietary hand on his grandfather's shoulder. He regards us with the same penetrating gaze, the same unsmiling mien we see in his posed photos as an adult. It is, to the best of my knowledge, the only picture of Gorey touching someone in an obvious gesture of affection.

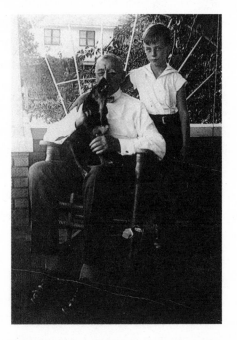

Gorey, age seven, in Bradenton, Florida, with his maternal grandfather, Benjamin S. Garvey, December 1932. *(Elizabeth Morton, private collection)*

Returning to Chicago in May of '33, eight-year-old Ted was packed off to something called O-Ki-Hi sleepaway camp, an "awful" experience he managed to survive by spending all his time "on the porch reading the Rover Boys."[24]

Clearly there was more than enough unpredictability and inexplicability in his world to inspire his life's goal, as an artist, of making everybody "as uneasy as possible, because that's what the world is like." "We moved around a lot—I've never understood why," he told an

interviewer when he was sixty-seven. "We moved around Rogers Park, in Chicago, from one street to another, about every year."[25] By June of 1944, when he left Chicago for his army posting to Dugway Proving Ground, outside Salt Lake City, he'd called at least eleven addresses home: two in Hyde Park, five in Rogers Park, two in the North Shore suburb of Wilmette, one in the city's Old Town neighborhood (in the Marshall Field Garden Apartments), and one in Chicago's Lakeview community.[26] He'd been bundled off to Florida twice, the second time to Miami, where in 1937 he attended Robert E. Lee Junior High, returning to Chicago for the summer of '38. All told, he'd gone to five grammar schools by the time he enrolled in high school.

In later years, Gorey would structure his everyday life through unvarying routines, some of them so ritualized they bordered on the obsessive-compulsive. It's hard not to see them as a response to the rootlessness of his early years—existential anchors designed to tether a self he often experienced as unmoored, disconcertingly "unreal," given to "drift." Compulsive in the colloquial if not the clinical sense of the word, Gorey's daily rituals may have provided a reassuring predictability, and thus a sense of stability, to a man marked by the frequent, never-explained disruptions that kept yanking the rug out from under him during his childhood.

Looking back from the age of seventy, he still couldn't make sense of his family's apparently arbitrary movements around the city. "I never quite understood that. I mean, at one point I skipped two grades at grammar school, but I went to five different grammar schools, so I was always changing schools...which I didn't like. I hated moving and we were always doing it. Sometimes we just moved a block away into another apartment; it was all very weird."[27]

In 1933, the Great Depression hung on the mental horizon like a thunderhead, darkening American optimism. It was the year the economy hit rock bottom, with one in four workers out of a job. And then

there was the waking nightmare of the kidnapping of the Lindbergh baby. A year ago that May, a horrified nation read the news of a truck driver's accidental discovery of the infant's badly decomposed body, partly dismembered, his head bashed in. Charles Lindbergh was one of the most famous people in the world; the child's abduction on March 1, 1932, and the unfolding story of the Lindberghs' fruitless negotiations with the kidnapper, mesmerized America, as did the manhunt that followed the gruesome discovery of Baby Lindy's remains.

Ted couldn't have been oblivious to the crime of the century, as the papers dubbed it. Maybe he followed the unfolding horror story in the *Chicago Daily News*, as his soon-to-be high school classmate Joan Mitchell did: the baby snatched from his bed in the dead of night; the creepy, barely literate ransom note ("warn you for making anyding public or for notify the Police").[28] Mitchell was sick with fear that bogeymen would spirit her away, too. And not without reason: her family was well-to-do, and Illinois, in the Depression years, was ground zero for kidnappings. Ransom payments from the rich were low-hanging fruit for gangsters, who grabbed more than four hundred victims during 1930 and 1931 alone, more than in any other state in the nation.[29] The abductions in Gorey's little books—Charlotte Sophia carried off by a brute in *The Hapless Child*, Millicent Frastley snatched up by man-size insects in *The Insect God*, Eepie Carpetrod lured to her doom by the serial killers in *The Loathsome Couple*, Alfreda Scumble "abstracted from the veranda by gypsies" in *The Haunted Tea-Cosy*—may be post-traumatic nightmares reborn as black comedy.

Gorey's awareness of the horrors of everyday life may have been heightened by his father's experiences as a crime reporter, too. By the time Ted was born, Ed Gorey was covering politics, but it's not inconceivable that the younger Gorey overheard his father reminiscing about his days on the police beat, writing stories like the ones Ben Hecht filed at the *Chicago Daily Journal*—gruesome fare such as the tale of a "Mrs. Ginnis, who ran a nursery for orphans in which she murdered an average of 10 children a year," and the one about the guy who dispatched his wife, lopped off her head, and "made a tobacco jar of its skull," as Hecht

recalled.[30] Then, too, as a newspaperman, Ed Gorey would have been a voracious reader of the dailies; it's easy to imagine his son riveted by the big black headlines screaming from his father's morning paper, never mind its lurid front-page photos. Could Ted have acquired his appetite for true crime at the breakfast table? The imperturbable voice in which he narrates his tales of fatal lozenges, deranged cousins, and loathsome couples sounds a lot like a poker-faced parody of police-beat reporting, with its terse, declarative sentences and just-the-facts deadpan.

At the same time, there's no denying the echoes, in his "Victorian novels all scrunched up," of nineteenth-century fiction, with its whispered intrigues and buried scandals. His vest-pocket melodramas owe a debt, too, to what were known in Victorian England as penny dreadfuls or shilling shockers—cheap, crudely illustrated booklets featuring serialized treatments of unfolding crime stories. And then there were the detective novels Helen and Ed Gorey read by the bushel. "Both my parents were mystery-story addicts," Ted remembered, "and I read thousands of them myself."[31] Agatha Christie, Ngaio Marsh, Margery Allingham, and Dorothy L. Sayers left their imprint on Gorey's imagination—Christie's books especially, with their characteristically English blend of snug domesticity and penny-dreadful horrors. "Sinister-slash-cozy," Gorey called it.[32]

Christie became the infatuation of a lifetime, and her take on the tea-cozy macabre is a pervasive influence. Gorey's devotion to the Queen of Crime was absolute, impervious to the passage of time and undeterred by snobbish eye rolling. "Agatha Christie is still my favorite author in all the world," he said when he was pushing sixty.[33] By the time he'd reached seventy-three, he'd read every one of her books "about five times," he reckoned.[34] Her death left him desolate: "I thought: I can't go on."[35]

On top of all that, he grew up in Prohibition-era Chicago—Murder City, in newsroom patois. For much of Gorey's childhood, Al Capone and his adversaries made the mental life of Chicagoans look like one of those spinning-headline montages in period movies. The horror of bloodbaths like the Saint Valentine's Day Massacre, in which hit men

lined gangsters up against a garage wall and raked them with machine-gun fire, reverberated in the mass imagination.

Given the time and place he grew up in, and his father's days on the police beat, it's hardly surprising that Gorey, asked why "stark violence and horror and terror were the uncompromising focus of his work," replied, "I write about everyday life."[36]

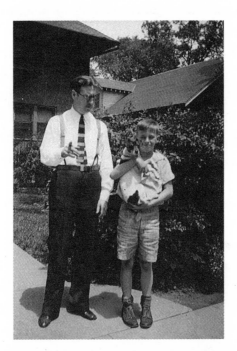

Ted with his father, Edward Leo Gorey, in Wilmette, Illinois, circa '34–36. Gorey is somewhere between nine and eleven.
(Elizabeth Morton, private collection)

Sometime around April 16, 1934, the Goreys moved from 1256 Columbia Avenue, in the North Side neighborhood of Rogers Park, to the snug, tree-shaded North Shore suburb of Wilmette. (Little is known about Ted's time on Columbia Avenue beyond the fact that he spent fourth grade at Joyce Kilmer Elementary School, a short walk from

the Goreys' red-brick apartment building, and that he received straight Es—for "excellent"—on his progress report.)[37]

This change of address was weirder than most, since his father had just landed a new job, not in Wilmette but in downtown Chicago. In 1933, he'd reinvented himself as publicity director of two luxury hotels, the Drake and the Blackstone. Both were bywords for elegance, playing host to champagne-by-the-jeroboam high rollers, backroom deal makers, and even presidents. Why Gorey's father moved his family *farther* from his workplace, to the suburbs north of the city, is a puzzler.

Maybe he wanted a better life for his family, a piece of the gracious living advertised by North Shore realtors. The Goreys' rental was "a cube shaped elephant grey stucco house" at 1506 Washington Avenue in West Wilmette, with "an upstairs sunroom that managed to have windows on all four sides," as Ted recalled it.[38] In the fall of '34, he enrolled in the sixth grade at Arthur H. Howard School, a cross between an elementary and a junior high school that spanned kindergarten through eighth grade. He was nine years old. How he managed the trick of skipping fifth grade we don't know; presumably, he tested out of it. As in Bradenton, Ted fit right in. "He does very superior work...with apparent ease, and socially he is well adjusted," his homeroom teacher, Viola Therman, noted on his spring '35 report card.[39] She was, she wrote, "anxious to see what he will accomplish with an activity program in the form of the puppet play [he is] now planning"—a revealing aside in light of the puppetlike nature of Gorey's characters and his fascination, near the end of his life, with puppet shows, which he staged in Cape Cod theaters with his hand-puppet troupe, Le Théâtricule Stoïque.

As of June '36, the Goreys had moved across town to the Linden Crest apartments at 506 5th Street, a block from the 4th and Linden El stop.

That September, Ted enrolled in the eighth grade at a nearby junior high, the Byron C. Stolp School, a shorter walk from his new address than Howard. Gorey, famously not a joiner as an adult, was the quintessential joiner in junior high: alongside his photo in the 1936–37 edition of the Stolp yearbook, *Shadows*, he's listed as assembly president as well

as a member of the typing club, the Shakespeare club, the glee club, and, not least, the art club.

Gorey's art teacher at Stolp was Everett Saunders, a former WPA painter and dedicated mentor to would-be artists. Saunders oversaw the art club, whose ranks included Warren MacKenzie and, improbably enough, Charlton Heston. MacKenzie would grow up to be a master potter whose Japanese-influenced clayware is prized for its understated beauty. Now ninety, he remembers Heston as "a real poser," a characterization confirmed by Heston's Stolp yearbook photo, in which the man who would be Moses, sporting a budding pompadour, gives the camera an eighth grader's idea of a smoldering gaze. (What can it mean that "Gorey always claimed with a straight face," according to his friend Alexander Theroux, that "Charlton Heston was 'the actor of our time'"?)[40]

MacKenzie, who coedited the 1937 *Shadows*, recalls Gorey's "really funny" cartoons for the yearbook's club pages. Ted executed nine full-page line drawings, among them a picture of a cat in an artist's smock and beret holding a palette and a dripping paintbrush (for the art club); a cat in an eyeshade, sweating bullets, up against a deadline from hell (for the journalism club); and a feline Romeo in a Renaissance cape, tearfully pacing his balcony under a crescent moon (for the Shakespeare club). They're cute in a Joan Walsh Anglund meets *Harold and the Purple Crayon* way that clashes with our image of what's Goreyesque.

At the same time, they *do* foreshadow the Gorey we know in their careful attention to costume—his fondness for patterns (plaids, checks, stripes) is already in evidence—and in their shading, where there's no mistaking his preference for neatly parallel lines as opposed to smudged effects or solid blacks. There's a naive charm to Gorey's illustrations, off-set by a self-assurance that's remarkable in a twelve-year-old. "His things all had a common feel about them," MacKenzie recalls, "and the instructor who was in charge"—Saunders—"said, 'Well, [his drawings are] going to be the theme of the yearbook this year,' and they were, and they were wonderful."

No one seems to know exactly when Helen and Ed Gorey divorced, though just about everyone agrees it happened in 1937. Betty Caldwell, then Betty Burns, a friend Ted had made at the Linden Crest apartments, recalls the "sad day" when she had to tell him, "'Ted, I can't see you anymore. We're going on a vacation; we're going to be gone for two weeks.' And he said, 'Betty, it's worse than that. My mother's divorcing my father. We're moving to Florida.'" On October 7, 1937, having graduated from eighth grade that June, Ted left for Florida with his mother.

Then and ever after, Gorey was silent on the subject of his parents' divorce. Beyond a passing remark that he saw more of his parents *after* the divorce than before, he took the Fifth on the whole business, especially on any psychological fallout he experienced as a kid. "I don't think I had even noticed they parted," he claimed, preposterously, in a 1991 interview.[41] In four years' worth of diary entries, he doesn't so much as mention his father, perhaps because they weren't in touch, possibly because they'd never been that close, or maybe because Ed Gorey's departure was clouded by scandal.

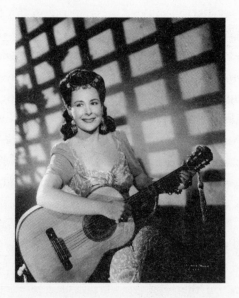

Corinna Mura in *Casablanca* (1942). *(Warner Bros./Photofest, Inc.)*

When he left Helen, sometime after June '37, it was for another woman: Corinna Mura, a guitar-strumming singer of Spanish-flavored torch songs. She was thirty-five; Ed was thirty-nine. It seems likely they met at the Blackstone: Mura played the nightclub circuit when she was in town. In addition to her career as a nightclub chanteuse, she was an occasional movie actress. There she is, about a half hour into *Casablanca*: the raven-haired singer in Rick's Café, strolling from table to table, troubadour-style, as she gives "Tango Delle Rose" her throbbing, emotion-choked all. And there she is again, a coloratura soprano amid the *citoyens* in the rousing scene where everyone belts out "La Marseillaise."

On screen and on recordings such as "Carlotta" (from the original cast album of the 1944 Broadway musical *Mexican Hayride*), Mura's persona was that of a glamorous Latina—a "Spanish songstress," in the showbiz patter of the day, at a time when "Spanish" was a blanket term for anyone we'd now call Latinx.[42]

Truth to tell, Mura was born Corynne Constance Wall in Brownwood, Texas, to David and Lillian Wall (née Jones). (Mura is what *muro*, Spanish for "wall," would be, presumably, if the noun were feminine.) Her Latina persona satisfied white America's racial fantasy of a colorful yet unthreatening otherness—"a dignified American girl" who "has the gay manner of a Latin" (as a newspaper profile put it), "cultured" enough to sing opera yet still "Mex" enough to take audiences on a journey down Mexico way.[43] That said, her passion for the musical traditions and cultures of Latin America was sincere. She toured South America, where "they absolutely loved her," according to her daughter Yvonne "Kiki" Reynolds—testimony not only to her virtuosity but to her genuine rapport with her audiences as well, since she didn't speak a word of Spanish. (She learned her Spanish-language songs phonetically.)

On July 2, 1937, Ed Gorey was in Austin, Texas, "getting married—quietly," he told a friend in a letter.[44] By October of that year, Ted and his mother were on their way to Florida. He plotted their road trip in green crayon on the map in his travel diary. As always, he confides

next to nothing to his diary, despite being uprooted, yet again, from his home and friends and despite the emotional upheaval of his parents' divorce and his grandfather's death. (Benjamin St. John Garvey had died the day after Ted's birthday in 1936, shortly after speaking to his grandson on the phone.)

Arriving in Miami in November of '37, Ted and his mother moved in with Helen's sister Ruth—then Ruth Garvey Reark—and her children, Joyce and John (called Jack). The Rearks were living in the house Gorey's grandmother Mary Ellis Blocksom Garvey had bought after she and Benjamin divorced. The Goreys lived in the one-bedroom, one-bathroom "independent suite," which had a screened porch of its own.[45] (It's worth noting that, for a boy on the cusp of puberty, sharing a bedroom with his mother may have been more than a little awkward.)

On first impression, Ted struck his Reark cousins as a cosseted creature—Little Lord Fauntleroy, if he'd been "raised in a high-rise in Chicago" and "doted on by females" is how Joyce puts it. "We picked on him some," she allows, recalling that her aunt Helen was "rather appalled at my brother and me. My mother always thought [Ted's mother] was overprotective.... Prue and Helen just doted on Ted. She didn't think it was good—too much feminine influence. He needed to get away from Mama, maybe." Joyce vividly remembers Aunt Helen solemnly instructing her niece and nephew that her little wonder's IQ was 165. "I remember being a little resentful when we were told what his IQ was.... My first reaction was, 'Well, I don't think he's *that* special!'"

Helen's insistence that the Rearks regard her fair-haired prodigy with appropriate awe notwithstanding, Joyce has fond memories of Ted. "He was fun," she says. "We played card games and we rode our bikes to school. Ted seemed to fit in [at Robert E. Lee Junior High]." He kept a baby alligator as a pet, which wasn't unusual in Miami in those days, says Joyce. "They're relatively harmless when they're babies. You'd just put it in the canal when you were tired of it."

Of Ted's inner life during the five and a half months he lived in Miami we know next to nothing. Entering the hormone-addled years

of adolescence, he showed no sign that his thoughts were turning to romance. As always, the objects of his affection were cats. His five-year diary reads like a case history of an obsession, with its "biographical sketch" of his cat Oscar and his breathless daily updates about Mrs. Reid's newborn kittens.[46] Cats, like books, were always there for Ted, offering uncomplicated affection and escape from the vexing complexities of human society.

But even cats could be a source of anxiety. The threat of euthanasia is ever present in his diary entries. He never knew if his kitten Goofy would have to be chloroformed because he couldn't be housebroken or if Susie II, the cute little tiger cat who "would chase [a] ball like [a] dog and bring it back," would have to be "put out of the way" after just four months because her "nervous system [was] broken down."[47] Diary entries solemnize the parade of little deaths. "One year ago today Bingo died," writes Ted on March 21; a drawing of a cross on what appears to be a burial plot accompanies the entry. A year ago that day, "Bingo's ear infection spread to brain, paralyzing front legs. Was put out of the way. Pretty broken up!"[48]

On April 18, 1938, having graduated from Robert E. Lee that March, Ted returned to Chicago. Helen rented rooms in the Marshall Field Garden Apartments in the city's Old Town neighborhood, then moved, in the fall of '39, to a high-rise apartment at 2620 North Lakeview.

This time they would stay put: apart from his time in the army, Ted lived there until he packed his bags for Harvard in September of '46; Helen would call 2620 North Lakeview home until she moved to the Cape in the mid-'70s.

Chances are she picked that address because it was convenient—a walk of about a half dozen blocks—to the Francis W. Parker School, where, a year earlier, thirteen-year-old Ted had entered the ninth grade. It was there that Gorey's sense of himself as an artist would take shape. At Parker, the outlines of the Gorey persona—eccentrically brilliant, quick with the offhand quip, charismatic and sociable yet unselfconsciously himself—would come into focus.

The Parker Gorey attended was housed in a picturesque pile in the Lincoln Park neighborhood. "The building looked like a Gorey," says Paul Richard, a Parker alumnus (class of '57) and, from 1967 to 2009, art critic for the *Washington Post*. There were "little secret compartments where you could hide in the different rooms," he recalls, "and every classroom [was] a different shape and size. It had a kind of spooky quality, especially if you had an imagination." It's unthinkable, says Richard, that a kid like Gorey—fond of mysteries, drawn to the gothic—*didn't* soak up the building's cozy spookiness.

A private institution, the school was founded in 1901 by Colonel Francis Wayland Parker, an enlightened educator who was staunchly opposed to the notion of the K–12 system as an assembly line for mass-producing standardized minds. Happily for Gorey, the arts were central to the Parker curriculum, a by-product of the colonel's belief that education must serve the whole child, fostering not only intellectual growth but civic engagement, aesthetic appreciation, and self-expression, too.

Gorey would have been Gorey even without Parker's influence, but the school's celebration of creativity, its embrace of interdisciplinary thinking, its foundational faith in the importance of making room for every style of mind to bloom—"Everything to help and nothing to hinder" was the colonel's maxim—undoubtedly played a part in making Gorey the artist he was, encouraging his restless intelligence, emboldening him in his intellectual idiosyncrasies, nurturing his growing sense of himself as an artist.[49]

The teacher who, more than any other, brought out the nascent artist in students like Gorey was Parker's self-appointed liaison to bohemia, Malcolm Hackett. A big man whose "strong, handsome face" was dominated, as a worshipful student recalled, by "deep-set eyes" and a bushy mustache, Hackett worked the van-Gogh-of-the-WPA shtick to the hilt, wearing lumberjack shirts and loose-fitting cotton pants and sandals at a time when teachers, even art teachers, wore suits and ties.[50]

Gorey's signature getup, in his New York years, recalls Hackett's insistence that "artist" isn't just a job description but an all-consuming identity, too, reflected in the way you dress. Playfully quirky (as opposed to calculatedly shocking), the classic Gorey look was every bit as self-consciously "artistic" as Oscar Wilde's famous "aesthetic lecturing costume" of velvet jacket and knee breeches. In fact, Gorey's New York persona is a textbook illustration of the Wildean truism "In matters of grave importance, style, not sincerity, is the vital thing."[51] (This holds true, in spades, for Gorey's art.) Hackett urged his students to stretch their minds by seeking out the work of timeless masters like Titian, Goya, and Manet at the Art Institute and, at showcases for vanguard art such as the Arts Club of Chicago, the work of modernists like the Viennese expressionist Oskar Kokoschka and the morbid magical realist Ivan Albright. But no less important, he preached, was the gospel truth that art isn't just something you do but, equally, something you *are*; the true artist is an artist in every fiber of his being, looking at the world with an aesthetic eye, using personal style to make an artistic statement.

Hackett was the only Parker teacher Gorey ever mentioned—"I had a good art teacher in high school," he said when his friend Clifford Ross, himself an artist, asked about his formal training—so he must've made *some* impression.[52] Certainly Hackett's emphasis on oil painting may have had the unintended consequence of disabusing Gorey of the notion that he was destined to take his place alongside the Old Masters. "I was going to be a painter," he told Ross. "The fact that I couldn't paint for beans had very little to do with it. I found out quite early in the proceedings that I really wasn't a painter at all. Whatever else I was, I was not a painter."[53]

Hackett himself was a painter of modest gifts. "You didn't really learn anything except his attitude," Paul Richard recalls. Then again, "if he didn't teach you how to cast shadows or render, he did teach you something: scorn for the proprieties," he says. "What he taught Joan [Mitchell] and Gorey was not a history or a discipline or a skill set but a subversion: Be an artist. Show it. Do anything you want."

But *épater*-ing the bourgeoisie in the Chicago of Gorey's youth was

more complicated than it sounds. On one hand, the city was easily cari-
catured as the Vatican of Babbittry. The city's reigning art critic, Eleanor
Jewett of the *Tribune*, was a former agriculture major who was implaca-
bly hostile to everything but academic kitsch. Josephine Hancock Logan,
whose stockbroker husband sat on the board of the Art Institute, raised
the alarm about cubism, futurism, and other horrors by founding the
Society for Sanity in Art in 1936. Chicagoans fell hard for the fanfare-
for-the-common-man hokum of regionalists like Thomas Hart Benton
and Grant Wood (whose *American Gothic* the Art Institute had acquired in
1930). On the other hand, the city was home to the black Chicago Re-
naissance of the 1930s and the New Bauhaus, founded in 1937 by László
Moholy-Nagy and other Bauhausians who'd fled the Nazis.

So you're teenage Ted Gorey, under the spell of the first artist you've
ever known up close, a "wholeheartedly, authentically, continually sub-
versive" bohemian (in Paul Richard's words) with the untamed mus-
tache to prove it.[54] How do you put into practice his credo that an artist
must be free, break the rules?

The answer, if you're Gorey, is: by turning your back on the future
and forging boldly into the past. At a moment when everyone's talking
about the Shock of the New, jolt them with the Shock of the Old: pro-
claim your love of silent film, insisting, "I really do believe that movies
got worse once they started to talk."[55] Provoke the provocateurs by an-
nouncing that although you're "perfectly willing to admit that Cézanne
is a great, great painter...anybody who followed him is a lot of hog-
wash," then watch jaws drop when you add, "And Picasso I detest more
than I can tell you."[56]

While we're on the subject of subversion, it's fascinating to speculate
about Gorey's aesthetic as a witty riposte to another aspect of the town,
and time, he grew up in: the "stormy, husky, brawling" manliness Carl
Sandburg extolled in his poem "Chicago" (1914), a concept defined,
in the City of the Big Shoulders, in corner-bar, working-class, Polish-

Irish–Italian terms.[57] Stanley Kowalski notions of masculinity, in the Midwest of the late '30s and early '40s, were more frankly homophobic than they are now, and an odd bird like Gorey would've found them oppressive.

Hackett, for instance, had no great love for gays; his plaid shirts, he-man mustache, and rough-and-ready aesthetic were a reaction, writes Patricia Albers, in *Joan Mitchell: Lady Painter*, "to the American stereotype of the artist as clubwoman's lapdog."[58] In *The Boardinghouse*, a chronicle of life in a house full of Art Institute students den-mothered by Hackett, Donald S. Vogel recalls the time the art teacher was "really mad, shouting mad," after catching a guy named Jules in flagrante with a male friend.[59] "Hackett's roar was heard throughout the house," and by day's end Jules's room was for rent.

What did Hackett make of Gorey? No one from his Parker days remembers Ted being anywhere near as flamboyant as he would later become, at Harvard. He wasn't openly regarded as gay by the Parker community, and whether he was or wasn't, says Robert McCormick Adams, who was a year behind him at Parker, was "insignificant in comparison to the fact that we were looking at a different aesthetic."

Still, it's hard to imagine that Hackett wouldn't have picked up on the cultural subtext of Gorey's emerging aesthetic, which Adams characterizes as "implicitly homosexual... concentrating on matters of style and presentation, and literature that was not common in our parents' homes at that time." As for Gorey, what would he have made of Hackett's boho macho? Would he have pushed back against it, following his teacher's admonition to reject received truths? Maybe that's the impulse behind Gorey's earliest recorded act of eccentricity: sometime during his Parker years, he painted his toenails green and went for a walk, barefoot, down Michigan Avenue.[60]

At Parker, Gorey's dawning awareness that his knack for drawing just might lead to something, maybe even a career, kept pace with his deep-

ening interest in art. He soon fell in with the art clique: Joan Mitchell, who would go on to international fame as an abstract expressionist painter; Mitchell's close friend Lucia Hathaway; and Connie Joerns, all of whom were smitten, to varying degrees, with the Hackett mystique. "There were four of us...whom [Hackett] inspired, and who existed as a group in the art studio," remembered Joerns. (A close friend of Gorey's for life, she would work alongside him in the art department at Doubleday and, like Ted, pursue a career as a freelance illustrator, authoring several children's books along the way.) "We referred to him as 'Mr. H' and the four of us quite frankly adored him."[61]

Fiercely intelligent and inimitably idiosyncratic, Gorey and Mitchell were drawn to each other; they "frequently 'did stuff' together," writes Albers, sowing the seeds of a casual friendship that was rekindled after Parker whenever both were back in town for the holidays.[62] Unsurprisingly, their pointed opinions and what was very likely a repressed rivalry gave their friendship "a mutually undercutting edge," Albers notes. Ted "was intrigued by Joan," recalled Joerns, but "thought her paintings were absolute garbage," an appraisal that remained unaltered over the years, despite Mitchell's ascent to art-world stardom.[63] According to Mitchell's first husband, Barney Rosset, who was two years ahead of Joan and Ted at Parker, the feeling was entirely mutual. "He wouldn't have even been an artist to her," said Rosset. (Rosset was another Parkerite who rattled the bourgeois complacency of postwar America: as head of Grove Press, he carried the battle standard for free speech, winning legal campaigns to publish such "pornographic" novels as Henry Miller's *Tropic of Cancer* and William S. Burroughs's *Naked Lunch*.)

When he wasn't hanging out with the art pack, Gorey was studying art or making it, more often than not. Lloyd Lewis, sports editor for the *Chicago Daily News*, published one of Ted's cartoons in his May 22, 1939, Voice from the Grandstand column, a weekly collection of sports-related cornpone.

More interesting than Gorey's cartooning—single-panel gags drawn in a style reminiscent of Chic Young's *Blondie*—is his pen name. ("I wanted to publish everything under a pseudonym from the very begin-

ning," he told an interviewer in 1977, "but everybody said, 'What for?' And I couldn't really explain why I wanted to. I still don't know exactly, except that I think what you publish and who you are are two different things. I don't really see that much connection.")[64] All but a few of Gorey's thirty-one noms de plume—memorialized on the dedication page of his last, posthumously published collection, *Amphigorey Again*—are anagrams of "Edward Gorey," but this, his first, is not: Sinjun is a phonetic rendering of the British pronunciation of Gorey's middle name, St. John—and a premonition of the Anglophilia that suffused much of his later work.

There's a gag-book facility to Gorey's stuff at this point, but if we look past the generic single-panel-cartoon style, we can see hints of originality. He's got an illustrator's knack for storytelling and a cartoonist's gift for visual humor. Consider the wall-size mural he painted for a dance celebrating Parker's athletic victories.

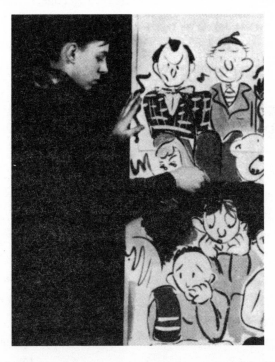

Gorey at work on a mural for a high-school social event, *Parker Record* yearbook (1942). *(Francis W. Parker School, Chicago)*

Described by the January 22, 1940, *Parker Weekly* as "a combination of Diego Rivero [sic], Salvadore [sic] Dali, and Botticelli," it depicted "the audience as a player views it after just having missed the basket."[65] Just look at that poor sap pulling his fedora down over his ears to drown out the guy nearby, snoring away, and the goofball in the front row, sipping two Cokes at once, a straw in each corner of his mouth. Already Gorey is attentive to the signals our clothes send about who we are: the Coke guzzler is wearing appropriately nutty trousers, loud slacks crawling with serpentine squiggles.

Intriguingly, Gorey's women—for example, the two cheerleaders sitting, knees bent at the same coquettish angle—are characterless mannequins, the same pert pinup babes that, right about then, were flaunting their painted curves in tattoos or on fighter planes. Betty Grable–esque cuties with upthrusting busts, they're jarringly unlike the women in his little books, tightly corseted Victorians or monobosomed Edwardians or Jazz Age flappers with boyish figures.

Ted had girls on the brain in those days, apparently: in a December 1940 column, the *Parker Weekly's* inquiring reporter quotes Gorey's response to the question, "What do you look forward to in 1941?"

Ted Gorey:
> Better marks in school.
> More pretty girls.
> An increase in allowance.
> More pretty girls.
> Better food in the lunchroom.
> More pretty girls.[66]

Nothing odd in that for a heteronormative, hormone-fueled fifteen-year-old boy, but a bit difficult to reconcile with the Gorey we know, who claimed to be "reasonably undersexed or something."[67]

His insistent interest in pretty girls notwithstanding, Gorey was consumed, in school and out of it, by his passion for the arts. He's clear on that point in his application for a Harvard College National Scholarship, submitted in January of his senior year at Parker: "My main interests lie in the field of Art."

> I do a great deal of drawing and painting myself and I am very much interested in Art. I attend exhibits at the Chicago Art Institute and other galleries regularly. Music interests me a great deal also. I go to the Chicago Symphony Orchestra concerts fairly often during the year. I like the Ballet very much and try to see it as many times as I can when there is a company in Chicago. The legitimate theater is one of the things I enjoy and I see most of the plays which come to Chicago. I go to the movies a lot and try to see all of the foreign movies which come here.[68]

To that wide-ranging cultural diet add books devoured by the shelfload. A good number of the titles he listed on his scholarship application were mysteries ("my favorite form of reading"): *The Thirty-Nine Steps* by John Buchan, books by Mary Roberts Rinehart, Ngaio Marsh, Rex Stout, Dorothy L. Sayers, G. K. Chesterton, and of course Agatha Christie—and true-crime anthologies, too, such as William Roughead's *Murderer's Companion*, a collection of deliciously macabre retellings of nineteenth-century crimes, and Edmund Pearson's *Studies in Murder*.

Not that Gorey subsisted on pulp alone. When the application asks him to list "all the books which you have read during the past twelve months," he's only too happy to inventory his prodigious intake of highbrow lit. "I am attaching an extra sheet for this purpose," he notes, matter-of-factly, "as this space is not large enough." The epic catalog that follows includes Homer's *Iliad* and *Odyssey*, Plato's *Republic*, works by Herodotus and Thucydides, Aristotle's *Poetics*, *Complete Greek Drama*, the *Oxford Book of English Verse*, Joyce's *Ulysses*, and Koestler's *Darkness at Noon*, along with fizzier fare such as S. J. Perelman, Dorothy Parker,

P. G. Wodehouse, and Robert Benchley. This is just a smattering of the sixty-nine titles he reels off, *apart from* the scads of mysteries he mentions by author only, too many to list. Sensing, perhaps, that the sheer number of books he claims to have read in a year, let alone their intellectual heft, might raise a skeptical eyebrow, he hastens to add, "I would be willing to be asked general questions on any of these books."

Reading insatiably, exploring Chicago's cultural offerings with gusto, Gorey was refining the approach that would make him a species of one as an artist. Consciously or not, he was stuffing the curiosity cabinet of his mind with ideas and images ("I keep thinking, how can I use that?") that would one day reappear, reimagined, in his art or writing.[69]

His forays into Chicago's art scene undoubtedly acquainted him with what would turn out to be another of his great passions, surrealism. At her eponymous gallery, the pioneering dealer and curator Katharine Kuh showed Miró, Man Ray, and the surrealist-influenced Mexican modernist Rufino Tamayo, all in '38, Gorey's first year at Parker. Improbably enough, the town that loathed modernism—the *Tribune* poured scorn on Kuh, and Sanity in Art protested her shows—proved surprisingly congenial to surrealism. The Arts Club, a private sanctum for the city's moneyed elite whose exhibitions were nonetheless open to the public, introduced Chicagoans to Salvador Dalí in a 1941 show and, in '42, to André Masson and Max Ernst; Gorey could easily have seen these shows.

Truth be known, though, he never had much use for surrealist art, beyond Ernst's collage novels and Magritte, who he once claimed was one of his three favorite painters. (Francis Bacon and Balthus were the other two.) Nonetheless, he was profoundly influenced by surrealist ideas. Asked, "Do you view yourself in the Surrealist tradition?" he said, "Yes. That philosophy appeals to me. I mean that is my philosophy if I have one, certainly in the literary way."[70]

In his books, he often employs surrealism's dream logic, as in the non

sequitur causality of *The Object-Lesson*, in which an umbrella disengages itself "from the shrubbery, causing those nearby to recollect the miseries of childhood" and it becomes apparent, "despite the lack of library paste," that something has happened to the vicar. Sometimes he makes use of Magritte's hallucinatory conjunctions, as in *The Prune People*, in which prim, proper Edwardians with prunes for heads go matter-of-factly about their affairs. Or he imagines the inner lives of objects—a very surrealist thing to do—as in *Les Passementeries Horribles*, in which hapless Edwardians are menaced by ornamental tassels grown to monstrous size.

But even when he isn't drawing on surrealism so obviously, his stories are often thick with that atmosphere of somnambulistic strangeness that is a surrealist trademark, as in the eerie, wordless *The West Wing*, a procession of frozen moments set in the usual Victorian-Edwardian mansion, in the usual crepuscular gloom, where everything—the enigmatic package tightly tied with twine in one room, the wave-ruffled water rising halfway up the walls in another, the nude man standing with his back to us on a balcony—manages to seem simultaneously like a clue in an Agatha Christie mystery and a symbol from Magritte's *The Key to Dreams*.

Gorey was a surrealist's surrealist: he understood that surrealism wasn't just the bourgeoisie's idea of dream imagery—limp watches, lobster telephones, the guy with the floating apple obscuring his face. It was meant to be an applied philosophy—a way of looking at everyday life, a way of being in the world. "What appeals to me most is an idea expressed by [the surrealist poet Paul] Éluard," said Gorey. "He has a line about there being another world, but it's in this one. And [the surrealist turned experimental novelist] Raymond Queneau said the world is not what it seems—but it isn't anything else, either. Those two ideas are the bedrock of my approach."[71]

He even went so far as to suggest that life, with its random juxtapositions and meaningless events, could be seen as a surrealist collage. "I tend to think life is pastiche," he said, adding drolly, "I'm not sure what it's a pastiche of—we haven't found out yet."

It was surrealism that led Gorey to what would become an overmastering passion: the ballet. In January of 1940, "I went off by myself to see the Ballet Russe de Monte Carlo do *Bacchanale*," he recalled, "because of its sets and costumes designed by Salvador Dalí, who had been sprung on me by *Life* magazine."[72] (At the age of fourteen, Gorey thought Dalí "was the cat's ass.")[73]

Bacchanale, unfortunately, was a letdown. But if Ted wasn't swooning over Dalí's decor—the dancers emerged from a ragged hole in the breast of the gargantuan swan in the backdrop—or his strenuously outrageous costumes (one dancer wore a fish head), he *was* bowled over by the ballerina who danced the role of Lola Montez in "enormous gold lamé bloomers encircled at their widest part by two rows of white teeth," an appropriately surrealist getup that was the handiwork of the renowned costume maker Karinska.[74] Gorey was entranced by Karinska's creations; fifty-five years later, in his foreword to *Costumes by Karinska*, a book about her work, he rhapsodized about costumes "I have fondly remembered, some for over half a century," such as "the satin and ruffled dresses for the cancan dancers in *Gaîté Parisienne*, whose combinations of colors I still think were the most gorgeous I ever saw."[75]

As well, he liked Matisse's brightly colored sets and abstract-patterned costumes for another ballet on the program, *Rouge et Noir*. As knots of dancers "formed and came apart" against the backdrop, a critic wrote, they created "wonderful blocks of color like an abstract painting set in motion."[76]

Already Gorey's omnivorous eye was drawn to set design, which he would dabble in for much of his artistic life, and to costumes, a fascination evident in the attention he lavished on his characters' dress, poring over Dover books such as *Everyday Fashions of the Twenties* and *Victorian Fashions and Costumes from Harper's Bazaar* to ensure they were period-perfect. In a sense, Gorey lived out his Karinska fantasy in his books, playing costumier to the casts of his stories (and, later, to the actors in his theatrical entertainments). On the page, where his imagination was

unbounded by budget or tailoring skills, he conjured up outfits so dazzling they beg for the stage or the fashion runway.

His appetite whetted, he began going to the ballet off and on, though he wouldn't become the obsessive balletomane we know until his conversion, sometime in the early '50s, to the cult of Balanchine and the New York City Ballet (whose principal costumier, from 1963 to '77, was Karinska).

By his senior year at Parker, Gorey had matured from a kid who liked to draw into the budding artist who would bloom at Harvard. Along with Mitchell and her friend Lucia Hathaway, he juried the school's Annual Exhibit of Students' Work (a more heroic undertaking than it sounds, since the show included 856 pieces of art, 22 of which were Gorey's). He did the sets and costumes for the senior play and, as a member of the social committee, handled the posters and decorations for extracurricular events. Somehow he found time, on top of all this, to art-direct the 1942 yearbook.

Yet despite this whirlwind of artistic activity, Gorey was far from an eccentric loner, hunched over his drawing board on prom night. "Though a newcomer to Joan's Class of '42, Ted had claimed a central position in that class, owing to a jaunty individualism," Patricia Albers asserts.[77] What made Gorey stand out, Robert McCormick Adams recalls, was "a conscious point of view that was not so much critical as it was independent, and somehow coherent." Central to that perspective was a wryly detached take on human affairs. "He was always putting his finger on ironies or absurdities," says Adams. His wit and easygoing self-assurance won him invitations to parties and dances at places with names like the Columbia Yacht Club, and he was part of the gang that hung out at the Belden, a drugstore just down Clark Street where Parkerites yakked and swigged chocolate Cokes and showed off their newly acquired vice, smoking.

Yet among the class photos in the 1942 yearbook, we find a blank

spot on the page where Gorey's thumbnail should be. Apparently he managed (accidentally on purpose?) to miss picture day. Alongside his name is the obligatory jokey biography, which in this case is surprisingly prescient: "Brilliant student... Art addict... Romanticist... Little men in raccoon coats."

The seventeen-year-old Ted who graduated from Parker on June 5, 1942, was more than just an art addict who doodled little men in raccoon coats. He'd already settled on a career in the arts, though he was sufficiently a child of the Depression to hedge his bohemianism with pragmatism, betting that commercial illustration was more likely to fatten his wallet than art for art's sake. To that end, he'd taken several courses in commercial art and cartooning at the School of the Art Institute of Chicago while still at Parker and had spent two summers, and a few terms' worth of Saturday sessions, studying at the Chicago Academy of Fine Arts. (Walt Disney was its most famous alum.)

Yet despite such preparations, Gorey set his sights not on art school but on Harvard. When asked, on the application, what he expected to get out of Harvard, he said, "I expect to get a good Fine Arts education so that I may enter the field of Fine Art or more probably, use it as a basis for entering the field of Commercial Art."[78]

The "historical and cultural advantages in Boston" were a draw, too, he noted. "I have lived all of my life in the Middle West and after I graduated from eighth grade I took a trip East," wrote Gorey. "I like New England better than any place I have ever been."[79] It's no surprise that Gorey felt right at home amid the death's heads grinning from the gravestones in Cambridge's Old Burying Ground, the crypts and obelisks in Boston's Mount Auburn Cemetery, and the brooding Victorians of Boston's Back Bay, whose windows reminded Henry James of "candid inevitable eyes" watching each other "for revelations, indiscretions... *or* explosive breakages of the pane from within."[80]

Herbert W. Smith, Parker's principal, recommended Ted for the Harvard College National Scholarship. In his letter to the college, Smith judges him "a boy of real brilliance," "highly gifted in art," a frontrunner "in any academic subjects in which swift reading and quick

comprehension bring success," though he tempers his praise with the observation that Gorey's gifts can sometimes get the better of him: "He is the *swiftest* reader but not the most reflective," says Smith, and "sometimes sacrifices accuracy to speed." Still, there's no denying his raw IQ: "He scores highest on such tests as the American Council of Psychological Examinations (100th percentile year after year)."[81]

Fascinatingly, the Harvard form includes a question about the applicant's limitations ("physical, social, mental"), to which Smith replies that Gorey, as "the only child of a highly intelligent but divorced couple," is prey to "social and financial insecurity." He's plagued, too, by occasional migraine headaches, an affliction that will bother him, on and off, for the rest of his life. These minor defects duly noted, Smith recommends him unreservedly; he is "an original and independent thinker" whose "boundless ambition and the *direction* of his development, quite as much as his high initial ability, make a career of unusual distinction seem likely." Gorey was awarded a scholarship to Harvard.*

He was accepted by Harvard in May, but with the draft hanging over his head—America was at war, and Congress was considering lowering the age of eligibility from twenty-one to eighteen—he decided to postpone his matriculation. As his mother later explained in a letter to the Harvard Committee on Admission, "By fall we knew that the chances of going through college before he would be in the Army were very slight, and he decided to attend the Art Institute for the fall term until Congress should decide about drafting the 18 year old boys."[82] That November, Congress approved the lowering of the age of eligibility to eighteen; on

*According to Elizabeth M. Tamny in an unedited early draft of her November 10, 2005, *Chicago Reader* feature, "What's Gorey's Story? The Formative Years of a Very Peculiar Man," Gorey was awarded scholarships to the University of Chicago and Carnegie Mellon as well. Reportedly his was the highest score in the Midwest the year he took the college boards. Tamny cites her phone interview with Andreas Brown as the source of these details.

December 5, FDR signed that decision into law. "When that was decided," Helen wrote, "we felt that it would be wise for him to enter the University of Chicago, where he had also been awarded a scholarship, as there was just a chance that he might be able to get a year's credit under the accelerated program." Gorey began classes at U of C in February of 1943, the month he would turn eighteen.

Four months into his studies, his number came up in the national lottery run by the Selective Service. On May 27, Gorey was inducted into the US Army at Camp Grant, near Rockford, Illinois. In June, he was sent to Camp Roberts, in central California, just north of San Miguel, for four months of basic training. IQ tests were part of the induction process, and as Helen Gorey—never one to hide her son's light under a bushel—recalled, "His grade in the Army intelligence test was 157, which was the highest mark they had ever had at Camp Grant at that time."[83] On completing his basic training, he underwent another round of examinations, after which he learned from the Board of Examiners, according to Helen, "that he had the highest marks they had seen."

Army life, Gorey wrote to his friend and former Parker schoolmate Bea Rosen, was dull to the point of deadliness.[84] At one point, he and his company were marched out into the wastelands around Camp Roberts and bivouacked there, God knows why, a state of affairs Gorey found "too, too feeble-making."[85] He and his fellow grunts were sleeping on brick-hard ground, he told Rosen, and subsisting on canned rations eaten cold. Dessert consisted of chocolate bars that tasted suspiciously like Ex-Lax and had "practically the same effect, if not more so." His mood was not improved when he managed to drop a rifle on his foot. The army routine alternated between torment and tedium; that, along with the infernal heat and lunar desolation of the place, was driving him out of his gourd, he claimed.

Gorey's voice on the page is something to hear, as far from the average GI writing home as Oscar Wilde's arch quips are from Hemingway's tough-guy bluster. He opens his letters to Rosen with stage-entrance salutations like "Darling," closes them with high-flown effusions ("tidal waves of passion" is a typical sign-off), and adopts pet names (he's

"Theo"; Rosen is "Beatrix the light of my life"). He affects a knowing-ness, a world-weariness; he indulges in high-opera histrionics and flights of fancy. It's the put-on persona of a teenage aesthete who has lived much of his young life between the covers of a book. Life, he insists, is a tear-sodden handkerchief, a crumpled straw in a soda glass sucked dry, a foot-draggingly gloomy procession of "frustrated desires" and "sex entanglements from what they tell me—I wouldn't know..."[86] (Interesting to note that at eighteen—an age when most young men are feeling their oats—he's already holding the subject of "sex entangle-ments" at arm's length.)

Gorey's letters are a study in camp. His tone is equal parts Sebastian Flyte, the charmingly unworldly idler from *Brideshead Revisited*, and the impulsive, outspoken Holly Golightly from *Breakfast at Tiffany's*, down to Holly's precious use of French to signal her cosmopolitan chic. In a letter to Rosen, Gorey sighs, "The ancient *esprit d'aventure* still lives but what can it do?"[87]

Gorey's summer in "God's garbage pit," as he called it, wasn't all cold canned rations and damp rot of the soul. Rummaging through the camp library in his never-ending search for something new to read, he happened on E. F. Benson's Mapp and Lucia novels. "I first discovered them during World War II—quite by accident, although I prefer to think of it as Fate—in the library of Camp Roberts, California, where I took my basic training in the summer of 1943," he remembered in "I Love Lucia," an appreciation he wrote for the May 1986 issue of *Vogue*.[88]

Fate indeed: Benson's comedies of manners arrived at just the right moment to influence Gorey's emerging persona, that of an arch, Anglo-philic aesthete. Wickedly witty and unimprovably English in their attention to small-town gossip and social jockeying, the Mapp and Lu-cia novels delight in the snobbery and pretensions of two smilingly vicious doyennes who elevate social climbing to a blood sport. As it happens, Benson (1867–1940) was gay, and the Mapp and Lucia nov-els are "cult classics...among gay readers," according to the literary critic David Leon Higdon, beloved for "their campy exaggerations, so-

cial jealousies, and gentle but not altogether affectionate social satire."[89] Was Gorey drawn to Benson's novels because he recognized in Benson's voice a kindred style of mind, a covert consciousness that wore its wit as an invisibility cloak?

Whatever the reason, the books made a lasting impression on him: when asked about his favorite authors, he often mentioned Benson. "If I were driven to decide what to take along to a desert island," he said in 1978, "it would be a toss-up among Jane Austen's complete works, [the eleventh-century Japanese novel] *The Tale of Genji*, the 'Lucia' books, or one of the Trollope series," adding, "I've read the 'Lucia' books so often I almost know them by heart."[90]

Four months after his arrival at Camp Roberts, Gorey completed his basic training, in the course of which he, the overwrought aesthete, last seen dropping his rifle on his foot, managed to earn expert badges in pistol and rifle marksmanship.

Then the army had new marching orders for Private Gorey: he was to enroll in college under the auspices of the Army Specialized Training Program (ASTP). "Note well the utterly hysterical fact that the Army is sending me to college to study languages under ASTP," he wrote Rosen.[91] Launched in 1943, the ASTP was intended "to provide the continuous and accelerated flow of high grade technicians and specialists needed by the Army."[92] Soldiers who scored high on military IQ tests were sent to select universities—in uniform, on active duty, and still subject to military discipline—for fast-tracked courses in engineering, medicine, and any of thirty-four foreign languages. Gorey was assigned to study Japanese, perhaps in advance of the anticipated occupation of Japan, where US administrators would be needed.

He entered the University of Chicago in the winter quarter of 1943. On November 8, he began courses. Two days later, he was diagnosed with scarlet fever and hospitalized for six weeks. Back on his feet, he reentered the program and was transferred, on February 7, 1944, to something called Curriculum 71, which entailed studying conversational Japanese along with contemporary history and geography. Then, on March 22, the army, with its usual sagacity, shut down the program

in mid-term, around five weeks before it would have ended. By Gorey's tally, he'd had "only two months" of study.[93]

In June, or thereabouts, the army, again demonstrating the discernment for which it is universally admired, put PFC Gorey's record-breaking IQ to good use: he was dispatched to Dugway Proving Ground, an army base in the Great Salt Lake Desert, to sit out the rest of the war as a company clerk.

CHAPTER 2

MAUVE SUNSETS

Dugway, 1944–46

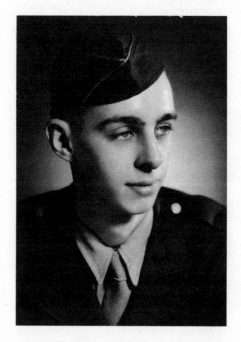

Private Gorey, US Army, circa 1943.
(Elizabeth Morton, private collection)

DUGWAY SITS ABOUT SEVENTY-FIVE miles southwest of Salt Lake City in a no-man's-land the size of Rhode Island. In the wake of Pearl Harbor, the army had gone looking for a suitably godforsaken patch of land where its Chemical Warfare Service could test chemical, biological, and incendiary weapons. It found it in Dugway Valley, as far from human habitation as any place in the Lower Forty-Eight and cordoned off by mountain ranges, helpful in shielding top-secret experiments from prying eyes.

Dugway Proving Ground was "activated"—officially opened—on March 1, 1942; when Gorey arrived, a little more than two years later, it still had a ramshackle, frontier feel. The high-security areas devoted to top-secret research and testing would've been off-limits to Gorey, restricting him to a cluster of buildings about the size of a large city block, maybe two blocks at best.

All around lay wastelands: salt flats, sand dunes, and, from the base to the jagged mountains rearing up to the north and south, the never-ending desert, tufted with saltbush and sagebrush. The stillness was profound, a ringing in the mind. The sky was painfully clear, by day a vaulted blue vastness, at night a black dome powdered with stars.

Not for nothing was the base's mimeographed newspaper called *The Sandblast*. "Dust from the local sand dunes, augmented by ancient lake-bed deposits (Lake Bonneville) and volcanic ash beds, pervaded everything each time the wind blew, which was most of the time," a former Dugwayite recalled.[1] New arrivals were greeted with the cheerful salutation, scrawled on the MP gatehouse, "Abandon hope, all ye who enter here," until top brass caught wind of the offending phrase and ordered it removed.[2]

Gorey was not enamored of Dugway. "It was a ghastly place, with the desert looming in every direction, so we kept ourselves sloshed on tequila, which wasn't rationed," he recalled in 1984. "The only thing the Army did for me was delay my going to college until I was twenty-one, and that I am grateful for."[3] His daily routine, as company clerk—technician fourth grade in the 9770th Technical Service Unit, in armyspeak—didn't exactly challenge Camp Grant's all-time high scorer on the army IQ test. He typed military correspondence, sorted mail, and kept the company's books. "There was this one company: it had all of three people," he remembered. "One man was in jail, one was in the hospital and one was AWOL for the entire time I was there. But every morning I had to type out this idiot report on the company's progress."[4]

It seems not to have occurred to Gorey, at the time, that swilling tequila and filing absurdist reports was preferable to crawling on your

belly through the malarial swamps of some Pacific atoll under withering fire from the Japanese or rotting in a German POW camp. You had hot chow, cold beer—hell, even a bowling alley—and weekend passes to Salt Lake City. Best of all, your chances of dying were next to nil.

Of course, Ted *had* to grouse. His image, well defined by the time he arrived at Dugway, required that he do his best impression of Algernon Moncrieff from *The Importance of Being Earnest*, distraught at the impossibility of finding cucumber sandwiches in the middle of the desert. There's no way of knowing how much of his horror was genuine and how much of it was part of a studied pose.

Gorey's time at Dugway wasn't *all* lugubrious attitudinizing. Relief arrived in the form of a dark-haired, bespectacled Spokane native named Bill Brandt. A gifted pianist and aspiring composer, Brandt was Dugway's librarian of classified materials, an assignment that freed him, on weekends, to work on his composing and counterpoint studies. (He would go on to a distinguished career as a professor of music at Washington State University.) "Bill was assigned to the Chemical Warfare Division and Gorey was assigned as company clerk," Brandt's wife, Jan, recalled. "Bill had to go to him to order supplies and one day found him reading an avant-garde book. Bill said, 'Oh! You're reading one of my favorite books.' A conversation started and they found they had many interests in common."[5]

Five years younger than Brandt, Gorey impressed the older man "as a spare, gawky...boy who played with words," Jan remembers. Brandt, too, had a quick wit and a knack for wordplay—specifically, puns. Brandt's own recollection, in an unpublished memoir, of his first encounter with the "new company clerk" portrays Gorey as "a slim, blond man, younger than I, who, I discovered, was literate, in contrast to the professional chemists or old Army types that made up the rest of the outfit. He had actually read the poetry of T. S. Eliot, and Somerset Maugham's novels!"[6]

Ted and Bill bonded over their shared interest in Eliot, classical music, and the movies. When Gorey came back from furlough in Chicago with Adolf Busch's four-record set of Bach's *Brandenburg Concertos*, he and Brandt commandeered the phonograph in the post library and listened to it "a couple of times late in the evening, when the others in the place had gone."[7]

Often, they'd work on creative projects. "I copied music, read, and composed while Gorey wrote the too, too decadent little plays," remembers Brandt, "or drew the equally decadent Victorians that he later became famous for." At some point, Gorey painted a cover illustration for Brandt's unpublished Quintet for Piano and String Quartet, op. 11 (1943), a whimsical depiction of Harlequin in a piebald body stocking, lounging in a lunar emptiness that suggests Gorey's idea of Dugway Valley. Overhead, fireworks whizbang against the night sky, a white-on-black fantasia of streaks and curlicues and chrysanthemum bursts. From Harlequin's rainbow-colored costume to the naïf, Chagall-ish looseness of the rendering, it's poles apart from the precise, sharp-nibbed aesthetic of Gorey's little books.

In time, their peas-in-a-pod rapport, artsiness, and manifest lack of interest in barhopping and skirt chasing in Salt Lake City invited the suspicion that Gorey and Brandt were more than good buddies. "Most of the other servicemen thought they were both gay," says Jan, "but Gorey never put his foot under the bathroom partition," so to speak. Brandt took Gorey's sexuality, or what he perceived to be Gorey's sexuality, in stride: "He was gay, but at that time, naive as I was, I had no idea what that meant and treated him just like anyone else, and his relationship to me was equally straight."

At Dugway, Gorey tried his hand at writing, hammering out a full-length play and a handful of one-acts. "The first things that I wrote seriously, for some unknown reason, were plays," he recalled. "I suppose there must have been some strong dramatic urge at the time. I never

tried to get them put on or anything. [T]hey were all very, very exotic and...pretentious, in a way. In another way, I don't think they were as pretentious as they might have been. I mean, I didn't go in for endless, dopey, poetic monologues for people; they moved right along. They were rather bizarre, I think, and were rather overwritten..."[8] Elsewhere, he added, "I always wonder what I thought I was doing then, because what I was writing was clearly unpresentable—closet dramas, for instance. I had very little sense of purpose, which was just as well, because then I wasn't disappointed about the outcome."[9]

Gorey's Dugway plays are indeed overwrought. All but one of their titles—typical Gorey kookiness such as *Une Lettre des Lutins* (a letter from the elves) and *Les Serpents de Papier de Soie* (the tissue-paper snakes)—are in French, though the plays themselves are in English, with the exception of a five-page effort untranslatably titled *Les Scaphandreurs*. The dialogue is sprinkled with French phrases, in the manner of Gorey's correspondence at the time. The characters have names like Piglet Rossetti and Basil Prawn and dress more or less the way you'd imagine people named Piglet Rossetti and Basil Prawn would dress—in purple espadrilles and "mauve satin ribbons [that] cling like bedraggled birds to bosom, thigh, and wrist."[10] They exclaim—there's a lot of exclaiming—things like "How unutterably mad!" and "How hideously un-*chic*," and, of course, "Divine!"[11] When they're not exclaiming, they're declaiming, in prose so purple it would bring a blush to Walter Pater's cheek: "Have you ever danced naked before a lesbian sodden with absinthe?"[12]

Yet despite dialogue so over the top it sounds, at times, like a John Waters remake of *The Picture of Dorian Gray*, Gorey's Dugway plays are remarkable if we remember that the author was only nineteen or twenty.[13] Too clever by half and too obviously derivative, they're self-indulgent juvenilia. But the dialogue does move right along: the characters riff off each other, volleying surrealist non sequiturs. A glimmer, at least, of the Gorey we know is recognizable in his first attempts at translating his sensibility onto the page.

The Victorian, Edwardian, and Jazz Age settings he'll revisit endlessly

in his little books are already in place. He's resurrecting nineteenth-century words long ago fallen into disuse, such as *distrait* and *fantods*, words that will become Gorey trademarks. His Anglophilia is in full flower, down to the use of British spellings. The love of nonsensical titles, preposterous names (Centaurea Teep, Mrs. Firedamp), even more preposterous place names (Galloping Fronds, Crumbling Outset), and absurd deaths (suicide by eating live coals, homicide by defenestration from a railway carriage) is amply in evidence. Speaking of names, he's already indulging his love of pseudonyms: all the plays are penned by "Stephen Crest."

As well, he's exploring what will become recurrent themes: the melancholy of lost time ("THE SCENE: An antique room, obscurely decaying"); the stealthy tiptoe of our approaching mortality (symbolized for Gorey by crepuscular or autumnal or wintry light); and, of course, angst, ennui, the banal horrors of everyday life, arbitrary and unpredictable turns of events, cruelty to children (a governess kills her charge's pet canary), the cruelty *of* children (a little girl bashes her big sister's head in with a silver salver), and murder most foul (a woman shoves her friend over a balustrade).[14]

His instinctive aversion to religion—specifically, Roman Catholicism—makes itself known, too. In *Les Aztèques*, a character jokes about painting a Crucifixion "with Christ nailed facing the cross instead of with his back to it," which would have the happy effect of making believers "hideously embarrassed"; in the untranslatably titled *L'Aüs et L'Auscultatrice*,[15] a man is fatally brained by a falling crucifix: an Act of God, played for laughs.

This is a far gothier, more calculatedly outrageous Gorey than we'll ever meet in his books. He's clearly in thrall to the Decadent movement associated with *Dorian Gray*, Baudelaire, and the perverse, pornographic drawings of Aubrey Beardsley. Already he knows that aestheticism, not naturalism, is the stylistic language he'll speak for the rest of his artistic life.

Yet in one startling way, the Gorey who speaks to us in the Dugway plays is utterly *unlike* the Gorey we know from his little books. The plays touch repeatedly on homosexuality and gay culture, and their treatment of these subjects is startlingly frank, given his later reticence on the subject of sexuality—his or anyone's. While obviously gay characters do have walk-on roles in his little books (and in his freelance illustration work, such as his cartoons for *National Lampoon*), their sexuality is usually treated lightly, with knowing, deadpan wit. With rare exception, Gorey's gays are Victorians or Edwardians or Jazz Age sophisticates, at a safe historical remove from the controversies of his historical moment (not to mention his private life).

In the Dugway plays, he takes us inside gay bars, something he never does in his books. There is talk, in *Les Aztèques*, of "chic dykes" and "violet eyed castrati" and boys dancing with boys, lilacs tucked coquettishly behind their ears.[16] In one scene, we're introduced to a guy who's "just broken up with some boy" who owns "an enormous mauve teddy bear named Terence," an image rich in gay symbolism. The teddy bear is borrowed from Evelyn Waugh's eccentric gay aristocrat Sebastian Flyte, who is never without his beloved childhood companion. And mauve was synonymous in the Victorian mind with aestheticism and gay bohemia, thanks to Wilde's signature mauve gloves; the association persists to this day in our linkage of lavender with gay culture. Gorey, who by Dugway was already well versed in Victorian literature and culture, was undoubtedly aware of the color's symbolism. When a character in *Les Aztèques* observes, "Incredibly mauve sunset," it's hard not to imagine that Gorey isn't sending up the Catholic conservative critic G. K. Chesterton's famous swipe at the dandified—and, by implication, gay—aesthete who, "if his hair does not match the mauve sunset against which he is standing, . . . hurriedly dyes his hair another shade of mauve."[17]

In the Dugway plays, Gorey is attempting to resolve the fuzzy outline of his creative consciousness—a welter of inspirations and affinities—into a sharply defined artistic voice all his own. At the same time, like everyone crossing the threshold between adolescence and adulthood, he's struggling toward self-definition as a person, ques-

tioning the parental wisdom and societal verities he's grown up with. Deciding who he wants to be includes coming to terms with his sexuality, however he defines it—or doesn't.

On the title page of *Les Aztèques*, Gorey uses an unattributed quotation for an epigraph. Each of us is given a theme all our own at birth, the anonymous author observes. The best we can hope for, in this life, is to "play variations on it." Fatalistic sentiments for a twenty-year-old. Is he resignedly accepting some aspect of himself he hadn't fully confronted until that moment, something he thought might be part of a passing phase but has come to realize is innate, irrevocable? On the cover sheet of *A Scene from a Play*, we read an even more enigmatic comment, an inscription to Brandt written in Gorey's flowing script: "For Bill—Because my friendship is inarticulate and indirection is the only alternative." He signs his inscription with the campy nom de plume he'll use, at Harvard, in all his letters to Brandt: "Pixie."

Gorey was formally discharged from the army on February 2, 1946, at the Separation Center at Fort Douglas, near Salt Lake City. He and Brandt maintained an affectionate, if fitful, correspondence afterward, but it seems to have trailed off after Gorey graduated from Harvard.

In later life, Gorey rarely mentioned his army years. "After more than twenty-five years of knowing him," says Alexander Theroux in *The Strange Case of Edward Gorey*, his memoir of his friendship with Gorey, "I had never once heard a single reference, never mind anecdote, of his Army life, or for that matter, of the state of Utah."[18] When the subject did come up in interviews, Gorey inevitably deflected it with a quip about the mysterious incident of the dead sheep, an event straight out of *The X-Files*.

In March of 1968, upwards of 3,800 sheep grazing in the aptly named Skull Valley, near Dugway, died from unknown causes. Although an internal investigation conceded, in the words of one Dugway commander, "that an open-air test of a lethal chemical agent at Dugway

on 13 March 1968 may have contributed to the deaths of the sheep," the army did not, and does not, accept responsibility for the event, contending that the evidence is inconclusive.[19] Whatever the cause, the incident became a flash point for outrage among antiwar activists and environmentalists—and a punch line for Gorey, who found a kind of black humor in the event.

When Dick Cavett asked him, in a 1977 interview, about his time in the army, he said, "Every time I pick up a paper and see, you know, that 12,000 more sheep died mysteriously out in Utah, I think, 'Oh, they're at it again.'"[20] Still, his memories of Dugway can't have been all *that* grim, given his tossed-off remark in a 1947 letter to Brandt: "If you ever get this, slob, write, and let me know what's been what since we parted at Dugway (do you ever think about the place?—Rosebud [a pet name for a mutual friend at Dugway] and I find ourselves getting sentimental about it every now and then)."[21]

Returning to Chicago, Gorey landed an afternoon job at an antiquarian bookshop specializing in railroadiana and a morning job at another bookstore. "I worked in a couple of bookstores, and as a consequence, spent all my salary on books; saw no one at all, and mentally stagnated on the beach on Sundays," he wrote Brandt. "I did manage to drag myself to hear a lot of chamber music (your influence), usually on stifling hot evenings when one was flooded in one's own perspiration. However, it all added to the intensity of the experience, or something."[22]

In May, Gorey notified Harvard of his intent to register that fall, taking the college up on its long-deferred offer and the scholarship that went with it, supplemented by the GI Bill of Rights. The flood of veterans swelled the class of 1950 to 1,645, the biggest in Harvard's history; more than half the incoming students were former servicemen, their entrée to one of the nation's most prestigious Ivies made possible by the GI Bill.

Asked, on his Veteran Application for Rooms, about his preference in roommates, Gorey said he'd rather share a room with "someone from New England or New York, not any younger than I am, the same religion if possible"—Episcopal, he says, elsewhere on the questionnaire—and "with interests along the lines I have indicated," namely, art and symphonic music and of course reading ("Mostly French and English moderns, both poetry and fiction").[23]

Setting aside his uncharacteristic (and unconvincing) partiality for a fellow Episcopalian—irreligious Ted doing his best to sound like a Harvard man rather than the bohemian weirdo he was?—his response is revealing. His bias in favor of East Coasters invites the perception that he wants to put some distance between himself and the Grant Wood provincialism of the Midwest. He's embarking on that quintessentially American rite of passage: pulling up stakes and moving far from home, where nobody knows you and you're free to flaunt your true self or, for that matter, try on new selves.

But if Gorey's departure for Harvard, at twenty-one, turned the page on his hometown days—he would spend the rest of his life on the East Coast, returning to Chicago for holidays, then infrequently, then hardly ever—the character, culture, and landscape of the city he grew up in left their stamp on him, if you knew where to look. Most obviously, there's his accent, softened by long years on the East Coast and crossed with the theatrical, ironizing lilt of stereotypical gay speech, but still a dead giveaway. We hear Chicago in Gorey's elongated vowels, especially in his long, flat *a*, which sounds like the *ea* in *yeah*: in recorded interviews, when he says "back" and "bad" and "happened," they come out "be-*yeah*-k" and "be-*yeah*-d" and "he-*yeah*-pened."

More profoundly, there's his impatience with phoniness and pomposity, a trait native to the industrious, pragmatic city of immigrants he grew up in. Chicago is famously a working-class, beer-and-kielbasa town, staccato in speech, blunt in expression, unpretentious to the point of pugnacity—"perhaps the most typically American place in

America," thought the historian James Bryce.[24] Being "regular" is a cardinal virtue.

Of course, Gorey was the *least* regular guy imaginable, an unapologetic oddity who thought of himself as "a category of one."[25] Still, Larry Osgood, who was in Gorey's class at Harvard, recalls their classmate George Montgomery saying something about Ted that Osgood "took as really odd at the time, but was really very, very insightful. He said, 'Ted's much more normal than the rest of you guys.'" The clique in question was largely gay, and some of its members were, in the parlance of the time, flamboyant in the extreme. "I thought, *That's odd*. But there *was* a level in Ted's personality, as outrageous as it was, of solid, middle-class values." Osgood agrees with Freddy English's characterization of Gorey as "a nice Midwestern boy" in bohemian drag. "The curious thing about Ted in those days, and probably always," he says, "was that his behavior, tone of voice, gestures, were characteristically queeny, no question about it, but at the core of his personality, he wasn't a queeny person at all. So except for this bizarre direction he went in in his work, he was a very middle-class, moralistic person."

Gorey once claimed, with his usual flair for the dramatic, that he was "probably fully formed" by the time he arrived at Harvard.[26] No doubt the essential elements of his style and sensibility *were* intact, many of them already jigsawed into place, but the Ted we know wasn't *quite* complete when he walked through the gates of Harvard Yard the week of September 16, 1946.

He would prove a lackadaisical French major, later recalling, "I bounced from the dean's list to probation and back again."[27] When it came to his extracurricular passions, however, he was an avid student, devouring everything by his latest literary infatuations, going to art films and the ballet, trying his hand at limericks and stories, and drawing constantly (little men in raccoon coats proliferate in the margins of his study notes). For the next four years, he'd be zealous in his true course of study: Becoming Gorey.

CHAPTER 3

"TERRIBLY INTELLECTUAL AND AVANT-GARDE AND ALL THAT JAZZ"

Harvard, 1946–50

GOREY, LIKE ALL INCOMING freshmen, had been assigned to one of the residence halls around Harvard Yard. Mower,* a small red-brick building completed in 1925, has its own courtyard, a patch of tree-shaded green that gives it a secluded feel. Gorey's new home was suite B-12, on the ground floor, a no-frills affair with two bedrooms giving onto a common study room with three desks and a fireplace. His roommates were Alan Lindsay and Bruce Martin McIntyre, about whom we know zilch, as he would say.

In his first month at Harvard, Gorey met a fellow veteran and fledgling poet with whom he soon formed a two-man counterculture. Frank

*Rhymes with *glower*.

O'Hara, his upstairs neighbor in Mower B-21, would go on to fame as a leading light in the New York School of poets (which included John Ashbery and Kenneth Koch, both Harvardians as well). Brilliant, intellectually combative, lightning quick with a witty comeback, O'Hara was a virtuoso conversationalist who turned cocktail-party repartee into an improvisatory art.

Like Gorey, he'd come to Harvard on the GI Bill. He, too, was Irish Catholic, but whereas Ted had slipped the traces of a Catholic upbringing early on, O'Hara had all the post-traumatic baggage of the lapsed Catholic: "It's well known that God and I don't get along together," he wisecracked in one of his poems.[1] But the most obvious evidence that he and Gorey were cast in the same mold was O'Hara's "drive for knowing about all the arts," an impulse that "was as tireless as it was unfocused," according to his biographer Brad Gooch, who adds that "he showed a genius, early on, for being in the know"—another Goreyan quality.[2] By 1944, when he enlisted in the navy, he'd become "something of an expert on the latest developments in twentieth-century avant-garde music, art, and literature," mostly by way of his own autodidactic curriculum, Gooch writes.[3] Like Gorey, O'Hara was fluent in modern art, bristling with opinions on Picasso, Klee, Calder, and Kandinsky. At the same time, he shared Ted's passion for pop culture, which for O'Hara meant the comic strip *Blondie*, hit songs by Sinatra and the big-band trumpeter Harry James, and, most of all, film: he was an ardent moviegoer, papering his bedroom walls with pictures of popcorn Venuses like Marlene Dietrich and Rita Hayworth. Insatiable in his cultural cravings, all-embracing in his tastes, unreserved in his opinions, O'Hara was in many ways Gorey's intellectual double, down to the fanatical balletomania.

The two were soon inseparable. They made a Mutt-and-Jeff pair on campus, O'Hara with his domed forehead and bent, aquiline nose, broken by a childhood bully, walking on his toes and stretching his neck to

add an inch or two to his five-foot-seven height, Gorey towering over him at six two, "tall and spooky looking," in the words of a schoolmate.[4]

Swanning around campus in his signature getup of sneakers and a long canvas coat with a sheepskin collar, fingers heavy with rings, Gorey was the odds-on favorite for campus bohemian, with the emphasis on odd. "I remember the first day Ted Gorey came into the dining hall I thought he was the oddest person I'd ever seen," said George Montgomery. "He seemed very, very tall, with his hair plastered down across the front like bangs, like a Roman emperor. He was wearing rings on his fingers."[5] Larry Osgood, a year behind Ted, shared Montgomery's double-take reaction the first time he saw Gorey. He was standing in line to buy a ticket to a performance by the Martha Graham Company when he noticed a "tall, willowy man" with his nose in a little book.[6] "Ted never stood in line for *anything* without a book in his hands," says Osgood. "One of the things that struck me about him and made me, in my philistine way, sort of giggle at him was [that] one of his little fingernails was about three inches long. He'd let it grow and grow and grow."

Gorey struck an effete pose. He affected a world-weariness and tossed off deadpan pronouncements with a knowing tone, an irony he underscored with broad, be-still-my-heart gestures—"all the flapping around he did," a fellow dorm resident called it.[7] Even so, he wasn't some shrieking caricature of pre-Stonewall queerness. "He was flamboyant in a much more witty and bizarre way that normal queens weren't," says Osgood. "Giving big parties and carrying on, listening to records of musicals and singing along to them" wasn't Gorey's style.

As always, Gorey defied binaries. His eccentric appearance belied a shy, reserved nature. His speech, body language, and cultural passions—theater, ballet, the novels of gay satirists of mores and manners such as Saki, Ronald Firbank, E. F. Benson, and Ivy Compton-Burnett—were a catalog of stereotypically gay traits and affinities. Yet no one in the almost exclusively gay crowd he traveled with ever saw him at gay bars such as the Napoleon Club or the Silver Dollar. He was either so discreet that he eluded detection or, as he later maintained, so yawningly uninterested in sex that there was nothing to detect.

O'Hara was impressed by Gorey's assured sense of himself, his refusal to apologize for his deviations from the norm, especially his blithe disregard for conventional notions of masculinity. O'Hara, who'd had his first same-sex experience when he was sixteen, was conflicted about his sexual identity—all too aware of his attraction to men but gnawed by the suspicion that gay men were sissies and haunted by fears of what would happen if his secret got out in the conservative Irish Catholic community where he'd grown up, in Grafton, Massachusetts. Posthumously, O'Hara would take his place on the Mount Rushmore of gay letters, but during his Harvard years he was torn between the closeted life he was forced to live whenever he returned home and the more liberated life he lived at Harvard and in Boston's gay underground.

Gorey's comparatively over-the-top persona was a revelation to O'Hara. "As his life in [his hometown] became more weighted and conflicted, O'Hara compensated by growing increasingly flamboyant at Harvard," writes Gooch. "His main accomplice in this flowering was Edward St. John Gorey," who constituted O'Hara's "first serious brush with a high style and an offbeat elegance to which he quickly succumbed."[8]

Style is key here: consciously or not, Gorey was acting out a "revolt through style," a phrase coined by cultural critics to describe the symbolic rebellion, staged in music, slang, and fashion, by postwar subcultures—mods, punks, goths, and all the rest of them. Gorey wasn't so much rebelling against the conformist, compulsorily straight America of the late '40s as he was airily disregarding it, decamping to a place more congenial to his sensibility, a world concocted from his far-flung fascinations and conjured up in India ink.

Growing up, Gorey and O'Hara had always been the smartest kids in any room they walked into. Now each had met his match, not just in IQ points but in cultural omnivorousness, creativity, and oblique wit. They fed off each other's enthusiasms, seeing foreign films at the Kenmore, near Boston University; sneaking into the ballet during intermission at the old Boston Opera House, on Huntington Avenue; and attending poetry readings on campus given by Wallace Stevens, W. H. Auden,

Edith Sitwell, and Dylan Thomas. Poking around in bookstores near Harvard Square, they initiated one another into the esoteric charms of writers sunk in obscurity.

Ronald Firbank (1886–1926), a little-known English novelist of the '20s, was typical of their rarefied tastes. If Gorey and O'Hara's aesthetic cult had a patron saint, it was Firbank, whose influence on both men lasted long after Harvard. O'Hara's wordplay, his ironic humor, and his witty interpolation, in his poems, of snippets of overheard dialogue owe much to Firbank. As for Gorey, he once cited the author as "the greatest influence on me…because he is so concise and so madly oblique," though he later qualified his admiration, conceding that he was "reluctant to admit" his debt to Firbank "because I've outgrown him in one way, though in another I don't suppose I ever will. Firbank's subject matter isn't very congenial to me—the ecclesiastical frou-frou, the adolescent sexual innuendo. But the way he wrote things, the very elliptical structure, influenced me a great deal."[9] (Gorey repaid the debt in 1971 when he illustrated a limited edition of *Two Early Stories* by Firbank.)[10] He also took from Firbank what he took from Japanese and Chinese literature, namely, the aesthetic of "leaving things out, being very brief," to achieve an almost haikulike narrative compression.[11] ("I think nothing," Firbank declared, "of filing fifty pages down to make a brief, crisp paragraph, or even a row of dots.")[12]

Gorey admired Firbank's exquisitely light touch, his mastery of an irony so subtle it was barely there; we hear echoes of Firbank's drily hilarious style in Gorey's prose and in his conversational bon mots. To the Goreyphile, Firbank sounds startlingly Goreyesque: "The world is disgracefully managed, one hardly knows to whom to complain."[13] In *Vainglory* (1915), Lady Georgia Blueharnis thinks the view of the hills near her estate would be improved "if some sorrowful creature could be induced to take to them. I often long for a bent, slim figure to trail slowly along the ridge, at sundown, in an agony of regret."[14] Can't you

just see that bent, slim figure trailing slowly through the twilight of a Gorey drawing?

A writer's style is inextricable from his way of looking at the world, and Gorey absorbed Firbank's sensibility along with his style. His habit of treating serious subjects frivolously and frivolous matters seriously, his love of the inconsequential and the nonchalant, his carefully cultivated ennui, his puckish perspective on the human comedy: all these Goreyesque traits bear the stamp of Firbank's influence.

Even Gorey's stifled-yawn lack of interest in the subject of sex— "Such excess of passion / Is quite out of fashion," a young lady observes in *The Listing Attic*—has its parallel in the can't-be-bothered languor that was part of the Firbank pose. "My husband had no amorous energy whatsoever," one of his characters confides, "which just suited me, of course."[15]

Gorey's most obviously Firbankian attribute is his immersion in the nineteenth century. Firbank was besotted by the same fin-de-siècle literature and aesthetic posturing whose influence wafts off the pages of Gorey's Dugway plays. A throwback to the Mauve Decade, he was "1890 in 1922," to quote the critic Carl Van Vechten.[16] ("I adore all that mauvishness about him!" a Firbank character cries.)[17] Yet, like Gorey, he was very much of his moment: his compressed plots and collagelike rendering of cocktail-party chatter were as modern in their own way as Gorey's Balanchinian economy of line, absurdist plots, and pared-down texts were in theirs.

Firbank, it should go without saying, was gay. He looms large in the prehistory of camp, the coded sensibility that enabled gays, in pre-Stonewall times, to signal their sexuality under the radar of mainstream (read: straight) culture and, simultaneously, to mock that culture with tongue firmly in cheek. To gay readers who could read the subtext in Firbank's pricking wit and "orchidaceous" style, as detractors called it, his prose hid his queerness in plain sight.

The content of his novels, which poked fun at bourgeois institutions such as marriage, had special meaning for gay readers, too. "One can imagine how such a flagrant parody of heterosexual mores might func-

tion within the gay subculture—reinforcing the self-esteem of those who thought their nontraditional sexuality a rebellion against the conventionalism of late Victorianism," writes David Van Leer in *The Queening of America*.[18] "An appreciation of [Firbank] became the litmus test of one's sexuality and of one's allegiance to the dandyism of post-Wildean homosexuality. When gay poet W. H. Auden announced that 'a person who dislikes Ronald Firbank may, for all I know, possess some admirable quality, but I do not wish ever to see him again,' his statement was not an aesthetic judgment. It was a declaration of community solidarity."

It's hard to imagine Gorey rejoicing in the gay "community solidarity" signaled by a fondness for Firbank. A nonjoiner if ever there was one, Gorey distanced himself from those, like the "very militant" museum curator he knew in later years, who insisted that their queerness was central to their identity.[19] "I realize that homosexuality is a serious problem for anyone who is—but then, of course, heterosexuality is a serious problem for anyone who is, too," he said. "And being a man is a serious problem and being a woman is, too. Lots of things are problems."

Too true. But being a homosexual in 1946, or facing up to the fact that you might be, was surely just a *little* bit more serious, as problems go, than being heterosexual. When Gorey arrived on campus, the *Harvard Advocate* was defunct, closed in the early '40s by outraged trustees who'd discovered that its editorial board was, for all purposes, a gays-only club. When the magazine resumed publication in 1947, it did so with the understanding that gays were banned from the board (a prohibition everyone disregarded but that was nervous-making nonetheless). During Gorey's Harvard days, a student caught making out with another young man was expelled. Shortly after he graduated, in the spring of 1951, two Harvard men who'd engaged in what O'Hara's biographer calls "illicit activities" got the axe as well—a regrettable affair that turned into a "horrible tragedy," says Gorey's schoolmate Freddy English, when one of the young men committed suicide.

Whether Gorey thought of himself as gay at Harvard and whether his emerging style and sensibility represented a coming to terms with his sexuality he never said. Still, as noted earlier, nearly all his influences during those formative four years, from Firbank to Compton-Burnett to E. F. Benson, were gay. Then, too, the fact that he was surrounded, for the first time in his life, by unmistakably gay men—one of whom, Frank O'Hara, had become a close friend (though not, it should be emphasized, a lover)—must have pressed the question of his own sexuality.

If he, like O'Hara and others in their clique, was struggling with his identity, the pervasive homophobia of the times must have affected him in some way. With the coming of the Cold War, right-wing opportunists whipped up fears of communist infiltration at the highest levels of government. Gays, they maintained, were an especially worrisome threat to national security, since their "perversion" rendered them vulnerable to being blackmailed into spying for the Russkies. Harvard's expulsions of gay students made the mood of the moment impossible to ignore.

A report by Gorey's freshman adviser, Alfred Hower, hints at shadows moving beneath the witty insouciance he showed the world. "Gorey seems a rather nervous type and not particularly well adjusted," Hower writes, adding, hilariously, "He started to grow a beard, which may or may not be an indication of some eccentricity."[20]

When his frequent absences from Harvard's required "physical training" course landed him on academic probation, his mother pled his case with Judson Shaplin, the assistant dean of the college. In a revealing letter, she laments the difficulty Ted is having adjusting to the demands of college life, noting that he coasted through grade school and as a result "just never learned *how* to study," a weakness compounded, in her eyes, by Parker's unorthodox, no-grades approach to academics.[21] But the roots of her son's fecklessness lie, she suggests, in the fact that Ted, "as the only child of divorced parents...has been handicapped by a combination of too much mother and too little masculine influence."[22]

To our ears, Helen Gorey's pat analysis of her son as a mama's boy, infantilized (and, presumably, sissified) by a smothering mother, sounds like an outtake from the script for Hitchcock's *Psycho*. But she was

only echoing the Freudian wisdom of her day. "From the 1940s until the early 1970s, sociologists and psychiatrists advanced the idea that an overaffectionate or too-distant mother...hampers the social and psychosexual development of her son," Roel van den Oever asserts in *Mama's Boy: Momism and Homophobia in Postwar American Culture*.[23]

It seems likely that this mounting intolerance toward gays—or, for that matter, any weirdo who came off as "very, very faggoty"[24] (George Montgomery's first impression of Gorey)—would have unsettled a college student trying to make sense of who he was. A nightmarish little vignette in Gorey's collection of limericks, *The Listing Attic* (most of which he wrote "all at once" in '48 or '49), suggests *something* was troubling him.[25]

At night, in a scene straight out of Hawthorne or Poe but perfect for the lynch-mob mentality of the McCarthy era, capering men encircle a statue, brandishing torches. On top of the statue—the famous bronze likeness of John Harvard in Harvard Yard—a terrified figure cowers as one of the revelers strains with outstretched torch to set him on fire. In the foreground, black trees shrink back in horror; even their shadows recoil, stretching toward us in the firelight. Gorey writes,

> *Some Harvard men, stalwart and hairy,*
> *Drank up several bottles of sherry;*
> *In the Yard around three*
> *They were shrieking with glee:*
> *"Come on out, we are burning a fairy!"*

Within a month of meeting, Gorey and O'Hara had decided to room together. On a November 21, 1946, application for a change of residence, Gorey says he'd like to move to Eliot House, a residential house for upperclassmen whose invigorating mixture of aesthetes, athletes, scholars, and "Eliot gentlemen" (young men with Brahmin surnames like Cabot and Lodge) was handpicked by the housemaster and eminent classicist John Finley.[26] A devout believer in Harvard's house system, which was modeled

on Oxford's residential colleges, Finley fostered the life of the mind over tea parties and at more formal symposia featuring luminaries such as the poet Archibald MacLeish and I. A. Richards, a founding father of New Criticism.

It wasn't until the beginning of Gorey's sophomore year, in the fall of '47, that Harvard approved his move to Eliot, where he and O'Hara ended up in suite F-13, a triple. O'Hara took one of the two little bedrooms; the third man, Vito Sinisi—a philosophy major who, in a zillion-to-one coincidence, had studied Japanese with Gorey in the Army Specialized Training Program at the University of Chicago—called dibs on the other; and Gorey slept in the suite's common room. By day, he could often be found there, at a big table near a window, drawing his little men in raccoon coats.

Gorey and O'Hara transformed their suite into a salon, furnishing it, in suitably bohemian fashion, with white modernist garden furniture rented from one of the shops in Harvard Square. A tombstone, pilfered from Cambridge's Old Burying Ground or perhaps from Mount Auburn Cemetery and repurposed as a coffee table, added just the right touch of macabre whimsy. (Founded in 1831, Mount Auburn is a bucolic necropolis in Cambridge, not far from Harvard. It's inconceivable that Gorey didn't frequent its winding paths; judging by his books, the prop room of his imagination was well stocked with Auburn's gothic tombs, Egyptian revival obelisks, and sepulchres adorned with urns and angels.)

Gorey and O'Hara decorated F-13 with soirees in mind; it was just the sort of place for standing *contrapposto*, cocktail in one hand, cigarette in the other, making witty chitchat. "The idea," said O'Hara's friend Genevieve Kennedy, "was to lie down on a chaise longue, get mellow with a few drinks, and listen to Marlene Dietrich records. They loved her whisky voice."[27] (Dietrich was to gay culture in the '40s what Judy Garland would be to later generations of gay men. Gorey carried a torch for her long after Harvard.[*])

[*]In a 1968 letter to his friend and children's book collaborator Peter Neumeyer, Gorey, having just seen Dietrich at a matinee, describes her as not so much "fantastically well-

Gorey and O'Hara continued to swap newly discovered enthusiasms and kindle each other's obsessions. The '50s would witness the birth pangs of what the '60s would call the counterculture. As youth culture pushed back against the father-knows-best authoritarianism and mind-cramping conformity of postwar America, Hollywood and the news media provided teenagers with templates for rebellion: the brooding, alienated rebel without a cause role-modeled by James Dean; the beatniks in Allen Ginsberg's "Howl" (1956) and Jack Kerouac's *On the Road* (1957). At Harvard in 1947, though, countercultures were strictly do-it-yourself affairs. Gorey and O'Hara were a subculture unto themselves within a larger subculture, the gay underground. At a moment when T. S. Eliot's high-modernist formalism held sway in literature classes and little magazines, its brow-knitting seriousness and self-conscious symbolism the order of the day, Gorey and O'Hara embraced the satirical, knowingly frivolous novels of writers like Firbank, Compton-Burnett, and Evelyn Waugh.

Gorey and O'Hara and their clique weren't defiantly nonconformist (although they were obliquely so) or overtly political (though there was a politics to their pose). Nor were they populist in the Whitmanesque way the Beats were or in the communitarian way the hippies were. Even so, says Gooch, "they were a counterculture," albeit "an early and élitist form of it"—textbook examples of what the cultural critic Susan Sontag called the "improvised self-elected class, mainly homosexuals, who constitute themselves aristocrats of taste."[28]

Joined, over time, by kindred spirit John Ashbery—a class ahead of them at Harvard and destined to win acclaim as a major voice in American poetry—Gorey and O'Hara defined themselves through their tastes, sense of style, and aesthetic way of looking at the world.

preserved, but like a younger, not so well-preserved second-rate version of the genre she herself created. Heaven knows she went through innumerable versions of herself, all equally artificial, but one was always aware of the person behind them, but that is scarcely in evidence at all now..." That said, her shtick is ageless, he concedes, admitting that a decade earlier he would have "swooned away with rapture." See *Floating Worlds: The Letters of Edward Gorey and Peter F. Neumeyer*, ed. Peter F. Neumeyer (Petaluma, CA: Pomegranate Communications, 2011), 126.

"Nobody was organized; there was just *style*, so to speak, rather than movements," says the critic and novelist Alison Lurie, a close friend of Gorey's at Harvard and afterward, during his Cambridge period. To Lurie, Gorey and his friends "represented an alternative reality" to the blustering machismo of iconic he-men like Norman Mailer (who impressed her as "a noisy, bullying kind of person" when she met him through his sister, Barbara, her classmate at Radcliffe).

Gorey, O'Hara, and their circle recoiled from the strutting, pugnacious masculinity epitomized by Mailer, but they staked out their position through taste, not the sort of polemical tantrums he staged. Ted "loved Victorian novels and Edwardian novels," Lurie recalls. "He would never have read with much pleasure *The Naked and the Dead*. This macho thing was very irritating to Ted and his friends.... So if you were tired of men behaving this way, these writers were very encouraging to you." Vets who'd seen combat, as Mailer had, looked down on men who hadn't, like Gorey, Lurie notes, "and sometimes they would show this, you know? So I suppose there was this kind of reaction to this violent masculine mystique that some of these guys came back with."

Gorey, O'Hara, and their inner circle shared an affection for the self-consciously artificial, the over-the-top, and the recherché. Their ironic, outsider's-eye view of society often expressed itself in the parodic, highly stylized language of camp. In her essay "Notes on 'Camp,'" Sontag defines that elusive sensibility as a "way of seeing the world as an aesthetic phenomenon ... not in terms of beauty but in terms of the degree of artifice, of stylization"—a definition that harmonizes with Gorey's remark, "My life has been concerned completely with aesthetics. My responses to things are almost completely aesthetic."[29] His work isn't campy in the *What Ever Happened to Baby Jane?* sense, but there's undeniably an element of camp in his poker-faced parodies of Victorian sentimentality and Puritan sermonizing.

With predictable perversity, Gorey decided to major not in art, despite his declaration in his application that he'd set his career sights on "some field of Commercial Art," or in English, a natural fit given his insatiable appetite for literature, but in French. "With hysterical disregard for practicality I decided to major in French," he told his army buddy Bill Brandt in a letter dated April 17, 1947. "As you well know for the simple reason of being able to write in the language."[30] (Brandt would "well know" this through his familiarity with Gorey's habit of giving the plays he wrote at Dugway French titles and of sprinkling them, and his correspondence, with French phrases.) "One and all, including my advisor, are just a teeny bit baffled by such an attitude," he admitted, "but then so am I."

In 1977, with the advantages of hindsight, he offered a more plausible explanation: "I figured I'd read anything I wanted to read in English, but I would have to force myself to read all of French literature. And I thought I would like to read all of French literature."[31] Unfortunately, Harvard turned out to have "a perfectly god-awful French department," in Gorey's estimation. His French classes were "dim proceedings," especially the survey courses, which were scheduled right after lunch, with the predictable result that he "would have a nice nap," but his French, he later claimed, was "absolutely atrocious."[32]

From his class notes, we see that Gorey's French courses force-marched him through Hugo, Rousseau, Montaigne, Montesquieu, Proust, Perrault, Pascal, and La Rochefoucauld, none of whom, with the exception of Perrault and La Rochefoucauld, seems to have made much of an impression. Perrault he liked because he was taken with "the funny, irrational quality of fairy tales" (although he also said they disturbed him).[33] As for La Rochefoucauld, Gorey seems to have found the witty, cynical Frenchman's way of looking at the world congenial to his own. Gorey shared La Rochefoucauld's perspective on *la comédie humaine*, expressed in tart truisms such as "We have all sufficient strength to endure the misfortunes of others" and "We always like those who admire us; we do not always like those whom we admire."[34] In an undergraduate essay on his maxims, Gorey

writes, "I myself happen to agree with La Rochefoucauld's estimate of Man almost completely."[35]

The French phrasemaker's deft way with the short, sharp zinger was a model of the pithiness and clarity Gorey would strive for in his writing. In his essay on the *Maximes*—which is brilliant, by the way; cogent and clear and startlingly assured in its critical judgments—he admires the lucidity of a style so transparent that it performs a kind of vanishing act in the reader's mind. "Personality and everything else which is in the slightest degree superfluous to his thought have been stripped away," writes Gorey.[36] This is fascinating on two counts: it reveals the scope of Gorey's artistic intellect, broad enough to appreciate an aesthetic poles apart from the effete, hothouse-orchid style epitomized by Firbank, and it foreshadows his use of stripped-down, prosy language to ironic, often comic effect.

Gorey's uncharacteristically self-reflective thoughts on La Rochefoucauld's ideas about morality and human nature speak volumes about his own philosophical views. "I think to myself: 'This is the way people are, their every action is explained once and for all.'"[37] La Rochefoucauld "sees Man as being motivated by one thing alone: *amour-propre*, or the love of self, all other motives being merely masks which more or less effectively conceal the same face beneath. Thus all actions have the same moral value, which is to say none at all."[38]

This is strong stuff, a premonition of the existentialism that will resurface in some of Gorey's more confessional letters to his friend and literary collaborator Peter Neumeyer. When he writes about La Rochefoucauld's "incurable pessimism" regarding human society, and of the "passion and suffering" beneath the "polite glaciality of his writing's surface," we're reminded of the Gorey who once confided to an interviewer, "I read books about crazed mass murderers, and say to myself, 'There but for the grace of God.' . . . In one way I've never related to people or understood why they behave the way they do. . . . I think life is the pits."[39]

In light of such remarks, it's tempting to hear Gorey speaking through Theodore Pinkfoot, one of the characters in *Paint Me Black*

Angels, a novel he produced some fifty-odd pages of at Harvard before abandoning it:

> I dislike people, I am incapable of hate, but they terrify me. Though I am always analyzing it, human nature bores me, really. I do not believe there are such things as goodness, loyalty, courage, nobility, and their opposites. There is no need for them.... Motives, for the most part, are fatuous and unexplainable; those of which people speak are at best irrelevant.[40]

Not that Gorey, at Harvard, was a mass murderer manqué or a misanthrope sunk in gloom. To be sure, he'd always felt a little alienated: he confided to Bill Brandt, in a typically histrionic letter written in the spring term of his freshman year, that he'd been going slowly insane since September, at a loss as to why he was there and what purpose the whole business served (although he was accumulating a wealth of "idiotic but fascinating isolated bits," he allowed). He spent the better part of his study hours procrastinating or, paradoxically, "wondering in an obscure sort of way why my grades aren't brilliant."[41]

But if his attitude toward his classes was lackadaisical, Gorey's appetite for culture-bingeing outside the classroom was undiminished. He regrets, in his letter to Brandt, that he hasn't made it to the Boston Symphony Orchestra, "what with going to see every play, after the great hiatus in my theatre-going days occasioned by the army, and the ballet, every performance needless to say, whenever there's a company in town..."[42] And even if he *has* been remiss in his symphony-going, he's been filling in the more obscure gaps in his record collection: "I have developed an unholy passion for everything pre-Bach of late, regardless of what it is."

He was drawing constantly, too. Visitors to Eliot F-13 sometimes found him scratching away imperturbably amid the social whirl. "They had the best parties going at Harvard," Donald Hall recalls. "They were

jolly, funny, lively, with a mix of people, many strangers to each other, that mixed well."[43] He remembers Gorey as a man of few words, able to focus on his work amid the hubbub. "You'd go into the room to talk with Frank and there would be Ted sitting at the desk drawing one of his Christmas cards."[44]

The academic paper trail that chronicles Gorey's Harvard years is a fossil record of his evolution as an artist: drawings crowd the margins and cover the flip sides of many of his class notes, creative-writing assignments, research papers, even memos to roomies. Gorey drew women in ball gowns, their plunging décolletages ostentatiously on display, their spiky-lashed, almond-shaped eyes strikingly reminiscent of Picasso's cubist muses. He drew nuns in wimples and claw-fingered crones hunched over cauldrons and elegant, loose-lined studies of society ladies who look as if they've stepped out of the pages of *Vogue*. He drew free-associated doodles—polymorphous whatnots melting into undulating something-or-others whose dream logic is reminiscent of the surrealist parlor game the exquisite corpse. Here, there, and everywhere, he drew his little men in raccoon coats, variations on an archetype that would soon have a name: Clavius Frederick Earbrass, the "well-known novelist" whose agonizing struggle with his book in progress—"He must be mad to go on enduring the unexquisite agony of writing when it all turns out drivel"—is chronicled in Gorey's first published book, *The Unstrung Harp*.

All along, he was writing, too. He wrote short stories, dozens of them, and reams of poetry (in French as well as English), trying his hand at everything from Petrarchan sonnets to limericks, working out problems in rhyme and scansion on the backs of old assignments. In a letter to Brandt written in the fall of '47, the first term of his sophomore year, he mentions having written, to date, "some seventy five limericks (projected number: 110), many of them sordid," which pegs them as early versions, most likely, of the grimly funny limericks in *The Listing Attic*.[45]

That fall, Gorey was at work on *Paint Me Black Angels*, too, or rather its fraught beginnings: "It has now reached the point where every time I sit down to start it again, psychological blocks of various nasty sorts start

sitting on my head," he told Brandt. "I have the vague suspicion that I shall still be working on the first chapter on my deathbed..."[46] This, of course, is Mr. Earbrass's plight in *The Unstrung Harp*, a comic-gothic meditation on the horrors of the blank page. Could Gorey's abortive attempt at a novel have been the midwife of the first of his little books? *The Unstrung Harp* is a novel writ small that showed him a way out of his impasse: rather than beat your brains out trying to make a masterpiece, write an unsmilingly unserious little book, a mere bagatelle, *about* writer's block. If *The Unstrung Harp* was the brainchild of the novel that never was, it may have confirmed Gorey in his belief that "the perfect works of art of this world...are almost invariably on a small scale."[47]

Most of Gorey's poems and fictions had their origins as assignments for the creative-writing classes he took in his sophomore year with the young poet John Ciardi. Boston born and bred from working-class Italian-American stock, Ciardi was a firm believer in poetry that spoke to a mass audience. Donald Hall, who took the course with Gorey and O'Hara, remembers him as "a superb teacher" who "took our writing seriously enough to give us a bad time."[48]

Intriguingly, it was Ciardi who fanned Gorey's interest in the mock moralistic, encouraging him to parody the sermonizing voice of traditional children's literature. Like Gorey, he recalled childhood as fraught with "intensities and losses," a time of "enormous violence," figuratively and literally.[49] He scorned the "sugar-coated moralities" of most poetry intended for kids, which he thought sounded as if it were "written by a sponge dipped in warm milk and sprinkled with sugar"; *his* children's verse, he said, was written "in the happy conviction that children were small savages with a glad flair for violence."

Gorey got to know Ciardi "fairly well"; he, O'Hara, and George Rinehart, son of the Rinehart who founded the New York publisher Holt, Rinehart & Winston (and grandson of the mystery writer Mary Roberts Rinehart), would often join their professor after class for

caffeine-fueled bull sessions at a nearby coffee shop.[50] When Ciardi and his wife needed some wallpaper steamed from the walls of the apartment they were renovating, they recruited Gorey, O'Hara, and Rinehart for the job. "They were at it for days as they played a game of killing insults," Ciardi recalled. "They were beautiful and bright and I have never come on three students as a group who seemed to have such unlimited prospects."[51] After a day's hard work peeling wallpaper while Rossini overtures blared from the record player, the trio would join Ciardi and his wife, Judith, for spaghetti washed down with wine. Judith thought the three young men were "the funniest people in the world, with tongues like scalpels."[52]

Ciardi had no doubt that O'Hara was a prodigious talent, writing "like a young Mozart," although the young poet's worship of style over sincerity led his professor to observe that he "showed his brilliance rather than his feelings."[53] As for Gorey, who shared O'Hara's fascination with irony, parody, artifice, and nonsense, along with his aversion to the earnest, confessional voice, Ciardi's comments on his papers are keenly insightful. Ciardi could be as pitiless in his written remarks as he was solicitous in class, and his analysis of Gorey's cultivated artificiality and ironic distance from his subject matter is both penetrating and prophetic, foreshadowing charges leveled at Gorey's work in later years.

Ciardi's response to a ten-page short story Ted submitted on October 27, 1947, for his English A-1a course is illuminating. "The Colours of Disillusion" (note Gorey's Anglophilic insistence on British spelling) is a Firbank knockoff, from its gossipy cocktail-party setting to the near-fatal preciosity of the writing. But it's not all Firbank; already Gorey's comic-macabre aesthetic is spreading its dark wings. The setting is vaguely Victorian-Edwardian, as is the language ("'How too frightening,' said a young man with a soigné moustache"); "the eldest lady of the party" is addicted to shilling shockers; a child is in peril; "great black beards" are fetishized, cathected with infantile notions of "all that was good and kind and moral and strong"; a young woman pours vitriol—literally—on her sleeping husband's face.[54]

Ciardi gives Gorey an A, then renders judgment in full: "It begins to

appear inevitable that I can never do more than pass your stories back with a question mark. Actually I think it's your question mark. Everything you're writing is flawless and unfinished. Unfinished in the sense that you're following your own instinct but haven't found it completely. When you do, it—your writing—will, I suspect, be either transcendent or simply pointless, depending on whether you follow it into some idea of order, or merely into the bric-a-brac of amusing reverie."[55] Ciardi is prescient in his observation that Gorey is guided by a lodestar all his own, as he will be for the rest of his creative life. And he's right to point out that Ted's sensibility is taking shape but hasn't yet coalesced.

But he misses the mark when he says that Gorey must choose between transcendence and pointlessness. Gorey, who straddled Taoism and Dadaism, irony and existentialist angst, made a career of defying dualisms, in the course of which he produced works that managed to be both marvelous *and* pointless, serious *and* frivolous. Again, Sontag is helpful: "There are other creative sensibilities besides the seriousness (both tragic and comic) of high culture," she writes in "Notes on 'Camp.'" "Camp involves a new, more complex relation to 'the serious.' One can be serious about the frivolous, frivolous about the serious."[56]

Ciardi's critiques were love notes compared to Professor Kenneth P. Kempton's comments on a story submitted for his English 1b course, which Gorey took in the spring of '49. "Your rococo manner, derived from self-consciousness and reading, is here made more than usually irritating by meager content spread very thin," he wrote in a critique that can be fairly described as withering.[57] He gave it a C.

Undeniably, Gorey's undergraduate efforts earn his professors' criticisms—and then some. The brittle artificiality of his drawing-room comedies, his thinly drawn characters, his inability to resist overegging the pudding of his prose style: the Firbankian posturing quickly grows tiresome. Then again, shameless imitation is part of any young writer's apprenticeship. "That's what happens to young people in college," said a friend of O'Hara's, commenting on Frank's Wildean affectations at Harvard. "They decide on their mentor and they go all the way trying to be like him."[58]

At the same time, there's a culture war going on here between naturalism and what I'll call unnaturalism: between the novel as an exercise in depth psychology, plumbing the neuroses of realistic characters, and the novel as a puppet show where we see the human comedy—the masks we wear, the little dramas we act out—from a wry, ironic remove. It's naturalism versus aestheticism, Hemingway in *A Moveable Feast* exhorting himself to "write the truest sentence that you know" versus Wilde in "The Decay of Lying" lamenting the "morbid and unhealthy faculty of truthtelling."[59] But we can also see this clash of artistic philosophies as a proxy war for the conflict between masculinity American-style (whose literary correlative is the "lean" and "muscular" style of tough-guy modernists like Hemingway and Mailer, with their terse sentences and their commitment to fiction as hard truth, straight up, no chaser) and its mauvish discontents.

In his little books, Gorey would, like the surrealists, the French avant-gardists known as the Oulipo group, and Victorian writers of nonsense verse such as Lear and Lewis Carroll, privilege formal experimentation over conventional storytelling (although he did believe in the importance of plot). Rather than the psychologically three-dimensional characters we meet in mainstream fiction, he preferred the stock types and mythic archetypes familiar from silent films and ballets, folktales and fairy tales, Kabuki and Noh theater, whodunits and penny dreadfuls.

This doesn't mean his work was divorced from lived experience: surrealism, aestheticism, and nonsense are no less capable than realism of accessing the deeper truths of the human condition. Brad Gooch's analysis of O'Hara applies equally to Gorey: "He didn't want to be a Hemingway, the sort of popular writer who reduced the complexities of felt life to an 'elegant machinery' while his characters pretended to a deceptive lifelikeness." Instead, as O'Hara put it, he wanted "to move towards a complexity which makes life within the work and which does not (necessarily, although it may) resemble life as much as most people think it is lived."[60]

After Harvard, Gorey would never again attempt long-form fiction. He would invent a genre all his own, one that partook of the illustrated

children's book, the mystery story, the graphic novel (Gorey anticipated the genre decades before Art Spiegelman's *Maus* popularized it, in 1986), the artist's book (conceptual artwork in book form), and tongue-in-cheek treatments of moralizing nursery rhymes (Heinrich Hoffmann's grisly-funny *Struwwelpeter* and Hilaire Belloc's *Cautionary Tales for Children* are the most obvious influences). His little books don't fit neatly into any category but Gorey, really. Yet they're inarguably a species of fiction, however uncategorizable, and Gorey would always think of himself as "first a writer, then an artist."[61]

By the spring of '49, O'Hara had gotten so tight with another Eliot House resident, Hal Fondren, that he was spending much of his time in O-22, Fondren's suite, which looked out on the housemaster's garden. A fellow vet who'd served as an air force gunner in England, Fondren was witty and cultured in the usual Anglophilic way: he liked to show off his collection of the early pamphlet editions of T. S. Eliot's *Four Quartets*, which he'd purchased as they came out, one by one.

Speaking of quartets, Gorey struck up a friendship with Fondren's roommate, Tony Smith. Smith, the scion of a wealthy Republican family, was an econ major who'd prepared at ultraexclusive Exeter. He doesn't seem like Gorey's type, but, against all odds, they began palling around.

Gorey and O'Hara were growing apart, partly as a result of O'Hara's absorption in Fondren and partly because their diverging creative trajectories and social styles were accentuating their differences. O'Hara's appetite for intellectual blood sports—cocktail-party games of oneupmanship—and his hard-partying, hard-drinking gregariousness contrasted sharply with Gorey's reclusiveness and dry, ironic style. "Gorey's style was never entirely appropriate for O'Hara," notes Gooch.[62] "As a schoolmate put it, Gorey's style was 'cool, English. Nothing could get to you. But then Frank was someone who everything got to.'"[63] Even so, Gorey continued to serve as a model

of unapologetic individuality for O'Hara, especially in his flamboyant manner and dress, a style later characterized by an obituary writer as "dandy nerd."[64]

The Gorey beard made its first appearance around this time.* Gorey later claimed, in an unpublished interview with a young fan named Faith Elliott, that he let his whiskers grow long to conceal the fact that he had a receding chin, "which is one of the things that's a deep, dark secret."[65] "If you pushed his beard, for a long face he had a very small chin," Mel Schierman, his friend from the New York City Ballet scene, confirms. "He made me do it one time." (In one of her letters to Ted at Harvard, Helen Gorey, ever helpful, enclosed a clipping of a magazine humor column quoting a "physiologist" who reassures weak-chinned readers that "a receding chin does not indicate weakness—either mental or physical.")[66]

Of course, if Ted's beard was a disguise for the shameful secret that he was a chinless wonder, it did double duty as a token of his affection for Wildean aestheticism, Edwardian dandyism, and nineteenth-century litterateurs like Edward Lear, who sported a majestic beard that's a dead ringer for Gorey's. An attraction to the beard as an emblem of Victorian manliness may be somewhere in there, too: Gorey's fiction, as far back as Harvard, is full of strapping chaps with luxuriant facial hair. Then, too, beards are masks, tailor-made for concealing your true self if you're the shy, reserved type.

The sneakers and the flowing coat, both as much a part of the Gorey look as his beard, were de rigueur by this time as well, though the coat wasn't yet the floor-length fur version that would later inspire dropped jaws on Fifth Avenue in Manhattan. "Tony [Smith] and Ted would go shopping every week at [the Boston department store] Filene's Base-

*It came and went, apparently: a photo of him in New York in the early '50s shows him beardless. In 1953 it comes to stay and soon attains an imposing Old Testament glory. "We heard through some family . . . that he has grown a beard," his father wrote a friend that year. "I wonder what he's trying to look like—a cross between Sir Thomas Beecham, Lennie Hayton, and Boris Karloff?" See Edward Leo Gorey's letter to Merrill Moore, April 24, 1953, Merrill Moore Papers, Manuscript Division, Library of Congress.

ment," Fondren recalled. "It was just at the time when those long canvas coats with sheepskin collars became very fashionable and they both wore them."[67]

Gorey may have borrowed the idea for his famous fur coat from the poet John Wheelwright (Harvard class of '20), an improbable mix of bohemian and Boston Brahmin who flew the flag of his nonconformity in the form of a floor-sweeping raccoon coat. But it's just as likely that he lifted the idea from Oscar Wilde, who in some portraits cuts a glamorous figure in his beloved fur coat. Certainly Gorey's habit, as a freshman, of wearing his hair "plastered down across the front like bangs, like a Roman emperor," as George Montgomery described it, sounds an awful lot like Wilde in the 1883 Sarony picture of him wearing his hair cut short, with a little fringe of a bang.[68]

As for the three-inch-long fingernail that caught Larry Osgood's eye, it's useful to know that Firbank wore his nails "long and polished," according to one of his biographers, "and what was unusual in a man is that they were stained a deep carmine."[69] When we learn that Firbank wore exotic rings on his pale fingers—jade rings from China, Egyptian rings made of blue ceramic—we can't help wondering if Gorey's signature rings were, in a sense, Firbank's.

Gorey's own explanation, when asked about the origins of his image in a 1978 interview, was predictably scattershot. "The thing is, my drawing tends to be rather Victorian and everything," he said, and "when I first got [fur] coats, they looked like...they were Victorian, you know, period pieces. (Now they don't, because other people are going for them.)...I've always worn a lot of jewelry, which nobody ever did...and I've had a beard for twenty-eight years...and when I first had it everybody said, 'Do you belong to the House of David or something?'"[70]

O'Hara would never be the screwball dandy Gorey was; still, he was taken with Gorey's independence of mind, manifest not only in his flamboyant dress but also in an intellectual curiosity that followed its own inscrutable logic and in a literary voice that was immune to prevailing trends and critical orthodoxies. In their sophomore year, Gorey and

O'Hara favored the Grolier Book Shop on Plympton Street, rummaging through tall shelves stuffed mostly with literary fiction and poetry or reading on the comfily dilapidated sofa that dominated the small but high-ceilinged shop. O'Hara was on a C. Day-Lewis jag, collecting all his novels, which to Gorey's mind were "sort of elegant, a little dull, concerning sensitive young English men in the early thirties."[71] Gorey was smitten with Ivy Compton-Burnett and was collecting the Penguin editions of her novels.

In the spring term of their junior year, however, the Mandrake Book Store on Boylston, near Harvard Square, was their preferred haunt. Unlike the cramped, dusty Grolier, the Mandrake had the feel of a comfortably appointed sitting room, with customers reading in chairs among the well-ordered shelves. Hal Fondren recalled, "I had an account there because I wanted every Henry Green novel.....Ivy Compton-Burnett, of course, was the patron saint of the group with Ted Gorey as her chief acolyte. We were all dying over the latest Ivy Compton-Burnett. You can't imagine the excitement it created."[72]

Compton-Burnett (1884–1969) was a bloodless anatomist of English society. Like Firbank's, her novels consist mostly of dialogue, much of it Wildean epigrams. They read like plays, which may go far in explaining Gorey's attraction to her work (and to Firbank's). A philosophical dialogue with the butler, Deakin, from *A Heritage and Its History* is worth reprinting in full:

"And we cannot depend on the silver lining, sir," said Deakin. "I have seen many clouds without it."

"I have never seen one with it," said Walter. "My clouds have been so very black."

"Well, the lighter the lining, sir, the darker the cloud may seem."

"You pride yourself on pessimism, Deakin," said Julia.

"Well, ma'am, when we are told to look on the bright side of things, it is not generally at a happy time."

92

"But it is good advice for daily life."

"Daily life harbors everything, ma'am. All our troubles come into it."[73]

A very Goreyesque sentiment.

Near the end of the spring term, in May of '49, Ted exhibited his watercolors at the Mandrake. The show was a success: "The tiny store was overflowing with an animated crowd of young students smoking, drinking, and, above all, uttering sharp, fast comments," Gooch reports.[74] Behind the scenes, however, Ted was coming unstrung, as he would say. O'Hara had announced his decision to move in with Fondren that fall, at the beginning of their senior year, a turn of events that left Gorey feeling "mildly abandoned," he later confessed.[75] Ted saw Frank as "moving onward and upward" in the spring of '49.[76] "I felt that after we stopped rooming together that he sort of expanded," said Gorey.[77]

Ted may be referring to O'Hara's forays into artistic territory outside the sharply defined borders of their shared style; beyond Firbank and Compton-Burnett into Beckett, Camus, and, soon enough, in New York, de Kooning, Helen Frankenthaler, Alice Neel. But Gorey's reference to O'Hara having "expanded" may have had a hidden meaning. According to Gooch, "O'Hara began to flirt during the spring term with some of the homosexual implications of the high style he had so cleverly absorbed" from Gorey.[78]

He'd started fooling around with various gentlemen in Eliot House. "There was some carrying on towards the end" of their two years as roommates, Gorey recalled. "He would occasionally come back bombed out of his wits."[79] It's ironic that Gorey's Anglophilic, inescapably gay "high style" beckoned O'Hara out of the closet, since Ted himself was securely closeted at Harvard, his outrageousness notwithstanding. Nonetheless, Gooch suggests, he was instrumental in O'Hara's

acceptance of his homosexuality. "He had friends in the Music Department who actually accused me of having *corrupted* Frank," Gorey said, "like in some turn-of-the-century novel."[80]

Many of O'Hara's Harvard conquests were men who thought of themselves as straight despite their willingness to bat for the other team in a pinch. In yet another irony, Gorey himself was involved, at that very moment, in a relationship with just such a man: Tony Smith.

The word *relationship*, in this case, means "all-consuming crush." Just how far things went we don't know, though Larry Osgood doubts the relationship got physical for the simple reason that Ted, he firmly believes, "did not then and never had a sex life."[81] That said, it's clear from a letter Gorey wrote to Connie Joerns that he made a clean breast of his feelings to Smith and that while Smith's response wasn't what Ted had hoped, the two did have an emotionally charged friendship, fraught with the soap-opera drama that would characterize all Ted's crushes to come. By the fall of '49, Smith had moved into F-13, leaving O-22 to Fondren and O'Hara, which suggests he was close to Gorey—either that or unusually accommodating to Fondren. (What F-13's third inhabitant, the apparently unflappable Vito Sinisi, made of this round of musical chairs is anyone's guess.)

"This was typical of Ted's crushes and attachments," says Osgood, who recalls Smith as "Ted's very straight roommate who never went out drinking or mixed at all with the gay group"—which included Osgood, his Eliot House roommate Lyon Phelps, O'Hara, Fondren, Freddy English, George Montgomery, and, less frequently, Gorey—who met for beers two or three times a week at Cronin's, a saloon whose ten-cent Ballantine on tap and close proximity to the Yard made it an ideal watering hole.[82] Smith was "perhaps a little boring," in Osgood's judgment.[83] Nonetheless, Ted fell for him. "I had the impression then, as now, that Ted was in love with him—unrequitedly," says Osgood. "The rest of us respected and sympathized with Ted's frus-

tration, although I think we never discussed it within his hearing and found the object of his affections a little odd."

Gorey's feelings for Smith blossomed in the fall of '48. By that December, however, the bloom was off the rose. In a long confessional letter to Connie Joerns written during Christmas break, he bemoans the dire state of his love life. Tony is in Fall River, he confides, and their relationship, such as it is, alternates between "utterly cloying and grim and addled"[84] but is never less than "peculiar," even at the best of times.[85] Tony, it seems, is the manly, closemouthed type, hopeless at self-analysis and all thumbs when it comes to teasing out the knots in romantic entanglements, whereas Ted tends toward the "hysterical," which makes for soap-operatic scenes, he tells Joerns.[86]

Gorey being Gorey, he manages to see the existential punch line in his predicament. It's ironic, he tells Joerns, that he, whose heart's delight is getting involved with someone, then spending "all my free time in mutual analysis of the situation," should end up with a lover who blanches in terror at the thought of baring his soul.[87] But this is play-acting. Two sentences later, the wry, self-mocking detachment gives way to anguish: he just might lose his mind, he says, if this "subterranean torture" goes on much longer.

Ted's claim that he was teetering on the brink of a nervous collapse wasn't just the usual fainting-couch histrionics. Shortly after he returned to Harvard for the spring term of his junior year, in '49, he was interviewed by assistant dean Norman Harrower Jr., presumably about his grades, which were slipping. "Says he has been having personal troubles all fall," Harrower writes in a January 29 note scribbled on Gorey's grade card. "Seemed extremely nervous and jittery. Smoked a cig. In short nervous puffs. His eyelids fluttered and he was very jumpy. Tried to get him to psych. But he feels that this is something that he ought to be able to force himself to control. He seemed to consider the possibility of a psych. and it may work. Queer looking egg."[88]

Whether Gorey saw a psychologist we don't know. But there's grist for the Freudian mill in the poems and stories he wrote in the spring and fall of '49, some of which can be read as oblique allusions to his

"personal troubles" with Smith or as veiled references to his feelings about his sexuality. In one poem, a lighthearted apologia for asexuality, he eschews the emotional (and literal) messiness of romantic entanglements and sexual passion for the solitary pleasures of Just Saying No:

> *I've never been one for a messy clinch*
> *a thigh to pinch*
> *let's keep calm.*[89]

By the end of January in '51, seven months after he graduated, Gorey was over his infatuation with Tony Smith, judging by his comments in a letter to Bill Brandt. His love life, fortunately, was "being nil," he wrote, now that the "little tin god" he'd worshipped for two years was more or less history, barring the occasional visit to spend the night.[90]

Being nil, Gorey decided, was the safest policy. "I am fortunate in that I am apparently reasonably undersexed or something," he said twenty-nine years later when asked about his sexuality. "I've never said that I was gay and I've never said that I wasn't. A lot of people would say that I wasn't because I never do anything about it."[91] Would they? Is having desires yet not acting on them really the same as not having any desires to act on?

Gorey, ever paradoxical, is saying two contradictory things simultaneously: that he's asexual ("undersexed") *and* that he might be gay but since he never does anything about it, he's as good as "neutral," as Compton-Burnett would say.* He's "fortunate" to be "undersexed," he says, implying that Fate decreed it. But doesn't his admission "I am probably terribly repressed" direct our attention to what, exactly, he's repressing?[92] "Every now and then someone will say my books are seething with repressed sexuality," he conceded.[93]

*Compton-Burnett lived for many years with Margaret Jourdain, a noted writer on interior decor and furniture, in what the Victorians would have called a Boston marriage—two women living together in a mutually supportive, though not necessarily romantic, arrangement. Whether their relationship was sapphic or merely sororal isn't known; Compton-Burnett referred to herself and Margaret as "neutrals."

In later life, when Gorey talked about sex, it was either with Swiftian disdain for its panting, grunting preposterousness — "No one takes pornography seriously," he scoffed — or with Victorian mortification at the very mention of the unmentionable.[94] When he talked about love, it was always in the past tense, as a farcical calamity that had befallen him, the sort of thing insurance claims adjusters file under Acts of God, like the flattening of the picnickers by the Wobbling Rock in *The Willowdale Handcar.* "You don't choose the people you fall in love with," he told an interviewer in 1980.[95]

In any event, his romantic imbroglios weren't true love, he implied, but mere "infatuations." Infatuations are a distinguishing characteristic of sexual immaturity — the stuff of adolescent crushes and teen-idol worship. Narcissistic at heart, they offer romance without the grunt work of relationship building, love without the hairy horrors of sex. "When I look back on my furious, ill-considered infatuations for people," said Gorey, "they were really all the same person."[96] Of course they were: the objects of our obsessions are ideal types, spun from fantasy. "I thought I was in love a couple of times, but I rather think it was only infatuation," said Gorey in 1992. "It bothered me briefly, but I always got over it. I mean, for a while I'd think, after some perfectly pointless involvement that was far more trouble than it was worth — I'd think, 'Oh God, I hope I don't get infatuated with anybody ever again.' . . . I realized I was accident-prone in that direction anyway, so the hell with it."[97]

Was it his traumatic two years of worshipping Tony Smith that made Ted say to hell with love, and even sex, forever? Larry Osgood thinks Gorey swore off sex long before he got to Harvard. "He did tell me — because we were close friends, and we would talk about these things — that he once had a sexual experience in his late teens, I think. And he hadn't liked it. And that was that. He wasn't going to do that again." Gorey didn't offer any details about the incident, but Osgood is convinced, from his intimate knowledge of Ted's emotional life, that it must have been a same-sex experience.

But whether it was a traumatic sexual encounter in his teens or his

tempestuous affair with Tony Smith at Harvard that put Ted off sex, Osgood is convinced "there was more choice in his abstinence than biology." Gorey "didn't want the distractions of emotional engagements," he says, "which would be messy, and he might get hurt, and in fact he *had* been hurt." John Ashbery said something strikingly similar when I asked him for his recollections of Gorey at Harvard. "There was something very endearing about him, almost childlike," Ashbery recalled. "At the same time, I feel that he was somehow unable and/or unwilling to engage in a very close friendship with anyone, above a certain good-humored, fun-loving level....I had the impression that he had constructed defenses against real intimacy, maybe as a result of early disappointments in friendship/affection."[98]

At the same time, Osgood thinks Gorey was being honest when he said that relationships are a distraction from the writing desk and the drawing board. An aesthete to the end, Gorey lived for Art, in the opinion of the *New Yorker* writer Stephen Schiff, who described him as someone who "cultivated the life of a vestal, the anchoritic handmaiden of his art."[99] "It's hard enough to sit down to work every day, God knows, even if you are not emotionally involved," Gorey told an interviewer. "Whole stretches of your life go kerplunk when that happens."[100]

Unsurprisingly, Gorey's grades had gone kerplunk during his "furious, ill-considered infatuation" with Tony Smith. Assistant dean Harrower notified him, on March 4 of '49, that he was on academic probation. As always, he managed to pull himself out of his death spiral: by July, he'd been relieved from warning, as the official notification put it.

He rallied his creative energies, too. Sometime between 1948 and '50, he created three little gems of commercial illustration, flawlessly executed cover designs for *Lilliput*, a British men's monthly that offered a pre-*Playboy* potpourri of humor, short stories, arts coverage, cartoons, and, daringly, soft-core "art nudes" depicting female models cavorting—

aesthetically, mind you—on beaches or in bohemian artists' studios. Whether his covers ever appeared in print or were just fodder for his commercial-illustration portfolio isn't known. The looming threat of graduation had concentrated his mind on the necessity of making a living, someday soon.

Gorey did submit his work to at least one publication outside Harvard. A rejection letter from the *New Yorker*, dated May 8, 1950, and signed "Franklyn B. Modell," thanks him, in the usual perfunctory way, for letting the magazine see his drawings. Pleasantries out of the way, Mr. Modell gets down to business: "While I readily recognize their merit, I'm afraid they are not suitable for *The New Yorker*. The people in your pictures are too strange and the ideas, we think, are not funny.... By way of suggestion may I say that drawings of a less eccentric nature might find a more enthusiastic audience here."[101]

This was the *New Yorker* of Harold Ross, the founding editor, who scolded E. B. White about his use of the unthinkably vulgar phrase "toilet paper," so "sickening" it "might easily cause vomiting"; home to cartoonists such as Peter Arno, an upper-crust East Coaster whose covers and single-panel gags took little notice of the Depression, the war, or other unpleasantries, except as punch lines.[102] Arno went down well with a dry martini at the Stork Club; Gorey's camp-gothic eccentricities, not so much.

(Happily, Gorey followed his instincts and had the satisfaction, forty-three years later, of seeing his work appear in the pages, and ultimately on the cover, of a *New Yorker* that was ready, at last, for the amusingly unfunny. Shortly after his death, the magazine dedicated its end page, by way of an elegy, to a Gorey illustration.)

Gorey graduated from Harvard on June 22, 1950, with an AB in Romance languages and literatures. His final report card records an A in English, a C in French, and a B in history, an appropriately erratic ending to an academic career that had zigzagged all over the place.

Outside the classroom, however, he floored the accelerator. Harvard is where Gorey perfected his image, stylizing his zany fashion sense and theatrical mannerisms into the persona that, with a few last tweaks (pierced ears, copious necklaces, sidewalk-sweeping fur coats dyed heart-attack green or yellow), would turn heads in Manhattan. More important, Harvard is where he sketched in the intellectual substance of his eccentric persona, drawing inspiration from writers like Firbank and Compton-Burnett. From Lear, he took the limerick form. Encouraged by Ciardi, he put to drily amusing use a mock-moralistic tone that parodied Victorian writing for children. Even the melancholy epitaphs at Mount Auburn Cemetery, mementos of the Victorian cult of mourning, and the Puritan reproaches to mortal vanity in the Old Burying Ground near Harvard Square had something to teach him: their lugubrious cadences and morbid sentiments, so melodramatic they verge on black comedy, echo in Gorey's verse.

He learned as much from his antipathies as he did from his sympathies: in several interviews, he returned to a subject dear to his heart, his adamantine hatred of Henry James, whose tendency to explain things to death he found wearisome, whose labyrinthine sentences maddened him, and whose characters he found morally repugnant, motivated by "utterly unpleasant arid curiosity."[103] In an essay for a comp lit class, he wrote, "James's favoured method of unfolding an action is to have it revealed, slowly, bit by bit, through inexhaustible questionings, probings, pryings, comparings on the part of onlookers of the main action....If anyone ever literally died of curiosity I am certain it must have been a Jamesian character."

Crucially, he discovered that he wasn't a novelist but that he might, by combining his gifts for narrative compression and epigrammatic wit with his meticulous, hand-drawn engravings, produce masterpieces of miniaturism that defy categorization. All the while, he was evolving as an artist, polishing his draftsmanship and, through his exploration of watercolor, developing a taste for subtle color harmonies and deliciously queasy hues.

But when it came to Gorey's maturation as an artist and a thinker,

nothing in his four years at Harvard affected him more profoundly than his relationship with Frank O'Hara. Their friendship introduced both men to new interests and influences; each sharpened his ideas about art, literature, music, film, theater, and ballet on the whetstone of the other's equally nimble, wide-ranging mind. Postmodernists *avant la lettre*, they embraced lowbrow, highbrow, and middlebrow tastes with gusto and without apology.

As important, each was present at the birth of the other's self-creation and, consciously or not, lent a hand. "All of us were *obsessed*," Gorey later recalled, characterizing the mood of their Harvard years. "Obsessed by what? Ourselves, I expect."[104] The bearded dandy nerd in Keds and fur coat, fingers dripping rings, was "a kind of this-is-me-but-it's-not-me thing," Gorey later confided.[105] Meaning: "Part of me is genuinely eccentric, part of me is a bit of a put-on."[106] He added, slyly, "But I know what I'm doing." (Another time, he struck a more poignant note, seeming almost trapped by his eccentric image: "I look like a real person, but underneath I am not real at all. It's just a fake persona.")[107]

Though Gorey and O'Hara crossed paths briefly after graduation through their involvement with the Poets' Theatre, in Cambridge, their friendship wouldn't survive long. After both men moved to Manhattan—O'Hara in '51, Gorey in '53—their lives intersected only occasionally, though they frequented the New York City Ballet, had friends in common, and lived just a subway stop apart.

Their diverging trajectories had something to do with it. In New York, O'Hara's engagement with contemporary art would draw him into the orbit of the abstract expressionists, whose frenetic socializing and improvisatory aesthetic would show him the way out of naturalism's imitation of life and into a poetry collaged out of scraps of life itself—snatches of conversation, things seen and freeze-framed by his camera eye, quotations from his encyclopedic reading and movie watching and gallery going. O'Hara was addicted to the Now—to art forms such as action painting, which captured "the *present* rather than the past, the present in all its chaotic splendor," writes Marjorie Perloff in *Frank O'Hara: Poet Among Painters*.[108]

Gorey, by contrast, immersed himself ever deeper in things past—silent movies, Victorian novels, Edward Lear, the Ballets Russes. Pursuing his solitary obsessions, he chased a vision all his own, wholly new yet sepia-tinted with a sense of lost time.* O'Hara was avant-garde; Gorey was avant-retro. At Harvard, Gorey distilled his influences into a concentrated essence that would nourish his art for the rest of his life. O'Hara, by the summer of '49, was shaking off his Firbankian affectations. Critiquing a friend's poem, he wrote, with mock condescension, "I can see certain tendencies in you which we all have to get rid of. With me it was Ronald Firbank, with you it looks a bit like the divine Oscar..."[109]

Their friendship came to grief over one of O'Hara's pointed wisecracks. Maybe there had always been a little rivalry beneath their sharp-witted jousting—who knows? But O'Hara's hipster derision at Gorey's Firbankian sensibility—so arch, so preciously aesthetic, so aloof from the cultural ferment of the moment—emerged undisguised in a jab that cut too close to the bone. "Ted told me that he'd seen Frank at some point shortly after he'd moved to New York," Larry Osgood remembers, "and Frank's opening remark, practically, was, 'So, are you still drawing those funny little men?' And Ted took great offense at that, and that was that for that relationship."

Years later, Gorey settled the score. Rolling his eyes at the idea that his former roommate, who banged out his poems on the fly, was some kind of genius, he told an interviewer, "I was astonished after his death, and even before, when he became a kind of icon for a whole gener-

*In that respect, he had much in common with the artist Joseph Cornell. Like Gorey, Cornell was a species of one whose work is essentially uncategorizable. Also like Gorey, he was deeply indebted to surrealism. He worked on a dollhouse scale (another Gorey parallel), fastidiously arranging found objects and images in wooden boxes. Masterpieces of lyrical nostalgia and surrealist free association, his works are collaged from vintage photos, old toys, antique scientific illustrations, rusty scissors and skeleton keys, and other Goreyesque oddments.

Cornell was likewise a fervent worshipper at the temple of Balanchine. Surely he and Gorey passed each other in the lobby of the New York State Theater, at Lincoln Center, during intermission. Yet there's no evidence they ever met, and neither, to the best of my knowledge, ever mentioned the other.

ation. If you know somebody really well, you can never really believe how talented they are. I *know* how he wrote some of those poems, so I can't take them all that seriously."[110]

O'Hara died in 1966, at the age of forty, killed by a teenager joyriding at night in a Jeep on the beach at Fire Island. At Harvard, in the first flush of their friendship, he'd written a poem for Ted that was later included in his posthumous collection, *Early Writing*. Titled, simply, "For Edward Gorey," it evokes not only the Victorian-Edwardian setting of Gorey's work and its insular, dollhouse psychology but also the sense of the Freudian repressed that haunts it. Referring to the "anger" underlying Gorey's "fight for order," he notes, "you people this heatless square / with your elegant indifferent / and your busy leisured / characters who yet refuse despite surrounding flames / to be demons."[111] He evokes the taxidermy stillness of Gorey's vitrine worlds ("You arrange on paper life stiller than / oiled fruits or wired twigs") and the obsessive cross-hatching that is a Gorey signature ("See how upon the virgin grain / a crosshatch claws a patch / of black blood...").

Strangely, in O'Hara's spyhole view of Ted's world, Gorey's funny little men are female: "You transfigure hens, your men cluck tremulous, detached..." Is this a coded reference to their gay circle at a time when it was common for gay men, among themselves, to jokingly adopt women's names? The poem ends on a moody, crepuscular note, wonderfully evocative of the perpetual twilight in which Gorey's stories always seem to take place: "And when the sun goes down," O'Hara writes, the hen-men's "eyes glow gas jets / and the gramophone supplies them, / resting, soft-tuned squawks."

Looking back in 1989, Gorey took stock of his time at Harvard and his friendship with O'Hara. "We were giddy and aimless and wanting to have a good time and to be artists," he said. "We were just terribly intellectual and avant-garde and all that jazz."[112]

CHAPTER 4

SACRED MONSTERS

Cambridge, 1950–53

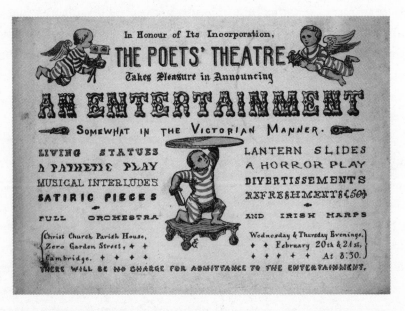

Edward Gorey, poster for "An Entertainment Somewhat in the Victorian Manner" by the Poets' Theatre. *(Larry Osgood, private collection)*

THE WAY GOREY TOLD IT, he kicked around Boston two and a half years after Harvard, drifting and dithering in the usual fashion. He was twenty-five and not exactly taking the world by storm.

"I worked for a man who imported British books," he recalled, "and I worked in various bookstores and starved, more or less, though my family was helping to support me."[1] He entertained vague ideas about pursuing a career in publishing. Or maybe he'd open a bookshop. His pipe dreams vaporized on contact with the unglamorous reality of bookselling. "I wanted to have my own bookstore until I worked in

one," he reflected in 1998. "Then I thought I'd be a librarian until I met some crazy ones."[2] In later, more successful days, he liked to say he was "starving to death" in his Cambridge years, although given his penchant for Dickensian melodrama, who knows if things were quite that dire?[3] "I never had to live on peanut butter and bananas, but close," he claimed in 1978.[4]

Shortly before graduating, he mentioned, over dinner at the Ciardis', that he planned to stay in Boston but hadn't yet found a place. On the spot, John and Judy offered him a room, rent free, in the house they shared with John's mother in the Boston suburb of Medford. All he had to do in return was feed their cat, Octavius, when they were away that summer.

Installed at the Ciardis', Gorey pounded the pavement hunting for jobs in publishing, then in advertising, but couldn't find a berth in either field, he told Bill Brandt in a letter.[5] He was writing, desultorily, mostly limericks in his penny-dreadful style. Four years later, he'd collect the best of them in *The Listing Attic*. According to Alexander Theroux, he "started 'an endless number of novels,' now, alas, all jettisoned."[6] "Having nothing to do," he wrote Brandt, "is the most demoralizing thing known to man."[7] Still, there were always scads of movies he was eager to see and a book, if not "several hundred," he couldn't wait to devour.

Jobless and footloose, Gorey started visiting his uncle Ben and aunt Betty Garvey and their daughters, Skee and Eleanor, at their summer house in Barnstable, on the Cape. The Garveys lived in suburban Philadelphia, but Betty, née Elizabeth Hinckley, came from old Cape stock. "Hinckleys have been on the Cape, in one way or another, from the *Mayflower*," notes Ken Morton, Skee's son. The Garveys' first summer house, near the water on Freezer Road, was the standard beach cottage—"very tiny," with "ratty cottage furniture," in Skee's recollection. It was so overstuffed with Garveys that Ted had to sleep on the porch, which didn't seem to bother him in the least.

The cramped confines were a goad to get up and go. Gorey and the gang were keen yard-salers and moviegoers and beachcombers and picnickers. "We drove all over the Cape, and you could swim at any

beach you happened to arrive at," Skee remembers. Sometimes they'd take their little motorboat, or a sailboat borrowed from relatives, out to Sandy Neck, an arm of barrier beach embracing Barnstable Harbor. It's a place of desolate beauty. The shoreline is littered with pebbles, spent ammo in the ocean's ceaseless bombardment of the land. The dunes are carpeted with bayberry, beach plum, sandwort, and spurge. Some are "walking" dunes, their wind-whipped sands slowly but inexorably engulfing stands of pitch pine and scrub oak. With their clawing branches and bony boughs, these skeletal forests look as if Gorey drew them. Little wonder, then, that he was drawn to them, and kept an eye peeled for fallen limbs beaten by the weather into suggestive shapes—driftwood that "never actually drifted," Ken calls it.

Shedding his Firbankian persona, Gorey slipped effortlessly into the new role of Cousin Ted, happy to be swept along in the currents of his relatives' daily routines and social rituals. He was spending his summer days on the Cape "being unlike my usual exotic self," he told Brandt, "messing about in boats (vide *The Wind in the Willows*) and having great fun observing Old New England in the person of my aunt's fantastically typical relatives."[8]

The Cape, in the late '40s and early '50s, was a world away from Ted's urbane, killingly witty Harvard clique. Often the Garveys would drop in on Betty's aunt and uncle, who also spent their summers on the Cape. "They had an open house almost every evening," says Skee, "with friends and relatives sitting around the living room, talking. It was a lot of gossip and a lot of family stories and he seemed to really enjoy that a lot." The Garveys and their "fantastically typical relatives" were only the first of a number of loose-knit groups that offered Ted a sense of belonging without the demands—or risks—of emotional intimacy. In years to come, the Balanchinians who orbited around the New York City Ballet, especially Mel and Alex Schierman; Cape Codders such as Rick Jones, Jack Braginton-Smith, Helen Pond, and Herbert Senn; and the actors in his nonsense plays and puppet shows would play that role in Gorey's life, blurring the line between social circle and surrogate family.

"I have almost no friends, but the few I do I like very much," Gorey confided in a January 1951 letter to Brandt.[9] Chief among them was Alison Lurie. In later days, she would earn a reputation (and a Pulitzer) as a writer of social satires—sharply observed, subtly feminist comedies of manners, most of them drily amusing in the English way. Barbara Epstein, her Radcliffe schoolmate (and, later, editor of her essays for the *New York Review of Books*), thought she was "witty, skeptical and articulate" and, even as an undergraduate, a supremely gifted writer.[10]

But when Lurie met Gorey, she was Alison Bishop, recent Radcliffe grad and newlywed. "After Ted finished Harvard he got a job working for a book publisher in Boston, in Copley Square," she recalled in 2008. "I was working there, too, at the Boston Public Library, and we used to have lunch together in a cheap cafeteria on Marlborough Street. Neither of us liked our jobs very much, but they had compensations—we got first look at a lot of books, and we could meet regularly."[11] Until Gorey moved to New York, in '53, she remembered, "we saw more of each other than of anyone else—we were best friends."

They'd met in '49, at the Mandrake, she thinks. They clicked instantly, bonding over their shared tastes in literature—"mostly literary classics and the poetry that people were beginning to read then."[12] Naturally, Gorey pressed Firbank and Compton-Burnett on Lurie, who liked Compton-Burnett but "couldn't stand Firbank; it didn't seem like literature, it was just posing. [Ted] liked the artificiality, the idea of an imagined world with artificial rules and a kind of old-fashioned overtone." They went to the ballet and museums and the movies, taking in foreign films and the old movies Gorey was especially fond of. The Gorey Lurie knew was, in all the essentials, the Gorey we know. "Ted then was much like he was always—immensely intelligent, perceptive, amusing, inventive, and skeptical, though he was completely unknown," she recalled.[13] "He saw through anyone who was phony, or pretentious, or out for personal gain, very fast. As he said very early in our friendship, . . . 'I pity any opportunist who thinks I'm an opportunity.'"

She and Gorey were a matched pair. "We gossiped, we talked about books and movies, I saw his drawings, he looked at what I was writing,"

she says.[14] "We were both Anglophiles, definitely. [We shared] a love of British literature and poetry and films and all that. We'd both been brought up on British children's books, so this was a world that was romantic and interesting to us.... Back then, when neither of us had been abroad, it was a kind of fantasy world."

The Gorey Lurie knew in Cambridge was "strikingly tall and strikingly thin," a head-turning apparition in his unvarying costume of black turtleneck sweater, chinos, and white sneakers—the standard-issue uniform of that late-'40s hipster, the literary bohemian.[15] (By then, he'd shed the long canvas coats with sheepskin collars that he sported at Harvard but hadn't yet replaced them with the floor-sweeping fur coats of his Victorian beatnik phase. They'd come later, when he moved to Manhattan.)

Gorey "was already eccentric and individual when I first knew him," said Lurie in 2008.[16] One of his distinguishing quirks, she remembers, was that enigmatic combination of sociability and reserve John Ashbery had in mind when he described Gorey as "somehow unable and/or unwilling to engage in a very close friendship with anyone, above a certain good-humored, fun-loving level." "He had a lot of friends," she notes, and could be gregarious in the right setting—she recalls him chatting with "a lot of people" who came into the Mandrake—but "was solitary in the sense that he didn't form a partnership with anybody."[17]

Not that there's anything wrong with that, she says. "Not everybody wants to wake up in the morning and there's somebody in bed with them, you know? Some people value their solitude, and I think Ted was like that. He wanted to live alone; he wasn't looking for somebody to be with for the rest of his life. He would have romantic feelings about people, but he wouldn't really have wanted it to turn into a full-blown relationship, and that's why it never did."[18] He wasn't a recluse, she emphasizes, just solitary by nature. "It was important to him to have a place where he could do, and be, by himself."

Some of Lurie's most sharply etched memories of Ted are recollections of their rambles in cemeteries, fittingly. In the Old Burying Ground, near Harvard Square, they made rubbings of the "really strange

and wonderful" headstones—impressions created by taping a sheet of paper onto a stone, then rubbing it with a crayon.[19] Visual echoes of the images they collected—urns and weeping willows from the nineteenth-century tombstones, grinning death's heads and skull-and-crossbones motifs and "circular patterns that looked like Celtic crosses or magical symbols" from the colonial grave markers—reverberate in Gorey's books and in the animated title sequence he created for the *Masterpiece Theatre* spin-off series *Mystery!* Unsurprisingly, Ted was much taken with "the older tombstones with strange inscriptions and scary verses," says Lurie. A particular favorite read:

Behold and think as you pass by,
As you are now, so once was I.
As I am now, so you will be.
Prepare to die and follow me.

"It was on one of these trips that I realized for the first time that I was not going to live forever," Lurie recalled. "Of course I knew this theoretically, but I hadn't taken it personally. We were in a beautiful graveyard in Concord"—Sleepy Hollow Cemetery, most likely, where Hawthorne, Thoreau, and all the Alcotts sleep on Authors Ridge—"and I said to Ted, 'If I die, I want to be buried somewhere like this.' And he said, 'What do you mean, *if* you die?'... He was more aware of mortality than I was," she reflects. "He'd been in the army, and even though he hadn't been overseas, he'd seen people come back from overseas. Or *not* come back."

At the same time, Gorey's susceptibility to the morose charms of Puritan memento mori had as much to do with his desire to escape the stultifying '50s, Lurie suggests, as it did any sense that we'll all end up moldering in the ground. "One of the things you want to remember is what the 1950s were *like*," she says. "All of a sudden everybody was sort of square and serious, and the whole idea was that America was this wonderful country and everybody was smiling and eating cornflakes and playing with puppies." Gorey's ironic appropriation, in his art, of

Puritan gloom and the Victorian cult of death and mourning "was sort of in reaction to this 1950s mystique ... that everything was just wonderful and we lived forever and the sun was shining," she believes.

That fall, the Ciardis set off for a year in Europe on John's sabbatical, leaving their "quite huge" apartment to Gorey "for a ridiculously low rental," he recalled.[20] In letters, he played the role he'd perfected by then, equal parts world-weary idler and hopeless flibbertigibbet, buffeted by life's squalls one minute, becalmed in the doldrums the next. "My life," he lamented in a letter to Brandt, "is as near not being one as is possible I think. However."[21] There's a world of meaning in that "however." It's the written equivalent of one of Gorey's melodramatic sighs, signifying something between ennui, weltschmerz, and the shrugging resignation summed up in the Yiddish utterance *meh*.

Of course, this business about his nearly nonexistent existence was mostly posing. Gorey wasn't half as indolent as his letters suggested. For example, he illustrated two covers for the *Harvard Advocate*, the 1950 commencement issue and that fall's registration issue.[22] Credited to "Edward St. J. Gorey," Ted's black-and-white cover for the commencement issue depicts two identical little men standing, in balletic attitudes, on a bleak beach—or is it an ice floe? *"L'adieu,"* says the caption. His deft use of highly stylized blocks of black against a white background recalls Beardsley's tour-de-force use of a monochromatic palette as well as the Japanese wood-block prints Gorey loved.

The registration issue made an indelible impression on John Updike, whose *Twelve Terrors of Christmas* Gorey would one day illustrate. "Gorey came to my attention when I entered Harvard in the fall of 1950," he remembered in 2003. "The Registration issue of *The Harvard Advocate*, the college literary magazine, sported a cover drawn by 'Edward St. J. Gorey' that showed, startlingly, two browless, mustachioed, high-collared, seemingly Edwardian gentlemen tossing sticks at two smiling though disembodied jesters' heads. The style was eccen-

tric but consummately mature; it hardly changed during the next fifty years..."[23]

Shortly before the Ciardis left for Europe, Dr. Merrill Moore dropped by to confer with John about his forthcoming book of poems. Ciardi moonlighted as editor of the Twayne Library of Modern Poetry, which was slated to bring out Moore's *Illegitimate Sonnets*. Moore was a psychiatrist—shrink to the Hollywood director Joshua Logan, the poet Robert Lowell, and about "half of Beacon Hill," Gorey cracked—and, incongruously, a prolific writer of sonnets.[24] During his visit, he happened to see some drawings Ted had given the Ciardis and "was much taken with them," Gorey told Brandt, "and the upshot, and very frazzling to my already tattered nerves, was that ever since I have been doing drawings for him of an indescribable nature (I do not mean obscene—he has even suggested some semi-o ones, but my Victorian soul shrieked 'Never!') at $10 per."

Gorey's six cartoons for the endpapers of *Illegitimate Sonnets* mark his first appearance, in the fall of 1950, in a commercially published book. Meticulously rendered in the style of his most polished work, they depict Gorey's signature little men acting out single-panel gags that riff on the notion of a sonnet-writing shrink. In "Dr. Merrill Moore Psychoanalyzes the Sonnet," for example, we see the neurotic Sonnet—personified as one of Gorey's Earbrass types—on the Freudian couch, free-associating a vision of himself huddled in a bell jar, about to be liberated by a hand brandishing a hammer.

All Gorey had to say about his professional debut as a book illustrator was, "The drawings are neither bad nor excellent, but the reproduction makes them look as if I'd done them with a hang nail on pitted granite."[25] *Illegitimate Sonnets* marked the beginning of a fruitful, if frazzling, relationship that would see Gorey providing endpaper cartoons for the third printing of *Clinical Sonnets* (which rolled off the presses in October of 1950, around the same time *Illegitimate Sonnets* came out); fifty-one drawings of his little men acting out sonnet-related gags plus the front-cover illustration for *Case Record from a Sonnetorium* in '51; and sixty-five illustrations for *More Clinical Sonnets* in '53, all of which were published by Twayne.

There's an unsettling quality to some of Moore's verse—a dark-ness behind the drollery. Take *More Clinical Sonnets*: most of the book's entries are sardonic portraits of neurotics and depressives; we can't shake the nasty suspicion that the objects of Moore's contempt are his own patients. Cartoonish but bleak, Gorey's drawings accen-tuate the underlying creepiness of Moore's blend of jocularity and cruelty.

Still, the exposure could only help Gorey's nascent career. Moore was well connected in the literary world and, over the course of their four-book collaboration, a tireless drummer for their cause. He even recruited Ed Gorey to target Chicago media. Gorey senior obliged, playing up the hometown-boy-makes-good angle with his PR connections; soon enough, the chitchat columns in Chicago pa-pers started to take notice of Moore's books—and Ted's art. By *Case Record*, he merited a title-page credit: "Cartoons by Edward St. John Gorey."

"I'm delighted that all goes so well," Ciardi, on sabbatical, wrote Moore from Rome. "I'm especially delighted that Gorey is getting this chance to launch himself: I have great faith in the final success of his little men. I think they will have to create and educate an audience for themselves, but I see no reason why they shouldn't..."[26]

Moore was unquestionably an ardent fan, telling Helen Gorey that he considered Ted "a finer illustrator than Tenniel," possessed of a rare combination of "satire, social reality, and general artistic integrity," though the shrink in him couldn't resist adding, "Much of this has been developed at the expense of a balanced personality..."[27] He sang Ted's praises to prospective publishers, most fortuitously Charles "Cap" Pearce of the New York publishing house Duell, Sloan and Pearce, a bit of matchmaking that secured Gorey a meeting with some of the com-pany's decision makers to discuss the possibility of a book of his own. (That book, when it came to pass, would be the first title published un-der his own name, *The Unstrung Harp*.)

"You were a tremendous success last night," Moore enthused in a celebratory telegram on December 2, 1951, the day after the meeting.[28]

"The entire company was captivated by your scrapbook your talents and yourself I am sure something good will come of it Cap Pearce called me this morning to tell me how delighted he was...Good luck you are launched now chum vous sera un succes fou goodbye Arno Cobean and Steig here comes...Gorey."*

Even as Ted was making his professional debut in *Illegitimate Sonnets*, he was being drawn into the creative ferment of the Poets' Theatre.

In 1950, verse drama was having its moment, and Cambridge was ground zero for American experiments in the form. The trend was fanned by resurgent interest in the verse plays of Stephen Spender, Yeats, Auden, and, most of all, T. S. Eliot. Eliot's thoughts on the poet as playwright struck a responsive chord in the pre-Beat literary bohemia of early '50s Cambridge. "Every poet...would like to convey the pleasures of poetry, not only to a larger audience, but to larger groups of people collectively," he had said in 1933, during a lecture at Harvard, "and the theatre is the best place in which to do it."[29] Putting theory into practice, he'd tried his hand at verse drama in *Murder in the Cathedral* (1935), about the assassination of Archbishop Thomas Becket in 1170. It was an unqualified success. In his later years, he'd turned his creative attentions increasingly to the stage, whether in verse plays such as *The Cocktail Party*, which won the 1950 Tony Award for best play, or in critical essays such as *Poetry and Drama*, delivered as a lecture at Harvard in November of 1950, just as the Poets' Theatre was getting under way.

The Theatre came together one hot June evening in 1950 at the poet Richard Eberhart's house, near Brattle Street, when, as the group's prospectus later put it, "several of New England's outstanding

*"*Vous sera un succès fou*" is French for "You will be a wild success." "Goodbye Arno Cobean and Steig here comes...Gorey": Peter Arno, Sam Cobean, and William Steig were marquee names in the *New Yorker*'s roster of cartoonists at the time.

poets joined forces with a group of younger writers in an effort to encourage poetic drama."[30] Lyon Phelps, Gorey's former housemate at Eliot House and an aspiring poet, floated the idea of a theater devoted to plays by poets. Eberhart and the Dublin-born actress and playwright Mary Manning Howe (Molly to everyone who knew her) were quick to embrace the concept, and others soon rallied to the cause: George Montgomery, in the capacity of photographer and set designer; Lurie, in the role of costumer and makeup artist; Gorey as set designer and graphic artist. A who's who of prominent poets and playwrights took their seats on the board of directors, among them Archibald MacLeish, Richard Wilbur, Thornton Wilder, William Carlos Williams, and Ciardi.

The fledgling group took its first bow on February 26, 1951, when it performed an evening of one-act plays—*Everyman* by John Ashbery, *The Apparition* by Eberhart, *Three Words in No Time* by Phelps, and *Try! Try!* by Frank O'Hara—in the basement auditorium of the Christ Church parish house, on Garden Street. In its early days, the company had no permanent home and performed wherever it could. In 1954, it took up residence at 24 Palmer Street, an alley behind the Harvard student co-op, or Coop, as it's known. Up a ramshackle flight of stairs, the performance space was a cramped loft behind an art gallery, accommodating seating for forty-nine, give or take a folding chair. The stage lights were jury-rigged from pineapple-juice cans. At sold-out shows, late arrivals perched on the perpetually drippy sink at the back of the room; their soggy backsides proclaimed their devotion to Art.

On *Try! Try!*'s opening night, the standing-room-only crowd of more than two hundred was packed four deep at the back of the room. Thornton Wilder was there. So were Archibald MacLeish and Richard Wilbur as well as up-and-coming young poets such as Robert Bly. Gusts of applausive laughter punctuated O'Hara's witty dialogue, volleyed between Violet, the disconsolate wife of a GI away at war (played by O'Hara's bohemian-debutante friend Violet Lang), and John, with whom she's having an affair (played by John Ashbery). Satirizing postwar melodramas like *The Best Years of Our Lives*, O'Hara waggishly

transposed the clichés of Hollywood tearjerkers about traumatized vets into the idiom of the Noh play, an ancient Japanese form then popular among the literary vanguard, who'd discovered it through Ezra Pound's anthology *Certain Noble Plays of Japan*. The set, by Gorey, was austere: an ironing board in a pool of light, an antique gramophone, and, painted on a pull-down shade, a window with a Goreyesque spider (also painted) dangling from one corner.

To Nora Sayre, a film critic and essayist, the group gave off the "exciting aura of a counterculture, which was very hard to locate in the Fifties."[31] Dylan Thomas gave his first American reading of *Under Milk Wood* at the Poets' Theatre. Their production of *All That Fall*, by Samuel Beckett, was the first in the States. The Beat poet Gregory Corso hung around, teaching the Harvard-educated poets hustler slang and driving Sayre half mad with his moocher's come-on: "Can I have the bacon out of your BLT?"[32] She remembers the company as "a home for poets and performers when artists were often classified as freaks, when academia was repressive, when homosexuality was regarded with horrified fascination," adding that "there were a number of openly gay men in the group, and some of the heterosexuals savored the audacity that mocked the conventional world."[33] Members drew inspiration from surrealism, Jacobean drama, Yeats's vision of a literary theater, and the lyrical, dreamlike cinema of Jean Cocteau—artistic lodestars that, to varying degrees, would guide Gorey's verse dramas and puppet shows on the Cape in later life. Sayre recalls him reading the Djuna Barnes novel *Nightwood*, a radical experiment in modernist prose as well a shockingly early instance of explicitly gay fiction.

Lurie's most vivid recollections of the group have less to do with its experiments in poetic drama and more to do with offstage histrionics. "There were secrets, confidences, collaborations, poems, and dramas *à clef* passed from hand to hand, public quarrels and reconciliations," she later wrote, "and the best scenes were not always played on stage."[34]

The inner life of the Poets' Theatre was dominated by Violet Ranney Lang—V. R. Lang in her life as a poet and playwright and Bunny to her friends, of whom Gorey, Lurie, O'Hara, and Larry Osgood were among

the closest. Living according to the Wildean principle "I put all my genius into my life; I put only my talent into my works," she was one of those people who are never offstage.[35] Her poetry showed promise, but her compulsive inability to let the thing be, rewriting her poems until she'd written the life out of them, was fatal. (In some cases, she revised a poem as many as forty times.) As for her acting, the unlikely juxtaposition of what Ashbery called her "mournful clown's face," dominated by large, doleful eyes, and her impeccable comic timing made her wonderful to watch onstage, but her range was limited to one role, the role she was born to play: Bunny Lang.[36]

Quick-witted and fiercely opinionated, she was charismatic, manipulative, mercurial, and, depending on your perspective, charmingly or exasperatingly eccentric. She had a genius for score settling. When a man named Parker wronged her, she ordered up a thousand stickers whose black lettering announced, against a background pink as boiled ham, "My name is Parker and I am a pig." She stuck them everywhere the luckless wretch was sure to pass, from his apartment-house door to his subway station to the bathroom in his office building to his favorite bar, leaving the man "in a state of continual nervous rage," Lurie recalls.[37] "Bunny was definitely one of the great sacred monsters," Gorey agreed.[38] Ted and Bunny were "very close," says Osgood. "Anecdotes about Bunny, they would please Ted enormously, just the strangeness and funniness and mischievousness of them." She shared his ironic, opera-box view of the human comedy, a gently mocking perspective that recalls the Wilde quotation "To become a spectator of one's own life is to escape the suffering of life."[39]

When she died at the age of thirty-two, on July 29, 1956, of Hodgkin's lymphoma, she left behind a slim—some would say slight—body of work, collected in *V. R. Lang: Poems & Plays with a Memoir by Alison Lurie.* But everyone who knew her agrees that her most memorable creation was her offstage persona. Even her funeral had a theatrical quality to it. Mount Auburn Cemetery, where she was laid to rest on a midsummer afternoon, provided the perfect backdrop for her last bow. With its Greek temples and Egyptian monoliths and

"marble Victorian nymphs wiping away marble tears under weeping willows," it "was like a painting," Lurie thought, "some crazy half-classical, half-romantic Arcadia."[40]

Amid the backstage dramas of the Poets' Theatre, Gorey was his wittily ironic self, aloof from the emotional maelstrom, although he savored the morsels of gossip he swapped with Lurie and Lang. Lurie thought he was "one of the sanest and calmest people in the whole organization."[41] He was unquestionably one of the most industrious. In his time with the Poets' Theatre, Gorey designed stage sets for *Try! Try!* and *Three Words in No Time* and, as important, a blizzard of posters and handbills, most of them drawn in a loose-lined, quick-sketch style. For Lang's *Fire Exit (Vaudeville for Eurydice)* (1952), he dashed off an evocative sketch of a downcast burlesque dancer in fishnet stockings, slumped in a chair. He also designed the group's logo, a classical Greek poet contemplating an actor's mask while a cherub drapes him in a toga bearing the group's name. And he came up with the arresting salmon-and-yellow-striped motif that embellished the theater curtain and the group's mailings. Even the tickets, with their antique typography (hand-drawn, naturally), were the product of his pen. Sayre recalled, "Gorey's late Victorian taste dominated the visual aspects of the first productions: he designed most of the sets, and his frowning cherubs and somber fantasies recurred in the Poets' backdrops and posters."[42] His aesthetic—the Victorian-Edwardian references, the gloomy-cartoony drawings, the hand lettering, the deliciously icky color schemes—defined what we'd now call the group's visual branding.

Not satisfied with designing stage sets and turning out a flurry of posters and other promotional materials, Gorey wrote two plays for the group, *The Teddy Bear, a Sinister Play* (credited, on the program, to a Mr. Egmont Glebe) and *Amabel, or The Partition of Poland* (attributed to Timothy Carapace). *Teddy Bear* premiered on February 20, 1952, as part of an evening of entertainments "Somewhat in the Victorian

Manner" whose divertissements also included something called "The Children's Hour" by Molly Howe and Gorey (writing under the name Mr. Edmund Godelpus); "Undine" by Mr. Eldritch Gorm (another Gorey pseudonym); and "The Entertainment," directed by Mr. Ector Gasmantle (Gorey again, behind an unimprovably Goreyesque nom de plume).

Sayre remembers *Teddy Bear* as "the kind of short nonplay that they [the Poets' Theatre people] esteemed."[43] As she recalls it, "a murderous Teddy bear was attached to a string on which it was slowly pulled offstage while a husband and wife argued with each other. (They didn't know that the bear was on its way to strangle their baby in the nursery)." In the bickering parents, we hear echoes of Gorey's childhood. *Amabel*, which premiered on May 22, 1952, in the Fogg Museum court, was a bit of Firbankian whimsy, buffeted by paroxysms of (tongue-in-cheek) angst. "The world's a garden full of bears," Amabel soliloquizes,

A pool of noisome balderdash,
A closet choked with rotting trash.
. . . A fearful trick, a frightful hoax,
An endless string of pointless jokes
—And all on me.
 One day I'll die.[44]

It was "very amusing," Lurie thought, "very much like the work he became famous for; kind of Victorian, kind of Edwardian. It had the kind of way-out characters and costumes that he had fun creating."[45]

The allure of the Poets' Theatre, for Gorey, had partly to do with its intellectual effervescence, partly to do with the personalities orbiting around the scene. "It was the most fun I had in the early days because of the variety of people who were involved," Ted recalled in 1984.[46] Theater is social by definition, of course, and he relished the opportunity to escape the isolation of the drawing board for a more collaborative art form and to be part of a collective that also served as a surrogate family of sorts. "It was goofy amateur theater where we all did very arty

plays and came up with all sorts of ideas and projects," he remembered. "'Ooo, goody,' we'd say, devising something or other. And then 'Oh, God, what was that all about?' as we watched it sink without a trace."[47]

Gorey's artistic activities—his involvement in the Poets' Theatre and his never-ending labors for Moore, who pelted him with letters suggesting cringeworthy ideas for illustrations such as "The sonnet's warts are removed by electric needle"—took place against the backdrop of everyday life, which went on in the usual uneventful way, enlivened now and then by minor dramas.[48]

In September of '51 he moved to a basement apartment at 70 Marlborough Street—a brownstone Victorian row house in Boston's Back Bay, a neighborhood that was an architectural mausoleum of well-preserved Victorians. Given the chance, he'd begun living with cats again. "The cats are . . . dismembering pigeons all over everywhere," he wrote in a letter to Alison Lurie, "and leaving snacks for later on in the evening lying about."[49] From then on, he'd never be catless.

That same year, he enlisted as a foot soldier in Illinois governor Adlai Stevenson's presidential run, mailing campaign literature—an eyebrow-raising spasm of activism in light of Gorey's later attitude toward politics, which alternated between disdain and apathy. Stevenson's opponent, the former general and World War II war hero Dwight D. Eisenhower, tapped into the commie-hunting mood of Cold War America to hand the witty liberal Democrat a crushing defeat. Deeply dispirited, Gorey washed his hands of politics forever. "I voted one time, for Stevenson in 1952," was his final word on the subject.[50]

Shortly before the election, there was another plot twist in Gorey's story, this one so farcical it seems like something out of his nonsense plays. On September 20, according to the *Chicago Daily Tribune*'s Society Notebook column, Edward L. Gorey and Mrs. Helen G. Gorey were remarried in the rectory of Chicago's venerable Holy Name Cathedral.[51]

Was the Goreys' late-life remarriage a tale of lovers fated to remain

together? Or was it an act of Good Samaritanism on Helen's part? Ed was not in robust good health; his years as a newsman and a flack—decades of late nights, boozing, and smoking—were catching up with him. Did she take him in for old times' sake, so he wouldn't die alone?

During his brief marriage to Corinna Mura, Ed Gorey had worked, from '39 to '41, as the director of publicity at the Chicago office of the Illinois State Council of Defense, which organized civil-defense teams—wardens who oversaw air-raid drills, volunteer spotters who scanned the skies for enemy planes. Mura, meanwhile, was bouncing between Chicago and New York, performing on the radio and playing nightclubs. In '41, Ed moved to Washington, DC, where, still in the employ of the defense council, he served as PR director of an office dedicated to securing armaments contracts and war-industry plants for Illinois. That same year, Mura left for Hollywood, where she signed with RKO. Sometime in the early '40s, they divorced. Mura's constant touring and the warring demands of DC and Hollywood must have taken their toll. (Their breakup seems to have been amicable; Ed corresponded with Corinna until his death, and his surviving letters are warmly affectionate.) After the war, Ed returned to Chicago, where by the late '40s he'd landed a job as public relations director for P. J. "Parky" Cullerton, the powerful, deep-pocketed alderman of the city's Thirty-Eighth Ward and chairman of the city council's finance committee.

What Ted thought of his parents' reunion we can only guess. "I remember [him] telling me about it when I went up to Radcliffe," says Skee Morton. (Skee, like her sister, Eleanor, went to Radcliffe.) "He took me out to the movies occasionally, and I remember he said once, 'Oh, incidentally, my parents got married again today.'" Eleanor added, "I remember him rolling his eyes when asked about his family."

Gorey's jaundiced reaction to his parents' remarriage isn't surprising. Father and son were poles apart. A hail-fellow-well-met type, always good for a laugh, with a toastmaster's supply of one-liners, Ed Gorey was the antithesis of his oddball, bookworm son in practically every way. Both were writers, it's true. But there the resemblances end. As a

reporter, Ed turned out workmanlike prose, indistinguishable from the characterless wire-service copy that unfurled from Teletype machines in newsrooms everywhere. By contrast, Ted's voice on the page is instantly recognizable. Tellingly, Gorey *fils* was "Ted" to family, childhood friends, and his social circles at Harvard and in New York and "Edward" to seemingly everyone he met after moving to the Cape but *never, ever* "Ed" if he could help it.

Skee is certain that Ted "was never close to his father." "We never heard anything about his father," Eleanor confirms. Ed "never came here [Cape Cod], and as far as Ted told me he never went there [Chicago], except perhaps at the end [of Gorey senior's life, when he was dying of cancer]."

As for the view from Ed Gorey's side of the father-son divide, he seemed bemused by his son. Early the following year, in a letter written in the jocose, life-of-the-party tone he affected in his correspondence, he confided to Merrill Moore about his eccentric son's antics, comparing his letters to "a joint report from Vera Vague, Gracie Allen, and Judy Canova."[52] At the very least, the older Gorey allowed, there was never a dull moment with Ted: "He has you either amused—or clutching the chandelier."★

In Chicago for the holidays with his newly remarried parents, Ted delivered "a joint lecture...shortly after New Year's with Miss Camille Chaddick, a director of the Northwestern Drama group," according to Judith Cass's puff piece in the *Tribune*—the fruit, most likely, of Ed's PR campaign for the Merrill Moore books. The *Trib* writer laid it on a little thick when she described Ted as "busy writing and directing for the Poets' Theatre...and with art assignments in his Boston studio."[53]

★Vera Vague was a screw-loose "spinster" created in the radio era by the actress Barbara Jo Allen. A fluttery hysteric, nonstop yakker, and font of misinformation on every subject, Vera was the sort of genially sexist stereotype that cracked them up on the Bob Hope and Rudy Vallée shows. In like fashion, Gracie Allen played a nutty, corkscrew-logic housewife to George Burns's wryly perplexed man of the house on *The George Burns and Gracie Allen Show* from 1950 to '58. Judy Canova, another movie actress and radio personality of the day, often played a gullible goofball hillbilly. (Odd that Gorey's father should compare his son exclusively to exaggerated caricatures of femininity.)

Gorey had, in fact, just published his first cover illustration for a national magazine. His artless, loose-lined sketch of a dapper chap in a trilby hat gazing at a cluster of onion-domed Oriental buildings (plunked, improbably, at the end of a wharf) adorns the cover of the November 1952 issue of *Harper's Magazine*. The image appears again inside the magazine, in the opening pages of "Evangelist," a short story by Joyce Cary with "drawings by Edward Gorey," the name he would use in his professional life from then on (when he wasn't writing under one of his countless pseudonyms). There are two more Gorey illustrations, done in the same freehand, "unfinished" style as the cover. His compositional skills are evident, as is his ability to hint at psychological depths with the subtlest of cues. We sense a subconscious interplay, a counterpoint of averted gazes and furtive glances, between the figures he arranges in little knots, each absorbed in his or her own thoughts. And his draftsmanship—specifically, his feeling for landscape and his attention to architectural detail—is getting better.

But in December of '52 Ted was nowhere near the conquering hometown hero suggested by Cass's breathless description. That June, he bemoaned the general state of his affairs in a letter to Alison Lurie, who'd moved away from Cambridge by then. "Existence, if one chooses to be optimistic enough to call it that, is, here, deadly," he writes. "I am on the verge of starvation and debtors' prison once again. I wrote Cap Pearce the end of last week for a job at Little, Brown, but he hasn't answered yet. . . . Being without the wherewithal to buy gin, I am drinking tonic all by itself."[54] He was going to redouble his assault on the job market, targeting libraries, "publishers, advertising agencies, and after that, Gawd knows." Meantime, "a small child (presumed) is beating furiously on the back fence with a poker. Too dreary."[55]

Things were about to change. Just before his Christmas trip to Chicago, he'd visited New York, where Barbara Epstein—a friend from his Harvard days, when she was Barbara Zimmerman—was an editor at Doubleday. Her husband, Jason, also a Doubleday editor, was launching Anchor Books, the company's first venture into what were then uncharted waters: quality literature published in mass-market paperback

format. Strictly speaking, Barbara wasn't on the Anchor staff, but she had her husband's ear, and Jason respected her "very strong sense" of the visual statement the new imprint should make.[56] Hiring Gorey to design covers for Anchor was her idea. "We had to have a cover designer, and Barbara suggested Ted—Teddles, as she called him," says Jason. "He was perfect. He was a genius." Gorey whipped up a portfolio of fake covers for them, which in his recollection were "as uncommercial as you can reasonably get."[57] Somehow, though, they were just the thing for Anchor as far as the Epsteins were concerned. "They offered me a job," said Gorey, "which at first I turned down because I didn't want to live in New York."[58]

His move to Manhattan would mark the true beginning of his long, dogged trudge to cult fame and, ultimately, more mainstream success than an incurable eccentric could have hoped for. Even so, thirty-four years in New York wouldn't do much to diminish his antipathy for the city. In another version of the story of his hiring by the Epsteins, he sharpened that point: "At first I said no, but then I thought, 'I'm not really surviving very noticeably in Boston, so I'll move to New York, much as I hate the place.' A thought I never lost sight of. It's just too much."[59]

"LIKE A CAPTIVE BALLOON, MOTIONLESS BETWEEN SKY AND EARTH"

New York, 1953

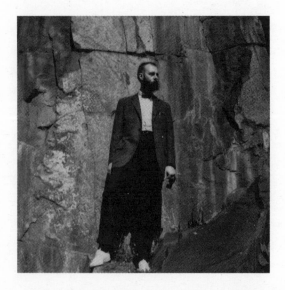

Gorey on the New Jersey Palisades near the George Washington Bridge,
November 1958. *(Photograph by Sandy Everson-Levy.
Bambi Everson, private collection.)*

"I MOVED TO NEW YORK at the beginning of 1953," recalled Gorey, "and embarked on what is laughingly called my career."[1] During his visit in December of '52, before going home to Chicago for the holidays, he'd apartment-hunted in Greenwich Village, whose time-honored bohemianism made it Gorey's natural habitat. Unable to find anything suitable in the Village, he'd settled, at last, on a studio apartment in an elegant four-story town house in the midtown neighborhood of Murray Hill.

Thirty-six East 38th Street is a brick-and-limestone-trimmed mansion built circa 1862 and remodeled in 1903 with a Beaux-Arts facade. The feel of the place was similar to that of his Marlborough Street apartment in Boston, except that he lived on the second floor rather than in the basement, "at the back and so quiet," he told Merrill Moore, "with a roof which I can use to sunbathe and the like."[2]

Gorey's new lodgings were handy for the Doubleday offices at 575 Madison Avenue, between 56th and 57th Streets. The art department was shoehorned into a single space on the sixteenth floor. "Nine people in one big room" is how Diana Klemin, the art director at the time, remembers it. Improbably, one of Ted's workmates was none other than Connie Joerns, his bosom friend from Francis Parker. Like Gorey, she'd moved to New York to seek her fortune. Joerns was a production assistant, handling pasteup and layout, though she doubled as an illustrator on occasion.

Job titles weren't taken all that seriously at Anchor. The Epsteins envisioned Gorey as a designer, creating a distinctive look for the trailblazing imprint, but Klemin thought of him, initially, as an inhouse artist. "I started out as an artist in the art department, then I switched over to being a book designer" is how he remembered it.[3] He underwent a brief apprenticeship, learning the ropes of bookcover production, before graduating to full-fledged design. "He was on the drawing boards," says Klemin, "fixing mechanicals [for freelancers like Leonard Baskin and Ben Shahn], doing paste-ups and designing jackets."[4] "Mechanicals," in the precomputer age, were templates created by pasting cover elements such as artwork and type proofs onto a sheet of stiff-stock paper; printers used this template to make a printing plate.

Doing pasteup involved laying out the artwork and typographic elements, such as the title. Type had to be specced—marked up with instructions that specified which typeface, font, and font size the printer should use. For Gorey, who didn't have a design-school knowledge of typefaces, it was a laborious, detail-intensive chore. Frustration, it turned out, was the mother of invention: the hand-lettered typography

that's so much a part of his work's anachronistic charm began as a quick-and-dirty solution to the demands of his job. "I really didn't know too much about type in those days, and it was simply easier to hand-letter the whole thing than to spec type," he told the design writer Steven Heller.[5] Everyone went gaga over Gorey's hand-lettered typography, "which I did very poorly, I always felt, but everybody seemed to like it. So I got stuck with it for the rest of my life."[6]

Lafcadio's Adventures by André Gide, cover design and illustration by Edward Gorey. *(Doubleday Anchor Books, 1953)*

Sure enough, the title, cover lines, and even the price on his first cover for Anchor, *Lafcadio's Adventures* by André Gide, are hand-lettered in an antique typeface style. By drawing them askew, he gives them a jaunty, animated quality that captures the madcap spirit of Gide's novel, a satirical thriller about a gang of con men who disguise themselves as priests in order to dupe a bunch of wealthy Catholic monarchists. Gorey sets the white title against a slate-blue trestle whose arches frame a series of vignettes: a furtive figure spying on red-cloaked priests, a lady in a

bustle and a hat with huge plumes, and so forth. In the foreground, a gawky youth—Lafcadio, we imagine—strikes one of Gorey's ballet poses, observing the goings-on. Gorey's visual wit and tonic use of color are on display, and the eye bounces around the busy scene, guided by his strong sense of composition.

The Wanderer by Alain-Fournier, cover design and illustration by Edward Gorey. *(Doubleday Anchor Books, 1953)*

By contrast, his cover for Alain-Fournier's *The Wanderer*, also published in '53, is masterful in its use of empty space: in a landscape whose austerity recalls the black-ink paintings of the Japanese sumi-e tradition, a lone traveler toils along a white road under a white sun in a white sky. The gusting wind whips his cape. Ahead looms the forest primeval, deep and dark. Compositions such as this, in which expanses of empty space—limitless vistas, big skies—are contrasted dramatically with single-hair details or densely crosshatched shadows, will become a Gorey signature.

Gorey had "a natural tendency toward black and white," he said.

"Line drawing is where my talent lies."[7] He claimed, in his usual self-deprecating fashion, to be helpless when it came to color. "With color," he told his friend Clifford Ross, "I have a tendency to wish to blow my brains out at some point or other. I always have trouble finishing color. I mean, I start out and put in the colors I like—olive green, and lemon yellow, and lavender. And I think, 'Oh, dear, there are other colors that have to go in this some way or other.' But I don't know what colors I want in there. And then I realize I don't want any more color than this at all. And so I sit there."[8]

He protested too much. One of the things that makes Gorey's Anchor covers so instantly identifiable, and so seductive, is what Diana Klemin calls his "very refreshing use of color." At times, his palette is reminiscent of the Japanese artists he loved, ukiyo-e masters of the wood-block print such as Hokusai, and of English illustrators such as Edward Ardizzone (1900–1979) and Edward Bawden (1903–89), both of whom he admired. We can detect, in some of Gorey's covers, the influence of Ardizzone's delicate watercolor washes and Bawden's linocuts, with their blocks of solid color and sharply incised lines. Gorey drew inspiration, more generally, from British book design, which he encountered by way of his fondness for British writers. "I was aware of British book jackets because I bought a lot of British books at the time," he said.[9]

Asked by Steven Heller about his partiality for colors that are "always muted, very earthy, and distinctly subtle," Gorey replied, "I guess I could have picked bright reds or blues, but I've never been much for that. My palette seems to be sort of lavender, lemon-yellow, olive-green, and then a whole series of absolutely no colors at all."[10] He was especially fond of his cover for *Travels in Arabia Deserta*, a classic of Victorian travel writing, which evokes the desolate beauty of the desert in "three different shades of blah gray-olive."[11]

Heller thinks Gorey's aesthetic was partly a child of necessity. "Having to use three flat colors plus black, rather than process color, was the factor that would give his paperback covers a certain silkscreened or etched look," he asserts in *Edward Gorey: His Book*

Cover Art & Design.[12] In process printing, translucent inks in three primary colors—cyan (blue), magenta (red), and yellow—are superimposed, in the form of countless tiny dots, to produce what are known as halftone images. For example, when cyan and yellow overlap, they make green. Flat-color printing, also known as spot-color printing, involves premixing inks to produce specific colors. Each color is printed discretely, a process that requires multiple runs through the printing press; the result is shapes that are crisply incised and colors that are more densely opaque than process colors—more solid looking.

Often Gorey exploits the theatrical potential of spot-color printing's defining aspect—its ability to create sharply defined areas, or spots, of pigment—by striking a single, plangent note of vivid color against a monochromatic or muted background. The results are dramatic: on *François Villon* (1958) by D. B. Wyndham Lewis, a lady in vermilion, framed by a black arch and set against Gorey's generic gray emptiness, stands out like a candle flame in the dark. Gorey will take this special effect to stunning heights in the 1977 Broadway production of *Dracula*, in which each of his black-and-white sets will incorporate a single blood-red element.

"Flat-color printing inks for Gorey are like the melodramatic extremes of light and dark for the noir cinematographer," Heller maintains. "The deliberate choice of hue is both design tool and dramatic device and is used to focus the viewer's eyes on a character."[13] His cover for *Thérèse* (1956) by François Mauriac is a case in point:

Color heightens anxiety in Gorey's cover for... *Thérèse*, about a woman who has poisoned her husband and reflects on her reasons, spending the novel recalling her deed. It is dominated by two shades of sienna, one for the ground, the other the sky. The viewer's eye, however, is directed to a crimson hat and coat on a woman sitting joylessly (or maybe not) alone on a small bench with her thoughts. Color washes over the minimally expressive line work and imposes a sense of sorrow over the entire vignette.

The viewer is encouraged to question what came before and what comes after this frozen moment.[14]

For Heller, this open-endedness, this invitation to participate in the act of making meaning, is a significant part of what makes Gorey's book covers so beguiling. I'd go further, arguing that this quality characterizes not just his cover art but his entire body of work; it's an essential aspect of what makes Gorey Gorey. Think of his revealing remark "I'm beginning to feel that if you create something, you're killing a lot of other things. And the way I write, since I do leave out most of the connections, and very little is pinned down, I feel that I'm doing a minimum of damage to other possibilities that might arise in a reader's mind."[15]

His palette of unsettling, ambiguous colors makes a philosophical point: the world is full of ambiguity and mutability, things that elude the snares of language. The best art, he believed, "is presumably about some certain thing, but is really always about something else."[16] In some ineffable, lavender, lemon-yellow, olive-green way, his use of color captures that feeling.

But Gorey's color sense wasn't the only aspect of his Anchor covers that elevated them above mere commercial come-on into works of art you could put in your pocket. On occasion, he used type and nothing else to decorate a book's cover, treating text as illustration. Stymied by the cerebral subject matter of the philosopher Søren Kierkegaard's two-volume *Either/Or* (1959)—a dialectical tug-of-war between ethics and aesthetics as seen from a Christian-existentialist perspective—Gorey did away with illustration altogether. For volume 1, he set the author's name in contrasting white type against a black square and the book's title in black type against a gray square. For the second volume, he reversed that color scheme, standing the logic of volume 1 on its head: the white type is now black, the black type is white. Viewed side by side, his covers for *Either/Or* mirror the dialectical structure of Kierkegaard's book, which presents its argument in the form of a debate. At the same time, Gorey slyly mocks the black-or-white binaries that underwrite much of Western philosophy.

From '53 until he left Doubleday, in 1960, he did the cover art on something like fifty books and handled the pasteup, lettering, or design of many others. If Jason Epstein had had his way, "the whole line" would've been "Edward Gorey," says Klemin, but she put her foot down, pointing out that at Vintage and Knopf the "sales department hated *their* paperbacks because they were all one design."

Epstein relented, and Klemin branched out, using illustrators such as Leonard Baskin, Ben Shahn, Robin Jacques, Ivan Chermayeff, and, in his hardscrabble, pre-Pop days, a young Andy Warhol, whom Gorey may have known passingly.[17] Even so, Gorey's work embodied the Anchor aesthetic as far as the Epsteins were concerned, and they continued to cherry-pick titles they wanted him to illustrate, discussing the details with Ted in their apartment after work. "They were beautiful, ravishing," said Barbara in 1992, talking about Gorey's cover illustrations. "He worked very slowly, with a tremendous perfectionism, and he would never let a drawing out of his hands if it was less than perfect."[18]

Anchor Books, founded in 1953 by twenty-four-year-old Jason Epstein, was in the vanguard of the paperback revolution. Robert de Graff fired the first salvo in 1939 when he launched the first mass-market paperback line in America, Pocket Books. Publishing's old guard had pooh-poohed de Graff's assumption that consumers would buy cheap paperbound reprints of classics and bestsellers. Book buying was an elite pastime, the exclusive province of those with the income and education to indulge in expensive status symbols like hardbound books.

What they couldn't foresee was a mass audience swollen by the millions of veterans who'd acquired the reading habit overseas, thanks to Armed Services Editions of popular paperbacks distributed free to the troops. After the war, many of them would go to college on the GI Bill, as Gorey and O'Hara had. Vets made up a sizable part of the new

book-hungry audience that gobbled up 2,862,792 copies of Pocket's *Five Great Tragedies* by Shakespeare the year it was published. Pocket Books were cheap—a quarter apiece—and they were everywhere, not just in tony big-city bookshops: de Graff distributed them to newsstands, drugstores, lunch counters, and bus and train stations. They flew off the racks.

A gold rush was on: competing imprints such as Avon, Dell, and Bantam sprang up throughout the '40s. Lurid covers by hack illustrators accosted the browser with all the subtlety of a peep-show barker. "Paperback publishers made no effort to distinguish classics from kitsch," writes the cultural critic Louis Menand.[19] "On the contrary, they commissioned covers for books like *Brave New World* and *The Catcher in the Rye* from the same artists who did the covers for books like *Strangler's Serenade* and *The Case of the Careless Kitten*." "Horrible," says Epstein. "They came out of the magazine business, the illustrators."

Anchor's covers were an indispensable part of his strategy, conveying at a glance the difference between serious literature for the educated millions, published in a "quality paperback" format, and books born to be pulped, like *My Gun Is Quick* by Mickey Spillane. While Gorey's visual rhetoric was sophisticated, speaking to "those in college and just after college," as Klemin put it, his work was illustrative in the time-honored sense, deftly conveying the mood of a novel or the subject of a scholarly work. "Ted was inimitable and gave the series its cachet; he gave it the look," says Epstein. "The covers made a huge difference. They said what we were trying to do."

"Within a year or so, Anchor Books was well-established and very profitable," Epstein recalls. "Since the titles belonged to the postwar intellectual zeitgeist, they all sold well, especially those with Gorey's covers."[20] By 1958, *Print* magazine, an influential voice in the fields of design and illustration, had taken notice of Gorey's innovative cover art. "There have been a group of Anchor Book covers that have a quality all their own," the unnamed editorial staffer proclaimed. "*Print* has discovered that these are the work of one man, Edward

Gorey. Gorey designs the covers, letters the titles, and very often the rest of the cover. He also does the final illustrations. This versatility has resulted in a unity of feeling...a quality that is highly distinctive."[21]

Just as Anchor blazed the trail for what would soon be known as the trade paperback, a format that would help democratize highbrow culture by bringing classics of world literature and philosophy to the masses, Gorey was part of a wave of designers and illustrators who used the four-by-seven cover as a canvas, transforming the book cover into a popular art form. Heller, who during his thirty-three years as an art director at the *New York Times* often used Gorey for freelance illustration work, groups him together with boundary-pushing designer-illustrators such as Milton Glaser, Seymour Chwast, and Leo Lionni. "What he created was an environment of original art for paperback books that had a personality, a character," says Heller.

At first glance, Gorey's work for Anchor looks reactionary next to the swinging, sophisticated modernism epitomized by Paul Rand's covers for Knopf and Alvin and Elaine Lustig's covers for Noonday and Meridian. But by asserting the virtues of anachronism—hand-drawn antique fonts as opposed to machine-produced type, Victorian and Edwardian imagery instead of jazzy abstraction—at a moment when postwar America was giddy with visions of a shiny new world of suburban dream homes and laborsaving gadgets, Gorey was postmodern *avant la lettre*. Like Frank O'Hara's poetry, his Anchor covers sampled and remixed high and low culture, referencing period styles as well as contemporary British illustration.

At the same time, he was unquestionably part of the paperback revolution, which, along with cultural forces such as television, rock 'n' roll, and the movies, gave rise to pop culture as we know it. "Paperbacks changed the book business in the same way that 45-r.p.m. vinyl records ('singles'), introduced in 1949, and transistor radios, which went on sale in 1954, changed the music industry," writes Menand.[22] Gorey's Anchor covers were part of that social transformation.

Yet they had things to say about Gorey's inner life, too. His Anchor covers introduce what will become psychological motifs in his work. The lone figure recurs, making his way through city streets, as on *The Secret Agent* by Joseph Conrad (1953), or lost in reverie on a railway platform, as on *The Middle of the Journey* by Lionel Trilling (1957). Gorey insisted that such motifs had more to do with his limitations as a draftsman than anything else. "There were certain kinds of books where I followed a routine, such as my famous landscape which was mostly sky so I could fit in a title," he said. "Things like... *Victory* [Joseph Conrad, 1957] and *The Wanderer* tend to have low-lying landscapes, a lot of sky, sort of odd colors, and tiny figures that I didn't have to draw very hard."[23]

Still, his solitary nature, his habit of viewing the human comedy with a Beckettian black humor, and his childhood memories of family strife and whispered tales of his grandmother Garvey locked away in a sanitarium make us think there's more here than meets the eye. Moody figures cluster in small groups. Often one person stands apart, regarded with a cold eye by the others. Furtive, sidelong glances are exchanged or gazes are averted altogether. Faces are expressionless masks, revealing nothing.

His covers for Anchor's reprints of Henry James novels are case studies in group psychology. Here Gorey psychoanalyzes with pen and ink, exposing the duels and subterfuges just beneath the drawing-room propriety of the Victorian and Edwardian ages in which James wrote. On *The Ambassadors*, a top-hatted man and a woman in dark blue formal dress stand marooned in a gray infinity, close in proximity but alone in their heads. On *What Maisie Knew* (1954), a little girl looks on anxiously while her parents hold what seems to be a heated conference in one corner of the room. The man holds his wife by one arm; he looms over her menacingly, and she shrinks away.[24]

Speaking of psychoanalysis, Gorey's assignments for Anchor inspired some of the most obviously gay imagery in his oeuvre. His cover

illustration for Herman Melville's *Redburn* (1957), a novel famous for its rampant homoeroticism, is so winkingly gay it teeters on the brink of self-parody. Many scholars now believe Melville was gay, or at least bisexual. In *Redburn*, a semiautobiographical bildungsroman about a young New Englander's first voyage on a merchant ship, Melville draws back the curtain on nineteenth-century shipboard life, where the line between homosocial fraternizing and love between men was a blurry one.

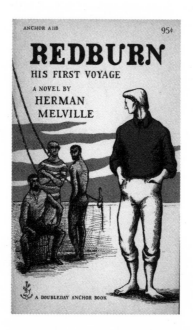

Redburn by Herman Melville, cover design and illustration by Edward Gorey.
(Doubleday Anchor Books, 1957)

Gorey's campy cover depicts a young sailor in a bright red shirt—Redburn, we guess—trading suggestive looks with a trio of seafarers, one of whom is sitting spraddle-legged, another of whom is standing with his firmly packed rump toward the young, er, seaman peering at him over his shoulder. There's a suspicious bulge in Redburn's crotch, and his hands are thrust into his pockets (for a round of "thumbfumble," perhaps, the diverting game played by the swingers in Gorey's parody of Victorian porn, *The Curious Sofa*). In case we didn't get the Freudian

hint, Gorey draws our attention to the upthrusting belaying pin, its phallic symbolism unmissable. (A gay friend of mine, on seeing this illustration, quipped, "Provincetown meat market.")

If this seems like a Freudian scavenger hunt run amok, finding phallic symbols everywhere, consider the critic Thomas Garvey's essay "Edward Gorey and the Glass Closet: A Moral Fable." Arguing that Gorey's imagery "was obviously coded as queer," Garvey chooses his *Redburn* cover as exhibit A in the case for a queer-theory reading of his work. "Gorey's design [for *Redburn*] is hilariously deadpan," he writes. "All it lacks is a word balloon with 'Yoo hoo, Sailor!' to make its come-hither subtext clear: the buttoned-up Redburn's hands frame his pubes, even as he gazes at the open crotch of a swarthy sailor (while his twin offers up his bum)."[25]

But behind Garvey's knowing tone is a searching analysis of mainstream culture's insistence on turning a blind eye to queer subtexts in Gorey's work and persona. Garvey isn't out to "prove" that Gorey is gay: "I never personally knew the talented Mr. Gorey," he says, "so I don't 'know' if he was gay or not." His point is that the gay imagery in Gorey's work, and the gay sensibility encoded in his ironic wit, his flamboyant style, and his pantheon of canonically gay tastes (ballet, Dietrich, silent film, Firbank, Compton-Burnett), urge us to consider his art and life in relation to gay culture and history.

Yet media coverage of Gorey is consistently—and a little too insistently—oblivious to the gay themes in his art, the gay influences on his aesthetic, the gay origins of his persona. The Gorey we meet in perfunctory newspaper profiles is a Dr. Seuss for Tim Burton fans; little is made of the gay subtext of his art and life, presumably because mentioning children's literature and homosexuality in the same breath stirs dark suspicions in the American mind, especially when the subject is an eccentric old gent who seems to enjoy killing off children (in his stories, at least). If such articles are to be believed, then "Gorey wasn't necessarily gay, even though he was a life-long bachelor who dressed in necklaces and furs," Garvey writes. "He was just asexual, a kind of lovable eunuch who spent his spare time

petting his cats down on the Cape when he wasn't drawing his funny little books."

Moving beyond *Redburn*, Garvey finds queer-coded images elsewhere in Gorey's work: a bearded Gorey alter ego standing naked on a "cold, lonely" balcony in *The West Wing* (1963), "his hands covering his...bum"; the dandyish Victorian uncle in *The Hapless Child*, staring "furtively at the tush of a male statue just before meeting his doom." It bears noting that the "eccentric" uncle, inevitably a lifelong bachelor who lived with a male friend, was a stock character in Victorian society, the secret of his sexuality hidden in plain sight. "Who was it who said most gay history lies buried in bachelor graves?" asks Douglass Shand-Tucci, a historian of gay culture.[26]

It's also worth pointing out that the image of a man with a well-rounded rear seen from behind is something of a motif in Gorey's work; it crops up not only in the instances Garvey records but also in the gold statuette of a male nude flexing his buttocks on the back cover of another Anchor title, Michael Nelson's *A Room in Chelsea Square*, a bitchy, high-camp comedy of manners about a young man who takes up with a sugar daddy in London. And there it is again in the fastidiously rendered bottoms of the gay young things (Herbert, Albert, and the "exceptionally well-made" Harold) "disporting themselves on the lawn" in *The Curious Sofa*, and in *The Other Statue*, where two foppish gents are staring intently at the backside of a well-muscled male statue whose crotch, covered by one of those fig leaves that only draws attention to what it pretends to conceal, is thrust toward us. In the near distance stands another beefy male statue, buttocks rampant. "On the roof a curious discovery was made," Gorey tells us in what is surely one of his most obliquely revealing lines.

Garvey singles out the image of the naked male figure seen "hind-side-to," as Gorey would say, in *The West Wing*. It's a poignant image in a somber, surrealist poem of a book, free from the camp-gothic whimsy of Gorey's better-known works. Drawn in what for Gorey is a highly realistic style, the man resembles him in beard and pose; it's hard not to see the picture as a self-portrait: the artist as a solitary, surrounded on

all sides by limitless gloom. A balustrade fences him off from the world. Clasping his hands, childlike, over his buttocks, he conceals the seat of his desire (so to speak). The sense of vulnerability and loneliness—of unrequited love; of never venturing beyond the adolescent crush, even in middle age—is palpable.

"Such an image, it goes without saying, could be troubling to gays and straights alike," Garvey argues.

> To straights, it means pondering the artist's identity not as some emasculated entertainer but as an actual sexual outsider, expertly manipulating their responses; to gays, it means facing the author's estrangement from that identity, and his horror of it. *And isn't being gay supposed to be wonderful now?* Well, when you look over the *oeuvre* of Edward Gorey, you get the distinct impression that he didn't think so. Which makes him a tricky subject for gay critics. For can you have a gay cultural hero who was alienated from gay sex?

Garvey coins the useful term *glass closet* to describe "that strange cultural zone" inhabited by people in the public eye who "simultaneously operate as both gay and straight." By dodging interviewers' questions about his sexuality with evasive or inscrutable replies while sublimating his homosexuality into his art and aesthetics, Gorey had it both ways, Garvey contends. "Gorey kept perfectly mum about his true nature to the press; he only spoke about it in his art. And in a way, to be honest, the glass closet was appropriate to his artistic persona, which was itself neither here nor there, but locked in a kind of alienated stasis. And as his books and designs became more popular with the mass audience, Gorey probably found the glass closet a *commercially* convenient place to reside as well."

Garvey thinks it's our duty to take a sledgehammer to Gorey's glass closet, especially now that he's dead. "We'd look down at a Jewish performer who concealed his or her religion, and we'd never tolerate a black performer who worked in whiteface," he contends. "Why is the glass closet so different?" He exhorts anyone who takes Gorey's work

seriously neither to "emasculate his gayness" nor to "deny his alienation from it. Both aspects of his personality *enrich* his art—which of course makes it less marketable but more moving."

Garvey resists the conventional reading of Gorey as a campier Charles Addams whose ironic perversity "allows his art to be re-purposed by heterosexuals into a tonic for the pressures of wholesomeness." For Garvey, there's a river of melancholy beneath the surface of Gorey's camp-macabre diversions. He reads Gorey's recurrent motif, the death of a child, as a metaphor for the death of innocence that comes with childhood's end. "And it's hard not to equate this 'death,'" he says, "with a similar childish 'death'—the onset of sexual experience." He cuts deep here, because one of the great unsolved mysteries of Gorey's life is what, exactly, happened at that first (and, by all accounts, last) at-tempt at sex, which put him off the idea forever. It's Gorey's Rosebud moment, the experience that made him who he was.

In New York, Gorey came closer to self-identifying as gay—if only in his mind and to a few close friends—than at any other time in his life, succumbing to crushes on several men, meeting friends for drinks in gay bars, moving in mostly gay circles. He was as cloaked as ever, main-taining the pose of an aloof asexual who finds the whole bothersome business of sex a matter of world-weary indifference. But his letters to Alison Lurie tell a different story.

He refers, now and then, to Third Avenue bars, shorthand for the string of gay gentlemen's bars on Third Avenue, where the unofficial dress code was conservative and the crowd was well turned out. (In a December 1953 letter to Lurie, Gorey announces that he can't bear looking so "tatty" a minute longer and is therefore opening a charge account at Chipp—a New York clothier known for its Ivy League style—and is having bespoke suit jackets made and is stocking up on cashmere sweaters and whipcord trousers. He is, he announces, per-ilously close to chic but hopes he'll achieve a newfound elegance "in

my own manner rather than the Madison Avenue-cum-Third Avenue gay bar one.")[27]

Known as the bird circuit (because so many of the bars had names like the Swan, the Golden Pheasant, and the Blue Parrot, in homage to Charlie Parker's famous jazz club, Birdland), the gay bars Gorey had in mind were sprinkled along Third Avenue between 50th and 60th Streets on the city's East Side. Frank O'Hara, who had moved to Manhattan in 1951, was living with Hal Fondren on East 49th between First and Second Avenues—a neighborhood O'Hara's biographer Brad Gooch describes as "bursting with gay bars," hangouts that O'Hara, Fondren, and Ashbery often cruised.[28] Gorey saw all three of his former schoolmates now and again, though whether he joined them in their barhopping isn't known.

The Village was a magnet for gay nightlife, too, and Gorey's letters reveal that he ventured downtown on at least a couple of occasions. In a September '53 letter to Lurie, he remarks, offhandedly, that a lesbian friend was going to take him to the Bagatelle, a "frightful" bar in the West Village.[29] Now long gone, the Bagatelle, at 86 University Place, was one of the few lesbian bars in '50s New York. In the back room, butch "daddies" (women in male drag, hair slicked back, breasts tightly bound with Ace bandages) competed for "mommies" ("lipstick lesbians" who dressed in a conventionally feminine manner). A warning light flashed, announcing a raid, whenever the vice squad barged into the front room. The Bag was a tough joint, catering to a working-class crowd. "If you asked the wrong woman to dance," the lesbian poet Audre Lorde recalled, "you could get your nose broken in the alley down the street by her butch."[30] It's hard to imagine Gorey in such a place; hard, even, to imagine him that far downtown in an era when "queer hunters" prowled the Village late at night. One such gang beat the Bag's bartender to death with bike chains. "Even in the Village, or especially in the Village, you couldn't be gay and feel safe," according to one of the bar's habitués.[31]

Gorey's furtive explorations of gay New York took place against a backdrop of raids and other forms of legalized harassment. Snickering car-

icatures of "pansies," "horticultural" young men, "the effeminate clan," and other "degenerates" were commonplace in newspaper reportage. The antigay witch hunt known as the Lavender Scare was given the seal of official approval on April 29, 1953, when President Eisenhower signed Executive Order 10450, barring homosexuals from federal employment on the grounds that their "perversion" made them vulnerable to Soviet agents who might blackmail them into spying for the Russkies.

In such a climate, Gorey's reticence about his sexuality is perfectly understandable. Of course, the fact that he was a solitary, bookish man who found solace in the arts and companionship in his cats may have had something to do with his circumspection, too. While he relished Larry Osgood's tales of his torrid love life, Gorey's "Victorian soul" would have quailed at the wham-bam-thank-you-ma'am assignations of gay friends like O'Hara. "The good love a park and the inept a railway station," O'Hara observed in his poem "Homosexuality," written in 1954.[32] "Tallying up the merits of each of the [subway] latrines" for the purposes of anonymous sex, he ends, plaintively, "It's a summer day, and I want to be wanted more than anything else in the world."

Did Gorey want to be wanted? Or did he really require nothing more than books, Balanchine, cats, and his work? In an August 1953 letter to Lurie, he confides that he feels "even less alive" in New York than he did in Boston and that, while he doesn't envy his friends the turbulence of their love lives, he does think he "ought to be having a few direct emotional experiences, however small."[33] He was twenty-eight when he wrote those poignant lines.

His letters to Lurie do make reference to occasional infatuations—*very* occasional, if his mention of two in the years spanning '53 through '58 is a full accounting. In a September '53 letter, he announces, out of the blue, that Larry Osgood introduced him to a friend from Buffalo. "I fear I have fallen in love with it very badly indeed," he confides.[34] "It" is a drop-dead-gorgeous thirty-year-old named Ed who may or may not be bisexual but is without question "almost perfectly narcissistic." Ed is taken with Ted, both "mentally and physically," and much two-fisted drinking ensues, culminating in a shrieking match outside a bar.

When Ed leaves town, an overwrought correspondence follows, though with no mention of when they'll see each other again, which Gorey finds odd, reasonably enough. In November, he tells Lurie that he's been suicidal because he hasn't heard from Ed; happily, a ten-page letter arrived before Gorey took drastic action.[35] Still, things continue weird: as he drifts off to sleep one night, he realizes he can only remember Ed with some difficulty, and when he does the indistinct personage who materializes in his mind's eye seems only vaguely related to the recipient of his love letters. "Very odd," he admits to Lurie, "but I imagine it all has to do with sex."

Come December, he's at least "partially cured" of his obsession, he tells Lurie, having discovered that a mutual friend was simultaneously carrying on with Ed.[36] Listening to his besotted friend agonize over *his* infatuation, Gorey realizes what an ass he's been, having seen himself "in the mirror, as it were," of his lovesick friend's addle-brained behavior.

Nevertheless, Ed has unsettled him to the extent that all manner of rash actions, from sleeping with strangers to taking the cloth, have suddenly gone from "the unthinkable to the ponderable."[37] Whether Gorey threw caution to the wind and buried his sorrows in one-night stands we'll never know, though that seems about as likely as his joining the Church. One thing is certain: that's the last we ever hear of Ed.

Life went on, as it tends to do. Gorey's job at Doubleday wasn't too bad, he wrote Lurie, although the low wages left him "financially in perfectly ghastly straits"; moreover, "about fifty percent of the work is veddy dull indeed, but I think that's probably rather a low percentage considering."[38]

He decorated his part of "the art department cubbyhole" with Goreyesque bric-a-brac, Diana Klemin remembers, including "a skeleton head." At times, having a resident weirdo came in handy, she says. "If you were on a project and you were stuck, and the editor was just unbearable, and you hated the assignment but you had to get it done,

you'd say, 'Ted, throw me a tantrum.' For three or four minutes, he would jump up and down and scream. All the tension went out of the art department."

During his lunch hour, Gorey would hit the art galleries on Madison Avenue or gulp a quick bite, then work on freelance assignments or his own projects. Sometimes he went out to lunch with Connie Joerns or Barbara Epstein.

He saw quite a bit of Barbara socially. Ted and Barbara "were as close as two people could be," Jason recalls. They had a jokey lingo all their own, an "Edwardian babble" in which "his name was Teddles, Barbara's name was Bubsy," a cigarette was a "ciggy-boo" or a "flaming bo-bo," and so on. Jason attributes their in-crowd argot to "that campy thing they all were doing" at Radcliffe and Harvard. "It was a way of being different and revolutionary. Others might have wanted to become Communists or Buddhists or something but that's what they were doing."

On occasion, Gorey went to parties at the Epsteins', a stunning two-story apartment with fireplaces, plural, on 67th between Central Park West and Columbus Avenue. Over cocktails, his favorite conversational topics were literature and gossip "in a gentle way," Jason remembers. "There wasn't a mean bone in his body." The truth of the matter, though, is that Ted "didn't like New York parties. He almost never invited people to his apartment."

Jason was one of the lucky few. "Everything about it was [in] great style," he says. It was "very elegant" but small and overstuffed, bulging at the seams with cats and curios and books packed two layers deep in built-in bookshelves and stacked in the fireplace, even. (By '53, Gorey had three cats. Ultimately, he'd keep as many as five in the one-room apartment.) It was so crammed with *stuff*, Epstein remembers, that there was nowhere to sit down. (When Tobi Tobias interviewed Gorey for *Dance Magazine*, in 1974, she got "the only chair—a drafting stool; Gorey, fidgeting with his many Indian silver rings, perched on the seat of a small stepladder...")[39] "There was no room for two in that apartment—or in that life," says Jason.

Gorey's collection of memento mori caught his eye. There was a

human skull and "an ivory carving of a dead person with flies all over it"—the sort of thing "crazy Catholics" kept around "to remind them of mortality," Jason thought—and a mummy's head, which Gorey, unbeknownst to his workmates, had kept wrapped in brown paper on the shelf of the Doubleday coat locker while waiting for its glass display case to be made. The head would, in time, find lifelong—if that's the word—companionship in the mummy's hand that Gorey also acquired. He kept the hand in a wooden box on one of his bookshelves. "It's only a child's," he told an interviewer, as if that explained things.[40]

At some point, Gorey's library overflowed his bookcases and engulfed everything: a journalist visiting his apartment in 1979 was agape at "*mountains*—better make that mountain *ranges*—rising from the floor, falling off the mantel, wedged against the bureau, stacked beside the bed. It's impossible to say with assurance that the floor holds a rug, since every square inch of space (except for a narrow aisle that snakes from the drawing board to a narrow hall containing a wall-kitchen and the bathroom) is taken up with cartons and packing crates. My wild hunch is that these contain books."[41]

Gorey never used his minuscule kitchenette, he claimed, because his apartment was so tiny that the smell of whatever he cooked would be hanging in the air "three weeks later."[42] Peter Wolff, a member of Gorey's New York City Ballet circle in the '70s, confirms that "every meal was eaten out at one horrible restaurant or another" whose only virtue was its proximity to 36 East 38th.

For someone who filled his pen-and-ink interiors with sumptuous decor, Gorey lived in conditions that would make a self-flagellating monk feel right at home: all that was missing was the scourge. The walls were scabrous with peeling paint. His floor-level bed had no headboard. When he sat in it, reading, he leaned against the wall; directly over his head hung "two large sculpted pieces of corpselike faces wearing expressions of extreme pain."[43] On another wall, a large antique sculpture of the crucified Christ, sans cross, added a touch of morbid religiosity. With his close-cropped hair and biblical beard, the suffering Messiah looked remarkably like Ted, a resemblance his friends were quick to point out.

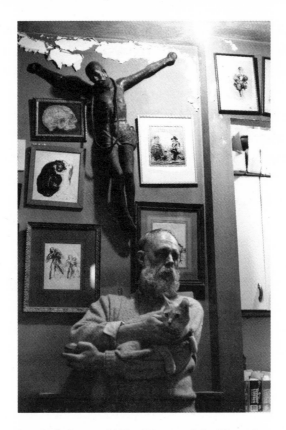

Gorey at 36 East 38th Street, 1978. *(Photograph by Harry Benson. Copyright Harry Benson Ltd.)*

Thirty-six East 38th was Gorey's cabinet of wonders, bohemian atelier, and Fortress of Solitude rolled into one. Doubleday's art department closed up shop at five, and if he wasn't going to the movies or the ballet, he went home, where he worked on drawings for his books until nine-ish, after which a little light reading—a mystery, more often than not—and so to bed. "All the brilliant thoughts and insights and such which I had about New York seem to have vanished or shriveled by this time," he wrote Lurie in March of '53. "It's just another place, with better bookstores, and more movies to go to."[44] Never a New Yorker in the Saul Steinberg sense—that is, one of those Gothamites whose "view of the world from Ninth Avenue," like the Steinberg cartoon of the same name, places Manhattan at the center of the universe—Gorey

always found the city "terribly provincial."[45] "Most of the people seem either hopeless or horrid or both, especially the cultural ones," he went on in his letter to Lurie, pseudosophisticated phonies who "looked and behaved as if they had emerged from the Remo," a Bleecker Street bar favored by gay culturati.[46] He ended on a wistful note: "I feel like a captive balloon, motionless between sky and earth," he said. "I want birds to bring me messages."

CHAPTER 6

HOBBIES ODD —
BALLET, THE GOTHAM BOOK
MART, SILENT FILM,
FEUILLADE

1953

IN THE FALL OF '53, Duell, Sloan and Pearce published the first of Gorey's hundred-odd little books, *The Unstrung Harp; or, Mr Earbrass Writes a Novel*. Gorey's meeting with Cap Pearce in Cambridge two years earlier had, at long last, borne fruit. He'd managed to write a good bit of the book at work. "I was fast and competent at what I was doing, as opposed to some people in the editorial department, who were scatterbrained to the point of lunacy, so I wrote a lot of my own books at Doubleday," said Gorey. "I began with *The Unstrung Harp*, which I thought was a neat trick. I had never written a book before, and it was all about writing, which I didn't know anything about."[1]

The Unstrung Harp holds up a magnifying glass to the agonies of the scribbling trade. Mr. Clavius Frederick Earbrass, a novelist of the hand-wringingly neurotic variety, wrestles with writer's block, the petty jealousies of the literary world, and the loneliness of the writing life. It's the

closest Gorey ever came to a conventional work of fiction: written in prose rather than verse, typeset rather than hand-lettered, with a paragraph of text on each left-hand page facing a full-page illustration on the right, it's his longest book by far, at sixty pages—a Victorian novel in miniature, its drawing-room dramas and writing-desk miseries writ small.

Of course it isn't a novel, or even a novella. His little books refuse to be categorized. What are they, exactly? Picture books for grownups? Precursors of the graphic novel? Mash-ups of Victorian literature, the comic strip, and the silent-movie storyboard? Throughout Gorey's career, the genre-defying size and tone of his books, never mind their content, would frustrate publishers and booksellers alike. Publishers were reluctant to market them to children, fearing that their morbid subject matter and gleeful amorality were inappropriate for tots and might enrage self-appointed morality police, who like to ban books. Booksellers didn't know if they were children's books or adult fare and were confounded, in any event, by their awkward format. (Even Jason Epstein found the unconventional size of Gorey's books a tough sell. Asked why he never published his in-house genius, he said, "He never asked me to," then added, "It would've been hard for me to publish [his books]—the format, I wouldn't know how to sell them. Where would you put them? You'd have to make a little box and put it on the counter somewhere.* It looked like a lot of trouble.")

Whatever else it is, *The Unstrung Harp* is a masterpiece of miniaturism in the literal and psychological senses. Its small format—five by eight inches—and intricate illustrations usher us into a dollhouse world. Gorey maintains a tight close-up on the domestic sphere and on the psychological interior it so clearly represented for him, a man who later turned his Cape Cod house into a museum of his obsessions and inspirations—in effect externalizing the contents of his mind.

The anxieties and eccentricities that afflict the book's high-strung pro-

*The Gotham Book Mart, which in time cornered the market on Goreyana, solved the problem of where to stock his books by doing just that. "His stuff was always at the cash register," former Gotham employee Janet Morgan told me. "It was kind of like the stuff people would buy at the last minute, kind of like the candy at the drugstore."

tagonist, its setting in the England of yesteryear (mostly in Mr. Earbrass's sprawling, gloomy mansion, Hobbies Odd, near Collapsed Pudding, in Mortshire), and its British vocabulary and syntax—wastebaskets are "dustbins," cookies are "biscuits," an "athletic sweater of forgotten origin and unknown significance" isn't worn backwards (for good luck while writing) but rather "hind-side-to"—contribute to the book's twee-gothic atmosphere. Gorey's whisker-fine lines and meticulous cross-hatching bring back childhood memories of Ernest Shepard's illustrations for *The Wind in the Willows* and Tenniel's pictures for the *Alice* books.

Yet in its tone, sophistication, and subject, *The Unstrung Harp* is anything but childish. The omniscient narrator speaks in a voice that is shockingly arch for its time, far from the bright-eyed breathlessness affected by most children's writers in the 1950s. It's the Gorey Voice, a deadpan that never cracks, but with a droll undertow; the distance between its sublime indifference and the lugubrious or odious or horrendous nature of the events it recounts is what makes for irony, and irony is what turns tragedy into black comedy in Gorey's world.

The Unstrung Harp. (Duell, Sloan and Pearce/Little, Brown, 1953)

149

Nor is the book's subject kid stuff. *The Unstrung Harp* is about "the unspeakable horrors of the literary life," as the author puts it, by which he means "disappointing sales, inadequate publicity, worse than inadequate royalties, idiotic or criminal reviews," and, worse yet, the terrors of the looming deadline and the blank page. "The best novel ever written about a novelist," Graham Greene called it in all apparent seriousness.[2]

Gorey's claim that he knew nothing about writing when he wrote *TUH* notwithstanding, he is sharply—and amusingly—perceptive about the brain-racking labor involved in giving birth to a novel. At one point, a minor character named Glassglue startles the author by materializing out of thin air—Gorey's amusing comment on the implicit loopiness of making up characters, then regarding them as real, as novelists do. Of course there's the inevitable crisis of confidence, a loss of faith not just in the book in progress but also in writing itself:

> Mr Earbrass has rashly been skimming through the early chapters, which he has not looked at for months, and now sees *TUH* for what it is. Dreadful, *dreadful*, DREADFUL. He must be mad to go on enduring the unexquisite agony of writing when it all turns out drivel. Mad. Why didn't he become a spy? How does one become one? He will burn the MS. Why is there no fire? Why aren't there the makings of one? How did he get in the unused room on the third floor?

At last, after the protracted agony of revision and a dustup over the book jacket, the book is published by Scuffle and Dustcough (a satirical echo, we suspect, of "Sloan" and "Duell"). But the torture isn't over: the author has to endure "an afternoon forgathering at the Vicarage vaguely in [his] honor," where he is buttonholed by Colonel Knout, Master of Foxhounds of the Blathering Hunt. A blustery, barrel-chested chap in tweeds and gaiters, the colonel "demands to know just what Mr Earbrass was 'getting at' in the last scene of Chapter XIV. Mr Earbrass is afraid he doesn't know what the Colonel is. Is what? Getting at himself. The Colonel snorts, Mr

Earbrass sighs." That's the sound of clashing masculinities, the one Firbankian, effete, the other Maileresque, overcompensating. We get Gorey's hint that the colonel has sniffed out something unmanly in Earbrass, who in an earlier scene wears a coat with a fur collar and cuffs that is virtually identical to the coat Oscar Wilde wore in his famous Sarony photos.

In the penultimate scene, we see Mr. Earbrass standing on the terrace at twilight, gazing into the gloaming with the stricken expression he always wears. "It is bleak; it is cold; and the virtue has gone out of everything." Twilight is the most Goreyesque hour, just as autumn is the most Goreyesque season; both are memento mori moments, inviting us to contemplate the impermanence of things, the folly of human vanity, the Meaning (or Meaninglessness) of Life.

To a surrealist such as Gorey, twilight is also a liminal zone, an uncanny space between the daylit world, ruled by the conscious mind, and the nighttime of the unconscious. (In a January 1957 letter to Lurie, he says of his drawing on the envelope that it "represents the heart's desire seen at twilight, the time when it most often is.")[3] A string of words bubbles up unbidden out of Earbrass's unconscious as he stands on the terrace. "Words drift through his mind: *ANGUISH TURNIPS CONJUNCTIONS ILLNESS DEFEAT STRING PARTIES NO PARTIES URNS DESUETUDE DISAFFECTION CLAWS LOSS TREBIZOND NAPKINS SHAME STONES DISTANCE FEVER ANTIPODES MUSH GLACIERS INCOHERENCE LABELS MIASMA AMPUTATION TIDES DECEIT MOURNING ELSEWARDS..."*

Like all free association, it invites us to mine it for hidden meanings. At its most existential, Earbrass's dispirited exhaustion is a disenchantment with language reminiscent of Beckett or Derrida. His stream-of-consciousness ruminations expose the workings of language for the parlor magic it is, revealing that words are defined not in any absolute sense but only in relation to other words (*CONJUNCTIONS*), especially the opposite of the idea expressed (*ANTIPODES*). As well, they question the either/or worldview that uses binary oppositions (*PARTIES/NO PARTIES*) as a philosophical mill for grinding out meaning. Each term in a binary is unthinkable without its opposite, as Taoism reminds us.

All is DEFEAT and DECEIT and INCOHERENCE, Beckett would add; nothing left but the fool's errand of using silence and incoherence in an attempt, funny in its futility, to speak outside language—to name the unnamable. "Nothing to communicate, no way of communicating, must communicate," says Beckett in *L'Innommable* (*The Unnamable*), a book Gorey owned. ("If I had to say I'm like anyone I suppose it'd be Gertrude Stein and Beckett," Gorey once observed—a startling admission but not, according to Andreas Brown, an improbable one.[4] "Gorey admired Beckett immensely," said Brown. "The occasionally gloomy but always existential Beckett, the absurdist writer tiptoeing to the edge of nonsense literature, appealed to Gorey greatly."[5]) Earbrass's seemingly random string of words is an unconscious attempt to express the inexpressible through surrealist dream logic, conjuring a meaning that is more than the sum of its linguistic parts. Paradoxically, it's simultaneously an admission of defeat, the sound of language becoming gibberish, surrendering any attempt at meaning. Is the book's title Gorey's idea of a Zen koan? Q: What is the sound of an unstrung harp? A: Silence, of course, which is its own kind of utterance, one that sometimes speaks louder than language in the same way that Gorey's use of blank space—visual "silence"—is wordlessly eloquent. Not for nothing was his motto "O, the of it all!"[6]

On the last page of *The Unstrung Harp*, Earbrass stands on a dock next to a small mountain of steamer trunks and portmanteaus. "Numb with cold and trepidation, looking at the churning surface of the Channel," he's about to leave for a vacation on the Continent. "Though he is a person to whom things do not happen, perhaps they may when he is on the other side." Although Earbrass, like Gorey, is a solitary, bookish homebody whose digestion is upset by travel, he both fears the unknown and hopes for a life-changing encounter outside the pages of a book.

"I am becoming seriously disturbed by the fact that I seem to be even less alive in NY than I was in Boston," Gorey wrote Lurie around the time the book came out. As mentioned earlier, he felt that he really "ought to be having a few direct emotional experiences, however

small." Does he dare risk the deeper, darker waters of experience in or-
der to immerse himself in life more fully? Earbrass's journey may give
shape to Gorey's yearning for a life lived firsthand rather than vicari-
ously, through books and movies.

"I lead a dreary life," Gorey told an interviewer during his New York
years, reprising the role of irrepressible gloompot. "My interests are
solitary, I don't do anything; it's an unlurid existence."[7] The truth of
the matter is that he was, in his own odd way, quite sociable. He
counted Connie Joerns, Alison Lurie, and Barbara Epstein among his
close friends, and members of his Harvard circle, such as Larry Osgood,
Bunny Lang, and Freddy English, orbited in and out of his life. He even
managed, at one point, to rekindle his friendships with Frank O'Hara
and his Francis Parker classmate Joan Mitchell, who'd moved to New
York in 1947. By the early '50s, she'd sharp-elbowed her way into the
boys' club of abstract expressionism and was a recognized member of
the New York School. (In an intriguing plot twist, she'd married an-
other Parker alum, Barney Rosset, in '49.)

Gorey's most enduring relationships during his New York years be-
gan as marriages of convenience, so to speak—cliques drawn together
by shared passions, such as film and ballet, or friendships rooted in
business dealings, such as his close working relationship with Andreas
Brown, owner of the Gotham Book Mart. "Most of my friends in New
York were my friends because we were all so busy going to things we
had no time to do anything else," he recalled in his Cape Cod years.
"I might never have seen people if I didn't see them that way," adding,
enigmatically, "Social events—*foof*.[8] You know."[9]

Shortly after arriving in the city, in that first winter of '53, Gorey
bought a ticket to the New York City Ballet. His infatuation with

narrative ballets in the classic style of the Ballets Russes and Ballet The-atre,* which had sent him into ecstasies in his high-school years, had waned considerably. By the time he saw the Ballet Theatre again, in 1950, after a long ballet drought during his exile in the Great Salt Lake Desert, "the first, fine careless raptures had worn off," he confessed, "and I wasn't really terribly interested in them anymore."[10] Still, he'd never seen the NYCB before, so he thought he'd give it a whirl.

His conversion to what would become an aesthetic religion crept up on him; it wasn't one of those Saul-on-the-road-to-Damascus moments that make for biographical melodrama. "The first year I went to the ballet four or five times, if that," he recalled. "I felt that Balanchine merely illustrated music, and that if you had seen his ballets once, you had seen them. But before long I was attending more often. By 1956 I was go-ing to every performance because it was too much trouble to figure out which twenty-five out of thirty I really had to see."[11] By then, he was "absolutely hooked on Balanchine, to the point where, I'm afraid, everybody else bores me. Rather."[12]

He ended up attending nearly every performance of every ballet staged by the company for the following twenty-three years—eight performances a week, five months out of the year, including as many as thirty-nine performances of *The Nutcracker* annually, until around 1979. (By then, Balanchine was in failing health, and the company's subordinate ballet masters, predominantly Peter Martins, were han-dling much of the choreography. Since ballet *was* Balanchine, as far as Gorey was concerned, he began going to the ballet less frequently, more or less stopping altogether after he moved to the Cape perma-nently, around 1983.)

In the early years, Gorey saw the NYCB at City Center, as everyone knew it—officially, the New York City Center of Music and Drama, on West 55th Street near Carnegie Hall. Built in the Moorish revival style in 1924, the former Mecca Temple of the Ancient Arabic Order of

*The precursor of the American Ballet Theatre.

the Nobles of the Mystic Shrine—the Shriners, by any other name— was an *Arabian Nights* fantasia come to life, crowned with a mosquelike dome. The theater where Balanchine's dancers performed is a delirium of arabesque details, all green, gold, and maroon; the polychrome tile-work on the cupola radiates outward in a spiderweb pattern, dizzying to behold. Gorey would buy a cheap seat—tickets for the nosebleed zone cost $1.80—then move down to sit at the foot of the stairs, at the front of the balcony.

For the old guard of City Ballet fandom, the years at City Center were the company's golden age. Balanchine was reinventing ballet, scrapping the sentimentality and theatrical mannerisms that made it seem like a museum piece moldering in Europe's attic. Sweeping away the cobwebs, he used classical technique to create a thrillingly new—and thoroughly American—ballet that championed pure form over storytelling, a move interpreted by most critics as a neoclassical re-action to romanticism.

Which it was, though he was capable of achingly bittersweet roman-ticism when a dance called for it, as in his *Liebeslieder Walzer* (1960) and *The Nutcracker* (1954). At his most radical, though, Balanchine was as modern as they come. In the plotless *Agon* (1957), dancers twist them-selves into angular shapes and strike friezelike attitudes, dodging the jabs of Stravinsky's dissonant music. A radical traditionalist, Balanchine cre-ated a neoclassical high modernism by pushing ballet technique to its limits. Even the use of rehearsal gear as costumes—black leotards and white tights for the women, white T-shirts over black tights for the men—signaled his sharp break with the artifice and sentimentality of Old World Romanticism, as did the bare stage, stripped of all scenery, and the silence in which *Agon* begins, the curtain rising on four male dancers standing motionless, their backs to the crowd. The Dadaist icon-oclast Marcel Duchamp compared *Agon*'s debut to the riotous opening, in 1913, of *The Rite of Spring*, which he'd also attended; Arlene Croce, who would later become the dance critic for the *New Yorker*, claimed not to have slept for a week after seeing the ballet's premiere.

New York's bohemian underground and the edgier members of its

cultural elite were entranced by the NYCB. Frank O'Hara was a devotee, naturally, attending "almost all the performances," according to Brad Gooch.[13] In "Notes from Row L," a brief appreciation written for the program of a 1961 performance, O'Hara rhapsodized that Balanchine's art is for those who "want your heart to beat, your blood to pound through your veins and your mind to go blank with joy..."[14]

Balanchine spoke to Gorey on many levels. When the ballet master said that ballet, "like the music of great musicians... can be enjoyed and understood without any verbal introduction or explanation," he was singing Gorey's song.[15] His insistence on dance as an expression of the ineffable, its *grand jetés* a leap beyond language, struck a chord with Gorey, as did Balanchine's impatience with what he saw as the reductionism inherent in critical attempts to articulate the "meaning" of his ballets.

Gorey's sense of what's lost when we try to use words to nail down meaning was honed by his need, as an illustrator, to complement a text by saying something in images that couldn't be said in words. Balanchine, as an illustrator of musical "texts," faced the same challenge: "His movement is never an exact illustration of the music, but rather an interpretation that [complements] the rhythm, quality, and density of the score," notes the dance writer Kirsten Bodensteiner.[16]

Expressing his frustration with the ways in which language maps its either/or binarism onto our thinking, Gorey reached, reflexively, for ballet as an example of something that's irreducibly itself, untranslatable into language: "All the things you can talk about in anyone's work are the things that are least important. It's like the ballet. You can describe the externals of a performance—everything, in fact, but what really constituted its core. Explaining something makes it go away, so to speak; what's important is left after you have explained everything else. Ideally, if something were good it would be indescribable. What's the core of Mozart or Balanchine?"[17]

Then, too, Balanchine, like Gorey, was a draftsman, though his drawings were sketched in space by bodies in motion. The sharp

attack he demanded in his dancers' footwork reminds us of the machinelike precision of Gorey's hatching and stippling; the crisp yet lyrical lines of Balanchine's dances, accentuated by his preference for ballerinas with impossibly long legs, are the choreographic equivalent of Gorey's line, which balanced economy with expressiveness. The formalist in Gorey responded to Balanchine's mastery of form—the classical architecture of his dances; his geometer's love of bodies resolving into kaleidoscopic patterns, then reassembling into new ones. It's not much of a stretch to see the visual aspect of Gorey's work as an extended meditation on pattern.

Also like Gorey, Balanchine was an eclecticist. Anything was fair game for his magpie mind: the grand tradition of the Imperial Russian Ballet in Saint Petersburg, the modernist avant-gardism of Diaghilev, the jazz and tap styles he explored in his choreography for Hollywood and Broadway, the folk forms he celebrated in *Western Symphony* (1954). "God creates, I do not create," said Balanchine. "I assemble and I steal everywhere to do it—from what I see, from what the dancers can do, from what others do."[18] "I have a strong sense of imitation," echoed Gorey, who believed his gifts lay in recombining elements rather than in creating something ex nihilo. In the end, it didn't matter, he thought, because his pastiches, like Balanchine's, always ended up inimitably his own. "So I can afford to indulge this kind of exercise, filch blatantly from all over the place, because it will ultimately be mine."[19]

The New York City Ballet, in its City Center years, was electrifying. That the company often performed to half empty houses only made Balanchine cultists and the dancers they adored feel they were part of something desperately important. Years later, Gorey wrote a wry love letter to the City Center era. Featured in a spring 1970 issue of *Playbill* and published in book form by the Gotham Book Mart in '73, *The Lavender Leotard; or, Going a Lot to the New York City Ballet* recalls that romantic time when Balanchine was turning out one masterpiece after another but the troupe lived from hand to mouth, supported—just barely—by a small but fervent fandom. "Of course, Gorey can't

describe...just how beautiful and exciting those fifty seasons were," wrote Tobi Tobias in *Dance Magazine*. "But he details it again for each of us, in the mind's eye...And he sums up the snobbery we—surely America's most fanatical audience outside Ebbets Field—cultivated as ardent supporters of that odd and wonderful troupe..."[20]

The Lavender Leotard. (Gotham Book Mart, 1973)

Balanchine's NYCB was "a breath of fresh air in a really old form," says Peter Anastos, the choreographer who cofounded the all-male comic ballet troupe Les Ballets Trockadero de Monte Carlo, which performs the classical repertoire in drag. "[It] was a complete break from the old world of ballet. So that's what [Gorey] fell in love with. And he loved those dancers, you know, people like Diana Adams and Tanny [Tanaquil] Le Clercq and some of those really odd dancers that Balanchine more or less discovered and trained."

Gorey was especially entranced by Patricia McBride, who joined the company in '59. She was "surely the greatest dancer in the world," he declared in a 1974 interview, though Adams, a statuesque beauty noted for her emotional intensity and long-legged line, was his "favorite dancer of all time."[21] Allegra Kent, who joined the NYCB in '53, was another Gorey favorite. Fey, fairylike, yet possessed of what Tobi Tobias

called "extreme plasticity, coupled with a supercharged poetic imagination," Kent could play the wide-eyed innocent, the passionate sensualist, or the Balanchinian vision of Woman as Untouchable Ideal.[22]

Gorey said he "suddenly burst into tears" over Kent's portrayal of the Sugar Plum Fairy in *The Nutcracker.* "I thought, she *is* the Sugar Plum Fairy; she really is a figment of this little girl's imagination, and she's going to vanish into air when they leave...."[23] (That Gorey, whose appreciation of Balanchine's work always struck his close friend and fellow Balanchinian Mel Schierman as "very intellectual," would be moved to tears by Kent's poignant evocation of the lost world of childhood offers a tantalizing clue to Gorey's own past.)

Later, long after the City Center era, Kent and Gorey became friends when she asked him to do a drawing for the invitation to a publication party for her aquatic-exercise book *Allegra Kent's Water Beauty Book* (1976). "One day my phone rang and this chirpy little voice came over the phone," said Gorey.[24] It was Kent, asking if she could send him a prepublication copy of her book. "I was sort of startled by this, because I always worshipped at her shrine." In due time, the book arrived. "Then she started sending me notes and things. She does things like write a note and then stitch it up inside a paper bag and mail it. I was just crazed, but it was very amusing."[25]

In 1978, Gorey approached Kent about starring in *Fête Diverse, ou Le Bal de Madame H—,** a ballet for which he'd written the scenario and was going to design the costumes and scenery. Peter Anastos would handle the choreography; the Long Island–based Eglevsky Ballet, founded by former Balanchine principal André Eglevsky, would perform it. As Anastos remembers it, the ballet was about "guests at a party suffering from some type of degenerative disease."[26] Kent signed on without a moment's hesitation.

At the costume fitting, Gorey decided Kent's "pale sea foam"–

**Fête Diverse* (literally, "diverse party") appears to be a Gorey pun on *faits divers*, miscellaneous short news items, often of a lurid or sensational nature, which were once a fixture in French newspapers.

colored dress would look better, she recalled, with "five hundred safety pins of various sizes...placed at random over the expanse of tulle."[27] This wasn't Gorey's nod to punk rock, whose iconic fashion statement was the safety pin, but rather to Kent's zany habit of adding them to her outfits as ornaments. ("I had to completely reconstruct the partnering in the *pas de deux* because the pins kept popping open," said Anastos, in a 1990 *New Yorker* profile.)[28]

Kent remembers *Fête Diverse* as "a delicious romp."[29] Anastos looks back on it as "colorful and silly, but really not much more than that."

> I was young and dumb enough to think that I could realize all the possibilities that were hinted at in the libretto. It's hard to build dramatic structure into Ted's work—it's all so atmospheric. Charles Addams's characters can have real lives, but Gorey's don't exist outside their condition.[30]

That said, "we *did* have Allegra Kent in the lead," he notes. "I always thought she was the complete Edward Gorey ballerina. Most of her performances seemed to have been drawn by him."

Asked, by *Vanity Fair*, "Who are your heroes in real life?" Gorey replied, "George Balanchine, Lincoln Kirstein,* Frances Steloff."[31]

Steloff, who died at the age of 101 in 1989, was the legendary founder of the Gotham Book Mart, which Gorey began frequenting shortly after moving to Manhattan. A treasure house of modernist poetry, literature, and avant-garde "little magazines," the Gotham was to literary America what Sylvia Beach's storied Shakespeare and Company was to Hemingway, Pound, and other English-speaking expats in Paris between the wars. Founded in 1920, it stood, incon-

*Lincoln Kirstein, the heir to the Filene's fortune, cofounded (with George Balanchine) the New York City Ballet in 1948.

gruously, in a five-story brownstone at 41 West 47th Street, smack in the middle of midtown Manhattan's diamond district, which had sprung up around it.

The Gotham (which closed in 2007 after eighty-seven years as a New York literary landmark) was every bibliophile's fantasy of a bookshop. A bell on the door jingled when you entered. The store was a warren of alcoves and aisles so narrow they were a tight squeeze for two abreast. The floorboards squeaked; the reassuring mustiness of old books hung in the air. In the spirituality section, a battered cardboard sign admonished, SHOPLIFTERS: REMEMBER YOUR KARMA!

George and Ira Gershwin, Georgia O'Keeffe, Woody Allen, Alexander Calder, Saul Bellow, John Updike, Jackie O., and Katharine Hepburn were devoted customers. Max Ernst mounted an exhibit of his work in the second-floor gallery; Salvador Dalí held a book signing at the store. J. D. Salinger liked to sneak in whenever he was in town, confident that he could browse unnoticed. One fine day, H. L. Mencken and Theodore Dreiser rolled in, "full of beer and gaiety," as one account has it, and proceeded to sign their books, "embellish[ing] them with long inscriptions."[32] When they'd exhausted their oeuvres, they autographed other authors' works, among them the Bible, which one of them inscribed, "With the compliments of the author." Sightings of Jorge Luis Borges were not uncommon. Janet Morgan, who oversaw the store's small press and poetry department, remembers the time Allen Ginsberg came in with his mother and a Brooks Brothers shopping bag: "I'm just kind of thinking, 'The Beat generation is *dead!*'" And then there was the time she was busy typing something up, "and someone's standing above me going, 'Do you take traveler's checks?' and it's David Bowie," buying Gorey books.[33]

Raised in Dickensian poverty, Steloff sold flowers to wealthy vacationers in Saratoga Springs, New York, where she grew up in the 1890s. "I never had books," she told an interviewer. "I never read the juveniles and classics. . . . I missed all that. It used to hurt. . ."[34] In later life, she revered books as sacred things and writers as initiates into the mysteries of creative genius. If a writer was especially hard up, she might

give him a temporary job to get him back on his feet: at one time or another, Ginsberg, Amiri Baraka, and Tennessee Williams all worked as clerks at the Gotham. (Williams, hopeless at tying up parcels with twine, was sacked by Steloff after a day on the job.) Henry Miller, Dylan Thomas, Marianne Moore, Anaïs Nin, William Carlos Williams, and Eugene O'Neill were just a few of the famous or soon-to-be-famous writers who flocked to the store, swapping literary gossip, making sure their books had pride of place, and, not infrequently, cadging a loan from Miss Steloff, as she was reverently known.

Gorey knew about the Gotham long before he moved to New York. According to Andreas Brown, he'd "established an association with [the] Gotham Book Mart in the early 1940s while still in the Army," through mail-order requests.[35] "When he came to the city to work he began making frequent visits to the bookshop and became a close friend" of Steloff, Brown recalls.

No doubt the two quietly uncompromising eccentrics recognized each other as birds of a feather. Steloff was a diminutive woman, her graying hair done up in a loose bun, her working costume a shawl, a frumpy blouse, and an apron, its pockets stuffed with seeds and dried fruit—the vegetarian fare she snacked on in lieu of lunch. Clerks dispatched to her apartment before the store opened were sometimes startled to find her in a yoga headstand, buck naked. (Steloff, a firm believer in the virtues of nudism, was unperturbed.)

With her eye for unselfconscious originality, she was drawn to Gorey's work. When he dropped by with copies of *The Unstrung Harp*, she took some on consignment, inaugurating a lifelong relationship between Gorey and the store. From the early '50s on, his little books were prominently displayed near the cash register. Through Brown's careful cultivation, that relationship would flourish. Acting as what Gorey called his unofficial manager—a role that encompassed publisher, gallerist, marketer, and merchandiser—Brown, who bought the store from Steloff in 1967, would prove instrumental in catapulting him from an obscure author whose mostly out-of-print books were the closely guarded secret of a jealous few to the much-admired object of a mainstream cult.[36]

Nineteen fifty-three turned out to be a watershed year for Gorey: not only did he move to New York, install himself at 36 East 38th Street, settle into the nine-to-five routine at Doubleday—his first real job—and publish his first book, he also immersed himself in the New York City Ballet, the Gotham Book Mart, and, lastly, the movie screenings hosted by the film historian William K. Everson—hubs of activity whose artistic pleasures, intellectual excitements, and social milieu would feed his art and fill his life throughout his time in New York.

Gorey discovered Everson's circle of movie buffs, the Theodore Huff Memorial Film Society, "not long after January 1953," according to Brown.[37] Originally known as the Film Circle, the Huff Society was a loose-knit group of movie buffs who met for screenings of rarely seen silents, early talkies, and foreign gems from the '20s and '30s. The group had coalesced in '52, when Theodore Huff and Everson, film historians and pioneering preservationists, started getting together with a few of their movie-industry friends to screen prints of hard-to-find titles. When Huff died, in March of '53, Everson renamed the group in his honor.

The Theodore Huff Memorial Film Society was just the sort of cultish group Gorey was drawn to, a secret society knitted together by shared obsession rather than camaraderie, like the "in crowd" dissecting Balanchine at City Center or the impossibly knowledgeable clerks at the Gotham or the cocktail-party aesthetes in Eliot House. A non-profit endeavor sustained (just barely) by ticket sales, the Huff Society scrounged projection space wherever it could—one month a film studio, another month a movie theater or even a room in a psychiatric institute (which was appropriate, Everson joked, given the oddballs his screenings attracted).

When Gorey met him, Everson was a publicist for independent film distributors. Later, he would win acclaim among cineastes as a pioneering preservationist of disintegrating silents (which movie studios viewed, at the time, as Dumpster fodder). An ardent cinephile with a prodigious

knowledge of pre-'40s film, he used the nearly twenty books he wrote on movie history to promote the serious study of the silent era.

By the 1970s, he'd amassed a hoard of more than four thousand feature films, which he kept in stacks in his overstuffed apartment on the Upper West Side. Huff Society members whom he found simpatico comprised an inner circle, invited to Saturday night screenings at his home. Gorey was one of the devotees who squeezed into Everson's living room. If an evening was oversubscribed and all the chairs were taken, overflow attendees sat on film canisters piled high.

"When my dad was having his Saturday night screenings, there was no other way to see these films that he was showing," says Everson's daughter, Bambi. "That's why we had this conglomeration of really wonderful people and then the people that came regularly." Among the wonderful people were Andrew Sarris, the noted critic and standard-bearer for the auteur theory, and Susan Sontag. As for the regulars, Bambi remembers them as "molelike people" with "pasty white skin" who "lived in their mothers' basements."

Gorey kept his distance. His devastating zingers were his way of discouraging chumminess, she believes. "The other people just sat in their chairs, feverishly writing notes, and during the break they would ask dumb questions," she says. Gorey, by contrast, "had a sardonic wit. . . . [W]hen one of the Great Unwashed would say something, he would come back with a witty retort."

"He definitely had a camp sensibility," recalls Howard Mandelbaum, an alumnus of Everson's Saturday night screenings and cofounder of the entertainment-photo archive Photofest. Ted's startling height, "thrift-store bohemian" garb, and stentorian delivery, perfect for broadcasting opinions about the evening's fare, made an impression on Mandelbaum, then a "pretty unworldly junior-high-school student." Gorey liked gossip, he recalls: "We talked about [the French model and actress] Capucine. She was a very beautiful actress who was rumored to have had a sex change, she was the mistress of William Holden, she was in *Song Without End, North to Alaska*. [He] enjoyed the possibility that she might have been a man."

Gorey and Everson struck up a friendship. They would remain friends until the '70s, when Gorey's attendance at screenings dropped off, presumably because of his growing freelance illustration workload. In the days before streaming services such as Netflix and premium cable, when the chance to see a rare or suppressed movie might come once in a lifetime (if ever), Everson's "incredible collection" was an Aladdin's cave for movie addicts. His Saturday night screenings gave Gorey a degree in film history, broadening and deepening his knowledge of pre–World War II cinema, specifically the silent era.

It's tempting to dismiss Gorey's comment that "movies made a terrible mistake when they started to talk" as his usual calculated outrageousness.[38] In this case, however, he was deadly serious. When an interviewer asked why silent films appealed to him, he replied, "It's what you had to leave out.... [O]ur imagination is engaged, whereas movies today get more in your face by the moment. What has killed movies is the special effects. See one screen filled with flames and you've seen all of them.... And if it's a special-effects movie, you've seen all the effects already in the trailer, so don't bother to go."[39]

Gorey's belief that the silents were superior to the talkies makes perfect sense in light of his aesthetic preference for the understated and the unstated, as in Asian art and literature, and his attraction to the highly stylized, as in Firbank and Balanchine. He abhorred Hollywood's increasing tendency to pander to the lowest common denominator for the same reason he lost patience with Henry James novels: the lunkheaded insistence on explaining things to death, which kills ambiguity and, with it, subtlety, leaving no room for imaginative participation by the audience. Film exerted a profound influence on Gorey's aesthetic. "I've been watching movies for close to seventy years," he told an interviewer in 1998. "My family took me to movies very early. I've always been an inveterate moviegoer. There was a period in New York where I would see a thousand movies a year."[40] If this strains credulity, bear in mind that Everson's screenings sometimes verged on endurance tests: "Movies used to be an hour long," Gorey recalled, "but we'd see twelve or fifteen movies and be bleary by the time it was all over."[41]

Consider, too, that Gorey, who detested Christmas—because it "really is a family holiday," he observed, revealingly—liked nothing better on December 25 than hanging around "with a lot of people who also didn't have any families or anything," seeing as many movies as they could cram in. "We used to go to four or five movies on Christmas Day. We'd have breakfast at Howard Johnson's, and then we'd go to a movie—and then we'd go back to the Howard Johnson's. Then we'd go to another movie, and go back to Howard Johnson's—'til about midnight."[42]

And then there were the tantalizing offerings of so-called revival houses—repertory cinemas such as the New Yorker, the Elgin, and the Thalia—which showed foreign films and Hollywood classics from the '30s and '40s, mostly. And the period, stretching over several years, when "the Museum of Modern Art started to go through its entire film collection on Saturday mornings," as Gorey recalled.[43] And the Buddhist temple on the Upper West Side that showed Japanese movies on weekends. (Gorey had a preternatural ability to pick up such off-the-radar blips.)

Little wonder, then, that his knowledge of the medium was prodigious. He could discourse with equal facility—and equal exuberance—on masterworks of early cinema such as Feuillade's 1918 serial *Tih Minh* and grind-house schlock like *Blood Fiend* (1967). (By his own admission, Gorey had an ungovernable "passion for horror movies," which, together with his "ability to sit through practically anything thrown on the silver screen," resulted in a cheery willingness to give the most overripe tripe a chance.)[44]

He seems to have seen *everything* and to have had a quotable opinion on even the most forgettable fare. But even he was barely able to make it through the 1968 Filipino horror movie *Brides of Blood*, though he did think the inclusion of "a band of Filipino dwarves whose presence was never commented upon" was a nice touch, adding, "It is things like this that keep one functioning sometimes. Me at least."[45] In a similar vein, he thought *The Mad Room* (1969), a horror movie starring Stella Stevens and Shelley Winters, was a disappointment, "mainly because

everyone has lost all sense of genre these days"; nonetheless, he rejoiced in the film's "delightful shots of a large, shaggy, and utterly lovable dog padding about with a severed hand in its mouth."[46]

With his artist's eye and oblique, surrealist angle on reality, Gorey brought a fresh perspective to thoroughly chewed-over fodder. Contrary to expectation, he "ended up quite enjoying" *Candy* (1968), a much-hyped psychedelic sex farce based on the novel by Terry Southern.[47] It was "a dreadful film," he allowed, but "its very ham-handedness and foolishness creates a sort of valid surrealist commentary, and it is marvelously cluttered with gewgaws and extravagances of décor that for some reason only the Italians are capable of anymore....I am beginning to think that most of the comment being made today *is* in the décor." He mentions, in several interviews, the "very Mondrian" palette ("dead white and then bright blue, bright red, bright yellow, and black") of *La Prisonnière* (1968), a twisted love triangle by the French director Henri-Georges Clouzot, known for his dark, often existentially bleak thrillers.

As a rule, though, Gorey was skeptical of much contemporary cinema, especially the overhyped and the winkingly hip. His true north was pre–World War II film, especially from the silent era. His book *The Hapless Child* was directly inspired by *L'Enfant de Paris*, a 1913 French silent directed by Léonce Perret, which he saw only once, at MOMA, but apparently never forgot. His unfilmed screenplay, *The Black Doll*, was "very much inspired by so many of the D. W. Griffiths that were made out in New Jersey,"* he said.[48]

Gorey being Gorey, he was never explicit about precisely *how* silent film influenced his work, beyond the fact that it played a large part in his decision to set his work in a Victorian-Edwardian '20s milieu. "I kind of think in a silent-film way," he said in a 1995 interview. "I think, looking back, I was seeing an awful lot of silent films and everything

*He's referring to the shorts Griffith directed for Biograph Studios in Fort Lee, the Hollywood of the pre–World War I years, where *The Perils of Pauline*, Theda Bara's "vamp" movies, and Mack Sennett's Keystone Kops comedies were filmed.

when I was starting out publicly, as it were. I think I tended to look at lots of film stills and so . . . I began to draw people that way, and pick up costumes and backgrounds . . ."[49]

We can detect the influence of silent movies in the anachronistic phrasing and ironic histrionics of his captions, which remind us of silent-movie intertitles, and in the existentialist blankness with which his characters confront the confounding and the calamitous, so reminiscent of the deader-than-deadpan Buster Keaton, who Gorey claimed was his "idol."[50] Keaton's face struck him "as having been the most fascinating of any actor's—that sort of deadpan is somehow far more mysterious and evocative than any amount of expressiveness," he thought.[51] (In yet another intriguing overlap with Beckett, the playwright was a great Keaton fan, too.[52]) In a sense, Gorey's fascination with deadpan is yet another reminder of his belief in the vital importance of leaving gaps for the viewer to fill in.*

The moody, gothic-surrealist crime serials of Louis Feuillade (1873–1925) epitomize that aesthetic of gaps—of loose ends and non sequiturs. Which is why he, of all silent filmmakers, and possibly all filmmakers, was unquestionably Gorey's favorite. Gorey once said that Feuillade was "the greatest influence on my work," period.[53] *Barrabas* (1920), Feuillade's silent thriller about the ruthless leader of a gang of brigands, was "the greatest movie ever made," he declared.[54] (Now might be the time to note that Gorey's reigning passion of the moment was *always* his favorite, regardless of the genre or medium. Still, there's no understating Feuillade's influence on his art.)

The director of more than seven hundred silents, most of them shorts or serials, Feuillade is best known for the multipart crime thrillers *Fan-*

**Deadpan* is a fittingly Goreyesque term. Like all dead metaphors, its literal meaning has been obscured over time by the figurative. Originally it referred to a corpselike expressionlessness (from *dead* plus *pan,* '20s slang for "face"). Deadpan humor, an essential component in black comedy, still retains a hint of its macabre etymological origins.

tômas (1913–14), *Les Vampires* (1915–16), and *Judex* (1916). Based on a wildly popular series of pulp novels, *Fantômas* chronicles the exploits of a Mephistophelean archfiend, a man of a thousand faces who walks among us disguised as a pillar of respectability—a banker, a judge, a bourgeois gentleman. The Houdini of villainy, Fantômas is an escape artist par excellence: grab him by the arms, as Inspector Juve and the journalist Jérôme Fandor do in *Juve contre Fantômas* (1913), and—what's this?! You're left holding the prosthetic arms attached to his Inverness cape as he bolts free, mockingly doffing his cap as he leaps into a cab. (Gorey, by the way, loved this scene, which struck the surrealist in him as "a wonderful dislocation of reality.")[55]

Like Batman's nemesis the Joker in *The Dark Knight* (2008), whose ravings about being an "agent of chaos" were directly inspired by Feuillade's archcriminal, Fantômas is only incidentally a burglar; what he's really up to is terrorizing the aristocracy, whose stuffy nineteenth-century morals and manners and sense of entitlement were stifling belle époque France. Likewise, the vampires in *Les Vampires* aren't undead bloodsuckers at all but rather members of a catsuited gang that seems to be half criminal conspiracy, half secret society. At heart, their bizarre crimes are acts of poetic terrorism against the social order.

In Feuillade's films, as in Gorey's work, Freud's concept of the repressed lurks behind the snobberies and starched proprieties of polite society. "The films are cozy, with domestic settings, and they have sinister underpinnings," said Gorey. "There's a German word which is the word for cozy but with the negative attached to it, so that it's cozy and sinister, settled and unsettling, cozy and uncozy."[56] The word he's looking for is *unheimlich*, Freud's term, introduced in his essay on the uncanny, for the sensation of "dread and creeping horror" that arises from the familiar rendered unfamiliar, the homey (*heimlich*) suddenly haunted. Unsurprisingly, the surrealists were devout fans of Feuillade's crime thrillers, which brought the horrors of the Grand Guignol into the sitting rooms and opera houses of the bourgeoisie and transformed the sunlit boulevards of Paris into uncanny backstreets of the unconscious. Gorey, who shared the surrealist poet Paul Éluard's belief that

"there is another world, but it is in this one," surely responded to that aspect of Feuillade's films.

He was captivated, too, by Feuillade's use of theatrical tableaux. Unlike his contemporary D. W. Griffith, who pioneered the use of cutting and camera movement in cinematic storytelling, Feuillade used a stationary camera, relying on his actors' movements to direct the eye. Using long takes and exploiting his sets' depth of field, he choreographed his actors' movements with the precision of a ballet master, a parallel surely not lost on Gorey.

Gorey rarely makes use of the cinematic tropes (the close-up, the low-angle shot, the aerial shot) whose influence is everywhere in comic books and graphic novels. Instead he places us in the position of a theatergoer looking at a proscenium stage, a point of view undoubtedly influenced by a lifetime of ballet going but no less the product of Feuillade's tableau-style filmmaking.

The French director Georges Franju, who remade *Judex* in 1964, was eloquent on the subject of the spell cast by Feuillade's tableaux: "He left on me the impress of a magic that was black, white, and silent.... In his shots where nothing happens, something can occur that profits from this nothing, this inaction, this void and silence, something that profits precisely from the waiting, from inquietude. This something is called mystery."[57] Looking at the wordless tableaux in Gorey's most gothic-surrealist works, such as *The West Wing*, *Les Passementeries Horribles*, *Les Urnes Utiles*, and *The Prune People*, we can see Feuillade's influence in their brooding inaction, their inexpressible mystery. Like the French filmmaker's, Gorey's was a magic that was black, white, and silent.

The gothic-surrealist atmosphere and imagery of Feuillade classics such as *Fantômas* and *Les Vampires* crept into Gorey's work. Irwin Terry, who writes the fan blog *Goreyana*, sees "instantly recognizable Gorey motifs" everywhere in Feuillade's silents—the "distinctive potted palms and pattern-on-pattern decor in the interior sets, a host of 1913 touring

cars, veiled mysterious women wrapped in dark clothing with only their heeled shoes peeking from the bottom of their wraps, men in top hats and frock coats. In short, many of the figures and places we have come to assume were [English] in Mr. Gorey's books are probably French."[58]

Sometimes Gorey's allusions to Feuillade are more oblique. Terry believes that the mysterious blank calling card hidden in plain sight in nearly every one of Gorey's books was inspired by the scene in the first installment of *Fantômas* in which "the disguised villain appears in the hotel room of a wealthy woman who asks, 'Who are you?' and is handed a blank calling card by the intruder."[59] Likewise, in *The Sopping Thursday*, a cat burglar scrambles along a rooftop clutching a purloined parasol. It's Gorey's nod to the scene in the *Vampires* episode "The Severed Head" in which one of the catsuited gang members skulks from roof to roof along the Paris skyline.

And then there's the prototype of Gorey's slinky, shifty-eyed vamps: Irma Vep, the mesmerizing killer queen of the Vampires, with her heavily shadowed, kohl-rimmed eyes and curve-hugging catsuit. (Her name is an anagram for "vampire.") Unforgettably played by the wild-eyed Musidora, Vep is a femme fatale with an anarchic spin—Theda Bara reimagined as a member of the Bonnot Gang, the band of anarchists whose bank robberies made them the tabloid antiheroes of belle époque France. The surrealists adored her.

Silent, mysterious, disquieting, dreamlike, Feuillade's silent black-and-white world had always been there, flickering in the movie palaces of the unconscious, waiting for Gorey to discover it.

CHAPTER 7

ÉPATER LE BOURGEOIS

1954–58

IN 1954, DUELL, SLOAN AND PEARCE published Gorey's second book, *The Listing Attic*, a collection of whimsically grim limericks that read like penny-dreadful items written by Edward Lear.

In a letter to the eminent literary critic Edmund Wilson (who had sent an appreciative but not entirely uncritical note to *The Listing Attic*'s author), Gorey apologizes for the "lack of ability" that "weakened" some of the limericks, especially the ones in French, his command of that language being "atrocious," he admitted, "except for reading purposes."[1] In his defense, he adds, the poems in *The Listing Attic* "were written rather in the manner that Housman says he wrote the *Shropshire Lad*—most of them all at once some five or six years ago, and then rewritten this year with a few new ones added. The drawings got dashed off in a month or so any old which way. A depressing thought."

The limericks written "five or six years ago" were the verses he was

172

fooling around with at Harvard. He'd fiddled with them during his time in Cambridge and, when Duell, Sloan and Pearce expressed interest in a follow-up to *The Unstrung Harp*, cherry-picked a suitable number, polishing them and adding new ones.

He adopted a looser, sketch-pad style for some of the *Listing Attic* illustrations that not only freed him up as an artist but that also seemed, with their roughed-out look, better suited to the book's grim, often grisly content. "I'm now working...on the drawings for my limericks," he wrote Alison Lurie in August of 1953. "Unfortunately, I can't seem to draw 'funny' drawings, and most of the ones I have done so far are not only morbid but serious."[2]

He's right: at their funniest (a relative term, in this context), the illustrations for *The Listing Attic* are black comedy; most of them could have done double duty as macabre engravings in a Victorian true-crime gazette. Gorey's drawings of a psychopath stabbing a woman with a rusty stiletto, an abusive husband knocking his wife's teeth out with a hammer, and a cocaine-addled young curate about to beat a small child to death leave little doubt that, if some of his books might have been profitably marketed to young readers, this was not one of them.

Of course the illustrations are only as dark as the subject matter, which at times crosses the line into outright nastiness. (Midway through his work on the book, in March of '54, he told Lurie that it was going to be "remarkably tasteless," noting that "an air of uneasy lunacy hangs over the whole thing.")[3] Wife beating, sex crimes, infanticide, random acts of senseless violence, parents who treat their offspring with the wanton cruelty of Dickensian villains: *The Listing Attic* is one dark little book. Gorey wasn't kidding when he said his mission in life was to make everybody as uneasy as possible. The incongruous pairing of shilling-shocker subject matter with the limerick, poetry's most frivolous form, only makes matters weirder. Crossing silliness with depravity, violence with dark humor, *The Listing Attic* is downright disturbing.

Reading *The Listing Attic*, we *do* get the impression Gorey's trying (perhaps a little too hard) to outrage. "I fear this is my *épater le bourgeois* work," he said in a letter to Peter Neumeyer.[4] Clifton Fadiman, a judge for the Book-of-the-Month Club and popularizer of Serious Literature, "once refused to quote from it in an article on limericks in *Holiday* because it was so horrid," Gorey claimed. Seen in its historical context—three years after *The Catcher in the Rye* gave voice to adolescent alienation, a year before Allen Ginsberg's "Howl" waved the flag for drugs, gay sex, and countercultural rebellion—*The Listing Attic* takes its quietly perverse place in a groundswell of intellectual discontent with the conformity of '50s America. (Gorey, of course, would've let out a theatrical groan at the suggestion that he was some sort of agent provocateur for the incipient counterculture.)

Even so, setting aside the obviousness of his nose tweaking and what Wilson, in his 1959 *New Yorker* essay, "The Albums of Edward Gorey," decried as the "awkwardness of meter and phrasing" of some of the poems, the book introduced themes and motifs that would recur in his work.[5]

Here, for the first time, we encounter the woman in peril and the hapless child, both silent-movie staples; the monstrous father figure; Gorey neuroses, such as "feeling somewhat unreal," and Gorey anxieties, such as finding parties "a terrible strain"; the association of the crepuscular with the uncanny; the fixation on luxuriant beards and mustaches, floor-length fur coats, and "white footgear intended for tennis"; the secret sorrows and "sense of unease" hidden in the darkness of the human heart; the psychopathologies of domestic life; and the alien ickiness of babies (a mother throws her infant at the ceiling "to be rid / Of a strange, overpowering feeling").

Gorey seems to find the whole idea of childbearing repugnant: Mrs. Keats-Shelley's children are born with monstrous deformities; a horrified father says of the newborn whose difficult birth has left his wife at death's door, "Can it be this is all? / How puny! How small!" (Alexander Theroux remembers Gorey telling him that there were only two reasons he'd walk out on a movie: "One. If an animal is being abused, shot, killed, or hurt in any way. Oh please! And two. Birth scenes! I

spent entire segments in the foyer during *Hawaii* with Julie Andrews heavy with pheasant and howling in hospital stirrups, and I wonder to this day why I did not continue all the way home.")[6]

Religion pops up in various forms, none of them promising, all of them good for a blasphemous laugh: a clerical student mortifies his flesh by wearing a hair shirt, eating dirt, and bathing in brine; a baby drowns in a baptismal font; a monk cries out, in the middle of mass, that the religious life is dreadful and obscene and stabs himself—revealingly?—in the buttocks. As we read the limerick in which the heartless Lord Stipple tells his puny, sad-eyed son, "Your mother's behaviour / Gave pain to Our Saviour, / And that's why He made you a cripple," it's a little hard to believe Gorey when he claims, "I'm not a 'lapsed Catholic' like so many people I know who apparently were influenced forever by it."

"There's a rather odd couple in Herts…" *The Listing Attic. (Duell, Sloan and Pearce/Little, Brown, 1954)*

Something strange is going on with gender in *The Listing Attic*: a naked lady, peering anxiously into a full-length mirror, fears that

she's "coming unsexed"; a "rather odd couple" of Edwardian gents in starched collars and bowler hats are of uncertain gender, since "they're never without / Their moustaches and long, trailing skirts." (They're cousins, we're told—the primary family tie in Gorey's world—but give the distinct impression of being a couple in the life-partner sense, which makes us wonder if *cousin* is a euphemism.) Gorey touches on the question of homosexuality more explicitly in his chilling depiction, discussed earlier, of a gang of Harvard men "burning a fairy."

Children are introduced, for the first time in Gorey's work, as emblems of vulnerability, which makes them perfect targets for willful cruelty and cosmic injustice. (Gorey—who, it should probably be noted, got on well with his friends' kids—always insisted that he used children for gothic-novel and silent-movie melodrama purposes because their vulnerability made them the perfect victims. "It's just so obvious," he told Stephen Schiff of the *New Yorker*. "They're the easiest targets.")[7] In Goreyland, little ones exist to be menaced or murdered outright, often in ingenious ways, as in the case of the infant whose nurse ties it to a kite out of spite and lets it float off into the wild blue yonder.

The Listing Attic marks other, less momentous firsts, too. The mysterious Black Doll, an armless, faceless cipher of a toy, calculated to give a child nightmares, makes its first appearance. There it is on the front cover, passing by a window in a row house whose curious flatness suggests a stage set. And there it is again, marching along a tall brick wall in the beautifully rendered surrealist snapshot that ends the book. It will put in cameos in *The Willowdale Handcar; or, The Return of the Black Doll*, *The West Wing*, and *The Tunnel Calamity*; appear on the cover of *The Raging Tide; or, The Black Doll's Imbroglio*; and make its final bow in Gorey's silent screenplay, *The Black Doll*.

The Listing Attic is the first of his books in which Gorey hand-letters the captions to his illustrations. The way he told it, he'd hand-lettered a few sample pages, and his publisher, like his bosses at Anchor, had gone gaga over his spidery, skittering type, sentencing him to hard labor for life. "They, the publishers, thought what a good idea hand-lettering

was, and since then I have never been able to stop," he kvetched in 1980. "I sometimes get *fearfully* bored lettering the damn things, especially since I really detest my hand-lettering."[8] Of course, Gorey was self-deprecating to a fault and, more to the point, a world-class self-dramatizer who loved to play the put-upon drudge.

His second book confirmed his near-total lack of what sales teams like to call commercial potential. "My first two books...didn't make any money, nor did [I] get paid much attention," he said in a 1977 interview. "Great piles of those books were remaindered on 42nd Street for nineteen cents several years later."[9] (As this is written, a New York antiquarian book dealer, Peter L. Stern & Company, lists a "very good plus" copy of *The Listing Attic*, first edition, dust jacket intact, for $375.)[10] In a letter to Alison Lurie, Gorey reported that *Attic* had sold only "a little over two thousand copies, which is sad," but noted that "it seems to have acquired a slight and dismal cachet with les boys."[11] If "les boys" was Gorey's Holly Golightly version of the slang term for gays (e.g., "the boys in the band"), it raises the intriguing question of whether gay readers were responding specifically to the gay influences in Gorey's work—its Wildean irony and Firbankian outrageousness. Were gays, ahead of the curve of popular taste in so many things, the first wave of Gorey fans?

Meanwhile, back in the everyday world, Gorey soldiered on at Doubleday, which in January of '54 was "particularly tedious and dull," he told Lurie. "I am in the frame of mind to have a real temper tantrum if I can find an excuse."[12] When he was not "struggling for Doubleday after hours," he was "whizzing from one ancient film to another."[13]

That February, he joined the American Society for Psychical Research, a New York–based organization founded in 1885, according to its literature, "by a distinguished group of scholars and scientists who shared the courage and vision to explore the uncharted realms of human consciousness," among them William James, the celebrated Harvard

psychologist and brother of Gorey's least favorite novelist, Henry.[14] In the first flush of his newfound enthusiasm, Gorey gobbled up "all the classic books on the subject in great gulps" and even recruited Lurie for an experiment in telepathy, the results of which were, as they inevitably seem to be, inconclusive.[15]

He later claimed, in a letter to Peter Neumeyer, to "have always, if desultorily and spasmodically, been interested in what is loosely [called] the occult."[16] That interest crescendoed in the late '60s, when the cultural atmosphere was thick with Eastern mysticism, New Age philosophy, pop astrology, and bestselling accounts of supernatural phenomena, whether fictional (Ira Levin's novel *Rosemary's Baby*, about devil worshippers in '60s New York) or purportedly real (Hans Holzer's paperback books on paranormal activity).

He believed in the occult and in parapsychological phenomena, he said, but only insofar as they're "indicative of the nature of things and the relations between them" as opposed to "the more specific kind of fortune-telling."[17] In other words, he "believed," in ironic quotes. For Gorey, the tarot, astrology, palmistry, and the *I Ching* were just so many ways of "by-passing the cause-and-effect, rational world in which we normally try to function." By translating reality as we know it into a symbolic language, systems of divination "show you things," he wrote Neumeyer, "which otherwise you might have much more trouble finding out." The ultimate goal, of course, was to internalize the logic of such systems, rendering them unnecessary. Thinking aloud on the page, he mused, Hadn't someone said that true mastery of the *I Ching* meant that it became "so much a part of you that your conscious mind would no longer need to consult it at all, and that then you would directly be apprehending the Tao and acting in accordance with it without any conscious thought"?

What Gorey is saying is that a *literal* belief in the predictive powers of the *I Ching*, the tarot, palmistry, and the like misses the point. Better to use them as boreholes down to the deeper reality underlying the world as we perceive it—what Taoists call *li*, the ever-changing, infinitely complex, ineffably meaningful order of nature.

His observation that the goal is to internalize the mind-set of the *I Ching*, an ancient method of divination closely associated with Taoism, so that you have direct access to the inexpressible, irresolvable mystery of things—*li,* by any other name—is a profoundly Taoist insight. But it's also surrealist to the core, if for *li* we substitute the surrealist concept of the Marvelous, the poetic mystery and uncanny beauty just beneath the surface of everyday life. Maintaining "an alert, elevated, other-worldly state of mind," the surrealist is always on the lookout for the Marvelous, according to the visual-culture critic Rick Poynor—that "moment when reality seems to open up and disclose its essence more fully."[18] In his brief but brilliant ruminations to Neumeyer, Gorey gives us as lucid an exposition of his philosophy as he ever gave, gracefully resolving his Taoism with his surrealism.

In March of '54, Gorey was reading Arthur Ransome, the English author whose *Swallows and Amazons* series of children's books are perennial favorites in the UK. Ransome, he told Lurie, was "second only to J. Austen in his ability to create a complete, small, realistic world. I begin to think that is what I most enjoy in books nowadays: little worlds. I suppose because I don't have one of my own, except in my work."[19]

Indeed, Gorey continued to be a person, like C. F. Earbrass, to whom things do not happen. In '55, he was invited, on the strength of his books, to a cocktail party swarming with admen, models, novelists, and other bright young things. But when the "young men who were pretending not to be interested in other young men began surreptitiously to get each other's phone numbers," Gorey ducked out. Just once, he confided to Lurie, he wished someone would consider him sufficiently attractive to want to put the moves on him, but no one ever did, or would, and he was "too bored" to make the first move.[20]

At Doubleday, he'd ascended from "merely having a job to embarking on a career," that of book designer—a change in job description

that left him hip deep in work but no richer for his troubles.[21] "Designing the insides of books is neither more nor less dull than designing their jackets, and so far it pays exactly the same," he groused.[22]

As always, his gloom was relieved by newfound passions, most notably his discovery, that fall, of *The Tale of Genji*, a classic of Japanese literature that Anchor had published in 1955. Written by Murasaki Shikibu, a lady-in-waiting in the imperial court of eleventh-century Japan, *Genji* is a tale of romantic love and court intrigue, full of musings on the impermanence of beauty and the short span of man's days. It's perfumed with the sweet sadness that clings to what the Japanese call *mono no aware*—the capacity to feel things deeply, especially the pathos of passing time, poignantly evoked by the ephemeral beauty of nature. For Gorey, the novel captured "subtleties of feeling about existence rarely dealt with in Western literature."[23] He was "enthralled," he told Lurie, by the Heian-era masterpiece, declaring it "*the* great novel of the world."[24]

It would go on to become his all-time-favorite work of fiction. By 1995, he'd reread the thousand-plus-page epic "six or seven times" yet was still "absolutely ga-ga" over it.[25] Something in Murasaki's evocations of the inexpressible mystery of being human spoke to Gorey in his deepest self. Japanese literature, he felt, "has a stronger sense of what life is like to the individual living it than any other literature I've ever read."[26] In a letter to Neumeyer, he quotes a line from Lady Murasaki's diary: "Yet the human heart is an invisible and dreadful being."[27]

In 1957, two books arrived on the cultural scene, one very obviously a children's book, the other a children's book at first glance, but on closer inspection maybe not. Both were about uninvited guests who insinuate themselves into bourgeois households then wreak havoc. Incarnations of the trickster—an archetype familiar from myth and folklore whose avatars include Brer Rabbit, Bugs Bunny, and Puck in *A Midsummer Night's Dream*—both invaders straddled the binaries of animal and

human, child and adult, wild and domesticated, malicious and mischievous. In that sense, they were boundary crossers in the best trickster tradition.

One was Dr. Seuss's Cat in the Hat, the top-hatted agent of chaos who blew away the idea that little learners should cut their teeth on stodgy, see-Spot-run-type stuff. The other was the ill-mannered animal "something between a penguin and a lizard" (as Gorey described it) that made its debut—seven months after the Cat—in *The Doubtful Guest*, published by Doubleday.[28] Both house-wrecking pranksters can be seen as advance scouts for the countercultural backlash against the '50s. (In retrospect, the Cat, with his candy-striped top hat and long-haired sidekicks, Thing One and Thing Two, looks like a cartoony premonition of the Grateful Dead guitarist Jerry Garcia in *his* red-and-white-striped top hat on the cover of the band's first record. And the Doubtful Guest, raising hell in his high-top sneakers and all-black getup—or pelt, or whatever it is—recalls beatnik bad boys such as Gregory Corso.)

But that's where the similarities between the two books end. The fast-talking, glad-handing Cat barges into what we assume is the suburban home of a pair of grammar-school kids—a brother and sister whose mother has left them alone, inexplicably, with the pet goldfish for a babysitter. Juggling the terrified fish in its bowl, balancing mom's cake on his stovepipe hat, the Cat unleashes playful mayhem. Seuss began as a cartoonist, and his style, as an illustrator, is cartoony—brash and boldly colorful. The text, constrained by his editor's requirement that he limit himself to a beginner's vocabulary, zips along in its repetitive, singsong way.

If *The Cat in the Hat* is a Looney Tunes short, *The Doubtful Guest* is one of Feuillade's gothic-surrealist silents. Gorey's hand-drawn nineteenth-century engravings are in a different universe altogether from Seuss's animated-cartoon aesthetic. The Cat's raucous world blares at us in bright reds and blues; the Doubtful Guest's is rendered in rich blacks and subtle shades of gray, its minute details and machinelike cross-hatching achieved with a hair-fine line. Seuss's tale careens along wildly, its lunatic pace conveyed by cartoon speed lines; Gorey tells his

181

story with frozen tableaux whose stillness showcases his gift for composition.

Through the Balanchinian (or, if you prefer, Feuilladian) arrangement of characters on his miniature stage, he creates satisfying visual rhythms. Likewise, his contrapuntal use of white space, solid black shapes, and fine-lined shading produces beautifully balanced compositions that make us want to linger on each scene, exploring every nook and cranny. At times, he lights his scene as if it were a movie set or a stage, dramatically spotlighting the central figure amid the surrounding shadows, as in the panel where the Doubtful Guest stands firmly planted, nose to the wall like a naughty child, while the family shuffles off to bed.

Gorey's decision to isolate his couplets on an otherwise blank page, facing his illustrations, allows us to savor his drawings, free from the distractions of language, while at the same time permitting us to appreciate the wittiness of his verse for its own sake. Taking note of his division of text and image, we realize just how much Gorey's books differ from such seemingly related genres as the comic book and the graphic novel, in which the text is appended to the illustrated panel as a caption or, more often, incorporated into it in the form of speech bubbles and thought balloons.

Gorey's writing is a world away from Seuss's, too, though both texts are written in rhyme, employing related meters. (Seuss uses anapestic dimeter for the most part, Gorey anapestic tetrameter, instantly familiar from Clement Clarke Moore's "A Visit from St. Nicholas.")* The tone

*Gorey's use of a meter that makes visions of sugarplums dance in most readers' heads makes us wonder if *The Doubtful Guest* is a parody of Moore's moldy chestnut. Both tales are set on winter nights in snowbound houses; both involve home invasions by bizarre beings, each "dressed all in fur, from his head to his foot." In both books, it's the man of the house who's most alarmed by the intruder. And both trespassers have a thing for chimneys: Saint Nick disappears up one at the end of Moore's poem; the Doubtful Guest betrays "a great liking for peering up flues."

It makes sense that Gorey, a confirmed Christmas loather, would satirize Moore's yuletide classic. Yet when Faith Elliott, a young fan interviewing him in his apartment on November 30, 1976, asked, "I might be wrong about this, but since *The Doubtful Guest* is done in the same meter as 'A Visit from Saint Nick,' is there any correlation?" he was quick to dismiss the idea. "Not that I know of," he said. "I didn't even know that it was." Still,

of Gorey's text is wittier and darker than Seuss's, deadpan rather than hyperkinetic. (Gorey, who generally avoided sniping at other picture-book authors, once decried the "endless numbers of children's books which are stuck together with the first rhyme that comes into some-body's head for an animal's name or something. Well, I don't wish to denigrate Dr. Seuss, but I mean, you know, 'the cat in the hat.'")[29]

The Doubtful Guest opens on one of Gorey's gaslit family scenes, dom-inated by that stock Gorey character, the bearded paterfamilias in his smoking jacket. The lord of all he surveys, he's a monument to the Edwardian-Victorian patriarchy. But his authority is about to be chal-lenged. It's the proverbial dark and stormy night. The doorbell rings, but "when they answered the bell on that wild winter night, / There was no one expected—and no one in sight." Craning their necks around the terrace of their elegant manor, they spy a puzzling creature perched on one of those large stone urns that proliferate in Goreyland. It—we never do learn its gender—resembles the offspring of a penguin and a raven, though its beady, bulging eyes recall Mr. Earbrass's perpetually anxious look. Without warning, it runs into the house and assumes the position of a disobedient child sentenced to stand "nose to the wall"; there it re-mains, deaf to everyone's screaming, until the defeated family shuffles off to bed. In the days that follow, it makes itself at home, turning the deco-rous domesticity of its hosts' family life upside down.

In its "fits of bewildering wrath," infantile orality (at breakfast, it eats "all the syrup and toast, and a part of a plate"), insatiable curiosity, and poltergeistlike destructiveness—it wrenches the horn off the new gramophone, tears apart books, puts roomfuls of pictures askew on their hooks—the Doubtful Guest embodies the bestial nature of babies, at least to a lifelong bachelor who never changed a diaper and who seemed to find the idea of childbearing distasteful and infants decidedly repugnant.

Gorey's decision to dedicate *The Doubtful Guest* to Alison Lurie (then

the parallels, even if unconscious, are provocative. (Elliott hoped to publish her interview, but never found a home for it. All quotes from her conversation with Gorey are taken from the original cassette tape.)

Alison Bishop), who was the mother of a toddler at the time, lends credence to the idea that the anthropomorphized creature of the title was Gorey's caricature of infancy, a reading Lurie subscribes to. "[*The Doubtful Guest*]...was inspired, more or less, by a remark I made to Ted when my first son was less than two years old," she said in 2008. "I said that having a young child around all the time was like having a houseguest who never said anything and never left. This, of course, is what happens in the story."[30] She expanded on this anecdote in an essay for the *New York Review of Books*. "I have sometimes thought that... *The Doubtful Guest*...was partly a comment on my inexplicable (to him) decision to reproduce," she wrote. "The title character in this book is smaller than anyone in the family it appears among. It has a peculiar appearance at first and does not understand language. As time passes it becomes greedy and destructive: it tears pages out of books, has temper tantrums, and walks in its sleep. Yet nobody even tries to get rid of the creature; their attitude toward it remains one of resigned acceptance. Who is this Doubtful Guest? The last page of the story makes everything clear:

"It came seventeen years ago—and to this day It has shown no intention of going away.

"Of course, after about seventeen years, most children leave home."[31]

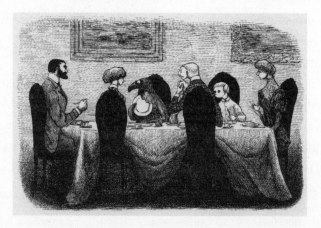

"It joined them at breakfast and presently ate / All the syrup and toast, and a part of a plate." *The Doubtful Guest. (Doubleday, 1957)*

184

Looked at from a biographical angle, the Doubtful Guest, in its "white canvas shoes" and Harvard scarf, is unquestionably an alter ego, a poetic evocation of Gorey as a little boy. Like Ted, it's a species of one—an only child. It's surrounded by screaming adults, as Skee Morton thinks her cousin often was in his early years. Also like Gorey, it's a born oddball, incapable of passing as a stuffy, dull-minded member of polite society, here represented by its adoptive family. (Doesn't every bright, alienated weirdo wonder if he's really adopted?)

The Cat in the Hat changed children's books as America knew them. An instant bestseller, it ushered in a more irreverent view of childhood and the beginnings of an antiauthoritarian streak in kids' culture. Most important, it killed off those insipid, boring goody-goodys Dick and Jane and injected the *bang-zoom!* anarchy of the animated cartoon into picture books. (Bart Simpson is a direct descendant of the Cat in the Hat.) Dr. Seuss joined Dr. Spock as one of mass culture's most profound influences on the childhoods of Baby Boomers. *The Doubtful Guest*, by contrast, sank with barely a trace, selling few copies and garnering even fewer reviews, mostly from "provincial sources," all of them "stressing how peculiar it is," Gorey lamented.[32]

What would Boomer childhoods, and Boomer ideas about childhood, look like if Gorey's wry, disquieting book about the oddness of babies—published in the peak year of the Baby Boom—had taken its place alongside Seuss and Sendak on America's shelves? That might have happened if Duell, Sloan and Pearce's marketing department had been less timid and more tuned in to educators' calls for beginner books that didn't taste like pablum. Sendak bemoaned publishers' reluctance to market Gorey as a children's author. "It was a received idea of children that had nothing to do with kids," he told an interviewer. More's the pity, he thought, because "Ted Gorey is perfect for children."[33]

"When I first started out, I wasn't trying to write for children because I didn't know any children," said Gorey in 1977. "Then again, I mean 'knowing' in the fashion of people who talk to the kiddies all the time. This simply would not work for me. However, I have thought that

more of my work might have been for children than anybody would ever publish on a juvenile list. *The Doubtful Guest* was for children, by my estimation. I used to try to persuade a publisher by saying, 'Why don't you bring this out as a children's book? I have an adult audience which will buy the book anyway. You might as well pick up some children along the line.' But they would not risk it, they'd get all twittery. So I gave up."[34]

"A free verse poem conscientiously about nothing at all, very despairing emotionally," is how Gorey described *The Object-Lesson* in a letter to Lurie.[35] Published in 1958 by Doubleday—and dedicated to Jason and Barbara Epstein—it was Gorey's first full-fledged venture into surrealism. Edmund Wilson was quick to note Gorey's debt to the movement in his *New Yorker* essay "The Albums of Edward Gorey." "Here you have another [Gorey] family, but their adventures are entirely Surrealist and remind one a little of such books of Max Ernst's as *La Femme 100 Têtes*," he wrote. "The 'story line' is always shifting; the situations are never explained."[36]

A string of more or less unrelated phrases that nonetheless flow seamlessly, *The Object-Lesson* follows the associative logic of a dream rather than the cause-and-effect plotting of a conventional narrative. "It was already Thursday," the story begins, "but his lordship's artificial limb could not be found." We see him on one leg, hopping mad, holding a limp trouser leg upright. Once again, the authority of one of Gorey's bearded patriarchs is under assault, this time in a manner whose Freudian symbolism is so obvious it verges on camp. (Castration complex, anyone?) Directing the servants to fill the baths, his lordship seizes a pair of fireplace tongs and sets off—in his pajamas, swaddled in the obligatory fur coat and Harvard scarf—for the edge of the lake.

At the lake, his lordship presents the Throbblefoot Spectre with a length of string; the forlorn wraith promptly fashions it into a cat's

cradle, to amuse itself.* Seating himself beside the statue of Corrupted Endeavour, his lordship awaits the arrival of autumn, that most Goreyesque time of year, with its melancholy nostalgia and its intimations of mortality. Things proceed from there with an illogic that somehow feels perfectly logical, thanks to Gorey's clever use of stock images evocative of Sherlock Holmes mysteries and Victorian ghost stories—the mysterious theft of the prosthetic leg, the unexplained lady in mourning costume, the disconsolate ghost, the villain disguised by a false mustache. As the book winds down, an ineffable sadness settles over its little world: "On the shore a bat, or possibly an umbrella, disengaged itself from the shrubbery, causing those nearby to recollect the miseries of childhood."

This sentence is not only one of the most beautifully wrought lines of gothic-surrealist poetry Gorey ever wrote, it is also one of the most densely allusive. His linkage of the twilight flight of a bat, or a forlorn umbrella, with recollections of childhood crosses Proustian reverie with gothic (the bat) and surrealist (Magritte's umbrellas) symbolism. The confusion between bat and umbrella recalls surrealism's combination of incongruous elements (quintessentially, "the chance meeting, on a dissecting table, of a sewing machine and an umbrella" in Lautréamont's novel, *Les Chants de Maldoror*) to create a new, dreamlike synthesis that destabilizes everyday reality, if only for a moment. The irresolvability of whether the dark, flapping thing in *The Object-Lesson* is bat or umbrella has the effect of making us view it as an uncanny conjunction of both.

The Object-Lesson is only thirty pages long, and its text totals just 224 words, but its depth of feeling, and its ability to provoke reveries, make it feel like a philosophical novel in miniature. The lesson hidden in plain sight, in this bit of gothic-surrealist-absurdist nonsense, is that "the cause-and-effect, rational world in which we normally try to function," as Gorey called it, is only part of the story. "I'm not a firm believer

*String was an enduring Gorey obsession. "Do you think it is too late for me to devote my life to something to do with String?" he wondered in a 1968 letter to Peter Neumeyer. (See *Floating Worlds*, 91.) The capitalization is his—an indication, perhaps, of the gravity of the subject.

in cause and effect," he told an interviewer.[37] Life, in Goreyland, is a random walk, full of mystery and melancholy, punctuated by the unpredictable and the inexplicable. Our earliest memories begin in the middle of things ("It was already Thursday..."); the slow fade to black, at the end of our lives, is similarly Shrouded in Mystery, "the tea-urn empty save for a card on which was written the single word: Farewell." Asking what it all means misses the point: namely, its pointlessness. That, perhaps, is the object lesson *The Object-Lesson* teaches.

The relationship between cause and effect hasn't been abolished in the world of *The Object-Lesson*; it's been rendered absurd. Gorey's use of conventional narrative structure, in which events proceed in chronological order, implies causality—*logical* causality. In fact, Gorey's story is an object lesson in what philosophers call the *post hoc, ergo propter hoc* error, a type of logical fallacy that results from the erroneous assumption that because one event follows another, it must be the result of the event that preceded it. (The Latin phrase means "after this, therefore because of this.") Of course, *The Object-Lesson's* surrealist-absurdist view of the world is a more psychologically accurate reflection of the way we experience our lives than the logician's "cause-and-effect, rational world."

The Object-Lesson was Gorey's attempt to write "a novel about nothing," he said. "I have always been sort of fascinated by that; you know, Flaubert's idea of writing a novel about nothing.... [T]hat's one of those tag lines that has always stuck in my head."[38]

His immediate inspiration, however, was Samuel Foote's prose poem "The Grand Panjandrum," a delightful bit of nonsense that gave us the titular phrase. Foote (1720–77) was an English comic actor known for his wicked satires of British society. When the actor Charles Macklin boasted that he could memorize any text upon a single hearing, Foote rose to the challenge by improvising, on the spot, a nonsense monologue calculated to strain the faculties of the most accomplished mnemonist: "So she went into the garden to cut a cabbage-leaf to make an apple-pie; and at the same time a great she-bear, coming down the street, pops its head into the shop—What! No soap? So he died; and

she very imprudently married the Barber: and there were present the Picninnies, and the Joblillies, and the Garyulies, and the great Panjan-drum himself, with the little round button at top; and they all fell to playing the game of catch-as-catch-can, till the gunpowder ran out at the heels of their boots."[39]

Of his books, *The Object-Lesson* was one of Gorey's favorites, he said, precisely because it didn't make any sense, and "those kinds of things are harder to do than almost anything else."[40] Following the lead of lit-erary experimentalists such as Georges Perec, the Oulipo[*] writer who set himself the task of writing a novel without using the letter *e*, Gorey often used formal constraints—the limerick form, nonsense verse, the abecedarian poem, the wordless narrative—as a conceptual goad to spur himself into unexplored creative territory. He seemed to thrive under such self-imposed restrictions.

Of course, it's his flawless marriage of text and image that makes *The Object-Lesson* such a feast for the imagination. Gorey counterpoints the playful perversity of surrealist word games and the cartwheeling nuttiness of Victorian nonsense with a melancholy atmosphere, "very despairing emotionally" in its oncoming autumn, descending twilight, letters destroyed unread, and cryptic messages on calling cards. Here and there, we catch glimpses of the shadows circling in the deeper waters of Gorey's subconscious: the father figure, loveless and unlovable; "the miseries of childhood"; his grandmother packed off to the Illinois East-ern Hospital for the Insane in Kankakee, Illinois ("At twilight, however, no message had come from the asylum").

[*]Sometimes spelled OuLiPo, Oulipo is an acronym for Ouvroir de Littérature Potentielle (Workshop for Potential Literature), an avant-garde literary collective founded in France in 1960 by Raymond Queneau and François Le Lionnais, a mathematician, tellingly. Tellingly because the Oulipo writers use rule-based generative devices such as "n + 7," which stipulates that the author must replace every noun in his or her text with the noun that follows it, seven entries later, in the dictionary. It's literature as word game, an approach heavily influenced by the linguist Ferdinand de Saussure. Oulipians, in Queneau's unfor-gettable formulation, are "rats who build the labyrinth from which they will try to escape." (See Mónica de la Torre, "Into the Maze: OULIPO," Poets.org, https://www.poets.org /poetsorg/text/maze-oulipo.) Texts generated through the use of Oulipo techniques have something of the quality of surrealist literature or, more accurately, of a surrealist literature written by mathematicians, one that eschews the subconscious altogether.

The illustrations, which are among Gorey's finest, enhance the autumnal mood, especially the indescribably beautiful drawing of the bat, or battered umbrella, swooping over the leafless trees. Gorey's loving attention to the intricate, fractal branchings of each twig, and their plaintive grasping after the airborne thing beyond their reach, betrays his close study of Japanese wood-block prints, in which nature has an animistic part to play. Then, too, they suggest a fondness for the uncanny, clawing forests of English illustrators such as Arthur Rackham.

A bat, or possibly an umbrella, disengages itself from the shrubbery in *The Object-Lesson. (Doubleday, 1958)*

"These seem to me the very best drawings that Gorey so far has done; he is really becoming a master," enthused Wilson, marveling at Gorey's mastery of composition, both at the level of individual panels and in the arc of the book. The "anxious-faced" woman in the opening scene, "lightly balanced at the right by a potted plant" and "thrown into rigid and sharp relief by a long expanse of curly-patterned wallpaper," is bookended on the book's last page, he points out, by the "three silent figures" facing "a long expanse of darkening sky, a background like the wallpaper in the first of the pictures, balanced by a remote little moon, which, in its place in the composition, has the value of the potted plant."[41]

Gorey's emotional life had, since his ill-fated crush on Ed from Buffalo in 1953, been "nil," as he liked to say. Then, in January of '58, at the age of thirty-two, he found himself confronting the worrisome possibility that he was "about to become Emotionally Entangled," as he told Lurie, with a "middle-aged Mexican of extremely bizarre appearance and character."[42] From the outset, he was buffeted by doubts about the object of his latest crush, who was as unlike him as unlike could be. Of course, discomfort was Gorey's comfort zone. At least, that's the impression he liked to give in his letters and interviews, where he often played the role of angsty, ennui-ridden neurotic (though with such be-still-my-heart histrionics—the full-body sighs, the woebegone declamations—that he let his irony show, revealing the whole thing for the pose it was). It's hard to make out, through the overgrowth of Gorey's Edwardian-Victorian verbiage and campy style, just how deep his feelings for the Mexican—whose name, by the way, was Victor—ran, but he seems to have been in the throes of one of his periodic infatuations, if not in love.

As was inevitably the case with Gorey's love life, things were fraught. It soon emerged that Victor, having been unlucky in love, was skittish about sex, which he seemed to regard as a recipe for romantic self-destruction. As a result, Gorey confided to Lurie in a letter that is startling in its candor, Victor issued a strict prohibition on hanky-panky, which Ted found odd, since it was Victor who'd initiated "the moderate erotic goings-on" during their first "encounter," at Victor's apartment.[43]

However moderate they were, the erotic goings-on suggest that Gorey, behind his public pose as a thirty-two-year-old virgin with a Victorian aversion to sex, wasn't entirely asexual.

Sadly, this, like Gorey's other abortive romances, was not to be. Victor, despite his "muscularity," boyish charm, and beguiling way of wearing heavy sweaters, was too busy to see Gorey with any frequency, dividing his time between illustrating fashion ads for Bonwit Teller and serving as arm candy for rich women. Then, too, he had a hair-raising

habit of making "rather creepy little remarks delivered in bubbly tones," such as, "Would you kill the cats if I asked you to?"[44]

In a letter dated April 1, Gorey tells Lurie that he's relegating Victor, like all his predecessors, to the dustbin of history. "Sinister Victor never turned up again after I last wrote you," he writes, "which is obviously Just as Well." You can almost hear the sigh.[45]

CHAPTER 8

"WORKING PERVERSELY TO PLEASE HIMSELF"

1959–63

UNEXPECTED TURBULENCE HIT Gorey's work life, too. In the fall of '58, Jason Epstein left Doubleday. There had been considerable backroom intrigue leading up to his departure; where book publishing's golden boy would end up next was "rather a secret of sorts," Gorey told Lurie, though he was confident Epstein would offer him a job "whenever the new whatever it is gets set up."[1]

By 1959, Epstein was ensconced at Random House, and his new sideline—a "children's book thing" called the Looking Glass Library—was up and running, with Gorey on staff, after a fashion. He still had one foot in the art department at Doubleday and was juggling his nine-to-five workload while doing illustrations for Epstein's fledgling company, all of which left him "in a state of total frazzle."[2] He hoped to jump ship to Looking Glass, he told Lurie, because it "would mean more money and prestige and time to work on my own things."[3]

On February 1, 1960, just shy of his thirty-fifth birthday, Gorey moved to Epstein's new venture after seven years at Doubleday. Founded by Epstein and Clelia Carroll, who had been Epstein's assistant at Anchor, the Looking Glass Library was a line of classic children's books in hardcover. "Modern educational theory has underestimated the old children's books, and the trend has been to have books no more complicated than the experience of the children who read them," Epstein told *Newsweek* in a clear jab at Seuss's use of vocabulary lists approved by early-learning experts. "We want to get away from categorization, and treat children as human beings."[4] (No mention was made of the happy coincidence that old children's books, especially the Victorian titles Epstein and Carroll had in mind, are often in the public domain, which lowers a publisher's overhead substantially. Dead Victorians tend not to demand royalties.) "The idea was that it was going to do for children's books what Anchor had done for the parents," Gorey recalled. "The books were not paperbacks, but rather paper over boards....It was really a neat batch of sometimes quite forgotten 19th-century stories. We tended to pick up stuff from England."[5]

Looking Glass, with its skeleton crew of four (secretary included) and its unconventional offices—away from "the garrets of Random House," as Gorey put it, in a "rather posh" apartment with a terrace on 69th Street, across from Hunter College—was congenial to Gorey's eccentricities in a way that the more buttoned-down Doubleday had never been. Epstein, who was up to his eyebrows in Random House affairs while worrying "frantically about [Looking Glass's] sales and whatnot," didn't meddle in the imprint's day-to-day operations, which suited Gorey just fine.[6]

His job title was art director, but he was happy to lend an editorial hand when a book played to his strengths: *The Haunted Looking Glass* (1959), an anthology of spooky stories, is both illustrated and edited by Gorey, with the predictable result that its table of contents is heavily weighted toward nineteenth-century English writers such as Algernon Blackwood, M. R. James, and Wilkie Collins.

Of course the design of the Looking Glass line, like Gorey's work for Anchor, was eye-catchingly fresh. Putting the traditionally unexploited real estate of the books' spines to shrewd use, Gorey designed titles to look "chic," as he put it, in a row on a shelf.[7] Volumes 1 through 10 were available as a boxed set; his distinctive hand-drawn typography, done in a wide variety of typefaces and colors, adorns all ten spines. The visual rhythms of the quirky lettering and disparate yet harmonious color schemes tickle the eye. Side by side, the books assume a collective identity—catnip to the collector, as Gorey, a case study in bibliomania, knew all too well.

He art-directed the twenty-eight titles published by Looking Glass between 1959 and 1961, when the imprint closed up shop.

Not all of Gorey's designs hit the mark. In a real-life plot twist that's stranger than fiction, he designed an Epstein and Carroll title destined to become a classic of Baby-Boom kid lit: *The Phantom Tollbooth* by Norton Juster, illustrated by Jules Feiffer. At least, he tried to. When Juster saw Gorey's page layouts, "the placement of the illustrations in relation to the text struck [him] as needlessly complex and fussy," writes Leonard S. Marcus, in his introduction to *The Annotated Phantom Tollbooth*.[8] Juster scrapped Gorey's work and redesigned the book himself.

The War of the Worlds. (Epstein and Carroll/Looking Glass, 1960)

On top of his design duties, Gorey did the cover art, and in some cases the illustrations, for *The Comic Looking Glass* (1961), *The Looking Glass Book of Stories* (1960), *The War of the Worlds* (1960), *Men and Gods* (1959), and *The Haunted Looking Glass*, mentioned earlier. Some of his illustrations, such as those for *Men and Gods*, a collection of Greek myths, have the perfunctory feel of work dashed off under deadline pressure. By contrast, his interior art for H. G. Wells's *The War of the Worlds* is superlative. The cover, too, is a stunner, its impact maximized by the clever strategy of wrapping the illustration around the front, back, and spine of the book. A nightmare panorama unfolds: lashing the air with their whiplike antennae, Martian war machines stalk flee-ing humans across the hills, zapping them to ashes with their death rays. Gorey's lurid palette of purple, orange, and grass green gives the scene a nightmarish unreality.

Compared to Doubleday, the production schedule at Looking Glass was considerably less demanding, which gave Gorey the time he dreamed of—time to crosshatch away at his own books, time to take on some of the growing number of requests for freelance work he was getting.

Gorey's freelance boomlet was partly the result of Edmund Wilson's groundbreaking essay on his work, which had appeared in the Decem-ber 26, 1959, issue of the *New Yorker*. Wilson was unquestionably *the* preeminent critic of his day, a lion of letters whose pronouncements were taken as holy writ by the cultural elite. In "The Albums of Edward Gorey," he let *New Yorker* readers in on the Gorey secret. "I find that I cannot remember to have seen a single printed word about the books of Edward Gorey," he began, "but it is not, I suppose, surprising that his work should have received no attention."[9] Admittedly, Gorey's body of work was slim, but Wilson attributed his obscurity to the fact that "he has been working perversely to please himself and has created a whole personal world, amusing and somber, nostalgic and claustrophobic, at the same time poetic and poisoned."

Wilson's essay is full of such insights. He notes the supreme impor-tance of "costume and furnishings" in Gorey's world, which is "some-

times late Victorian," "sometimes of the early nineteen-hundreds," and "sometimes, though more rarely, of the twenties"; he is quick to notice that the bearded patriarch, "evidently domineering, probably a little cruel," is "the most impressive figure in Mr. Gorey's world"; and he is thoughtful on the point of Gorey's relationship to surrealism and to contemporary English illustrators such as Ronald Searle.[10] With an almighty whack, he drives straight down the fairway, establishing some of the major themes of Gorey criticism. Yet he ends on an affectingly personal note: "These albums give me something of the same sort of pleasure that I get from Aubrey Beardsley and Max Beerbohm, and I find that I like to return to them."[11]

Wilson had remarked on the "morbid Edwardian household" of *The Doubtful Guest* and, more generally, on the "macabre or Surrealist character" of Gorey's work.[12] But in 1960, Gorey pulled a switcheroo: *The Bug Book* was as colorful and cute—there's no other word for it—as the book immediately preceding it, *The Object-Lesson*, was somber and brooding. (Like the Doubtful Guest, Gorey was himself a boundary crosser, jumping from one side of a philosophical dualism to the other just when we thought we'd got him pegged.)

The Bug Book had originally been published in December of '59 in a privately printed edition of six hundred copies under the Looking Glass colophon. A glorified Christmas card, it was an attention-getting way of introducing the newly launched imprint to everyone in the book business. In March of 1960, Jason and Clelia reprinted it for the general market under their Epstein and Carroll imprint, another Random House venture.

The Bug Book was the first Gorey story to be printed in color and the first Gorey title that was unequivocally a kid's book. Printed in perky primary colors and drawn in a generically childlike stick-figure style, *The Bug Book* tells the story of two blue antlike bugs who live in an upended teacup with a chunk missing from the rim, leaving a

notch that's convenient for ingress and egress. "They were frivolous, and often danced on the roof," hand in hand. (Are they a couple? They seem to be, and their matching coloring—both are baby blue—invites us to read them as a same-sex couple.) They live in a close-knit community—a rare thing in a Gorey story—with three red bugs and two yellow ones. This being Goreyland, they're all cousins, naturally. "All the bugs were on the friendliest possible terms and constantly went to call on each other. . . . And had delightful parties."

A pall falls over things when the neighborhood bully crashes the party—a big black bug ("who was related to nobody") with the menacing headgear of a stag beetle and an attitude problem to match. Gorey uses his gift for understatement to hilarious effect: "The other bugs were dubious, but nevertheless made an attempt to be friendly," notes the caption beneath a drawing of one of the yellow bugs attempting to shake the interloper's claw. Cut to: the unfortunate peacemaker hurtling through the air, knocked ass over teakettle by the big bug. "It was not a success," the narration informs, with perfect deadpan. Distraught, the little bugs conspire to rid themselves of the pestilence by dropping a big black stone onto the big black bug, with satisfyingly splattery results. The terror vanquished, they slip his remains into an envelope, address it "To whom it may concern," and leave it "propped against the fatal stone to be mailed," after which they throw a celebratory party, "complete with cake crumbs and raspberry punch." *The Bug Book* is the only Gorey title with an unambiguously happy ending. Good triumphs over evil, and everyone lives happily ever after.

Of course, since it's a Gorey book, we can't entirely suppress the feeling that there's something tongue-in-cheek about this uplifting tale for tots. Gorey's faux-naïf style puts an ironic spin on things, underscoring our sense that his "tiny work for children," as he called it, is simultaneously a parody of tiny works for children. At once sincere and ironic, it can be appreciated on either level—or both. In that light, *The Bug Book* can be seen as paving the way for post–Baby Boom kiddie entertainments such as *The Ren and Stimpy Show* and *The Simpsons*, which use irony and double entendre to appeal to parents, too.

As for *The Bug Book*'s commercial prospects, the subject filled him "with profound apathy," he told Alison Lurie that March, on the eve of the book's publication.[13] Adopting his half joking doomsayer mode, he predicted it, like his previous efforts, would vanish into oblivion, adding wryly, "As you can see, success in the form of Edmund's article hasn't spoiled me." Come September, he sent Lurie the cheering news that a pest-control company was interested in copies of *The Bug Book* as a gift for its clients. "Success is right around the corner," he deadpanned.[14]

Nevertheless, he plugged away at his books in progress and his freelance assignments. In his March letter, he told Lurie that he'd finished another book, called *The Hapless Child*, which Epstein had promised to publish that fall, and that he was "about two-thirds of the way through...an alphabet about the dreadful deaths of twenty-six tiny children." It would appear in '63 as *The Gashlycrumb Tinies*.

Nineteen-sixty also saw the publication of *The Fatal Lozenge*, by the New York publisher Ivan Obolensky. (This was Gorey's fourth publisher. "I never changed publishers; they always changed me, as it were," he protested in a 1977 interview. "They all thought they were going to make more of a splash with whatever particular book they were doing at the time. And then they'd do, like, one or two, and the splash didn't arrive. So they would say reluctantly, 'Well—'")[15]

Subtitled *An Alphabet*, *The Fatal Lozenge* was Gorey's first foray into the genre. He would go on to perform variations on the abecedarium theme in five books,* one of which, *The Gashlycrumb Tinies*, would become his best-known title.

The alphabet book is one of the oldest forms of children's literature. Rhyming couplets, illustrated by woodcuts, aided memorization. Early examples wedded ABCs and Calvinist catechism. *The New England*

*They are, in chronological order, *The Fatal Lozenge*, *The Gashlycrumb Tinies*, *The Utter Zoo*, *The Chinese Obelisks*, and *The Eclectic Abecedarium*.

Primer, ubiquitous in late-seventeenth-century America, is typical of the genre:

A In Adam's Fall
We sinnèd all.
B Heaven to find;
The Bible Mind.
C Christ crucify'd
For sinners dy'd.
D The Deluge drown'd
The Earth around.[16]

Gorey's interest in the alphabet book was undoubtedly a by-product of his interest in Lear, well known for loopy abecedaria like "Nonsense Alphabet" (1845) ("P was a pig, / Who was not very big; / But his tail was too curly, / And that made him surly").[17] His library reveals a longstanding fascination with the form, with a predictable focus on the nineteenth century. On his bookshelves, we find *A Moral Alphabet* (1899) by Hilaire Belloc, *A Comic Alphabet* (1836) by George Cruikshank, a Dover facsimile of *The Adventures of A, Apple Pie, Who Was Cut to Pieces and Eaten by Twenty Six Young Ladies and Gentlemen with Whom All Little People Ought to Be Acquainted* (circa 1835), and of course Lear in abundance.

At the same time, he couldn't have been oblivious, as an illustrator working in commercial book publishing, to the waves Dr. Seuss was making in kid lit. Alphabet books were playing an important part in reshaping American ideas about childhood. Consider Seuss's *On Beyond Zebra!* (1955), whose boy narrator dreams up a new alphabet for kids who think outside the Little Golden box ("In the places I go there are things that I see / That I *never* could spell if I stopped with the Z"). Or Sendak's *Alligators All Around* (1962), in which "shockingly spoiled" reptilian protagonists throw tantrums and juggle jelly beans with abandon. These and other unconventional abecedaria celebrate *Romper Room* radicals who flout the rules. Seen in their cultural and historical context, they look like premonitions of the hippie era, with

its worship of nonconformity and its elevation of the child to a cultural icon, not to mention its stoner humor and acid-soaked song lyrics.

Though he seemed barely to notice the counterculture of the '60s, beyond the Beatles, Gorey was in his own quietly perverse way more iconoclastic than Seuss or Sendak. In *The Fatal Lozenge*, as in *The Listing Attic*, his combination of a children's genre (in this case, the ABC book) with dark subject matter and black comedy is both mordantly funny and unsettling, especially when he crosses the line, as he occasionally does, into the "sick humor" of contemporaries such as the cartoonist Gahan Wilson. When an interviewer mentioned to Sendak that the grisly drawing of an infant skewered on the point of a Zouave's sword in *The Fatal Lozenge* was the moment when Gorey went "down the road of no return as far as publishers were concerned," Sendak quipped, "That's why he was so loved. There's never enough dead babies for us."[18]

The Zouave used to war and battle
Would sooner take a life than not:
It scarcely has begun to prattle
When he impales the hapless tot.

The Fatal Lozenge. (Ivan Obolensky, 1960)

The literary theorist George R. Bodmer places Gorey's ironic, sardonic ABCs in the context of a postwar push-back, among children's authors such as Seuss and Sendak, "against the limits of imagination, or the limits the outside world would impose on imagination . . ."[19] In his essay "The Post-Modern Alphabet: Extending the Limits of the Contemporary Alphabet Book, from Seuss to Gorey," Bodmer calls Gorey's "anti-alphabets" a "sarcastic rebellion against a view of childhood that is sunny, idyllic, and instructive."[20] Gorey's mock-moralistic tone satirizes received wisdom about the benignity of parents and other authority figures: a magnate waiting for his limousine "ponders further child-enslavement / And other projects still more mean"; two little children quail in terror at the sight of their towering, bearded uncle, for they "know that at his leisure / He plans to have them come to harm." Yet Gorey also punctures the myth that children are little angels: a baby, "lying meek and quiet" on a bearskin rug, "Has dreams about rampage and riot / And will grow up to be a thug." (The rug's enormous, snarling head, with its bared fangs, is an omen of mayhem to come.)

Talking about *The Fatal Lozenge* in 1977, Gorey said, "This was a very early book and at that date I was not above trying to shock everyone a bit."[21] In that sense, his sixth book is so similar to his second that it might as well be called *Son of Listing Attic*. The drawings are more accomplished (though they're nowhere near the perfection he attained in *The Object-Lesson*) and more coherent stylistically, but Gorey gives in to the same snickering nastiness that weakens the earlier effort.

A good part of the book consists of the usual droll riffing on stock characters and situations borrowed from gothic novels, penny dreadfuls, Conan Doyle, and Dickens. But just as clearly, there's more going on in *The Fatal Lozenge* than enfant terrible-ism ("trying to shock everyone a bit") or the larger trends identified by Bodmer: the bohemian backlash against the suffocating normalcy of the Eisenhower era and the growing resistance, led by Drs. Spock and Seuss, to outdated, repressive ideas about childhood and parenting. The recurrence of themes closer to home—the beastliness of babies, the depravity of the clergy (a nun is

"fearfully bedevilled"), the furtiveness and shamefulness of homosexual desire, here associated with child molestation and even more monstrous perversions ("The Proctor buys a pupil ices, / And hopes the boy will not resist / When he attempts to practice vices / Few people even know exist"[22])—makes us feel, at times, as if we're eavesdropping on a psychotherapy session. That these disconcerting images come to us in the reassuring wrappings of a children's book makes *The Fatal Lozenge* even more disquieting.

Gorey, as far as we know, never spent time on the Freudian couch, though he did cross paths with someone who was in therapy "forever," wrestling with his closeted homosexuality and his unhappy childhood, when the other kids ostracized him as a sissy.[23]

That someone was Maurice Sendak, whom Gorey met when Sendak dropped by the Looking Glass offices to discuss book ideas with Jason Epstein. "I remember how much I admired Ted," Sendak recalled in a 2002 interview. "I just loved his work....I loved the line. I loved the sort of scintillating toe dance that he does. It was his love of ballet which was a part of that."[24] He had great respect for Gorey's technique. "He was so totally in control. And he was so elegant and he was so refined....Like Mozart."[25]

The respect was mutual, though Gorey expressed his high opinion of Sendak's art in a predictably oblique way: perusing children's books led him to the "sad conclusion," he told Peter Neumeyer, "that except for Ardizzone and Sendak, I am about the best around. A sad commentary on the state of things if ever there was one."[26] Nonetheless, he said, "I *do* like Sendak, especially *Mr. Rabbit** (an otherwise absolutely *vile* book); his own writing I am ambivalent toward."[27]

An irascible loner and uncompromisingly honest artist who, against all odds, hit the commercial—and critical—jackpot, Sendak had a

Mr. Rabbit and the Lovely Present by Charlotte Zolotow, published by Harper & Row in 1962.

deeply felt sympathy for Gorey. He knew what it was like to spend long years in the wilderness, more or less ignored by the critical elite, scraping by financially. But unlike Seuss, who knew "how to satisfy the customer," and unlike himself, who had no inkling of how to satisfy the customer but managed to nonetheless, "Ted had no intention of satisfying the customer," Sendak thought.[28]

He urged his editor at Harper & Row, the legendary Ursula Nordstrom, to take up Gorey's cause. An indefatigable champion of "good books for bad children," Nordstrom was at the barricades of the revolution in children's literature from 1940 to 1970, mentoring Sendak, Tomi Ungerer, Shel Silverstein, E. B. White, and others who were reinventing and reinvigorating kids' books. She was a Gorey enthusiast, Sendak recalled, but in the end "couldn't quite put a hold on him."[29]

Not that she didn't try: having cajoled Gorey into a contract for something called *The Interesting List*, she wrote a series of typically playful letters, urging him to get a move on, as first one deadline passed, then another. It was all for naught. Gorey sent her a few drawings, but the manuscript never materialized—done in, most likely, by his wandering interests, towering workload, and benign neglect of his career.[30] Whether out of bohemianism or just plain contrarianism, he seemed to view the very idea of striving as pushily self-important. "I have a lot of friends in New York who are involved in various enterprises where they're always fanning their careers," he said with affectionate contempt.[31] In the wake of *Dracula*'s success, he recalled, "I began to realize what it would be like to be rich and famous, but I've decided unh-unh."

Sendak got to know Gorey during their New York years. Like John Ashbery and so many others, he found Ted "generous and funny" but never felt as if he truly knew him.[32] He was nagged by the feeling that Gorey had truer friends elsewhere—a sentiment shared by nearly everyone who knew Ted, curiously.

One of the few times he "felt intimate" with Gorey, oddly enough, was when a bizarre bit of absurdist comedy broke the ice of what Sendak called Gorey's "aloof and refined-looking" persona.[33] After

not having seen Gorey for a year, he spotted him striding along Fifth Avenue in his signature getup—fur coat, earrings, all of it—and trotted up, tugging Ted's sleeve to get his attention. (Sendak was short and squared-off, a Jewish garden gnome from Brooklyn. Maybe he thought Gorey, towering above the foot traffic, hadn't noticed him.) "He looked askance and he seemed to either not remember me or not to wish to recognize me. I got pissed. So I tugged harder, and then he turned to me—and his eyes—his face looked like Nosferatu—and he actually yelled. He said, 'Rape!' . . . [H]e thought I was a molester." Sendak was rattled. "Of course then he smiled and I knew it was all right."

Sendak regretted that he and Gorey weren't closer. "If we could have talked more, we might have shared ideas," he said, "but he was not a sharer."[34] Then, too, their personalities were comically dissimilar. An avowed misanthrope and career depressive, Sendak was a product of the New York Jewish culture of kvetch epitomized by Woody Allen and Larry David. Gorey, on the other hand, was about as *goyische* as they come: a WASP from the Midwest, Episcopalian by background, Anglophile by inclination, whose chitchat touched on everything (but sex) while revealing next to nothing about himself or his work.

Even so, the two men had much in common, intellectually and artistically: both were ravenous consumers of culture, high and low, and shameless borrowers from anyone or anything that caught their eye. Both were masters of the picture-book medium who helped transform it into a serious art form. ("A true picture book is a visual poem," Sendak believed—an apt description of Gorey titles like *The Object-Lesson*.)[35] Both were virtuosos of pen-and-ink draftsmanship and epigrammatic storytelling; both were snubbed by the art world as mere illustrators. Both experimented with genre and format, from the alphabet book to the miniature book (in Sendak's case, the *Nutshell Library*) to the mock cautionary tale (*Pierre: A Cautionary Tale in Five Chapters and a Prologue* was Sendak's entry in that category). Selma G. Lanes's perceptive comments on Sendak's style in *The Art of Maurice Sendak* could do double duty as an analysis of Gorey's:

His early popularity notwithstanding, Sendak has at no time during his career been in step with the mainstream of American children's book illustration. In the mid-fifties, when bold exploitation of color, abstract design, outsized formats, and showy technical virtuosity abounded, Sendak's work remained consistently low-key, curiously retrograde and nineteenth-century in spirit. The use of crosshatching was introduced into his illustrations right from the start.... Sendak's drawings actually achieve the look of nineteenth-century wood engravings.[36]

On a more personal note, both understood "the miseries of childhood," and, as Sendak pointed out in an unpublished interview with Kevin Shortsleeve, a scholar of children's literature, both were gay.[*]

As a gay man who wrote and illustrated children's books, Sendak knew too well what an explosive combination that was in an America whose dream life was haunted by nightmares of predatory pedophiles. "Well, just look at the time we [he and Gorey] both grew up in America, as artists, both gay—and we had to hide that," he told an interviewer.[37] As a *New York Times* article on Sendak noted in 2008, "A gay artist in New York is not exactly uncommon, but Mr. Sendak said that the idea of a gay man writing children's books would have hurt his career when he was in his 20s and 30s."[38]

Paradoxically, the closet inspired gay artists like him and Gorey to become virtuosos of subtext, he maintained. "When you look at the new gay-lib," Sendak observed, "you say, gee whiz, why did we suffer so much? But I think it added to what we were doing.... We had to adapt more cunningly."[39] The need to hide in plain sight gave rise to sly, secretive systems for signaling queerness, he thought. Consider Gorey's

[*]Or, more accurately, Sendak was gay and Gorey was a professed asexual whose social presentation of self was stereotypically gay and whose only sexual experiences, as far as we know, were with members of the same sex. Whether that makes him gay or an asexual who on rare occasions experimented with gay sex or just someone who exemplifies the range of human sexual experience I leave to the reader. Gore Vidal's assertion that there are only homo- or heterosexual *acts*, not individuals (since in his view we're all bisexual by nature), puts an interesting spin on the question.

books: "They all had what appealed to me so much—aside from the graphics and the writing—[which] was the wicked sexual ambiguity that ran through all of it. I remember a jacket he did for...a novel by Melville, *Redburn*. And the jacket summed up completely the kind of confused homosexuality of that novel....So erotic and yet so simple. You can look at it any way you like....[H]e buried a lot of information about himself in the art."[40]

Coincidentally, another novel by Melville, *Pierre; or, The Ambiguities*, was the key that opened the closet door for Sendak. Teaching a course at the University of California at Berkeley, he was discussing his illustrations for a 1995 edition of the book, unblushingly homoerotic drawings that brought the novel's gay themes to the fore. A female student asked "whether the intensity of...the homoeroticism—which was flagrant—reflected anything in my life." To his own astonishment, he found himself admitting that, well, yes, it did: he was gay. "It was a wonderful moment," he said. "I can see her face right now...like a little votive lamp leading me on. Leading me to explain things. It was wonderful. I wish Ted had that. But maybe he didn't seem to ever want it."[41]

Gorey's professional orbit brought him into contact with other illustrators and cartoonists whose work, like Sendak's, cast a long shadow in the mass imagination. He was friendly with Charles Addams—to whom he was often compared, a lazy analogy Gorey found irritating. "Neither of us really cared for the comparison," he said. "We thought we were doing basically different things, with little overlap. The Addams Family had more to do with role reversal; I've always leaned in my own direction."[42]

He's right. Addams turns conventional morality and bourgeois propriety upside down—a carnivalesque prank that *reaffirms* the social order by providing a harmless outlet for our fear of death and fantasies of murdering our bosses and spouses. Perversely funny as his single-

panel gags can be, his brand of black humor lite only sneaks a peek at the darkness Gorey peers deep into. The Addams Family, for all its creepiness and kookiness, is a close-knit, mutually supportive unit, more *heimlich* than *unheimlich*.

Still, the two men got on. Addams, a bon vivant who collected crossbows, picnicked in graveyards, and used an embalming slab for a coffee table in his Manhattan apartment, was by all accounts great fun. Gorey must have admired his surrealist wit, not to mention his subtle wash technique and precise line.

"I love Charles Addams's stuff," Gorey professed. "We had the same agent.* I occasionally would have lunch with him. I was told he envied me because I had a more highbrow reputation than he did."[43] Conversely, Gorey seems to have envied Addams his commercial success: "I suppose there's always the possibility somebody will come along and want to do the equivalent of *The Addams Family* movie with my stuff. Well, I'm not that rich, so I'd probably say, 'Go ahead.'"

Another artist whose work left an indelible stamp on the pop unconscious in the '60s and whose trajectory carried him through Gorey's life was the French-born illustrator and children's book author Tomi Ungerer. Politically outspoken and gleefully perverse, Ungerer was equally in tune with the emerging counterculture and the childhood he never outgrew. He wrote and illustrated morally ambiguous children's books such as *The Three Robbers* (1961), designed antiwar posters, and turned out bizarre, satirical art-porn depicting bondage freaks strapped into sex

*For once, Gorey's famously infallible memory is playing tricks on him. Addams was one of those rare birds in the illustration world who was so famous that he needed no agent, although Barbara Nicholls, who ran a Manhattan gallery specializing in original art by *New Yorker* cartoonists and illustrators, sometimes lent a hand with reproduction rights. Gorey may have gotten the mistaken impression that his illustration agent, John Locke, handled Addams, too, because clients in search of Addams sometimes came to Locke, whose star-studded roster included just about everyone who was anyone. Eileen McMahon, an agent with John Locke Studios from 1988 until the agency's closing, in 1997, told me in a June 7, 2017, e-mail that she believes Addams "could very well have worked with John" in instances when clients came to Locke with assignments that were "too good to miss."

Kevin Miserocchi, executive director of the Tee and Charles Addams Foundation, thinks it's entirely possible that Addams and Gorey lunched, perhaps at the Coffee House, a members-only club in midtown Manhattan frequented by *New Yorker* artists and editors.

machines (*Fornicon*, 1969). Like Gorey (and Sendak, whom he knew socially), his unfettered imagination was darkened by a sense of the absurd—a gift, in his case, from the Nazis, who occupied not only his hometown of Strasbourg during the war but also his family's house. Like Gorey, he had no stomach for "the mushy sentimentality" of American children's books of the day, "all semi-realistic, with smiling children and pink cheeks."[44]

An "absolute fan" of Gorey's work, especially of his writing— "everything he ever published, I collected"—Ungerer sang his praises to his Swiss-German publisher, Daniel Keel of Diogenes Verlag, a bit of matchmaking that resulted in a relationship that began in '63 with *Eine Harfe ohne Saiten* (*The Unstrung Harp*) and endures to this day. But, echoing Sendak's experience, his attempt to strike up a friendship with Gorey came to naught. "I said, 'I love your work and I'd like to meet you because I think we have a lot to share,'" he said, recalling the time he called Gorey on a whim. "And I just hit into *nothing*. I am outgoing and he was inkeeping—he was an innkeeper!"

Chagrined though he was, he understood and even respected Gorey's standoffishness. Ungerer's own books were "for the child in me," he says, and he assumed "it was the same thing with Gorey. Innocence takes discipline, and this applies absolutely to Gorey. I'm talking about his thinking: one must be aware of one's innocence and preserve it. He kept to himself to be what he was."

In that sense, the two artists were comrades in arms, their mismatched social styles notwithstanding. "I just did my thing," says Ungerer. "Once I had my first chance, I just decided to do what I felt like doing, but then it turned out that we"—he, Gorey, Sendak, and illustrators like them—"were a group of people who changed children's books in America."

Gorey hit his stride in the late '50s, harmonizing the haikulike concision of his writing with the flawless economy of his India-ink line in

The Doubtful Guest. By *The Object-Lesson*, in '58, he'd elevated the pic-
ture book, a genre dismissed by most critics as kid stuff, into something
rich and strange—just *what* no one was exactly sure. Were his little
books intended for precocious children of unwholesome disposition?
Or were they bedtime reading for decadents? Camp-gothic divertisse-
ments for "les boys"? None could say. Nor did anyone seem to grasp
that, with *The Object-Lesson*, he'd placed the picture book at the service
of mysteries deep and dark—haunting childhood memories, existential
questions.

The '60s were a time of artistic exuberance for Gorey, beginning
with *The Curious Sofa* and *The Hapless Child*, both published by Ivan
Obolensky in '61. In *The Hapless Child*, we find him in a deliciously
ironic mood. Charlotte Sophia, the only child of well-to-do Victorian-
Edwardians, is frolicking in the parlor with fur-coated, mustachioed
Papa; Mama looks on with fond regard.* But wait: something's moving
in our peripheral vision. Through a door ajar, we glimpse a reptilian
thing creeping by on all fours, a cartoony version of those grotesques
tormenting Saint Anthony in medieval paintings. It lurks in nearly every
scene, playing Where's Waldo? with the reader—a cryptic in-joke from
Gorey to himself. "The devil is in the details," as the art historian Joseph
Stanton wittily points out.[45] Stanton reads Gorey's imps as agents of
chaos; they're there to ensure that every turn of events is a turn for the
worse.

And they are: Papa, a colonel in the army, is dispatched to some
colonial adventure in Africa, then "reported killed in a native uprising."
Mother falls into a decline, as women often do in Victorian novels,
and expires. An uncle who might have come to Charlotte Sophia's
rescue is fatally "brained by a piece of masonry." Alone, unloved, the

*Charlotte Sophia's namesake just might be Gorey's great-great-grandmother Charlotte
Sophia St. John (1811–95). She's the mother of Helen Amelia St. John Garvey, maker
of mottoes and greeting cards and the wellspring, according to family lore, of Gorey's
artistic talent. After her husband fell sick, Helen supported the family by painting post-
card illustrations in watercolor, which she sold to the Chicago publishing house A. C.
McClurg & Co.

poor dear is bundled off to boarding school, where the teachers and the other girls single her out for capricious cruelties: schoolyard bullies tear her beloved doll, Hortense, limb from limb. Unable to bear it any longer, she escapes, only to be kidnapped and sold to "a drunken brute." He forces her to make artificial flowers; she subsists "on scraps and tap-water." Terrified by one of his drunken rages, Charlotte Sophia flees into the streets, where she's promptly flattened by a motorcar. The driver is—who else?—her father, "who was not dead after all" and has been searching high and low for his lost child. Clad in motorist's goggles and a floor-length leopard-skin coat—a preposterous getup whose comic-grotesque effect mocks the tragedy of the scene—he holds the frail creature in his arms as she gasps her last. Naturally, "she was so changed, he did not recognize her." Curtain.

A tongue-in-cheek spoof of Victorian sentimentality and silent-movie melodramas about children in peril, such as D. W. Griffith's *Orphans of the Storm*, *The Hapless Child* plays to the Oscar Wilde in all of us. (When Dickens jerked readers' tears with the three-hankie death of the angelic orphan Little Nell, in *The Old Curiosity Shop*, Wilde—a sworn foe of Victorian schmaltz—famously remarked, "One must have a heart of stone to read the death of Little Nell without laughing.")[46] "There's so little heartless work around," said Gorey. "So I feel I am filling a small but necessary gap."[47]

The Hapless Child is "clearly meant to remind readers of a well-known type of nineteenth-century novel for girls—Frances Hodgson Burnett's *Sara Crewe* is a model of its kind—in which a young heroine is wrenched, usually by the death of a parent or a reversal in family fortune, from a life of privilege and plunged into deprivation and misery," writes the art critic Karen Wilkin.[48] More immediately, the book was inspired by *L'Enfant de Paris* (1913), a silent by the French director Léonce Perret that Gorey saw just once, at one of the Museum of Modern Art's Saturday morning screenings. (His visual memory was remarkable.) "The movie starts out exactly the way *The Hapless Child* does," he recalled, although the book "deviates quite early" from the plot of the film.[49] (In the movie, as in Gorey's book, the orphan is

snatched up and sold to an abusive, hard-boozing cobbler, but unlike Charlotte Sophia, she's watched over by a kindhearted soul, the cobbler's apprentice.)[50]

In hindsight, Gorey felt *The Hapless Child* was "excessive."[51] "Overdone is the best way I can put it," he said, meaning that he found the book's satire heavy-handed. (The book *is* dedicated, after all, to the arch, over-the-top V. R. Lang, a hapless child in her own right and hardly one to shrink from excess.)

To this reader, the tone seems just right, a witty caricature of Dickensian sentimentality and silent-era weepers. The drawings, too, are superb, fastidiously rendered in Gorey's fine-lined style with the usual attention to period detail: the ashlar walls, umbrella stands, balustrades, spoke-wheeled motorcars, and, naturally, the wallpaper are so dizzily detailed they look as if they were drawn with the aid of a jeweler's loupe. ("Wallpaper is my bête noir," Gorey told Peter Neumeyer. "I put aside *The Hapless Child* after about three drawings for several years because I couldn't face the notion of drawing any more wallpaper.")[52]

Charlotte Sophia is the very type of the Gorey child, a woebegone thing whose perpetually mournful gaze and expressionless mouth, hardly more than a hyphen, mark her as a victim-in-waiting. She invites our hilarity, not our sympathy. The sheer number of her Job-like afflictions heightens the comic effect, pushing the needle from tragedy into farce. Gorey gives us *Oliver Twist* with an ending by Beckett: unlike the saintly waifs of Victorian sentiment, ennobled by their suffering and rewarded in the hereafter, Charlotte Sophia endures her tribulations to no end. Things happen, more or less without reason, then you die, beaned by a hunk of masonry or run down by a motorcar. Sometimes the cosmos plays an existential prank at your expense: the motorcar is driven by your father, who's combing the streets in search of you, a turn of events that reduces your death to an absurdist punch line. Of course, from an absurdist perspective, *all* deaths are a punch line: the good news is, you're born; the bad news is, you die. Life is a death sentence.

The Curious Sofa, Gorey's third book with Ivan Obolensky, is strikingly different from The Hapless Child in tone, style, and setting, though both are genre parodies. Whereas The Hapless Child is dark with cross-hatching, The Curious Sofa is bright and airy, its playful line drawings dancing against all-white backdrops. Most of The Hapless Child is set in gloomy, claustrophobic interiors; much of The Curious Sofa takes place outdoors. Gorey's compositions are as beautifully balanced as ever, but he eschews solid blacks, breaking up the blank space with busy patterns, mostly on the characters' clothing. The style suits the story's breezy wit, just as the silent-movie murk of The Hapless Child is a better fit for that story's ironic-gothic mood. Even the hand-lettered typography is uncharacteristically loopy, its curlicues more suggestive of handwriting than printed type.

Subtitled A Pornographic Work by Ogdred Weary (Gorey's first use of what would become a signature gimmick, the anagrammatic pen name), The Curious Sofa opens with Alice eating grapes in the park. She'll be eating them in every scene in the book, which may be Gorey's shorthand for her sexual availability: grape as symbol of fertility and Dionysian indulgence. As events unfold, Alice loses her innocence—if she ever had any: she's half wide-eyed ingenue, half slyly knowing New Woman, as the independent, free-spirited working girls of the 1920s were known. (The story takes place in the Jazz Age.) Herbert, "an extremely well-endowed young man," introduces himself, and we're off and running. A page later, they're in a taxi, "on the floor of which they did something Alice had never done before." All we see of them is Alice's hand clutching a single grape; the cabbie keeps one eye on the road and the other on the backseat, smiling lasciviously.

And so to the home of Herbert's aunt, Lady Celia, who requests that Alice "perform a rather surprising service," after which the three of them work up an appetite for dinner with "a most amusing game of Herbert's own invention called 'Thumbfumble.'" The trio is treated to an after-dinner visit from Colonel Gilbert and his wife, both of whom have wooden legs "with which they could do all sorts of entertaining tricks." Bestiality is all in good fun, too: the next day, Herbert, the "unusually well-formed" butler, Albert, and the "exceptionally well-

made" gardener, Harold, frolic on the lawn with Herbert's "singularly well-favoured sheepdog, and many were the giggles and barks that came from the shrubbery."

Looking out the window she saw Herbert, Albert, and Harold, the gardener, an exceptionally well-made youth, disporting themselves on the lawn.

Herbert, Albert, and Harold disport themselves on the lawn in *The Curious Sofa*. (Ivan Obolensky, 1961)

Staging the juicy stuff just offstage, hinting at the unmentionable through the winking use of epithets and euphemisms: in *The Curious Sofa* Gorey suggests everything but reveals nothing, a rhetorical strategy that's hilariously effective. Just as Henry James's habit of leaving nothing to the reader's imagination drove Gorey to distraction, it's porn's literal-

minded insistence on showing us everything—the gooey, grunting mechanics of the act—that irked him. A masterpiece of innuendo in which everything is implied but nothing is shown, *The Curious Sofa* is his satirical revenge on the genre.

Near the end, things take a sinister turn, modulating from frolicsome debauchery into a darker key. The change in mood is signaled by everyone's favorite line: "Still later Gerald did a terrible thing to Elsie with a saucepan," a sexual transaction so abominable it proves fatal to Elsie. Bullwhips are produced. Things come to an, er, climax during a visit to the home of Sir Egbert, who shows the swingers his notorious sofa. "Alice felt a shudder of nameless apprehension." Here Gorey is unbeatable: the sofa, which has nine legs and seven arms, is kept in "a windowless room lined with polar bear fur." Locking his guests in, Sir Egbert pulls a lever, bringing the mechanized sofa to life. What began as a sexual romp ends in Lovecraftian horror: "When Alice saw what was about to happen, she began to scream uncontrollably..."[53]

Is there a more eloquent ellipsis in all of literature?

"I think, in a way, *The Curious Sofa* is possibly the cleverest book I ever did," Gorey once remarked. "I look at it, and I think, 'I don't know quite how I managed this because it really is quite brilliant.'"[54] Undoubtedly. And it's very possibly the most quickly written of his books, whipped up in a single weekend.

He offered various accounts of its origins. It was inspired partly by *Story of O*, he said, a French novel whose de Sadean fantasies of dominance and bondage caused a stir when it was published, in 1954. Edmund Wilson—a man of prodigious sexual appetites—had recommended it to him. Trudging through it, Gorey thought, "Oh, Edmund, this is absurd. No one takes pornography seriously."[55] And so he didn't. "If you will notice it," he told an interviewer, "*The Curious Sofa* begins the same way as *The Story of O*, which is what finally set me off—where I think he picks her up in the park and puts her in a taxi after that."[56] A rainy afternoon spent slogging through *The Hundred and Twenty Days of Sodom* by the Marquis de Sade (in French!) left its mark, too. "I was ready to blow my brains out after wading through that,"

said Gorey. "But I always wonder how people can manage to write pornography.... There are only so many things you can do and so forth and so on."[57]

Alison Lurie thought she played a role in summoning the muse as well. When she and Ted were friends in Cambridge, she learned, at her job in the rare books department of the Boston Public Library, of "a locked stack full of old-fashioned erotica, and if you worked there, or a friend worked there, it was possible to look at these books," she recalled. "I think that some of them were probably one source of *The Curious Sofa*.... At that time there was a lot of censorship and complaint in the press about erotic or suggestive fiction, which Ted thought of as rather silly and hysterical."[58]

As always, Gorey is complicated. In *The Curious Sofa*, same-sex love—between Alice and Lady Celia's "delightfully sympathetic" French maid and between Sir Egbert and his effeminate-looking friend Louie—is as common, and as accepted, as the heterosexual sort. Yet if we assume the perspective of an author who is not so much a closeted, or at least nonpracticing, gay man as an asexual, the book looks less like a satirical comment on sexual repression in midcentury America than it does a shudder of amused revulsion at the ickiness of *all* sex. "Is the sexlessness of your books a product of your asexuality?" an interviewer asked. "I would say so," said Gorey, noting that, in *The Curious Sofa*, "no one has any sex organs."[59] *The Curious Sofa* bears the dedication "For others," which could be a nod to Gorey's gay readership but might just as easily be a veiled expression of solidarity with a group that, in '61, was barely known, even to other sexual minorities: asexuals. What, exactly, is Ogdred Weary weary of? The mind-bending tedium of everyone else's obsession with sex, perhaps? Then, too, *The Curious Sofa*, for all its bed-hopping high jinks, begins as a winking parody of erotica but ends up a horror story. And, like so many horror stories, it's conservative at heart, ending on a parochial-school note: immorality is sternly punished.

Gorey, with characteristic wit, once said, "I think it's really about a girl who's got an obsession for grapes more than anything else."[60] He

216

was astonished, in later years, to discover that the book had a juvenile following. "People have come to me and said, 'My child just adores *The Curious Sofa*,'" he told an interviewer. "At first this baffled me, but apparently they find it funny."[61]

Gorey was a dust devil of productivity in 1961. Not only did he produce two books of his own, but several books he'd illustrated were also published that year.

Lippincott brought out *The Man Who Sang the Sillies*, a book of children's nonsense verse by John Ciardi. Cartoony, with a naive quality, Gorey's illustrations recall Edward Lear's charmingly artless sketches for *his* nonsense poems, a style that suited Ciardi's Learian kookiness perfectly. Over the course of the decade, Gorey would illustrate five more titles by his former Harvard professor, mostly in the same loose, sketchy style: *You Read to Me, I'll Read to You* (1962), *You Know Who* (1964), *The King Who Saved Himself from Being Saved* (1966), *The Monster Den; or, Look What Happened at My House—and to It* (1966), and *Someone Could Win a Polar Bear* (1970).

Houghton Mifflin's publication of *Scrap Irony*, an uneven collection of sometimes clever, sometimes strained satirical poetry, marked the beginning of Gorey's association with Felicia Lamport. A practitioner of that much-snubbed form light verse, Lamport rattled off topical poems for her Muse of the Week in Review column in the *Boston Globe*, lampooning politicians, poking fun at fads and trends, and satirizing women's roles in society. Gorey counterpointed Lamport's satirical zingers in *Scrap Irony* with what a *New York Times* review of the book praised as "cheerfully saturnine illustrations"—the usual droll, delicately limned cartoons of characters in Victorian-Edwardian or sometimes 1920s costume.[62] His relationship with Lamport lasted more than two decades, spanning *Cultural Slag* (1966) and *Light Metres* (1982), but became more fraught over time, as his star ascended and her shtick grew stale.

He was also turning out illustrations for magazines, doing the occasional freelance book jacket, and punching the clock at the Looking Glass Library. Then, in 1962, Epstein's "children's book thing," which had been on shaky financial footing for a while, folded.

Gorey landed almost instantly at 3 West 57th Street—Bobbs-Merrill, where from '62 through '63 he spent a dreary year as art director. After Looking Glass, Bobbs-Merrill's more corporate atmosphere felt suffocatingly buttoned-down to Gorey. To make matters worse, the place was badly run, he thought. (He and his similarly disgruntled coworkers referred to their employer as "Boobs Muddle.") Mercifully, Gorey was fired sometime in '63—collateral damage in a managerial power struggle. "Eventually there was internecine warfare, and I was unfortunately on the side of the president, who got fired with all his entourage," he said. "Which was just as well. After that I just had too much freelance work to look for another job, and I moved up to the Cape."[63]

Truth to tell, Gorey didn't "move up to the Cape" in the sense of pulling up stakes at 36 East 38th Street. He kept his apartment, but from '63 on more or less lived on the Cape whenever the New York City Ballet wasn't performing. Nonetheless, he had made a decisive break with the nine-to-five world. Out of patience with the deadline grind and gray-flannel culture of corporate publishing, he realized he had enough freelance work to make a go of it as a self-employed illustrator and—despite his aesthete's pose as a languid idler—a prolific producer of little books.

NURSERY CRIMES — *THE GASHLYCRUMB TINIES* AND OTHER OUTRAGES

1963

Gorey with Skee Morton and her mother, Betty Garvey, July 22, 1963. Note Ted's *contrapposto* stance, reminiscent of the ballet. *(Photograph by Eleanor Garvey. Courtesy Elizabeth Morton, private collection.)*

IN HIS LAST YEAR at Looking Glass, Gorey managed, despite the threat of impending doom, to publish two of his own books. He'd found a home, in '62, for *The Willowdale Handcar* at what would soon be his new employer, Bobbs-Merrill, and self-published *The Beastly Baby* that same

year under the colophon of his newly launched Fantod Press, using his Ogdred Weary pen name. The first edition consisted of five hundred copies, many of which were sold by the Gotham Book Mart.

Fantod was a child of necessity, founded to publish a book no one would touch. "I thought, 'Oh, I've been sitting around looking at this stupid little thing for many years,'" he recalled. "'Waste not, want not' was always my motto, so I founded the Fantod Press."[1] (The name derives from "the fantods," nineteenth-century slang for "heebie-jeebies.")

He'd written the book in 1953, shortly after Alison Lurie had given birth to her first child. When Lurie sent a snapshot of her newborn, Gorey' replied with a belated shower gift, *The Beastly Baby*. "I got into a kind of flap over the weekend," he explained in a letter to the new mother, "flap" being Goreyese for "creative frenzy"; the result—inspired, perhaps, by the photo—was a book, dedicated to Lurie's new arrival, that was "apparently very odd indeed, as it horrified Bubsy [Barbara Epstein] rather..."[2]

The Beastly Baby is a minor Gorey work—a one-line joke, amusing enough in a mean-spirited way. The drawings are done in the dashed-off, unfinished manner of *The Listing Attic*, whose calculated outrageousness *The Beastly Baby* shares. The baby itself is a nasty piece of work, a Humpty Dumpty of hatefulness, "not merely obese but downright bloated." As in folktales and fairy tales, its freakishness—two left hands, too many toes on one foot and not enough on the other—is visible evidence of moral depravity. (The book begins as an arch takeoff on the Brothers Grimm: "Once upon a time there was a baby. It was worse than other babies.") We see it chortling after tearing kitty's head off, a ghastly noise Gorey describes as a "choked gurgling, reminiscent of faulty drains."

Babies, in Goreyland, tend to be either abject creatures, deserving of victimization, or monstrous. The Beastly Baby is a bad seed of the worst sort; its horror-struck parents try to rid themselves of it, but Fate keeps intervening. It grows older and bigger by the minute, "and what this would eventually lead to, no-one liked to think." Providentially, an eagle snatches up the child; struggling to get a better grip on its un-

cooperative prey, the bird punctures the bloated creature. "There was a wet sort of explosion, audible for several miles."

Gorey seemed surprised that publishers shunned the book. When he showed it to Cap Pearce at Duell, Sloan and Pearce, the publisher acted jittery, Gorey told Lurie, and kept giving him strange looks. "He even dragged out a bottle and gave me a drink, this being eleven o'clock in the morning," Gorey wrote.[3] The obviously shaken Pearce said, somewhat unconvincingly, that he'd take *The Beastly Baby* under advisement, "but intimated that in ten years perhaps the public would be ready for it."

As for Lurie, she sent Gorey a postcard thanking him for sending a copy. "The boys love it," she wrote. "Yesterday they were running around, pointing their toy guns at each other, saying, 'I'm the beastly baby and I'm shooting up the bric-a-brac.' So I want you to know that there's one family in the world in which your books are just as much a beloved part of childhood as Beatrix Potter."[4]

The Willowdale Handcar is one of the capstones of Gorey's body of work. Each scene is a postage-stamp masterpiece, the understated wittiness of its prose joined seamlessly to needlepoint-fine drawing. The surrealism of the story's dreamlike chain of events is suffused with what the *New Yorker* writer Stephen Schiff calls "an air of almost metaphysical mystery."[5]

That, in fact, is what *The Willowdale Handcar* is: a metaphysical mystery—specifically, a metaphysical mystery in the guise of a silent movie. (The book is dedicated to Lillian Gish.)[6] Three young people—Edna, Harry, and Sam—discover their ticket out of dull-as-dishwater Willowdale: a handcar at the railroad station, which they promptly mount and ride out of town, following the call of the open road. The time, as always, is vaguely Victorian-Edwardian; the town, whose name recalls the Wilmette of Gorey's boyhood as well as the 1888 small town in the *Twilight Zone* episode "A Stop at Willoughby" (1960), appears to be somewhere in the Midwest. Thematically, *The*

Willowdale Handcar is a variation on a quintessentially American myth—the road trip. Gorey's illustrations, most notably the Hop-peresque picture of a house burning mysteriously in the middle of a vast field, and Wobbling Rock tumbling off its pedestal to crush some picnickers, are among his finest. The draftsmanship is impeccable, the compositions beautifully balanced.

Running on a parallel track to the dominant narrative is an Agatha Christie subplot involving the mysterious Nellie Flim, a missing person whose "frantic face" the trio glimpses pressed against a parlor window as a train flashes past and whom they ultimately meet up with, tied to the tracks like the imperiled heroine of one of D. W. Griffith's Biograph shorts. When they free her, she hops on her bicycle and rides away without explanation. A week later, they think they see her "walking the grounds of the Weedhaven Laughing Academy."

As for the metaphysical mystery, the description on the book's back cover is intriguing, especially if we entertain the possibility that Gorey wrote it, as authors sometimes do. "In which three Pilgrims find mystery, abort peril and partake of religious community," the blurb reads. "And the discerning Reader discovers Meaning in their Progress." We're invited to read the Willowdale trio's trip in explicitly religious terms: as an allegorical journey—a pilgrim's progress, not to put too fine a point on it.

Is *The Willowdale Handcar* a "subtle yet magisterial view of the human condition," as Schiff suggests, chronicling our voyage from youth to tomb?[7] Undoubtedly the book has an elegiac feel: death and decay are everywhere, from the burning house to the trio's contemplative stop at a cemetery to the final scene, a wonderfully evocative drawing of the travelers pumping their handcar into the Stygian gloom of a tunnel. "At sunset they entered a tunnel in the Iron Hills and did not come out the other end." The pitch-black mouth of the tunnel that swallows the travelers forever is inescapably tomblike, a portal to Hamlet's "undiscovered country from whose bourn no traveler returns." Willowdale is suggestive, too: weeping willows, in Victorian memorial iconography, symbolize mourning.

At sunset they entered a tunnel in the Iron Hills
and did not come out the other end.

The Willowdale Handcar. (Bobbs-Merrill, 1962)

As for the Black Doll of the title, it, too, remains a cipher. We see it only briefly, sitting on a writing desk.* Perhaps it's meant to be an absent presence—a disquieting reminder of the irreducible mystery of things. An effigy of the god of naught, it personifies the black hole in Gorey's cosmos, right where the discerning Reader looks for Meaning.

During his tedious time at Bobbs-Merrill, Gorey produced three classic works, one of which, *The Gashlycrumb Tinies*, would become his best-

*Ah, but that desk belongs to the renowned poet Mrs. Regera Dowdy, whose name is an anagram for "Edward Gorey." Is Gorey saying that the Black Doll is his muse, a symbol of the mysterious impulses that inspire his work?

known title—the dictionary definition, in the public mind, of the Goreyesque.

The Gashlycrumb Tinies; or, After the Outing; *The Insect God*; and *The West Wing* appeared in 1963, in a boxed set published by Simon and Schuster called *The Vinegar Works: Three Volumes of Moral Instruction*. It debuted a year after the arrival of Maurice Sendak's four-volume *Nutshell Library*. Since he knew Sendak and seemed to have kept abreast of children's book publishing, it's unlikely Gorey hadn't gotten wind of Sendak's wry take on Puritan primers and *Struwwelpeter*-type cautionary tales. Whether *The Vinegar Works* is his response we don't know, but the timing is suggestive.

Written in sprightly dactylic couplets, *The Gashlycrumb Tinies* is a mocking abecedarium steeped in the gothic aesthetic and the real-life horrors of the penny dreadful. It purports to teach children their ABCs through the unhappy (but often hilarious) ends of twenty-six lugubrious-looking children: "A is for Amy who fell down the stairs / B is for Basil assaulted by bears," and so on. *Tinies* was inspired, said Gorey, by "those 19th century cautionary tales, I guess, though my book is punishment without misbehavior."[8]

The drawings are wonderful, in their restrained way. Gorey's compositions, as always, are expertly balanced: he conducts duets between dark or densely patterned shapes and white or gray space and between his little victims and the mostly empty spaces that surround them.

Gorey could be a great single-panel gag artist when he wanted to be. The verse is often uproarious, and the artwork showcases his cartoonist's gift for illustrating a joke in the most amusing way. "N is for Neville who died of ennui" takes an inherently hilarious notion—expiring from world-weariness, a concept only Gorey could dream up—and makes it even funnier by showing us nothing but the top of Neville's bored little head, his black-dot eyes peering blankly at us out of an enormous window. (This was one of Gorey's favorite scenes. When an interviewer noted one of the many paradoxical aspects of the man—"He delivers punch lines and sardonic commentary with ease, but rarely laughs"—Gorey observed, "I don't set out to be funny. Obviously, if I find myself giggling

about something, I'll keep it in. . . . I must say I did think at the time that 'N is for Neville who died of ennui' was rather fetching.")[9]

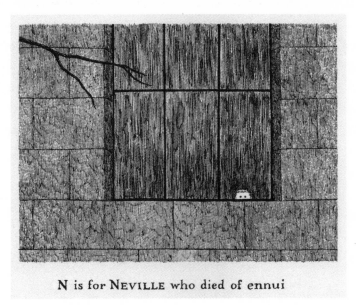

N is for NEVILLE who died of ennui

The Gashlycrumb Tinies. (Simon and Schuster, 1963)

Gorey's ironic distance absolves us of the moral obligation to empathize. It gives us license to chuckle at the messy end we know is in store for the dapper little gent in tweeds, eagerly opening his booby-trapped gift in "T is for Titus who flew into bits." Sometimes it's the cluelessness of the little dears that turns tragedy into slapstick: why is Olive, in "O is for Olive run through with an awl," tossing such a nasty implement into the air? To see where it will land? In *The Gashlycrumb Tinies*, parents are nowhere to be seen, leaving children to their fates, which, nine times out of ten, the little ninnyhammers richly deserve.

Actually there *is* one parental figure in the book. The cover illustration depicts Death as a skeletal nanny surrounded by his charges. Like the child-snatching bogeyman of every parent's worst nightmares, Death is only posing as the Tinies' guardian. The book's back cover reveals their fate: a cluster of headstones huddles where the children stood. This, presumably, is what happened "after the outing." Death is

ever present, even in the coziest domestic settings, just waiting for one dumb move (say, swallowing tacks), a freak accident (suffocating under a rug), or an Act of God (managing, somehow, to be devoured by mice). And it doesn't make exceptions for youth or cuteness.

The Gashlycrumb Tinies broaches the subject of death in a children's book, or at least in what looks like a children's book. And it did so at a time when the Little Golden Books, which dominated kinderculture, were serving up a steady diet of treacle and mush. Seen in that light, it really *does* offer moral instruction after all. Gorey's gift to his youngest readers is a book of ABCs that uses a variation on that schoolyard staple, the dead-baby joke, to teach them that death is part of life. "When you were a child, would you have relished *The Gashlycrumb Tinies*?" an interviewer asked. "Probably, yes," was his predictable reply.[10]

Wonderfully weird as it is, grotesquely funny as it is, *The Insect God* is a slight work—another one-line joke and, at fourteen panels, one of Gorey's shortest. A cautionary tale, told in rhyme, about the dangers of taking candy from strangers (and what could be stranger than man-size mantids who sacrifice humans to their six-legged deity?), *The Insect God* recounts the fate of little Millicent Frastley (one of Gorey's funniest faux-English names).

We meet her in the park, where she's playing unattended, "nibbling grass." "There was no one with her to keep her from straying / Away in the shadows and oncoming dark." (Adults in Goreyland are *always* neglectful.) A sinister "black motor" rolls up, looking like a funeral hearse on spoked wheels, and a "tiny green face" regards the startled mite. Out comes an arm with two elbows (Gorey has a flair for the telling detail) holding a tin of cinnamon balls; Millicent is tempted, and in a trice she's snatched up and spirited away.

After long hours on the road, the insects and their victim arrive "at the foot of a vast and crumbling wall," a moment Gorey stages with a superbly cinematic sense of visual drama: the car, little more than a

black silhouette in the middle distance, is stopped before a dark, brooding monolith of a mansion, so colossal it reduces the vehicle to toylike proportions. All those hours spent watching silent movies have paid off: Gorey deftly intercuts a shot of the Frastleys, anguishing over what has become of Millicent, then returns us to the mansion's ballroom, where the mirrors are "streaked with a luminous slime." Leaping "through the air with buzzings and twangings," the monstrous mantids "work themselves up to a ritual crime." Their frenzy culminates in the stripping and stuffing of little Millicent into "a kind of pod," after which she is, at last, "sacrificed to THE INSECT GOD."

Brow-knitting analysis of a one-line joke runs the risk of becoming a joke itself. Still, the title is a giveaway: something's going on with religion. Gorey's insects resemble praying mantises; their blood sacrifice can be read as a sardonic parody of Christianity—an Aesop's fable for unbelievers. Is Gorey's lapsed Catholicism showing? To atheist eyes, the insects' worship of an insect god calls to mind Voltaire's quip that man created God in his own image.

Gorey, of course, was no help. The inspiration for *The Insect God*, he claimed, was some medieval woodcuts of insects he'd seen on cards or notepaper at the Metropolitan Museum. "Poor Millicent. It wasn't her fault."[11]

What, exactly, is *The West Wing*? That it's one of Gorey's bona fide masterpieces everyone seems to agree: the Gorey scholar Karen Wilkin thinks it's one of his "most beautiful and poetic achievements"; Mel Gussow, writing in the *New York Times*, called it a "wordless masterwork."[12]

Yes, but what *is* it? At first glance, it's a picture book that tells its story in thirty "silent" panels, meaning: without a word of accompanying text. Gorey's first experiment with wordless narrative, it was surely prompted by his fondness for playing with form. But he liked to toss critics a red herring by pointing out that the book was dedicated to Edmund Wilson, who had taken him to task for the awkwardness of his limericks in *The Listing Attic*. "Edmund Wilson castigated me wildly for

them," he told an interviewer. "That's why when I finally dedicated a book to him, it had no text. I thought, 'That will fix you, Edmund. Now what will you be able to say?' "[13]

A visual poem in pen and ink, *The West Wing* is a series of scenes linked by the free-associated logic of dreams.* Nearly all the exquisitely rendered drawings depict rooms in what appears to be the usual Gorey manse, most of them empty yet all of them thick with atmosphere. We can't shake the creeping sensation that something has happened, or is about to happen, or *is* happening before our unseeing eyes in the spirit realm. What's going on in the fourth panel, where an open door in one bare, disused-looking room gives onto the open door in another? There's a sense of communication between the two untenanted rooms; of something passing between them. The main character in *The West Wing*, as in all haunted-house stories, is the house itself.

The West Wing. (Simon and Schuster, 1963)

*According to the Gorey collector Irwin Terry, "The dates on the back of the drawings show that the art was created in no particular order over a two year period." See Irwin Terry, "Beautiful Remains: The Vinegar Works on Display," *Goreyana*, March 27, 2013, http://goreyana.blogspot.com/2013/03/beautiful-remains-vinegar-works-on.html.

Nowhere is Gorey's synthesis of surrealism and the gothic more seamless. He has mastered the surrealist art, perfected by Magritte, of charging the most banal imagery with an occult electricity and of presenting the marvelous—a room full of ocean, its ruffled waters halfway up the walls; a boulder sitting on a Chippendale table—with jarring matter-of-factness. But he's fluent, too, in his use of gothic and horror-movie tropes: a sheeted ghost glimpsed in a mirror, a mummy making its foot-dragging way down a hall, a flickering candle floating in midair.

The book's title underscores its spookiness: the West, in religion, myth, and folklore, is the land of the setting sun—the abode of the dead. Since time immemorial, the sun's nightly disappearance in the west has been seen as a descent into the afterworld. The Western Lands, in the ancient Egyptian Book of the Dead, are where the departed live and gods and monsters dwell. Twilight is the Goreyest time of day, as noted earlier, because it's "neither one thing nor the other"—not day, not night, but in between, a transitional state like dying, which it has come to symbolize. (The dying of the light in the west recurs in Gorey stories. In *The Unstrung Harp*, "there is a drowned sort of yellow light in the west, and the impression of desolation and melancholy is remarkable.")

Twilight is a borderland, and "the border of borders is of course death," Gorey told Peter Neumeyer.[14] Then comes a revelation: "The title the book does not have, but which is there in my mind, is *The Book of What Is in the Other World*"—a chapter in the Egyptian Book of the Dead detailing the sun god Re's descent into the underworld through a portal in the far west and his travels in the kingdom of the dead during the night.[*]

In a 1963 interview, Gorey left no doubt about the book's meaning: "The West Wing," he said, "is where you go after you're dead."[15] That candle hanging in midair (held, we assume, by some spectral hand) leaves us, on the book's last page, with a potent image of the frailty and brevity of human existence. Soon it will gutter and go out, an extinction foreshadowed by the act of closing the book, which has the effect

[*]Of course Gorey owned a copy.

of snuffing it. On the back cover, a skull-faced moon peers down on the mansion, whose stone facade and pitch-black windows give it the look of a sepulchre or a death's head. *The West Wing* is Gorey's gothic-surrealist Book of the Dead.

It's also the purest expression of his belief that meaning is in the eye of the beholder and that the most successful works of art leave gaps for us to fill, avoiding the Jamesian pitfall of leaving "nothing left to think about, nothing left to question," as Gorey put it.[16] *The West Wing* is *nothing but* gaps, a truism literalized in panel 16, which consists almost entirely of a densely crosshatched wall with an empty niche in it. *Fill the niche*, Gorey urges.

All this time, Gorey was holding down his day job at Bobbs-Merrill and juggling freelance assignments such as his illustrations for *Let's Kill Uncle* (1963) by Rohan O'Grady, a deliciously sinister novel about a ten-year-old orphan's plot to do away with his fiendish uncle before he (the uncle) can murder him (the orphan) for his inheritance—just the sort of thing that would appeal to Gorey, who once observed, "When I was 12, I read a book called *A High Wind in Jamaica* by Richard Hughes. In it, good-natured pirates rescue some kids from a hurricane. But in the end the kids are responsible for having the pirates hanged. That killed the myth about innocent children for me. It was the sort of book you never forget, and you never feel the same because of it. I didn't need *Lord of the Flies* as a paradigm."[17]

On a lighter note, he illustrated *Three Ladies Beside the Sea* (1963) by the opera director Rhoda Levine, who dabbled in children's fiction when the mood struck her. Told in quatrains, *Three Ladies* is a bittersweet mystery story (of a sort): why, Edith and Catherine wonder, does their friend Alice spend her life literally out on a limb—perched in the branches of a spindly, leafless tree, scanning the skies? "I am looking out there for a bird I saw once, / Who sang to me as he flew by" is Alice's poignant explanation, which may or may not be a veiled reference to lost love. There's a

windswept Cape Cod melancholy to some of the drawings, especially the scene in which we see Alice, who has at last come down from her tree, standing by the water's edge, gazing out to sea. On the sand nearby lies a single tiny seashell, an emblem of loneliness.

Interestingly, Alice's first appearance, sprawled in the spidery branches of her tree, is a visual echo of the scene in *The Blue Aspic* in which the unhinged opera fan Jasper Ankle escapes from the insane asylum by climbing a tree overhanging the wall. Karen Wilkin makes a convincing case for the image as an allusion to the Paul Klee etching *Virgin in the Tree*—yet more evidence of Gorey's wide-ranging tastes and photographic eye.

Gorey's prolific streak continued, in '63, with his book *The Wuggly Ump*, published by Lippincott. It's another one-line joke, but a hilarious one, a relentlessly perky parody of the "sunny, funny nonsense for children" that made him shudder. According to Gorey, it was the only one of his books that was published as a children's book, but adults are quick to catch on to its mockery of the hyperventilating cheeriness of bad kiddie lit. Drawn in a suspiciously whimsical style and narrated in chipper couplets, *The Wuggly Ump* begins with a juvenile trio gamboling among the posies. It consists of two girls and a boy, a recurring configuration in Gorey's work, perhaps in fond memory of Cape Cod summers with Skee and Eleanor Garvey. (His most obvious homage to that inseparable trio is *The Deranged Cousins*, inspired by a beachcombing ramble with the Garvey sisters.) The sky is bright turquoise; the children are wreathed in smiles—a rare thing in Goreyland. "Sing tirraloo, sing tirralay," they chirp. "The Wuggly Ump lives far away."

Of course, all confidence is false confidence in Gorey's cosmos: the Ump, it turns out, is too close for comfort—on the next page, in fact. Gorey's answer to Lewis Carroll's Jabberwock, it looks like a cross between an overgrown rat and a dinosaur and wears its bear-trap maw in a perpetual toothy grin, which makes it look both goofy and frightful. The Ump subsists on "umbrellas, gunny sacks, / Brass doorknobs, mud, and carpet tacks," but clearly wouldn't scruple at a juicy child. ("Enumeration or lists of things form an essential part of Nonsense," Elizabeth

Sewell notes in her landmark study *The Field of Nonsense*. Both Lear and Carroll were fond of lists, she reminds us, the more absurdly miscellaneous the better—a tendency that encourages the bizarre juxtapositions beloved by the surrealists.)[18]

Soon enough, bright-smiling death is at the door and, in a jiffy, the children are in the monster's belly. But Gorey's satire of the grammar-school catechism of pep and positivity follows the script to a T: the children, like all good children in midcentury children's books, look on the sunny side of life, even if they've been swallowed whole. "Sing glogalimp, sing glugalump," they warble cheerily "from deep inside the Wuggly Ump."

Gorey claimed that *The Wuggly Ump*, like *The Insect God*, was the result of his "imitative" tendencies rather than the desire to say something. "I tend to be very imitative, so if I see something I like, I think, 'Oh, I'd love to do something like that,'" he said in a 1977 interview. "The original impetus may be totally goofy. I remember, and I really still don't know what the connection is, *The Wuggly Ump* started from a book about that size. I don't know what the text said because it was in German; it was by Christian Morgenstern. But it was a little Easter book with rabbits and eggs and God knows what else.* What that has to do with *The Wuggly Ump*, do not ask me."[19]

Of course, some would argue, as the Duchess does in *Alice*, that "everything's got a moral, if only you can find it."[20] In their essay "Nonsense and the Didactic Tradition," Celia Catlett Anderson and Marilyn Fain Apseloff locate *The Wuggly Ump* ("a masterpiece satire on children's verse") in the tradition of nonsense poems characterized by an "absurdly understated reaction to serious disasters."[21] The children's comments on the Ump's nasty habits and ferocious aspect are hilariously discreet in that upper-class English way: "How most unpleasing, to be sure!" As Anderson and Apseloff point out, "It is a type of humor that has proved very popular in the twentieth century. Generated at times by

*Christian Morgenstern (1871–1914) was a German poet and writer of satirical, Lear-inspired nonsense verse, of which the best known is his darkly funny *Gallows Songs* (1905). The Easter-themed book Gorey mentions is probably his children's book *Ostermärchen* (Easter fairy tale).

the fact that some things are so horrific they can be dealt with only with laughter, nonsense attacks didacticism and simplistic piety in a manner similar to that used in the theater of the absurd." If the twentieth century teaches us anything, it's that the monster isn't always slain in life's theater of the absurd, and even if he is, he often devours a lot of innocents first—a very Gorey moral indeed.

The Wuggly Ump's dedication reads, "For my parents." We don't know if it's an oblique comment on Gorey's upbringing; he could be arbitrary, dedicating whatever he happened to be working on to some obscure personage without implying any relationship between story and dedicatee. (In what may be the best dedication in literary history, he dedicated his 1983 anthology, *Amphigorey Also*, to "the dog at Gay Head, 27.iv.83," referring to the clay cliffs at Gay Head, a beach on Martha's Vineyard. A close second is his dedication of *The Abandoned Sock*, for no other reason than the sound of the name, to "Velveola Souveraine," a brand of soap popular around World War I.)

Nonetheless, the timing of the dedication suggests that it must have *some* significance: the book came out the year Edward Leo Gorey died of cancer of the liver, the collateral damage of one too many nights carousing with the gentlemen of the press and Chicago pols. He was sixty-five.

We have no idea what Ted's relationship with his father was like near the end of Ed's life; he makes next to no mention of either parent in his correspondence and was evasive when asked about them in interviews and casual conversation. "They were very unlike," says Skee Morton, of Ted and Ed. "He did go back to Chicago when his father was dying. He had cancer and I think it went downhill quite quickly."

Touchingly, Ed claims bragging rights to his son's accomplishments in a July '62 letter to Corinna, reporting with manifest pride that Ted is now "Art Director and production manager and book designer for Bobbs-Merrill."[22] He promises to send her copies of the forthcoming

Ciardi titles and one of Ted's own, a children's book—*The Wuggly Ump*, most likely. Writing in his jokey, toastmaster mode, he reminisces about Ted's recent visit, for Father's Day, just after he (Ed) got out of the hospital. The elder Gorey cracks wise about his eccentric offspring's "luxuriant red beard" and his habit of pairing Brooks Brothers outfits with "old beat-up white sneakers." To the very end, Edward Leo Gorey seemed as baffled as ever by his son.

As for Gorey's feelings toward his father, the card called "The Ancestor" in his parodic tarot, *The Fantod Pack*, may offer a clue. It depicts the archetypal Gorey father figure, a Victorian-Edwardian gent in the mandatory beard and fur-collared overcoat, secure in his social status and hirsute manliness. But where his face should be, above the beard and mustache, is nothing, a featureless blank. He's a cipher—the Dad Who Was Never There.

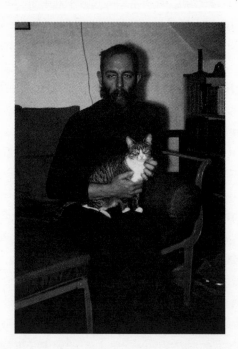

Gorey in his attic room at the Garveys' summer house in Barnstable, Cape Cod, 1961. (*Photograph by Eleanor Garvey. Elizabeth Morton, private collection.*)

Whether Edward Leo's passing had much of an effect on Ted, and whether he made his peace with his father before he died, is, like so many intimate matters in Gorey's life, shrouded in mystery, as they say. More consequential in the long run was his firing from Bobbs-Merrill and his self-reinvention as a full-time freelance illustrator and book designer (and, of course, author).

With the newfound freedom of being self-employed came the joy of spending more than half the year on the Cape, far from the Manhattan he abominated, in the rambling old house the Garveys had bought in Barnstable, on Millway Road. "Virtually, my life is arranged around the New York City Ballet," Gorey told an interviewer. "I leave New York to work at Cape Cod the day the season closes and I arrive back the day before it opens."[23]

He'd wanted to buy into the Garvey house, but ironing out the legal details proved to be too much of a headache, so it was agreed that Ted would help furnish it with his antique-shop finds. He claimed the attic as his own, sleeping and working in a little chamber—the proverbial garret—just off the low-ceilinged, heavy-beamed main room.

Illuminated by a single small window, it has the feel of a ship's fo'c'sle. Like so many other writers, Gorey seemed to prefer spaces that concentrate the mind and minimize distractions. (His studio in the house he bought in 1980, in the nearby village of Yarmouth Port, would have made a monk's cell feel spacious.) Most artists need natural light to work by, the more the better; Gorey's willingness to sacrifice light for glorified closets that shut out the world underscores his point that he thought of himself as a writer first. (Of course there was another reason that Gorey, unlike most artists, didn't require natural light or a space bigger than a broom closet: he didn't draw from life. Instead he relied on his prodigious imagination and vast library, especially Dover books such as *Victorian Cottage Residences, Children of the Past in Photographic Portraits,* and *Victorian and Edwardian Fashion,* to bring Goreyland to life.)

Nineteen sixty-three marked a turning point in Gorey's artistic life.

He'd published four books, one of which, *The Gashlycrumb Tinies*, would come to be seen as his signature work, the epitome of the Goreyesque, and another of which, *The West Wing*, would be recognized as a masterpiece. Yet another, *The Wuggly Ump*, would be hailed in retrospect as a salvo in the postwar revolution in children's books, a cultural insurgency whose advance guard included Seuss, Sendak, Ungerer, Silverstein, Beverly Cleary, and Roald Dahl, among others. In hindsight, the scene in *The Wuggly Ump* in which the children slurp up their "wholesome bowls of milk and bread" reads as an eye roll at the mush publishers were serving America's kids.

"The main audience in those days for children's books was the school and library market, and we felt that they probably wanted more wholesome books," says Ann Beneduce, who as an assistant editor at Lippincott worked with Gorey on *The Wuggly Ump* and the Ciardi titles he illustrated. "He opened the door to a whole realm of illustration that was there but was not being catered to."

Attitudes about childhood have changed, she points out, as have children themselves. "There are many very ironic books and scary books; there's a more sophisticated child audience than there was then." These days, she notes, "there are many books that are parodies of the classic tales, and children love that; they love being so sophisticated that they can see how foolish these things are. I think Ted Gorey was onto it before the rest of them; he really opened the gate. Children like roller coasters, as long as they're well strapped in, and I think there's some of the same feeling in Ted's books—a feeling of dread that has a smile at the end."

CHAPTER 10

WORSHIPPING IN
BALANCHINE'S TEMPLE

1964–67

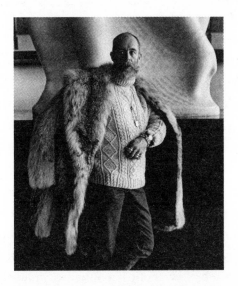

Gorey near one of the Nadelman sculptures on the promenade at the New
York State Theater, 1973. *(Photograph by Bruce Chernin. Image provided by the
Alpern Collection, Rare Book & Manuscript Library, Columbia University.)*

ON THE EVENING OF April 23, 1964, the New York City Ballet opened
the doors to its new home, the New York State Theater at Lincoln
Center,* with a gala performance of Balanchine's *Allegro Brillante* and

*Renamed in 2008, the New York State Theater is now the David H. Koch Theater, after
the philanthropist and archconservative political donor—a name many New Yorkers of the
liberal persuasion refuse to use.

Stars and Stripes. It was, for all practical purposes, Gorey's new home, too, five months out of the year.

As in all the rituals that governed his life, he was compulsive in his devotion to routine, arriving for 8:00 p.m. performances at 7:30, when the doors opened. Yet he sometimes spent long stretches in the lobby if he didn't like one of the evening's offerings. Gorey "had to be there on time, partly (he would say) because maybe they would change the order of the program, but I think it was just his compulsion—he *had* to be there," says Peter Wolff, a ballet friend of Gorey's who now sits on the board of the George Balanchine Foundation. "It was all part of his insane routine."

During intermissions, Gorey could be found in the theater's main lobby, the Grand Promenade, located above the orchestra level. Three tiers of undulating balconies overhang the room; Elie Nadelman's massive, generously proportioned female nudes, sculpted in white marble, bookend it. Inevitably, Gorey was near a bench by the east stairs, at the center of a circle of gossipy, inexhaustibly opinionated ballet obsessives. Toni Bentley, a Balanchine dancer turned author whose *Costumes by Karinska* features a foreword by Gorey, recalls him "leaning in his full-length fur coat, in his full-length beard, against the left-side Nadelman statue at intermission every single night."[1]

Gorey "was very breezy about his opinions," tossing them off in an artless manner, says Peter Anastos. "He just sat back and proclaimed evident truths about the company from a lofty cloud."[2] He had a flair for the bitchy bon mot, dubbing Suzanne Farrell and Peter Martins, neither of whom he could abide, "the world's tallest albino asparagus."[3] Asked about the moldy chestnuts of the classical repertoire, he sniffed, "*Les Sylphides*? Where they're all looking for their contact lenses?"[4] That said, his pronouncements were never mean-spirited. "Even if Ted hated something or somebody or some costume or set, and covered it with abuse, it was never really very fearsome," Anastos emphasizes. ("You can often hear me bitching about somebody's performance, but I'm bitching on a terribly high level," said Gorey.)[5]

Behind the bitchy witticisms, however, was a profound appreciation

of Balanchine's genius, says Anastos—"a knowledge and a familiarity with every arcane aspect of life at the NYCB going back to City Center days" coupled with a fluency in the vocabulary of ballet (arabesques and *grand jetés* and *penchés* and all the rest of it) that enabled Gorey to pick apart a dancer's performance on a technical level and compare it to another ballerina's interpretation of the same steps, way back when. He tossed off his aperçus in a nonchalant manner that dared the listener to take them seriously, although dance critics such as Arlene Croce, of the *New Yorker*, and intellectuals such as Susan Sontag, who knew Gorey from Bill Everson's screenings, knew better. "They'd want to know what he thought of things," Peter Wolff recalls. "He was experiencing it on a different level." People who didn't know Gorey may have thought he was "a campy character because of the way he dressed and spoke and all that," says Croce, but he impressed her as "utterly serious...a thoughtful man who made penetrating remarks" yet was "genuinely witty."

To those who weren't admitted into his charmed circle, however, Gorey could exude an in-crowd snootiness. Even old friends such as Larry Osgood and Freddy English got the freeze-out, since they were mere balletgoers, not acolytes of the Balanchine cult. "Ted would be holding court with his admirers and his fellow aficionados and you couldn't get near him," says Osgood. "He wouldn't even recognize old friends who might try to approach him during the intermission."

Some of this may have been high-school-cafeteria cliquishness, but it might have had something to do with Gorey's secretiveness, too. He lived a compartmentalized life, maintaining strict boundaries between his social lives: between his Harvard friends and his ballet coterie, between his New York circle and his Cape Cod crowd, and so on. For the nearly three decades he went to the ballet, the Promenade crowd *was* his social life when the NYCB was in residence. "I have very little social life, because the only people I have time to see are the ones I'm going to the ballet with," he said.[6]

New York City in the '60s and '70s was the dance capital of the world. Balanchine was producing works of genius; the NYCB was a

239

serious contender for the most dazzling collection of dance talent on the planet; avant-garde choreographers such as Merce Cunningham, Alvin Ailey, Twyla Tharp, and Paul Taylor were blazing trails for modern dance. The fever-pitch anticipation that greeted the premiere of a new work by Balanchine is unimaginable today, when the New York City Ballet no longer dominates New York's cultural consciousness. "Being in New York in the '70s with Balanchine working was like being in Salzburg when Mozart was working," Wolff recalls. "It was like abstract expressionism: it was of its time; it was wildly earth-shattering."

Seeing a Balanchine premiere was an indispensable part of being culturally au courant, of understanding the zeitgeist. "The lobby of the State Theater was the one place where you could see, night after night, literary intellectuals like Susan Sontag, the poetry critic David Kalstone, the essayist Richard Poirier, the cartoonist Edward Gorey, the music and dance critic Dale Harris, the editor of Knopf, Robert Gottlieb—and dozens of others," recalled Edmund White, the novelist and memoirist, in his essay "The Man Who Understood Balanchine."[7] "We were all enjoying a rare privilege—the unfolding of genius. Balanchine had started out in imperial Russia, reached his first apogee under Diaghilev in France and, in the 1930's, moved to the United States, where he led dance to summits it had never known before."

Gorey's sentiments exactly. "I feel absolutely and unequivocally," he said in 1974, "that Balanchine is the great genius in the arts today. . . . My nightmare is picking up the newspaper some day and finding out George has dropped dead."[8]

When Gorey wasn't worshipping in Balanchine's temple, he was hard at work at the drawing board (if he wasn't at the movies). Nineteen sixty-four saw the release of a spoken-word record, *The Dream World of Dion McGregor*, a collection of monologues by the "sleep talker" Dion McGregor, along with a companion book of McGregor's somniloquies. Gorey illustrated both, employing the laborious fine-line technique

he reserved for his own work and projects that caught his fancy, as McGregor's voice-overs for his zany dreams apparently did.

An aspiring songwriter, McGregor suffered, supposedly, from a sleep disorder that caused him to narrate his dreams aloud. His roommate tape-recorded these nightly sessions, and Decca Records released the results. Shot through with macabre humor and brimming with bizarre imagery, McGregor's babblings sound like a cross between sketch comedy and the trance poems spouted by Robert Desnos at surrealist séances. His nocturnal emissions, as one wag called them, told of cemeteries for midgets, "food roulette" played with a poisoned éclair, and a cottage whose closets were fitted with meat hooks, handy for hanging overnight guests ("See that they *swing* properly. Yes, on their meathooks. Gorgeous meathooks").[9] The record flopped, but it's easy to see why Gorey would have gotten a bang out of it.

Meanwhile, the little books kept coming. In 1964, Gorey published *The Nursery Frieze,* another Fantod Press production. It was, he later wrote Peter Neumeyer, "perhaps my favourite work of mine."[10] In an interview, he said, "I tend to like the ones that make the least obvious sense," ticking off *The Nursery Frieze, [The Untitled Book],* and *The Object-Lesson* as examples.[11]

When Gorey says *The Nursery Frieze* makes less "obvious" sense than most of his books, we have to wonder if he's putting us on. To most readers, the question is whether it makes *any* sense. True to its name, the book consists of a long friezelike procession of squat, dark creatures—or, very possibly, a single creature caught in successive in-stants, like the galloping horse in Eadweard Muybridge's stop-motion studies of animal locomotion. Judging from the rough sketches included in the exhibition catalog for Karen Wilkin's *Elegant Enigmas: The Art of Edward Gorey,* the beast began as a hippopotamus; by the time it made its debut in print, it had morphed into an anxious-looking capybara, or maybe a tapir, or something in between. Marching fretfully through cartoon-lunar terrain reminiscent of the sublimely empty landscapes of George Herriman's *Krazy Kat,* it utters, in rhyming couplets, a series of non sequiturs: "Archipelago, [cardamom], obloquy, tacks / Ignavia,

samisen, bandages, wax," and so on, through "Corposant, madrepore, ophicleide, paste / Jequirity, tombola, sphagnum, distaste," all the way to "Wapentake, orrery, aspic, mistrust / Ichor, ganosis, velleity, dust."

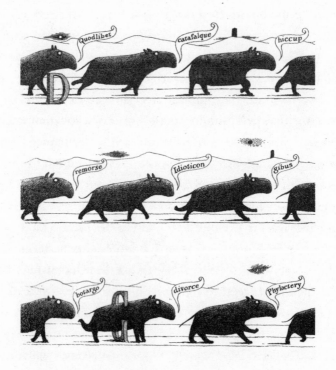

The Nursery Frieze. (Fantod Press, 1964)

As Gorey would groan, in the middle of movies that drove him bonkers, "Can someone please tell me what this is in *aid* of?"[12]

We can try. First, that worried, capybaralike creature is a nonsense-verse staple, the imaginary beast, like Carroll's Bandersnatch, Lear's Pobble Who Has No Toes, and Sendak's Wild Things. It takes its place in the Gorey bestiary alongside the Doubtful Guest, the Wuggly Ump, Figbash, and the Bahhum Bug (from *The Haunted Tea-Cosy*), to name a few. It tells us that we're in nonsense territory, as does Gorey's list of heterogeneous things, which, as mentioned earlier, is an essential non-sense trope. By rattling off a catalog of weird words that tickle his fancy

and roll trippingly off the tongue, Gorey is also giving us an inventory of the arbitrary. Such nonsense lists mock taxonomy's attempts to impose order on a disorderly world in the same way that Borges does in "The Analytical Language of John Wilkins," the essay that inspired Gorey's unfinished book, *The Interesting List*.

Speaking of categories, Gorey was that specific species of eccentric, the collector. Like Zeph Clagg in *The Willowdale Handcar* with his prized collection of more than seven thousand telephone-pole insulators, he amassed all sorts of things: cats, of course, and books by the ton, but also finials and antique potato mashers and pewter salt and pepper shakers and countless other curiosa. Yet he hoarded immaterial things, too: ideas and images (he could see the entire NYCB repertory "like a movie in my head," he claimed) and, of course, words, which he jotted down in his ever-present notebook with the satisfaction of a lepidopterist snaring a butterfly.[13] Newspaper puzzle pages were an inexhaustible trove of obscure, archaic, and sesquipedalian words, too. When the Cape Cod gang was having dinner, Ted would "quickly finish and then start doing the [*New York Times*] crossword puzzle or the acrostic," says Ken Morton. "He just found it joyful to manipulate words and letters." In *The Nursery Frieze*, as in later books such as *The Glorious Nosebleed* (1975), in which every sentence ends with an adverb, and *[The Untitled Book]*, whose text consists entirely of gibberish, Gorey gives himself over to the unalloyed pleasures of wordplay.

That said, the words spoken by Gorey's capybara-whatsit weren't just plucked out of a hat. Gorey *chose* them—after coming across them in his battles with the crossword or his peripatetic reading—and because he chose them, they, like the odd bits of driftwood he picked up in his beachcombings, have things to tell us about his interests and outlook. Some are predictably Goreyesque: *dismemberment*, *exequies* (funeral rites), *catafalque* (a raised bier for a coffin), *Gehenna* (in the Old Testament, a fiery place where the souls of the wicked are tormented, or, if you prefer, a valley near Jerusalem where the followers of Moloch sacrificed children). In keeping with his interest in old-fashioned things, many of the words in *The Nursery Frieze* are nineteenth-century relics

such as *gibus* ("a collapsible top hat operated by a spring," according to the *Collins English Dictionary*).[14] A surprisingly high percentage have religious associations, such as *epistle*, *hymn*, *thurible* (a censer used in ecclesiastical rituals), and *purlicue* (the reviewing, in Presbyterianism, of a previous sermon)—evidence of Gorey's abiding interest, however sublimated, in religion. A few of the words evoke the idler persona Gorey liked to affect: *ignavia* (indolence) and *velleity* ("1. volition in its weakest form. 2. a mere wish, unaccompanied by an effort to obtain it"—was there ever a more Goreyesque sentiment?).[15]

The oddest thing about *The Nursery Frieze* is its ostensible purpose: to act as a decorative band around a tot's room and, presumably, promote the notion that reading is "fun–damental," as the literacy campaign has it. Gorey's matter-of-fact presentation of preposterous words such as *febrifuge* and *jequirity* as age-appropriate vocabulary is funny on its face. And what sort of parent would adorn his or her child's nursery with a frieze whose subtext seems to be morbid religiosity and death? Imagine laying yourself down to sleep, after praying the Lord your soul to keep, with thoughts of dismemberment and Gehenna in your little head! Doomfully, the last word in the frieze is *dust*, to which we all return, a gloomy sentiment perfect for the Puritan nursery. Sweet dreams.

In 1965, Gorey brought out *The Sinking Spell*, his fourth and last title with Ivan Obolensky, and *The Remembered Visit*, published by Simon and Schuster.[16]

An amusing, bemusing little Victorian-surrealist mystery without a solution, or, better yet, an absurdist joke without a punch line, *The Sinking Spell* has the feel of Charles Fort's matter-of-fact retellings of those mind-boggling freak occurrences now called Fortean phenomena. Fort was especially fascinated by weird weather, specifically, what he called falls—red rain, black snow, showers of frogs or fish, "thunderstones," "the fall of a thousand tons of butter," and so forth.[17] The tale of a mysterious presence that descends, by degrees, through an Edwardian

household, unsettling everything it touches, *The Sinking Spell* would be right at home in a Fort collection like *The Book of the Damned*.

Told in couplets, Gorey's story begins with the arrival, in the middle of an Edwardian family's croquet game, of a "creature floating in the sky." Gorey never describes it, and it remains invisible to us throughout the story, though it's plainly visible to the family. Closer and closer it comes, until, "morose, inflexible, aloof," it hovers just above their house. It moves ever downward, floor by floor. It frightens the maid, "declines in fretful curves / Among the pickles and preserves," and finally disappears forever into the cellar floor.

No one in the unflappable, well-starched family has any idea "just what can be meant / By this implacable descent," nor do we. Gorey hazarded the theory, in a letter to Peter Neumeyer, that the book had something to do with crossing borders, passing into realms from which there is no return. A "sinking spell," in the nineteenth century, was a sudden collapse, from illness, into a dead faint or deathlike sleep. The title is a pun: Gorey's sinking spell is a literal one, a diabolical enchantment that causes something to descend from the heavens, passing wraithlike through anything in its path, en route, we assume, to the underworld. Once again, Gorey's subject is death. Ultimately, though, he seemed as baffled as the family in the story by the dreamlike events that bubbled up from his unconscious.

Tinged with a sense of lost time and suffused with regret, *The Remembered Visit* is one of Gorey's serious works, though he undercuts that seriousness, as always, with his light touch. The writing is inimitably Goreyesque—"Tea was brought: it was nearly colourless, and there was a plate of crystallized ginger"—and the drawing is superb: in the opening scene, in which we see Drusilla on an ocean liner, the overlapping patterns of the stylized waves recall the seas in prints by Hokusai and Hiroshige.

When Drusilla's parents go on an excursion and never return, she

takes their disappearance (or is it her abandonment?) in stride. A family friend, Miss Skrim-Pshaw, takes her to meet Mr. Crague, "a wonderful old man who had been or done something lofty and cultured in the dim past." They take tea in a garden "where the topiary was being neglected." Mr. Crague can't show Drusilla his albums filled with beautiful pieces of paper, he regrets, because they're upstairs in his room; she promises to mail the old gent "some insides of envelopes she had saved" when she gets home.

Days melt into months; months dissolve into years. Catching sight of one of those fiendish little imps last seen in *The Hapless Child*, Drusilla remembers Mr. Crague. Hunting for the envelope linings she'd promised to send, she happens on an old newspaper, which informs her that he died "the autumn after she had been abroad." In a flashback, we see him slumped in the garden where the trio had tea. "When she found the pretty pieces of paper, she felt very sad and neglectful. The wind came and took them through an open window; she watched them blow away."

In one of his letters to Peter Neumeyer, Gorey reveals that *The Remembered Visit*, subtitled *A Story Taken from Life*, *was* indeed "a story from real life, the germ anyway."[18] Dedicated to Consuelo Joerns, the book was inspired by Joerns's encounter with the English actor and stage designer Edward Gordon Craig (1872–1966). "The visit itself took place when Connie was introduced to...Craig in the south of France," Gorey writes, "and the paper collection is true." A pioneer of symbolism in scenic design, Craig used movable colored screens in conjunction with richly tinted lighting to create dramatic visual harmonies.

Following the surrealists' lead, Gorey produced the story by channeling his unconscious. "At the risk of sounding potty," he tells Neumeyer, "the sentence 'Mr Crague asked Drusilla if she liked paper' was something I felt strongly at the time I was incapable of, that it came from somewhere else."[19] He notes that it's not in his "usual vein" and speculates that it has something to do with innocence. (There's the whispered hint of a Humbert-Lolita flirtation in Crague's comment, which echoes the old come-on "Would you like to come upstairs to see my etchings?")

Perhaps *The Remembered Visit* isn't really *about* anything in the conventional narrative sense. Rather, it evokes a mood—a sense of longing and, most of all, the ache of regret, a feeling that sneaks up on us as the years go by.

In the fall of '65, Gorey taught a course called "Advanced Children's Book Illustration" at the School of Visual Arts, a college of art and design on East 23rd Street. SVA stressed professional experience over academic credentials, recruiting its faculty from artists working in commercial fields.

Gorey returned to SVA in the fall of '66 to teach two sessions of "Advanced Children's Book Illustration" and again in the fall and spring of '67 to teach "Children's Picture Books" ("A workshop for those who want to write and illustrate their own books, with emphasis on the development of ideas and on creative individuality").[20] He's listed among the faculty in the 1968–69 course catalog as well, but what course he taught, or whether he just guest-lectured, we don't know.

Nor do we know whether he was driven to teach, as so many freelancers are, by the need to bolster his income. Likewise, we have no inkling of what kind of professor he was. It's hard to imagine Gorey, who by his own admission tended "to be very inconsequential and trail off," running a classroom. But SVA invited him back, so he must've passed muster.

To announce his 1965 course, Gorey produced a brochure, wittily designed in the form of a book jacket. The course name is given on the spine, and Gorey's thumbnail biography, along with details about the class's meeting time and so forth, appears on the back. A course description, included on the jacket flaps, is worth quoting at length:

The course will emphasize the creative and imaginative aspects of illustrating—and writing—children's books and give practical experience in techniques, media, design, and typography. Included

will be an informal history of children's books, their illustrations, and their illustrators, and a survey of the field now, ranging from the picture book for the youngest child to the novel for the young adult, from the most popular work to the most sophisticated. The course will deal, also, with the nature of illustration, its various kinds and purposes, its relationship to text, and the two conceived as an entity.... The main work of the course will be illustrating and designing a complete book.[21]

Gorey's emphasis on the interrelationship of text and image ("the two conceived as an entity") goes to the heart of his approach to illustration, which was rooted in a deep understanding of the way words and images can form a whole greater than its parts. "I think my drawing is not terribly good at best, but I do know how to illustrate a book better than most," he once observed. "Illustrations shouldn't be smaller than the book—that's why you couldn't possibly illustrate Jane Austen. At the same time, they shouldn't be larger. Aubrey Beardsley's drawings for *Salome* make Oscar Wilde seem in a way rather idiotic. The drawings are so powerful they create their own world, and one more interesting than Mr. Wilde's. They are a perfectly terrible job of illustration, demolishing the text they are attached to."[22]

On the front cover of Gorey's brochure is a stick-thin man jauntily attired in a seersucker jacket and broad-brimmed straw hat; a defeated-looking corvid roosts on his head. He's perched on the capybarapotamus from *The Nursery Frieze*, which is lumbering along with the same look of wide-eyed unease it wore in that book.

The creature was Gorey's totem animal in those days. His business card from that period depicts an identical pair of the beasts trotting past each other, caught in the moment of their conjunction. BOOK DESIGN reads the word balloon—more of a banner, really—unfurling from one creature; EDWARD GOREY says the other.

Significantly, Gorey chose not to identify himself as an illustrator, a job title he may have seen as too limiting. His training in book design at Doubleday and his bibliophile's fascination with books as

objects converged in a vision of the book as a medium for creative expression and formal innovation. "My training caused me to be very conscious of what constituted a book, so I have always been very careful in coordinating the parts of my books, putting them together," he said in a 1978 interview.* "I naturally think in terms of how many pages there will be, how the pages turn, and so forth."[23] Gorey saw every detail of book production, no matter how mundane, as an invitation to design—a philosophy that, when given full rein, yielded benchmarks of the book designer's art, elegant yet economical, as in his 1972 omnibus, *Amphigorey*.

Nineteen sixty-six brought up a bumper crop of Goreys.

The December issue of the men's magazine *Esquire* featured "A Chthonian Christmas," the sort of holiday feature Gorey was often asked to do—to his undying vexation, no doubt, given his detestation of holidays. This was the golden age of magazines, and *Esquire* was riding high, its ad-fat issues overstuffed with the innovative New Journalism of zeitgeist dowsers such as Tom Wolfe and Gay Talese, fiction by heavy hitters such as Norman Mailer and John Cheever, and celebrity profiles. At 360 pages, the December 1966 issue had an editorial budget that could easily afford witty frivolities like the Fantod Pack, the Gorey tarot that was part of "A Chthonian Christmas."

"A Chthonian Christmas"—the Goreyan adjective means "of, or

*David Hough, who as the production director for adult books at Harcourt Brace and Company worked with Gorey on *The Haunted Tea-Cosy* and *The Headless Bust*, offers a fascinating behind-the-scenes look at just how attentive Gorey was to every detail of the production of his books. "Edward understood and was meticulous about the production of his books (the paper, the binding, the trim size, the printing)," Hough told me in a September 6, 2012, e-mail. "Edward's art boards were meticulous. There was only a rare boo-boo that he had to correct. He certainly didn't need editing—though I remember a bit of ruckus over that hyphen in *The Haunted Tea-Cosy*. His art came self-contained and perfect.... I think people should be reminded that he was a meticulous and hardworking craftsman as well as an artist of genius."

relating to, the underworld"—includes eight Gorey cartoons. In one vignette, a trio of children find Father sprawled beside the hearth, throttled with a Christmas stocking. In another, a man, confronted by the December days left on his wall calendar, eyes his gas range speculatively. Behind the black humor, we detect a whiff of the loneliness that's only made bleaker by other people's holiday cheer.

The centerpiece of "A Chthonian Christmas" is a two-page gallery displaying the Fantod Pack, a set of twenty tarot cards designed and illustrated by Gorey.★ As late as 1969, his interest in esoteric matters was still going strong. "In answer to your queries," he wrote Peter Neumeyer that January, "of course I believe in graphology, also palmistry, the *I Ching*, the tarot, astrology, and all those other delicious things you can find in places like thesaurusi (can that be the plural? No, it can't, it must be thesauri), which turn out to mean prognostication by means of snail tracks or something."[24] (As noted earlier, Gorey's "belief" wasn't a literal faith in the oracle's prophetic powers. The Taoist in him thought it might be one of many ways of tapping into the Tao, while his inner surrealist hoped it might prove useful in accessing the unconscious.)

Gorey didn't intend the Fantod Pack to be taken all that seriously, but like most of his jokes it hints at hidden truths. After all, he chose the images that make up his Major Arcana, handpicking them from the visual lexicon of characters, objects, plants and animals, and landscapes that recur in his work. (The Major Arcana are the tarot's trump cards.)

Like Magritte's surrealist painting *The Key to Dreams* (1930), the Fantod Pack is an inventory of unlike things whose only connection is their role in the artist's personal mythology: urns ("The Urn"); the bearded, fur-coated, hypermasculine gent ("The Ancestor"); dead, dying, and ill-used children ("The Child," a grinning skeleton tot pulling a wooden animal on wheels); the Black Doll (which, unlike the other

★The Fantod Pack has been published as an actual pack of cards in various versions. It first appeared in 1969, in pirated form, as a cheaply produced deck released by the Owl Press. In 1995, the Gotham Book Mart published a quality edition. The most recent version is the laminated, crisply printed set produced by Pomegranate in 2007.

nineteen trumps, bears no title and has no explanation beyond "In the words of the old rhyme: What most you fear / Is coming near").

On the back of each card, Figbash—the Doubtful Guest's curious cousin, an inscrutable creature with a long-beaked, featureless face; a squat, short-legged body; and impossibly long arms—rides a unicycle while balancing a platter on his upraised hands. On the platter sit a skull, a chalice, and a candle, barely more than a stump but still burning—memento mori rich in occult associations, though their spookiness is undercut by Figbash's antics.

"The Bundle." *The Fantod Pack. (Gotham Book Mart, 1995)*

Each of the Fantod Pack's cryptic images dares us to uncover its meaning. But one card, "The Bundle," suggests that the key to Gorey's dreams will always elude us. A bulky package tied up with a latticework of ropes, it calls to mind *The Enigma of Isidore Ducasse* (1920), a surrealist object created by the photographer Man Ray in homage to Ducasse's deathless line, in his novel, *Les Chants de Maldoror*, "beautiful as the chance meeting, on a dissecting table, of a sewing machine and an umbrella."* In Ray's case, we know what's inside the lumpy blanket tied with twine: a sewing machine. The contents of Gorey's bundle, on the other hand, are unknowable.

To those who believe that "eroticism is all-pervasive, almost claustrophobic, in his little books," as the author of one magazine profile asserted, "The Bundle" will invite the obvious Freudian reading: a stifled sexuality, kept tightly under wraps.[25] At the same time, it has a huddled, abject look; its outline strongly suggests a shrouded figure with its head on its knees—the universal posture of despair. Like the rest of Gorey's "great secrets," it's an arcanum whose purpose is to remain arcane.

True to its name, *The Inanimate Tragedy* (Fantod Press, 1966) is a tragedy—a farcical tragedy, but a tragedy nonetheless—of Death and Distraction, Destruction and Debauchery, as its Greek chorus puts it. The Greek chorus, in this case, is a thicket of overemoting pins and needles, part of a cast of commonplace objects that also includes a marble, a thumbtack, a pair of buttons, a bit of knotted string, and a "No. 37 Pen point."

Joseph Stanton, in his essay for the exhibition catalog *Looking for Edward Gorey*, reads *The Inanimate Tragedy* as a fatalistic "tragedy of manners" that lampoons human society as a war of all against all in which "intrigue and gossip undermine reputations and destroy lives."

*Really, the Comte de Lautréamont's line, since Ducasse wrote his 1868 protosurrealist novel under that pen name.

Things end badly, in a comedy of terrors. Grappling on the brink of the Yawning Chasm, the villains of the tale, the Knotted String and the Four-Holed Button, lose their footing and plummet into the crevasse. Lemminglike, the other characters follow them over the brink: the Two-Holed Button flings itself into the Chasm, quickly followed by the Pins and Needles. For no good reason, the "Half-Inch Thumbtack" drops dead.

There's no causal relationship between any of the scenes in *The Inanimate Tragedy*, and much of the action lacks any discernible motivation (though the fact that we're discussing the dramatic motivations of thumbtacks and buttons is a testimonial to Gorey's absurdist wit). Yet Gorey manages, through the measured repetition of motifs (gossip, plotting, the Two-Holed Button's high-strung reactions, the chorus's interjections), to give his desktop drama a Sophoclean fatefulness.

Where are we? Somewhere on surrealism's topography of the unconscious, where the tools and toys of everyday existence come uncannily to life. The featureless waste where most of the action takes place—a white nothingness bifurcated by a horizon line—recalls Yves Tanguy's moonscapes, littered with cosmic debris, and the lonely stretch of Catalonian beach where Salvador Dalí's limp watches washed ashore.

But can mundane things such as thumbtacks and buttons be reborn as surrealist objects? No doubt, especially if they blur the line between animate and inanimate. Peter Neumeyer told Gorey that he found the book not only "surreal" but also "cold and steely—quite chilling I think—in its suggestion of a depopulated world" reminiscent of the uncanny dreamscapes of "Lewis Carroll, early still life surrealists with pots and pans, or Fernand Léger cogs and wheels."[26]

Nonsense literature turns an irreverent eye on the system that structures our understanding of our societies, ourselves, even our realities: language. *The Inanimate Tragedy* isn't nonsense, but its inscrutable story unfolds in a series of non sequiturs that obscure as much as they reveal. It reminds the literary theorist Peter Schwenger of the leaps of illogic that characterize "the most jumbled dreams" and of the psychologist Jean Piaget's "description of children's narratives where 'causal rela-

tionships are rarely expressed, but are generally indicated by a simple juxtaposition of the related terms.'"[27] In his essay "The Dream Narratives of Debris," Schwenger writes,

> The large cast of characters [in *The Inanimate Tragedy* is] playing out a drama to which we do not have access. It's not just that we don't have the answers; we don't even know the questions.... Yet every frame of this drama seems to be fraught with significance, even while the frames don't always link up with one another. Not only are the characters of this tragedy bits of debris; narrative elements themselves have become a kind of bric-a-brac that can be willfully shuffled...[28]

For Schwenger, *The Inanimate Tragedy* is at once "a sly satire of narrative, especially its more melodramatic nineteenth-century versions," and a postmodern critique of narrative's claim that it tells us "the truth," whether that truth is the hard fact of nonfiction, the representational truth of literary realism, or simply the causality that gives a story its shape and meaning.[29] Gorey raids the grab bag of conventional fiction for his plot devices—"reversals, mistaken identities, miscommunications and secrets"—but divorces them "from the specious promise of 'truth,'" Schwenger argues. "In place of truth he gives us play, a play beyond the rules of the game, or rather a play *with* the rules of the game."

The Inanimate Tragedy was published in *Three Books from the Fantod Press*, a paperback collection issued in a yellow envelope that also included *The Pious Infant* and *The Evil Garden*. (Printed in an edition of five hundred copies, it was the first of four such collections bearing that name.)

In *The Pious Infant*, Gorey is once again in mock-moralistic mode, with wickedly funny results. Told in prose and shorter by half than his thirty-page norm, it's a merciless parody of Puritan children's literature, inspired by *A Token for Children: Being an Exact Account of the Conver-*

sion, Holy and Exemplary Lives, and Joyful Deaths of Several Young Children (1671–72) by the Puritan divine James Janeway, an enormously popular book in its day. Gorey's hero, Little Henry Clump, is a model of plaster-saint piety, scolding other boys for "sliding on the ice" on Sunday ("Oh, what a shame it is for you to idle on the Sabbath instead of reading your Bibles!") and taking care to blot out, in books, any "frivolous mention of the Deity." But the Lord moves in mysterious ways: God expresses his love for Little Henry by buffeting him with a freak hailstorm. The child sickens and dies but goes to his reward: "Henry Clump's little body turned to dust in the grave, but his soul went up to God."

Gorey's parody uses the Calvinist gloom and grim didacticism of the original to mock the guilt, hypocrisy, and hell-haunted terrors that fire-and-brimstone fundamentalism has inflicted on generations of American children. How close to home that critique struck we don't know, though it's difficult to imagine that the dry chuckle of irreligious sentiment that echoes through Gorey's work doesn't have *something* to do with his parents' abortive attempts to raise him as a Catholic.

Amusingly, Gorey once played the role of devil's advocate in real life. Chris Garvey, the son of Gorey's cousin William Garvey, recalls the time he and Ted talked about the Faith of Our Fathers. "I was going to Catholic school at the time," he says, "and I had made up a play altar and was playing at being a priest, and we talked a little bit about religion, and I probably gave him some Catholic-school answers, and he said, 'Oh my God, you're the pious infant!' I said, 'What's that?' He said, 'Well, it's a book I wrote and it's like you've come to life!'"

Gorey rarely mentioned Aubrey Beardsley, but the magnificent orchestration of black and white in *The Evil Garden* strongly resembles Beardsley's dramatic, Japonism-influenced drawings for *The Yellow Book* magazine, which Gorey knew.

The bold interplay of inky black and stark white that made Beards-

ley's work so arresting in the 1890s was his ingenious solution to the limitations of photomechanical printing, which reproduced all lines and solids in the same tone value; intermediate shades had to be suggested through stippling, cross-hatching, or striated lines. In *The Evil Garden*, Gorey utilizes a nearly identical technique for his scenery but renders his characters in an almost diagrammatic style that recalls the *ligne claire* (clear line) aesthetic of the Belgian cartoonist Hergé (whose Tintin comics Gorey collected).

The book recounts, in rhyming couplets, an Edwardian family's ramble through a botanical garden. The park looks Edenic but soon reveals itself to be one big booby trap, a turnabout foreshadowed by the eerie sound, as they enter the garden, of "falling tears" that "comes from nowhere to the ears." Great-Uncle Franz has the life wrung out of him by a constrictor; a carnivorous plant swallows an aunt feetfirst; "A hissing swarm of hairy bugs / Has got the baby and its rugs." As night descends on the doomed family, Gorey brilliantly reverses his polarities, switching for the last two scenes from nearly all-white backgrounds with black accents to pitch-black backdrops with white elements floating here and there. The effect is that of a shivering minor chord, sustained by the orchestra's string section, as the curtain falls.

Rounding out Gorey's bibliography for 1966 was *The Gilded Bat*, a gothic valentine to the Diaghilev era, when the Romantic ballet of the nineteenth century was giving way to the modernism pioneered by choreographers such as Balanchine. It's also an affectionately humorous tribute to Gorey's first, unforgettable encounter with the ballet, in January of 1940, when he saw the Ballet Russe de Monte Carlo at Chicago's Auditorium Theatre.

Drawn in a fine-grained, almost pointillist style, *The Gilded Bat* begins in the Edwardian era and ends in the '20s, paralleling the life span of the Ballets Russes. Young Maudie Splaytoe's ascent from toiling ballet student to anonymous trouper in the Ballet Hochepot's corps de ballet

to "the reigning ballerina of the age, and one of its symbols," mirrors the rise of modernism, which Diaghilev and the Ballets Russes helped midwife.

Simon and Schuster published *The Gilded Bat* in book form, but it had been serialized earlier that year in *Ballet Review*, whose readers had fun sleuthing out Gorey's obscure references and inside jokes. Yet *The Gilded Bat* is more than Trivial Pursuit for balletomanes. As Selma G. Lanes points out in her essay "Edward Gorey's Tantalizing Turns of the Screw," "It is, at once, a work of grim satire and deep seriousness. Nowhere does Gorey's melancholy grasp of the realities of the artist's daily existence get hammered home more insistently."[30] *The Gilded Bat* counterpoints the gauzy fantasies the audience sees with the bleak reality of an artist's life. We see Maud in her cheerless room, washing her leotards in the sink: "Her life went on being fairly tedious." Even after she becomes "the reigning ballerina of the age," her life is "really no different from what it had ever been": we see her, alone as always, working out at the barre; she's such a washed-out soul that she's on the verge of disappearing into the enveloping gloom, a grayness created by a blizzard of minute pen strokes.

It's those innumerable dots and dashes, as much as the scene itself, that tell us something about the solitary, laborious hours Gorey invested in his art—at the expense, perhaps, of intimate relationships. When he shows us Maud monkishly devoted to her art, untouched by the passion seething all around her, it occurs to us that he's confiding something about himself. (Most of that passion, intriguingly, is same-sex desire: Miss Marshgrass, the mannishly lesbian backer of Madame Trepidovska's ballet school, becomes jealous of Madame's attentions to Maud; in another scene, a pair of epicene, limp-wristed male dancers flirts backstage while Maud's father looks on with distaste.)

When Serge, a member of the company, develops "an unlikely infatuation with her"—the adverb is instructive—the disconcerted Maud has a heart-to-heart with the Hochepot's manager, the Baron de Zabrus, who assures her that "only art [means] anything." He echoes the thoughts of the Diaghilevian impresario Boris Lermontov

in Michael Powell and Emeric Pressburger's ballet film *The Red Shoes* (1948), a movie Gorey would not have missed and that may well have influenced *The Gilded Bat*. Denouncing a ballerina "who is imbecile enough to get married," Lermontov warns his protégée, the young ballerina Vicky, "You cannot have it both ways. A dancer who relies upon the doubtful comforts of human love can never be a great dancer—never!" "That's all very fine, Boris, very pure and fine, but you can't alter human nature," says the choreographer Ljubov. Lermontov replies, "No, I think you can do better than that—you can ignore it."[31]

That, in a nutshell, was the Gorey strategy for avoiding romantic distractions: ignore your nature, and it'll go away. He saved his passion for his art and sublimated any desires he might have had into a kind of cultural eros—his love of books, his cinephilia, and most of all his balletomania. "It was to ballet that Edward Gorey gave, I think, most of his adult passion," writes Alexander Theroux in *The Strange Case of Edward Gorey*.[32] "He was capable of great adoration, truly Stendhalian in power, and over the years he was explicitly devoted to such great ballerinas as Patricia McBride, Maria Calegari...and...Diana Adams."[33]

The Gilded Bat is dedicated to Adams, one of Balanchine's "muses" and Gorey's "favorite dancer of all time."[34] She was "crystal clear, absolutely without mannerisms, and she had one of the most beautiful bodies I ever saw in a ballet dancer—flawless proportions, those ravishing legs," he recalled. "If I had to name the single greatest performance I ever saw, I'd say it was Diana rehearsing *Swan Lake*. She had no make-up on and a ratty old whatever dancers rehearse in, and she was chewing gum, and she walked through half of it, but it suddenly had all the qualities..."

Prima-ballerina worship, like its close cousin opera-diva adulation, is a gay cliché, like a fondness for show tunes or a fanatical devotion to Streisand. Peter Stoneley argues, in *A Queer History of the Ballet*, that gay men in the "mid-twentieth-century"—that is, pre-Stonewall— "tended to identify with [female] stars who gave 'an excessive or parodic

performance of femininity,' such as Joan Crawford, Mae West, and Marlene Dietrich."[35] The cartoonish femininity of such stars was so obviously a put-on that rather than reinforcing gender norms, it undermined them by underscoring the point that femininity and masculinity are roles we perform, a kind of drag. In like fashion, ballet struck a subconscious chord with gay men because it, too, makes "visible an 'excessive' and obviously 'worked' version of gender," Stoneley asserts, "whereby the woman produces, through much labor, an extreme version of lightness and delicacy."

Gorey's passion for the ballet is too aesthetically complex, his appreciation of Balanchine's genius and the artistry of dancers like Diana Adams too profound, to be squeezed into a queer-theory pigeonhole. Still, the gay veneration of prima ballerinas such as Dame Margot Fonteyn is so well established, and ballet's association with gay culture such a commonplace, that ignoring those connections would amount to willful blindness. *The Gilded Bat* isn't just a book about the ballet; it's also a profoundly *gay* book about the ballet: slyly coded references to same-sex desire keep popping up, and Diaghilev and the Ballets Russes are central to the story. "In the decades following Diaghilev's death, the legends of the Ballets Russes served as touchstones that revealed the presence of queerness," Stoneley writes. "One need not admit one's own sexual preferences, nor inquire into another person's, when one could more cautiously discover a mutual enthusiasm for and knowledge of Nijinsky and the Ballets Russes."[36]

At the same time, Gorey's balletomania was an aesthetic religion. "The more I go on, the more I feel Balanchine was the great, important figure in my life," he told his friend Clifford Ross. "In what way?" Ross wanted to know. "Well, sort of like God," said Gorey, in all seriousness.[37] Both Christianity and the ballet are about transcendence: ascending to heaven, *grand jetés*, the Rapture, the Black Swan's never-ending fouetté in *Swan Lake*. Both conjure visions of gravity defied, dreams of weightlessness that are really about a leap out of the mundane into the sublime.

Gorey's light touch and understated wit give *The Gilded Bat* a somber

frivolity, but the image he leaves us with—Mirella's gilded bat wings floating against the darkness—is truly affecting. "At the gala her costume was suspended from the centre of the stage while the music for her most famous variation was played in her memory." (She'd met her end a page earlier when "a great dark bird" flew into the propeller of her plane.) Gorey evokes one of the most poignant moments in ballet history: shortly after Pavlova died of pneumonia, having refused the surgery that might have saved her life but would have ended her career as a dancer, her company performed as scheduled, but her solo was danced by a spotlight on the empty stage.

Ballet's evanescent illusions of beauty and transcendence are purchased at the cost of isolation and the grinding monotony of practice, four or five hours a day, year in, year out—an ascetic regimen Gorey, who scratched away a good part of his life alone in little rooms, knew all too well. For some, though, "only art means anything." Pavlova's last words, according to legend, were "Get my 'Swan' costume ready."[38]

In December of '67, on the eve of her eightieth birthday, Frances Steloff sold the Gotham Book Mart to Andreas Brown. Anxious about what would happen to the legendary store when she went to the great remainder bin in the sky, her most devoted customers had urged her to appoint an heir. For $125,000, Brown got a renowned literary mecca, a stock of some five hundred thousand volumes, a fifth-floor walk-up above the shop, and Steloff as "consultant." (She "fooled them all by living to be 101," he later joked.)[39] He must never think of himself as the Gotham's owner, she gravely informed him, only its caretaker. Oh, and she would continue to reign supreme over the alcove where books on Eastern mysticism and New Age spirituality were shelved. And her overfed cats would still have the run of the store.

Brown had made a name for himself in the book trade as an appraiser of rare books and manuscripts. En route to Europe from the West Coast

in 1959, he'd made a pilgrimage to the shop. He was standing near the register when an assortment of diminutive volumes, priced from fifty cents to a buck, caught his eye. Intrigued, he had a half dozen or so of the "funny little books" shipped to his home, in San Francisco. "Well, when I got home from Europe and I read them, I said, 'We've got another extraordinary human being that's doing something no one's ever done before,'" he recalled decades later.[40]

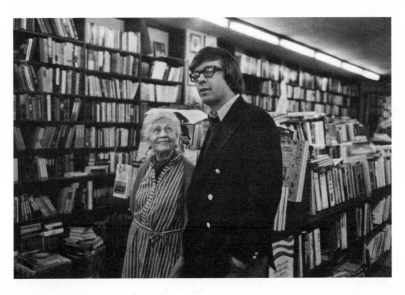

Frances Steloff and Andreas Brown in the Gotham Book Mart, 1975. *(Photograph by Larry C. Morris. Used by permission of Larry C. Morris/*The New York Times*/Redux.)*

Soon after moving to Manhattan to oversee the running of the Gotham, he met Gorey, a frequent visitor to the store. "When I told him how much I admired his work, he got a little nervous," Brown remembered. "He was a little shy about that kind of thing."[41]

Under Brown's guidance, the Gotham promoted new waves of literary avant-gardists while staying true to the modernist icons in Steloff's personal pantheon. As the Gotham's sales of Gorey's deliciously "biscuity" little books (Theroux) outstripped those of any other store, Gorey's relationship with the Gotham's new owner deepened.[42] In 1970, the Gotham

brought out *The Sopping Thursday* under its own imprint. It was the first of eight Gorey titles Brown would publish. Publishing Gorey meant that the store had ready access to first editions of those titles, which would in time command stratospheric sums among collectors. Shrewdly, Brown double-dipped, wooing collectors with pricey limited editions, signed and numbered, then striking a deal with a corporate publisher to produce a more affordable version for the trade market. To promote the release of *The Sopping Thursday*, he mounted an exhibition of Gorey originals in the Gotham's upstairs gallery, initiating what would become an annual trend.

Ahead of the marketing curve, he had the bright idea of launching a line of merchandise. In '77, the Gotham began selling Gorey-branded products, an ever-expanding category that at one time or another included Gorey bookmarks, Gorey calendars, Gorey posters, Gorey postcards, Gorey stationery, Gorey mugs, Gorey stickers, rubber stamps of Gorey illustrations, beanbag dolls of Gorey characters, Doubtful Guest pins (and other "high quality Gorey sterling silver jewelry items"), Gashlycrumb Tinies watches, "small plush cats in Gorey striped sweaters (by Gund)," and on and on.[43]

Thus was Gorey turned into a "cottage industry," as the man himself put it with his usual good-natured resignation.[44] In a 1986 interview, he was less flippant, admitting, "Frankly, I'd be lost without the Gotham Book Mart. I feel my reputation to date depends to such a great extent on them."[45]

Brown's masterstroke was the Amphigoreys, a series of anthologies that brought Gorey's out-of-print titles back into print. Noting that most of Gorey's little books were scarcer than unicorn's horns, Brown negotiated a deal with the publisher G.P. Putnam's Sons to reprint fifteen of them in omnibus form. Published in '72, *Amphigorey* was the first of three such collections produced in Gorey's lifetime. (The others were *Amphigorey Too* in '75 and *Amphigorey Also* in '83. A fourth, *Amphigorey Again*, was published posthumously, in 2006.) It was a smashing success and did much to make him an unmissable landmark on the literary map.

CHAPTER 11

MAIL BONDING —
COLLABORATIONS

1967–72

Gorey and Peter Neumeyer on the buoy in Barnstable Harbor, sometime
between September '68 and October '69. *(Photograph by Harry Stanton. Used
by permission of Peter Neumeyer. This photograph first appeared in* Floating Worlds:
The Letters of Edward Gorey & Peter F. Neumeyer, *ed. Peter Neumeyer,
Pomegranate, 2011.)*

NURTURED BY BROWN'S TIRELESS PROMOTION, the Gorey cult grew
steadily in the '60s and '70s. His little books helped spread the gospel, as
did his freelance illustrations, which never stopped rolling off his one-
man assembly line. In 1967 alone, while teaching "Children's Picture

Books" at the School of Visual Arts, he turned out covers and interior illustrations for *The Christmas Bower* by Polly Redford, an anticonsumerism parable that required a flock of exotic birds, handled with painstaking ornithological exactitude; *Son of the Martini Cookbook* by Jane Trahey and Daren Pierce, a boozy humor title that found the usual Gorey characters getting blotto at chic '60s cocktail parties; and *Brer Rabbit and His Tricks*, Ennis Rees's retelling of the classic folktales accompanied by Gorey drawings done with an uncharacteristically frisky line and fleshed out, in watercolor, with an equally out-of-character palette of goldenrod and terra-cotta.

That year Gorey published just one title of his own, *The Utter Zoo*. The third of his five abecedaria, it is a descendant of the medieval bestiary (fantastical compendia of beasts—real, rumored, and mythological—that crossed natural history with Christian allegory). As well, it owes a debt to poetic bestiaries such as Borges's *Book of Imaginary Beings*, Lear's alphabet books, and maybe even Dr. Seuss's zany *If I Ran the Zoo* (1950), with its Tizzle-Topped Tufted Mazurkas and Wild Bippo-No-Bunguses.

There are parallels to modern art, too: looked at from the right angle, Gorey's arrangements of spiderwebby line, white space, and stippled or crosshatched solids are reminiscent of abstract compositions by Franz Kline and Mark Rothko. If the comparison seems strained, consider this aperçu from a review of *Amphigorey*: "Developmentally, Gorey has been moving away from the more overt (though not unsubtle) humor of the first book collected here, *The Unstrung Harp*, toward the sort of white-on-white, black-on-black statements of minimal art."[1]

As for the text, *The Utter Zoo* is wordplay for wordplay's sake at its whimsical best. We meet all manner of Goreyesque beasts whose names roll around on the tongue as satisfyingly as gobstoppers: the fitful Epitwee; the Ippagoggy, which subsists on paste and glue; the Yawfle, a heap of hair with beady eyes that stares unblinkingly at nothing.*

*Gorey's whimsical, often comic-grotesque names, most of them preposterously British-sounding, owe an obvious debt to Lear. But do they also take a page from Dickens, the

Beneath the Learian nonsense, there's a psychological subtext to *The Utter Zoo*. Many of the chimerical creatures share personality traits with the author: some are shy and reclusive ("The Boggerslosh conceals itself / In back of bottles on a shelf"; the Dawbis "shuns the gaze of passers-by"); some face the world with the same inscrutable affect Gorey wore in journalistic photos ("The Fidknop is devoid of feeling"; the Mork has "no expression on its face"); some stuff their homes full of hoarded curios ("The Gawdge is understood to save / All sorts of objects in its cave"). One, the euphoniously named Ombledroom, sports a Goreyesque earring in one ear and is "vast and... visible by night," like our large, attention-getting friend in fur coat and Keds at ballet intermissions. Most affecting of all is the Zote, the only one of its kind, as Gorey surely was. And then there's the title, with its echoes of "too utterly utter," the phrase used to mock Wildean aesthetes; it makes us wonder if this book about weird beings is also about those who see themselves as Other.

Fascinatingly, Gorey wrote a review that same year, for the *Chicago Tribune*, of a book called *Animal Gardens*, Emily Hahn's study of the cultural politics of zoos. The only book review he ever published, it offers convincing evidence that he would have made an able critic if he'd turned his hand to reviewing books instead of writing them. His review goes straight to the heart of the matter: animal rights. Zoos, he argues, are a cruel kindness. Boredom takes its toll on wild things in captivity; forcing them to perform makes them anxious; permitting the public to feed them can be fatal, since, "innocently or not," animals are sometimes poisoned.[2] Yet for all their faults, zoos may be many species' last, best hope for survival, Gorey concedes. "Human greed, cruelty and

unchallenged master of allegorical, allusive, and deliciously onomatopoetic names? Gorey liked the darker Dickens—*Our Mutual Friend* ("because it's so scary"), *Bleak House, Great Expectations* ("with Miss Havisham brooding in the cobwebbed room")—and must have savored names like Melvin Twemlow (*Our Mutual Friend*), Woolwich Bagnet (*Bleak House*), and Uncle Pumblechook (*Great Expectations*). (See Jane Merrill Filstrup, "An Interview with Edward St. John Gorey at the Gotham Book Mart," in *Ascending Peculiarity: Edward Gorey on Edward Gorey*, ed. Karen Wilkin [New York: Harcourt, 2001], 83.) It's interesting to note, in light of Gorey's fondness for Victorian epitaphs, that Dickens, who shared Gorey's habit of strolling in graveyards, wasn't above borrowing a juicy name from a headstone.

stupidity have wiped out numerous species in the past," he writes. "As the world's human population grows, more and more of the animals' natural habitats will be polluted and destroyed, and they will be able to survive only in zoos."[3]

The idea of animal rights wouldn't enter the public conversation until 1975, when the philosopher Peter Singer published *Animal Liberation: A New Ethics for Our Treatment of Animals*. Well in advance of social trends, Gorey reveals a deep sympathy for nonhuman beings.

Actually, Gorey *did* produce another book in '67, though it was a collaborative effort. Published, like *The Utter Zoo*, by Meredith Press, *Fletcher and Zenobia* was Gorey's rewrite of a story by the illustrator Victoria Chess. She "had written a version expressly so that she could illustrate it," Gorey recalled. The publisher "loved the drawings but felt the text was unsatisfactory. So they asked me to write her a text. I kept the plot but transformed Zenobia from a human being into a doll. It was too spooky having a real live person hatched from an egg."[4]

Fletcher and Zenobia is the magical-realist tale of a cat named Fletcher who finds himself stranded in a skyscrapingly tall tree, which he'd scrambled up "in a moment of thoughtless abandon."[5] (A very Gorey phrase.) A quirky, headstrong antique doll named Zenobia hatches out of a papier-mâché egg, they dance the night away in the treetops, and the two friends fly away "to the great world" astride a giant moth. Mirroring Chess's art, with its riotous detail and eye-popping palette, Gorey's text is richly descriptive, almost hallucinatory in its supersaturated colors and gustatory delights: "Zenobia had baked a lemon cake with five layers, which she covered with raspberry icing and walnuts and decorated with green and blue candles."

With its lyrical, dreamy air, the book is unlike anything in Gorey's oeuvre, not only because it, like its 1971 sequel, *Fletcher and Zenobia Save the Circus*, was illustrated by another artist but also because the narrative scaffolding isn't his. Still, his voice seeps into the story. When

we hear echoes of an unhappy childhood—Zenobia was traumatized by her former owner, "an unfeeling child" named Mabel, who, "you will not be surprised to learn[,]...had fat wrists"—we know we're hearing Gorey.

☙

"On the whole, I enjoy collaborating with people," Gorey told an interviewer who asked about the *Fletcher and Zenobia* books. "They usually produce the text, and I do the drawings without consulting them."[6]

In the summer of '68, he met the collaborator of a lifetime, Peter Neumeyer, with whom he *would* consult—intensely. The two men crammed the creation of three children's books into thirteen months, from September '68 to October '69: *Donald and the...*, *Donald Has a Difficulty*, and *Why We Have Day and Night* (published, respectively, in 1969, '70, and '70 by Addison-Wesley, Gorey's own Fantod Press, and Young Scott Books). Gorey found Neumeyer more congenial to his mind than anyone he'd ever met; an intellectual intimacy sprang up between the two almost instantly, fueled by postcards and letters that flew thick and fast.[*]

Neumeyer, an assistant professor at the Harvard Graduate School of Education, was writing a textbook for freshman English classes. Harry Stanton, his editor at Addison-Wesley, visited him at home to discuss the book. Returning from the kitchen with glasses of bourbon, Neumeyer found Stanton brandishing a spiral-bound watercolor pad he'd noticed on his desk. "Peter, forget about the textbook. Let's do children's books."[7]

The pad in Stanton's hand was a picture book Neumeyer had written and illustrated to amuse his three young sons: *Donald and the...*, a deadpan account of a little boy captivated by a white worm that turns out to be a maggot, which metamorphoses, as maggots will, into a house-

[*]Edited by Neumeyer and published by Pomegranate in 2011, their correspondence is collected in *Floating Worlds: The Letters of Edward Gorey & Peter F. Neumeyer*.

fly with "beautiful luminous wings."[8] Not exactly your average bedtime story, but Stanton's superiors signed off on the idea, with the caveat that Neumeyer's amateur watercolors should be replaced by the work of a professional illustrator. Someone recalled Gorey's unforgettable covers for Anchor, and the deal was done.

Stanton thought writer and illustrator should meet, so he took them sailing on the Cape, off Barnstable, in his little boat. "For the most part, Ted and I sat stone-cold silent, bow and stern, stumped for easy banter," Neumeyer recalled.[9] He broke the ice—inadvertently—by dislocating Gorey's shoulder. They were stepping off the dinghy onto the pier when the boat shot out from under Gorey and Neumeyer grabbed him, saving him from a dunk in the bay but leaving him with "his left shoulder protruding from his back like the broken wing of a bird." Waiting in the emergency room at the Hyannis hospital, they struck up a lively conversation over the first drafts of Gorey's illustrations, which Stanton happened to have in his car. That conversation lasted thirteen months.

Neumeyer, who had a PhD in English, was widely and deeply read but wore his learning lightly. (*Donald and the . . .* was inspired partly by John Clare's benign tolerance of flies, which the eighteenth-century writer regarded as "the small or dwarfish portion of our own family," and partly by Uncle Toby in Laurence Sterne's *Tristram Shandy*, who shoos a fly out a window with the benediction, "Go, poor devil, get thee gone, why should I hurt thee?—This world surely is wide enough to hold both thee and me.")[10] Intellectually curious, with a discursive style of mind, he was the perfect dance partner for Gorey. Their two-hundred-something-page correspondence—seventy-five letters and more than sixty postcards, stretching over thirteen months—records "the rapid growth of a deep and mutual friendship," says Neumeyer.[11] As well, it chronicles a collaboration of uncommon inventiveness kindled by a shared delight in each other's wide-ranging, playful intellects. Gorey's exuberance expressed itself not only in lengthy missives but also in charmingly illustrated envelopes—works of art in which finely drawn, delicately painted bats, slugs, and lizardlike creatures disport

themselves, clutching banners emblazoned with Neumeyer's Medford, Massachusetts, address.

The letters double back, always, to the books they're working on, punctuated, for comic relief, by mutual expressions of annoyance at the vexations of their editor, Harry Stanton. (His "fatal defect," Gorey thought, was his "mad urge to think all the time, and roll things around in his mind, until they disintegrate into crumbs.")[12] But their intellectual curiosity—the joy of poking around in the magpie nests of each other's minds—leads them, inevitably, down fascinating conversational byways, such as their shared fondness for *Hydriotaphia, Urn Burial, or, a Discourse of the Sepulchral Urns Lately Found in Norfolk*, an eccentric omnium-gatherum about everything and nothing by the seventeenth-century English physician and writer Sir Thomas Browne.

Gorey treats his letters as comic monologues, diary entries, philosophical dialogues, commonplace books. He's frequently funny: "It slipped my mind, the surface of which is notoriously smooth and unmarked, like a blancmange."[13] But prone to the blues: "Early or rather earlier in the day I was feeling madly euphoric with the absolutely splendid futility of everything, but now I am depressed, and want to have a good cry. Perhaps I am hungry."[14] Angst is his constant companion: "I tell myself not to remember the past, not to hope or fear for the future, and not to think in the present, a comprehensive program that will undoubtedly have very little success."[15] Yet he manages to take "life in stride and with good cheer," in Neumeyer's words.[16] He has a surrealist's eye for the strangeness of the everyday: "When you see a glove lying in the street do you think that, somewhere, someone has lost a hand?"[17] And the weirdness of the body, regarded with an alienated eye: "But *is* one familiar with one's thumbs? I mean if one were suddenly confronted with them, detached as it were, would one recognize them? In looking at my own, they do not somehow seem terribly identifiable."[18]

He's deeply moved by art and literature and has the analytical powers of a gifted critic. An exhibition of Francis Bacon's work leaves him

"swooning at the sheer beauty of the painting in them," so much so that he can imagine "being able to live with the triptych where something horrid has taken place in the middle panel; all that gore and even the zipper on the bag are superbly painted."[19] He abhors the "ghastly self-indulgence" and "slimy soul-searching" of *The Catcher in the Rye* but is powerfully affected by the poems of Rainer Maria Rilke, perhaps too much so: "I must say the more doom-and-gloom ones strike all too many chords in my tiny head, and I get overcome."[20]

One of the biggest revelations in the Gorey-Neumeyer letters is what Gorey called "E. Gorey's Great Simple Theory About Art," as revealing a statement of his aesthetic philosophy as we're ever going to get.[21] Simply put, it's "the theory ... that anything that is art ... is presumably about some certain thing, but is really always about something else, and it's no good having one without the other, because if you just have the something it is boring and if you just have the something else it's irritating."[22] Then, too, things "that on the surface ... are so obviously" about one thing make it "very difficult to see that they are really about something else entirely."[23] He finds a helpful passage in an anthology of Japanese court poetry, "something to the effect that there must be a something which is above and beyond ... what the poem says and the words that say it if the poem is to be a good one ..."[24]

E. Gorey's Great Simple Theory About Art isn't so simple. It owes something to his Taoist rejection of the either/or epistemology of Western philosophy. And to his Derridean-Beckettian awareness of the limits of language. And to his Asian-Barthesian belief in the importance of ambiguity and paradox as spaces where readers can play with a text, making their own meanings. And to his surrealist sense that "there is another world, but it is in this one" (Paul Éluard). Yet above and beyond all that, there's still something mysterious in his Great Simple Theory, an elusive idea or maybe just an inexpressible quality that's more than the sum of these philosophical parts. In a postcard to Neumeyer, Gorey quotes Plato's *Gorgias*: "There is no truth; if there were, it could not be known; if known, it could not be communicated."[25]

Another striking thing about the Gorey we meet in the Neumeyer

letters is just how deeply, searchingly spiritual and metaphysical he is. He quotes from the philosopher George Santayana and the Bhagavad Gita; is thoughtful about *Zen and the Birds of Appetite* by Thomas Merton, the Trappist monk whose writings on Eastern religion and philosophy were popular in the '60s; and tells a lovely story about kite flying that perfectly captures the dogma-free lightness of his thought:

> And then today, when the wind was more fitful, at the risk of sounding remarkably silly, though I don't think to you, the kite at the end of the string was all sorts of things: a marvelous metaphor (not the right word but...) for art (?) in that from the movements of the visible object one can deduce the invisible ones of the wind, a remark that could hardly be phrased less elegantly; then obviously, but nonetheless touchingly on that account I felt, the kite as a bird, and from that the bird as a soul... with confused bits of the Chuang-Tzu/butterfly notion,* to the point of wondering who is the flyer, who the flown (dear me, I am getting tackier and tackier in my expression).[26]

Most startling of all, the Gorey of the Neumeyer letters is acutely self-analytical and, at times, nakedly vulnerable. "Having got into bed and turned out the light, I quietly burst into tears because I am not a good person," he confides.[27] (Why, he doesn't say.) This is a Gorey we've barely glimpsed until now—except in a few of the Lurie letters, and then only through the veil of the ironic, Wildean persona he often affected.

The Gorey-Neumeyer friendship was one of almost telepathic creative rapport and, atypically for men of that era, emotional openness. Of the two men, Gorey emerges as the more confessional—a shockingly out-of-character turn for someone who describes himself in one letter as one of those "emotionally impoverished types."[28] In another, he admits, "I find any direct expression of my feelings not difficult, but

*Chuang Tzu was a Taoist sage who lived circa 399–295 BCE. Gorey is referring to his famous philosophical tale of waking after dreaming he was a butterfly only to wonder if he was a butterfly dreaming he was a man.

impossible, so you will have to know without one [that] they are about our having met and our working together now and in the future."[29] Of course what he did right there was express his feelings by leaving blanks for Neumeyer to fill in. Soon enough, though, he drops his guard, confiding, "You know far more about me than anyone else in the world," and adding elsewhere, "I guess that even more than I think of you as a friend, I think of you as my brother."[30]

As for Neumeyer, he was "too congested in spirit," he confessed, "to answer with the freeness" Gorey's profession of "kinship" required, but he assured his friend, "Your existence has made something of this world that [it] hadn't the possibility of before."[31] Decades later, he was less reserved, freely admitting in a 2010 interview that his friendship with Gorey "was irreplaceable, in my estimation, and was *very* warm and very loving, and will always mean a great deal to me."[32]

For a little over a year, the two men inhabited a bubble of reciprocal inspiration—the shared consciousness of creative collaborators that the novelist William S. Burroughs and the painter Brion Gysin called "the third mind."[33] Gorey is convinced that "us is more exciting and worthwhile than anything I might be doing on my own."[34] In a later letter, he says, "I can't think of a word to identify what we seem to have spontaneously created between us; the temptation to visualize a creepy but lovable monster must be resisted."[35]

In the end, it couldn't be resisted: as the friendship deepens, a mythical beast called the Stoej-gnpf takes center stage in Gorey's envelope art. It's a close relative of the creature from *The Nursery Frieze*. Hippo-shaped yet sleekly froglike in its more acrobatic moments, with a black pelt and the usual beady Gorey eyes, it lumbers along on all fours or swings from a trapeze or scoots along on roller skates or gazes dolefully, like Hamlet, at a skull. The name is an anagram of the two men's initials (Edward St. John Gorey and Peter Florian Olivier Neumeyer), and, as its name suggests, the creature is a totem—the droll embodiment of a rare friendship, sometimes moody, often high-spirited, always mysterious. It puts a "creepy but lovable" face on their shared creative unconscious.

For those with a tendency toward shyness or reserve, the epistolary form can be liberating. Letter writing, with its combination of distance and intimacy, the solitary and the social, had a disinhibiting effect on Gorey, eliciting analyses of himself and his art that cut far closer to the bone than anything he said in his interviews. He confides his anxieties, his insecurities, his enduring passions, his everyday pleasures, his philosophies of life and art. And he does so in a way that suggests another, truer Ted behind the Wildean aesthete, the eccentric litterateur, the Puckish observer of the human comedy. Is this the Real Gorey? Or just one more aspect of a man who contained multitudes?

"Much of what I know of Ted, I learned from these letters," says Neumeyer. "However, to suggest that Gorey 'revealed' his inner self in these letters would be an overstatement. Just who Edward Gorey's inner self might have been remains highly conjectural."[36] He wonders if even the man himself unriddled that riddle. "Quotidian 'reality' was problematic for Ted," he notes, "so he was not entirely joking when he signed one letter 'Ted (I think)' and wrote in another, 'There is a strong streak in me that wishes not to exist and really does not believe I do.'" Neumeyer, for his part, "never doubted Ted's presence."[37] Reading Gorey's letters forty-plus years later brings back "his generosity, his humor, and—yes—his genius." Brief though it was, their friendship ran deep, he believes. "I still insist that we each found the other necessary, and we each spoke as true to his own heart as he was able at the time."[38]

"After little more than a year, the correspondence dwindled as abruptly as it began," Neumeyer recalls.[39] Perhaps they simply couldn't sustain the pace and intensity of their correspondence. Gorey was overwhelmed by his many freelance-illustration deadlines; Neumeyer had taken a job at the State University of New York at Stony Brook and was juggling family responsibilities and a heavy course load. Whatever the reason, the two men drifted apart. "We talked by phone, but then after a time, we completely lost touch," remembers Neumeyer, who was eighty-seven at the time of this writing. "I'm sorry about that. Was then; am now. I truly can't assign or even guess at a 'reason.' Some things appear without reason, and that's how it went."[40]

Just as suddenly as it had appeared on that late-summer day in 1968, the Stoej-gnpf vanished, as rare things will.

The books that came out of the Gorey-Neumeyer collaboration have an indescribable something about them—a whiff of metaphysical mystery, maybe—despite story lines that seem almost nonexistent if you synopsize them: Donald befriends a "white worm" that turns out to be a fly larva; Donald gets a splinter in his calf, and his mother removes it; four kids grope around in the dark, wondering why night falls, until their big brother explains it to them.

Still, there's an enchanting oddness to the books that derives, in large part, from the fact that they're children's books by two men who weren't entirely sure what a children's book was and didn't much care. "I truly can't recall Ted ever once having used the word 'child,'" Neumeyer recalled, "let alone the words 'children's book.'...Of all the people I've known, nobody has been less interested in children....[H]e didn't talk or think about 'creating books for children,' as I recall."[41]

"The next morning Donald jumped out of bed to see his worm." *Donald and the... (Addison-Wesley, 1969)*

274

The *Donald* books, and *Why We Have Day and Night*, are more about mood and a way of looking at the world than plot, and Gorey's drawings, which are among his best, enrich them immeasurably, imbuing the story—that "certain thing" the book "is presumably about"—with the other, imponderable thing they're *really* about. It's E. Gorey's Great Simple Theory About Art in action.

Technically, Gorey's illustrations for the *Donald* books are tours de force. Working in a Beardsleyesque vein rich in references to Japonism, chinoiserie, and Victoriana, he produced some of his most intricately filigreed drawings ever. The tablecloth covering the little table where Donald keeps the jar with his pet "worm" in it is a marvel, with its alternating bands of meanders, scrolls, and other Greek-revival motifs. Even the inside covers are stunning—eye-buzzing exercises in pattern-on-pattern whose juxtaposition of Victorian wallpaper, friezes, and tilework showcase Gorey's command of the pen-and-ink medium. His decision, in *Why We Have Day and Night*, to render the illustrations in scratchboardlike white on black is pure genius. When he introduces a splash of radiant orange, it has the effect of a cymbal crash.

Gorey's drawings are full of visual witticisms, some of them so subtle you only catch them on second or third reading. On the front cover of *Donald and the . . .* , Donald stands beside one of those Ming vases the Victorians loved; a googly-eyed Chinese dragon adorns it. On the back cover, Donald and his mother are amazed to see Donald's seafaring father with the dragon perched on his shoulder. In *Donald Has a Difficulty*, he gets a splinter while pushing with might and main against a tree. It's an exercise in futility, just the sort of thing a little kid would do. Closing the book, we see, on the back cover, the unbudgeable tree . . . toppled.

Neumeyer didn't think *Donald and the . . .* "was about much of anything," but Gorey encouraged him to take it seriously, he recalls, investing it "with meaning beyond what I saw . . ."[42] "My words are very simple. And Gorey . . . 'loads every rift with ore,'" he told an interviewer, quoting Keats on the importance of freighting every line with meaning. "He just takes the text and runs with it. . . . I mean, [there are]

stories within the story that are hidden. So it becomes an entirely different story, and he doesn't need to change a word..."[43]

⚜

In an April '69 letter to Neumeyer, Gorey lamented the hamster-wheel horrors of the freelance life. "I am working like mad, which has put me into a sort of continuing stupor, so that I keep myself half-thinking of work whatever else I am doing at the time," he wrote.[44] He worried about fainting "dead away from exhaustion and troubled sleep," adding, "I get all wound up, and have the most gharstly dreams..."

Chronic fatigue notwithstanding, his voracious consumption of culture (books, movies, the ballet) continued unabated. Neumeyer marveled at his ability to "do more things in one day than seems possible," calling him "a man with sixty-hour days."[45] In '68, the year he met Neumeyer, Gorey published two of his own books, *The Other Statue* (with Simon and Schuster) and *The Blue Aspic* (with Meredith Press), and illustrated six by other authors, most memorably his swooningly beautiful interpretation of *The Jumblies* by Edward Lear, published by Young Scott.

At first glance, *The Other Statue* looks like another one of Gorey's country-manor whodunits: Lord Wherewithal has been murdered by thieves intent on making off with the Lisping family's oldest heirloom, the Lisping Elbow, despite its being "made of wax and of no value to anyone else"—the proverbial senseless crime, taken to surrealist extremes. But just when we think we're settling into well-worn Agatha Christie territory, we find ourselves in a comedy of menace like one of Harold Pinter's absurdist plays.

The Other Statue sends up social mores. The book is dedicated to Jane Austen—"absolutely my favorite author in the whole world," Gorey once claimed.[46] His satire, however, is far more sardonic than Austen's comedies of manners. In keeping with his dim view of men of God, one of the creepiest characters in *The Other Statue* is a clergyman with little pig eyes who lurks "in a remote corner of the shrubbery" and preaches heresy, not piety, "at a bethel in the slums." The devious governess, Miss

Underfold, stands conventional morality on its head, too: wearing a hat festooned with black lilies, dancing at a club called the Soiled Dove, she turns the symbolism of doves and lilies—purity and innocence—upside down. The bearded, fur-coated Gorey look-alike Dr. Belgravius shares "a curious discovery" with his nephew while ogling the bare buttocks of a male statue; later, we see the two men passing a poster bearing the Latin legend NIHIL OBSTAT, meaning "nothing contrary to faith or morals"—the Catholic Church's term for a text that has secured the censor's approval. In this context, the phrase has an ironic ring.

Announced, on its cover, as part of a never-completed series called The Secrets, *The Other Statue* leaves us with nothing but secrets. For no known reason, little Augustus's "stuffed twisby" is stolen and disemboweled, joining Hortense, Charlotte Sophia's dismembered doll in *The Hapless Child*, as one of Gorey's symbols of the miseries of childhood. Miss Quartermourning loses a slice of cucumber from her sandwich, a tragedy of Wildean proportions, and, in one of those haikulike lines Gorey manages to infuse with a world of meaning, "a sudden gust came up from nowhere and rushed through the trees"—an image that somehow captures the inexpressible sadness of being alive. The harder we stare at his eerily beautiful drawing of a grove of trees at dusk, the more their leaves seem to rustle on the page, animated by countless tiny pen strokes.

Gorey's command of his medium—his pinprick stippling and spider-silk cross-hatching, his exquisite sense of compositional balance—is on display as well in *The Blue Aspic* and *The Jumblies* (and, a year later, in his equally masterful treatment of another Lear title, *The Dong with the Luminous Nose*, also published by Young Scott). In *The Blue Aspic*, his delirious drawing of the prima donna Ortenzia Caviglia in the role of Tsi-Nan-Fu is at once a fond homage to the Japanese wood-block tradition he loved and a witty study in ironic Orientalism. The decorative pattern on Caviglia's kimono pays tribute to the Japanese tradition of tenkoku[*] stamps, and the stage set's elaborately sculpted clouds and

[*]Tenkoku seals, hand-carved stone seals inscribed with pictographs representing the user's identity, are a time-honored tradition in Japan.

curlicue waves recall the highly stylized depictions of nature in ukiyo-e prints by Hiroshige and Hokusai. In his illustrations for *The Dong with the Luminous Nose*, Gorey goes further, nicking his storm-tossed waves, with their talons of foam, from Hokusai's *The Great Wave off Kanagawa*.

"As Tsi-Nan-Fu Caviglia had her greatest triumph." *The Blue Aspic. (Meredith Press, 1968)*

The Blue Aspic is a tragicomedy about idol worship gone wrong. (The time, as always, is somewhere between 1890 and 1930.) Jasper Ankle, a pathetic nebbish whose only distinguishing characteristic is his rabid fandom, stalks the opera singer Ortenzia Caviglia, the object of his adoration. Gorey underscores the perverse symbiosis of worshipper and idol by giving them the same surname. (*Caviglia* is Italian for "ankle.") He crosscuts between their intertwined lives, juxtaposing Caviglia's ascent to fame and fortune with Jasper's spiral into misery and madness. In the end, Ankle is driven to kill what he can't have, ritually stabbing Caviglia in the throat.

Written long before celebrity stalkers like Mark David Chapman (the colorless schmuck who gunned down John Lennon) were tabloid fixtures, *The Blue Aspic* reminds us that *fan* is, after all, short for *fanatic*.

Gorey, Balanchine's most obsessive fan, is making a joke about the neurotic roots of fandom at his own expense. (The book is dedicated to Larry Osgood, who thinks he may have been the one who introduced Gorey to the NYCB.) But the story can also be read as a half joking, half melancholy meditation on unrequited love, especially that immature fixation we call a crush.

All Gorey's romantic entanglements were crushes, as far as we know; he seemed to prefer real-life soap opera to sex. Whatever romantic yearnings or erotic dreams he had were sublimated into his ballet mania. His greatest love was Balanchine's dances, whose fleeting sublimity could be possessed more fully than any lover, secure forever in his memory while demanding nothing more than spectatorship.

Gorey turned forty-three in 1968. He was in demand as a freelance illustrator and beginning to earn critical recognition as an artist and author, if that year's show at the Minneapolis Institute of Arts is any indication. He'd had a show in December of '65 at the California College of Arts and Crafts in Oakland—*Original Drawings by Edward Gorey*—but this was his first exhibition at a major museum. The Minneapolis Institute gave *Drawings and Books by Edward Gorey*, which opened on September 18 and ran through October 27, the full-court press.

Yet like most artists, he was still prey to self-doubt. Rhoda Levine, whose *Three Ladies Beside the Sea* Gorey had illustrated, had a new book in the works and was determined that he would do the drawings. Set in contemporary suburbia, *He Was There from the Day We Moved In* is the story of a big, lovable galoot of a sheepdog that comes, unannounced, with a boy's new house. The book is far afield in subject, style, and setting from Gorey's home turf. In the published version, which came out in '68, his line has a hesitant, diffident quality, unlike the confident, sharply incised draftsmanship on display in the Neumeyer books. Tinting his line drawings with wan watercolor washes, he ren-

ders the characters in a quasirealistic, semicartoony style that can't quite decide which it wants to be.

The assignment was an awkward fit. When Gorey met Levine and her publisher, Harlin Quist, to discuss the book, things went badly off the rails. Harlin Quist Books was gaining a reputation for innovative children's books showcasing some of the hippest illustrators in the States and Europe. Quist was going places and knew it. They ordered drinks in a deserted bar on Madison Avenue; Gorey had wine. "We were sitting there," Levine recalls, "and Harlin is sort of talking about publishing the book, and Ted drank that much wine"—a smidgen, she indicates, with two fingers—"and he started to cry.... There were tears in his eyes, running down his cheeks, and I said, 'Ted, what's the matter?' and he said, 'What's the matter? I can only draw in one way.' I was so stunned.... I said, 'So could William Blake. So could Henry Fuseli.'" Quist was mortified and hustled everyone out of the bar and into taxis. In Levine's recollection, the two men never dealt with each other directly again. "Ted, when he would bring the drawings, he'd kind of slip them under Harlin's door."

Gorey's creative energies, in any event, were undiminished. Nineteen sixty-nine saw the publication of his second Lear title, *The Dong with the Luminous Nose*, and two books of his own, *The Iron Tonic* and *The Epiplectic Bicycle*, not to mention *Donald and the* His illustrations for *The Jumblies* and *The Dong with the Luminous Nose* are among his finest, a heartfelt tribute to the Victorian fantasist who was one of his oldest, deepest influences.* They're also among his quirkiest. Not only are the egg-shaped, spindly-legged minikins scurrying about in both books utterly unlike the dour Victorian-Edwardians who populate Gorey's own books, but the landscapes are also "similarly atypical," notes Karen Wilkin, who contends they're "among the most inventive, tonally complex" drawings in his body of work.[47]

*The flap copy for the 1968 Young Scott edition of *The Jumblies* quotes Gorey: "'The Jumblies'...was taught to me by my grandfather when I was four or five, and it has always been one of my favorites."

It's clear Gorey felt a kinship with Lear (1812–88), whose Victorian surrealism celebrates the outsider. Best known for "The Owl and the Pussycat," Lear "more than anyone else tossed aside the didactic tone and moral-instruction agendas of the reading materials that 19th-century parents favored for their children," notes Joseph Stanton, delighting young readers with his nonsense alphabets, fantastical beings, and ear-tickling coinages such as "scroobious pip" and "runcible spoon."[48] Gorey followed his lead into darker corners of the unconscious, giving the limerick and the abecedarium an ironic-gothic spin and creating a funny-grotesque bestiary all his own, teeming with Fantods and Figbashes, Wuggly Umps and Ombledrooms.

But beyond those artistic similarities lie intriguing parallels between the two men's lives. Lear suffered from bouts of melancholia—"the Morbids," he called them—as did Gorey, to a lesser degree. Lear, like Gorey, was unlucky in love and lived alone; in Gorey fashion, his boon companion was a cat, a stump-tailed tabby named Foss. Lear fell passionately in love with a dear male friend who wasn't that way inclined; their friendship survived, but Lear spent forty sorrowful years tortured by one-sided passion.

All surrealist whimsy on the surface, Lear's nonsense often has a melancholy underside. Like *The Blue Aspic*, *The Dong with a Luminous Nose* is a tale of unrequited love. The Dong—a forlorn little chap in a billowing white overcoat, as drawn by Gorey—falls head over heels for the Jumbly Girl, only to have his heart broken when she sails away. He spends the rest of his nights seeking—in vain—"to meet with his Jumbly Girl again," searching high and low by the light of his luminous nose. Circumstances conspire against the Dong, as they did against Lear's "unnatural" passion.

Whether Lear's solitary life and thwarted passions touched something in Gorey we don't know, but he must have been aware that Lear was gay, since his biographer Vivien Noakes is unequivocal on that point in *Edward Lear: The Life of a Wanderer*, which Gorey owned (along with thirty-one other books by or about Lear). An asthmatic and an epileptic as well as an unconsummated homosexual, Lear had a keen sense of himself as an outsider, as did Gorey.

He would surely have agreed with Gorey's oft-stated belief that *all* the best nonsense is shadowed by sadness. Despite being more optimist than pessimist, Gorey was prone to occasional bouts of existential despair. "Every now and then I do think life is a crock," he said. "Basically, it's really just *awful*. I do think it's stupidity that makes the world go round."[49] Consequently, "if you're doing nonsense it *has* to be rather awful, because there'd be no point. I'm trying to think if there's sunny nonsense. Sunny, funny nonsense for children—oh, how boring, boring, boring. As Schubert said, there is no happy music. And that's true, there really isn't. And there's probably no happy nonsense."[50]

That same year, Gorey produced a nonsense book that, while not happy nonsense in the sunny, funny sense, is frolicsome, in a manic sort of way. Drawn in a kooky style that suits its tone perfectly, *The Epiplectic Bicycle* (Dodd, Mead) is a gallimaufry of slapstick, head-scratching non sequiturs, and mock moral instruction. Note, by the way, that it's "epiplectic," not "epileptic," a common mistake. *Epiplectic* is the adjectival form of *epiplexis*, a rhetorical tactic in which a reproachful question is posed as a means of goading listeners into agreement.

The title encourages us to read *The Epiplectic Bicycle* as a work of moral instruction for Dadaists, though on the other hand Gorey may just be leading us down the garden path—like the bicycle of the title, a machine with a mind of its own that takes a little boy and girl for a ride through a dreamlike landscape plagued by lightning strikes, alligator attacks, and other Acts of God. The story begins on "the day after Tuesday and the day before Wednesday"—in other words, in a timeless time, perhaps the nonexistence before birth—and ends with the unsettled-looking children contemplating their deaths, perplexingly evidenced by an obelisk "raised to their memory 173 years ago." Was their bicycle ride symbolic of life's journey? Are they ghosts who don't know they're ghosts? As always, Gorey is about as much help as the oracular black bird that warns the children to "beware of this and that."

His last book of the '60s, *The Iron Tonic; or, a Winter Afternoon in Lonely Valley* (Albondocani Press), is as moody and cinematic as *The Epiplectic Bicycle* is hopped up and cartoony. Beginning in a "grey hotel"

for the "aged or unwell"—a departure lounge for the afterlife, notable for its institutional grimness*— *The Iron Tonic* is composed of a series of outdoor scenes, most of them long shots. In each "still," a detail is revealed through what Peter Neumeyer calls "monocular inserts, making the pictures have a movement and dimension kindred to film."

A winter nocturne just fourteen pages long, *The Iron Tonic* drifts, dreamily, from strollers marooned in a sea of snow to a woman addressed by God in "a voice both ungenteel and loud" to three people in a graveyard who regret that "the monuments above the dead / Are too eroded to be read." The rhymed couplets play variations on well-known Gorey tropes—toppling statues, forlorn orphans, Fortean objects falling from the sky—but the illustrations perform a somber, pensive counterpoint that gives the book an elegiac feeling.

A fugitive and lurid gleam Obliquely gilds the gliding stream.

The Iron Tonic. (Albondocani, 1969)

The drawings are among his most beautiful, especially the scene in which a figure stands marooned in the snow-cloaked wilds of Lonely Valley, taking in the white vastness and the bare black branches of the

*Fascinatingly, Gorey's rendering of the "grey hotel" on the book's first page bears a strong resemblance to the Illinois Eastern Hospital for the Insane, in Kankakee, Illinois, as it appears in postcard photos circa 1906–9, when Gorey's grandmother Mary Garvey was institutionalized there.

trees while "a fugitive and lurid gleam / Obliquely gilds the gliding stream." Gorey once said he was "really quite obsessed with landscape" but didn't "know how to deal with it";[51] *The Iron Tonic* gives the lie to such protestations.* Of course his landscapes are highly stylized, like the Japanese woodcuts he admired. "I've never really attempted to create any form from nature," he said. "I often think, 'Oh, wouldn't this vista make a lovely landscape drawing.' But I wouldn't dream of attempting it."[52] His are Taoist landscapes: the spiky trees in *The Iron Tonic*, their black branches like gothic tracery against the surrounding whiteness; the "ancient mound" rising out of the snow like a breaching whale; and the "absolutely useless stone" adrift in the dark hint at the presence of *li*, the underlying order of things that expresses itself, paradoxically, in the nonlinear patterns and asymmetry of nature. Like Gorey's other serious works—*The Object-Lesson, The Willowdale Handcar, The West Wing*, and *The Remembered Visit*—*The Iron Tonic* is thick with philosophical mystery. And, as always, the source of that mystery is nowhere in the book.

The '70s made Gorey a household name, at least in households where PBS was the channel of choice and Sunday breakfast was unthinkable without the *New York Times*. The years that traced the arc of his ascent spanned '72, when *Amphigorey* hit bookstore shelves, through '77, when *Dracula* opened on Broadway with Gorey's scene-stealing sets, to 1980, when the PBS program *Mystery!* debuted, captivating viewers with its animated Gorey titles.

He rang in the '70s by publishing three books he'd begun in 1969: *The Chinese Obelisks, The Osbick Bird* (both Fantod Press productions), and *The Sopping Thursday*, his first outing with the Gotham Book Mart imprint, marking the beginning of a relationship that would last un-

*The book is dedicated, interestingly, "to the memory of Helen St. John Garvey"—the great-grandmother (1834–1907) from whom he got his artistic talent, according to family lore. She specialized in landscapes.

til 2001, with the posthumous publication of *Thoughtful Alphabet VIII (The Morning After Christmas, 4 AM)*. *Obelisks*, Gorey's fourth abecedarium, is the only one of his books in which he plays the lead role: a fur-coated, sneaker-shod Author—not Artist, tellingly—who goes for a walk . . . and ends up dead, naturally, struck down by an urn "dislodged from the sky" by a thunderclap. *The Sopping Thursday* is a mystery of transcendent banality involving the disappearance of an umbrella (and, far less consequentially in Goreyland, an infant). Gorey's parade of black silhouettes—parasols, ornate wrought-iron fences—against a gray downpour perfectly captures the ennui of a rainy day, its dreariness driven home by the drip-drip repetition of mind-numbing declarations such as "Last night it did not seem as if today it would be raining."

All told, Gorey produced twenty-three of his little books in the '70s, not counting the omnibuses *Amphigorey* and *Amphigorey Too* in '72 and '75, postcard collections (*Scènes de Ballet* in '76, *Alms for Oblivion* in '78, and *Interpretive Series: Dogear Wryde Postcards* in '79), *Gorey Posters* (published by Abrams in '79), and the assemble-it-yourself *Dracula: A Toy Theatre* (Scribner, 1979).

Nineteen seventy-one witnessed the arrival of *Story for Sara* (Albondocani Press), a perverse little cautionary tale by the protosurrealist Alphonse Allais, and *The Salt Herring* (Gotham Book Mart), a diverting exercise in pointlessness (a man swings a dried herring from a string, end of story) by Charles Cros, like Allais a nineteenth-century French precursor of the modernist avant-garde. Gorey translated both books in addition to illustrating them. Hot on their heels came two notable works, *The Deranged Cousins* and *[The Untitled Book]*, along with a slighter effort, *The Eleventh Episode*. Written under the anagrammatic pseudonym Raddory Gewe, *Episode* is *The Hapless Child* redux. In this version, the victim gets the upper hand: after dispatching—with a pin—a masher who, like the drunken brute who terrorized Charlotte Sophia, "intended harm," an ingenue flees "to places ever more remote," where she spends her days "in painting Scenes from Life on trays." Gorey supplies the moral: "'Life is distracting and uncertain,' / She said and went to draw the curtain."

Seventy-two brought *Leaves from a Mislaid Album* (Gotham Book Mart), a gallery of portraits of furtive sleuths, slinky vamps, willowy maidens praying by moonlight, and a portentous man in black clutching one of Gorey's calling cards, whose whiteness seems to glow against his dark garb. Issued as a collection of cards, *Leaves* can be "read" in any order, but however they're shuffled Gorey's wordless illustrations give off a psychic mustiness redolent of gothic novels, murder mysteries, and the photo albums of old and inbred families with skeletons in the closet.

Published that same year, *The Awdrey-Gore Legacy* (Dodd, Mead), by D. Awdrey-Gore, is another deconstructed narrative that invites the reader to play author, reconstructing it any which way. It's Gorey's fond parody of Agatha Christie, all red herrings—arsenical buns, blowgun darts, the "curate/vicar/dean/bishop" who is also an escaped lunatic, the lady novelist in mannish tweeds who has a "passion for...other ladies"—and no solution. (Or is there? The last clue is a postcard inscribed I DID IT. E. G. DEADWORRY—the author of the book's "introductory note" and, yes, another of Gorey's anagrammatic pseudonyms.)

The following year, Gorey published his affectionately irreverent tribute to the NYCB, *The Lavender Leotard*, and his (as yet unfilmed) screenplay, *The Black Doll* (both Gotham Book Mart), as well as *A Limerick* (Salt-Works Press), a one-line joke, a mere four panels long, about the unhappy end of Little Zooks, "of whom no one was fond"; *The Abandoned Sock*, another inquiry (like *The Inanimate Tragedy* and *Les Passementeries Horribles*) into the secret lives of objects, in this case a sock that seeks its fortune in the wide, wide world, having decided that life with its mate is "tedious and unpleasant"; *The Disrespectful Summons*, a sermon on the evils of witchcraft that would gladden the heart of Cotton Mather (the witch, Miss Squill, is cast into the Flaming Pit); and *The Lost Lions*, in which the hunky, mustachioed movie star Hamish, "a beautiful young man who liked being out of doors," finds true love not in one of his devoted fans but in the lions he raises—until they're shipped off to Ohio for the winter, leaving him staring disconsolately into the snowbound wilds of New Jersey. (The last three titles were released as *Fantod IV: 3 Books from Fantod Press*.)

Categor y (Gotham Book Mart), a throwaway collection of loopy, antic cats romping through wordless tableaux, was his lone publication under his own name in '74, but he made up for lost time in '75, knocking out *L'Heure Bleue* (Fantod Press) and his fifth alphabet book, *The Glorious Nosebleed* (Dodd, Mead), whose every line ends in an adverb, as in: "He exposed himself Lewdly," the caption for a drawing of a bowler-hatted chap in an Eton collar flashing a little boy. *Les Passementeries Horribles* (Albondocani Press) and *The Broken Spoke* (Dodd, Mead) came next, in '76. In the former—another of Gorey's "object-oriented" works, in which things play leading roles—unsuspecting Victorian-Edwardians are menaced by overgrown ornamental tassels. *The Broken Spoke* consists of sixteen whimsical "cycling cards from the pen of Dogear Wryde" depicting such affecting scenes as "The Crumbath Cyclery by Moonlight" and "Innocence, on the Bicycle of Propriety, Carrying the Urn of Reputation Safely over the Abyss of Indiscretion." In '77, *The Loathsome Couple* (Dodd, Mead) appeared, followed in '78 by *The Green Beads* (Albondocani Press), about Little Tancred, who meets "a disturbed person whose sex was unclear" and who leads Tancred on a wild-goose chase for the, er, family jewels. It was Gorey's last picture book of the '70s.

Among Gorey's most memorable titles of the decade (in addition to those discussed elsewhere in these pages— *The Osbick Bird*, *The Lavender Leotard*, *The Black Doll*, *The Lost Lions*, and *L'Heure Bleue*) were *The Deranged Cousins*, *[The Untitled Book]*, and *The Loathsome Couple*.

A tale of murder, religious mania, and the perils of beachcombing, *The Deranged Cousins* chronicles the misadventures of three orphans, Rose Marshmary, Mary Rosemarsh, and Marsh Maryrose (the man of the trio and an obvious Gorey surrogate, the ghost of a Harvard *H* still visible in the stitched outline on his sweater). During a stroll along the shore, Rose and Mary quarrel over a bed slat they've found, and Mary deals Rose a fatal blow with a brown china doorknob. Things go from bad to worse:

Mary descends into morbid religiosity, and Marsh expires after drinking "the dregs of a bottle of vanilla extract he discovered in the mud."

Dedicated to "Eleanor and Skee, a souvenir of Labor Day 1965," *Cousins* was inspired by a ramble along the shore in Barnstable. ("Needless to remark, nothing happened after we took the walk," Gorey hastened to add when he and Dick Cavett discussed the book, although they really did find a bed slat, a doorknob, and a bottle of vanilla extract, he said.)[53] *The Deranged Cousins* is a darkly funny caricature of his affectionate, easygoing relationship with the Garvey sisters.

But it's equally about Cape Cod's "low-tide dolor," as the poet Robert Lowell described the distinctive mood of coastal Massachusetts.[54] It's Gorey's only book set on the Cape, and his camera eye captures the characteristic features of its low-lying landscape, from its salt marshes to its low-tide muck to its scrublands. The ocean is an agent of fate: its cast-off oddments sow strife among the cousins, setting events on their doomed course, and Mary is swept away in the end by an "unusually high tide." To Cape Codders, the ocean's changeable moods are indistinguishable from Acts of God, an ever-present reminder that the deep can swallow you up, even if you're a "religious maniac" like Mary.

Credited to Edward Pig, *[The Untitled Book]* is a little ditty, sung in a nonsense tongue, about the collapse of meaning. Throughout the book's sixteen panels, Gorey's "camera" frames a fixed shot, as in Feuillade's tableaux, of the same flagstone-paved yard. In the darkened window of a nearby house, an unsmiling boy appears—a Puritan, judging by his boy's frock, with its frilly collar. He watches impassively while an ant plays ring-around-the-rosy with various Gorey totems—a frog, a bat, a pair of stuffed whatsits. "Flappity flippity, / Saragashum; Thip, / thap, / thoo," chants the gibberish text. Without warning, a big black thingamajig streaks, cometlike, out of the sky, sending the playmates scurrying. The boy is left alone to contemplate the empty yard.

The book's theme, argues Selma G. Lanes in her study of children's literature, *Through the Looking Glass*, is the "attempt at divining some rudimentary pattern from the world's unreason."[55] If so, the moral of Gorey's story is that all such attempts are doomed to failure. Unlike *The Nursery Frieze*, whose seemingly meaningless mumbo jumbo turns out to be composed of bona fide words, the text of *[The Untitled Book]* is pure gibberish. Moreover, Gorey eschews rhyme, his usual strategy for imposing order on nonsense. The results are far from the Victorian surrealism of Lear and Carroll and closer to the Dadaist sound poetry of Hugo Ball and Lucky's word-salad monologue in *Waiting for Godot*. Even the title implies a loss of faith in language; like Gorey's signature exclamation, "O, the of it all!" it uses erasure to express the inexpressible.

(Interestingly, Gorey was painstaking in his choice of *just the right* meaningless, made-up words for *[The Untitled Book]*. In a rough draft of the text, we see him working his way through "gumbletendum, gumbletendus, splotterbendus, sopplecorum, lopsicorum, lorum, ipsifendum, ipsibendum, ipsilorum, ipsiborum," before settling on "ipsifendus."[56] The last five words, by the way, are clearly inspired by *lorem ipsum*, the Latinate gobbledygook graphic designers use to create dummy page layouts.)

Of all the books he wrote, Gorey counted *[The Untitled Book]* among his favorites because, like *The Nursery Frieze* and *The Object-Lesson*, it made "the least obvious sense."[57] Lanes calls it "a perfectly rounded little dance-drama in which nameless threats come, are seen, and neither conquer nor are conquered. It is so self-contained and tightly choreographed a work that, its alien reality notwithstanding, it is curiously satisfying."[58] Irwin Terry thinks it may well be Gorey's "most perfect book," combining "beautiful artwork, language, nonsense, and pure 'absurdist art' sensibilities. . . . Each panel is rendered with infinite detail, yet all 16 drawings . . . show the exact same courtyard that was redrawn (with weather variations) for each illustration. This technical tour de force is the backdrop for the 'drama' that takes place within the scenes. I always have Camille Saint-Saëns's *Danse Macabre* running through my

head when I read this book, which makes me feel like I am 'looking at music.'"[59]

There's one title in which Gorey treats the subject of murdered children not with the usual camp-gothic irony but with a pathos spiked with pitch-black humor. That book is *The Loathsome Couple*. It's the only Gorey title in the true-crime genre, and it's light-years away from the Firbankian wit or tea-cozy gothic of his other books. The events in question were the so-called Moors Murders, in which a pair of sullen, dead-eyed psychopaths, Ian Brady and Myra Hindley, raped and killed five children, ages ten to seventeen, near Manchester, England, between July of 1963 and October of 1965, then buried their bodies on the desolate, fog-haunted Saddleworth Moor. In one case they forced a ten-year-old girl to pose for pornographic photos, then tape-recorded her heart-rending screams and pleas as they tortured her to death. Even if you're a true-crime aficionado, as Gorey was, the tawdry awfulness of the crimes makes you want to scrub your mind with bleach.

Gorey had followed the story in the papers. "That disturbed me dreadfully, even after years of reading crime stories," he recalled. "I'm all for elegant, goofy murder. This upset me, and it became the one text I felt compelled to write."[60] The book's dedication to William Roughead, whose reassuringly Sherlock Holmesian accounts of nineteenth-century crimes Gorey loved, serves as a kind of talisman—a piece of the "sinister-slash-cozy" stuff he usually cuddled up with, brandished against the charmless horrors to come.

By transporting the subject to his familiar Victorian-Edwardian milieu, Gorey holds it at arm's length, creating an aesthetic distance that enables him to extract a queasy humor from his tale. Never has evil been more banal, from the killers' dispiritingly inept attempts at lovemaking ("When they tried to make love, their strenuous and prolonged efforts came to nothing") to their celebratory meal af-

ter murdering, "in various ways," little Eepie Carpetrod, a ghastly repast of "cornflakes and treacle, turnip sandwiches, and artificial grape soda." Often, the imagery is nearly lost in a blizzard of cross-hatching. "I purposely made the drawings as . . . unpleasant, uncharming as I could," he said.[61]

"When they tried to make love, their strenuous and prolonged efforts came to nothing." *The Loathsome Couple. (Dodd, Mead, 1977)*

Readers found the book every bit as charmless as he'd hoped. When Gorey's literary agent, Candida Donadio,* submitted the manuscript to

*Though he appears to have mentioned her in only one interview, the legendary—and legendarily hard-driving—Candida Donadio of Donadio & Olson was from around 1961 on Gorey's literary agent. Known as a tough negotiator with a keen eye for literary game-changers, Donadio sold Joseph Heller's *Catch-22* and Philip Roth's *Goodbye, Columbus*. Her client roster included those authors as well as Thomas Pynchon, Nelson Algren, John Cheever, Jessica Mitford, and Mario Puzo, among other marquee names. In the 1991 article in which Gorey mentions Donadio, the author ticks off the other professional relationships in Gorey's life: "For almost thirty years, he has had the same editor (Peter Weed [at various publishing houses, it bears noting]), the same agent (Canada [sic] Donadio), the same artist's rep (John Locke), and for over twenty years, ever since Andreas Brown acquired the Gotham Book Mart, the same co-publisher and gallery. . . . Clifford Ross . . . handles Gorey's film, television, and subsidiary rights." Cliff Henderson, "E Is for Edward Who Draws in His Room," *Arts and Entertainment*, October 1991, 20.

Robert Gottlieb, then an editor at Simon and Schuster, Gottlieb was aghast, observing that it wasn't funny (a masterpiece of understatement). "Well, Bob," Gorey rejoined, "it wasn't supposed to be funny."[62] When it was published, by Dodd, Mead, in 1977, some bookstores returned it. One sent "a very revealing letter saying, 'We think this book is absolutely revolting. Everyone in the store has read it and we refuse to carry it!' "[63]

Uncharacteristically, it was a book he felt he *had* to do, almost against his will. "I resisted writing it for quite some time, and it really is one of those things I had to get off my chest," he told an interviewer.[64] Elsewhere, he said, "That was the rare story where I felt I was working out feeling on the page."[65] But what was he working out? If you believe the lazy cliché, infanticide was *his* life's work. "I saw in them a lot of myself," he later admitted, noting, in the same interview, "I've been murdering children in books for years."[66]

Gorey's blandly matter-of-fact narration and the existential cluelessness of his blank-faced characters strip away the mythic aura that surrounds serial killers. Hopeless bunglers who fail at everything, from love to child killing (in the sense that their subsequent murders are "never as exhilarating as the first one had been"), Harold Snedleigh and his partner in crime, Mona Gritch, are revealed for the gray nonentities they are.* Of course, the less they look like monsters, the more they look like you and me. And vice versa.

All this time, Gorey was simultaneously churning out illustrations for newspapers, magazines, and books by other authors. Some projects, such as *Donald Has a Difficulty* and *Why We Have Day and Night*, both

*What are we to make of the fact that *The Loathsome Couple* is also Gorey's only romance novel, a tale of star-crossed lovers? The term *lover* probably overstates the case; Harold and Mona meet at "a Self-Institute lecture on the Evils of the Decimal System," where they "immediately [recognize] their affinity." Their bond, as with many partners in serial murder, is an unwholesome symbiosis that has little to do with genuine affection. Still, it's the only Gorey story with an adult relationship at the center of it, and, as with his own short-lived affairs, it's a dismal failure.

published in 1970, gave full rein to his talents as a literary collaborator and master of visual subtext whose illustrations added parallel narratives. But whether the job was a true meeting of the minds or just another gig to pay the bills, he eschewed hackwork, using all but the most throw-away assignments as opportunities for trying on new styles and, while he was at it, stretching the definition of what was and wasn't Goreyesque.

Gorey's last dance with Ciardi, *Someone Could Win a Polar Bear* (1970), finds him playing against type: his depiction, on the book's front cover, of a tyke effortlessly hoisting an enormous white bear aloft against a canary yellow background is done in a scribbly style that looks as if it had been drawn in grease pencil. Gorey's rough line captures the naive charm of a grade-schooler's crayon drawing.

Ciardi was one of Gorey's tent-pole clients—Old Faithfuls whose re-liable patronage cushions a freelancer from the feast-or-famine cycles that make self-employment so ulcerating. John Bellairs, a writer of young-adult novels—gothic thrillers and supernatural mysteries with a coming-of-age twist—was another.

Gorey provided dust jackets, paperback covers, and in many cases frontispieces for twenty-two Bellairs (or Bellairs-inspired) novels, be-ginning in 1973 with *The House with a Clock in Its Walls*. But the real gems are the back covers, brooding landscapes reminiscent of Ger-man Romanticism. The tumbledown castle subsiding into the heath on *The Secret of the Underground Room* and the thicket of trees huddled in a snowy field under a lemon-meringue sunset on *The Lamp from the Warlock's Tomb* are beautifully handled. Generations of middle-school readers discovered Gorey through Bellairs's books.

Younger readers encountered him in Florence Parry Heide's Tree-horn series, about the magical-realist misadventures of a little boy (named Treehorn, improbably enough), which Gorey illustrated in the fine-lined, boldly patterned style of the *Donald* books. Artist and author were well matched. Heide's omniscient narrator recounts Treehorn's antic adventures—his inexplicable dwindling in *The Shrinking of Tree-horn* (1971); his discovery, in *Treehorn's Treasure* (1981), that money really does grow on trees; his encounter with a sleep-deprived genie in

Treehorn's Wish (1984)—in an emotionally flat, matter-of-fact manner reminiscent of Gorey's authorial voice. Tuned to the sixty-cycle hum of mental life in '70s suburbia, her deadpan storytelling goes hand in glove with the flattened affect of Gorey's characters, with their pinprick eyes and perpetually fretful eyebrows. Heide's adults, who talk past each other and are hilariously oblivious to Treehorn's exclamations about genies and money trees, are the neglectful parents we've met in Gorey stories, updated for the "me" generation.

Gorey's illustrations for Heide's books are virtuoso improvisations on the theme of pattern on pattern. In one eye-jangling scene in *Treehorn's Wish*, Gorey plays syncopated visual rhythms on the competing plaids of the kitchen tablecloth and Dad's slacks and jacket, Treehorn's pin-striped pants and rugby shirt, Mom's argyle skirt, the parallel lines of the spindles in the chair backs, and the carpet's mod, orb-weaver-on-LSD motif.

Treehorn's Wish. (Holiday House, 1984)

Speaking of mod, Gorey is at ease in Treehorn's swinging '70s in a way that he wasn't in *He Was There from the Day We Moved In*. Jarring as it is to see Gorey characters in go-go boots and flares, he's clearly

having fun with the contemporary fashion and decor. When Treehorn's teacher sends him to the principal, we note the mass-produced abstract painting near the secretary's desk, a black curlicue on a white background. Naturally, the principal, a strenuously groovy dude in a double-breasted suit who spouts power-of-positive-thinking platitudes, has a *bigger* painting of a *bigger* black curlicue on his office wall.

With its mod ascots, TVs (TVs! In a Gorey drawing!), and suit-coat lapels so wide they could double as ailerons, *The Shrinking of Treehorn* reminds us, with a jolt, that outside the bell-jar world where Gorey lived most of his imaginative life, the '70s were in full swing.

In New York City, that meant white flight, rising crime, urban decay, and a budget crisis that in 1975 would push the city to the brink of bankruptcy. New York in the '70s meant open-air drug bazaars; subway cars whose interiors were tattooed, floor to ceiling, with graffiti; backstreets riddled with abandoned cars, their carcasses picked clean and left to rust. It meant walking down the middle of the street because you didn't want to make it easy for the muggers lurking in doorways. If you were female, it meant asking cabbies to wait until you were safely inside your apartment building, even if it was only a fifteen-foot walk from the curb. The heroin trade flourished. Sanitation strikes made the city an all-you-can-eat buffet for vermin. "In the 1970s New York was so shoddy, so dangerous, so black and Puerto Rican, that the rest of white America pulled up its skirts and ran off in the opposite direction," says Edmund White in *City Boy: My Life in New York During the 1960s and '70s*.[67]

Which was just fine by the aspiring Jackson Pollocks, wannabe Lou Reeds, William S. Burroughs epigones, freaks, gays, and hustlers who had moved to the city to get away from Middle America. Rents were low, especially in the disused industrial lofts of SoHo—an essential prerequisite for a thriving bohemia. And thrive it did, giving rise to the minimalist music of Steve Reich and Philip Glass,

the performance art showcased at the Kitchen, the experimental theater staged at La MaMa, the underground movies shown at art houses such as the Thalia, the emerging punk scene at CBGB's and Max's Kansas City, and the hip-hop culture taking root in the South Bronx.

Gay New York was flourishing, too. Having burst out of the closet in '69 with the Stonewall riots and successfully lobbied the American Psychiatric Association to remove homosexuality from its list of mental disorders in '73, gays exulted in their newfound pride and sense of community at Christopher Street bars, on the dance floor at Studio 54, and, more covertly, in leather bars, bathhouses, and the derelict, decaying West Side Piers. David Bowie, bisexual chic, *Cabaret* (1972), *The Rocky Horror Picture Show* (1975), disco, the Village People, and *The Joy of Gay Sex* (1977), coauthored by White, helped hoist queer culture into mainstream visibility (if not acceptance, as Anita Bryant's antigay Save Our Children campaign made clear). At last, the young gay men who came of age in the '70s, and who had spent their childhoods in the shadow of the Lavender Scare, being bullied on schoolyards and reviled in the media, were free to be out and proud.

Did Gorey, who had made the rounds on the Third Avenue bird circuit and visited the odd gay bar in the Village in the early '50s, ever wander down to Christopher Street? It's hard to imagine him in the louche milieu of the Stonewall Inn. Although TV would later initiate him into the delights of disposable culture, Gorey was resolutely a creature of high culture in his New York years, steeped in Balanchine's ballets, silent movies, nineteenth-century novels, and his own Victorian-Edwardian, gothic-surrealist fantasies. He moved, wraithlike, through the '70s as he had the '60s, seemingly untouched by the social turbulence and cultural frisson of the times. Vietnam, Kent State, Stonewall, Watergate, gay lib, disco, feminism, Son of Sam, the New York Dolls, punk rock, the black and Latino culture all around him in New York: none of these pivotal events, social phenomena, or tabloid names receives so much as a mention in any of Gorey's letters or interviews.[68] As always, he went his own catlike way, unperturbed by current events,

impervious to prevailing attitudes. (He did, however, get both his ears pierced in '77 or thereabouts—a daring move made possible by the mainstreaming of gay fashion statements, although even gay men drew the line at *one* pierced ear. "I've been meaning to do it for about 25 years and never got up the nerve till now," he told an interviewer from *People* magazine.)[69]

There *are* a few sidelong glances at the '70s—specifically, the gay culture of the era—in Gorey's work from that time. *National Lampoon*, the wildly irreverent humor magazine dedicated to the principle that nothing is sacred, let Gorey run long on his tether; he exercised his editorial freedom by submitting out-of-character cartoons like the gags published under the title "The Happy Ending" in the magazine's March 1973 issue. Two of the twelve single-panel cartoons are gay-themed; neither, curiously, was chosen for inclusion in the *Amphigorey* collections.

One shows a long-haired, epicene young man with bedroom eyes standing behind a mailbox; he's getting the eyeball from a foppish older gent with a man purse slung over his shoulder. "New York at last," the caption reads, "with a face that made long-distance trucks grind to a screaming halt, and what had been, until forty-three hours ago, the biggest basket in North Dakota." The slang and insider references require some unpacking: "long-distance trucks" may be a winking reference to "the trucks," as they were known—the big rigs parked under the elevated highway on the city's West Side. Before AIDS swung its scythe, gay men would meet for anonymous sex in the dark, cavernous interiors of the Mack trucks' unlocked trailers. As for "the biggest basket in North Dakota," a "basket," in the gay slang of the day, was a man's genitalia, clearly outlined in tight-fitting pants. The well-endowed young hustler may have been the pride of North Dakota, Gorey suggests, but he's got plenty of competition in the Big Apple. It's amazingly knowing stuff for a man who gave—or appeared to give—the gay lifestyle a wide berth.

Gorey's work intersected with the gay underground of the '70s more dramatically in *The Story of Harold* (1975), for which he provided the cover and six interior illustrations. A novel of "sadism and bisexuality,

tenderness and human love" (in the words of its cover blurb), it's by "the famous children's book author you all know," Terry Andrews. If the name doesn't ring a bell, that's because "Terry Andrews" was really George Selden, author of the much-loved children's classic *The Cricket in Times Square*. The novel is a semiautobiographical account of Andrews's bouts of S&M sex with a married man, his bizarre liaisons with a masochist, and his friendship with an emotionally disturbed little boy.

Edmund White believes *Harold* is "the earliest document that renders the feel of Downtown Village gay life in the 1970s—the mix of high culture and perverse sex, the sudden transformation, say, from a night at the opera to an early morning at the baths," shot through with "the Sade-like conviction that sexual urges are to be elaborated rather than psychoanalyzed..."[70]

What Gorey made of a novel whose narrator rhapsodizes about the delights of fisting (inserting his fist up his partner's anus), rimming (tonguing someone's anus), and the "endless love-making" that turns him into a "phallic Frankenstein...pure cock from head to toe," we'll never know.[71] At a cursory glance, his illustrations look innocuous; they seem to sidestep the book's X-rated passages, focusing entirely on the harmless antics of the little boy, whom Gorey depicts as a pint-size Edwardian gentleman, derby, waistcoat, and all. Look closer, though, and you'll see Gorey's salacious sight gags everywhere: in the phalluses hiding in the decorative motif garlanding the planter beside Harold (not to mention the tubes of K-Y Jelly on the nearby coffee table) to the minuscule but still unmistakable penises lurking in the crown molding in another illustration to the nudge, nudge-wink, wink resemblance, in a scene set in a gym, of the free weights to upthrusting members with bulging testicles. The cultural historian M. G. Lord, who was friends with Selden, says the author got a kick out of spotting the hidden penises in Gorey's illustrations. "To him," she says, "they were like the 'Nina's in a Hirschfeld."[72]

It's interesting to note that the man who once claimed to "blush crimson at the other end of the phone" when people who'd read *The Curious Sofa* tried to inveigle him into illustrating pornographic novels

had no qualms, when a gay publisher approached him about reprinting *The Story of Harold*, about being associated with the book.[73]

Gorey's career gathered speed in '72 with the release of *Amphigorey*. The collection was one of Andreas Brown's brainstorms. He'd been plying William Targ, an editor at Putnam, with first editions of Gorey titles in a scheme to "get him hooked," he later admitted.[74] Reeling in his catch, Brown proposed an anthology of Gorey's increasingly scarce little books, whetting the editor's appetite with talk of windfall profits. Seduced, Targ offered Gorey a $5,000 advance, and the deal was done. *Amphigorey* "grew out of a genuine need," Brown recalled in 2003. "His audience, primarily, back in the '60s and '70s, was young people, college and university students, and as his early books became rarer and rarer—they would sell for 50 or a hundred dollars apiece, even then—the students simply couldn't afford them. So I went to Edward, very cautiously, and explained [that the anthology Brown had in mind] would make all these books more readily available to his younger clientele."[75] It took all his wiles to convince Gorey, who was allergic to self-promotion, that an affordable omnibus of his hard-to-find books would be a gift to his growing fandom, not to mention rocket fuel for his career.*

Once convinced, however, Gorey took the bit in his mouth, design-

*Interviewed for a Gorey profile in the British newspaper the *Independent*, Brown talked about Gorey's resistance to the *Amphigorey* format. "Edward's concern was that in making an anthology, the little books would be transposed into a larger format, putting several pictures on a page. And that would destroy the rhythm—which he'd very carefully constructed—of moving through the story, page by page, frame by frame, caption by caption, so it was almost like looking at a silent film. Well, we finally persuaded him, much against his better judgment..." See Philip Glassborow and Susan Ragan, "A Life in Full: All the Gorey Details," *Independent on Sunday*, March 23, 2003, 26–32.

The books were indeed a commercial success, as Brown predicted, but Gorey was right: the format doesn't do justice to his intent and seriously diminishes the impact of his little books. Moreover, the quality of the reproductions is notably inferior to that of the originals (a state of affairs put right in recent years by Pomegranate's fine reprints of some of the titles included in the *Amphigoreys*). Readers who only know Gorey from the omnibuses will be struck, on reading him in the format he intended, by his pacing—the filmlike visual rhythms Brown mentions—and by the rich illustrative detail, much diminished in the *Amphigorey* collections.

ing every aspect of the book, from its hand-lettered text (including the copyright page) to its layout to its whimsical covers, where fat, sassy Gorey cats gambol in, on, under, and around the letters of the title (a pun, by the way, on *amphigory*, a piece of nonsense writing, typically in verse). Out in time for the Christmas season, the book was a runaway success. The *New York Times* chose it as one of the year's five note-worthy art books, hailing "the macabre drolleries of one of the finest illustrators around," and the American Institute of Graphic Arts desig-nated it one of the year's fifty best-designed volumes.[76] By the following October, the book had sold forty thousand copies, "largely through col-lege bookstores," the *New York Times* reported, and had "just gone back to press for 50,000 more."[77] "It looks as if the Gorey cult might soon become a small mob," the *Times* writer thought. By '75, the book was in its eighth printing.

"The book has never gone out of print since 1972," says Brown. "I imagine there are a quarter of a million copies that have been put into print, maybe more, and it *dramatically* changed Edward's life in the sense that, for the first time, the mainstream retail book indus-try carried Edward Gorey in their stores. They were no longer these peculiar...little books that didn't fit on the regular shelf and you didn't know whether to put it in the children's department or adult literature or humor."[78] In Brown's educated guess, "millions became addicted as a result of that book."

CHAPTER 12

DRACULA

1973–78

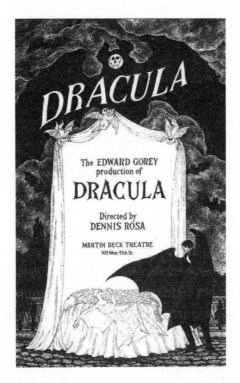

Gorey poster for the Broadway revival of *Dracula*, 1978.

IN 1973, BRAM STOKER'S *DRACULA*, which Gorey had first encountered when he was five years old, cast its bat-winged shadow across his life again.

John Wulp, a director, producer, and playwright, was planning to launch his Nantucket Stage Company with a production, that summer, of the stage play based on Stoker's novel. *Dracula* had premiered on Broadway in 1927 with the unknown Bela Lugosi as the count, his first

major English-speaking role. Wulp's version would open, somewhat less auspiciously, on the "minuscule stage at one end of a large assembly room" in Nantucket's Cyrus Peirce Middle School.[1] At a cocktail party, an "old drunk stumbled up" and buttonholed Wulp, telling him he really ought to get Edward Gorey to design the production. Wulp knew Gorey, though not well; Frank O'Hara had introduced the two men at the New York City Ballet. Still, he hazarded a call. "Sure, why not?" was Gorey's game reply.

Gorey met with the director, Dennis Rosa, and they sketched out what Wulp calls "a grand plan" for the set design, after which Ted "just went home and did his drawings and sent them to me." Brilliantly, he conceived the drop curtain, proscenium, and backdrops as blown-up illustrations. By doing so, he put the scenery in knowing quotation marks, renouncing realism for an aestheticism that emphasized the play's affinities with the gothic novel and Victorian melodrama. (He also made a virtue of inexperience: "I can no more design three-dimensional stage settings than I can fly," he insisted.)[2]

Gorey's stage design made theatergoers feel as if they'd stepped into one of his books. The proscenium was flanked on either side by sinister pansies springing from skull-shaped planters; their little "faces"—the characteristic blotches of dark color on a pansy's petals—revealed themselves, on closer inspection, to be death's heads. A winged skull, borrowed from Puritan graveyard iconography and reimagined with bat wings and vampire fangs, spanned the top of the arch. The drop curtain portrayed Lucy, the vampire's victim, menaced by the count in the light of a skull-faced moon.

Dracula was a thumping success, according to Stephen Fife, who understudied the part of Renfield, the abject wretch enslaved by the vampire's mesmeric powers. When the play opened, "the audience went nuts," he recalled, "stamping their feet, screaming, exceeding what anyone had expected."[3] For playgoers and critics alike, the sets were the star of the show. "Everything is cross-hatched—the proscenium arch, dropped curtain, scenery (out of a window of a cross-hatched room, to a cross-hatched landscape)," marveled the *New York Times* drama critic

Mel Gussow, a Gorey devotee who would prove, over the course of his long life at the paper, to be a tireless advocate for the Gorey cause. "Stylized like a thirties movie, everything is in black and white (even the emotions), except for occasional, ominous drops of red."[4]

Emboldened by the rave reviews, Wulp set his sights on Broadway, only to discover that a producer named Harry Rigby, another "great Edward Gorey fan," had snapped up the professional rights. (Wulp had only secured the summer-stock rights.) Rigby was trying to wheedle Ricardo Montalban into the title role. It would take Wulp three years' worth of maneuvering to get the Broadway rights. In the meantime, he pressed Gorey to swear an oath of loyalty to his vision of the play, telling him, "Edward, you know this was really all my idea; you must give me a letter saying that you will not design the show for anybody else." Gorey signed on the line.

Gorey amused himself, in '74, by writing movie reviews for the *SoHo Weekly News* under the anagrammatic pseudonym Wardore Edgy. Founded in 1973, the *News* was an alternative newsweekly, like the *Village Voice*. Gorey's weekly column, ingeniously titled Movies, consisted almost entirely of deliciously bitchy eviscerations, written in a dishy, just-between-you-and-me voice that crossed Ronald Firbank with John Waters. His description of Gene Hackman as "exerting all the fascination of a water stain"[5] will live in infamy; so, too, his observation that Regina Baff in *Road Movie* resembled "a disemboweled mattress"[6] and that Elizabeth Wilson's "facial contortions" in *Man on a Swing* "would be excessive on Daffy Duck."[7]

Informed by an autodidact's quirky knowledge of the medium and its history, Gorey's verdicts are guided by the unwavering compass needle of his idiosyncratic tastes. Passing judgment on Robert Altman's movies, he was happy to admit he didn't have "the faintest clue to what they are meant to be in aid of."[8] (The phrase is a patented Goreyism. Alexander Theroux remembers Gorey's mental torment during *Bobby Deerfield*,

a 1977 tearjerker about a race-car driver in love with a terminally ill woman. "Gorey literally moaned through the entire movie," Theroux recalls, "squawking, 'Oh, for Christ's sake!' and snapping several times out loud, 'Can someone please tell me what this is in aid of?'")

Yet the more he detests a film, the more fun he has with it. Gorey's reviews, like Gore Vidal's talk-show banter, are vehicles for bon mots, the wickeder the better. He finds *The Great Gatsby* (1974), with Robert Redford and Mia Farrow, "boring, boring, boring" to watch but great fun to hate: "Bruce Dern's splendidly bushy mustache, which so effortlessly stole *The Laughing Policeman* from Walter Matthau's lower lip, has here been reduced to a Twenties' lower-half-of-the-upper-lip affair, and its semi-loss seems to have reduced him to a glassy eyed querulousness."[9] Sam Waterston looks like "the offspring of Roddy [McDowall] and Tony Perkins." Al Pacino is "the name of a local hole in space."[10]

The paper soldiered on 'til '82, but Gorey stopped writing for it in late '74 or early '75; why he called it quits, Michael Goldstein, the *News's* publisher, can't recall. At their best, Gorey's reviews combine a playful cattiness with an appreciation of the fan mentality as against the mind-set of the professional critic. Gorey was unabashedly an amateur in the Barthesian sense of the word, meaning a critic who hasn't forgotten how to love the thing he's writing about (cinema), even if he hates the example at hand (*The Great Gatsby*).

The important thing was to have a heated opinion, the more self-parodically melodramatic the better. Gorey's most poisonously witty quips are so over the top we know they're at least part put-on, which is the lion's share of the fun, as is his unrestrained glee in hating what our social betters—the critics—tell us we're supposed to like and liking what we're told is beneath contempt. I defy you to read his verdict on the state of the Hollywood movie in the '70s and not guffaw: "Young man overheard saying to his girlfriend around NYU: 'Make a movie of it, Roseanne, and shove it up your ass.' It is this sensibility, I feel, that accounts for so much of the filmmaking today."[11]

Gorey may have dropped his *SoHo Weekly News* column simply because he was stretched thin. On top of his freelance work, there were exhibitions, such as his show *Plain and Coloured Drawings*, at the Graham Gallery in Manhattan, and *Phantasmagorey: The Work of Edward Gorey*, at the Sterling Memorial Library at Yale. Organized by his friend Clifford Ross, *Phantasmagorey* was Gorey's first major retrospective; it traveled around the country for three years. (The artist did his best to pooh-pooh the conclusion that he had "arrived," saying, "Usually my work is exhibited as part of a cookie festival with tennis.")[12]

Then, too, he may have been distracted by his personal affairs, most consumingly his last, great crush.* In July of 1974, Gorey began sending lavishly illuminated envelopes to Tom Fitzharris, a darkly handsome young man who was twenty-one years his junior. (Gorey was forty-nine; Fitzharris, twenty-eight. Where and when they met we don't know.) According to Glen Emil, the Gorey collector and scholar, each letter "contained a single card, with a hand-lettered literary quotation drawn upon one side, of significance known only to the sender and its recipient."[13] Susan Sheehan, writing in the *New Yorker* about an exhibition of the envelopes, notes that the "ideas seemed to play off conversations between the two friends, things mentioned in passing."[14]

As he did in his correspondence with Peter Neumeyer, Gorey used his letters to share gleanings from his encyclopedic reading—quotations from his commonplace book that resonated with his philosophical outlook or struck sparks in his imagination: "Inspiration is the moment when one knows what is happening. In general, we do not know what is happening"—Magritte. "Everything we come across is to the point"—John Cage. "Our own journey is entirely imaginative. Therein lies its strength"—Céline. And on a lighter note: "Life is too short not to travel first class"—Wyndham Lewis.

*As far as we know, that is.

Gorey created these works of art, intended for an audience of one, at the very moment when mail art was going full tilt. Loosely associated with the neo-Dada movement called Fluxus, mail art used the letter and its envelope as artistic mediums and the postal service as a democratic alternative to the elitist art world. Mail artists sent their friends cryptic, high-concept, or goofy messages in envelopes decorated with collages, found objects, or images created with rubber stamps; the letter became art as soon as it was mailed. It was very much a New York phenomenon; Ray Johnson, who founded the network of mail artists known as the New York Correspondance [sic] School, was perhaps its best-known practitioner.

While Gorey was undoubtedly driven to decorate his envelopes out of a compulsive aestheticism, not to mention *horror vacui*, it's unlikely that he was unaware of the mail art phenomenon, given his insatiable appetite for culture. Whether or not Gorey thought of the Fitzharris letters as mail art, he seemed to view them as an aesthetic expression of some sort. Fitzharris soon "noticed that the envelopes were numbered—a series," writes Sheehan. "He was not surprised to see the calculation behind the whimsy; Gorey's genius was as organized as it was prolific."[15]

But regardless of whether he thought of them as avant-garde art, Gorey's illustrated envelopes for the Fitzharris letters are spectacular— among the "finest examples of [his] artistry, rivaling any of his book illustrations," in Emil's judgment. "Their sheer entertainment—the character development and lightness of delivery—[is] very appealing.... Gorey's draftsmanship seems especially precise and crisp, unlabored and free."[16]

Gorey's letters—fifty of them, all told—kept coming at the rate of one a week for a little less than a year.[17] A good number of the envelopes feature the pair of bandit-masked dogs who star in *L'Heure Bleue* (1975). As in the book, each member of the couple wears a letterman's sweater adorned with the letter *T*, one for Tom, one for Ted. Clearly a close friendship was taking root, at least in Gorey's mind. Peter Wolff remembers a quiet, clean-cut, "nice-looking Middle American–type younger guy" materializing out of nowhere in Gorey's intermission

crowd, sometime in '74. Wolff recalls talk among the lobby clique of Ted's latest crush.

Then, in the late summer of '75, Gorey and Fitzharris went abroad. From August 28 through September 23, Gorey made a circuit of the starkly beautiful islands off Scotland's west coast—the Outer Hebrides, the Orkneys, the Shetlands, Fair Isle—with Fitzharris as a companion for part of the trip. At some point, Gorey made a pilgrimage to Loch Ness. ("I did not see the monster," he later quipped, "to my great regret—the great disappointment of my life, probably.")[18]

We don't know whose idea the trip was, though given Gorey's romantic attachment to the islands it was almost certainly his. It was inspired, he always claimed, by an irresistible desire to experience in person the landscapes he'd seen in the Powell and Pressburger movie *I Know Where I'm Going!* (1945), starring Wendy Hiller and Roger Livesey. A romance set in the Hebrides, rich in local color, the film has attracted a cult following. The noir novelist Raymond Chandler fell under its spell, telling a friend, "I've never seen a picture which smelled of the wind and rain in quite this way nor one which so beautifully exploited the kind of scenery people actually live with, rather than the kind which is commercialized as a show place. The shots of Corryvreckan alone are enough to make your hair stand on end (Corryvreckan, in case you don't know, is a whirlpool which, in certain conditions of the tide, is formed between two of the islands of the Hebrides)."[19]

"I saw the movie," said Gorey, "and fell in love with the scenery and knew I wanted to go there." It was the only time that he ventured outside the United States (other than a brief trip with his Garvey grandparents, at the age of seven, to Cuba and Key West). Unbelievably, Gorey, whose imaginative life was steeped in England and Englishness, flew into Prestwick airport, in Glasgow, and out of Heathrow airport, in London, without setting foot in England, beyond Heathrow and maybe the odd railway platform.[20] Alison Lurie thinks he knew on some level that the England of his imagination—the Anglophile's England, not to

be found on any map—wouldn't survive a collision with the real thing. "England before, let us say, 1930 or '40—that was the period that he liked," she says, "and he didn't want to see the England of supermarkets and shopping carts—the Americanized, commercialized England that developed after World War II."

Gorey's explanation, in an interview years after the fact, was, "I'm not interested in places from a cultural point of view, thank you. I went for the scenery more than anything else."[21] It could have sprung from his pen: gloomily beautiful peatlands, ancient tors jutting out of the landscape, standing stones like the megaliths at Callanish in the Hebrides, sheer cliffs plunging into boiling foam.

Something in the severe beauty of these remote hunks of rock spoke to him, but what did it say? Did it bring on the Celtic twilight, as he liked to call the romantic melancholy that was his Irish birthright? Gorey turned fifty that year; maybe the movie's heartbreaking love story, set against the desolate beauty of the landscape, stirred something in him at a moment when he was wondering, possibly, if he was going to spend the rest of his life alone. "I know where I'm going / And I know who's going with me," goes the movie's theme song, a haunting, centuries-old Scottish-Irish ballad. "I know who I love / And the devil knows who I'll marry."

Sometime during the trip, Fitzharris and Gorey parted company. "When I asked him about the trip, he said [that] after two weeks or something Tom had gone off with a nurse," Skee Morton recalls. "And so Ted went on alone." (A female nurse, it should probably be added; there wasn't any doubt in the minds of Wolff and the others who met him that Fitzharris was straight.) Gorey headed off for "the most remote islands he could get to," as Skee remembers it. "I know he was much taken by the west of Scotland; I think he liked it being so remote and desolate. He even talked, but not very seriously, about moving there, but he wouldn't have been able to take the cats because of the quarantine they had then."[22] It was Gorey's last trip abroad.

Back in New York, he reassumed his place among the chatty Balanchinians in the State Theater; Fitzharris, like all painful memories,

was consigned to Lethe, the river of forgetfulness, never to be mentioned again. "Ted never said anything about anything," Wolff recalls. "But there was a sense that [he] was sad about something." In retrospect, some of the quotations from his letters to Fitzharris take on a bittersweet, sometimes even Beckettian subtext: "I've always thought of friendship as where two people really tear one another apart and perhaps in that way really learn something from one another"—Francis Bacon. And: "I often think I am possessed with things I really want, but when I come to search find it only a shadow"—diary of a Dutch sailor put ashore on the island of Ascension.

L'Heure Bleue assumes a melancholy air, too, if we read it as a bittersweet memento of what was almost certainly the last of Gorey's unrequited crushes. Published under his Fantod Press imprint the year he and Fitzharris took their trip, it's a gorgeous book, the only Fantod printed in two colors, black and a lush cerulean blue. The title derives from the French term for that fleeting period in early dawn or late dusk when the indirect light of the sun paints the sky a shimmering blue. It's a time of day rich in poetic associations: ambiguity, ambivalence, wistfulness, time slipping away. (In English, it's the "magic hour.")

Was Gorey in a blue mood, reflecting on love, loneliness, and passing time? *L'Heure Bleue* is cryptic—an extension, perhaps, of his correspondence with Fitzharris. We feel as if we're overhearing a conversation between intimates, full of in-jokes, oblique references, coded allusions. In each panel, the dogs exchange enigmatic snatches of dialogue, surrealist non sequiturs that recall the hermetic languages couples and close friends slip into. Here they are, strolling alongside topiary versions of themselves. "It seems to me wine warms up very quickly." "I never know what you think is important." In another panel, they're standing in front of a wrought-iron fence on which the ivy is making arabesques. "I never insult you in front of others." "I keep forgetting that everything you say is connected."

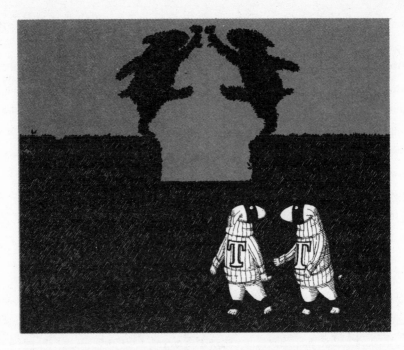

"I never know what you think is important." *L'Heure Bleue. (Fantod Press, 1975)*

L'Heure Bleue is somber nonsense. The inadequacy of language and the impossibility of communication is a theme, as it was in Gorey's correspondence with Fitzharris. In one of his letters, he quoted George Gissing's 1889 novel, *The Nether World*: "Is there such a thing in this world as speech that has but one simple interpretation, one for him who utters it and one for him who hears?"

The book opens with the two dogs, in the Ted and Tom sweaters they wear throughout the book, contemplating a half finished phrase hanging in the air against the silhouette of darkened trees under a luminous blue sky—a subtly surrealist conjunction of night and day that calls to mind Magritte's *Empire of Light* paintings. "Ove one anoth," the ornate antique typography spells out. It wants to be "Love one another," but the letters the dogs hold—*R* and *O* in one dog's paw, *ZDEM* in the other's—ensure that phrase will never be completed. "Move one another" is the best they can hope for, though whether that means moving in the romantic sense

of affecting someone emotionally or in the adversarial sense of budging another solitary from his set ways in a contest of wills is a mystery.

In the last panel, we see them sitting on top of a Ford Model T–type car, riding away from us into the blue. A tiny inscription beneath the back window tells us, in French, that the drawing is based on a photograph by "T.J.F. III"—Thomas J. Fitzharris III by any other name. Knowing what we know, the book's ending feels like a nocturne for Gorey's hapless attempts at relationships over the years. In 1992, he told Stephen Schiff of the *New Yorker* that he'd more or less given up on love. "I mean, for a while I'd think, after some perfectly pointless involvement that was far more trouble than it was worth—I'd think, 'Oh God, I hope I don't get infatuated with anybody ever again.' And it's been sixteen, seventeen years, so I think I'm safe."[23] Seventeen years was exactly the span between that interview and his ill-fated trip with Fitzharris.

In 1975, Putnam capitalized on the success of *Amphigorey* by publishing *Amphigorey Too*, which collected twenty of Gorey's little books. It was dedicated, "For Tom Fitzharris."

By '76, Gorey's career, if not his love life, was on a roll.

Wulp had at last gotten the professional rights to *Dracula*, raised the money to mount a production, and rounded up some coproducers. Dennis Rosa, who'd directed the Nantucket show, was back in the director's seat. Frank Langella, then a svelte, dark-haired lady-killer, would play the title role. Gorey would redesign his sets for Broadway.

On October 20, 1977, "the Edward Gorey production of *Dracula*," as everyone insisted on referring to it, opened at the Martin Beck Theatre to almost universal acclaim.* Receiving the marquee treatment in the PR campaign gave Gorey the fantods: "It makes me feel quite faint and utterly far away," he moaned.[24] Still, it was inevitable: Langella got top billing in the program, but Gorey's stunning sets stole the show.

*The Martin Beck, on West 45th Street, is now the Al Hirschfeld Theatre.

Always ill at ease in the spotlight, Gorey tried to brush off the accolades by belittling his sets as amateur efforts, pointing out, "It's the first time I've ever designed a Broadway show."[25] True enough, although he had, in a sense, been apprenticing as a stage designer. He'd designed the Nantucket production, of course, and in 1975 he'd done the costumes and backdrop for act 2 of *Swan Lake* for a production by the Long Island–based Eglevsky Ballet.

Reviewing that performance for the *New York Times*, Don McDonagh dismissed the ballerina and dancer who danced the pas de deux as "not one of the most memorable pairings" but was lavish in his praise of Gorey's talents. "What was of uncommon interest was the scenery, which had a haunted feeling of mischief as much as menace," wrote McDonagh. "The lake had a darkened castle on a small island and a large brooding cloud that suggested a bird of prey with the hint of a swan trapped between its wing and head. It was fiendishly effective, and one wonders why no one has tapped Mr. Gorey's considerable talent for ballet design before now for our major companies."[26] Finally, he'd done the backdrop for a production of *Giselle* mounted in early '77 by Peter Anastos's troupe, Les Ballets Trockadero de Monte Carlo. In her *New Yorker* review, Arlene Croce praised the Gorey decor, a "sorrowful vista dominated by weeping willows and dotted with funeral urns."[27]

Gorey's first order of business, in reimagining the *Dracula* sets for the Martin Beck Theatre, was scaling up to Broadway proportions the versions designed for the shoe-box stage of the Cyrus Peirce Middle School. The arched, cryptlike vault that framed all three acts had to be blown up from twelve to thirty-five feet in height, as did the scenery nestled within it, which changed with each act. (In addition to the masterstroke of adding a jot of red to each black-and-white scene, another flash of ingenuity on Gorey and Rosa's part was the use of the vault's arches as frames into which the backdrops for each act—plugs, as the canvas-covered inserts are called in the trade—could be slotted.)[28]

Gorey redrew the sets on a quarter-inch-to-a-foot scale (as opposed to the standard half-inch-to-a-foot ratio) to avoid "acres of crosshatching," then handed his sketches off to Lynn Pecktal, the scenic

supervisor, who oversaw the building and painting of the sets.[29] Pecktal marveled at the fine-grained detail of "the books [in Dr. Seward's library], the wallpaper in the bedroom, the coffin scene, full architectural sketches, stonework, statues, all of that." Gorey's scenery, which cost one-eighth of the show's budget, was "more lavish and detailed than is usual on Broadway," Mel Gussow noted in his *New York Times Magazine* profile of Gorey.[30]

Writ large, Gorey's obsessively crosshatched drawings, with skulls and bats hidden everywhere, were breathtaking. In act 1, set in the library in Dr. Seward's sanatorium, every leather-bound volume was lovingly rendered, as were the bats and skeletons flanking the good doctor's fireplace. In Lucy's boudoir, the setting for act 2, the drapes of her four-poster were held aloft by bat-winged putti; black-and-white pansies with death's-head faces writhed, serpentlike, out of vases embellished with skeletons. And in the third act, set in the burial vault where Dracula sleeps in his coffin, mummified corpses reposed in niches and Gorey's bat-winged, vampire-fanged skulls adorned the pillars. The costumes, too, delivered witty asides: Dracula's watch chain was strung with teeth (canines, naturally), and the lunatic Renfield wore striped asylum pajamas with bat-shaped buttons and Goreyesque sneakers with bat silhouettes on their toes.

In Gorey's work, "decor becomes description," as Gussow insightfully pointed out. "Between bindings, he is his own stage and costume designer as well as author and director.... Theatrical design was a natural next step."[31] Of course, being Gorey, he *would* do the unexpected thing, and in his *Dracula* scenery, he did just that, creating sets that dance on the line—there's that betwixt-and-between theme again—between bringing the book's illustrations to life and transposing the play into the black-and-white flatland of the printed page. As always in Gorey's aestheticized worldview, life imitates art more than art imitates life.

Reviewers, with very few exceptions, swooned over Gorey's sets. *Newsweek* judged them "magnificently macabre" and "spiked with irony," "all in blacks and whites and grays, as if the blood had been drained from them."[32] "Dazzled and dominated" by Gorey's set, *Time's*

reviewer concluded that, while the cast acquitted itself well, "the show belongs first, last, and almost always to Gorey and Langella," presumably in that order.[33]

One of those very few exceptions, to no one's surprise, was the invincibly nasty John Simon, a theater critic who specialized in malice toward all but especially toward women, whose physical quirks he caricatured with waspish cruelty. And gays: he derided *The Octette Bridge Club* by P. J. Barry as "faggot nonsense" and was heard to observe, in a theater lobby, "Homosexuals in the theater! My God, I can't wait until AIDS gets all of them."[34] The *New York Times* theater critic Ben Brantley, who is gay, thinks "a lot of the things that he identifies with gay sensibility are certain kinds of irony, a sense of talking in quotation marks, and what we often call camp..."[35] Thus when Simon sniffed, in his *New York* magazine review of *Dracula*, that "camp is there even before the actors commence: in Edward Gorey's sets," he's insinuating there's something queer about the ironic-gothic, comic-macabre vibe they give off.[36] Deploring Gorey's "misguided" decision to blow his drawings "up to mammoth size," he writes, "Now, Gorey drawings are fine in their proper place and format; here they look like postage stamps carrying on as if they were Picasso's *Guernica*—a sort of farcical megalomania that is the essence of camp."[37]

Whatever camp is—and in Simon's case it seems to be the gnawing fear that everyone gay is in on a joke that he doesn't get—it isn't "farcical megalomania." Nevertheless, he raises a legitimate point: Is Gorey's brilliantly understated wit of a piece with its miniaturist aesthetic? Does it lose its charm when translated to "mammoth size"?

One member of *Dracula*'s audience agreed with Simon wholeheartedly, and that theatergoer was Gorey. He went to see a preopening rehearsal at the Wilbur Theatre, in Boston—the play opened out of town, as shows often do, in hopes of working out the kinks before running the critical gauntlet in New York—and was horrified when he saw his drawings enlarged to monstrous proportions. "I practically had cardiac arrest, is what I practically had," he told Dick Cavett. "I felt the scale was wrong, that I should have done them on a larger scale. I don't

like blown-up drawing very much. . . . I think some kind of monumentality crept into the set, which I wasn't prepared for."[38]

He was the odd man out. In 1978, Gorey was up for a Tony Award for best set design and best costume design. But *Dracula* nabbed two other Tonys, one for most innovative production of a revival and one for costume design. "That was one of the more preposterous things," he kvetched in 1996. "I did all of eight costumes and they were zilch but everybody loved the sets. There was somebody else who deserved the set design award much more than I did that year, so they didn't feel like they could give that one to me. They gave me the costume award instead."[39] Gorey couldn't be bothered to attend the awards ceremony. ("I was off at the movies somewhere, probably," was his only explanation.)[40] He gave his Tony to a friend.*

He did manage, however, to cash the fat checks he received from the box-office proceeds. "He made a ton of money," confirms Peter Wolff, his lawyer friend from the Balanchine scene, who reviewed Gorey's contract for *Dracula*. Not that much lawyering was required: Wulp wanted to ensure that Gorey was well rewarded for his work on the play. It was his idea that Ted should receive 10 percent of the profits from *Dracula*. If that sounds extraordinary for a set designer, it is. Wulp explains the unusual arrangement with the shrugging admission, "I liked Edward. I really liked him. He was fun. And I loved the way *Dracula* looked . . . and I loved the fact that he disliked it so much. . . . I think I probably said to him, 'Well, you might not like it, but it really made you well off.'"

That it did. The show ran for almost three years, closing on January 6, 1980, after 925 performances, during which time Gorey's checks kept coming. *Dracula* earned "in excess of $2 million," the *New York Times* reported.[41] There were touring companies in the States, too, and in '78 a short run in England, which, while not ter-

*The friend donated it, after Gorey's death, to the Edward Gorey House. Located in Gorey's former home in Yarmouth Port, Massachusetts, the Gorey House showcases exhibitions devoted to the artist and his work. It opened in 2002.

ribly successful from a producer's-eye view, earned Gorey £42,000 for the rights to his set designs.

Andreas Brown, always quick off the mark maximizing the commercial potential of Gorey's work, created a merchandising outfit to market "I saw *Dracula*" T-shirts, *Dracula* tote bags, and other tie-in merchandise. (The artist, with his usual wry pessimism, named it Doomed Enterprises.) "I got lawyers and agents and merchandisers—the whole schmear," said Gorey.[42] Brown mounted an exhibition in the Gotham gallery of his set designs and costume drawings, ringing up more than $17,000 in sales in the first week.

Gorey was anointed a demicelebrity by the mainstream media. There were profiles in mass-circulation glossies such as *Us* and *People*, which wondered, in its implacably middlebrow way, if Gorey would turn out to be the "Charles Schulz of the macabre," a prospect that must've struck terror in his heart.[43] In December of '77, he made his only appearance on a nationally broadcast TV talk show, *The Dick Cavett Show*, wearing blue jeans and radiantly grimy Keds and, God knows why, a heavy sweater, which ensured that he glittered with sweat under the hot lights. Trying to put his foot-joggling, finger-twiddling subject at ease, Cavett adopted a glib, bantering manner, asking if he hadn't been "lured into garages by strange people." "No," came the wary reply. "Any more than the average child? Any more than I was?" Cavett pressed. "I think less," Gorey rejoined. "I don't remember ever being lured anywhere by anybody."[44]

Bill Cunningham, the *New York Times* photographer whose photos of New Yorkers flaunting their personal styles were a city institution until his death, in 2016, devoted his January 11, 1978, column to Gorey, juxtaposing one of Gorey's self-portraits, from *The Chinese Obelisks*, with photos of him loping around the city in some of his twenty fur coats. "In the beginning, when he was relatively unknown, he contented himself with a vintage raccoon," writes Cunningham. By the

'70s, he notes, "Mr. Gorey was no longer a relative unknown. He was no longer even a cult figure.... By the time the curtain went up on the year 1978, there was Mr. Gorey, a fur cry from his old pelt, swathed in Russian sable."[45]

Ben Kahn Furs, a New York City furrier, got in on the act, commissioning Gorey to design a line of thirty-odd fur coats for men, which premiered in '79. "I purposely did slightly more bizarre ideas," said Gorey. "There was no use doing sketches of conventional coats, though I'd say there are plenty of fairly conventional things in the collection."[46] Representative of the fairly *un*conventional things in the Gorey line was a jacket inspired by a letterman's sweater, made of nutria dyed red, and, of course, a *Dracula*-inspired cape, "a voluminous, black broadtail affair lined in red silk," as the *New York Times* described it.[47]

Seventy-eight also saw Gorey stage-managing the design of a window display, late one night in early July, for Henri Bendel, the chic Fifth Avenue retailer of women's fashion. He oversaw the strategic placement, on black-clad mannequins, of his homemade bats and frogs, hand-sewn and stuffed with rice. Another Goreyesque touch was what the *Times* described as "unborn creatures called Pheetus Pairdew" — another beanbag creation — nestled here and there.[48] (The name is a Gorey in-joke, a phonetic rendering of "fetus *perdu*" — or lost fetus.) "The windows are unreal," said a passerby the next morning. "The clothes are unreal. Would you wear anything so ghastly?"

Even more ghastly was something called *A Gorey Halloween*, an ABC children's special that was broadcast, inexplicably, on October 30, 1978. Based — *very* loosely — on Gorey's characters, it had something to do with four children in a haunted mansion and included a two-minute segment titled "The Gilded Bat," which had nothing to do with *The Gilded Bat*, although it did feature Allegra Kent flapping about in a bat costume. The show starred "the most obnoxious assortment of child actors," Faith Elliott recalls. "Among the pieces they desecrated was *The Doubtful Guest*. I remember some kid continuously shouting, 'Benjamin! Where's Benjamin?'"[49]

Seventy-eight was Gorey's moment. Robert Cooke Goolrick had

anticipated his breakthrough when he wrote, in the March 1976 issue of *New Times* magazine, "After 25 quiet years, Gorey is a hot act. Prices for first editions have shot up, prices for drawings have doubled.... The ubiquitous Peter Bogdanovich is interested in movie rights. Money is being raised for a film of Gorey's one un-illustrated prose work, a silent film script called *The Black Doll*. Cultists fume while the Gotham and Putnam's cash registers jingle. Andreas Brown chuckles and says, 'There is about to be in this country a Gorey explosion.' And at the center of it all stands Edward Gorey himself, who cocks his head with shy, quizzical amusement: 'A Gorey explosion? How *very* apt. Little bits of me all over the place...' "[50]

By '78, little bits of him *were* all over the place. There he was in Cunningham's column, and in Henri Bendel's windows, and in Ben Kahn's latest line of furs for men, and in "Dracula Damask" wallpaper from Kirk-Brummel Associates, based on the bat-infested wallpaper seen in Lucy's boudoir, and on ABC—to a minus effect—in *A Gorey Halloween*, and in *Fête Diverse, ou Le Bal de Madame H—*, the ballet whose scenario, costumes, and scenery he'd cooked up for the Eglevsky company. Then, too, there was his latest book, *The Green Beads*, and of course *Dracula*, which was still packing them in. "There is some talk about an Edward Gorey boutique in a major department store and a model room designed by Mr. Gorey," the *New York Times* reported. "If it all works out, 1978 may be the year of the haunted house look."[51]

But his crowning achievement, as far as he was concerned, was *Gorey Stories*, the musical revue based on his books that opened off-Broadway in December of '77 and moved to Broadway in October of the following year.

A series of songs and sketches based on Gorey classics such as *The Gashlycrumb Tinies* and *The Doubtful Guest*, *Gorey Stories* was conceived by Stephen Currens, an actor who got the brain wave of adapting Gorey's little books for the stage. The composer David Aldrich pro-

vided Victorian–Edwardian musical settings. The show went over like gangbusters when they mounted a production, in '74, at the University of Kentucky, where both Aldrich and Currens were students. Currens set his sights on New York. Slow dissolve to opening night, December 8, 1977, at the WPA Theatre, an off-Broadway house in Manhattan. The *New York Times* theater critic Mel Gussow, ever the Gorey booster, proclaimed the show a "merrily sinister musical collage of Goreyana" whose libretto showcased "Gorey the gifted writer" of prose that's "as intricate and as elegant as his spidery pictures."[52] The scenery, "a neat black and red checkerboard set," was intended merely to invoke "the master's haunting world," not re-create it down to the last crosshatch; the spotlight was on Gorey's writing.

Gorey was as charmed by *Gorey Stories* as he'd been underwhelmed by *Dracula*. "I saw it four times," he said. "If someone had told me I would have to put anything of mine on stage, I would have said it wasn't possible, but they did a fine job with the stories, and the music is very good.... What they didn't attempt with *Gorey Stories* was to make it look like my work particularly."[53]

John Wulp threw his hat in the ring as producer, along with Harry Rigby (the same Harry Rigby who'd dreamed of taking *Dracula* to Broadway), among others. Gorey would design new sets and costumes; Lynn Pecktal would reprise his *Dracula* role of scenic supervisor. Descriptions of Gorey's scenery are hard to come by, but he told the *Times* that the sets would consist of "an abstract room and an abstract summer house, and while they will be in color, they will not exactly be the colors of the rainbow."[54]

Gorey Stories (subtitled *An Entertainment with Music*) opened at the Booth Theatre on October 30, 1978, after fifteen preview performances. Then, in a twist of fate straight out of a Gorey story, it closed that same evening. Consensus holds that it was done in by an ill-timed strike by the city's newspaper pressmen, as they were called. The presses that produced New York's three major dailies had stopped rolling, obliterating any hope of reviews. As a result, the show sank like Little Zooks, the unloved infant in *A Limerick* who drowns in a lily-choked pond.

Those reviews that did appear, published after the strike ended, on November 5, by which time *Gorey Stories* was history, suggest that the show wouldn't have lasted long on Broadway even without a newspaper strike. Clive Barnes, writing in the *New York Post*, applauded *Gorey Stories* as "unique, odd, perverse, and engagingly entertaining" but thought it was "theatrical" without being "theater," asserting that Gorey's work simply didn't lend itself to the stage—a charge that would be leveled at the nonsense "entertainments" he mounted on the Cape in his late, semiretired years.[55]

Such criticisms would dog subsequent attempts to adapt Gorey for the theater, such as *Tinned Lettuce* (1985), *Amphigorey* (1994), and *The Gorey Details* (2000). In Gorey's work, word and image form an artistic gestalt; the combined effect is greater than that of text or illustration alone. Watching the cast of *Gorey Stories* chirping out a sprightly choral reading of *The Gashlycrumb Tinies* makes you realize, in an instant, just how indispensable his drawings are to the pleasures of his work.

Then, too, Gorey's slighter offerings, such as the limerick about Little Zooks, don't pretend to be anything but fribbles; their brief length and drawing-room scale are proportionate to their pleasures. They're the literary equivalent of a bite of trifle; the very act of putting them onstage makes them feel overdone rather than understated, and understatement is the essence of Gorey's droll wit. ("Edward is rather like chamber music," says Clifford Ross. "You can't turn him into a symphony.")[56]

That understatement is the sum of his laconic narration, his characters' flattened affect, and the oblique, sometimes hopelessly obscure nature of his absurdist (and absurdly erudite) humor. Which makes for more problems: actors like to act, and they like to make audiences react, whereas Gorey's stories, even at their most amusing, are designed to elicit a small, wry smile—the face a cat makes when it's licking feathers off its chops—rather than a belly laugh. Giving Gorey the musical-comedy treatment is a fraught proposition, like staging Kafka's *Metamorphosis* as a figure-skating routine. (The opera director Peter Sellars puts his finger on the nub of the problem when he explains why *Dracula* didn't feel very Gorey to him. Broadway is "all about 'selling'

everything," he says—"people coming right down to the middle stage and belting something. What I missed entirely in the Broadway shows was the mystery, the haunted quality, and the reserve and the secrecy, because Broadway is about showing it all.")

Not that Gorey would have been fazed by any of these objections. "[*Gorey Stories*] was the only time I appreciated my own work, because it had nothing to do with me—somebody else did it," he said. "The minute I heard things I'd written coming out of other people's mouths, I absolutely adored it . . ."[57]

That, of course, is what makes a writer want to be a playwright. Gorey had succumbed to the romance of the footlights, and in his last decade or so he would spend most of his creative energies on plays, not books. *Gorey Stories*, meanwhile, "developed a kind of half-life on the amateur circuit," as Gorey put it.[58] Samuel French published the script, and the show has become, over time, a Halloween favorite.

Nineteen seventy-eight was memorable for Gorey in one other way: on October 11, Helen Dunham St. John Garvey Gorey died. She was eighty-six and had been living, for a year or so, in an assisted-living facility in Barnstable village, just down the road from the house on Mill-way where Gorey lived with his cousins when the City Ballet wasn't performing. Built in 1880, the Harbor View Rest Home was a stately mansion, "quite grand," as Skee Morton recalls it, "with big rooms, high ceilings, and marble fireplaces."[59] Gorey and his cousins referred to it, with predictable black humor, as "Hemlock Manor."

As Skee remembers it, Ted had moved his mother to the Cape in the fall of '76, when it had become obvious that she was too infirm to continue living alone in her Chicago apartment. He was dutiful in his visits to Hemlock Manor, and Skee dropped in now and then, but Ted's aunt Isabel, Helen's sister, rarely stopped by, despite living only a few minutes' drive away. A lifetime of sibling rivalry between the two strong-willed women had taken its toll.

Like his aunt, Gorey had a charged relationship with his mother. "Distance enhanced their relationship" is Eleanor Garvey's dry way of putting it. Says Skee, "They would talk on the phone...and I think that worked better than when she was actually there telling him what to do—'Put on your boots,' and things." The devoted mother of a gifted only child, she could be nudgy and suffocatingly oversolicitous. Her letters to Ted at Harvard are full of don't-forget-to-wear-your-rubbers reminders and promises of care packages: "I will get a batch of cookies off this weekend. Guess I told you I spent last one making fruitcakes, which are all bedded down waiting for the holidays."*

Then again, caricaturing Helen Gorey as a smothering mother is too easy. For a good part of Gorey's youth, she was a single parent supporting a child whose quirky brilliance and artistic mind she only half understood. On one of the rare occasions when Gorey spoke openly about his family, he said of his mother, "We were far closer than I really wished most of the time, and we fought a good deal right up until the time she died, at the age of 86. She was a very strong-minded lady."[60] In another conversation, he was even more pointed: "She had a stroke when she was about 80 and her entire character changed. All her hypocritical love for humanity vanished. Any parent-child relationship has its sides, you know. With Mother I was always getting carried away. I'd say, 'Oh, Mother, let's face it. You dislike me sometimes as much as I dislike you.' 'Oh, no, dear,' she'd say. 'I've always loved you.'"[61] "But did she love your work?" the interviewer asks. Gorey chooses his words

*Helen's insistence on sending her son fruitcakes *would* explain Gorey's imperishable aversion to the Christmas confection. He insisted there was only one fruitcake in existence, endlessly regifted around the world. One of his Christmas cards depicts a festive scene: a Victorian family, bundled up against the cold, disposing of unwanted fruitcakes—is there any other kind?—by heaving them into a hole in the ice. "My mother used to spend entire summers making fruitcake," he said. "She wrapped them in brandied cloth. I always gave them away. I could never bear to say, 'Mother, I hate fruitcake.'" (See Joseph P. Kahn, "It Was a Dark and Gorey Night," *Boston Globe*, December 17, 1998, C4.) Of course, being Gorey, he was always happy to upend expectations at the drop of a hat. "Actually, someone gave me one a few years ago," he admitted after his mother was gone. "I ate it. It wasn't bad."

carefully: "She *appreciated* it. But, poor dear, she had become very sour toward me in the last five years of her life. She was, however, lovely to everyone else."[62]

Skee confirmed that Helen "didn't really understand [Ted's] work all that well," noting, "I don't think she was terribly artistic." True enough: Helen Gorey always seemed a bit baffled by her eccentric artist son. "I still don't know where he gets his ideas," she told an interviewer. "They seem to just sprout out of his head. He says, 'I get an idea and I put it down and I don't know if it means anything or not.' I think it does, but I don't know and he doesn't know." She laughed. "But then, Ted always did puzzle me."[63]

Still, it's significant that Gorey's first anthology, a book he must've known would send up a bigger flare than anything he'd done to date, was dedicated, "For my mother."

CHAPTER 13

MYSTERY!

1979–85

In 1979, WGBH, the Boston affiliate of PBS, approached Gorey about creating animated title sequences for the soon-to-be-launched *Mystery!*, a *Masterpiece Theatre* spin-off devoted to British mysteries and crime dramas.

Herb Schmertz, the head of PR at *Masterpiece*'s corporate underwriter, Mobil Oil, had an ear cocked to the cultural buzz. Gorey's *Dracula* fame preceded him, and Schmertz thought his work would be perfect for the new show's opening titles and closing credits. It had just the right air of Agatha Christie whodunit and gothic spookiness. Joan Wilson, the show's producer, needed little persuading. And she knew just the man to turn Gorey's distinctive black-and-white imagery into animated sequences: Derek Lamb, a British animator known for his innovative work with the National Film Board of Canada.

All that remained was to beard Gorey in his den, or, rather, in Wilson's office at WGBH. Lamb, a fervent fan of Gorey's work, was

"morbidly curious" to meet the man, he later confessed, having heard a rumor that Gorey had two left hands.[1] (Seriously.) He broke the ice by screening his award-winning short *Every Child*, an avant-pop cartoon about a cherubic foundling whom no one wants. "I like it" was Gorey's verdict. "It's so sinister." Then they got down to business. Gorey had prepared a detailed script for the title sequence, which Lamb remembered as "an intriguing concept using a Victorian children's puppet theater."

Unfortunately, its running time would have been somewhere around twenty minutes—a smidge overlong for an introduction that was supposed to last thirty seconds, tops. "They said it would last too long," said Gorey. "I said, 'Not if you make it go fast enough. If you just zip right around, it would probably take two minutes.' But no, it would take hours. I thought, 'Oh, for heaven's sake.'"[2] There was "some serious pouting," as Lamb remembered it, "and a lot of staring out the window."[3] Seven hours and several meals later, it was agreed that Lamb and his Montreal-based team of animators would pore over Gorey's books and rough out a storyboard, based on selected stories, that would fit within the allotted time. With luck, it would meet with Gorey's approval.

Janet Perlman, Lamb's wife at the time and his partner in their animation company, Lamb-Perlman Productions, recalls him combing through the first two *Amphigoreys*, Xeroxing images that caught his eye, then cutting them out and arranging them on a table, moving this scene here and that one there to create a free-associated narrative flow. "They're disconnected images," yet "closely related enough that they don't surprise you when one image goes to something completely different afterwards," notes Eugene Fedorenko, one of the animators who worked on the *Mystery!* titles.

Gorey gave the storyboard his begrudging go-ahead and agreed to draw a few defining images, one for each of the scenes, that would serve as reference points for the animators. Lamb, Fedorenko, and Rose Newlove, another member of the team, traced Gorey's "key frames," as they're known in the trade, then produced the drawings, twelve for

each second of movement, that created the transitions between Gorey's images, making the storyboard's static tableaux come alive.

Fedorenko recalls the difficulties of animating Gorey's bell-jar world. Rich in textures and dense with scene-setting details, a Gorey drawing isn't "an image that you can hold up for two seconds and then switch to another one," he points out. "They last and last and last." Gorey's dizzily intricate patterns had to be confined to the backgrounds; dressing a character in one of his richly detailed outfits would have sentenced the animators, at twelve drawings per second, to the cross-hatching treadmill. (These, remember, were the days of hand-drawn animation.) To further complicate matters, Gorey's busiest patterns had to be avoided, since they produced a moiré effect on the low-resolution video of the day.

Perlman was struck by the virtuosity of Gorey's draftsmanship. In an effort to capture his style as exactly as possible, she used a loupe to study his drawings and worked at his scale, using a crow-quill dip pen similar to the one he used. Noting his precise, accurate rendering of "the proportions of the urns, of the gravestones, of the finials," she describes Gorey as a careful observer who never cut corners. "His patience is unbelievable. There was no easy thing about all of that cross-hatching; it was very fine work, and takes a long time to do."

Her observations help explain why Hollywood hasn't translated Gorey's work into the animation medium. Even the experimental animators who pop up in animation festivals seem to have judged the challenge of putting Gorey on the screen too daunting. More's the pity, since he once told an interviewer who asked him if he had any interest in animated versions of his books, "I would love to do full-length movies, but nobody's ever asked me, so what the heck, you know."[4]

When *Mystery!* debuted on February 5, 1980, viewers were entranced by the opening, a dreamlike procession of playfully sinister Gorey vignettes: a widow in Victorian mourning dress, celebrating her husband's demise with a glass of wine, graveside; bowler-hatted sleuths shadowing a culprit, flashlights in hand; a swooning ingenue in an evening gown; a cocktail party of shifty-eyed suspects pretending not to notice the stiff sinking into the lake. The French-Canadian composer

Normand Roger's slinky minor-mode tango, inspired by the rhythm of the tiptoeing sleuths, is the glue that holds everything together. Roger's wife at the time provided the ingenue's melodramatic moan.

Gorey was predictably saturnine. "Derek Lamb was responsible for the whole thing," he groused.[5] Still, the *Mystery!* titles spread his name far beyond the Broadway theatergoers who'd seen *Dracula*. Generations succumbed to the dark drollery of the animated sequences,[6] and advertising campaigns featuring Gorey graphics and tie-in merchandise such as the *Mystery!* sarcophagus box, a coffin-shaped pencil case with a Gorey skeleton embossed on its lid, spread the Gorey gospel while promoting the series. So, too, did the black-and-white *Dracula*-style sets, thick with Gorey cross-hatching, used in the early years of the series. When Vincent Price, and subsequently Diana Rigg, introduced each evening's episode, they stood before a backdrop whose writhing wallpaper and hand-drawn decor were unmistakably Goreyesque. (Price called the set "Gorey Manor.")

And then there were the "Fantods," as WGBH cleverly dubbed them, rolled out in *Mystery!*'s third season—two- or three-minute dramatic readings of Gorey stories, accompanied by still images from his books, that filled out the hour at the end of a show. (British programs tended to run short by American standards.) *Mystery!* reached far into the hinterlands, where the morbid humor and arch sensibility of the Fantods sometimes furrowed the brows of Babbitts. From time to time, WGBH and Mobil received letters from viewers concerned about the Fraying of Our Moral Fabric, so alarmingly evidenced by Gorey's stories. An outraged member of the viewing audience in Bellaire, Texas, deplored the Fantods as "satanic," especially the one that made light of the "gruesome deaths" of little children (*The Gashlycrumb Tinies*); PBS should cease airing the "evil cartoons" posthaste![7] A viewer in Santa Barbara was no less appalled by the *Tinies*, decrying the segment as "the most sick presentation I have ever seen on television." And then there was the dyspeptic *Masterpiece* fan in Andover, Massachusetts, who thought Gorey was a "ghoul" and that PBS was hell-bent on "spreading his spores." The network owed the affronted millions out in Televi-

sionland "some kind of explanation, somewhere," for this "savagely tasteless" fare.

Gorey, predictably, was delighted by the Fantods. Of all the aspects of the show that bore his stamp, they alone met with his unreserved approval.

His affair with the theater continued to seduce him away from the writing desk. In 1980, he designed sets for an irreverent postmodern take on *Don Giovanni* that premiered in Manchester, New Hampshire, in September of that year as part of the festival known as Monadnock Music. The director was a twenty-three-year-old wunderkind named Peter Sellars. In decades to come, he would earn a reputation as opera's enfant terrible, outraging the old guard with works like *Nixon in China*, set to a chugging minimalist score by John Adams.

All these years later, Sellars retains vivid impressions of his afternoon at the house on Millway, brainstorming set designs with Gorey. "While I proposed some rather wild things to do with the material, Ted's answer was to create sets that were pure Palladio"—he laughs—"just sheer balance and clarity and absolutely nothing wild-eyed." (Andrea Palladio, the Renaissance architect, championed a neoclassical aesthetic of clarity and symmetry. His ideas experienced a resurgence in the eighteenth century, giving rise to the style known as Palladianism.) Mostly white, with what Sellars calls "slightly etched, slightly fraught" line drawings of eighteenth-century architectural elements, Gorey's flats were suspended against a pitch-dark background, their archways opening onto blackness. Sellars reads his juxtaposition of primal darkness and elegant restraint as a metaphor for the role of repression in Gorey's work. "What we do as artists is affirm the presence of the secrets," he says.

In '81, Gorey designed the drop curtains for the Royal Ballet's revival, at Covent Garden, of *The Concert (or, The Perils of Everybody)*, a comic ballet by Jerome Robbins. One depicts a cartoonish piano scuttling along on prehensile claw feet, its keyboard looking like a toothy maw; in another, the piano is dead, flat on its back, stiff-legged. Broken

black umbrellas dance like bats in the gray sky, lashed by gusting winds. The *New Yorker* cartoonist Saul Steinberg had done curtains for an earlier version of the ballet, but the *New York Times* dance critic Alastair Macaulay judged Gorey's superior to Steinberg's "in drawing, in fantasy, and in wit."[8]

Robbins, it turns out, had met Gorey back in the City Center days and had been much amused by his eccentricities. He described the fantastic apparition in a letter to Tanaquil Le Clercq:

> At first all you can see of him is his beard and mustache, then you start to see his eyes and teeth and some of his expressions; then you notice all the rings he wears and finally the fact that although he wears a rather elegant fur-lined coat his feet are shod in worn out sneakers. As an added fillip you perceive that the skin between his socks and the cuffs of his pants is very white and crowded with black and blue marks. Dear Abby what do you think?[9]

Gorey's involvement with the theater continued in '82, when he illustrated Harcourt's new edition of *Old Possum's Book of Practical Cats*. Written by T. S. Eliot to amuse his godchildren, it's a lighthearted romp in verse through the secret world of felines. *Cats*, the Andrew Lloyd Webber musical based on Eliot's book, had premiered in London's West End the year before and would be coming to Broadway in '82. "We expect sales to soar once the play is running," Harcourt's marketing director told the *New York Times*.[10]

Gorey's following ensured that the hardcover edition sold out within two months of publication. In no time flat, Harcourt was doing a land-office business in the paperback edition, too. When the musical opened at the Winter Garden Theatre that October, sales of the book spiked off the charts. Once again, Gorey had lucked into an unexpected windfall; the book's steady sales, propelled by what was then the longest-running musical in Broadway history, kept him in royalty checks for the rest of his life—one of several sources of steady income that afforded him a level of comfort and financial security in his white-bearded years. "*Drac-*

ula of course was very remunerative because I had a piece of the show," he revealed in a 1982 interview, but "what I make a lot of money now on is...T. S. Eliot's *Old Possum's Book of Practical Cats*. The fact that *Cats*, the Broadway show, is based on it [means] it sells like hotcakes. I mean, my drawings have nothing to do with the show, but it's in both paperback and hardbound and it's selling like mad."[11]

Old Possum is rambunctiously silly, drawing on Eliot's fondness for Edward Lear (mostly in the cats' names, such as Bombalurina and Jellylorum and Rumpelteazer). Of course Gorey was an incurable ailurophile and a Lear devotee, so the match was a perfect one. Working in his meticulous, fine-lined style, he portrays a tiger-striped feline on an ottoman, contemplating with deep satisfaction his secret cat name, which "no human research can discover"; a tabby conducting a chorus of mice; and the Jellicle cats cavorting under the moon, camouflaged in the dark by their tuxedo markings.[12] (Gorey is scrupulous in his attention to the distinctive patterns of various cat breeds.)

Old Possum's orange, black, and white cover is another of Gorey's little masterpieces, depicting cats of various breeds striking dandyish poses in top hats and bowlers or brandishing Japanese fans decorated with feline motifs or, in a clever bit of *mise en abyme*, reading *Old Possum*, its cover a copy of the book's actual cover. They're posed against a many-tiered neoclassical monument, a layer cake of capitals and balusters whose details reflect Gorey's close study of Dover books. Wittily, he duplicates the scene, as seen from behind, on the back cover.

Drawing on a lifetime of close observation, Gorey captures cats' sleepy guile, their loopy antics, their majestic indolence, their solitary nature. Of all his characters, his cats are the only ones who look truly happy. Unlike his humans, who manage to look both deadpan and doleful, Gorey's felines sport ear-to-ear grins. (Or maybe cats' muzzles just look that way, and we're anthropomorphizing, as we always do. It would be like Gorey to leave that question unresolved.) In melancholy moments, he seemed to regard humanity as another species altogether. Contrariwise, he seemed to see cats as kindred spirits, occasionally referring to them as "people." He told an interviewer, "It's very inter-

esting sharing a house with a group of people who obviously see things, hear things, think things in a vastly different way."[13]

With the same matter-of-fact contrarianism that made him insist that the "movies made a terrible mistake when they started to talk," Gorey contended that "the musical theater has been downhill" since Gilbert and Sullivan. He never missed a chance, during the *Dracula* craze, to drop the hint that he much preferred G&S's Victorian comic operas to bloodsucking. Now that *Dracula* was a success, he told *New York* magazine, "I wish someone would invite me to splash fresh paint on Gilbert and Sullivan."[14]

Someone did, and as usual that someone was John Wulp. Wulp was teaching scenic design in the drama department at Carnegie Mellon—just the place for a Gorey version of *The Mikado*, it occurred to him. "I knew that Edward, a great fan of Gilbert and Sullivan, had long wanted to design this show, and I thought it would be ideal for a school production," he recalls.[15] The department chair, Mel Shapiro, was agreeable. So was Gorey—under one condition, as Wulp remembers it: "that the production be a traditional one with no gimmicks," true to Gilbert and Sullivan.

The Mikado; or, The Town of Titipu was written at the height of Japonism—the infatuation, in Victorian England and belle époque France, with Japan—or, rather, the Japan of Western fantasies, a land of beguilingly exotic customs and culture, so far away it might as well have been Mars to an Englishman of the time. Yet Gilbert and Sullivan's Japan is an Orientalized Britain: *The Mikado* is a pointed satire, in kimonos and topknots, of British politics and Victorian manners and mores. At the same time, Gilbert was sincerely interested in Japanese art and culture, and the Japanese aesthetic was undoubtedly part of what appealed to Gorey, along with the sparkling tunes and the libretto's zippy wit.

After *Dracula* and *Mystery!*, Gorey was wary of being typecast as the guy who cranked out whimsically macabre black-and-white scenery by

the yard. Now he had a chance to play against type, and he seized it, creating enchanting, pastel-colored backdrops that recall floating-world prints as well as the delicate washes of English watercolorists such as Edward Ardizzone. His drop curtain, "East Parade, Titipu" (reproduced in *The World of Edward Gorey*), depicts Japanese villagers promenading along a waterfront, flanked by a neat row of Tudor houses that look as if they've been airlifted from Stratford-upon-Avon; one of the strollers shelters under the sort of black parasol no British banker or barrister would be seen without rather than the Japanese bamboo model. His costumes are equally clever: the Mikado and Pish-Tush wear pajamalike Japanese trousers and split-toed socks, but their fanciful kimonos wed the traditional billowing sleeves to a Victorian gentleman's suit jacket and cravat; their hats cross the British top hat with the lacquered head-dresses worn by Japanese nobility of the period.

When the show opened at Carnegie Mellon's Kresge Theatre, on April 14, 1983, Wulp was aghast. Shapiro had reconceived Gilbert and Sullivan's Victorian comic opera as a country-and-western musical. "Mel either forgot [Gorey's] request or chose to disregard it," he re-members. "The show itself was bizarre: Edward's beautiful, witty sets and costumes presented a view of Japan as it might have been imagined by an eccentric Victorian Englishman, while the actors behaved like fugitives from the Grand Ole Opry."[16] The reviewer for the *Pittsburgh Post-Gazette* shared Wulp's discomfiture. Visually, the production was "quite stunning," he thought, applauding Gorey's sets and his "thor-oughly delightful" costumes, "which incorporate a range of styles from Japanese kimonos to Edwardian knickers."[17] He was disconcerted, though, to hear the inhabitants of Titipu speaking in a cornpone twang and thought the hayride high jinks in one act dragged the show "into the realm of the lowest TV sitcom"—Gilbert and Sullivan meet *The Beverly Hillbillies*.

What Gorey made of this desecration is anyone's guess. In a rare vi-olation of his ban on travel, he'd gone to see the show, but what he thought of it not even Wulp knows. As in Gorey's own stories, events took a bizarre turn after he saw the production: his real motivation

in making the trip to Pittsburgh, it turned out, was his desire to see Marcel Duchamp's enigmatic, unsettling last work, the perverse—some might even say pornographic—installation *Étant Donnés* (1966), at the Philadelphia Museum of Art. "He wasn't interested, really, in *The Mikado*," says Wulp. "He was quite clear on his intent: he was going to go to Pittsburgh to see the show, then pop up to Philly to see the Duchamp. He was fascinated with it."

Gorey never ceases to amaze. Who could've imagined that the man who claimed to "blush crimson at the other end of the phone" when someone asked him to illustrate something X-rated would make a pilgrimage (all the way to Philly, which for Gorey's purposes might as well have been Saskatoon) to see a surrealist's idea of a peep show?

Installed in the wall of a gallery full of Duchamp's work, *Étant Donnés* appears, at first glance, to be a weathered rustic door set in an arch of bricks. Peer through the two peepholes in the door, though, and you'll see what looks like the aftermath of a sex murder: on the grass in the foreground sprawls an uncannily realistic female mannequin, naked; in one hand, she holds aloft (rigor mortis?) an antique gas lamp. Her hairless sex looks like a wound. Nothing moves but a glittering waterfall pouring into a toy lake. The effect is both eerily realistic and obviously staged, somewhere between a crime-scene photo and a natural-history-museum diorama. Jasper Johns, the Pop artist, called it "the strangest work of art in any museum."[18]

Gorey was a man full of locked rooms whose art is about what isn't said and isn't shown. Was he intrigued, as a stage designer and aspiring playwright, by Duchamp's stagecraft? Was he taken by the intimacy and secrecy of a theater designed for an audience of one? (*Étant Donnés* can only be viewed by a single person at a time.) Was he drawn by Duchamp's combination of voyeurism and concealment? Did he respond to the presentation, in Duchamp's piece, of sexuality as mysterious, dark, closeted? Maybe he saw the intensely personal work (which Duchamp had worked on in secret and which was revealed to the world only after he died) as a surrealist shrine to desire—something he claimed not to feel but that seemed to haunt him nonetheless.

"My nightmare is picking up the newspaper some day and finding out George has dropped dead," Gorey had said in 1974.

On April 30, 1983, his worst fears were realized: George Balanchine died. He was seventy-nine. For Gorey, it was the end of a sustained crescendo of genius that had lasted nearly three decades, diminishing only at the very end, when Mr. B., as his dancers knew him, was reduced to a shadow of his brilliance by heart problems, failing eyesight, and—catastrophically for a choreographer—a deteriorating sense of balance brought on by Creutzfeldt-Jakob disease. The City Ballet was scheduled to perform that day, a Sunday, and the show went on, as it must. Lincoln Kirstein, the City Ballet's cofounder, stepped in front of the curtain just before the matinee performance began. Addressing the hushed crowd, he said, "I don't have to tell you that Mr. B. is with Mozart, Tchaikovsky, and Stravinsky."[19] The man Gorey called "the great, important figure in my life...sort of like God" was gone.

For almost thirty years, Balanchine's art had been Gorey's aesthetic lodestar. Mr. B.'s dances meant everything to him, though their significance can't be measured by any direct influence on his work. "There wasn't very much I could take directly from George," he told Clifford Ross.[20] Of course, thirty years spent watching Balanchine's dances had to have *some* effect. Most obviously, Gorey's characters often strike balletic poses and tend to stand with their feet turned out, in ballet positions. (As did Gorey himself, according to Alexander Theroux: "He invariably stood in the naturalistic stance known as *contrapposto*, hand on hip, like Gainsborough's *Blue Boy* or Donatello's *David*, but at times he would appear almost in balletic 'turn out' or fully cross-legged—a gay icon—in exaggerated pose.")[21] "It's not so much conscious, but I think I realized early on one of the things that makes ballet what it is, is that it's the maximum of expressiveness," said Gorey. "You know, obviously, when your legs are turned out, they're, well, like Egyptian art or something. You know, each piece is the way it's most expressive: the profile, the profiles of the legs, the front of the torso, the front of the hands, and stuff."[22]

Then, too, Gorey people, though hardly ever *in* motion, often seem as if they've just moved or are about to move. "In Edward Gorey's drawings, everybody is at a tipping point where they're off-balance, so you know they're not in a static pose," Eugene Fedorenko points out. To be sure, his carefully staged tableaux seem about as dynamic as daguerreotypes next to the action-packed drawings of illustrators like Ralph Steadman and cartoonists like Jack Kirby, whose characters explode out of the picture plane. Yet through balletic attitudes—a tilt of the head, a hand gesture, the slightly off-center inclination of the torso—Gorey offers the subtlest suggestion of movement.

More profoundly, his clarity and concision—the witty brevity of his writing, the economy of his line, his eloquent use of negative space, his beautifully balanced compositions—harmonize with the Balanchinian aesthetic. Mr. B's choreography is "pared down to something that is irreducible and Ted had that," says Peter Sellars. "Everything unnecessary is eliminated and the strange empty space that results is psychologically charged."

Gorey found wisdom in Balanchine's artistic philosophy—"Everything he ever said about art I just thought was so true"—and inspiration in his approach to his craft.[23] "George Balanchine's choreography has had—it's totally impossible to put into words—but somehow the way he works has influenced me a great deal," said Gorey. "The way he works with dancers; in a sense I'm trying to emulate his thinking."[24] On occasion, he went into greater detail about what he meant by that. "Well, I think one thing he taught me, above all, is, 'Don't waffle,'" he said. "'Better don't do' was one of his phrases. Or, on the other hand, 'Just do it!' You know, don't dither."[25] "How does a writer-illustrator apply that?" the interviewer wondered. "Well, I try not to presuppose what I'm doing," Gorey replied. "I just do it."

CHAPTER 14

STRAWBERRY LANE FOREVER

Cape Cod, 1985–2000

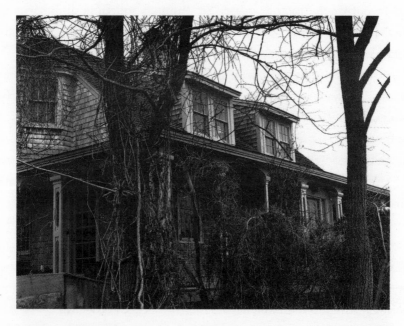

The house on Strawberry Lane, Yarmouth Port, Cape Cod. *(Photograph by Kevin McDermott. Copyright Kevin McDermott, 2000. This photograph first appeared in* Elephant House: or, The Home of Edward Gorey *by Kevin McDermott, Pomegranate, 2003.)*

GOREY HAD WONDERED, as early as '74, what he'd do when Balanchine died. "Do I watch the company go into a slow decline or do I say, 'That's it. I saw it. It's past,' and just go away?"[1]

The romantic version, now written into myth, is that Gorey just went away—moved to the Cape permanently the year Balanchine died in "an act of aestheticism worthy of Oscar Wilde," as Stephen Schiff put it in the *New Yorker*.[2] In fact, he left the city more in the manner

of someone inching offstage than a dancer doing a *grand jeté* into the wings. There's no doubt that he *decided*, that year, to break his practically perfect record of attendance at the City Ballet and remain on the Cape during ballet season. (Andreas Brown confirms that Gorey "resolved to leave" the city in '83.[3] His decision, around that time, to start shipping the tonnage of his library up to his cousins' house in Barnstable argues Brown's point; even more decisive was his permanent relocation of his cats to the Cape. HOME IS WHERE YOUR CAT IS proclaims a sentimental plaque hanging in the Millway house.)

He kept his apartment on East 38th until 1986, using it as a base of operations during visits to the city. But his primary residence from 1983 to '86 was the house on Millway and, from '86 on, his own home in Yarmouth Port. In late '79, he'd used his *Dracula* earnings to purchase a two-story, early-nineteenth-century house on the east side of the Yarmouth Port common, or village green, just down the road from his cousins' house. Formerly a sea captain's home, it had begun life as that most iconic of Cape Cod houses, a "Federal-style full Cape," notes Kevin McDermott in *Elephant House: or, The Home of Edward Gorey*, but was expanded and remodeled by later owners.[4] Built in 1820 or thereabouts, 8 Strawberry Lane was a fixer-upper: some of its windows were broken, the gray shingles were in a state of decrepitude, the roof needed replacing, the grounds were engulfed by weeds. In other words, it was perfect. Ted "was attracted by the unkempt yard and air of genteel decay," Skee Morton recalls.[5]

Gorey would spend seven years renovating his house, living, all the while, at Millway, in the attic where he'd spent so many summers. He tore down walls to create more spacious rooms and removed two bathrooms but decided the roof could wait 'til he'd moved in. The roof obliged, though not for long. "Very early one morning," shortly after he'd installed himself, "Gorey awoke to a crashing noise in the next room," the *Washington Post Book World* reported in a '97 profile. "He yelled at the cats to knock it off. Presently, there was another crash. When he finally got up and looked, it turned out part of the ceiling had fallen in."[6]

Despite his extensive remodeling of his new home's interior, he left the exterior more or less as it was. Shaggy with splintered shingles, it looked like a weather-beaten ship adrift in a sea of weeds, wild clematis clambering up its north side. Lawn mowing? Perish the thought. "The grass and burdock...was almost always feet long and swaying," recalls Alexander Theroux. "The sunken and squeaky old front porch was wonky and broken in places..."[7]

And then there was the poison ivy insinuating itself into the living room through a crack in the wall. And the family of raccoons that took up residence in the attic. And the *other* raccoons who lived in the crawl space under the house. According to Rick Jones, a member of Gorey's inner circle on the Cape, he let the squatters stay to atone for his sins as a former wearer of raccoon-fur coats. Then a skunk joined the party; at that, he drew the line and evicted the lot of them.

The house's original owner, Captain Edmund Hawes, was lost in a storm at sea. Whether the captain's restless shade still stood watch who can say, but Gorey did mention a few otherworldly occurrences. Once, a number of his finials simply vanished, he claimed, along with his collection of miniature teddy bears. And then there was the time he was sitting on the couch with four or five of his cats when suddenly "everyone turned," staring intensely at nothing, as if something invisible to human eyes—a visitor from the spirit realm?—was passing through the room.[8]

After the contretemps over *The Mikado*, John Wulp landed in the drama department at New York University, where he headed the newly founded Playwrights Horizons Theater School. In 1985, he decided to mount a musical production of unpublished texts Gorey had lying around. The choreographer and ballet dancer Daniel Levans would direct; David Aldrich, who had done the music for *Gorey Stories*, would compose the score; and the man himself would design the sets and costumes. The former consisted almost entirely of an enormous can of menacingly large lettuce leaves; the latter included bat costumes and some Victorian-

Edwardian getups, all in taupe and complemented by sneakers. (Gorey was adamant: "No modern sneakers, only the classic variety.")[9]

The threatening lettuce leaves derived from the title, *Tinned Lettuce*, whose vaguely Victorian ring and eccentric English silliness were classic Gorey. *Where* he'd stumbled across the phrase he couldn't remember, but he was "a firm believer that it exists somewhere."[10] Asked what it meant, he said it meant nothing—always a virtue, in his estimation. Elsewhere, he said the phrase captured the very essence of the ephemeral, a concept dear to the Gorey heart. "Thinking about his title after the fact, Mr. Gorey wondered what tinned lettuce, if it existed, would look like," Mel Gussow wrote in the *New York Times*. "His answer: Ghastly Brine..."[11] Like *Gorey Stories*, *Tinned Lettuce* was a vaudevillian musical revue consisting of dramatic vignettes with songs and dances interspersed throughout. The playlets had names like "The Frozen Man, or, Going Farther and Faring Worse," "The Towering Rage," and "The Black Lobster." They were drawn, with the exception of "The Object-Lesson" and "The Nursery Frieze," from Gorey's unpublished writings ("things I haven't gotten around to doing drawings for"), a strategy he'd employ when he turned his hand to amateur theater on Cape Cod.[12]

From the first, Gorey proceeded on the Balanchinian assumption that psychology was irrelevant to his plays. His works for the stage were about Victorian nonsense, mock moralizing, surrealism, silliness, absurdism—anything but psychological motivations and character development. "They wanted to know what their characters' motivations were," he said of *Tinned Lettuce*'s undergraduate cast. "There are no motivations. There is nothing underlying."[13]

"He wanted flat characters...almost like a drawing," says Jane MacDonald, a trained actor who'd worked in the professional theater in New York and LA before becoming a stalwart of Gorey's Cape Cod troupe. "It's hard to make a drawing. I wanted to make this character come to life and sometimes I would fill it up or give it more of an attitude or a twist than he wanted."[14] "Less acting," Gorey would admonish from the director's chair.

He was more involved in the production, at NYU's Tisch School of the Arts, than he'd ever been in a show based on his work. "Edward attended every audition and every rehearsal, just about," Wulp recalls. "He just adored *Tinned Lettuce*." Kevin McDermott, then a twenty-one-year-old acting student at NYU, later to perform in a number of Gorey's works, remembers auditioning for the revue. While a pianist played a tango, he and a gaggle of actors struck Egyptian temple–frieze poses. "With a combination of deathly seriousness and total nonchalance," he recalls, "we moved across the floor. Huge gulps of laughter filled the room. Sounding like a cross between a large gull and a hyena, it was coming from behind the table. I had never heard anything like it. It was Edward Gorey's giant, infectious laugh."[15]

Gorey enjoyed himself mightily at performances, too. Irwin Terry sat behind him at one of the shows. "It was general admission," he recalls, "so we sat right behind him on purpose. He hooted, whooped, and generally had a gay old time watching his work on stage. It was almost more entertaining watching him than the performance itself—but the combination was priceless."[16]

Tinned Lettuce was scheduled to run from April 17 to 27 but was held over through May 4. Gussow, as always, was enthusiastic: "The Throbblefoot Spectre loiters in a distraught manner, a wedding is held in the Church of the Whited Sepulchre and people fall mysteriously from balustrades or fling themselves into Yawning Chasms."[17] Gorey had a ball, which was all that mattered as far as he was concerned. "We had so much fun," Wulp remembers. "He loved to laugh."

Over the next decade and a half, Gorey would invest much of his prodigious creative energy in writing, producing, and directing productions of his theatrical work all over the Cape, uncategorizable affairs with unimprovably Goreyesque titles such as *Lost Shoelaces* (1987), *Useful Urns* (1990), *Stuffed Elephants* (1990), *Flapping Ankles* (1991), *Crazed Teacups* (1992), *Inverted Commas* (1995), and *Moderate Seaweed* (1999). He had, he told an interviewer in 1996, contracted a serious case of stage fever: "In the last 10 years, I've done a lot of very local theater. I write, I direct, I design, I do everything. I even act if something hap-

pens to somebody in the cast. A lot of the actors I use are people who look like I might have drawn them. I even choose the music. That's really what I enjoy. People sometimes say it's such a pity this isn't going somewhere else and I say, 'Well, where would it go?' "[18]

As one nonplussed audience member noted, these productions were often impenetrable to the uninitiated. "The very mystery and under-statement that makes for good visual art and reading made for terrible theater," a theatergoer recalled. Take *Useful Urns*, he said: "There were these big stage pieces shaped like urns that would move about the stage with actors popping out saying various unconnected phrases. I read an interview with one of the actors who admitted that Edward Gorey him-self was one of the few appreciative audience members. Even though many people would walk out of these shows, he would remain un-daunted and the actors were carried on by his chortling laughter and their sense of camaraderie."[19]

Snug in the attic at Millway, Gorey proceeded—in fits and starts, as funds allowed—with the renovation of 8 Strawberry Lane. From time to time, he made forays into Manhattan for infusions of culture, stay-ing at 36 East 38th Street. Sometime around '86, however, the person he'd sublet his apartment to ratted him out, informing the landlord of Gorey's largely absentee status so that he, the new tenant, could take over the lease—an act of jaw-dropping perfidy, though hardly an uncommon one in New York's cutthroat real-estate market. Gorey's apartment was rent-controlled—a real plum. In the end, his sublessee's treachery forced his hand, putting a period at the end of his New York years.

There was a fittingly Goreyesque denouement to the whole affair. He'd asked some friends to move everything out of his apartment ("be-cause I was already back up here on the Cape") but had neglected to tell them about the mummy's head gathering dust in his closet.[20] "It didn't occur to me to say, 'And don't forget the mummy's head!'" As it

happened, they didn't notice the mysterious object swaddled in brown paper on the top shelf. The super, however, did. "I got a call from a detective at some precinct or other who said, 'Mr. Gorey, we've discovered a head in your closet,' and I said, 'Oh, for *God's* sake, can't you tell a mummy's head when you see one? It's thousands of years old! Good grief! Did you think it took place over the *weekend*?' They said, 'Well, you can have it back,' and then they never sent it back to me, so I don't know what happened to it. I had the detective's name and phone number and I lost that so I've never been able to get it back—not that I'm really desperate to get it back."

Gorey had always been "a terrible creature of habit," as he was the first to admit, and at sixty-one was only more so. Ensconced at 8 Strawberry Lane, he soon laid the rails for his daily routines, without which he would "go to pieces," he claimed.[21]

He settled into the habit of eating breakfast and lunch, day in, day out, at Jack's Outback, a café minutes away from his house. (The authors of *The World of Edward Gorey* wryly note that he simply switched his "allegiance from New York City Ballet to Jack's Outback, where, 'all things considered,' he . . . maintained an almost perfect attendance for breakfast and lunch.")[22] Jack's served comfort food: pot roast, chicken potpie, eggs Benedict. Compulsion dictated that Gorey sit in the same spot every day: at the far end of the counter, near the door, for breakfast and on the long bench on the right-hand side of the dining room for lunch, unless he was eating with friends or conducting an interview, in which case he would sit in the third booth on the right. His menu selections were set in stone, too. His guest checks for the month of June 1998, preserved for posterity at the Edward Gorey House, are a case study in repetition: "2 poached in a bowl, ham, white toast" (breakfast, 6/6); "2 poached in a cup, ham, white toast, fruit cup in a bowl" (6/7); "egg salad, white toast butter only, fruit cup in a bowl" (6/9); "2 poached in a bowl, ham, white toast" (6/11); you get the idea.

There's an existential comfort—purchased at the price of monotony—in knowing where you'll be eating breakfast tomorrow morning and every tomorrow thereafter and that, barring Acts of God, it will involve poached eggs. "Life is distracting and uncertain" was a Gorey maxim; repetition imposes order on an unpredictable world. (His wardrobe, like his daily dining habits, reflected his preference for predictability, at least in mundane matters: shopping for clothes, he'd buy half a dozen copies of a shirt if it caught his eye.) It's hard not to see Gorey's beloved routines as a bulwark against the unpredictable and the unsettling, a lifelong reaction to a childhood marked by constant disruption.

Jack's proprietor was Jack Braginton-Smith, one of life's character actors. His long-running role was that stock type the Lovable Curmudgeon. He looked the part, with the rumpled features of a wizened codger, his white hair permanently mussed, like ruffled feathers. A staunch Yankee who "was of the mind you would need a passport and shots to go off Cape Cod," as his daughter Dianna Braginton-Smith puts it, he served up insults as an amuse-bouche, in a New England accent thick as chowder. "The jibing and the repartee was part of the performance—his way of interacting with the people in his community," she says.

Like the cocktail parties in Eliot F-13 or the intermission confabs in the State Theater lobby, Jack's would become a social stage for Gorey. A community watering hole frequented by quirky locals, it was Yarmouth Port's answer to the bar in *Cheers*. Customers took their own orders, poured their own coffee, bused their own tables. When the lunch rush overwhelmed him, Braginton-Smith would scrawl an exasperated note and slap it on the door: GO AWAY. They never did.

Braginton-Smith, who died in 2005, was hopeless as a businessman but a born conductor of collective mood, creating a bantering, gossip-swapping vibe that made his restaurant "the heart of the town," says Dianna, a place where "a bunch of people who were on their own" could be "comfortable being alone together"—a singularly Yankee trait, in her opinion. (Gorey, never one for Garrison Keillor sentimentality, said that Jack's Outback provided "the illusion of what most

people think of as village life. You hear everything that's going on and a lot of things that aren't going on.")[23]

In time, Gorey shed his New York persona. His fur coats had been synonymous with his gothic-beatnik image, so it's fitting they went first. Making a grand entrance was outlandish on the Cape, especially in a double-breasted otter coat with sable trim; Yarmouth Port had an artsy element, but it leaned toward Yankee eccentricity, not Wildean aestheticism. Besides, animal-rights activists had made wearing fur an act of moral turpitude. Gorey put the coats in storage for good.

"His whole New York City getup with the jeans and the jewelry and the fur coats and making big entrances and waving bejeweled hands around was, by his own admission, a bit of a put-on," says Ken Morton. "He was acting." When Gorey hung up his furs for the last time, what remained were his unfeigned idiosyncrasies: the stagy delivery, the obscure passions, the unpredictable opinions on everything under the sun, the obsessive routines—"the certain flamboyances that were always there, that were not an affectation," as Morton puts it.

Mothballing his natural diffidence took a bit more doing. "When he first came in here, he'd come in with a book," recalled Braginton-Smith. "He'd read his book, eat his food, out the door, he's gone. But the people that come in here have a sense of humor, and they have an affinity for one another, and...it began to get to him so that he wasn't as aloof....And then it got to the point where he was *really* friendly, didn't read his book anymore, intruded in private conversations, told people his opinion—and he was very opinionated, and he had the statistics to back up his thoughts—so that, at the end, he was a tyrant!"[24]

Before long, Gorey was one of the gang, taking his personalized coffee mug from the rack reserved for regulars. Getting into the swing of things, he started ringing himself up, recording lunch totals of, oh, $14,028—acts of everyday Dada that gave Braginton-Smith fits when he went over the day's receipts. Taking note of the oversize bowl for gratuities near the door, Gorey made a sign calculated to wring a tip from the flintiest heart. Framed by distrait children and women in widow's weeds, the hand-lettered text beseeched, PRAY FORGET NOT THE

WIDOWS AND ORPHANS. (It counterpointed another sign that warned, UNATTENDED CHILDREN WILL BE SOLD AS SLAVES.)

The two men struck up a ribbing, riffing friendship that was resolutely unserious. In all the years he and Gorey knew one another, said Braginton-Smith, they "never had *one* serious discussion, not *one*, because he was on such an intellectual level that I couldn't reach. So we did fantasy all the time, little vignettes back and forth. I didn't intrude in his life and he didn't intrude in mine and it was a perfect relationship because we didn't owe anybody anything."[25] "They were both deeply reclusive and guarded people," says Dianna, "and they recognized that in each other and respected each other's need to be unavailable. They could be unavailable in the same space together, and that is a great gift if you are somebody who feels that discomfort but still wants to be known."

Gorey and Braginton-Smith went to antiques auctions, a favorite pastime, and took in shows at the venerable Cape Playhouse in Dennis, since 1927 the epicenter of a thriving summer theater scene. (The Playhouse was one of the birthplaces of summer stock, attracting A-listers such as Bogie, Bette Davis, Henry Fonda, and Gregory Peck.) Braginton-Smith's friends the Broadway set designers Helen Pond and Herbert Senn did the scenery for Playhouse productions, and Gorey began socializing with them and Braginton-Smith, often at the couple's breathtaking home, a deconsecrated Unitarian Universalist church built in the Gothic style in 1836, where they hosted unforgettable parties.

The building's austere white clapboard exterior belies a ravishing interior, tastefully appointed with antique furniture and Goreyesque curios—deer horns mounted on plaques, cast-iron tassels from Victorian cemetery fencing—and stage-magic illusions: the carved Gothic tracery on the ceiling and lustrous marble flooring turn out to be hand-painted trompe l'oeil.

Senn, an Anglophile whose tastes ran to Gothic revival, christened the house Strawberry Hill in homage to Horace Walpole's Twickenham mansion of the same name.[26] Unsurprisingly, he and Gorey got on swimmingly. A supremely cultured man, Senn, who died in 2003, had an

encyclopedic knowledge of design history, was an aficionado of classical music, and was entranced by Russian art, from Léon Bakst's opulent costumes and scenery for Diaghilev's Ballets Russes to Palekh, the folk art of painting miniatures on lacquered boxes. His library ranged over such topics as decorative antique ironwork, Klee, Klimt, and the carceral nightmares of Piranesi. Pond, the quieter of the two, liked to listen while Senn and Gorey talked. As they chatted, Ted fed potato chips to their black Labrador, Lucky, a violation of house rules impermissible for anyone but him. What did they talk about? "Usually nothing after 1750," quips Rick Jones, who was sometimes part of the group.

Pond and Senn inaugurated a tradition of inviting friends who might be spending Christmas morning alone—Gorey, Jones, and Braginton-Smith—over for breakfast. Gorey was famous for not bringing gifts ("He would give you a gift any time he wanted to give you a gift," says Jones, but "not for any specific time") and for his obscenely rich scrambled eggs. In truth, they were the surrealist painter Francis Picabia's eggs, prepared according to Alice B. Toklas's recipe for "eggs Francis Picabia"—stirred constantly over very, very low heat for a very, very long time with copious amounts of butter.

Despite never eating in, during his New York years, Gorey had become a dab hand in the kitchen after many a summer cooking for his relatives. When the Garveys moved into Millway, he "decided he wanted to learn how to cook," Skee Morton recalls. Her mother, Betty Garvey, "sort of coached him along, and then it got so that he was cooking all our dinners." He stocked up on cookbooks—Julia Child's *Mastering the Art of French Cooking*, Craig Claiborne's *Kitchen Primer*, *The Shaker Cookbook*, *The Boston Cooking-School Cook Book* by Fannie Merritt Farmer, first published in 1896—and tried his hand, when the mood struck him, at surrealist cuisine. "A couple of times, he made us completely blue dinners," says Skee. "He dyed the mashed potatoes blue and had a casserole they put curaçao in that made it bluish, and there were probably blueberries involved." No blue aspic, oddly enough.

On occasion, he had friends or family over for dinner. "He loved big tureens," Pond recalls, perhaps for the theatricality of the presentation, pos-

sibly because they resembled urns. "We used to go to his house to dinner, Herbert and Helen and I," Braginton-Smith remembered, "and we were in the kitchen one time—he was cooking—and he flambéed his beard. We killed ourselves laughing. That was the *last* time we got invited to dinner—Herbert, Helen, or myself. He was an absolute joy."[27]

Mel and Alexandra ("Alex") Schierman were around, too, with their kids, Anthony and Annabelle. Ballet friends going back to the City Center days, they'd bought a vacation house in Yarmouth Port, and Gorey seemed to regard them as family. He'd drop by without warning, flopping down on the couch and making himself at home. "I remember him storming into the house, saying, 'I'm starving! When's dinner?'" says Anthony. Gorey would sit around, sipping Campari, while Annabelle's dog, a Lab–border collie mix, snuggled up against him, its head on his lap. "I do feel like he felt some kind of refuge with my parents," Anthony reflects. "They didn't want anything from him except friendship. They really liked and respected his work, but that was never a topic; they bonded over shared interests in cultural things, like movies and music and TV shows."

As for Gorey's relationship with the Schierman *kinder*, "he was just delightful," Mel remembers. What, no secret scheming to smother them under a rug or catapult them into a lily-choked pond? "That was a pose," he says. "He liked to create an image of himself, because of *The Gashlycrumb Tinies* and all that, but that was not Ted." Gorey treated the Schierman children "as adults," Mel recalls. "He took an interest in them as people, not as children." Anthony does recollect his being a bit discomfited by the infant Annabelle, though. "He just wouldn't know what to do with a [small] child. You could hand him my little sister as a three-year-old and he'd just be, like, 'What is this? What am I supposed to do here?'"

Orbiting around Gorey's inner circle was Alexander Theroux, who lives in West Barnstable. They'd met in '72, after which Theroux wrote a profile that appeared in the June '74 issue of *Esquire*. He and Gorey

idled away countless afternoons chatting in Ted's "quiet and cool" kitchen, taking tea—"Lapsang Souchong, which gives off the scent of freshly tarred roads at 50 yards"—and munching cinnamon toast.[28]

Theroux's admiration for Gorey's talents was boundless, but his delight in his conversation was almost as ardent. "Mind you, it was not that the man was trying to be something, contriving, say, to appear a cavalcade of wit, merely that, rather like Dr. Samuel Johnson, he happened to have sharp, remarkable 'views' on all sorts of subjects, almost all worthy of note."[29] Theroux was the perfect foil: Harvard-educated and absurdly erudite, with the sort of mind that's flypaper for droll anecdotes and words so obscure they can't be found in the *OED*.

If Gorey was Johnsonian in his easygoing brilliance and aphoristic wit, Theroux was Boswellian in his ability to show him off to best advantage. "I was always feeding him meat to provoke reactions about movies or whatever," he recalls. Gorey was "full of obiter dicta," he says, "full of gnomic remarks."

In his slim memoir of their friendship, *The Strange Case of Edward Gorey*, Theroux captures the digressive pleasures of Gorey in full flow:

> He could discuss *The Simpsons* or the worth of the old actor James Gleason with the same passion that he brought to an explanation of what Ludwig Wittgenstein meant by the "synopsis of trivialities." Any given conversation with him could range from—as it once did and which I made note of—the geometry of cats' ears to G. W. Pabst's film technique, *Little Lulu*, Bronowski on the age of huts, low water levels on Cape Cod, who danced *Giselle* in 1911, and the invincible vulgarity of the preposterous Kathie Lee Gifford and the host of miniature faces she was constantly pulling.[30]

As well, he gives us deft sketches of Gorey's physical presence and eccentric behavior:

> Gorey...spoke in a rather fey tone, heavily sibilant, and his voice, mirthful almost always among friends, could border on glee when

he was enthusiastic or excited.... When he became reflective about something, pondering, say, a question you asked, he had a way of clenching his hand and pressing it to his mouth, looking into the far distance as if the answer had just flown away.... When he was not petting a cat, dramatic gestures, along with heavy sighs or moans, almost always accompanied his highly various conversation. He would chatter on with a kind of...self-amused intolerance of things, squawking through a very pronounced sibilance in moments of both delight and exasperation with his own slang expressions, like, "Not on your tintype!" "Snuggy-poos, *desist!*"—when addressing his cats—"Talk about loopy!" "What is that blather about?"[31]

The Strange Case is itself delightful and exasperating; you'd fling it at the nearest wall if it weren't so unputdownable. It's written in the Boswellian style, meaning: it's a garrulous, gossipy portrait of the man in full, stuffed with scandalous morsels of gossip, piquant table talk, and the author's insights into the Great Man's mind and art, some of which are acutely perceptive and some of which are a country mile wide of the bull's-eye. There are closely observed sketches of Gorey being Gorey, quotations (and misquotations) from magazine and newspaper profiles, and side trips into the weeds of Theroux's enthusiasms and bêtes noires, with bits of potted biography embedded throughout, like currants in a scone. Following the meandering, apropos-of-nothing logic of a conversation over afternoon tea and toast, it isn't really in aid of anything, especially—which is part of its perverse charm.

Less amusingly, it's got some notable groaners when it comes to errors of fact.[32] Theroux's style tends toward the hyperbolic; that and the absence of footnotes leave the reader uneasy about what to take as verbatim Gorey and what to chalk up to exaggeration for effect.[33] Did "outraged mothers" *really* send Gorey copies of *The Beastly Baby* "ripped to shreds"?[34] Did he *really* say, "Barbara Walters, I'm afraid, belongs to the communion of kitsch, rather than the art of communication"? (For a man who cordially loathed self-conscious cleverness, the line's too clever by half, a little too epigrammatic in its tidy parallelism.)[35]

Still, Theroux shows us Gorey from a new and revealing angle, his silhouette outlined by his likes and dislikes. "He lived according to his tastes, unfettered by second-hand opinions," writes Theroux.[36] What did he like? "He liked the way Humphrey Bogart said 'Thursby' [in *The Maltese Falcon*] and the way Robert Newton said 'Jim Arkins' [in *Treasure Island*] and the way Audrey Hepburn said 'chocolate' and the way unshaven Akim Tamiroff said, 'Drunken bum—I should shoot you in the *fooooot*.' "[37] What else? "Along with cats, Gorey loved tea... *Dick Van Dyke Show* reruns... his Cuisinart... a glass of Glenfiddich, hard shaving soap, the palace purple coral bells of the perennial plant *Heuchera micrantha*... papyrus... and the actor James Cagney."[38] As for what he didn't like, the list is long, but a nibble gives a taste: "brussels sprouts, false sentiment, minimal art, overcommitment to work, being solicited for blurbs, the music of Andrew Lloyd Webber," and "movies about *ea*-ting," as he told Theroux in "a malicious lilt, 'like *My Dinner with André* and *Like Water for Chocolate*.' "[39]

Superficial, you say? An aesthete like Gorey would point out that we're as defined by our likes and dislikes as we are by what we regard as our core convictions—if not more so: our politics and religious beliefs mark us as members of clubs for the like-minded, whereas our tastes—idiosyncratic, intuitive, capricious—are often more revealing about who we really are. Sontag again, from "Notes on 'Camp'": "To patronize the faculty of taste is to patronize oneself. For taste governs every free—as opposed to rote—human response. Nothing is more decisive. There is taste in people, visual taste, taste in emotion—and there is taste in acts, taste in morality. Intelligence, as well, is really a kind of taste: taste in ideas."[40] As a thought experiment, Theroux's attempt at building a Unified Theory of Edward Gorey from his antipathies and sympathies is frequently illuminating in ways that more conventional character sketches are not.

Of course, as Theroux notes, Gorey was more than the sum of his opinions on B movies, brussels sprouts, and Kathie Lee Gifford. "You talk about the complicated icosahedron of the human spirit," says Theroux. "He was coming from 16 different places. He had all the ear-

marks of a [stereotypically] gay man—the rings, the sibilance in his voice, walking down Fifth Avenue or Lexington Avenue with a big fur coat and sneakers and many rings and an insect pendant, going to the ballet. He was outlandishly up front with it, but he was in many ways a very shy man. Gorey was trying to complete himself by that floral, highly decorative, unbelievably showy front." Theroux's conclusion? "He was a completely complicated, conflicted person in thousands of ways, as all brilliant people are."

Gorey's day-to-day existence on the Cape was, in his own estimation, "featureless."[41]

Granted, you could set your watch by his arrival for breakfast or lunch at Jack's. When he wasn't there, a likely spot for Gorey sightings was Parnassus Book Service, a used-book store on Route 6A, just around the corner from his house. If he wasn't sitting cross-legged on the floor, rearranging books as he browsed (an unshakable compulsion for anyone who's ever worked in a bookstore), you'd find him gabbing with Isobel Grassie, a Parnassus clerk and actress in community theater productions who shared his devotion to soap operas. (Gorey dedicated *The Water Flowers* to Grassie.) Judith Cressy, who spent several college summers in the early '70s clerking at Parnassus, recalls Gorey's appetite for Flaubert, books on Japanese art and culture (especially Noh and Kabuki), and "novels that nobody else cared about," such as the social-satirical fictions of Angela Thirkell, an English novelist of the 1930s. As she came to know Gorey's fondness for "icky Victorian stuff," she took to setting aside titles she thought might interest him—books on "nineteenth-century cabinets of curiosities with taxidermied animals," Victorian hair jewelry, and "photos of dead children arranged as peaceful little angels."

One title that caught her eye was L. H. Bailey's *Manual of Gardening: A Practical Guide to the Making of Home Grounds and the Growing of Flowers, Fruits, and Vegetables for Home Use*, published in 1910. The book's pen-and-ink illustrations were beautifully limned, she thought,

but "*odd*. There'd be this funny little drawing of...*almost* symmetrical plantings, but then there was this tree that was in the wrong place and there would be a caption that would say, 'A regrettable vista,' or something. It looked like an Edward Gorey drawing, and the caption was like an Edward Gorey caption. The whole book was full of these Edward Goreyisms that were done before he was born." When Cressy showed Gorey some photocopies of the book's illustrations, "he just whooped and rolled up the papers and tucked them in his pocket and ran away. He got it immediately."

The result was *The Improvable Landscape* (Albondocani Press, 1986), which Gorey dedicated to Cressy. A note-perfect send-up of Bailey's didactic *Manual*, it's a kind of cautionary tale for gardeners and landscape architects; Gorey's impeccably deadpan renderings of "a less than ornamental pond," "a meaningless hedge," "an unsuccessful vista," and other horticultural mishaps provide object lessons in what *not* to do.

Parnassus's owner, Ben Muse, also kept an eye out for books he knew would grab Gorey, such as the Greek-Irish writer Lafcadio Hearn's whimsically weird sketches of Japanese culture in the 1890s and his translations of grotesque Japanese folktales, full of man-eating goblins and crabs with human faces. After a little arm-twisting, Muse "conned" (his words) the long-suffering, ever-acquiescent Gorey into letting him publish one of his books. In '92, Parnassus Imprints released *The Betrayed Confidence*, a compilation of seven of Gorey's Dogear Wryde postcard sets, spanning 1976 to 1990.

In his Yarmouth Port years, Gorey was far from a recluse. He was out and about in his bright yellow Volkswagen Beetle with its OGDRED vanity plate, not exactly the sort of thing you'd drive if you wanted to elude celebrity stalkers. Then, too, he was in the book, as they used to say, right there between Gorewitz and Gorfinkle; you could ring him up, and fans sometimes did. Others put pen to paper, unaware that their fan mail was headed for the dustbin of history, or at least the "six enormous cartons of unanswered letters, contracts, old theater programs, that sort of thing" into which he unceremoniously tossed a good deal of his incoming mail.[42] "I just don't connect very well," was his explanation. "I

352

connect less well as the years go by. At one point I drew a postcard up, which says: 'You've written me to no avail / Because I never read my mail.' Every now and again I send one of those out with my signature on it. Every once in a while you hear about somebody like Carol Burnett, who says, 'Oh, I answer every fan letter I get, in my hand,' and I think, 'This isn't *possible!* Are you *insane?* Have you no priorities?!' "

Determined fans, such as the underground cartoonist Johnny Ryan, a clerk at the Hyannis Barnes & Noble, where Gorey had done a book signing, simply showed up unannounced on his doorstep. Ryan and a friend invited him to lunch, and the trio spent the next two hours at Jack's, discussing the fine points of *Buffy the Vampire Slayer*, *The X-Files*, "and any movies that had animals in them, like *Paulie*, *Dr. Dolittle* (the one with Eddie Murphy), or *Dunston Checks In*," in Ryan's recollection.[43] (Their lunch took place in the early '90s.) After lunch, Gorey stepped behind the cash register and rang them up, which Ryan found amusing.

The following weekend, he and Gorey conducted a more formal interview for issue 8 of Ryan's self-published zine, *Angry Youth Comix*. "This time, we had a whole list of questions we wanted to ask him," says Ryan.[44]

Q. Who was your favorite Stooge from the Three Stooges?
 A. Who's the one with the bangs?
Q. Who's the biggest asshole you ever met?
 A. Robert Frost. He wouldn't shut up about how much he hated his parents.
Q. Have you ever listened to Howard Stern?
 A. Life's too short for all that gassing.

Ryan and his friend took to dropping in on Gorey "to see if he wanted to hang out, which in retrospect seems incredibly obnoxious, but . . . he was always very nice and willing to sit and talk to us. We used to bring him copies of our zines/comix but he probably just threw them in the garbage or something. I don't think they were really his cup of tea, but we really didn't care."[45]

Ryan was forty-five years Gorey's junior, and his scabrous, willfully crude comics crossed the self-flagellating confessionalism of underground artists like R. Crumb with the postpunk cynicism of Peter Bagge, the grunge cartoonist known for his bilious, bleakly funny strip *Hate*. Ryan's work had next to nothing in common with Gorey's, but the older artist's boundless imagination and independence of mind impressed the twentysomething cartoonist mightily.

"Mr. Gorey was a consummate individual," says Ryan. "He had an original mind and he did his own thing, both in the way he lived his life and in the way he worked. I mean, his work is so unique it can't even be classified. Are his books comics or graphic novels or children's books or surrealist art books or gothic fiction? They're all of these things. And nobody has ever been able to pull that off before or since."[46]

"Since I've been living up here,... at some point or other I succumbed to television," Gorey told an interviewer in 1995, "so there I am, parked in front of the television more often than not, making stuffed animals or reading or drawing or writing..."[47]

During his thirty years in New York, he'd never owned a television. Defying the cultural logic of the times, he'd lived a life unplugged from the media feed that shaped the American mind. Chances are good he missed the on-camera murder of Lee Harvey Oswald, JFK's funeral cortege, the Beatles on *Ed Sullivan*, Neil Armstrong on the moon, the Watergate hearings, the nightly horrors of Vietnam. If Gorey took much notice of the political and social tremors registered by TV's seismograph, he never mentioned it. When he *did* discover the delights of the boob tube, he was drawn to everything *but* news programming, current-affairs shows, and the self-consciously high-middlebrow fare served up by PBS. (He made no exception for *Mystery!*, claiming he was fed up with "overly psychologized detectives and their problems.")[48]

In his last decade and a half, he made up for lost time, glutting himself on mass-market TV and late-night box-office bombs with the

same omnivorous relish that characterized his consumption of books and art films. "*The Avengers* is coming back on," Gorey told an interviewer, obviously exultant. "I adore Diana Rigg. I think she's the greatest thing since shredded wheat.... This week we're truly blessed with two episodes of *Dallas*. And, oh, God, those Mexican vampire movies on Channel 27."[49] *Dark Star*, a cult sci-fi comedy, was "tacky in a nice sort of way," he thought ("They made outer space look like the size of a phone booth"), but what the world needed was "a horror movie about demon people on roller skates."

The big open-beamed room on the second floor of his house, up a narrow, steep flight of stairs, was Gorey's TV room—his "entertainment center in all its squalor," as he called it.[50] "Being a collector, he videotaped his favorite shows," Kevin McDermott notes in *Elephant House*, his book of photographs documenting every nook and cranny of Gorey's domestic world. "He taped every episode of *Buffy*. On the sofa were seven or eight television guides: one for the satellite dish, one for the cable, one for local programs, etc. He knitted a small, pocketed remote holder to house the many remotes. Edward feigned not being able to do the simplest household chore, but he could program the VCR to switch taping from cable to satellite on West Coast time."[51] Betraying the same compulsion that led him to affix little white stickers to his CDs, recording the dates he'd first listened to them, he was scrupulous in labeling each videotape, noting the program title, air date, even the time it ran.

Profiles of Gorey inevitably mention his passing infatuations with soaps such as *All My Children* and *Days of Our Lives* or his devotion to *Golden Girls* or his long-running addiction to *Buffy*, *The X-Files*, and *Star Trek*, partly as evidence of the unselfconscious postmodernism of his eclectic tastes and partly for comic effect. (*The man who lived for Balanchine and rhapsodizes about eleventh-century Japanese literature watches* Alf *and* Magnum, P.I.*! Who knew?*) Gorey, of course, was quick to puncture inflated theories about his TV viewing: asked, by an interviewer, if his was "a scholarly interest in American pop culture," he replied, "No, I just like trash."[52]

What he watched is less interesting than the associations it sparked

or the droll observations it inspired, tossed off with an amusingly blasé air. Here he is on his friend (and fellow Cape Cod resident) Julie Harris in the prime-time soap *Knots Landing*, which aired from '79 to '93: "Much as I adore Julie, she's theater to her fingertips, if you know what I mean. She never would've appeared in *Knots Landing* if she had any real standards, but...she was absolutely marvelous. She played this kind of ditzy lady who wanted to be [a] country-and-western singer and who was writing songs. She was acting up a storm all the time, and she was very funny and very touching. Alec Baldwin was her psychotic son, who eventually fell off the building, I believe; he was a born-again fake minister or something. Oh, it had everything. But she was absolutely wonderful....I do wish she would do something that [isn't] quite so *lofty*; it's got to be Tolstoy or *nothing* these days."[53]

Gorey's through-the-looking-glass view of things makes his pronouncements on even the most forgettable shows entertaining. "I'm also very partial to surrealist sitcoms," he told an interviewer. "There was one called *Stat*, a medical one. It had—oh dear. One of those actors whose name is Ron."[54] Trawling the depths of public-access cable TV one Sunday morning, he was smitten with a morbidly obese woman who sang Seventh-day Adventist hymns of her own composition written in what Gorey called a country-gospel style. She was a "genius," he thought—"in a curious way."[55] He genuinely liked her, he maintained, insisting that she had "quite a nice voice, actually." Then again, she *did* remind him of the inimitable Florence Foster Jenkins, a socialite and would-be coloratura soprano whose tin ear and pitiless mangling of opera lyrics reduced audiences to helpless mirth in '40s New York.

Sitting on a couch, flanked by a wall of floor-to-ceiling bookshelves that ran much of the length of the house, with more books in piles all around, he watched his shows and movies while hand-sewing the beanbag creatures he sold at his theatrical performances to raise money for his troupe. Using richly colored, ornately patterned fabrics, Gorey made dolls of every conceivable species, from Figbash, his vaguely avian answer to Max Ernst's bird-headed totem, Loplop, to iconic members of

the Gorey bestiary such as cats, bats, elephants, frogs, and rabbits. Truth to tell, they weren't beanbag animals in the strict sense, since he stuffed them with rice. (Which is why he stored them in the fridge: mice like rice.)

Gorey's stitching, like his cross-hatching, was machinelike in its precision—"precise and perfect and *very* close," Ken Morton says. "He was very dexterous, very good at doing small, detailed things." His nimble fingers seemed to have a mind of their own; eager to be occupied, they'd fiddle with his rings if nothing more absorbing was at hand. "Throughout the conversation, Gorey's hands never come to rest," an interviewer from the *Providence Sunday Journal* observed. "They are molding a rubber band one minute, twisting it into a variety of shapes, testing its elasticity, feeling its texture. A few minutes later, the hands are tearing pieces of cellophane tape, sticking them at random onto the cover of the black sketch book that Gorey always has with him. The tape strips form an abstract design."[56] He was, as Morton puts it, "very . . . gesture-ful," yet as the *Journal* vignette suggests, his fiddling wasn't just a nervous tic; it had as much, or more, to do with Gorey's irrepressible impulse to create.[57]

Anthony Schierman was struck by Gorey's effortless mastery—in his sixties, mind you—of multitasking. In the mid-'80s, Schierman spent a high-school summer living with Gorey at Strawberry Lane while working as a dishwasher at a nearby restaurant. "He'd read a novel a day *while* watching five TV shows, sitting there knitting stuff, making these beanbag things, going to the movies at night, eating out twice a day," he recalls, "and then still [find] time to do the drawings that he did. I don't remember him sleeping very much."

At a glance, the life of a man who lived alone with a clowder of cats, ate at the same short-order joint twice a day, and proclaimed himself "passionately devoted to reruns" of sitcoms like *Golden Girls* is, by any objective standard, "featureless."[58] But as in Gorey's little tragi-

comedies, in which the most Grand Guignol events occur offstage or in the padlocked vaults of the psyche, the quirky, revealing goings-on in his everyday life took place between his ears, or behind closed doors.

Consider his house. Inside, it was a yard-saler's idea of a *wunderkammer*— a cabinet of wonders, one of those private museums that emerged in the sixteenth century as the Enlightenment was gathering steam. Progenitors of the natural history museum, they were crammed full of all manner of fossils, freaks of nature, archaeological artifacts, clockwork automata, unicorn horns, mermaid hands, mummies, pieces of the True Cross, skeletal deformities, bezoars, zoological specimens, and, foreshadowing the surrealists, curiously shaped things (stones, deformed vegetables) that resembled other things, all promiscuously jumbled together with the zany taxonomic logic of the Heavenly Emporium of Benevolent Knowledge, the make-believe taxonomy Borges cites in his essay "The Analytical Language of John Wilkins."

Gorey tended to socialize outside his home. Friends who were allowed entrée rarely saw more than his kitchen, which served as Gorey's parlor. ("It is the only bearable room," he claimed.)[59] "Few were invited to venture past this room," confirms Kevin McDermott. "Edward usually met guests outside on the porch, or he waited with a book on a bench in the common across the way. He and his company would then depart for their destination. Elephant House remained for the most part Edward's private world."[60] (Elephant House, according to McDermott, was the "special name, known only to a few people," that Gorey gave his "great bulky home," possibly because its shaggy gray hide of splintering shingles resembled elephant skin or, more likely, because the antique white porcelain toilet he'd removed from an upstairs bathroom reminded him of an elephant's head.[61] He was so taken with it he repurposed it into an end table.)

The inner sanctum of that world, just off the TV room, was Gorey's studio, a closet-size workspace barely big enough to swing a cat in. In keeping with his preference for rooms without a view in order to minimize distractions, his studio's single window was all but obscured by the tangled branches of a majestic southern magnolia—"brought back from Mount Vernon in a small pot," according to a plaque at the Gorey

museum, "by the sisters who owned and resided in this house, Louise and Olive Simkins, during one of their 'motoring trips' from 1928 (or perhaps 1929)."

Dominating the little room was his drawing board, smeared and splotched with black ink and the white tempera he used to correct mistakes. ("I correct drawings only in a very minor way—with white tempera and/or a razor blade," he said, meaning that he would either white out a mistake or cut it out with a knife, in his case a vintage matte knife. "In desperation I may redraw a segment and paste it over if I feel unable to redo the rest of the drawing as well a second time.")[62] Tools of the trade littered his desk: a metal ruler, a draftsman's triangle, an old rotary phone (whose on/off buttons the cats liked to step on, disconnecting Gorey midconversation), and of course his pens and ink bottles.

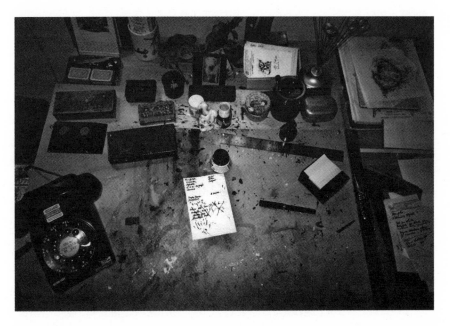

Gorey's desk, Strawberry Lane. *(Photograph by Christopher Seufert)*

Gorey had, for many years, scratched away on Strathmore two-ply matte-finish paper with Hunt 204 pen points dipped in Higgins India ink. When he discovered Pelikan ink and Gillott's exquisitely fine-

nibbed tit-quill pen points, he switched allegiances. The tit quill, he told Clifford Ross, was "very small and, by a brilliant bit of packaging," could only be bought "a dozen at a time on a little card that was wrapped in cellophane. And of course, by the time you got them home, at least three of the 12 were totally useless. One of them would usually last for about a year. Some of them were split in the first place and others you couldn't use for more than about three lines. They cost 20 times as much as any other penpoint and then they stopped making them. I had a real *crise*."[63] He went—"with reluctance"—back to the Hunt 204. "None of these—paper, pen, and ink—seem to be what they once were," he lamented in 1980, "so I expect I am getting old."[64]

By his Cape Cod days, Gorey was using an ergonomically correct kneeling chair; the sight of his six-foot-plus frame hunched over his drawing board, in his tiny studio, must've been something to see. As he drew, a few familiars looked on: squatting on his desk were some metal frogs; nearby sat a framed photo of a bull terrier, the breed he would've owned if he owned a dog. ("I think they're so wonderful," he told a reporter from CBS News. "I just love their looks.")[65] Over his desk were postcards of paintings by Goya and Matisse, along with a framed award for "Very Superior Pencil Sketches," bestowed in 1849 on his great-grandmother Helen Amelia St. John Garvey, from whom, according to family lore, he got his talent. The room's decor also included one of Helen Amelia's small botanical studies, some Japanese wood-block prints, and, on a more Goreyan note, what Mel Gussow described as "an Indian sculpture of a tiger devouring a missionary."[66]

An ink stain down the wall behind his desk testified to the truth of Gorey's remark, to an interviewer, that "anywhere from one to six cats are almost always sitting on wherever I am working."[67] The cats' antics sometimes cost him dearly when they bounded across his drawing board. According to Kevin McDermott, "His archives contain more than one example of a dried puddle of spilled ink destroying a large, complex crosshatched drawing."[68] Ever the Taoist, Gorey simply refilled his inkwell and started over.

Christopher Seufert, a filmmaker who from August of '96 until Gorey's death, in 2000, shot footage of him for a documentary he hoped to make, was one of a very few visitors who were allowed to explore beyond the kitchen. He was fascinated to discover installationlike arrangements of curiosa amid the clutter. "He seemed to treat his house almost like a gallery, because things would change," Seufert recalls. "You'd be in there one day and you could tell everything was set up very deliberately, and the next day there would be, like, a new display."[69] The house on Strawberry Lane was an evolving work of installation art, frequently rearranged and ever expanding, all for an audience of one.

It was also a case study in the eros of collecting. Gorey's irresistible urge to collect, like his obsessive devotion to Balanchine's art, afforded a rare opportunity for a man who claimed to be "reasonably undersexed" to give himself over to desire—the desire to have and to hold, to *possess*. Collecting, writes Christine Davenne in *Cabinets of Wonder*, a book about cabinets of curiosities, is "close kin to passion and excess."[70]

A whiff of fetishism has clung to collecting ever since Freud proposed that the collector's desire is prompted by the unconscious mechanism of psychological substitution. "When an old maid keeps a dog or an old bachelor collects snuffboxes," he declared, "the former is finding a substitute for her need for a companion in marriage and the latter for his need for—a multitude of conquests."[71] Freud was careful to note that an attachment to such "erotic equivalents" was normal enough; after all, *he* was a collector himself. He'd begun accumulating his famous trove of tribal totems and archaeological artifacts shortly after his father's death, a "most poignant loss" whose blow was softened by the acquisition of objets d'art that proved to be a "source of exceptional renewal and comfort."

Nonetheless, Freud's analysis paved the way for pop-psych caricatures of the collector as sexually frustrated and socially maladjusted. In psychoanalytic studies of collecting, there is talk of a libidinal attachment to the idealized object, of a yearning for the absent phallus. Noting "the traumatic events in so many collectors' early lives," the psychoanalyst Werner

Muensterberger observes in *Collecting: An Unruly Passion*, "It is easy to see how affection has been displaced to things, rather than to people, who have proven not to be reliable."[72] The glib dismissal of collectors as damaged or deviant has become a fixture of pop psychology, from the psychologist April Benson's parable, in the *New York Times*, of a "desperate and childless" woman whose traumatic miscarriage and birth of a stillborn baby drove her to amass "a vast graveyard of porcelain dolls" to the French philosopher Jean Baudrillard's gothic-Freudian depiction of the collector as a man over forty who "invests in objects all that [he] finds impossible to invest in human relationships," the "sultan of a secret seraglio" whose possessions are his "harem" and who "can never entirely shake off an air of impoverishment and depleted humanity."[73]

Such descriptions hardly fit Gorey. Still, there's no denying the psychological peculiarities of a lifelong solitary who claimed that cats were the love of his life, whose flat affect invited speculation about whether he was on the autism spectrum (he wasn't),[74] and who didn't do handshakes and shrank from hugs. ("Did you ever see him hug anyone?" I asked Skee Morton. She searched her memory. "He hugged me at my father's funeral," she decided at last. "I think that's the only time." "Physical contact...was not in Edward's repertoire" is the way Carol Verburg, who produced all but two of his Cape Cod theatricals, puts it. "His level of physical contact was cat level.")[75]

Whether some psychic trauma drove Gorey to displace his deepest affections to cats and collections "rather than to people, who have proven not to be reliable," who can say? The literary critic Mario Praz, a fanatical collector who'd spent his childhood as a lonely singleton and who, too, ended up alone in a museum of his own making, surrounded by bibelots and curios, Empire furniture and neoclassical marbles, once remarked that his mania for rare and precious things was indeed a substitute, a craving for "a mistress of another kind, safer and more exciting" than the unreliable human sort.[76]

The quintessential Gorey obsessions, when it came to collecting, were of course books ("I can't go out the door without buying books") and, in a sense, cats.[77] Playing to type, he also collected finials—the hood ornament of Victorian culture, so to speak—and nineteenth-century postmortem photographs of children, affectingly posed. ("Everyone says 'Don't tell them that!'" he confided to an interviewer. "I have a friend in New York who has a huge collection of postcards.... He goes to these postcard shows and sheepishly says, 'Any dead babies?' to the dealers. He tells me 'I hate it! I hate it!' I say, 'Well, just keep looking!'")[78] To no one's surprise, Gorey collected Mexican Day of the Dead papier-mâché skulls and owned a toothless human skull, which he jauntily outfitted with a pair of antique spectacles.

Of course, these are the sorts of things we'd expect Gorey to collect. Less predictable was his flirtation with numismatics, which yielded a handful of Roman coins bearing the image of Trebonianus Gallus (206–253 CE), a not terribly successful emperor who was murdered by his own troops. He was much taken with "sandpaper drawings," as they're erroneously called—pictures done in charcoal on stiff-stock paper coated with a ground of marble dust and varnish. A pastime of young ladies in the mid-nineteenth century, the work tends toward picturesque landscapes and romantic fantasies, such as moonlight shimmering on black waters (the ever-popular Magic Lake theme). Some practitioners worked in pastels; Gorey, unsurprisingly, preferred the grisaille variety. "The ones that are imaginary landscapes are kitschy, because they're sort of castles on the Rhine and blah-ty blah-ty blah-ty," he said. "I think people just kind of made them up, you know; you did obelisks and ruins and columns and trees."[79]

Also in the entrance room was a chest that, according to Kevin McDermott, "contained over three hundred pounds of rusting metal objects, including machine parts, stakes for railroad ties, and old tools."[80] "I just like rusted iron," Gorey told an interviewer.[81] "Edward had a fondness for the texture of decay," says McDermott.[82]

In light of Gorey's Japanophilia, it's hard not to see "fondness for the texture of decay" as an expression of wabi-sabi, the Japanese aesthetic that singles out the beauty "of things imperfect, impermanent, and

incomplete . . . of things modest and humble . . . of things unconventional," as Leonard Koren defines it in *Wabi-Sabi for Artists, Designers, Poets & Philosophers* (a book Gorey owned).[83] Wabi is understated, austere beauty, made more perfect by its imperfections—the tea-ceremony utensil that has been broken and repaired and because of this defect is more beautiful than a flawless but characterless brand-new one. Sabi, according to Koren, is the "beauty of things withered . . . taking pleasure in that which is old, faded, and lonely."[84] "Edward appreciated objects that indicated some degree of prior use—things that had had a life," says McDermott.[85]

Things imperfect, impermanent, incomplete: these were the sorts of things Gorey loved best. In a sense, his entire oeuvre, steeped in the gothic aesthetic, nineteenth-century ballet and opera, penny dreadfuls, Sherlock Holmes, *Dracula*, silent film, and semimythologized visions of the Victorian, Edwardian, and Jazz Ages, can be seen as a monument to the "beauty of things withered," to "taking pleasure in that which is old, faded, and lonely."

What else did Gorey collect? Rocks. Gorey loved rocks. He kept beach pebbles in bowls by his kitchen sink, covered in water to restore their submarine luster. In fact, rocks proliferated all over the countertop—a surrealist's idea of a Zen rock garden. (His dearest dream, as we know from one of his postcards to Peter Neumeyer, was to make a pilgrimage to the renowned rock garden at the Zen temple Ryōan-ji, in Kyoto.) "If you were to die and come back as a person or thing," ran one of the questions in *Vanity Fair*'s Proust questionnaire, "what would it be?" "A stone" was Gorey's reply.[86] "I had a terrible trauma this week," he told the *New Yorker* writer Stephen Schiff. "I didn't know what had become of my favorite rock. And I thought, 'Oh my God, I can't live.' Fortunately, it was found."[87]

Do we detect a subtle philosophical statement in Gorey's habit of lavishing as much attention on his minutely detailed renderings of rocks as he did on his human characters? His rocks *are* characters in the sense that they're always individuals, never generic: think of the Wobbling Rock in *The Willowdale Handcar* and the "absolutely useless stone" in *The Iron Tonic*. But they're also characters in the animistic sense of Japan-

ese folktales, in which inanimate things exude a presence. "Few people seem to notice that a largish part of my stuff is not about human beings," he said. "I mean, I've done several books about inanimate objects. . . . I just don't think humanity is the ultimate end."[88]

Whether he thought rocks have inner lives who knows, but he certainly didn't regard humans as the crown of creation. Of course, Gorey's geophilia also aligned him with the surrealists, for whom weird geological formations were the solidified stuff of dreams. Poetically suggestive rocks were charged with occult power. "Stones—particularly, hard stones—go on talking to those who wish to hear them," wrote André Breton in his essay "The Language of Stones." "They speak to each listener according to his capabilities; through what each listener knows, they instruct him in what he aspires to know."[89]

In fact, Gorey's relationship to the objects he collected was surrealist to the core. He would've fit right in among the exhibitors at *Exhibition of Surrealist Objects*, held at the Galerie Charles Ratton, in Paris, in 1936. The show included what Marcel Jean described, in *The History of Surrealist Painting*, as natural objects ("stibnites from Transylvania"), "interpreted" natural objects ("a monkey-shaped fern, as found in florists' shops"), "perturbed" objects (a wineglass melted and twisted like ribbon candy by the eruption of Mont Pelée, in Martinique, in 1902), objets trouvés (found objects, such as a "book that had spent some time in the sea and was encrusted with shellfish"), and "interpreted" objets trouvés ("roots, round pebbles, and various rock structures arranged in such a way that they took on an added meaning or seemed to reveal some hidden message").[90]

Gorey's collections abounded in "interpreted" natural objects: rocks that resembled frogs; a hunk of driftwood that looked like an elephant's head. The surrealists exploited the dream logic of analogy; Gorey's witty, poetic ability to see the figurative hiding in the literal—the frog in the rock, the elephant in the driftwood—underscores the extent to which he viewed the world with a surrealist eye.

"Interpreted" objets trouvés, "arranged in such a way that they took on an added meaning or seemed to reveal some hidden message," were everywhere at 8 Strawberry Lane, too. Gorey had a surrealist's under-

standing of the uncanniness of the double and of the disquieting sense of a collective presence evoked by multiple copies of a thing. "This is something I learned from Ted," Ken Morton says. "One wrench is just a wrench. But get a lot of them, and it becomes something." Flat surfaces in Gorey's home tended to be populated by groups of objects arranged just so—doorknobs, finials, telephone-pole insulators, metal graters. ("Greater graters and lesser graters," he dubbed them.)

He arranged a flock of pewter salt and pepper shakers on a tray, then balanced it on a stool in a back room on the first floor. Thus arrayed, they looked like people, he thought, or maybe chess pieces. Gorey collected "spherical objects," as he liked to say: bocce balls, glass fishing floats, terra-cotta globes from "Smith & Hawken, or wherever."[91] These, too, went into the back room, arranged on the floor in patterns that were satisfying to the eye. More spherical objects joined the colony, heaped high in bowls. In time, they claimed the room as their own; Gorey christened it the Ball Room. There was just enough space, in the center of the room, for his exercise bike, prescribed by his doctor. Surrounded by spherical objects, he pedaled placidly, reading as he cycled.

Sometimes Gorey's imagination ran riot, extracting multiple meanings from a single object, as was the case with the pile of antique cobbler's tools called "lasting pincers," which he'd found in an antiques shop. "They look vaguely like lizards or something, combination birds' heads or lizards," he told an interviewer. "Oh, dear, it's all so *complicated*. There was a very famous French horror movie called *Eyes Without a Face*. Long before I ever saw the movie, there was a still that was reproduced a lot, with a young lady who had been operated on—they were removing her face, and they had those things that pry the skin away, keep the skin separated. So there's this photograph of her lying there with this slight trickle of blood around the outline of her face, with all these... instruments attacking her. It impressed me a lot at the time. Anyway, lasting pincers look sort of like that. If it weren't for Max Ernst, of course, none of this would anybody look at as being..." He trailed off, then added, apropos of nothing, "But you know, if you look at this"—he held up a pair of pincers—"it looks like a person, sort

of."[92] And there you have it: an object lesson in the surrealist alchemy of free association, which transmutes a thing, natural or man-made, into what the New York gallerist Julien Levy called a "concrete realization of the dream or of irrationality," under whose uncanny influence "reality may begin to assume the dreamed-of aspects."[93]

One of Gorey's obsessions seems less surrealist than Freudian: his mania for stuffed animals. On the second floor, in an alcove near his bedroom, aging, worse-for-wear elephants, cats, and other creatures slumped on built-in shelves. More were heaped, pell-mell, on a chest in his bedroom. According to Kevin McDermott, Gorey "preferred old, worn stuffed animals—the more worn, the better"; whether that was just another instance of his wabi-sabi sensibility or some muffled echo of the miseries of childhood, who knows?[94] His was a cloudless Midwestern childhood, he always claimed, but there's something about a seventy-two-year-old man who still has his childhood bear ("not a teddy bear, but a bear, fuzzy") and who collects stuffed animals at yard sales, battered creatures orphaned by children who'd outgrown them, that suggests otherwise.[95] "I wondered if something bad happened to him once that he never told us about, that he never told anybody about," Morton mused.[96]

Dolls and stuffed toys are enigmatic presences in Gorey stories, cathected, as Freud would say, with psychic energy: in *The Other Statue*, Augustus is frantic upon discovering that his "stuffed twisby" is missing; Charlotte Sophia's only friend in the world, her doll, Hortense, is "torn limb from limb" by the mean girls at the orphanage in *The Hapless Child*; and the Black Doll is a surrealist cipher, a floating signifier haunting Gorey's narrative landscape.[97]

"Like another Edward—Lear—he was a cheerfully morbid bachelor uncle who refused the injunction of St. Paul to put away childish things," John Updike observes of Gorey in his foreword to McDermott's book.[98] Gorey in his seventies had the same unfettered imagination he had in grammar school, evident in his never-ending delight in playing with words, images, and objects.

In that context, his collection of stuffed animals and animal figurines seems like an innocent pleasure—an expression, however goofy, of his

fondness for animals as well as his childlike attachment to cuddly toys. Looked at in the light of his books, though, in which children are ill treated, abandoned, or worse, the animals in Gorey's alcove—the cast-off transitional objects of nameless children long since grown up, grown old, or dead—assume an abject air, like the artist Mike Kelley's assemblages of grungy crocheted animals and abused plush toys scavenged from thrift stores.

One of Gorey's most obliquely revealing remarks about his childhood can be found in a letter to Peter Neumeyer. Prompted by his reading of *Contrary Imaginations*, a critique of IQ tests and prevailing definitions of intelligence, he tells Neumeyer that Francis Parker's principal "lived in the same decaying mansion on the south side of Chicago as did a little group called, I think, the Human Engineering Laboratory which devised intelligence tests so, needless to remark, we got a new one of some sort about every week, sometimes oftener..."[99] What he wants to know from Neumeyer, then a professor at the Harvard Graduate School of Education, is "just how important intelligence tests are in the education scheme of things.... [W]hat I really mean is...how seriously do they affect the life of a child in school and his development?"[100] When we remember his mother loftily informing Gorey's Florida cousins that her wunderkind's IQ was 165 and trumpeting his record-breaking score on the army intelligence test, it's hard not to hear a plaintive note in Gorey's question. Intelligent and articulate beyond their years, prodigies are, by definition, dour little adults, like the tinies in Gorey stories.

At the risk of pop psychologizing, one can't help wondering: did Gorey, a great one for paradox, have in late life the childhood he never had as a kid? He collected teddy bears ("in a desultory sort of way"), read Nancy Drew mysteries 'til his dying day, and devoted much of his last decade or so to puppet shows, traditionally a children's genre.[101] "One of the great deprivations of my life is that I never learned how to make papier-mâché," he once lamented, "and now it's too late."[102] Except it wasn't: Gorey crafted his puppets himself, molding their heads out of papier-mâché—the stuff of lost time.

CHAPTER 15

FLAPPING ANKLES, CRAZED TEACUPS, AND OTHER ENTERTAINMENTS

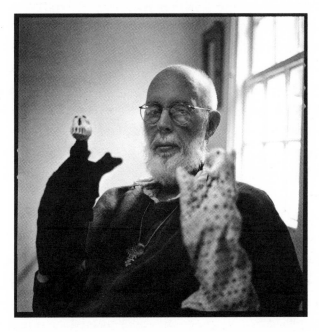

Gorey with two members of Le Théâtricule Stoïque.
(Photograph by Brennan Cavanaugh)

ASKED, IN A 1998 INTERVIEW, if he'd been bitten by the theater bug while designing *Dracula*, Gorey said, "Well, I think, in a kind of way, it's been theater all along."[1] Of course it had been, from his high-school raptures over the Ballets Russes to his Dugway plays to his all-consuming affair with the Poets' Theatre to his passion for silent film to his fascination with Kabuki and Noh to *Dracula*, *Gorey Stories*, and *Tinned Lettuce*. Then, too, many of Balanchine's ballets had story lines,

369

however loose, and some, such as *The Nutcracker*, were wordless plays, incorporating elements of pantomime and costume drama.

Tellingly, Gorey's earliest literary efforts were plays. "Apparently I must have had a leaning toward theater at the very beginning and I didn't follow it up," he said.[2] In a 1977 interview, he regretted the road not taken: "I tend to drift my way through existence, and if I had decided to direct myself a little more than I ever did, I think I probably would have worked in the theater more."[3]

With *Lost Shoelaces*, a "musical entertainment" performed at the Woods Hole Community Hall in August of '87, Gorey came full circle to the evening of entertainments "Somewhat in the Victorian Manner" that he'd staged in 1952 with the Poets' Theatre. Genie Stevens, a director whose work with the Woods Hole Theater Company Gorey had seen and liked, had approached him about bringing his work to the stage. Gorey was agreeable but urged her to adapt some of his unpublished work rather than rehash ground already covered by *Gorey Stories*. He supposed he could do a flyer or a poster for the show, he said. Perhaps he could make the props, too. And the sets. And the costumes. Come to think of it, when was she going to hold auditions? He might as well pop by. Clearly he hadn't forgotten the fun he'd had with the Poets' Theatre, putting on arty plays in an atmosphere of goofy amateurism.

Riffling through the pile of pages Gorey had given her, typed on yellow legal-pad sheets, Stevens realized that *Lost Shoelaces* was going to be "really tricky." "I've directed a lot of Shakespeare and Shakespeare is *much* more straight ahead than Edward's work," she says. "I couldn't make head or tail of what to do with it, exactly. It was like an evening of Victorian entertainments, where somebody would come out and recite and somebody would sing and somebody would do a dance and often there was a tragic ending." The question was, how to translate Gorey from the page to the stage? "What's it *about* is a very funny question, because what are any of his books *about*? They're about strange things happening, but they're more about tickling your brain, having you become engaged with words and ideas."

Consider "The Folded Napkin," a send-up of the "rational

amusements"—drawing-room recitals and Chautauqua-style lectures—popular with the Victorian bourgeoisie, a relentlessly self-improving lot. The silent skit featured an actor in black turtleneck and black tights solemnly displaying, for the audience's edification, illustrations of napkins folded in various ways. "People were on the floor laughing," says Stevens. "It built and built, there was music behind it, and it was just hysterically funny."

Another playlet, "The Besotted Mother: or, Hubris Collected For," was, in Gorey's words, a "heart-rending little work about a mother whose child is eaten by a pack of wild dogs."[4] Scrimping and saving, the doting mother buys her little darling an outfit made of "bunny fur." Confident that her dear one is snug against the elements, she leaves the child outside the greengrocer's while she's inside, buying eggplants. (Eggplants, like turnips, are surrealist fetishes in Goreyland, charged with occult significance. To Gorey, the eggplant was "an otherworldly fruit" with a portentous presence, says Eric Edwards, who performed in many of his entertainments, as he liked to call them.[5] As an inside joke, he dubbed his stable of players the Aubergine Company.) Predictably, a pack of ravening dogs "tears this child in bunny fur to pieces!" Gorey told an interviewer.[6] For the coup de grâce, he selected, as an ironic backdrop to the carnage, what Stevens recalls as a "very sweet, soothing" piece by Chopin.

A hodgepodge of unrelated playlets performed by actors and hand puppets, *Lost Shoelaces* was the mold from which nearly all Gorey's subsequent entertainments were cast. Based, like *Tinned Lettuce*, on his books or on unpublished texts he hadn't gotten around to illustrating, they weren't exactly plays, he admitted, but neither were they revues, "because they don't start and stop, they just sort of drivel along without interruption."[7] Somewhere between verse drama, Victorian parlor entertainments, and surrealist vaudeville, they were born of "a theatrical sensibility more illuminated by Dada, Beckett, and Japanese art" than by traditional theater, thought Carol Verburg.[8] "I'm not at all interested in realistic theater," Gorey confirmed.[9] The stars by which he navigated as a dramatist included "old-time musicals," "anything that emanates

from Japan—Kabuki, Noh, anything of that sort," as well as "ballet, opera"—in short, "anything that's highly stylized."[10]

Puppets were perfect for Gorey's embrace of artifice, especially the enigmatic little heads he sculpted out of CelluClay, a brand of instant papier-mâché. Expressionless personages with pinhole eyes, a cursory nose (at best), and no more than a suggestion of a mouth (if that), they were as cryptic as the characters in his books. Their costumes—the glove hiding the puppeteer's hand—were, by contrast, as eye-catching as their faces were unremarkable, hand-sewn by Gorey from material in wild patterns, from plaid to polka-dot, star-spangled to striped.

Gorey once claimed that the inspiration for his puppet plays struck when he was toying with the idea of staging the tragedies of the Stoic philosopher Seneca—closet dramas noted for their grisly descriptions of revenge killings. "There's a famous collection of Elizabethan translations, which are absolutely quite wonderful," he recalled. "I kept thinking, 'Oh, wouldn't this be fun to do Seneca with puppets.'"[11]

It's just preposterous enough to be true. But a paper he wrote for a French class at Harvard in 1947, proposing a stage design for Pierre Corneille's verse tragedy *Horace* (1640), is more revealing about Gorey's vision of a theater whose "unnaturalist" aesthetic reveled in striking tableaux, special effects, choreographed movement, and poetic language rather than depth psychology, naturalistic acting, and the willing suspension of disbelief. He imagines automatons, remote-controlled by backstage technicians, that glide across the stage on rails like "a child's electric train," their prerecorded lines crackling through the PA system.[12] Gorey's thespian robots would create a jarringly ironic distance between the "passions and sufferings" of Corneille's tragedy and their impassive features and "artificial" gestures, "synchronized with those of other characters" to create kinetic patterns reminiscent of classical ballet.[13] As envisioned, his mechanized *Horace* would have had more in common with the Bauhaus choreographer Oskar Schlemmer's Machine Age ballets than conventional theater.

At the same time, Gorey's remote-controlled puppets realize the aesthete's dream of an art about art, focused on form, fluent in historical

allusion, rejoicing in the impulse to play (with images, words, ideas), and freed at last from the gooey sentimentality and showbiz hamminess that afflict commercial theater. It's an aesthetic he would embrace to the fullest, some forty years later, in his Cape Cod entertainments.

Lost Shoelaces marked the debut of the puppet troupe Gorey called Le Théâtricule Stoïque (the stoic little theater), and of Eric Edwards, Vincent Myette, Joe Richards, and Cathy Smith—charter members of the close-knit company that for more than a decade would dedicate itself to the performance of Gorey's entertainments. The show was notable, too, as the first—and last—time anyone but Gorey occupied the director's chair. With Stevens's departure—she'd taken a job in New York—he assumed the role, a part he'd continue to play throughout his decade-long involvement with community theater on the Cape.

Gorey's approach to directing was laissez-faire—in the extreme. "As a director, Edward's favorite maxim was that the director's job is to keep the actors from running into the furniture," recalls Carol Verburg, who began working with him in 1990, producing his shows and acting as director's assistant.[14] He "scoffed at motivation and character development," she says.[15] In her brief reminiscence, *Edward Gorey Plays Cape Cod*, she draws a parallel between Gorey's refusal to connect the dots for his actors (or, for that matter, his audience) and the aesthetic of understatement, omission, and ambiguity that characterizes his books. It was his intent "simply to show what happened to whom," she believes, freeing cast and audience alike to make whatever sense they might of his always oblique, often inscrutable texts.

In Gorey's works for the stage, the spotlight is squarely on language—language at play, freed from the need to make sense (though not the requirement to make *non*sense). "My stuff is fairly carefully written, so I don't feel that anything needs explaining," said Gorey. Thus his dictum "There is no motivation, just read the lines."[16]

Paradoxically, Gorey demanded expressive subtleties from his puppets that would've reduced Jim Henson to tears. (We're talking, remember, about the emotive possibilities of a lump of papier-mâché no bigger than a golf ball, with pinprick eyes, a perfunctory nose, and no mouth.)

As if coaxing emotion out of a puppet with only rudimentary facial features weren't challenging enough, the props *were* the puppets on occasion. Gorey's surrealist eye for objets trouvés, as well as his bricoleur's delight in transmuting whatever's at hand into something wondrous, led him to scour "yard sales for promising objects—less for illustration than for provocative juxtaposition," notes Verburg.[17] Balls of yarn, strings of beads, bags of confetti, glass doorknobs—seemingly anything might be reborn as a prop or even a puppet.

Eric Edwards recalls a hilarious exchange between Gorey and Cathy Smith, who was puppeteering a pair of clothespins in the Théâtricule version of *The Bug Book*. "Edward was really quite annoyed, because we weren't putting enough emotion into these clothespins," he says. "Cathy was jiggling this clothespin for all it's worth, and Edward would say, 'I want to see this clothespin emote,' and Cathy goes, 'Edward, they're only *clothespins!*'"[18]

Jane MacDonald, who'd spent years mastering the art of "filling out a character and giving it everything [it] needs to become real," was bemused, at first, by Gorey's demand that puppets—even clothespins—emote but human actors deliver their lines in a deadpan, declamatory style.[19] His characters had—at least apparently—no more psychological depth than Lear's or Lewis Carroll's or the stock types in silent movies because Gorey, as always, is paradoxical: "He wanted the interior that was never spoken, so there *was* actorly work to be done there" after all, says MacDonald.[20] The ideal Gorey actor managed the neat trick of hinting obliquely while revealing next to nothing. "Everything the surface could express he wanted; the rest was secret. That's his whole thing: he liked what was withheld." Unlike the Freudian repressed, Gorey's repressed *stays* repressed, just beneath the surface of everyday life, irradiating it with mystery. "He wanted everybody to leave with questions."

They did. Some simply left: on more than one occasion, half the audience decamped at intermission, baffled beyond endurance. Cathy Smith recalls, "Theater people would say things like, 'Have you ever thought about *pace?* Are you *trying* to bore the audience?'" George

Liles, a reviewer for the *Cape Cod Times*, warned "those not familiar with Gorey" that *Stuffed Elephants*, performed in 1990 at the Woods Hole Community Hall, consisted largely of "a lot of unhinged characters wandering about in gardens, peering perplexedly in and out of windows, haunted by vague memories."[21] Still, the show's twenty little vignettes about "kidnapping, pederasty, incest, murder, and boredom" were "grim and prim and full of foreboding nonsense," he conceded. "Parents briefly grieve the loss of a child, but it passes quickly, and they shrug and go dancing." He was especially taken with the company's treatment of *The Nursery Frieze*, performed in the dark by players equipped with those little toy wheels that spin, throwing off sparks, when you pump a plunger.

By contrast, Liles was less than charmed by Le Théâtricule Stoïque's adaptation of Stuart Walker's 1917 "portmanteau play," *Six Who Pass While the Lentils Boil*, when he saw it at the Theatre on the Bay in Bourne in 1995: "The puppet show is a shrill and pointless little drama that begins with the provocative title and then goes downhill."[22] The whole thing was "a plodding and self-indulgent exercise," he decreed.

Gorey settled the score, after a fashion, with *Epistolary Play*. An eye-rolling retort to A. R. Gurney's schlocky *Love Letters*, which he loathed, it was also a wry comment on middlebrow theatergoers—the "I laughed, I cried" demographic, whose appetite for sentimental flapdoodle, with a side serving of pseudosophistication, encourages the worst in commercial theater. "It's like a disease," he said of the Gurney warhorse in 1997, the year his takeoff on it premiered at the Cotuit Center for the Arts.[23] A chronicle of two intertwined lives, told in letters, *Love Letters* is a perennial favorite with actors, since the dialogue is read, not memorized; cash-strapped community theaters love it, too, since it requires a cast of only two and little more than a suggestion of a set. As a result, Gorey groaned, "it gets done about five times a year" on the Cape, "whose population is well under 200,000."

Driven to distraction by Gurney's "perfectly appalling piece of gibberish," he decided to dash off a play for two players reading letters aloud. "Well, needless to remark, it ran totally and completely amok,"

he admitted.[24] Instead of two characters, Gorey's *Epistolary Play* has sixteen, played by two overworked actors, not to mention an "incredibly complicated plot" that went "absolutely nowhere" in the usual convoluted manner.[25] He recalled audience members wandering dazedly up after performances, asking if they could have a copy of the script to read, which he took to mean, "I couldn't follow this! I'm exhausted!"

Gorey seemed airily unconcerned about audience reactions or even whether there *was* an audience. "I went to a play in Provincetown and there were two people there—and Edward—in the whole theater, and it was a good-sized theater," Rick Jones recalls. "He laughed away and enjoyed himself, had no care whatsoever—he had his own private theater and loved it." On the other hand, there *were* audience members who got it, says Jill Erickson, who joined the troupe in 1994. They were the ones who "came repeatedly because they wanted to see what we were going to do on any given night."

As it happens, it's that very unpredictability—the ever-evolving nature of a live, collaborative art form like the stage play, so dramatically unlike the static, solitary art of pen-and-ink drawing—that glued Gorey to his seat night after night. Staging his entertainments was "very satisfying in a way that doing a book isn't," he said. "No matter how many performances you see of it, it's sort of different every time. With a book, . . . it may strike you differently, you know, at one time or another, but it doesn't have the kind of wonderful open thing that the theater does."[26]

Unbound from the page, refracted through the idiosyncratic sensibilities of his actors, Gorey's work took on a life of its own, a sea change that charmed him. "Edward sits in his little room and does this all by himself," Genie Stevens observes. "It must've been fairly enthralling to see a group of people bring his two-dimensional characters to life, before his eyes." In fact, Gorey was so captivated by the experience that he tinkered incessantly with his scripts, adding bits of dialogue and driving his actors half mad in the process. "He liked to invent everything as it went along and invent it all over again the next day, if time permitted," Verburg recalls.[27]

Challenging as they were, Gorey's entertainments attracted a small but fervent following. They enjoyed their most rhapsodic reception in October of '98, when the troupe performed *English Soup* at Storyopolis, a bookstore and art gallery in Los Angeles, on Halloween weekend. (It was the first and only time the troupe left the Cape. Gorey, naturally, refused to travel.) "It was *phenomenal*," recalls Jamie Wolf, who served as stage manager for the West Coast shows. "We ended up booking two more shows [at Storyopolis]; we did five shows in three days. The cover of the *LA Times Magazine* was Gorey's *Gashlycrumb Tinies*. We had people like Dweezil Zappa in the audience. Smashing Pumpkins showed up. I was hanging out, getting ready for the first rehearsal, and I realized I was with Gabriel Byrne."

The company played to standing-room-only crowds. "People expected something dark and creepy and all of the actors came out in white, the stage was totally white," says Wolf. "It was not at *all* what they were expecting—which was really good; it was what Edward liked. It took the audience the whole play to understand what they were seeing." But by the time the curtain fell, they "understood that they'd just had an evening with Edward Gorey. They were expecting 'A is for Amy who fell down the stairs / B is for Basil assaulted by bears...' and they didn't get any of that."

The troupe's rapturous reception in LA turns out, in retrospect, to have been the capstone of Gorey's theatrical career. Jane MacDonald believes his work for the stage was just coming into its own, and after "seeing the impact and the receptivity for him and his work" at Storyopolis, she thinks it would have reached a wider audience if its momentum hadn't been cut short by Gorey's death a year and a half later.[28] Gorey's puppet shows would have been perfect for TV, she believes. To be sure, Le Théâtricule Stoïque would never have played *Sesame Street* or bumped Cirque du Soleil off the Vegas marquees. But Gorey's writing for the stage *had* evolved, evincing a growing awareness of what made for good theater. His "original vision," realized in *Lost Shoelaces*, was "very two-dimensional, very book-derived," says Verburg.[29] By *Flapping Ankles* (1991) and *Crazed Teacups* (1992), both

performed by the Provincetown Theatre Company at the Provincetown Inn, he was responding to actors' and audiences' reactions, she points out, writing "pieces that were somewhat more theatrical in a conventional sense, although without ever leaving his fundamentally episodic, kaleidoscopic, juxtaposed-rather-than-connected approach to making art."[30]

Sadly, his breakthrough work didn't see the light of day until after his death. Two days after he died, Verburg, who was staying at Strawberry Lane to keep an eye on Gorey's five cats, took a distraught call from the composer Daniel Wolf. He'd only just learned of Gorey's death, days after finishing the score for something called *The White Canoe: An Opera Seria for Hand Puppets.**

Wolf had written Gorey in 1999, asking if he was interested in collaborating on a piece of musical theater for puppets. Gorey's answer was *The White Canoe*, a libretto based on "A Ballad: The Lake of the Dismal Swamp," a lachrymose piece of verse by the Irish Romantic poet Thomas Moore (1779–1852). The poem takes its title from a vast marsh that in Moore's day sprawled over southeastern Virginia and northeastern North Carolina. An uncanny place, the Dismal Samp inspired tales of haunts; Moore spun the local lore into an eerie, atmospheric poem about a young man who, driven mad by the death of his beloved, goes looking for her in the trackless wastes of the swamp and is never seen again.

"I spent that grim summer rehearsing with Le Théâtricule Stoïque," Verburg recalls in *Edward Gorey Plays Cape Cod*, "sewing puppet costumes, trying to guess what Edward meant by such cryptic marginal notes as 'Spirits of the swamp: insects: Loie Fuller[†] sleeves' and 'alli-

Opera seria (Italian for "serious opera," as opposed to *opera buffa*, "comic opera") appeared in Naples in the late seventeenth century; Alessandro Scarlatti is perhaps its best-known practitioner. Works in this genre featured expository sections sung in a recitative, or "talky," style, alternating with dramatic arias sung in the highly ornamented bel canto style, often by castrati.

†Loie Fuller (1862–1928), a contemporary of Isadora Duncan, was the most famous proto-modernist dancer of her day. Her delirious *Serpentine Dance*, performed in a billowing, translucent costume of China silk under innovative colored lighting (which she invented), made her the darling of belle époque Paris, an inspiration to Rodin and Toulouse-Lautrec.

gators have tails.'"[31] On September 1, 2000, five months after Gorey's death, *The White Canoe* opened at Freedom Hall in Cotuit.

Verburg still thinks it was the best thing he wrote for the theater, reconciling his eclectic interests with "enough dramatic structure to make the piece really successful."[32] The show "represented a real triumph of his constantly shifting approach to theater, all the different things he tried: the parodies, the meaningless things, the books that he dramatized," she says. "By *The White Canoe*, he knew what he was doing, and that broke my heart, because he really *got it*, [but] didn't get to see it and we didn't get to go on from there."[33]

Apart from a handful of reviews in local papers such as the *Cape Cod Times* and scattered mentions in his later interviews, Gorey's entertainments have received scant notice and virtually no in-depth analysis. This has largely to do with the decision by the Edward Gorey Charitable Trust, which oversees his copyright, not to publish his plays. Why the trustees haven't seen fit to do so is unclear, though there is the perception, in some quarters, that Gorey's entertainments were silly little fribbles, the self-indulgent diversions of the semiretired. Since only a half dozen or so of the Théâtricule's performances survive, captured on video by Christopher Seufert, it's difficult to judge the merits of Gorey's theatricals in the context of his larger oeuvre.

Are they "so avant-garde, so completely original" that they'll be recognized one day as "a seminal theatrical movement," as Verburg contends?[34] It's a tall claim to make for such a slight body of work. More to the point, it's unfair to burden Gorey's studiously frivolous little bagatelles with the historical significance of a trailblazing movement. Does *Omlet; or, Poopies Dallying*,[35] a puppet play stitched together from Gorey's "favorite nonsensical bits of early pirate *Hamlets*" (Verburg), really belong on the timeline of experimental theater, alongside Richard Foreman's raw, confrontational Ontological-Hysteric Theater and the postmodern spectacles of Robert Wilson?[36] Yet if we view Gorey's works for the stage as a wonderfully stunted branch of the genealogical tree that yielded the closet drama and the verse play, we can give them their due as a kooky, irrepressibly Goreyan portmanteau of

poetry and theater without overinflating their importance in relation to his more enduring work as an author and illustrator.

For his part, Gorey was unquestionably invigorated by his rediscovery of the theater at a time when his commercial illustration had become mere drudge work. By all accounts, he found the opportunity to experiment—to *play*—with words and images and ideas in a medium associated with amateurishness, and in a location far from anywhere, giddily liberating. Both the setting and the shoestring unpretentiousness of community theater ensured that his efforts would be written off by the smart set as mere dabbling, which suited him just fine. "After half a century, he was going back to what he had done in college—this position . . . of having nothing expected of him and nobody particularly paying attention, judging in any high-stakes way the work that he was doing," says Verburg. "He was completely free to experiment. By this time, his position as a New York artist involved things like, 'Will you please sign ten thousand book plates?' which was mind-crushingly boring for him. So he blossomed all over again, which I think is the story of Edward's life—he was perpetually blossoming all over again because of his ceaseless curiosity and boundless intellect and imagination."[37]

CHAPTER 16

"AWAKE IN THE DARK OF NIGHT THINKING GOREY THOUGHTS"

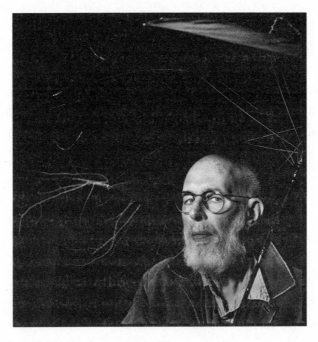

Edward Gorey, circa 1999. *(Photograph by Brennan Cavanaugh)*

PERPETUAL BLOSSOMING NOTWITHSTANDING, Goreyphiles lamented that his amateur-hour theatricals, as they saw them, were distracting him from his *real* work. "When I'm in six weeks of rehearsal and three weeks of production, I don't do a *thing* the other part of the day," he conceded to public-radio host Christopher Lydon.[1] Lydon was regretful: "So we're losing Gorey books because of this?"

We were. Gorey confirmed in a 1997 interview that he hadn't done what he ironically referred to as a "major book"—a squawk

381

of self-mocking laughter underscored the preposterousness of the phrase—"since *The Raging Tide* in 1987, I guess."[2] (Nineteen eighty-seven, as we know, was the year he mounted *Lost Shoelaces*, inaugurating his theatrical career on the Cape.) Even so, he noted, he *had* "whipped up a lot of little stuff over the past couple of years."

The diminutive defies us to take it seriously. As in his theatricals, the throw-it-at-the-wall-and-see-if-it-sticks air of his "little stuff" bespeaks a desire to wriggle out of the straitjacket of a style that was starting to cramp his imagination. Gorey abhorred the thought of repeating himself. Beginning in the early '80s, in his waning days in New York, and continuing through his years on Strawberry Lane, he embraced his inner dabbler. Experimenting with styles and formats far afield from the meticulous, crosshatched draftsmanship of defining works like *The Doubtful Guest*, he gave free rein to his love affair with form and genre.

In much of his literary output from this period, he abandons narrative for the childish pleasures of novelty genres that blur the line between book and game or book and toy. "The older I've gotten, the more I've tended to like things you can fiddle around with," he said in 1995.[3] Many of the titles from this time are designed to be played with as much as read.

In *Mélange Funeste* (Dreadful mixture; Gotham Book Mart, 1981), he explored the possibilities of the "slice" book, so called because its pages are sliced crosswise into thirds, enabling the reader to mix and match parts of an illustration by turning sections of a page. By flipping this segment or that, the reader of *Mélange Funeste* is able to reassemble the heads, torsos, and legs of a desiccated corpse, an ingenue, a mustachioed gent, and one of those catsuited burglars from Feuillade's *Les Vampires*, among others, into a seemingly endless number of chimeras—a game-like gimmick that transposes the surrealist game exquisite corpse into the book medium.

Les Échanges Malandreux (very loosely, The awkward ex-changes; Metacom Press, 1984) makes use of a similar device: each page is divided into four hand-sewn "gathers of folded pages," as Irwin Terry calls them.[4] By turning the leaves in the quadrants, the reader is able

to create disjointed dialogues, all with the stiff syntax and baffling non sequiturs of the nonnative speaker. The top two panels feature various figures; questions and answers are printed on the right and left sheaves at the bottom. A typical combination yields an Edwardian motorist in a floor-length fur coat and goggles asking a sickly creature in a wheelchair, "Has anyone looked under the stairs?" to which the invalid replies, unaccountably, "I have forgotten you."

We hear echoes, here, of those stock dialogues in foreign-language phrase books whose robotic unnaturalness gives them a surrealist air, and of *English as She Is Spoke* (1855), an unintentionally hilarious conversational guide written by a Portuguese man who didn't speak a lick of English. Between the laugh lines, though, Gorey seems to be saying something about the limits of language—specifically, the impossibility of translation in anything but the most hopelessly inexact sense.

Gorey exploited the interactive technology of the pop-up book in *The Dwindling Party* (Random House, 1982), which uses flaps and pull tabs to immerse the reader in a country-manor mystery where child-devouring grottoes and leviathans lurking in the moat pick off the MacFizzet family one by one. In *E. D. Ward, a Mercurial Bear* (Gotham Book Mart, 1983), he tried his hand at the paper-doll dress-up book. Officially by Dogear Wryde, this "paper pastime" enabled readers to dress a teddy bear (of indeterminate gender) in a variety of men's and women's costumes, from a lace-sleeved granny dress to a suit of armor to a corset and tutu to a letterman's sweater.[5]

He indulged his fancy for miniature books in *The Eclectic Abecedarium* (Anne & David Bromer, 1983), a tiny tome measuring 1-1/16 by 1-5/16 inches, hand-bound by a master bookbinder. A fondly mocking "homage to Mrs. Barbauld"—meaning Anna Lætitia Barbauld, the eighteenth-century woman of letters whose serious consideration of the needs and desires of young readers revolutionized children's literature—*The Eclectic Abecedarium* parodies both the earnest didacticism and small format, designed for little hands, of Barbauld titles such as *Lessons for Children* (circa 1778) as well as the crude woodcut illus-

trations and singsong couplets of nineteenth-century chapbooks such as *Pleasing Rhymes, for Children*. Some of Gorey's maxims are eminently practical ("Don't try to cram / The dog with Jam"); some shudder at the terrors of religion ("There is an Eye / Up in the sky"); some give off a whiff of weltschmerz ("Beyond the Glass / We see life pass").

In *The Tunnel Calamity*, Gorey resurrected a Victorian parlor amusement known as the peep-show or tunnel book, so called because one of the most popular applications of the optical novelty depicted the world's first subaquatic tunnel, the Thames Tunnel, completed in 1843. Gorey's *Tunnel* employs the same design as its nineteenth-century precursors: a series of die-cut panels joined together, accordion-style, between two covers. Expanded to their full length and viewed through a peephole in the front cover, the overlapping panels produce the illusion of depth. *The Tunnel Calamity* brings to life an alarming manifestation in the tunnel between East Shoetree and West Radish on St. Frumble's Day—an unexpected sighting of the fearsome Uluus, long thought to be extinct. In the distance, the Black Doll can just be seen, sitting in an oculus.

Such titles don't compare, in pen-and-ink virtuosity or literary substance, to classic works like *The Object-Lesson*, *The West Wing*, and *The Iron Tonic*. But Gorey's ingenuity in marrying the quirky formats of children's genres such as the pop-up book and antique novelties such as the peep-show book to literary devices scavenged from Dada, surrealism, and Oulipo gives them a charm all their own—an inspired inconsequentiality.

Then, too, despite their tossed-off feel, Gorey's experiments with form in the last two decades of his life were, in their unserious way, philosophical investigations. By requiring the reader's physical participation—mixing and matching the sections of a trisected page, fiddling with flaps and pull tabs, peering through a peephole—Gorey draws our attention to the reader's role in making meaning. These books underscore his long-standing belief in what Roland Barthes called the writerly text, which invites us to fill in its gaps, read between its lines.

At the same time, such titles dramatize the extent to which the the-

ater had taken center stage in Gorey's imaginative life: pop-up books like *The Dwindling Party*, exquisite corpses between two covers such as *Mélange Funeste*, and peep-show books like *The Tunnel Calamity* turn the act of reading into a theatrical event in which the book performs the narrative. In the immersive, wordless *Tunnel Calamity*, the reader's roving eye creates the story line in the same way that camera movement constructs film narrative. The peephole beckons us through the fourth wall onto the stage set; the more we manipulate the book's concertina-like structure, the more narrative detail it reveals.

Clearly Gorey is attempting to translate that "wonderful open thing that the theater does" into the book medium. But his late-life flirtations with interactivity are also manifestations of his commitment, going back decades, to the aesthetic of open-endedness. Experiments in indeterminacy like *The Raging Tide, The Helpless Doorknob: A Shuffled Story* (publisher unknown, 1989), and *The Dripping Faucet* (Metacom Press, 1989) take to playful extremes his desire to turn the traditional narrative into a garden of forking paths—a nonlinear text whose interactive nature makes a coauthor of every reader, ensuring new narrative twists with every reading.

The deck of twenty illustrated cards that comprise *The Helpless Doorknob* can be reshuffled to yield, by Gorey's count, 2,432,902,069,736,640,000 Agatha Christie–esque mysteries. Most if not all of the combinations juxtapose unremarkable occurrences with ominous goings-on, producing that Goreyesque blend of the droll and the disquieting, somewhere between Feuillade and Magritte: "Agatha taught Adolphus to dance the one-step." "Adela flung Angela's baby from an upstairs window." "Angus concealed a lemon behind a cushion." "A disguised person came to one of the side doors."

By comparison, *The Raging Tide* looks conventional enough: it arrives in the familiar guise of one of Gorey's thirty-page books (though it's bigger than most) and has no sliced pages, pop-ups, or peepholes to bedevil us. But that's where any similarity to a conventional picture book ends. A tour de force of pattern-on-pattern composition, it's easily one of Gorey's most surrealist titles. The action—to talk of plot seems absurd—consists of a slapstick melee fought with dish

mops, loofahs, mourning pins, and antimacassars in a landscape littered with giant severed thumbs (inspired, quite possibly, by the nineteenth-century French cartoonist J. J. Grandville's engraving *The Finger of God*). The combatants are Gorey's faceless comic-grotesques, Figbash and the hairy whatsit Skrump and the shrouded Naeelah and Hooglyboo, a teddy bear with a broken arm and an amputated leg: "Skrump flung a damp sponge at Naeelah." "Figbash scattered cracker crumbs on Hooglyboo." And so forth. There's no more rhyme or reason to their Dadaist battle royal than there is to Tweedledum and Tweedledee's quarrel in *Through the Looking-Glass*.

Then, too, the self-deconstructing design of the book makes a hash of causality, not to mention meaning. Each of the book's two-page tableaux offers the option of proceeding to one page or another (though rarely the next): "If you loathe prunes more than you do turnips, turn to 22. If it is the other way around, turn to 21." Fittingly, the book offers a choice of two endings: in one of *The Raging Tide*'s alternative universes, "everyone went joyously to an early grave"; in the other, "they all lived miserably for ever after." Naturally, the Black Doll is nowhere to be found, except on the book's cover.

Gorey grew more, not less, experimental in his later decades. *The Dripping Faucet*, which, true to its subtitle, can be manipulated to create as many as *Fourteen Hundred & Fifty Eight Tiny, Tedious, & Terrible Tales*, recalls the Oulipian writer Raymond Queneau's iconoclastic slice book, *Cent Mille Milliards de Poèmes* (One hundred thousand billion poems, 1961), a collection of ten sonnets whose lines are printed on individual strips, enabling the reader to replace any sentence with the corresponding one in any of the other poems. (Gorey knew Queneau's work, and the system of paper flaps used in *The Dripping Faucet* is markedly similar to the one used in *Cent Mille Milliards*.) *The Helpless Doorknob* calls to mind Vladimir Nabokov's Gordian knot of a novel *Pale Fire*, a satirical metafiction written in the form of a 999-line poem by the (imaginary) poet John Shade, accompanied by an exhaustive exegesis by the (equally imaginary) critic Charles Kinbote. Nabokov lets the reader chart her own course through the text; the book "can be read either unicursally,

straight through, or multicursally, jumping between the comments and the poem," notes the literary theorist Espen Aarseth—a navigational freedom replicated in the manifold possibilities of *The Helpless Doorknob*. (*Doorknob* may, in fact, have been inspired by *Pale Fire*. Kinbote digresses at length about the kingdom of Zembla, a fictionalized version of the Russian archipelago Novaya Zemlya. By curious coincidence, one of the cards in Gorey's book of changes announces, "Alfred returned from Novaya Zemlya.")

Gorey's texts "you can fiddle around with" also invite comparison to the Web-like "hyperfictions" of Robert Coover, whose narrative branchings, made possible by hypertext software, entreat the reader to choose this plotline or that. They remind us, too, of postmodern metafictions such as Julio Cortázar's novel *Hopscotch*, which encourages readers to do just that—hopscotch through its 155 chapters as directed by a Table of Instructions or simply by following their own noses through the narrative.

Gorey, it turns out, was the Benjamin Button of avant-gardism, evolving backwards from the twee aestheticism of his Harvard period into the Edwardian surrealism of his New York era and, finally, into the gleeful Dadaism of his white-haired years, when he opened the throttle of a radicalism more commonly associated with youth.

In his last two decades, Gorey pared down his style. During his minimalist period, as he called it—a phase that encompassed *The Dancing Rock* by Ogdred Weary, *The Floating Elephant* by Dogear Wryde, and *The Pointless Book; or, Nature & Art* by Garrod Weedy (all 1993, the first two released by an unknown publisher, the third by Fantod Press)—he did away with text altogether and stripped illustration to its barest bones. Perhaps it was the cost of his all-consuming affair with the theater, which left little time for hours of painstaking cross-hatching. Or maybe it was the result of dimming eyesight and diminished technique—the collateral damage of old age. Whatever the reason,

his characters became more caricatured, at times almost cartoonish, in comparison to the more realistic portraiture of his New York period. Gone was the spiderweb delicacy of his classic style, replaced by a thicker, bolder line. Gone, too, were the eye-buzzing pattern-on-pattern compositions and dizzily detailed wallpaper of his heyday, exchanged for monochrome backdrops.

Dancing Rock and *Floating Elephant* are flip books—or, rather, a flip book, since the two titles are printed back-to-back: riffle the pages one way, a rock makes its way across the page; flip them in the other direction, an elephant traverses the blank expanse. The rendering, in either case, is rudimentary. Yet it's practically baroque compared to the stick figures acting out French words (*Horreur! Au secours! Tralala!*) in *La Balade Troublante* (The disturbing stroll; Fantod Press, 1991) or the chicken scratches and curlicues of *The Pointless Book.* (Gorey claimed, with a perfectly straight face, that *The Pointless Book* was his "ultimate philosophical statement," a wordless mini-manifesto that "says everything about the relationship in literature between nature and art"—a remark that's either a wry reminder of Gorey's Derridean disbelief in the epistemological claims of language or a bit of conceptual leg pulling—or both. Irwin Terry, the Gorey collector, thinks it was "an exercise in seeing just how mad his devotees really were. I will go so far as to say I got mad at Mr. Gorey when this book arrived in the mail.")[6]

In his postcard sets *Q.R.V. Unwmkd.* Imperf. and *Q.R.V. Hikuptah* as well as his series of broadsides, *Thoughtful Alphabets* (all 1996, publishers unknown), Gorey abandoned his inkwell entirely, creating loosely joined collages of details snipped from nineteenth-century engravings (or, more likely, from some of the many Dover clip art books he owned). In the *Alphabets*, cutlery, cardiovascular organs, and other oddments form swirling debris clouds; enigmatic phrases, each word beginning with a successive letter of the alphabet, hover around them: "Hopeless Infatuation. Jellied Kelp. Listless Meandering. Nameless Orgies..." In the *Q.R.V.* cards, Gorey turns an Ernstian eye to nineteenth-century advertising, anatomical diagrams, and natural-history texts, grafting a centipede onto a coffin that's marching along on trousered legs; perching an unborn bird on

a bush that looks suspiciously like a network of capillaries.

Alexander Theroux claims that Gorey admitted he'd "lost his talent around 1990. He was doing a drawing once and said that."[7] In Terry's view, the turning point is *The Just Dessert* (Fantod Press, 1997), which for him marks "a decided turn in Mr. Gorey's signature drawing style."[8] An abecedarium whose kooky, cartoonish drawings pay waggish homage to nineteenth-century primers, its "illustrations are simpler and less refined" than Gorey's previous work, a shift he attributes to the artist's age and "increasing interest in theater work." Not only did Gorey's theatricals rob Peter to pay Paul, demanding long hours of rehearsal that might otherwise have been spent at the drawing board, but they may have influenced his aesthetic as well, Terry speculates. "The characters in *The Just Dessert* strongly resemble Mr. Gorey's handmade puppets," he points out, "and the format of the drawings" suggests "a puppet stage."

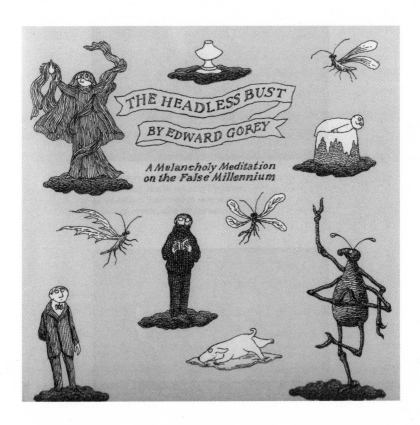

The Headless Bust. (Harcourt Brace, 1999)

Yet Gorey was dipping his toe, at least, into a simpler style as early as '83 in *The Eclectic Abecedarium*, whose hand-drawn, faux-naïf "woodcuts" anticipate those of *The Just Dessert*. By '92, in *The Doleful Domesticity* and *The Grand Passion* (both Fantod Press), Gorey is crossing the artless crudity of his faux-woodcut aesthetic with a cartoony silliness. He employs a variation on this style in his last two books, *The Haunted Tea-Cosy: A Dispirited and Distasteful Diversion for Christmas* and *The Headless Bust: A Melancholy Meditation on the False Millennium* (1997 and '99, both Harcourt Brace). A striking departure from the Gorey of *The Doubtful Guest* and *The Gashlycrumb Tinies*, his late style is notable for its featureless mauve backgrounds and perfunctory approach to ornament: carpets and tablecloths are covered, as usual, with busy patterns, but they're rendered in a loose, sketchy manner. Gorey's crosshatching has a burlap coarseness, far from the fine weave he used to use, and his characters' pinprick eyes have morphed, somewhat alarmingly, into cartoony bug eyes.

Not everyone was taken with Gorey's new style. "What really distinguishes Gorey are his meticulous, mock-lugubrious drawings," a reviewer contended in the *Harvard Crimson*. "His handwriting imitates printing, his close hatching resembles lithography, and his creatures, even his houseplants, pose like silent-movie actors. The combination of care and whimsy in his illustrations is delightful, even wonderful. Unfortunately, the comparative crudeness of the drawings in *The Headless Bust* is immediately noticeable. The lines are thicker, and the awkward delicacy of his figures is diluted."[9]

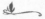

Even as Gorey's interest in crosshatching his life away was waning, mainstream recognition of his work was on the rise—not that he gave a stuffed fantod. As Clifford Ross told the *New Yorker* writer Stephen Schiff in 1992, "Edward has kept himself protected from success. I was

telling him on the phone about some of the projects we were working on for him, but he wasn't responding. Finally he said, 'Oh, I suppose that means now I can die.' Sometimes with him nothing happens, because nothing is exactly what he wants to happen."[10] "I really don't think I was ever terribly ambitious" was Gorey's way of dispatching the subject.

> And the more I go along, the more I think how awful it would be to be rich and famous. I'd love to be rich, but being famous—I think if you ever give any thought to it, then you say, "Well, you know, I'm not famous *enough*. Why don't I have a one-man show at the Metropolitan Museum?" And this way you drive yourself absolutely crackers. So I try not to think about it.... More and more, I think you should have absolutely no expectations and do everything for its own sake. That way you won't be hit in the head quite so frequently. I firmly believe what someone said—that life is what happens when you're making plans.[11]

The Met never called, but he was at least demifamous. "Edward Gorey and the Tao of Nonsense," Schiff's lengthy profile in the November 9, 1992, issue of the *New Yorker*, introduced him to a generation too young to remember *Dracula*. A month later, on December 21, a Gorey cover graced the magazine at long last—belated compensation for that sniffy rejection letter he received in 1950, informing him that his characters were "too strange" while "the ideas, we think, are not funny" but that there might be hope if he turned his hand to "drawings of a less eccentric nature." Forty-two years later, the world had caught up with Edward Gorey; what had seemed too strange, too eccentric, too perversely unfunny for a world of Avon ladies and Oldsmobiles and firm-jawed men in gray flannel suits at last made perfect sense.

In the '90s, one of those periodic swells of interest was lapping at Gorey's shores. People kept mounting productions of Gorey revues: *Amphigorey [Also]: A Musicale* at the Perry Street Theatre in Manhattan, in 1994; *Amphoragorey* at the Provincetown Repertory Theatre,

in 1999; *The Gorey Details: A Musicale* at Century Center Theater in New York, in 2000.* A revered figure in the world of book-cover illustration, he could afford to pick and choose what little commercial work he still took on. In '93, Harcourt reprinted *Amphigorey Also*, another Gorey omnibus, originally published by Congdon & Weed in '83. In '96, *The World of Edward Gorey*, the first book-length study of his work, appeared. It featured a wide-ranging interview by Clifford Ross, a critical essay by Karen Wilkin situating Gorey's work in an art-historical context, and an abundance of illustrations—pages from his sketchbooks, Anchor covers, exquisitely colored costume and set designs for *The Mikado*, plates from published (and, teasingly, unpublished) works.

But the leading indicator of Gorey's growing significance as a point of cultural reference was the increasing use by arts reviewers of "Edward Gorey–like" or, better yet, "Goreyesque" as a descriptor. Soon enough, pop culture certified his iconic status by paying him consumer capitalism's highest compliment: appropriation—theft with kid gloves on. The man whose utterly original vision sprang, paradoxically, from a "strong sense of imitation," one that led him to "filch blatantly from all over the place, because it will ultimately be mine," had lived long enough to see himself imitated.

Foremost among the filchers was the movie director Tim Burton, whose brand of morbid whimsy owes an obvious debt to Gorey, as does his somber palette. Shadowed by cross-hatching and deformed by the dream logic of German expressionism, Burton's stop-motion feature *The Nightmare Before Christmas* (1993) crosses Gorey with *The Cabinet of Dr. Caligari*. The star of the film, Jack Skellington, is an elegant skeleton in black tie who bears a more than passing resemblance to the dapper, top-hatted Death on the cover of *The Gashlycrumb Tinies*. The writhing, half ruined brick buildings and forced perspectives of Halloweentown, where Jack lives, are Burton's nod to Gorey and to the British cartoonist

*Under way in Gorey's last months, *The Gorey Details: A Musicale* opened after his death on October 16, 2000.

Ronald Searle. "We tried to put a lot of Gorey-type textures on our sets," the director, Henry Selick, confirmed.[12] "We took sets and actually spread clay on them or plaster and then inscribed lines all over them to give it that sort of etched, textured feel—to make it look almost like a living illustration."[13]

Burton's animated movies often take shape on his sketch pad. He is an artist himself, and his cartoony, loose-lined illustrations for *The Melancholy Death of Oyster Boy & Other Stories* (1997), a collection of gloomily amusing doggerel, suggest a cross between Gorey, Searle, and Quentin Blake. His humor is broader, and often more grisly, than Gorey's, and his twee-goth aesthetic is decidedly un-Goreyish in its weakness for B-movie camp and Boomer irony. Even so, *Nightmare* and *Oyster Boy*, as well as later stop-motion movies such as *Corpse Bride* (2005) and *Frankenweenie* (2012), testify to Gorey's enduring influence on his aesthetic (his assiduous omission, in interviews, of any mention of Gorey notwithstanding). "Lurking alongside Tim Burton's monstrous creations is the inescapable specter of...Edward Gorey," writes Eden Lee Lackner in her essay "A Monstrous Childhood: Edward Gorey's Influence on Tim Burton's *The Melancholy Death of Oyster Boy*." "From Burton's preference for thin lines and a certain sparseness of detail in his illustrations—often suggesting rather than fully delineating each characteristic—to his playfully macabre plotlines and themes, Gorey is always there."[14]

Gorey is there, too, in the 1997 video for "Perfect Drug," an angsty, edgy song by the electroindustrial band Nine Inch Nails. Directed by Mark Romanek, the short film transports the group's singer, Trent Reznor, to a goth's idea of an absinthe delirium, a punk-Edwardian gloomscape submerged in blue, black, and green. Dropped clues to Gorey's influence are everywhere: women in Victorian mourning veils stand on a windblown hill; a trio of top-hatted men are gathered on a windswept moor; a toppled obelisk lies in pieces. Reznor mopes around a haunted mansion in an Edwardian getup, listening disconsolately to a gramophone and drowning his sorrows in absinthe. There's a sculpture of a colossal hand, recalling the gargantuan thumbs in *The Raging Tide*; some spooky topiary straight out of Gorey's 1989 book *Tragédies Topi-*

ares; and, jutting out from behind an enormous urn, the legs of some ill-fated mite, like the "foot inside a stripéd sock" protruding "from underneath a rock" in *The Evil Garden*. The story, such as it is, seems to have something to do with a dead child, whose melancholy portrait we see in an antique locket.

The fashion world, too, acknowledged Gorey's influence. In his books, he'd always lavished on period costume the same devoted attention he paid to interior decoration and architectural style. Then, too, he was a fashion plate in his New York years, a surefire head turner in his Edwardian beatnik getup, immortalized in Bill Cunningham's *New York Times* column about well-dressed New Yorkers.

In her 1996 fall-winter collection, "Bloomsbury," the designer Anna Sui returned the compliment. Sui was drawn to Gorey and his work by her interest in "the '70s '20s," as she calls them: the rediscovery, by pop-culture tastemakers in the economically turbulent, socially permissive '70s, of the economically turbulent, socially permissive '20s—a retro fixation that bore fruit in movies like *Cabaret*, *The Sting*, and *The Great Gatsby*. For Sui, Gorey was the missing link between the two decades. "I was here in New York when *Dracula* was on Broadway," she recalls. "That was during the punk days, and of course everyone was really into vampires at that point, so [Gorey] was one of our folk heroes. When I was in school in the '70s at Parsons, I had some friends who were so obsessed with him that they used to follow him around. I would always hear about how eccentric his dress was, with his big raccoon coat. . . . [He] was really of that moment, for a lot of us." Sui pored over Gorey's books, soaking up his black-and-white crosshatched aesthetic as well as his impeccable renderings of period fashions.

But the most devoted of Gorey's votaries in the 1990s was Daniel Handler, known to millions of young readers as Lemony Snicket, author of the thirteen ironic-gothic young-adult mystery novels that comprise A Series of Unfortunate Events. The first two books in the series, *The Bad Beginning* and *The Reptile Room*, were published in September of 1999. Handler sent copies of each to Gorey "with a note saying how much I admired his work and how I hoped he forgave me

all I stole from him. He never replied and died not long after, so I've always said that I like to believe that I killed him."[15]

Whether Gorey ever read the books is anyone's guess, but if he did, he was surely struck by Handler's fond appropriation of his Victorian–Edwardian–Jazz Age setting, macabre subject matter, ironic tone, black humor, and antiquated, Latinate vocabulary. Even Handler's decision to write under a kooky pseudonym, and to create an enigmatic persona to go with it, was inspired by Gorey.

Intriguingly, Handler was seduced not by Gorey's drawings, as most readers are, but by his literary style and voice. "Obviously, the strange world of his illustrations filtered through," he says, "but I always think that how I managed to find a space on the map of children's literature where there was room to set up camp is because I stole from someone who's usually the victim of the theft of his illustrations, but I stole how he wrote his captions." In other words, Handler saw Gorey as Gorey saw himself: as a writer first.

Handler's a rare bird in this regard. As the literary critic Michael Dirda points out, "Nearly everyone...speaks admiringly of the artist's meticulous crosshatching and melodramatic, gothicky vision.... Not enough praise, however, has been awarded to Gorey's superb prose: he possesses the ear of a great parodist, and indeed virtually all his albums are pastiches of some previous genre.... The perfectly balanced periodic sentences owe something to the laconic campiness of Ronald Firbank and to the affectless dialogue and humor of Ivy Compton-Burnett."[16]

Handler's alter ego, Lemony Snicket, narrates A Series of Unfortunate Events in a voice modeled on Gorey's, at once arch and deadpan, sincere yet leg pulling. "It seems very romantic but very cynical; it seems ironic but it's not campy," says Handler of Gorey's tone. "The first time the Lemony Snicket books were reviewed in the New York Times, they called Snicket the love child of Edward Gorey and Dorothy Parker, and I thought, 'My life is now complete; I'm exactly where I wanted to be my entire life!' "[17]

The same year that A Series of Unfortunate Events debuted, a British "dark cabaret" trio called the Tiger Lillies had begun setting to music a big cardboard box full of unpublished prose and poetry that

Gorey had mailed to the group. He'd heard their musical treatment of Heinrich Hoffmann's *Struwwelpeter* and thought their comic-grotesque aesthetic was, as the Lillies' lead singer, Martyn Jacques, recalls, "the cat's pajamas."[18] When Gorey proposed they collaborate, Jacques, who was already a devotee, leapt at the chance. He set to work composing songs for Gorey's lyrics in the Tiger Lillies' patented style—his quavering, camp-gothic falsetto backed by accordion-driven music that's equal parts Victorian music hall and Weimar nightclub.

"We were going to do a show together, and just a couple of days before I flew out [of the UK to meet Gorey on the Cape], he died," says Jacques. "I cried. I'd spent several months practicing so I could sing him the songs. I'd imagined myself sitting there at dinner with him, singing him a song, and then we'd talk about it, and then we'd move on to the next one, like that. I'd learned them all, practiced them all; I was really upset."*

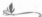

When Gorey published a regular-size edition of *Q.R.V.* in 1990, through Fantod Press, he'd expanded the title to *Q.R.V. The Universal Solvent*. Q.R.V.—which made its first appearance in an earlier version of the same title, a miniature book published by the booksellers Anne and David Bromer in 1989—is Gorey's surrealist take on nineteenth-century nostrums such as Effervescent Brain Salt and Burdock Blood Bitters. By turns sinister, salubrious, and silly, it not only "pickles beets and bleaches sheets," it prolongs life and bends your mind into the bargain, inducing hallucinations of "felons hurling melons."[19]

In like fashion, the universal solvent, a legendary substance sought by alchemists, possessed miraculous medicinal properties. Some thought it was nothing less than the fabled philosopher's stone, which had the

*When Jacques's songs finally saw the light of day, they'd been reborn as a collaboration between the Tiger Lillies and the Kronos Quartet, a contemporary classical ensemble. Released in 2003, *The Gorey End* received a Grammy nomination for best classical crossover album.

power to transmute lead into gold and bestow immortality. In keeping with alchemy's pre-Enlightenment dream of attaining hermetic wisdom through a kind of allegorical science, the stone symbolized spiritual perfection, as Gorey would have known from his copy of *Alchemy: The Secret Art* by Stanislas Klossowski de Rola.

Spiritual and religious themes swim beneath the surface of the Q.R.V. postcard series, *Q.R.V. Unwmkd. Imperf.* and *Q.R.V. Hikuptah*, published in '96. Behind the surrealist silliness, an autumnal mood suffuses them—a dying of the light, made even more melancholy by death-of-God ruminations. Gorey shows his hand in the title of *Q.R.V. Hikuptah*: the foreign-sounding word is one of the ancient names for Egypt, meaning "mansion of the soul of the god Ptah," the creator god of the ancient Egyptians and patron of craftsmen.[20] Like Gorey, Ptah was bald and bearded; also like Gorey, he was closely associated with funerary rites and the afterworld. Did Gorey see himself, at seventy-one, as having one foot in the grave?

In *Q.R.V. Unwmkd. Imperf.*, he seems to be settling scores with God, whom he rejected a lifetime ago when he threw up at mass. "Do you suppose God *really* knows / What He has done to me?" runs the first card's gibing couplet. "Yet if it's true, what can I do / But take to Q.R.V.?"[21] In another, he resigns himself to life in a clockwork world abandoned by its maker: "With God Almighty being flighty, / And absent frequently, / It's up to you to make it through / The day—with Q.R.V."[22]

Gorey would surely have let loose with a mortified groan if he'd lived to hear Andreas Brown observe, "His work is an exploration of the existence of God, of man's attempt to try to locate and define God."[23] Yet overblown as Brown's claim sounds, Gorey *is* wrestling, in his loopy, Learian way, with the same meaning-of-life-in-a-godless-cosmos questions that plagued existentialists such as Sartre and Camus. Of course, being Gorey, he alludes to his dark night of the soul obliquely, in deceptively silly singsong couplets. Still, thoughts of fleeting time, fading memories, lost love, illness, and age seem to be weighing on his mind in 1996, if the Q.R.V. cards and *Thoughtful Alphabets* are any indicator. "All is on fire, fear, and desire, / Remorse

and misery, / Illness and rage, revenge and age, / And also Q.R.V.," he writes in *Q.R.V. Unwmkd.* Imperf.[24]

"He was troubled by insomnia," Mel Gussow later reported, "awake in the dark of night thinking Gorey thoughts."[25] The season of his life was right for such musings: he'd turned seventy the previous year and had suffered a heart attack in '94, the same year he learned—all in a single week, mind you—that he had prostate cancer and diabetes. "I figured I was going to be dead in a week, so I began to think about it a lot," he said in a '96 interview.[26] Naturally, he told no one: both Skee and Rick Jones learned of his maladies from a passing mention in a *New York Times* profile.

CHAPTER 17

THE CURTAIN FALLS

GOREY, AS WE KNOW, loved to melodramatize the horrors of everyday life. "I'm suffering from bronchitis at the moment," he told an interviewer in 1992. "Psychosomatic bronchitis, I'm sure. But nevertheless, it's bronchitis. Oh, it's all too much, too grim, too lovely, too—how should I put this? It's general chaos."[1]

Yet depending on his mood, he could be curiously indifferent to his own mortality. When he learned, in '94, that he had prostate cancer and diabetes, and had suffered a heart attack without knowing it, he thought, "Oh gee, why haven't I burst into total screaming hysterics?" The answer, he decided, was: "I'm the opposite of hypochondriacal. I'm not entirely enamored of the idea of living forever."[2] Happily, the diabetes turned out to be "very controllable," and a monthly "shot in the fanny" kept his cancer in check, so he wasn't too worried, or so he claimed in 1996.[3] "I may not live forever but I feel perfectly fine all the time."

In truth, things were more complicated. His doctor had recommended a test in Boston (to determine his suitability for an implantable device to prevent future heart attacks, most likely).[4] He asked Skee to drive him to the procedure, which required that he be sedated, then decided at the last minute—God only knows why—not to go through with it after all.[5] "He had a fear of doctors and hospitals," Kevin McDermott believes. "Near the end of his life his doctor gave him three options for dealing with his heart condition: have a pacemaker implanted, take a high dose of medicine and be monitored at the hospital, or, as a temporary measure, take a smaller dose of medication at home. Edward chose the third."[6]

In 1999, Gorey published what would turn out to be the last book released during his lifetime, *The Headless Bust*, "a melancholy meditation on the false millennium," which did for New Year's Eve what *The Haunted Tea-Cosy*, Gorey's parody of *A Christmas Carol*, did for Christmas Eve. A wryly saturnine rebuke to New Year's jollity, it's the tale of Edmund Gravel, the Recluse of Lower Spigot—any resemblance to Edward Gorey, the recluse of Yarmouth Port, is entirely coincidental—who in the small hours of New Year's morning receives a visitation from the Bahhum Bug, the man-size beetle who in *The Haunted Tea-Cosy* guided Gravel through a parade of cautionary visions. This time, Gravel and the Bahhum Bug are spirited away, in clouds that Gorey ominously likens to shrouds, to be shown the secret "shame, also disgrace," behind the closed doors of other people's lives: "a certain X—, / Who looked to be of neither sex, / Was charged"—like Oscar Wilde—"with gross indecency / Which everyone could plainly see"; and so forth. Most disconcertingly, there's a big, black monument to the unknown—an omen, surely, of unhappy things to come in the New Year.

Four months into the new millennium, death—the subject of so much of his work—came for Edward Gorey. It came not at the point of a rusty stiletto or in the jaws of predatory topiary or from the fatal effects of eating ill-mashed turnips or from being sucked dry by a leech, assaulted by bears, brained by falling masonry, flattened by an urn dislodged from the sky, or as a result of unendurable ennui.

On Wednesday, the twelfth of April, 2000, he was struck down by a heart attack.

He and Rick Jones were in the TV room. Jones was changing the battery in Gorey's new cordless phone, a task that was beyond Edward's home-repair know-how, or so he professed. Mission accomplished, Jones turned to him and said, "Edward, do you believe this battery cost *twenty-two dollars?*" Gorey, who was sitting on the couch, flung his head back with a groan, making Jones think he was feigning melodramatic horror at the scandalousness of the price. He wasn't. Jones called 911, and the EMTs came almost instantly. They did all they could, but when the ambulance left, taking Gorey to Cape Cod Hospital, in Hyannis, it drove away slowly—never a good sign. "They weren't in any rush to get to the hospital," says Jones. Edward "was alive but not functioning at all."

"They said that if his body didn't kick back in and start operating on its own within three days, there was not really any possibility that it was going to," Carol Verburg remembers. She and Connie Joerns, who had come up from Martha's Vineyard, where she lived, held a bedside vigil. Family and friends, Aubergine players among them, drifted in and out of Gorey's hospital room. The three days ticked by, but he showed no signs of reviving. The attending physician asked the family if they wanted to respect his wish, expressed in a living will and a health-care proxy, that he not be kept alive by artificial means. They did. He was taken off life support and died several hours later.

"Connie and I had each brought a copy of *The Tale of Genji* to read to him," says Verburg. "We both stayed there all day, but then Rick [Jones] was having all the close friends over for dinner that night, and Connie left to clean up and get ready. I stayed and read to him the scene where the hero takes leave, decides to go into self-imposed exile, and looks around at the places that he's been and thinks about how painful it is to leave but how necessary. Then I told Edward we'd be back after dinner. By the time I got to Rick's house, the hospital had already called and said that Edward had died, apparently just moments after I left." Skee recalled one of the nurses saying, "It was almost as if he wanted to be alone at the end."[7]

Edward St. John Gorey died at 6:30 p.m. on Saturday, April 15, 2000. He was seventy-five. The cause of death, according to his death certificate, was cardiac arrest brought on by ventricular fibrillation, a serious disturbance in cardiac rhythm in which the heart stops pumping—the result, in Gorey's case, of his chronic ischemic cardiomyopathy (the weakening and enlargement of the left ventricle). Alexander Theroux claims in *The Strange Case of Edward Gorey* that Gorey's doctor had told him just six days earlier to check into Cape Cod Hospital for five days' observation. Following his long-standing habit of ignoring things he found disagreeable, Gorey turned a deaf ear to his doctor's advice and went about his business.[8]

Skee Morton can't confirm Theroux's account of events. More to the point, she thinks it's "very unlikely" that Ted would've discussed his health-care issues with Theroux, given that he didn't confide in her or any of his close friends when it came to such matters.[9] One thing is clear: the "pacemaker" (McDermott) Gorey chose not to have implanted—more accurately, an implantable defibrillator, which uses electrical pulses to jolt the heart back into its normal rhythm when arrhythmias occur—would almost certainly have given him a few more years, perhaps many more.[10]

An interviewer once asked Gorey, "Your work is often concerned with death; what's your own attitude toward death?" He replied, "I hope it comes painlessly and quickly."[11] An answered prayer. Or maybe just the perfectly scripted end to a theatrical life.

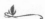

The obituaries came thick and fast. In some cases, Gorey got front-page treatment. His family was staggered to discover how big a celebrity Cousin Ted was. Skee recalls, "A half page in the *New York Times*"— "*Two* obituaries in the *New York Times*," Ken corrects. "The front page of the *London Times*," continues Skee, "*People* magazine, the *Los Angeles Times*. We just thought, *wow*."

Anglophile that he was, Gorey would've been pleased by the accolades

he received in the British papers, not just in the *London Times* but in the *Independent*, the *Guardian*, and the *Daily Telegraph* as well. The Francophile in him would've gotten at least a modicum of pleasure (modified by mortification) out of *Le Monde*'s insistence that he'd created a language as inventive as Lewis Carroll's or Lear's with the extravagance of Joyce and the profundity of Beckett. And he would have been drily amused by the *New Yorker*'s wreath-laying: a Gorey illustration of '20s ingenues with bedroom eyes frolicking with topiary creatures come to life, accompanied by the caption, "Postscript: Edward Gorey (1925–2000)." Henry Allen, writing in the *Washington Post*, perceptively framed Gorey as a "narrative illustrator" who "reached deeper into the educated American psyche" than the cartoonist with whom he was often paired, Charles Addams.[12] "Not only did he defy the clamorous Doris Day optimism rampant at the start of his career" in the 1950s, wrote Allen, "but he also vivisected the beast of Victorian and Edwardian society, which still lingers as an example for moral and social rectitude. He set almost all his work in England. No doubt he understood how powerful that particular public-television dream remains in the American imagination—a sort of psychic theme park."[13] A Reuters story reporting Gorey's death noted, with fittingly sinister suggestiveness, "It was not clear if there were any survivors."[14]

There were, however, beneficiaries. Gorey's personal estate was estimated, in the probate of his will, at $2,250,000.[15] Of that, he left tidy sums of $100,000 each to Connie Joerns and Robert Greskovic, dance critic for the *Wall Street Journal* and a member of Gorey's intermission clique at the State Theater. To the Wadsworth Atheneum in Hartford, Connecticut, whose visionary director A. Everett "Chick" Austin had sponsored George Balanchine's immigration to America, in 1933, he bequeathed his art collection, which was every bit as eclectic as you'd expect: photographs by Atget, drawings by Balthus, lithographs by the French postimpressionist Pierre Bonnard, a drawing done in 1558 by Pieter Brueghel the Elder, prints by Dubuffet, Delacroix, Klee, Miró, Munch, and Goya (from his mordant *Los Caprichos*, naturally), a painting titled *Dandelions in a Blue Tin* by the reclusive modernist-primitivist Albert York, to whom Gorey had dedicated *The Prune People II* (Al-

bondocani Press, 1985), and, touchingly, a landscape by Edward Lear. It wasn't all highbrow stuff, though: the sandpaper drawings he'd hunted down in antiques shops were included, too, as were cartoons by the English absurdist Glen Baxter and the zany *New Yorker* stalwart George Booth.

But his largest bequest was to nonhuman beings. Gorey's will mandated the creation of the Edward Gorey Charitable Trust, whose primary purpose is to use any income generated by his "literary and artistic property" in the service of animal welfare.[16] This, after all, is the man who insisted on saving earwigs when family members discovered them on bouquets and who had qualms about putting out poison bait for ants. It was this Taoist mind-set that led him to create a charitable trust that supports such organizations as the Elephant Sanctuary in Hohenwald, Tennessee; the Xerces Society in Portland, Oregon, dedicated to invertebrate conservation; and Bat Conservation International in Austin, Texas.

As coexecutor, along with Clifford Ross and Gorey's attorney, R. Andrew Boose, of Gorey's will, Andreas Brown moved swiftly to "secure the property," as Kevin McDermott puts it.[17] The day Gorey died, Brown contacted McDermott, who was then working for the Gotham on various Gorey-related matters. "It would be necessary to remove valuable art and other objects from the house immediately," McDermott recalls, "and then begin the arduous task of sorting through the massive accumulation of Gorey's life."[18] A week after Gorey's death, McDermott took the pensive, quietly affecting photos collected in *Elephant House*, painstakingly documenting the museumlike environment Gorey had created, with its many little installations. "I realized the uniqueness of Edward's home would soon be gone and that it needed to be preserved in some way," he says.[19]

Brown made the trip from Manhattan to Yarmouth Port "almost every weekend during the year after Edward died," Rick Jones recalls, excavating manuscripts, original art, notebooks, and, tantalizingly, unpublished work from what Gorey had called the "ever-increasing pile of debris" he'd lived in.[20] Brown discovered "hundreds of stories and sketches, some finished, some unfinished," the *New York Times* reported—"a trove of [Goreyana], with ample material for many

future books and for plays based on his work."[21] This precious detritus, along with iconic artifacts such as his drawing board and memorabilia that had been lovingly preserved by Helen Gorey—childhood drawings, family photo albums, even baby shoes and a bib (MADE BY EDWARD'S AUNT RUTH, BECAUSE APPARENTLY HE DROOLED A LOT, as a placard in the Edward Gorey House's 2016 show, *Artifacts from the Archives*, informed)—was transferred by Brown to a storage unit in the New York City area, where it still reposes, inaccessible to scholars but occasionally on loan for exhibits at the Gorey House, which opened its doors to the public in 2002.

Among the gems Brown unearthed was the seemingly complete manuscript of a previously unknown book from around the time of *The Unstrung Harp*, done in Gorey's early, Earbrass style—*The Angel, The Automobilist, & Eighteen Others*. Another jaw-dropper consisted of a number of pages from an unfinished manuscript for something called *Poobelle; or, The Guinea-Pig's Revenge* (circa mid-'50s), a perversely funny little parable about the perils of mistreating your pet, drawn in a style that at times recalls Garth Williams's furry, soft-focus rendering.

A legal document filed in 2007 by Boose on behalf of the trust describes the Gorey archive, "including his original drawings and other works of art and the original manuscripts for many of his literary works," as consisting of "more than 10,000 items," valued by an appraiser for Christie's auction house "at a gross fair market value of more than $4.6 million."[22] Whether this hoard of Goreyana locked away in a New York City storage unit has been inventoried, and whether the "ample material for many future books and for plays based on his work" will ever come to light, is known only to Boose and Brown, Ross having resigned his position as trustee in late 2000.

The aftermath of Gorey's death was suitably Goreyesque, marked by portentous events and mysterious developments. The weekend after he died, Jane—the small but imperious queen of his clutter of cats—spent

long hours curled up on his empty bed. Photographing in the musty, cobwebby "hidden room"—a disused chamber on the second floor, its doorway concealed by a bookcase—McDermott noticed a bust of Charles Dickens on the windowsill, facing out, toward the Yarmouth Port common. He snapped it. Weeks later, when he printed the photo, he was startled to see Gorey's bearded face reflected in the rain-speckled window. It was Dickens's, of course, but when he showed the image to Gorey's friends and family, they, too, "saw him clearly in the reflection," McDermott writes in *Elephant House*. "Perhaps Edward was leaving us something as mysterious as the message written on the card found in the empty tea urn at the end of *The Object Lesson*—the single word 'farewell.'"

And then there was the business with the lights.

In the chaotic days after Gorey's death, Brown asked Carol Verburg to stay at Strawberry Lane to look after the cats. "I am a person who doesn't believe in ghosts and has never had any experience with ghosts," she says. "In his house, I begged him to haunt me and he didn't. But I would be standing in the bathroom and the light would suddenly go out. This happened all over the house, wherever I was: the light would suddenly go out and then it would go back on again after a while. I finally just stood there and said, 'Edward, is this you? Look, if you're trying to tell me something, would you turn the light out now?' Nothing. 'Is there something you want me to do?' Nothing. I asked all the questions I could think of, and nothing happened, and then I said, 'So is this thing with the lights just totally random and meaningless and has nothing to do with you at all?' And then the light went out. It was just *so* Edward!"

Queerest of all, though, was the Mysterious Affair of the Misplaced Ashes. Gorey was cremated. In accordance with his wishes, some of his ashes were shipped to Woodland Cemetery in Ironton, Ohio, the ancestral hometown of the American branch of the Garvey tree (whose roots were anchored in Limerick, Ireland—the perfect punch line to Gorey's life story, given his close association with that poetic form). There, in the Garvey family plot, his mother and aunt Isabel were already at their ease,

alongside his great-grandparents Benjamin and Helen Amelia St. John Garvey (the maker of "Very Superior Pencil Sketches"), and his great-great-grandmother Charlotte Sophia St. John, mother of Helen Amelia (and namesake of the ill-fated mite in *The Hapless Child*). An interment card in Woodland's files records the burial of Gorey's cremated remains in lot 32, section 7—the Garvey plot—on July 15, 2000. Yet no gravestone marks the spot where Gorey's cremains were purportedly interred. A funeral director in Yarmouth Port ordered a price quote on a headstone from the Buckeye Monument Company in Ironton but never purchased it. Had Gorey gotten the memorial he deserved (surmounted, naturally, by one of those enormous Victorian urns he was so fond of), it would have borne one of the two inscriptions he offered when Richard Dyer asked him, in 1984, what his epitaph would be. "[T]wo of my expressions spring to mind: 'Oh, the of it all' and 'Not really,' " he said.* "That's right, 'Oh, the of it all' without anything in the middle; just leave the middle out. And, yes, I think, 'Not really.' "[23] In the end, though, it's only fitting that the man whose art was an art of the unseen and the unspoken, and whose enigmatic life was Freud's idea of an Agatha Christie mystery, is buried (if he's buried at all) in an unmarked grave.

As for the rest of his ashes, some were cast over the waters of Barnstable Harbor near the lighthouse on Sandy Neck by a boatload of friends and family. It was September 10, "a lovely sunny warm day," as Skee recalls it—not "overcast and gray and hammering with rain," as Theroux has it in *The Strange Case of Edward Gorey*, a bit of meteorological humbug that, while appropriately Goreyesque, is belied by Skee's memories, not to mention family photos.[24] "There were so many other people in boats enjoying it that we had to go quite far out to find a private, secluded sandbar," she remembers."[25] Some of Gorey's ashes were scattered; others were placed on a wreath of branches taken from the southern magnolia outside his studio window and set adrift, to float out to sea on the sun-dappled waters. ("It was low tide, still going out,"

*What those two catchphrases reveal about Gorey and his art is the stuff of dissertations.

says Skee. "We planned it that way.") With the family's blessing, Rick Jones set a few handfuls aside to be mingled with the ashes of Gorey's cats when all five—Jane, George, Thomas, Alice, and Weedon—had died, then strewn in the wilds of 8 Strawberry Lane, following Edward's offhanded directive to just "throw me in the yard." (Gorey's closest friends did exactly that at a "Gathering for a Scattering" on June 25, 2011, after Jane, the last holdout, had gone to her reward.)

Shortly after Gorey's death, there had been a memorial soiree at Strawberry Hill, billed as "A Gathering...of the friends of Edward Gorey." On June 5 of 2000, friends and family gathered in Herbert Senn and Helen Pond's chapel turned glorious parlor to celebrate Edward's art and life. People sipped drinks. An ensemble played the music he loved best, pieces by baroque composers such as Handel, Bach, and Purcell.

Appropriately, there was a whiff of mystery in the air. People who'd known Gorey for years were surprised to meet emissaries from hidden corners of his life, friends he'd never so much as mentioned. "Being a solitary person, he gave his full focus to whoever he was with," says Carol Verburg. "Whatever you were interested in, he knew something about it, so that he had a different friendship with each person that he was friends with. That became really quite startling after he died. There was no group of people who felt that they all knew him in the same way; rather, each little set of people or individual felt that they knew him in a different way..."

But did anyone *really* know him? Did he even want to be known?

"You know far more about me than anyone else in the world," he told Peter Neumeyer in a 1968 letter.[26] Yet as noted earlier, even Neumeyer doubted that he truly knew Gorey. He wasn't alone in that sentiment. "I never thought I really knew Ted," says Skee Morton. "I was always aware that we saw only one side of him and that there were others that we knew little or nothing about."[27] Mel Schierman, too, felt their "friendship was long, comfortable, accepting, but Ted

never revealed himself." Gorey's flamboyant persona was a weapon of mass distraction, he thinks, a shy, secretive man's way of misdirecting the world's attention. "It was not an aesthetic—it was protection," says Schierman. "'Look at the rings; don't look at me. Look; don't ask, don't probe.'" When that ruse failed, Gorey barricaded himself behind a book—a tactic that not only afforded refuge from social situations but also broadcast the message, loud and clear, that he was unavailable. The beard was another mask. So were the pseudonyms. That Ashbery quotation from so long ago comes reverberating back: "He was somehow unable and/or unwilling to engage in a very close friendship with anyone, above a certain good-humored, fun-loving level.... I had the impression that he had constructed defenses against real intimacy, maybe as a result of early disappointments in friendship/affection."

Interviewers who attempted to lift the curtain on Gorey's inner life were greeted with monosyllables. Attempts to make sense of his art were discouraged on the grounds that, too often, such inquiries lead to pop-psych poking and prodding. "Gorey is miserable discussing his work," Stephen Schiff observed in his *New Yorker* profile. "His eyes dart. Gradually, he withdraws into a silence punctuated by 'tsk's and groans."[28]

The title of Theroux's book says it all: Gorey was indeed a strange case—and an uncrackable one. The man who loved mysteries was himself a mystery—even to himself, it seems. "He was not entirely joking," Neumeyer thought, "when he signed one letter 'Ted (I think)' and wrote in another, 'There is a strong streak in me that wishes not to exist and really does not believe that I do.'"[29] It's one of Gorey's most cryptic remarks. What can he mean? Is the Taoist-deconstructionist in him saying that the self is a fiction—a "center of narrative gravity," as the philosopher of mind Daniel Dennett calls it, narrated into existence by the voice in our heads? "Our tales are spun, but for the most part, we don't spin them; they spin us," Dennett writes in *Consciousness Explained*. "Our human consciousness, and our narrative selfhood, is their product, not their source."

Maybe Gorey's fundamental unknowability lies in the fact he was "neither one thing nor the other, particularly"; adamantly this and

the next minute just as emphatically that, tongue firmly in cheek the whole time, as if to mock the very idea of binary oppositions. Asked in the Proust questionnaire what his current state of mind was, he replied, "Changeable."[30] Water, emblem of mutability and symbol of the Tao—the ever-changing, unpredictable "watercourse way"—was his element, he told Neumeyer, an observation that casts a revealing light on his oft-repeated admission that he was "a great one for drift."[31]

The man was a walking paradox. But of all the contradictions he contained, his sexuality was surely the most puzzling. Everyone who encountered him assumed he was gay, yet he maintained, to his dying day, that he was a neutral. Nonetheless, his crushes, as we know, were entirely male. Was he, like some gay men of his generation, simply someone who wished he hadn't been born that way? Is that what he meant when he told Lisa Solod of *Boston* magazine that he was "fortunate" to be "apparently reasonably undersexed or something"?[32] Expatiating, in another interview, on his fatalistic philosophy, he questioned the idea of free will, opining, "You never really choose anything. It's all presented to you, and then you have alternatives. You don't choose the subject matter of anything you write. You don't choose the people you fall in love with."[33] That last sentence echoes with regret.

The question of Gorey's sexuality has all the makings of a good mystery. Consider the Curious Case of the Missing Admission. In the Solod interview, as reproduced in *Ascending Peculiarity: Edward Gorey on Edward Gorey*, he responds to the pointed question "What are your sexual preferences?" with the legendary dodge, "Well, I'm neither one thing nor the other particularly."[34] But in the original, unexpurgated version of the article, as it appeared in *Boston* magazine, he adds, "I suppose I'm gay. But I don't really identify with it much. [*laughs*]."[35]

Kevin McDermott, who worked for Andreas Brown during the editing of *Ascending Peculiarity*, was "disheartened" by the deletion of that all-important afterthought, a smoking gun if ever there was one. The decision, he claims, was Brown's. As a gay man who was much younger than Gorey, McDermott thought it was "a brave thing he was doing there, as a man of that generation—finally saying it. And then he qualified it, which

I think is totally appropriate because that's probably true; when he said he was asexual, I'll take him at his word." Why Brown excised it McDermott has no idea. Maybe he was "concerned that Edward wouldn't be taken seriously as an artist because he was a gay artist," he speculates.

Gorey's own preference, of course, was that he be seen not as a type—a gay artist or even an artist—but as an individual. "What I'm trying to say," he told Solod, "is that I'm a person before I am anything else."[36] His response reads, in historical hindsight, as a rebuke to identity politics. He goes on to question the ghettoization of female poets in feminist anthologies and the personal-is-political stance of his museum-curator friend, a "very militant" gay man who held that "his creative life and his homosexuality were one and the same," a position Gorey regarded as "hogwash, dear, hogwash!"

From our historical vantage point, when the cultural battle lines are drawn over issues related to racial, religious, sexual, and gender identity (all complicated by the question of class), Gorey's remarks seem blithely entitled. Rolling an incredulous eye at the idea of "a big anthology of...say, *women* poets," he underscores the patent preposterousness of identity politics (as he sees it) by pointing out, "You're not going to find an anthology of heterosexual male poets, or anything like that!"[37] Which misses the point entirely, of course. You're not going to find an anthology titled *Heterosexual Male Poets* because there's no need: the vast majority of poetry anthologies consist largely if not exclusively of poetry written by heterosexual males. Gorey seems to be wearing the blinkers of white male privilege. Likewise, he betrays a curious blind spot when it comes to the ways in which the personal is inescapably political if you're gay, an obliviousness that seems especially odd when we recall that he lived in New York in the '70s, when, as Edmund White has written, "we gay guys wore whistles around our necks so we could summon help from other gay men when we were attacked on the streets."[38] Peter Wolff recalls the time he and Ted were strolling along Fifth Avenue, Ted in a mink coat, "and somebody said 'Faggot!' right to his face." Gorey feigned incomprehension, asking Wolff what the man had said. "He had to've heard it," says Wolff, "but he chose not to."

Yet it's also possible that Gorey was *ahead* of his time, and not just his but ours as well. Was the radical doubter—who questioned not just who he was but *whether* he was—raising a skeptical eyebrow about this whole business of constructing identity, not to mention a collective identity, around sexuality? In like fashion, was he questioning the underlying assumptions of what it means to be gay? If you're a bundle of stereotypical tastes and behaviors—"flamboyant" dress, swooping vocal tones, balletomania, an inordinate fondness for Gilbert and Sullivan and *Golden Girls*—but chaste as a vestal, can you really be said to be gay? "A lot of people would say that I wasn't [gay] because I never do anything about it," Gorey observed.[39]

Then, too, he didn't *self-define* as gay, and isn't the right to define oneself a cornerstone assumption of identity politics? Connect the dots of Gorey's responses to the are-you-gay question and they add up to asexuality, which is, in a way, very Taoist of him. In a world built on philosophical binaries, bisexuality is threatening enough, as White points out. Bisexuals, he contends, "keep a low profile, not because they're ashamed but because everyone distrusts and fears them. Tribes have only two ways of treating interstitial members; they either make them into gods or banish them."[40] Asexuality is beyond interstitial; it steps outside the sexual continuum altogether. Asexuals are the Bartlebys of human sexual response; like the protagonist of Melville's novel, they simply "prefer not to."

In his classic coming-out memoir, *City Boy*, White, an early standard-bearer for the notion of a gay literature, reflects on how he came to regard it, and even the essentialist definition of a gay identity, with an ambivalent eye. He cites the French philosopher Michel Foucault, who was gay but "very much against identity politics and 'the culture of avowal,' by which he meant a culture that thought every individual had a secret, that that secret was sexual, and that by confessing it one had come to terms with one's essence." Gorey would have agreed. An open secret yet irresolvably mysterious even so, his sexuality was an essential part of who he was and the art he made but hardly the essence of who he was.

"He didn't want it to become the sole center of his life," says Peter Anastos. "I think that's what happened in my generation, starting in the '60s and '70s. People let their homosexuality become the absolute center of their lives and there was nothing else. I've known a lot of [gay] guys Ted's age and . . . they just see it in a whole different way. Being gay is not the center of their lives. . . . Ted never struck me as closeted; he just was who he was." Guy Trebay, a fashion writer for the *New York Times* and a keen-eyed observer of culture, sums it up neatly: "Whether his mysterious lifelong retreat was a flight from sex or a simple desire to be a solitary cat-loving, raccoon-coat-wearing Firbankian geek . . . I respect the decision to hold the line. Why queer him? He was far queerer than queer."[41]

At the June 5, 2000, memorial party at Strawberry Hill, the actress Julie Harris read *The Osbick Bird*, Gorey's story about a gawky bird, half toucan, half flamingo, that swoops down out of the blue one day to land on Emblus Fingby's derby. The two become bosom friends, joining in lute-flute duets and playing games of double solitaire so frenzied that the cards get "battered past repair," after which "they would not speak / to one another for a week." An interspecies romance, it's unnatural, admittedly, though apparently platonic. But then, given the human condition—we're born alone, we die alone, we're as isolated by language as we are knitted together by it—isn't *every* romantic relationship unnatural? Gorey, who never quite got the hang of romance, seemed to think so.

When Fingby dies, his constant companion is by his side, devoted to the last. Or so it seems.

He was interred; the bird alone
Was left to sit upon his stone.
But after several months, one day
It changed its mind and flew away.

413

It's classic Gorey: the ineffable inscrutability of things; the sublime pointlessness of life; "the of it all." People love us, and then they don't. You get emotionally involved with someone, and "whole stretches of your life go kerplunk." You may "look like a real person" but really you're masked by "a fake persona." You might telegraph the most obvious social signals of queerness, but really be "neither one thing nor the other particularly," a pose that may, of course, be yet another "fake persona" behind the face you show the world, like the selves within selves in a Russian nesting doll. Or not. "To catch and keep the public's gaze / One must have lots of little ways," Gorey slyly reminds us in *The Awdrey-Gore Legacy.*

"The true artist is a man who believes absolutely in himself, because he is absolutely himself," said Oscar Wilde.[42] Whatever else he was, Gorey was incomparably, unimprovably himself, a model of uncompromising (yet unaffected) originality. Dick Cavett gave voice to the thoughts of countless fans who, having fallen for Gorey's work, ended up equally smitten with the man behind it. "I have to tell you that I have total admiration for your work," confessed Cavett near the end of their interview, "and I think, also, for your lifestyle—that dreadful phrase. The idea that you live exactly as you want to. You do, apparently, a very satisfying kind of work. I find it just marvelous to look at, but I can imagine that it must be wonderful to do.... And I'm talking, also, about the fact that if you want to go to the ballet 50 nights in a row, you do; if your work isn't ready by the time the publisher wants it to be, apparently this doesn't get you terribly upset. [O]f the thousands and thousands of kinds of lives there are to lead, most people opt for one or two of the best-known ones. And you have done exactly, as I see it, what you want to do."[43]

Not only that, but "working quite perversely to please himself," as Edmund Wilson so memorably put it, he created "a whole little world," a black-and-white wonderland so transportingly Goreyesque that many who encounter it wish they could live in it, taking tea with "Mr C(lavius) F(rederick) Earbrass" at his country manor, riding the Willowdale Handcar, wandering the haunted halls of the West Wing, discovering at last

414

just what it was Gerald did to Elsie with that saucepan, maybe even hazarding the horrors of Sir Egbert's unspeakable sofa, with its nine legs and seven arms, and, in the end, solving the mystery of the portentous Black Doll. "My background in anthropology really was appropriate," says Chris Seufert, reflecting on the experience of filming Gorey for his documentary. "My sense, shooting him, was that he was indeed the last of a disappearing race. That's the sense you got with Edward—he was the last member of some race, maybe an alien race. But the thing with Edward was, there *was* no race. It was only ever Edward. He was the most one-of-a-kind person you'd ever meet."[44]

A line from *The Utter Zoo* comes floating back:

About the Zote what can be said?
There was just one, and now it's dead.

Bust of Charles Dickens peering from the window of the "hidden room" at Strawberry Lane the week after Gorey's death. *(Photograph by Christopher Seufert)*

415

ACKNOWLEDGMENTS

To my unsinkably optimistic agent, Andrew Stuart of the Stuart Agency, who first believed in this book; to Little, Brown's former executive editor Michael Sand, who bought it; and to Sand's successor, Michael Szczerban, who did battle with the Leviathan, slashing it down to readable size with just the right mixture of sensitivity and steely resolve, must go pride of place. Thank you, gentlemen, for your faith in Gorey and his Boswell. (Michael Szczerban was ably assisted by Nicky Guerreiro, who attended to all the little—but all-important—details.) Barbara Clark's impeccable copyedit, fastidiously grammatical yet thoughtful on questions of style, saved me from dangling participles and other crimes too monstrous to mention.

I owe an incalculable debt of gratitude to Skee Morton and Eleanor Garvey, who were unstintingly generous with their memories (and memorabilia) of their cousin, and to Ken Morton, who vouched for my bona fides with Gorey's inner circle, scanned photos by the boatload, answered my endless questions with equanimity, and served as a reliably sane and perspicacious sounding board throughout the writing of this book.

To Rick Jones, executive director of the Edward Gorey House, I'm deeply indebted as well: Rick's unfailing attentiveness to my unending questions, his willingness to open the Gorey House for my private perusal, and his many other kindnesses, large and small, were enormously helpful. (Gregory Hischak, who came aboard as the museum's curator when I was putting the finishing touches on this book, was a gracious guide to all things Gorey, too.)

Christopher Seufert, the Cape Cod photographer and filmmaker

whose documentary *The Last Days of Edward Gorey* (Mooncusser Films) sketches an intimate portrait of the man in his Yarmouth Port days, was lavishly kind in hosting private screenings of that work in progress; providing transcripts of his interviews with Gorey, Gorey's Cape Cod circle, and Gorey aficionados such as Daniel Handler (Lemony Snicket); sharing hard-to-find recordings of Gorey appearances on radio and TV; and, more generally, extending Yankee hospitality.

Elizabeth Tamny's incomparable skills as a researcher, along with her newshound's knowledge of Chicago history, especially machine politics, proved invaluable, as did her *Chicago Reader* article on Gorey's childhood.

Gorey's friends from his Harvard and Cambridge days—Alison Lurie, Freddy English, and Larry Osgood—submitted to lengthy interviews (and a farrago of follow-up questions, in Osgood's case) with good-humored forbearance. Their intimate impressions of Ted, still vivid after all these years, enriched my understanding of him considerably. Peter Neumeyer, whose *Floating Worlds* reveals a side of the man unknown to even his closest friends, offered searching reflections on their brief but intense, bordering on telepathic, collaboration. His answers to my questions, together with his book, deepened my understanding of Gorey's inner life profoundly.

Robert Bock, Eric Edwards, Vincent Myette, Joe Richards, Cathy Smith, Genie Stevens, and Jamie Wolf—stalwart troupers, all, of the Aubergine Company and Le Théâtricule Stoïque—took me into their confidence, but Jane MacDonald, Jill Erickson, and Carol Verburg deserve special mention for the revealing light they shed on Gorey the playwright and Gorey the director.

Kevin Shortsleeve's collegial generosity in sharing his unpublished interview with Maurice Sendak permitted me to tell, for the first time, the story of Sendak's high regard for Gorey's talent and his poignant sense of their kinship as gay men. I'm grateful, too, to Lynn Caponera and the Maurice Sendak Foundation for approving my use of excerpts from Professor Shortsleeve's remarkable conversation with Sendak. Maureen O'Hara was wonderfully generous, as well, in her

willingness to grant permission to quote from her brother Frank's poem "For Edward Gorey."

Ailina Rose, dance historian and founder of the Ailina Dance Archives, shared generously of her encyclopedic knowledge of ballet in general and the New York City Ballet in particular. Her excavation, from the buried history of pre–Balanchine ballet in America, of the first ballet Gorey attended was a eureka moment.

It should go without saying that a book this long, written over the course of seven years, is in some sense a collective effort, involving the proverbial cast of thousands. I'm truly grateful to everyone who lent a hand. (*Roll credits.*)

Al Vogel (public affairs office, US Army Dugway Proving Ground, Utah); Alex Gortman; Alexander Theroux; Amy Taubin; Andy Kaplan (archives director, Francis W. Parker School, Chicago); Ann Beneduce; Anna Sui; Annabelle Schierman; Anthony Schierman; Antonia Stephens (Sturgis Library, Barnstable, Massachusetts); Arlene Croce; Bambi Everson (and her husband, Frank Coleman); Barney Rosset (and his wife, Astrid Myers-Rosset); Belinda Cash (Nyack Library reference desk); Ben Muse; Beth Kleber (School of Visual Arts archives); Betty Caldwell; Carolyn Tennant; Charlie Shibuk; Chris Garvey; Christi and Tom Waybright (Woodland Cemetery, Ironton, Ohio); Christina Davis (curator, Woodberry Poetry Room, Harvard University); Cindy Zedalis; Daniel Handler (a.k.a. Lemony Snicket); Daniel Levans; David A. Brogno, MD, FACC; David Hough; Dennis Rosa; Dev Stern; Diana Klemin; Dianna Braginton-Smith; Donald Hall; Dore Sheppard, PhD, LCSW (whose psychotherapeutic insights and wry wit saw me through more than a few dark nights of the soul); Ed Pinsent; Ed Woelfle; Edmund White; Edward Villella; Eileen McMahon; Eugene Fedorenko; Faith Elliott; Florence Parry Heide; Genie Stevens; Glen Emil (Goreyography.com); Greg Matthews (special collections librarian, Holland and Terrell Libraries, Washington State University); Guy Trebay; Haskell Wexler; Helen Pond; Howard and Ron Mandelbaum; Irwin Terry (Goreyana.blogspot.com); J. W. Mark; Jan Brandt; Jane Siegel (Rare Book and Manuscript Library, Columbia University); Janet

Morgan; Janet Perlman; Janey Tannenbaum; Jason Epstein; Jean Lyons Keely; Jillana; John Ashbery; John Solowiej; John Wulp; Johnny Ryan; Joseph Stanton (University of Hawaii); Joyce Lamar (née Reark); Judith Cressy; Julius Lewis; Justin Katz (the Edwardian Ball); Kathleen Sullivan (Nyack Library reference desk); Keith Luf (WGBH archives); Kevin McDermott; Kevin Miserocchi (executive director, Tee and Charles Addams Foundation); Laura Romeyn; Lynn Pecktal; Margaret Heilbrun; Maria Calegari; Mark Romanek; Martyn Jacques; Mary Joella Cunnane (archivist, Sisters of Mercy West Midwest Community); Maura Power; Mel Schierman; Michael Goldstein; Michael Vernon; Neil Gaiman; Normand Roger; Patricia Albers; Patricia McBride; Patrick Dillon; Patrick Leary (Wilmette History Museum); Paul Richard; Peter Anastos; Peter Sellars; Peter Wolff; Rachel Quist (cultural resources management officer, US Army Dugway Proving Ground, Utah); Rhoda Levine; Richard Wilbur; Robert Bruegmann (distinguished professor emeritus of art history, architecture, urban planning, University of Illinois at Chicago); Robert McCormick Adams; Rosaria Sinisi; Ross Milloy; Roy Bartolomei; Steve Silberman; Steven Heller; Ted Drozdowski; Tom Berman (Nyack Library reference desk); Tom Zalesak; Tomi Ungerer (and his wife, Yvonne Ungerer); Tony Williams; Tony Yanick; Uta Frith; Victoria Chess; Warren MacKenzie; William Garvey; Yvonne "Kiki" Reynolds (and her son Gregory Reynolds).

Lastly, to Thea Dery, who gamely endured seven years' worth of anecdotes, allusions, and dinner-table disquisitions on the man, goes special commendation. In a very real sense, she grew up with Gorey.

A NOTE ON SOURCES

Every assertion of fact in these pages is, to the best of my knowledge, true. There are no composite characters, imagined internal monologues, or conjectural fictions intended to give the reader a God's-eye view of things experienced by Gorey alone. Though I've opted not to cite the sources of mere matters of fact in hopes of sparing the reader a wearying trek through a bramble patch of footnotes, every who, what, where, and when in this book is based on credible sources.

For example, my account of Gorey's childhood—where he lived, where he went to school, and so forth—relies on public records accessible through Ancestry.com; extensive research in local archives on my behalf by the Chicago-based journalist Elizabeth Tamny; interviews with Gorey's cousins Skee Morton, Eleanor Garvey, and William Garvey as well as Francis W. Parker schoolmates such as Robert McCormick Adams, Jean Lyons Keely, Barney Rosset, and Haskell Wexler; hours spent wading through student newspapers and yearbooks from Gorey's time at Parker; anecdotes and observations gleaned from *Joan Mitchell: Lady Painter*, Patricia Albers's superb biography of Gorey's friend and Parker classmate; Helen Gorey's reminiscences in her letters to Ted (included in the Edward Gorey Collection at the Harry Ransom Center, University of Texas at Austin); and Gorey's boyhood diaries as well as his recollections in interviews.

Research of this breadth and depth lies behind every chapter. In the seven years it took to write the story of Gorey's life, I conducted more than seventy-eight in-depth interviews with people who'd known Gorey, each of which was recorded and transcribed to ensure accuracy. All direct quotations without citations are taken from these interviews.

In addition, I tracked down the addresses Gorey called home during his Chicago boyhood, made pilgrimages to his Harvard dorms, and visited his former apartments and homes in Cambridge, Manhattan, and Cape Cod. I pored over correspondence, photographs, and unpublished art and writings at the Edward Gorey House, in private collections, and in university archives.

Among the latter, I drew on the Alison Lurie Papers in the Division of Rare and Manuscript Collections at the Cornell University Library; the Andrew Alpern collection of Gorey publications and ephemera as well as the Barney Rosset Papers in the Rare Book and Manuscript Library at Columbia University; the Edward Gorey Collection at the Harry Ransom Center, University of Texas at Austin; the Felicia Lamport Papers at the Schlesinger Library, Radcliffe (and Lamport's correspondence with her publisher and Gorey in the archives of the Houghton Mifflin Company at the Houghton Library, Harvard); yearbooks, school newspapers, and student literary publications at the Francis W. Parker School; Gorey's student records in the office of the registrar at Harvard; the archives of the Poets' Theatre at the Houghton Library; the Merrill Moore Papers in the Library of Congress; the Edward Gorey Collection, as well as the Edward Gorey Personal Library, in the Special Collections of the San Diego State University Library; and the bequest of original Gorey art, illustrated envelopes, and ephemera to the Art Institute of Chicago by Gorey's Parker friend Sylvia Sights (née Simons).

A GOREY BIBLIOGRAPHY

As noted early on, quotations from titles written by Gorey aren't cited in endnotes because virtually all his books are unpaginated. More to the point, few of them run longer than thirty pages, most of which are sparsely populated with text; readers curious to track down quotations shouldn't have much difficulty doing so.

Here, in the order of their publication, is a list of the Gorey books referred to in these pages. A complete list of Gorey's works up to 1996 can be found in Henry Toledano's *Goreyography* (San Francisco: Word Play Publications, 1996), the only comprehensive Gorey bibliography to date. (Edward Bradford's *F Is for Fantods*, a brief "bibliographic checklist" published in 2008 by the Edward Gorey House, is devoted exclusively to Gorey's Fantod titles.)

Publication information for titles illustrated but not written by Gorey is given in the text, at first mention.

The Unstrung Harp; or, Mr Earbrass Writes a Novel (New York and Boston: Duell, Sloan and Pearce/Little, Brown, 1953)

The Listing Attic (New York and Boston: Duell, Sloan and Pearce/Little, Brown, 1954)

The Doubtful Guest (Garden City, NY: Doubleday, 1957)

The Object-Lesson (Garden City, NY: Doubleday, 1958)

The Bug Book (New York: Looking Glass Library, 1959)

The Fatal Lozenge: An Alphabet (New York: Ivan Obolensky, 1960)

The Curious Sofa: A Pornographic Work by Ogdred Weary (New York: Ivan Obolensky, 1961)

The Hapless Child (New York: Ivan Obolensky, 1961)

The Beastly Baby by Ogdred Weary (New York: Fantod Press, 1962)

The Willowdale Handcar; or, The Return of the Black Doll (Indianapolis and New York: Bobbs–Merrill, 1962)

The Vinegar Works: Three Volumes of Moral Instruction

> *The Gashlycrumb Tinies; or, After the Outing* (New York: Simon and Schuster, 1963)

> *The Insect God* (New York: Simon and Schuster, 1963)

> *The West Wing* (New York: Simon and Schuster, 1963)

The Wuggly Ump (Philadelphia and New York: J. B. Lippincott, 1963)

The Nursery Frieze (New York: Fantod Press, 1964)

The Sinking Spell (New York: Ivan Obolensky, 1964)

The Remembered Visit: A Story Taken from Life (New York: Simon and Schuster, 1965)

The Gilded Bat (New York: Simon and Schuster, 1966)

Three Books from the Fantod Press [I]

> *The Evil Garden: Eduard Blutig's Der Böse Garten* in a translation by Mrs Regera Dowdy with the Original Pictures of O. Müde (New York: Fantod Press, 1966)

> *The Inanimate Tragedy* (New York: Fantod Press, 1966)

> *The Pious Infant* by Mrs Regera Dowdy (New York: Fantod Press, 1966)

Fletcher and Zenobia, based on a story line by Victoria Chess and illustrated by Chess (New York: Meredith Press, 1967)

The Utter Zoo (New York: Meredith Press, 1967)

The Blue Aspic (New York: Meredith Press, 1968)

The Other Statue (New York: Simon and Schuster, 1968)

The Epiplectic Bicycle (New York: Dodd, Mead, 1969)

The Iron Tonic; or, a Winter Afternoon in Lonely Valley (New York: Albondocani, 1969)

Three Books from the Fantod Press [II]

> *The Chinese Obelisks: Fourth Alphabet* (New York: Fantod Press, 1970)

> *Donald Has a Difficulty* by Edward Gorey and Peter F. Neumeyer (New York: Fantod Press, 1970)

> *The Osbick Bird* (New York: Fantod Press, 1970)

The Sopping Thursday (New York: Gotham Book Mart, 1970)

Why We Have Day and Night by Edward Gorey and Peter F. Neumeyer (New York: Young Scott Books, 1970)

Three Books from the Fantod Press [III]

> *The Deranged Cousins; or, Whatever* (New York: Fantod Press, 1971)

> *The Eleventh Episode* by Raddory Gewe, drawings by Om (New York: Fantod Press, 1971)

> *[The Untitled Book]* (New York: Fantod Press, 1971)

Fletcher and Zenobia Save the Circus, illustrated by Victoria Chess (New York: Dodd, Mead, 1971)

Story for Sara: What Happened to a Little Girl by Alphonse Allais, put into English and with

drawings by Edward Gorey (New York: Albondocani, 1971). Henry Toledano notes, "This is a virtual rewrite and consequently a primary work," meaning he regards it as written by Gorey.

Amphigorey (New York: Putnam, 1972)

The Awdrey-Gore Legacy by D. Awdrey-Gore (New York: Dodd, Mead, 1972)

Leaves from a Mislaid Album (New York: Gotham Book Mart, 1972)

The Black Doll: A Silent Film (New York: Gotham Book Mart, 1973)

Categor y: Fifty Drawings (New York: Gotham Book Mart, 1973)

The Lavender Leotard; or, Going a Lot to the New York City Ballet (New York: Gotham Book Mart, 1973)

A Limerick (Dennis, MA: Salt-Works, 1973)

Three Books from the Fantod Press [IV]

 The Abandoned Sock (New York: Fantod Press, 1973)

 The Disrespectful Summons (New York: Fantod Press, 1973)

 The Lost Lions (New York: Fantod Press, 1973)

Amphigorey Too (New York: Putnam, 1975)

The Glorious Nosebleed: Fifth Alphabet (New York: Dodd, Mead, 1975)

L'Heure Bleue (New York: Fantod Press, 1975)

The Broken Spoke (New York: Dodd, Mead, 1976)

Les Passementeries Horribles (New York: Albondocani, 1976)

Scènes de Ballet (n.p.: no publisher indicated, 1976)

The Loathsome Couple (New York: Dodd, Mead, 1977)

Alms for Oblivion Series: Dogear Wryde Postcards (n.p.: no publisher indicated, 1978)

The Green Beads (New York: Albondocani, 1978)

Dracula: A Toy Theatre (New York: Scribner, 1979)

Gorey Posters (New York: Harry N. Abrams, 1979)

Interpretive Series: Dogear Wryde Postcards (n.p.: no publisher indicated, 1979)

Les Urnes Utiles (Cambridge, MA: Halty-Ferguson, 1980)

Mélange Funeste (New York: Gotham Book Mart, 1981)

The Dwindling Party (New York: Random House, 1982)

The Water Flowers (New York: Congdon & Weed, 1982)

Amphigorey Also (New York: Congdon & Weed, 1983)

The Eclectic Abecedarium (Boston: Anne & David Bromer, 1983)

E. D. Ward, a Mercurial Bear by Dogear Wryde (New York: Gotham Book Mart, 1983)

The Prune People (New York: Albondocani, 1983)

The Tunnel Calamity (New York: Putnam, 1984)

Les Échanges Malandreux (Worcester, MA: Metacom Press, 1984)

The Prune People II (New York: Albondocani, 1985)

The Improvable Landscape (New York: Albondocani, 1986)

The Raging Tide; or, The Black Doll's Imbroglio (New York: Beaufort Books [Peter Weed]), 1987)

The Dripping Faucet (Worcester, MA: Metacom Press, 1989).

The Helpless Doorknob: A Shuffled Story (n.p.: no publisher indicated, 1989)

Tragédies Topiares: Dogear Wryde Postcards (n.p.: no publisher indicated, 1989)

Q.R.V. (Boston: Anne & David Bromer, 1989)

Q.R.V. The Universal Solvent (Yarmouth Port, MA: Fantod Press, 1990)

La Balade Troublante (Yarmouth Port, MA: Fantod Press, 1991)

The Betrayed Confidence (Orleans, MA: Parnassus, 1992)

The Doleful Domesticity (Yarmouth Port, MA: Fantod Press, 1992)

The Grand Passion (Yarmouth Port, MA: Fantod Press, 1992)

The Dancing Rock by Ogdred Weary (n.p.: no publisher indicated, 1993)

The Floating Elephant by Dogear Wryde (n.p.: no publisher indicated, 1993)

The Pointless Book; or, Nature & Art by Garrod Weedy (n.p.: no publisher indicated, 1993)

The Retrieved Locket (Yarmouth Port, MA: Fantod Press, 1994)

The Fantod Pack (New York: Gotham Book Mart, 1995)

Q.R.V. Unwmkd. Imperf. (n.p.: no publisher indicated, 1996)

Q.R.V. Hikuptah (n.p.: no publisher indicated, 1996)

Thoughtful Alphabets (n.p.: no publisher indicated, 1996)

The Just Dessert (Yarmouth Port, MA: Fantod Press, 1997)

The Haunted Tea-Cosy: A Dispirited and Distasteful Diversion for Christmas (New York: Harcourt Brace, 1997)

The Headless Bust: A Melancholy Meditation on the False Millennium (New York: Harcourt Brace, 1999)

Thoughtful Alphabet VIII (The Morning After Christmas, 4 AM) (New York: Gotham Book Mart, 2001)

Amphigorey Again (New York: Harcourt, 2006)

Saint Melissa the Mottled (New York: Bloomsbury, 2012)

NOTES

A NOTE ON NOTES

In order to beat back the kudzulike overgrowth of endnotes, I've employed the following convention: the first time a source is quoted in any given paragraph, the quoted matter is accompanied by an endnote. If the next quotation in that paragraph is from the same page of the same source, no endnote is used. Only when a quotation from a new page or source appears in that paragraph is a new endnote introduced. In those instances where confusion is likely to arise from the appearance in a single paragraph of quotations from a single author but different sources—say, a lecture by Alison Lurie and my unpublished interview with her—I've broken my rule of not citing interview quotations.

INTRODUCTION: A GOOD MYSTERY

1 Edmund Wilson, "The Albums of Edward Gorey," in *The Bit Between My Teeth* (New York: Farrar, Straus and Giroux, 1965), 479.

2 Neil Gaiman, e-mail message to the author, January 26, 2011.

3 Entry for "Girl Anachronism," Dresden Dolls Wiki, http://dresdendolls .wikia.com/wiki/Girl_Anachronism.

4 "Allow Us to Explain . . . ," Edwardian Ball website, https://www.edward ianball.com/about-the-ball.

5 Richard Dyer, "The Poison Penman," in *Ascending Peculiarity: Edward Gorey on Edward Gorey*, ed. Karen Wilkin (New York: Harcourt, 2001), 123.

6 Alison Bechdel, "My 10 Favorite Books: Alison Bechdel," *New York Times*, February 5, 2016, https://www.nytimes.com/2016/02/05/t-mag azine/entertainment/my-10-favorite-books-alison-bechdel.html.

7 Maria Russodec, "A Book That Started with Its Pictures: Ransom Riggs Is Inspired by Vintage Snapshots," *New York Times*, December 30, 2013, http://www.nytimes.com/2013/12/31/books/ransom-riggs-is-inspired -by-vintage-snapshots.html.

8 Deborah Netburn, "Found Photography Drives 'Miss Peregrine's Home for Peculiar Children,'" *Los Angeles Times*, May 17, 2011, http:// latimesblogs.latimes.com/jacketcopy/2011/05/miss-peregrines-home-for -peculiar-children-ransom-riggs.html.

9 Stephen Schiff, "Edward Gorey and the Tao of Nonsense," in *Ascending Peculiarity*, 152.

10 Daniel Grant, "Illustrators Risk the Stigma of 'Second-Class' Artists," *Christian Science Monitor*, October 10, 1989, https://www.csmonitor .com/1989/1010/umag.html.

11 Tobi Tobias, "Balletgorey," in *Ascending Peculiarity*, 23.

12 Lisa Solod, "Edward Gorey: The *Boston Magazine* Interview," *Boston*, September 1980, 90.

13 Stephen Schiff, "Edward Gorey and the Tao of Nonsense," *New Yorker*, November 9, 1992, 84.

14 Thomas Curwen, "Light from a Dark Star: Before the Current Rise of Graphic Novels, There Was Edward Gorey, Whose Tales and Drawings Still Baffle—and Attract—New Fans," *Los Angeles Times*, July 18, 2004, http://articles.latimes.com/2004/jul/18/entertainment/ca-curwen18/3.

15 Solod, "Edward Gorey," 86.

16 Mark Dery, "Self-Dissection: A Conversation with Satirical English Author Will Self," *Boing Boing*, January 21, 2015, http://boingboing.net /2015/01/21/self-dissection-a-conversatio.html.

17 Edward Gorey, *The Listing Attic*, in *Amphigorey: Fifteen Books* (New York: G. P. Putnam's Sons, 1972), n.p.

18 "Classical Japanese literature": Alexander Theroux, *The Strange Case of Edward Gorey* (Seattle: Fantagraphics Books, 2000), 26. "To work in that way": Tobias, "Balletgorey," 23.

19 Edward Gorey, "Miscellaneous Quotes," in *Ascending Peculiarity*, 239.

20 Lao Tzu, *Tao Te Ching: A New English Version*, trans. Stephen Mitchell (New York: Harper Perennial Modern Classics, 2006), 1.

21 Robert Dahlin, "Conversations with Writers: Edward Gorey," in *Ascending Peculiarity*, 35.

22 Ibid.

23 Dyer, "Poison Penman," 110.

24 Lao Tzu, *Tao Te Ching*, quoted in Alan Watts, *What Is Tao?* (Novato, CA: New World Library, 2000), 22.

25 Dyer, "Poison Penman," 123.

26 Solod, "Edward Gorey," 90.

27 Ibid., 92.

28 Dyer, "Poison Penman," 123.

29 "[The] comic macabre": Mel Gussow, "Edward Gorey, Artist and Author Who Turned the Macabre into a Career, Dies at 75," *New York Times*, April 17, 2000, http://www.nytimes.com/2000/04/17/arts/edward-gorey -artist-and-author-who-turned-the-macabre-into-a-career-dies-at-75 .html. "Morbid whimsy": Aimee Ortiz, "Edward Gorey: Writer, Artist, and a Most Puzzling Man," *Christian Science Monitor*, February 22, 2013, http://www.csmonitor.com/Innovation/Horizons/2013/0222/Edward -Gorey-writer-artist-and-a-most-puzzling-man-video. "The elusive whimsy": Michael Dirda, *Classics for Pleasure* (Orlando, FL: Harcourt, 2007), 33. "[The] whimsically macabre": Robert Cooke Goolrick, "A Gorey Story," *New Times*, March 19, 1976, 54.

30 Solod, "Edward Gorey," 77.

31 Karen Wilkin, "Edward Gorey: An Introduction," in *Ascending Peculiarity*, xx.

32 Edward Gorey, "The Doubtful Interview," in *Gorey Posters* (New York: Harry N. Abrams, 1979), 7.

33 Schiff, "Edward Gorey and the Tao of Nonsense," *New Yorker*, 84.

34 Ken Morton interviewed by Christopher Seufert in "Edward Gorey Documentary Rough Cut Sample Featuring Ken Morton (His Cousin)," from Christopher Seufert, *The Last Days of Edward Gorey: A Documentary by Christopher Seufert*, posted on YouTube by Seufert on March 21, 2014, at https://www.youtube.com/watch?v=KqE0x8clKEA, and subsequently removed.

35 Edward Gorey interviewed by Dick Cooke on *The Dick Cooke Show*, a Cape Cod–based weekly public-access cable TV program, circa 1996. DVD copy of videotape provided to the author by Christopher Seufert.

36 D. Keith Mano, "Edward Gorey Inhabits an Odd World of Tiny Drawings, Fussy Cats, and 'Doomed Enterprises,'" *People* 10, no. 1 (July 3, 1978), 72.

37 Claire Golding, "Edward Gorey's Work Is No Day at the Beach," *Cape Cod Antiques & Arts*, August 1993, 21.

38 "Looking out the window": Edward Gorey, "Edward Gorey: Proust

Questionnaire," in *Ascending Peculiarity*, 185. "Never could understand": Alexander Theroux, *The Strange Case of Edward Gorey*, rev. ed. (Seattle: Fantagraphics Books, 2011), 157.

39 J. B. S. Haldane, *Possible Worlds and Other Papers* (New York: Harper & Bros., 1928), 286.

40 Myrna Oliver, "Edward Gorey: Dark-Humored Writer and Illustrator," *Los Angeles Times*, April 18, 2000, http://articles.latimes.com/2000/apr/18/local/me-20939.

41 Gorey, "Miscellaneous Quotes," 240.

42 Solod, "Edward Gorey," 96.

43 Ibid., 95.

44 Theroux, *Strange Case*, 2000 ed., 27.

45 Curwen, "Light from a Dark Star," 4.

46 Quoted ibid., 2.

CHAPTER 1. A SUSPICIOUSLY NORMAL CHILDHOOD: CHICAGO, 1925–44

1 Jan Hodenfield, "And 'G' Is for Gorey Who Here Tells His Story," in *Ascending Peculiarity: Edward Gorey on Edward Gorey*, ed. Karen Wilkin (New York: Harcourt, 2001), 5.

2 Karen Wilkin, "Edward Gorey: An Introduction," in *Ascending Peculiarity*, ix.

3 "Did not grow up": Hodenfield, "And 'G' Is for Gorey," 5. "Happier than I imagine": Jane Merrill Filstrup, "An Interview with Edward St. John Gorey at the Gotham Book Mart," *The Lion and the Unicorn* 2, no. 1 (1978), 22.

4 Dick Cavett, "The Dick Cavett Show with Edward Gorey," in *Ascending Peculiarity*, 55.

5 Edward Gorey interviewed by Faith Elliott, November 30, 1976, in Gorey's apartment at 36 East 38th Street, New York City. Unpublished. Audio recording provided to the author.

6 Alexander Theroux, *The Strange Case of Edward Gorey* (Seattle: Fantagraphics Books, 2000), 7.

7 Edward Gorey interviewed by Christopher Lydon for *The Connection*, November 26, 1998, WBUR (Boston's National Public Radio affiliate). Audio recording provided to the author by Christopher Seufert.

8 Filstrup, "An Interview with Edward St. John Gorey," 76.

9 Richard Dyer, "The Poison Penman," in *Ascending Peculiarity*, 125.

10 Ibid.

11 Stephen Schiff, "Edward Gorey and the Tao of Nonsense," in *Ascending Peculiarity*, 143.

12 At least that's what he told Dick Cavett in a 1977 interview (see *Ascending Peculiarity*, 57). Oddly, he told Jane Merrill Filstrup, in an interview published the following year, that his "first drawing" was "done at age three and a half" (see *Ascending Peculiarity*, 75). Given Gorey's precocity in other areas, not to mention the crudity of the drawing, the earlier date seems more likely.

13 Filstrup, "An Interview with Edward St. John Gorey," 75.

14 Ibid.

15 Cavett, "The Dick Cavett Show," 54.

16 "'Tried to Drive Me Insane,' Wife Asserts in Suit; Phone Man Kept Her in Sanitarium Until Reason Fled, She Declares," *Chicago Examiner*, February 17, 1914, 2.

17 Lisa Solod, "Edward Gorey," in *Ascending Peculiarity*, 96.

18 Edward Gorey, "Edward Gorey: Proust Questionnaire," in *Ascending Peculiarity*, 182.

19 Gorey, Elliott interview.

20 Solod, "Edward Gorey," 106.

21 Gorey, Elliott interview.

22 Alexander Theroux, *The Strange Case of Edward Gorey*, rev. ed. (Seattle: Fantagraphics Books, 2011), 84.

23 Edward Gorey to his mother, Helen Garvey Gorey, n.d., 1932. The letter in question was exhibited in *Elegant Enigmas: The Art of Edward Gorey / G Is for Gorey—C Is for Chicago: The Collection of Thomas Michalak*, two exhibitions that ran simultaneously from February 15 to June 15, 2014, at the Loyola University Museum of Art, Chicago. Quote transcribed by my research assistant, Elizabeth Tamny.

24 Dyer, "Poison Penman," 113.

25 Schiff, "Edward Gorey and the Tao of Nonsense," 151.

26 See Elizabeth M. Tamny, "What's Gorey's Story? The Formative Years of a Very Peculiar Man," *Chicago Reader*, November 11, 2005, 30.

27 Simon Henwood, "Edward Gorey," in *Ascending Peculiarity*, 166.

28 A. Scott Berg, *Lindbergh* (New York: G. P. Putnam's Sons, 1998), 242.

29 See Patricia Albers, *Joan Mitchell: Lady Painter* (New York: Alfred A. Knopf, 2011), 52.

30 Ben Hecht, *A Child of the Century* (New York: Simon and Schuster, 1954), 153, 156.

31 Dyer, "Poison Penman," 113.

32 Schiff, "Edward Gorey and the Tao of Nonsense," 156.

33 Dyer, "Poison Penman," 113.

34 Annie Nocenti, "Writing *The Black Doll*: A Talk with Edward Gorey," in *Ascending Peculiarity*, 207.

35 Theroux, *Strange Case*, 2000 ed., 7.

36 Ibid., 65.

37 Board of Education, City of Chicago, Registration Card, April 16, 1934, digital scan obtained from Chicago Public Schools, Department of Compliance, Former Student Records, May 31, 2012.

38 Edward Gorey, letter to Jane Langton, February 20, 1998, Jane Langton Papers, Lincoln Town Archives, Lincoln, MA.

39 "Ted Gorey Report Card, Grade 6 1934–35, Room Teacher Viola Therman," archived in "Howard School, Wilmette, Illinois, 6 and 7 grades, 1934–1937," *G Is for Gorey— C Is for Chicago*, http://www .lib.luc.edu/specialcollections/exhibits/show/gorey/education/howard -school-wilmette-illin.

40 Theroux, *Strange Case*, 2000 ed., 32.

41 Cliff Henderson, "E Is for Edward Who Draws in His Room," *Arts and Entertainment Magazine*, October 1991, 18.

42 *Radio Guide,* June 1, 1935, "Programs for Wednesday, May 29," archived at the Internet Archive, http://archive.org/stream/radio-guide-1935 -06-01/radio-guide-1935-06-01_djvu.txt.

43 Donna Grace, "Charm Secrets by Entertainer," *Windsor Daily Star*, July 5, 1940, n.p.

44 Edward Leo Gorey, letter to John Boettiger, September 26, 1937, John Boettiger Papers, Franklin D. Roosevelt Presidential Library and Museum, Hyde Park, NY.

45 Joyce Garvey LaMar, e-mail message to the author, July 17, 2012.

46 Edward Gorey, five-year diary, entry for February 18, 1938. Reviewed at the Edward Gorey House.

47 Gorey, five-year diary, July 2, 1939.

48 Gorey, five-year diary, March 21, 1938.

49 Dan Frank, "Colonel Francis Parker," an essay by Francis W. Parker's principal on the *My Hero* website, July 24, 2012, https://myhero.com/ Colonel_Parker?iframe=true.

50 Donald Stanley Vogel, *The Boardinghouse: The Artist Community House, Chicago 1936–37* (Denton: University of North Texas Press, 1995), 5.

51 Oscar Wilde, *The Importance of Being Earnest,* in *The Annotated Oscar Wilde,* ed. H. Montgomery Hyde (New York: Clarkson Potter, 1982), 355.

52 Clifford Ross and Karen Wilkin, *The World of Edward Gorey* (New York: Harry N. Abrams, 1996), 33.

53 Ibid.

54 Paul Richard, e-mail message to the author, October 4, 2011.

55 Schiff, "Edward Gorey and the Tao of Nonsense," 143.

56 Ross and Wilkin, *The World of Edward Gorey,* 11.

57 Carl Sandburg, "Chicago," in *Poetry* 3, no. 6 (March 1914), 191, https://www.poetryfoundation.org/poetrymagazine/browse?contentId=12840.

58 Albers, *Joan Mitchell,* 88.

59 Vogel, *The Boardinghouse,* 80.

60 See Albers, *Joan Mitchell,* 89.

61 "Email Exchange Between Connie Joerns and Tom Michalak 11.7.13.," quoted in "Edward Gorey at the Francis W. Parker School," *G Is for Gorey—C Is for Chicago,* http://www.lib.luc.edu/specialcollections/exhibits/show/gorey/education/edward-gorey-at-the-francis-w-.

62 Albers, *Joan Mitchell,* 90.

63 Ibid.

64 Robert Dahlin, "Conversations with Writers: Edward Gorey," in *Ascending Peculiarity,* 49.

65 "Socialites on Top Again," *Parker Weekly* 29, no. 12 (January 22, 1940), 1.

66 Quoted in "Edward Gorey at the Francis W. Parker School 2," *G Is for Gorey—C Is for Chicago,* http://www.lib.luc.edu/specialcollections/exhibits/show/gorey/education/parker-2.

67 Solod, "Edward Gorey," 102.

68 Edward Gorey, Harvard College National Scholarship Application, January 26, 1942, in Edward Gorey student records, Office of the Registrar, Faculty of Arts and Sciences, Harvard University.

69 Henwood, "Edward Gorey," 161.

70 Filstrup, "An Interview with Edward St. John Gorey," 84.

71 Ibid.

72 Edward Gorey, foreword to *Costumes by Karinska,* by Toni Bentley (New York: Harry N. Abrams, 1995), n.p. The show Gorey saw is undoubtedly the Ballet Russe de Monte Carlo's Wednesday afternoon (2:30 p.m.) performance on January 3, 1940, at Chicago's Auditorium Theatre; the program, in order, consisted of *Rouge et Noir, Bacchanale,* and *Shéhérazade.*

73 Edward Gorey, "The Doubtful Interview," in *Gorey Posters* (New York: Harry N. Abrams, 1979), 6.

74 Gorey, foreword, *Costumes by Karinska*, n.p.

75 Ibid.

76 Grace Robert, *The Borzoi Book of Ballets* (New York: Alfred A. Knopf, 1946), 258.

77 Albers, *Joan Mitchell*, 89.

78 Gorey, Harvard College National Scholarship application.

79 Edward Gorey, Harvard College application for admission, February 6, 1942, in Edward Gorey student records, Harvard University.

80 Quoted in Ariel Swartley, "Henry James' Boston," *Globe Magazine* (Boston), August 12, 1984, 10–45.

81 Herbert W. Smith, Harvard College National Scholarship application, school record form, January 28, 1942, 1–6.

82 Helen Gorey, letter to the Committee on Admission, Harvard College, September 6, 1946, in Edward Gorey student records, Harvard University.

83 Ibid.

84 Edward Gorey, letter to Bea Moss (née Rosen), addressed to "Darling," n.d., in "Unpublished Gorey (letters to Bea Moss)" folder, Edward Gorey Collection, San Diego State University Library Special Collections.

85 Gorey, letter to Moss, addressed to "Dear Beatrix the-light-of-my-life," n.d., San Diego State University Library Special Collections.

86 Gorey, letter to Moss, addressed to "Beatrix my beloved," n.d., San Diego State University Library Special Collections.

87 Ibid.

88 Edward Gorey, "I Love Lucia," *Vogue*, May 1986, 180.

89 David Leon Higdon, "E. F. Benson," in *The Gay and Lesbian Literary Heritage*, ed. Claude J. Summers (New York: Routledge, 2002), 84.

90 Filstrup, "An Interview with Edward St. John Gorey," 84.

91 Gorey, "Dear Beatrix the-light-of-my-life."

92 "The Army Specialized Training Program: A Brief Survey of the Essential Facts," *Journal of Educational Sociology* 16, no. 9 (May 1943), 543.

93 Edward Gorey, Harvard College Application to Register, July 5, 1946, in Edward Gorey student records, Harvard University.

Notes

CHAPTER 2. MAUVE SUNSETS: DUGWAY, 1944–46

1 Ronald L. Ives, "Dugway Tales," *Western Folklore* 6, no. 1 (January 1947), 54.

2 Ibid., 53.

3 Richard Dyer, "The Poison Penman," in *Ascending Peculiarity: Edward Gorey on Edward Gorey*, ed. Karen Wilkin (New York: Harcourt, 2001), 113.

4 Edward Gorey, "The Doubtful Interview," in *Gorey Posters* (New York: Harry N. Abrams, 1979), 5.

5 Janet "Jan" Brandt, unpublished book report on *Ascending Peculiarity* for her book group e-mailed to the author. She wrote the report before her husband, William E. "Bill" Brandt, died; he reviewed it and offered insights and information, which she incorporated.

6 All quotations from William E. Brandt are from his undated, unpaginated, unpublished memoir, relevant excerpts of which were photocopied and mailed to the author by Jan Brandt.

7 Brandt, unpublished memoir.

8 Edward Gorey interviewed by the Boston-based TV and radio interviewer Christopher Lydon, circa 1992. Unedited audiotape. Copy of tape provided to the author by Christopher Seufert.

9 Jane Merrill Filstrup, "An Interview with Edward St. John Gorey at the Gotham Book Mart," in *Ascending Peculiarity*, 21.

10 Edward Gorey, *Les Serpents de Papier de Soie*, n.d., 1. Photocopy of typed manuscript of unpublished Gorey play provided to the author by Jan Brandt.

11 "How unutterably mad!": Edward Gorey, *A Scene from a Play*, March 28, 1945, 4. Photocopy of typed manuscript of unpublished Gorey play provided to the author by Jan Brandt. "How hideously un-*chic*": Ibid., 6. "Divine!": Ibid.

12 Edward Gorey, *L'Aüs et L'Auscultatrice*, n.d., 3. Photocopy of typed manuscript of unpublished Gorey play provided to the author by Jan Brandt.

13 Gorey's handwritten notes to Brandt on the cover pages of the only plays he dated, *A Scene from a Play* and *Les Aztèques*, read "March 28, 1945," and "July 14, 1945," respectively. It seems likely that he inscribed the typescripts immediately after finishing them or at least shortly thereafter, though there's no way to be certain. So those two plays, at least, were written after February 22, 1945, when he turned twenty; whether he wrote any of the others before that date we don't know.

14 Gorey, *Les Serpents*, 1.

15 An *auscultatrice* is "a nun appointed to listen to all conversation between

435

the other nuns and their friends or visitors," according to Alexander Spiers, *A New French-English General Dictionary* (Paris: Librairie Européenne de Baudry/Mesnil-Dramard, 1908), 64. As for *aüs*, the Belgian-American writer Luc Sante, who is fluent in French, defined it in an April 21, 2015, tweet to me as a slang term for a nuisance customer who won't buy anything. Knowing Gorey's fondness for wordplay, I'm inclined to believe he chose the words for their alliterative qualities rather than their meanings. In its rhymes and rhythms, the phrase recalls Jane Austen's *Sense and Sensibility*—perhaps no accident, given Gorey's devotion to Austen.

16 Edward Gorey, *Les Aztèques*, July 14, 1945, 15, 47. Photocopy of typed manuscript of unpublished Gorey play provided to the author by Jan Brandt.

17 G. K. Chesterton, "The Miser and His Friends," quoted in *The Universe According to G. K. Chesterton: A Dictionary of the Mad, Mundane, and Metaphysical*, ed. Dale Ahlquist (Mineola, NY: Dover Books, 2011), 4.

18 Alexander Theroux, *The Strange Case of Edward Gorey* (Seattle: Fantagraphics Books, 2000), 8.

19 Jim Woolf, "Army: Nerve Agent Near Dead Utah Sheep in '68; Feds Admit Nerve Agent Near Sheep," *Salt Lake Tribune*, January 1, 1998, PDF archived on the United States Nuclear Regulatory Commission website, 4, http://pbadupws.nrc.gov/docs/ML0037/ML003729062.pdf.

20 Dick Cavett, "The Dick Cavett Show with Edward Gorey," in *Ascending Peculiarity*, 60–61.

21 Edward Gorey, letter to Bill Brandt, April 17, 1947, 4, William E. Brandt Papers, Manuscripts, Archives, and Special Collections, Washington State University Libraries, Pullman.

22 Ibid., 2.

23 Edward Gorey, Veteran Application for Rooms, July 9, 1946, in Edward Gorey student records, Office of the Registrar, Faculty of Arts and Sciences, Harvard University.

24 Quoted in Andrew J. Diamond, *Chicago on the Make: Power and Inequality in a Modern City* (Oakland: University of California Press, 2017), 1.

25 Christopher Lydon, "The Connection," in *Ascending Peculiarity*, 224.

26 David Streitfeld, "The Gorey Details," in *Ascending Peculiarity*, 178.

27 Dyer, "Poison Penman," 113.

CHAPTER 3. "TERRIBLY INTELLECTUAL AND AVANT-GARDE AND ALL THAT JAZZ": HARVARD, 1946–50

1 Quoted in Brad Gooch, *City Poet: The Life and Times of Frank O'Hara* (New York: Alfred A. Knopf, 1993), 6.

2 Ibid., 47.

3 Ibid.

4 Ibid., 115.

5 Ibid.

6 Larry Osgood, interview with the author at Osgood's home in Germantown, New York, April 28, 2011.

7 Gooch, *City Poet*, 115.

8 Ibid., 114–15.

9 "The greatest influence": Alexander Theroux, *The Strange Case of Edward Gorey* (Seattle: Fantagraphics Books, 2000), 57. "Reluctant to admit": Richard Dyer, "The Poison Penman," in *Ascending Peculiarity: Edward Gorey on Edward Gorey*, ed. Karen Wilkin (New York: Harcourt, 2001), 123–24.

10 Published in New York in 1971 by Albondocani Press, *Early Stories* collects "The Wavering Disciple" and "A Study in Opal" with four illustrations by Gorey.

11 Tobi Tobias, "Balletgorey," in *Ascending Peculiarity*, 23.

12 Quoted in Michael Dirda, *Bound to Please: An Extraordinary One-Volume Literary Education* (New York: W. W. Norton, 2005), 180.

13 Ronald Firbank, *Vainglory*, in *The Complete Ronald Firbank* (London: Gerald Duckworth & Co., 1961), 149.

14 Quoted in Dirda, *Bound to Please*, 181.

15 Ibid., 180.

16 Carl Van Vechten, *Excavations* (New York: Alfred A. Knopf, 1926), 172.

17 Ronald Firbank, *Concerning the Eccentricities of Cardinal Pirelli* (London: Gerald Duckworth & Co., 1929), n.p., archived on the Project Gutenberg website, http://www.gutenberg.ca/ebooks/firbankr-cardinalpirelli /firbankr-cardinalpirelli-00-h.html.

18 David Van Leer, *The Queening of America: Gay Culture in Straight Society* (New York: Routledge, 1995), 27.

19 Lisa Solod, "Edward Gorey," in *Ascending Peculiarity*, 102.

20 Alfred Hower, Freshman Advisor's Report, January 10, 1947, in Edward

Gorey student records, Office of the Registrar, Faculty of Arts and Sciences, Harvard University.

21 Helen Gorey, letter to Judson Shaplin, assistant dean of Harvard College, dated "Saturday, March 1st," 2, in Edward Gorey student records, Harvard University.

22 Ibid., 1.

23 Roel van den Oever, *Mama's Boy: Momism and Homophobia in Postwar American Culture* (New York: Palgrave Macmillan, 2012), 1.

24 Gooch, *City Poet*, 115.

25 Edward Gorey, letter to Edmund Wilson, July 28, 1954, Edmund Wilson Papers, Yale Collection of American Literature, Beinecke Rare Book and Manuscript Library, Yale University.

26 Gooch, *City Poet*, 107.

27 Ibid., 117.

28 "They were a counterculture": Quoted in Stephen Schiff, "Edward Gorey and the Tao of Nonsense," in *Ascending Peculiarity*, 152. "Improvised self-elected class": Susan Sontag, "Notes on 'Camp,'" in *A Susan Sontag Reader* (New York: Vintage, 1983), 117.

29 "Way of seeing": Sontag, "Notes on 'Camp,'" 106. "My life has been concerned": Dyer, "Poison Penman," 121.

30 Edward Gorey, letter to Bill Brandt, April 17, 1947, 1, William E. Brandt Papers, Manuscripts, Archives, and Special Collections, Washington State University Libraries, Pullman. All quotations from Gorey letters to Brandt are from letters found in the Brandt Papers.

31 Dick Cavett, "The Dick Cavett Show with Edward Gorey," in *Ascending Peculiarity*, 58.

32 "Dim proceedings": Dyer, "Poison Penman," 113. "Absolutely atrocious": Robert Dahlin, "Conversations with Writers: Edward Gorey," in *Ascending Peculiarity*, 47.

33 Jane Merrill Filstrup, "An Interview with Edward St. John Gorey at the Gotham Book Mart," in *Ascending Peculiarity*, 79–80.

34 François, duc de La Rochefoucauld, in John Bartlett, *Familiar Quotations* (Boston: Little, Brown, 1919), archived at Bartleby.com, http://www.bartleby.com/100/738.html.

35 Edward Gorey, untitled article on the *Maximes* of La Rochefoucauld, n.d., 6, Edward Gorey Collection, Harry Ransom Center, University of Texas at Austin.

36 Ibid., 4.

37 Ibid., 2.

38 Ibid., 8.

39 "Incurable pessimism," "passion and suffering," "polite glaciality": Gorey, untitled article on the *Maximes*, 9. "I read books": Theroux, *Strange Case*, 2000 ed., 26–27.

40 Edward Gorey, fourth part of a novel, *Paint Me Black Angels*, December 14, 1947, 3, Edward Gorey Collection, Harry Ransom Center, University of Texas at Austin.

41 Gorey, letter to Brandt, April 17, 1947, 1.

42 Gorey, letter to Brandt, April 17, 1947, 3.

43 Donald Hall, letter to the author, February 9, 2011, 1.

44 Quoted in Gooch, *City Poet*, 117.

45 Gorey, letter to Brandt, November 10, 1947, 1.

46 Ibid.

47 Gorey, untitled article on the *Maximes*, 6.

48 Donald Hall, "English C, 1947," in *John Ciardi: Measure of the Man*, ed. Vince Clemente (Fayetteville: University of Arkansas Press, 1987), 53.

49 Edward Cifelli, *John Ciardi: A Biography* (Fayetteville: University of Arkansas Press, 1998), 297.

50 Dahlin, "Conversations with Writers," 28.

51 John Ciardi, letter to Donald Allen, in *Homage to Frank O'Hara*, ed. Bill Berkson and Joe LeSueur, rev. ed. (Bolinas, CA: Big Sky Books, 1988), 19.

52 Cifelli, *John Ciardi*, 145.

53 Quoted in Gooch, *City Poet*, 120.

54 Edward Gorey, "The Colours of Disillusion," October 27, 1947, 1–10, Edward Gorey Collection, Harry Ransom Center, University of Texas at Austin.

55 Ibid.

56 Sontag, "Notes on 'Camp,'" 114–15, 116.

57 Edward Gorey, "A Wet Sunday, Vendée, Whatever Year Scott's Novel Was Translated," April 14, 1949, n.p., Edward Gorey Collection, Harry Ransom Center, University of Texas at Austin.

58 Gooch, *City Poet*, 117.

59 Oscar Wilde, "The Decay of Lying," in *The Artist as Critic: Critical Writings of Oscar Wilde*, ed. Richard Ellmann (New York: Vintage, 1970), 294.

60 Gooch, *City Poet*, 131.

61 Phil Thomas, "Gorey Writes First, Draws Later," *Gettysburg Times*, January 9, 1984, 7.

62 Gooch, *City Poet*, 118.

63 Ibid.

64 Elizabeth Hollander, "The End of the Line: Rory Dagweed Succumbs," *Goodbye*, n.d., n.p., https://web.archive.org/web/20010217224104/http://www.goodbyemag.com//mar00/gorey.html/.

65 Edward Gorey interviewed by Faith Elliott, November 30, 1976, in Gorey's apartment at 36 East 38th Street, New York City. Unpublished. Audio provided to author.

66 W. E. Farbstein, "Debunking Expedition," *Collier's Weekly*, n.p., n.d., magazine clipping included in Helen Gorey, letter to Edward Gorey, n.d., Edward Gorey Collection, Harry Ransom Center, University of Texas at Austin.

67 Gooch, *City Poet*, 133.

68 Ibid., 115.

69 Ifan Kyrle Fletcher, "Ifan Kyrle Fletcher," in *Ronald Firbank: Memoirs and Critiques*, ed. Mervyn Horder (London: Gerald Duckworth & Co., 1977), 25.

70 Unedited footage of ABC reporter Margaret Osmer interviewing Gorey in 1978 about his fur coats. Digital copy of videotape provided to the author by Christopher Seufert.

71 Gooch, *City Poet*, 121.

72 Ibid., 135.

73 Ivy Compton-Burnett, *A Heritage and Its History* (New York: Simon and Schuster, 1960), 10.

74 Gooch, *City Poet*, 136.

75 Ibid., 133.

76 Ibid., 132.

77 Ibid., 133.

78 Ibid.

79 Ibid.

80 Ibid., 116.

81 Larry Osgood, e-mail message to the author, January 6, 2013.

82 Larry Osgood, e-mail message to the author, November 21, 2012.

83 Osgood, interview with the author.

84 Edward Gorey, letter to Consuelo Joerns, December 30, 1948, 1, Edward Gorey Collection, Harry Ransom Center, University of Texas at Austin.

85 Ibid., 2.

86 Ibid.

87 Ibid.

88 Student's Status, August 1, 1949, 2, in Edward Gorey student records, Harvard University.

89 "I've never been one for a messy clinch" (untitled poem), n.p., Edward Gorey Collection, Harry Ransom Center, University of Texas at Austin.

90 Gorey, letter to Brandt, January 30, 1951, 3.

91 Solod, "Edward Gorey," 102.

92 Ibid., 97.

93 Ibid., 102.

94 Ibid., 103.

95 Ibid., 105.

96 Ibid.

97 Schiff, "Edward Gorey and the Tao of Nonsense," 149.

98 John Ashbery, e-mail message to the author, March 2, 2011. Ashbery requested that the following credit/permission line be appended to this endnote: "Quotations/excerpts from unpublished correspondence with John Ashbery used in this volume are copyright © 2011 by John Ashbery. All rights reserved. Used by arrangement with Georges Borchardt, Inc. for the author."

99 Schiff, "Edward Gorey and the Tao of Nonsense," 148.

100 Dyer, "Poison Penman," 119.

101 Franklyn B. Modell, letter to Edward Gorey, April 27, 1950, 1, Edward Gorey Collection, Harry Ransom Center, University of Texas at Austin.

102 David Remnick, "The New Yorker in the Forties," *New Yorker*, April 28, 2014, http://www.newyorker.com/books/page-turner/the-newyorker-inthe-forties.

103 Filstrup, "An Interview with Edward St. John Gorey," 85.

104 Dyer, "Poison Penman," 115.

105 Alexander Theroux, *The Strange Case of Edward Gorey*, rev. ed. (Seattle: Fantagraphics Books, 2011), 37.

106 Solod, "Edward Gorey," 96.

107 Ibid., 105.

108 Marjorie Perloff, *Frank O'Hara: Poet Among Painters* (Chicago: University of Chicago Press, 1997), 21.

109 Gooch, *City Poet*, 140.

110 Dyer, "Poison Penman," 115.

111 Frank O'Hara, "For Edward Gorey," in *Early Writing*, ed. Donald Allen (Bolinas, CA: Grey Fox Press, 1977), 65.

112 Gooch, *City Poet*, 123–24.

CHAPTER 4. SACRED MONSTERS: CAMBRIDGE, 1950–53

1 Clifford Ross and Karen Wilkin, *The World of Edward Gorey* (New York: Harry N. Abrams, 1996), 33.

2 Joseph P. Kahn, "It Was a Dark and Gorey Night," *Boston Globe*, December 17, 1998, C4.

3 Steven Heller, "Edward Gorey's Cover Story," in *Ascending Peculiarity: Edward Gorey on Edward Gorey*, ed. Karen Wilkin (New York: Harcourt, 2001), 232.

4 D. Keith Mano, "Edward Gorey Inhabits an Odd World of Tiny Drawings, Fussy Cats, and 'Doomed Enterprises,'" *People* 10, no. 1 (July 3, 1978), https://people.com/archive/edward-gorey-inhabits-an-odd-world-of-tiny -drawings-fussy-cats-and-doomed-enterprises-vol-10-no-1/.

5 Edward Gorey, letter to Bill Brandt, January 30, 1951, 2, William E. Brandt Papers, Manuscripts, Archives, and Special Collections, Washington State University Libraries, Pullman. All quotations from Gorey letters to Brandt are from letters found in the Brandt Papers.

6 Alexander Theroux, *The Strange Case of Edward Gorey* (Seattle: Fantagraphics Books, 2000), 12.

7 Gorey, letter to Brandt, January 30, 1951, 2.

8 Ibid.

9 Ibid.

10 Nicholas Wroe, "Young at Heart," *The Guardian*, October 24, 2003, http://www.theguardian.com/books/2003/oct/25/featuresreviews .guardianreview15.

11 Alison Lurie, "Of Curious, Beastly & Doubtful Days: Alison Lurie on Edward 'Ted' Gorey," transcript of remarks delivered at the Edward Gorey House's Seventh Annual Auction and Goreyfest, October 4, 2008, http://www.goreyography.com/north/north.htm.

12 Alison Lurie, interview with the author.

13 Lurie, "Of Curious, Beastly & Doubtful Days."

14 Lurie, interview with the author.

15 Lurie, "Of Curious, Beastly & Doubtful Days."

16 Ibid.

17 Lurie, interview with the author.

18 Ibid.

19 Lurie, "Of Curious, Beastly & Doubtful Days."

20 Gorey, letter to Brandt, January 30, 1951, 1.

21 Ibid.

22 *Harvard Advocate* 133, no. 6 (Commencement Issue, 1950), and *Harvard Advocate* 133, no. 7 (Registration Issue, 1950), respectively.

23 John Updike, foreword to *Elephant House: or, The Home of Edward Gorey*, by Kevin McDermott (Petaluma, CA: Pomegranate Communications, 2003), n.p.

24 Gorey, letter to Brandt, January 30, 1951, 3.

25 Ibid.

26 Edward M. Cifelli, *The Selected Letters of John Ciardi* (Fayetteville: University of Arkansas Press, 1991), 71.

27 Merrill Moore, letter to Helen Gorey, April 21, 1953, 2, Merrill Moore Papers, Manuscript Division, Library of Congress. All quotations from Moore's correspondence with Helen Gorey, Edward Leo Gorey, and Edward Gorey are taken from this collection.

28 Moore, telegram to Edward Gorey, December 2, 1951.

29 T. S. Eliot, *The Use of Poetry and the Use of Criticism* (London: Faber and Faber, 1964), 154.

30 Alison Lurie, "A Memoir," in *V. R. Lang: Poems & Plays; With a Memoir by Alison Lurie*, by V. R. Lang and Alison Lurie (New York: Random House, 1975), 13.

31 Nora Sayre, "The Poets' Theatre: A Memoir of the Fifties," *Grand Street* 3, no. 3 (Spring 1984), 98.

32 Ibid., 92.

33 Ibid., 98.

34 Lurie, "A Memoir," 14.

35 Oscar Wilde, *The Wit and Humor of Oscar Wilde*, ed. Alvin Redman (Mineola, NY: Dover Publications, 1959), 64.

36 Brad Gooch, *City Poet: The Life and Times of Frank O'Hara* (New York: Alfred A. Knopf, 1993), 147.

37 Lurie, "A Memoir," 60.

38 Gooch, *City Poet*, 148.

39 *Oscar Wilde's Wit & Wisdom: A Book of Quotations* (Mineola, NY: Dover Publications, 1998), 1.

40 Lurie, "A Memoir," 71.

41 Lurie, "Of Curious, Beastly & Doubtful Days."

42 Sayre, "The Poets' Theatre," 95.

43 Ibid.

44 Edward Gorey, *Amabel, or The Partition of Poland*, written in February–May 1952, n.p., typewritten copy of unpublished play, Felicia Lamport Pa-

pers, Schlesinger Library, Radcliffe Institute for Advanced Study, Harvard University.

45 Sarah A. Dolgonos, "Behind the Macabre: In Memoriam of Edward Gorey," *Harvard Crimson*, June 5, 2000, 2, http://www.thecrimson.com/article/2000/6/5/behind-the-macabre-ponce-asked-what/?page=2.

46 Richard Dyer, "The Poison Penman," in *Ascending Peculiarity*, 116.

47 Theroux, *Strange Case*, 10.

48 Moore, letter to Edward Gorey, October 22, 1951, 2.

49 Edward Gorey, letter to Alison Lurie, June 22, 1952, 2, Alison Lurie Papers, Division of Rare and Manuscript Collections, Cornell University Library. All quotations from Gorey's correspondence with Lurie are taken from the Lurie Papers at Cornell.

50 Theroux, *Strange Case*, 12.

51 Society Notebook, *Chicago Daily Tribune*, October 22, 1952, B1.

52 Edward Leo Gorey, letter to Merrill Moore, April 24, 1953, 1.

53 Judith Cass, Recorded at Random, *Chicago Daily Tribune*, December 17, 1952, B7.

54 Gorey, letter to Lurie, June 22, 1952, 1.

55 Ibid., 2.

56 Jason Epstein, interview with the author at Epstein's home in Manhattan, March 29, 2011.

57 Carol Stevens, "An American Original," *Print*, January–February 1988, 51.

58 Heller, "Edward Gorey's Cover Story," 232.

59 Clifford Ross, "Interview with Edward Gorey," in *The World of Edward Gorey*, 33, 36.

CHAPTER 5. "LIKE A CAPTIVE BALLOON, MOTIONLESS BETWEEN SKY AND EARTH": NEW YORK, 1953

1 Edward Gorey, audiotape of an interview with Ed Pinsent, the edited version of which appeared in *Speak* magazine in fall 1997 as "A Gorey Encounter" and was subsequently republished in *Ascending Peculiarity: Edward Gorey on Edward Gorey*, ed. Karen Wilkin (New York: Harcourt, 2001). Pinsent provided me with a digital copy of the interview tape.

2 Edward Gorey, letter to Merrill Moore dated "Tuesday night" (in 1953, most likely March), 1, Merrill Moore Papers, Manuscript Division, Library of Congress.

3 Robert Dahlin, "Conversations with Writers: Edward Gorey," in *Ascending Peculiarity*, 28.

4 Carol Stevens, "An American Original," in *Ascending Peculiarity*, 130.

5 Steven Heller, "Edward Gorey's Cover Story," in *Ascending Peculiarity*, 234.

6 Ibid., 233.

7 Jane Merrill Filstrup, "An Interview with Edward St. John Gorey at the Gotham Book Mart," in *Ascending Peculiarity*, 76.

8 Clifford Ross, "Interview with Edward Gorey," in *The World of Edward Gorey*, by Clifford Ross and Karen Wilkin (New York: Harry N. Abrams, 1996), 28.

9 Heller, "Edward Gorey's Cover Story," 235.

10 Ibid.

11 Ibid., 236.

12 Steven Heller, *Edward Gorey: His Book Cover Art & Design* (Portland, OR: Pomegranate, 2015), 17.

13 Ibid.

14 Ibid.

15 Stephen Schiff, "Edward Gorey and the Tao of Nonsense," in *Ascending Peculiarity*, 154.

16 Edward Gorey, letter to Peter Neumeyer, October 2, 1968, in *Floating Worlds: The Letters of Edward Gorey & Peter F. Neumeyer*, ed. Peter F. Neumeyer (Petaluma, CA: Pomegranate Communications, 2011), 19.

17 Andreas Brown dismisses the idea that Warhol and Gorey ever crossed paths at Doubleday—or anywhere else, for that matter. "They never, ever communicated or had any association that I know of," he said. See "Warhol & Collecting Books," Andreas Brown interviewed by Kathryn Price, curator of collections at the Williams College Museum of Art, August 6, 2015, archived on the Williams College YouTube channel, https://www.youtube.com/watch?v=JL6TBUl8MGM.

 Yet a 1977 profile asserts that Gorey rubbed elbows with Warhol at Doubleday in the early '50s and that "years later, he was surprised by Warhol, who recognized him on the street in New York, greeting him as a celebrity of equal rank in bohemian circles." (See Craig Little, "Gorey," *Packet*, October 30, 1977, 19. They had, at least, shared a marquee: Warhol appeared in the November 1952 issue of *Harper's* that featured Gorey's debut on the cover of a national magazine; Warhol's pen-and-ink drawing, done in the jittery, blotted-line style popular-

ized by Ben Shahn, accompanies Shirley Jackson's short story "Journey with a Lady."

18 Schiff, "Edward Gorey and the Tao of Nonsense," 155.

19 Louis Menand, "Pulp's Big Moment: How Emily Brontë Met Mickey Spillane," *New Yorker*, January 5, 2015, http://www.newyorker.com/magazine/2015/01/05/pulps-big-moment.

20 Jason Epstein, *Book Business: Publishing Past, Present, and Future* (New York: W. W. Norton, 2001), 66–67.

21 "Edward Gorey," *Print*, January–February 1958, 44.

22 Menand, "Pulp's Big Moment."

23 Heller, "Edward Gorey's Cover Story," 235.

24 Gorey "became very well known" for his James covers, he said, the irony of which was not lost on the man who claimed to hate James "more than anyone else in the world except for Picasso." "But your covers for James are fairly astute interpretations," Heller protested. "Well," said Gorey, "everybody thought, 'Oh, how sensitive you are to Henry James,' and I thought, 'Oh sure, kids.' If it's because I hate him so much, that's probably true." See Heller, "Edward Gorey's Cover Story," 236.

25 Thomas Garvey, "Edward Gorey and the Glass Closet: A Moral Fable," *Hub Review*, March 19, 2011, http://hubreview.blogspot.com/2011/03/imaginary-frontispiece-with-author-in.html. All Thomas Garvey quotations are taken from this page.

26 Douglass Shand-Tucci, *The Crimson Letter: Harvard, Homosexuality, and the Shaping of American Culture* (New York: St. Martin's Press, 2003), 34.

27 Edward Gorey, letter to Alison Lurie dated "Monday, lunch" (December 1953), 3, Alison Lurie Papers, Division of Rare and Manuscript Collections, Cornell University Library. All quotations from Gorey's correspondence with Lurie are taken from the Lurie Papers at Cornell.

28 Brad Gooch, *City Poet: The Life and Times of Frank O'Hara* (New York: Alfred A. Knopf, 1993), 194.

29 Gorey, letter to Lurie dated "Friday evening" (September 10, 1953), 2.

30 Audre Lorde, *Zami: A New Spelling of My Name* (Berkeley and Toronto: Crossing Press, 1982), 221.

31 Kevin Cook, *Kitty Genovese: The Murder, the Bystanders, the Crime That Changed America* (New York: W. W. Norton, 2014), 47.

32 Frank O'Hara, *Selected Poems*, ed. Mark Ford (New York: Borzoi / Alfred A. Knopf, 2008), 61.

33 Gorey, letter to Lurie dated "Saturday evening" (August 1953), 1.

34 Gorey, letter to Lurie dated "Wednesday noon" (September 30, 1953), 1.

35 Gorey, letter to Lurie dated "Thursday noon" (November 6, 1953), 2.

36 Gorey, letter to Lurie dated "Monday lunch" (December 1953), 1.

37 Ibid., 2.

38 Gorey, letter to Lurie dated "Saturday afternoon, shortly after five" (March 1953), 2.

39 Tobi Tobias, "Balletgorey," in *Ascending Peculiarity*, 14.

40 Haskel Frankel, "Edward Gorey: Professionally Preoccupied with Death," *Herald Tribune*, August 25, 1963, 8.

41 Marilyn Stasio, "A Gorey Story," *Oui*, April 1979, 85.

42 Filstrup, "An Interview with Edward St. John Gorey," 20.

43 Stasio, "A Gorey Story," 130.

44 Gorey, letter to Lurie dated "Saturday afternoon, shortly after five," 2.

45 Alden Mudge, "Edward Gorey: Take a Walk on the Dark Side of the Season," *BookPage*, November 1998, https://bookpage.com/interviews/7968-edward-gorey#.WiA-YEtrz66.

46 The San Remo Café, a bar at 189 Bleecker Street that closed in 1967, was a popular watering hole for writers, painters, musicians, and other bohemian scenemakers. William S. Burroughs drank there. Gore Vidal put the moves on Jack Kerouac there, then took him back to the Chelsea Hotel for a roll in the hay. Leonard Bernstein, Delmore Schwartz, Miles Davis, James Baldwin, Allen Ginsberg, and, as it happens, Frank O'Hara were often seen there. It drew a mixed crowd but struck the actor Judith Malina as having a "gay and intellectual" vibe. See Stephen Petrus and Ronald D. Cohen, *Folk City: New York and the American Folk Music Revival* (New York: Oxford University Press, 2015), 154.

Though Gorey told Lurie he hadn't set foot in the place since he "came to rest" in Manhattan, there's evidence to suggest he went there at least once with Frank O'Hara and Joan Mitchell. Did he ever rub elbows with boldfaced names such as Ginsberg, Burroughs, Baldwin, or Bernstein? Fascinating to imagine.

CHAPTER 6. HOBBIES ODD—BALLET, THE GOTHAM BOOK MART, SILENT FILM, FEUILLADE, 1953

1 Richard Dyer, "The Poison Penman," in *Ascending Peculiarity: Edward Gorey on Edward Gorey*, ed. Karen Wilkin (New York: Harcourt, 2001), 118.

2 Quoted in Andreas Brown, "2012 Hall of Fame Inductee: Edward

Gorey," Society of Illustrators website, https://www.societyillustrators
.org/edward-gorey.

3 Edward Gorey, letter to Alison Lurie, January 7, 1957, 1, Alison Lurie
Papers, Division of Rare and Manuscript Collections, Cornell University
Library. All quotations from Gorey's correspondence with Lurie are
taken from the Lurie Papers at Cornell.

4 Kevin Kelly, "Edward Gorey: An Artist in 'the Nonsense Tradition,'"
Boston Globe, August 16, 1992, B28.

5 Antioch Jensen, "Edward Gorey Glory," *Maine Antique Digest*, March
2011, 32C.

6 Edward Gorey, "Edward Gorey: Proust Questionnaire," in *Ascending Peculiarity*, 187.

7 Haskel Frankel, "Edward Gorey: Professionally Preoccupied with Death,"
Herald Tribune, August 25, 1963, 8.

8 In an article he wrote for the *Wall Street Journal*, Robert Greskovic
shed some light on his friend's cryptic utterance. "The exclamation,
something of a favorite of Gorey's during the nearly three decades I
was acquainted with him, was perhaps a conflation of 'phooey' and
'pshaw' and maybe a dog's sneezing," he writes. "[He] used this expression to dismiss any number of things, particularly something about
himself, especially if it bordered on gushing enthusiasm." See Robert
Greskovic, "Home Sweet Museum," *Wall Street Journal*, June 28, 2002,
https://www.wsj.com/articles/SB1025226629964498880.

9 Stephen Schiff, "Edward Gorey and the Tao of Nonsense," in *Ascending
Peculiarity*, 141.

10 Tobi Tobias, "Balletgorey," in *Ascending Peculiarity*, 15.

11 Dyer, "Poison Penman," 120.

12 Tobias, "Balletgorey," 15.

13 Brad Gooch, *City Poet: The Life and Times of Frank O'Hara* (New York:
Alfred A. Knopf, 1993), 219.

14 Quoted in Gooch, *City Poet*, 219.

15 Quoted in "George Balanchine," New York City Ballet website, http:
//www.nycballet.com/Explore/Our-History/George-Balanchine
.aspx.

16 Kirsten Bodensteiner, "George Balanchine and *Agon*," *ArtsEdge*, http:
//artsedge.kennedy-center.org/students/features/master-work/balanchine
-agon.

17 Dyer, "Poison Penman," 123.

18 Gayle Kassing, *History of Dance: An Interactive Arts Approach* (Champaign, IL: Human Kinetics, 2007), 196.

19 Jane Merrill Filstrup, "An Interview with Edward St. John Gorey at the Gotham Book Mart," in *Ascending Peculiarity*, 82.

20 Tobias, "Balletgorey," 14.

21 Ibid., 18.

22 Tobi Tobias, "On Balanchine's 'Ivesiana,'" *Seeing Things* (Tobias's blog), May 3, 2013, http://www.artsjournal.com/tobias/2013/05/on-balanchines-ivesiana.html.

23 Tobias, "Balletgorey," 18.

24 Robert Dahlin, "Conversations with Writers: Edward Gorey," in *Ascending Peculiarity*, 46.

25 Ibid., 47.

26 Arlene Croce, "The Tiresias Factor," *New Yorker*, May 28, 1990, 53.

27 Allegra Kent, "An Exchange of Letters, Packages, Moonstones and Mailbox Entertainment," *Dance Magazine*, July 2000, 66.

28 Ibid.

29 Allegra Kent, *Once a Dancer . . . : An Autobiography* (New York: St. Martin's Press, 1997), 264.

30 Croce, "The Tiresias Factor," 53.

31 Gorey, "Proust Questionnaire," 185.

32 W. G. Rogers, *Wise Men Fish Here: The Story of Frances Steloff and the Gotham Book Mart* (New York: Harcourt, Brace & World, 1965), 161.

33 Bowie seems to have been a Gorey fan. After his death, in a *Guardian* column collecting readers' accounts of their close encounters with Bowie, a contributor identified only as "BookmanJB" describes meeting Bowie at a party in the Greenwich Village apartment of Jimmy Destri, keyboardist for the New Wave band Blondie. They hit it off, and BookmanJB was frequently summoned to Bowie's New York apartment for wide-ranging conversations over dinner, often literary in nature, always intensely intellectual. "We became good friends," he writes. "He came to my birthday party that year and gave me a signed first edition of an Edward Gorey book, which he, David, inscribed to me. I still have it." See James Walsh and Marta Bausells, "'Wherever One Went with Him, There Was a Seismic Shift': The readers who met David Bowie," *The Guardian*, January 18, 2016, https://amp.theguardian.com/music/2016/jan/18/david-bowie-readers-memories.

34 Lynn Gilbert and Gaylen Moore, *Particular Passions: Talks with Women Who Have Shaped Our Times* (New York: Clarkson Potter, 1981), 9.

35 Brown, "2012 Hall of Fame Inductee."

36 Christine Temin, "The Eccentric World of Edward Gorey," *Boston Globe*, November 22, 1979, A61.

37 Andreas Brown, foreword to *The Black Doll: A Silent Screenplay by Edward Gorey with an Interview by Annie Nocenti*, by Edward Gorey (Petaluma, CA: Pomegranate Communications, 2009), 4.

38 Annie Nocenti, "Writing *The Black Doll*: A Talk with Edward Gorey," in *Ascending Peculiarity*, 200.

39 Ibid.

40 Annie Nocenti, "Writing *The Black Doll*: A Talk with Edward Gorey," in *The Black Doll*, 12.

41 Ibid.

42 Christopher Lydon, "The Connection," in *Ascending Peculiarity*, 216.

43 Dahlin, "Conversations with Writers," 31–32.

44 Edward Gorey, letter to Peter Neumeyer, in *Floating Worlds: The Letters of Edward Gorey & Peter F. Neumeyer*, ed. Peter F. Neumeyer (Petaluma, CA: Pomegranate Communications, 2011), 33.

45 Ibid.

46 Ibid., 230.

47 Ibid., 148.

48 Nocenti, "Writing *The Black Doll*," in *The Black Doll*, 21.

49 Simon Henwood, "Edward Gorey," in *Ascending Peculiarity,* 158.

50 Nocenti, "Writing *The Black Doll*," in *Ascending Peculiarity*, 200.

51 Gorey, letter to Neumeyer, *Floating Worlds*, 138.

52 In light of the many ways in which their aesthetics, philosophical outlooks, and sensibilities overlapped, it seems only fitting that Gorey should end up illustrating some of Beckett's books, as he did when the Gotham Book Mart published *All Strange Away* (1976) and *Beginning to End* (1988). When Beckett received his copy of *All Strange Away* with Gorey's illustrations, he was much pleased, pronouncing it "a beautiful edition." See the *Fathoms from Anywhere: A Samuel Beckett Centenary Exhibition* website, Harry Ransom Center, University of Texas at Austin, http://www.hrc.utexas.edu/exhibitions/web/beckett/career/allstrange /manuscripts.html.

53 Henwood, "Edward Gorey," 158.

54 Nocenti, "Writing *The Black Doll*," in *Ascending Peculiarity*, 198.

55 Ibid., 212.

56 Ibid., 198.

57 Quoted in Dudley Andrew, *Mists of Regret: Culture and Sensibility in Classic French Film* (Princeton, NJ: Princeton University Press, 1995), 33.

58 Irwin Terry, "Fantomas," *Goreyana*, February 12, 2011, http://goreyana .blogspot.com/2011/02/fantomas.html.

59 Ibid.

CHAPTER 7. *ÉPATER LE BOURGEOIS*: 1954–58

1 Edward Gorey, letter to Edmund Wilson, July 28, 1954, Edmund Wilson Papers, Yale Collection of American Literature, Beinecke Rare Book and Manuscript Library, Yale University.

2 Edward Gorey, letter to Alison Lurie dated "Saturday evening" (August 1953), 1, Alison Lurie Papers, Division of Rare and Manuscript Collections, Cornell University Library. All quotations from Gorey's correspondence with Lurie are taken from the Lurie Papers at Cornell.

3 Gorey, letter to Lurie dated "Wednesday evening" (March 10, 1954), 1.

4 Edward Gorey, letter to Peter Neumeyer, in *Floating Worlds: The Letters of Edward Gorey & Peter F. Neumeyer*, ed. Peter F. Neumeyer (Petaluma, CA: Pomegranate Communications, 2011), 147.

5 Edmund Wilson, "The Albums of Edward Gorey," in *The Bit Between My Teeth* (New York: Farrar, Straus and Giroux, 1965), 481.

6 Alexander Theroux, *The Strange Case of Edward Gorey* (Seattle: Fantagraphics Books, 2000), 43–44.

7 Stephen Schiff, "Edward Gorey and the Tao of Nonsense," in *Ascending Peculiarity: Edward Gorey on Edward Gorey*, ed. Karen Wilkin (New York: Harcourt, 2001), 145.

8 Jean Martin, "The Mind's Eye: Writers Who Draw," in *Ascending Peculiarity*, 90.

9 Robert Dahlin, "Conversations with Writers: Edward Gorey," in *Ascending Peculiarity*, 27.

10 Peter L. Stern & Company, Inc., http://www.sternrarebooks.com/pages /books/21714P/edward-gorey/the-listing-attic.

11 Gorey, letter to Lurie dated "Saturday afternoon" (December 1954), 2.

12 Gorey, letter to Lurie dated "Wednesday night" (January 19, 1954), 2.

13 Gorey, letter to Lurie dated "Sunday afternoon" (circa spring 1954), 2.

14 "About the Society," American Society for Psychical Research website, http://www.aspr.com/who.htm.

15 Gorey, letter to Lurie dated "Saturday afternoon" (February 13, 1954), 1.

16 Gorey, letter to Neumeyer, *Floating Worlds*, 160.

17 Ibid.

18 Rick Poynor, "A Dictionary of Surrealism and the Graphic Image," February 15, 2013, *Design Observer*, http://designobserver.com/feature/a-dictionary-of-surrealism-and-the-graphic-image/37685.

19 Gorey, letter to Lurie dated "Wednesday evening" (March 10, 1954), 1.

20 Gorey, letter to Lurie dated "Saturday evening" (February 12, 1955), 2.

21 Gorey, letter to Lurie dated "Sunday afternoon" (May 2, 1955), 1.

22 Gorey, letter to Lurie dated "Saturday afternoon" (August 1955), 2.

23 Jane Merrill Filstrup, "An Interview with Edward St. John Gorey at the Gotham Book Mart," in *Ascending Peculiarity*, 85.

24 Gorey, letter to Lurie dated "2 October 57," 2.

25 Simon Henwood, "Edward Gorey," in *Ascending Peculiarity*, 169.

26 Filstrup, "An Interview with Edward St. John Gorey," 85.

27 Gorey, letter to Neumeyer, *Floating Worlds*, 61.

28 Gorey, letter to Lurie dated "Saturday afternoon" (August 1955), 1.

29 Christopher Lydon, "The Connection," in *Ascending Peculiarity*, 226.

30 Alison Lurie, "Of Curious, Beastly & Doubtful Days: Alison Lurie on Edward 'Ted' Gorey," transcript of remarks delivered at the Edward Gorey House's Seventh Annual Auction and Goreyfest, October 4, 2008, http://www.goreyography.com/north/north.htm.

31 Alison Lurie, "On Edward Gorey (1925–2000)," *New York Review of Books*, May 25, 2000, http://www.nybooks.com/articles/2000/05/25/on-edward-gorey-19252000/.

32 Gorey, letter to Lurie dated "29 December 1957," 1.

33 Kevin Shortsleeve, unpublished phone interview with Maurice Sendak, February 12, 2002, 7. Now a professor of English at Christopher Newport University, Shortsleeve was then a graduate student at the University of Florida. He spoke with Sendak as part of his research for his master's thesis on Gorey and his relationship to children's literature. This and all subsequent excerpts from Professor Shortsleeve's interview are quoted by permission of the Maurice Sendak Foundation.

34 Filstrup, "An Interview with Edward St. John Gorey," 76.

35 Gorey, letter to Lurie dated "29 December 1957," 1.

36 Wilson, "The Albums of Edward Gorey," 483.

37 Lydon, "The Connection," 226.

38 Dahlin, "Conversations with Writers," 43.

39 Quoted in Douglas R. Hofstadter, *Metamagical Themas: Questing for the Essence of Mind and Pattern* (New York: Basic Books, 1985), 213–14.

40 Dahlin, "Conversations with Writers," 42.

41 Wilson, "The Albums of Edward Gorey," 483–84.

42 Gorey, letter to Lurie dated "20 January 1958," 1.

43 Gorey, letter to Lurie dated "6 Feb 58," 2.

44 Ibid.

45 Gorey, letter to Lurie dated "1 April 1958," 1.

CHAPTER 8. "WORKING PERVERSELY TO PLEASE HIMSELF": 1959–63

1 Edward Gorey, letter to Alison Lurie dated "19 September 58," 1. Alison Lurie Papers, Division of Rare and Manuscript Collections, Cornell University Library. All quotations from Gorey's correspondence with Lurie are taken from the Lurie Papers at Cornell.

2 "Children's book thing": Gorey, letter to Lurie dated "Tuesday morning" (1959), 1. "In a state of total frazzle": Gorey, letter to Lurie dated "19 March 1959," 1.

3 Gorey, letter to Lurie dated "3 August 1959," 1.

4 "The Child as a Human," *Newsweek*, September 7, 1959, 80.

5 Steven Heller, "Edward Gorey's Cover Story," in *Ascending Peculiarity: Edward Gorey on Edward Gorey*, ed. Karen Wilkin (New York: Harcourt, 2001), 236–37.

6 Gorey, letter to Lurie dated "Saturday afternoon, March 12th, 1960," 1.

7 Gorey, letter to Lurie dated "3 August 1959," 1.

8 Leonard S. Marcus, introduction to *The Annotated Phantom Tollbooth* (New York: Alfred A. Knopf, 2011), xxxiv.

9 Edmund Wilson, "The Albums of Edward Gorey," in *The Bit Between My Teeth* (New York: Farrar, Straus and Giroux, 1965), 479.

10 Ibid., 479–82.

11 Ibid., 484.

12 Ibid., 482, 479.

13 Gorey, letter to Lurie dated "Saturday afternoon, March 12th" (1960), 2.

14 Gorey, letter to Lurie dated "18 September 1960," 2.

15 Robert Dahlin, "Conversations with Writers: Edward Gorey," in *Ascending Peculiarity*, 30.

16 Quoted in Melvyn Bragg, *The Adventure of English: The Biography of a Language* (New York: Arcade Publishing, 2004), 152.

17 Edward Lear, "Nonsense Alphabet" (1845), Poets.org, https://www.poets.org/poetsorg/poem/nonsense-alphabet.

18 Kevin Shortsleeve, unpublished phone interview with Maurice Sendak, February 12, 2002, 4–5.

19 George R. Bodmer, "The Post-Modern Alphabet: Extending the Limits of the Contemporary Alphabet Book, from Seuss to Gorey," *Children's Literature Association Quarterly* 14, no. 3 (Fall 1989), 116.

20 Ibid., 117.

21 Dahlin, "Conversations with Writers," 45.

22 The predatory gay pedophile—a stock bogeyman in the American unconscious—reappears in another Gorey alphabet book, *The Glorious Nosebleed* (1975). In the vignette for the letter *L*, a bowler-hatted chap flashes a nonplussed Little Lord Fauntleroy. "He exposed himself Lewdly," the caption reads. As a little boy, Gorey was striking, with intense blue eyes and delicate features. Could his professed asexuality—or repressed homosexuality, or whatever it was—never mind his lifelong distaste for the Catholic Church, have been the result of sexual molestation during his brief time in Catholic school?

There isn't a shred of evidence to support this speculation, but given the epidemic of child sex abuse by priests, it's hardly beyond the realm of possibility. According to the *Chicago Tribune*, allegations of child sex abuse against "more than 65 priests" in the city's archdiocese were substantiated by documents released by the Church. (Most of these incidents occurred before 1988. See Manya Brachear Pashman, Christy Gutowski, and Todd Lighty, "Papers Detail Decades of Sex Abuse by Priests," *Chicago Tribune*, January 21, 2014, http://articles.chicagotribune.com/2014-01-21/news/chi-chicago-priest-abuse-20140121_1_abusive-priests-secret-church-documents-john-de-la-salle.)

On the other hand, Larry Osgood is convinced that Ted's life-changingly unpleasant initiation into the mysteries of sex happened in his late teens. Whatever the case, one thing is certain: clergymen are inevitably sinister figures in Goreyland.

23 "Maurice Sendak: On Life, Death, and Children's Lit," interview with Sendak on the NPR program *Fresh Air*, originally broadcast September

20, 2011, and archived at http://www.npr.org/2011/12/29/144077273/maurice-sendak-on-life-death-and-childrens-lit.

24 Shortsleeve, Sendak interview, 8.

25 Ibid., 13.

26 Edward Gorey, letter to Peter Neumeyer, in *Floating Worlds: The Letters of Edward Gorey & Peter F. Neumeyer*, ed. Peter F. Neumeyer (Petaluma, CA: Pomegranate Communications, 2011), 227.

27 Ibid., 228.

28 Shortsleeve, Sendak interview, 5.

29 Ibid., 8.

30 Fascinatingly, two versions of the book's jacket, both finished, together with a couple of illustrations from the manuscript, *did* materialize. They turned up in a collection of materials selected by Andreas Brown from the archives of the Edward Gorey Charitable Trust and lent to the Gorey House for its 2016 exhibit *Artifacts from the Archives*.

The book, whose full title is *The Interesting List of Real/Imaginary} {People/Places/Things*, was almost certainly conceived as a version of the book Gorey proposed to Peter Neumeyer in an October 4, 1968, letter. Tentatively titled *Donald Makes a List*, the idea, Gorey notes, is "obviously inspired by... the Borges one, but then I am always one for filching technical inspiration, as the result never bears any relation whatever to the original." See *Floating Worlds*, 45.

"The Borges one" was the (entirely fictitious) taxonomy cited by Borges in his essay "The Analytical Language of John Wilkins." Supposedly quoted from an ancient Chinese encyclopedia, it organizes the animal kingdom into such whimsical categories as "those that belong to the emperor," "mermaids," "stray dogs," "those that are included in this classification," "those that tremble as if they were mad," "those drawn with a very fine camel's-hair brush," "those that have just broken the flower vase," and "those that at a distance resemble flies." See Jorge Luis Borges, *Selected Non-Fictions*, ed. Eliot Weinberger (New York: Penguin Books, 1999), 231.

The idea had come to Gorey as a result of Neumeyer's having suggested he might like Borges. Never one to pass up a potential literary pleasure, he "rested not," he wrote, "until I had everything in English, which proved so thwarting because they kept reprinting the same things, and then I managed to get a few more things by resorting to French, and finally, despite three years of high school Spanish twenty-five years ago,

the collected works in Spanish and a Spanish dictionary, which await a period of settled calm to be deciphered in," he wrote Neumeyer. "In *Other Inquisitions*, 'The Analytical Language of John Wilkins' contains a list of animals which I am determined to illustrate someday; it may well be the best list of anything ever made..." See *Floating Worlds*, 38.

31 Lisa Solod, "Edward Gorey," in *Ascending Peculiarity*, 108.

32 Shortsleeve, Sendak interview, 5.

33 Ibid., 9.

34 Ibid., 8.

35 Selma G. Lanes, *The Art of Maurice Sendak* (New York: Harry N. Abrams, 1998), 110.

36 Ibid., 51.

37 Shortsleeve, Sendak interview, 13.

38 Patricia Cohen, "Concerns Beyond Just Where the Wild Things Are," *New York Times*, September 9, 2008, http://www.nytimes.com/2008/09/10/arts/design/10sendak.html.

39 Shortsleeve, Sendak interview, 13.

40 Ibid., 8.

41 Ibid., 13–14.

42 Ted Drozdowski, "The Welcome Guest," *Boston Phoenix*, August 21, 1992, 7.

43 Ron Miller, "Edward Gorey, 1925–2000," *Mystery!* website, http://23.21.192.150/mystery/gorey.html.

44 Andrew M. Goldstein, "Children's Book Icon Tomi Ungerer on His Radical, Anti-Authoritarian Career," *Artspace*, January 15, 2015, http://www.artspace.com/magazine/interviews_features/meet_the_artist/tomi-underer-interview52564.

45 Joseph Stanton, *Looking for Edward Gorey* (Honolulu: University of Hawaii Art Gallery, 2011), 83.

46 Quoted in Howard Fulweiler, *Here a Captive Heart Busted: Studies in the Sentimental Journey of Modern Literature* (New York: Fordham University Press, 1993), 65.

47 Ellen Barry, "Dark Streak Marked Life of Prolific Author," *Boston Globe*, April 17, 2000, C5.

48 Karen Wilkin, "Mr. Earbrass Jots Down a Few Visual Notes: The World of Edward Gorey," in *The World of Edward Gorey*, by Clifford Ross and Karen Wilkin (New York: Harry N. Abrams, 1996), 63.

49 Dahlin, "Conversations with Writers," 32.

50 Apparently, *The Hapless Child* came full circle with its origins when
 "some nit made a movie of [it]," according to Gorey in one of his letters
 to Peter Neumeyer. Writing in November of '68, he says he is going to
 see a screening of the film, which he notes was made "ages ago." In a
 later letter, he reports, "The short, semi-animated film the young man
 made from [*The Hapless Child*] had its merits: quite straightforward, bits
 of Beethoven, someone I can't remember, and some of the more sinister
 sawing away at the strings from Vivaldi's Seasons; he did however leave
 out the supernatural element, if that is what it is, entirely." By "super-
 natural element," Gorey must have meant the devilish imp in each scene,
 a revealing remark that supports Stanton's theory that the evil sprites are
 intervening in human affairs, steering the unhappy course of Charlotte
 Sophia's life. See *Floating Worlds*, 117, 127.

51 Jane Merrill Filstrup, "An Interview with Edward St. John Gorey at the
 Gotham Book Mart," in *Ascending Peculiarity*, 77.

52 Gorey, letter to Neumeyer, *Floating Worlds*, 86.

53 Gorey, as we know, was well familiar with the literature of Victorian sen-
 sationalism. The Edward Gorey Personal Library, at San Diego State
 University, includes copies of scholarly studies such as Thomas Boyle's
 *Black Swine in the Sewers of Hampstead: Beneath the Surface of Victorian Sen-
 sationalism* and Louis James's *Fiction for the Working Man, 1830–1850: A
 Study of the Literature Produced for the Working Classes in Early Victorian Ur-
 ban England.*

 Thus it seems likely that the startling similarity between the ending
 of *The Curious Sofa* and a bizarre scene in a "blood," as penny dreadfuls
 were alternatively known, is more than mere coincidence. In his classic
 work of Victorian sociology, *London Labour and the London Poor*, Henry
 Mayhew mentions a costermonger who routinely read bloods aloud to
 his illiterate workmates. One choice passage "took their fancy wonder-
 fully," the man recalled; Mayhew gives us chapter and verse:

> With glowing cheeks, flashing eyes, and palpitating bosom, Venetia
> Trelawney rushed back into the refreshment-room, where she
> threw herself into one of the arm-chairs. . . . But scarcely had she
> thus sunk down upon the flocculent cushion, when a sharp click,
> as of some mechanism giving way, met her ears; and at the same
> instant her wrists were caught in manacles which sprang out of the
> arms of the treacherous chair, while two steel bands started from

the richly carved back and grasped her shoulders. A shriek burst from her lips—she struggled violently, but all to no purpose: for she was a captive—and powerless!

See "The Literature of Costermongers," in Henry Mayhew, *London Labour and the London Poor*, vol.1, *The Street-Folk*, archived at the Tufts Digital Library, https://dl.tufts.edu/catalog/tei/tufts:MS004.002.052.001 .00001/chapter/c4s19.

So uncannily similar is Venetia's fate to Alice's that it's difficult not to believe that Gorey borrowed a few cogwheels, at least, from the penny dreadful in question when he was making up Sir Egbert's diabolical sofa.

54 Dahlin, "Conversations with Writers," 40.
55 Solod, "Edward Gorey," 103.
56 Dahlin, "Conversations with Writers," 39.
57 Ibid.
58 "Alison Lurie, "Of Curious, Beastly & Doubtful Days: Alison Lurie on Edward 'Ted' Gorey," transcript of remarks delivered at the Edward Gorey House's Seventh Annual Auction and Goreyfest, October 4, 2008, http://www.goreyography.com/north/north.htm.
59 Solod, "Edward Gorey," 102–3.
60 Dahlin, "Conversations with Writers," 40.
61 Filstrup, "An Interview with Edward St. John Gorey," 78.
62 Charles Poore, "Books of the Times," *New York Times*, October 28, 1961, 19.
63 Heller, "Edward Gorey's Cover Story," 237.

CHAPTER 9. NURSERY CRIMES—*THE GASHLYCRUMB TINIES* AND OTHER OUTRAGES: 1963

1 Dick Cavett, "The Dick Cavett Show with Edward Gorey," in *Ascending Peculiarity: Edward Gorey on Edward Gorey*, ed. Karen Wilkin (New York: Harcourt, 2001), 62.
2 Edward Gorey, letter to Alison Lurie dated "Friday evening" (September 10, 1953), 1, Alison Lurie Papers, Division of Rare and Manuscript Collections, Cornell University Library. All quotations from Gorey's correspondence with Lurie are taken from the Lurie Papers at Cornell.
3 Ibid., 2.
4 Alison Lurie, "Of Curious, Beastly & Doubtful Days: Alison Lurie on

Edward 'Ted' Gorey," transcript of remarks delivered at the Edward Gorey House's Seventh Annual Auction and Goreyfest, October 4, 2008, http://www.goreyography.com/north/north.htm.

5 Stephen Schiff, "Edward Gorey and the Tao of Nonsense," in *Ascending Peculiarity*, 146.

6 Lillian Gish and her sister, Dorothy, were occasional, much-revered guests at Bill Everson's screenings of their films. The Gishes had been movie stars since movies began, to borrow the headline of Lillian's obituary in the *New York Times*: Dorothy's comic gifts made her shine in silent comedies directed by Griffith protégés, while Lillian captivated audiences with her unlikely combination of porcelain-doll features, feminine vulnerability, and strong-willed resourcefulness in Griffith classics such as *The Birth of a Nation* (1915), *Intolerance* (1916), and *Broken Blossoms* (1919). It's all but certain that Gorey met the Gish sisters, since he "worshipped" Lillian, he told Neumeyer, and wouldn't have missed a screening of her films.

7 Schiff, "Edward Gorey and the Tao of Nonsense," 145.

8 Haskel Frankel, "Edward Gorey: Professionally Preoccupied with Death," *Herald Tribune*, August 25, 1963, 8.

9 Scott Baldauf, "Edward Gorey: Portrait of the Artist in Chilling Color," in *Ascending Peculiarity*, 174.

10 Jane Merrill Filstrup, "An Interview with Edward St. John Gorey at the Gotham Book Mart," in *Ascending Peculiarity*, 76.

11 Robert Cooke Goolrick, "A Gorey Story," *New Times*, March 19, 1976, 58.

12 "Most beautiful": Karen Wilkin, "Edward Gorey: Mildly Unsettling," in *Elegant Enigmas: The Art of Edward Gorey* (Petaluma, CA: Pomegranate Communications, 2009), 26. "Wordless masterwork": Mel Gussow, "Edward Gorey, Artist and Author Who Turned the Macabre into a Career, Dies at 75," *New York Times*, April 17, 2000, http://www.nytimes.com/2000/04/17/arts/edward-gorey-artist-and-author-who-turned-the-macabre-into-a-career-dies-at-75.html?pagewanted=all.

13 Robert Dahlin, "Conversations with Writers: Edward Gorey," in *Ascending Peculiarity*, 48.

14 Edward Gorey, letter to Peter Neumeyer, in *Floating Worlds: The Letters of Edward Gorey & Peter F. Neumeyer*, ed. Peter F. Neumeyer (Petaluma, CA: Pomegranate Communications, 2011), 55.

15 Frankel, "Edward Gorey," 8.

16 Schiff, "Edward Gorey and the Tao of Nonsense," 154.

17 Alexander Theroux, *The Strange Case of Edward Gorey* (Seattle: Fantagraphics Books, 2000), 11–12.

18 Elizabeth Sewell, *The Field of Nonsense* (McLean, IL: Dalkey Archive Press, 2015), 74.

19 Dahlin, "Conversations with Writers," 35–36.

20 Lewis Carroll, *Alice's Adventures in Wonderland & Through the Looking-Glass* (New York: Bantam Dell, 2006), 72.

21 Celia Catlett Anderson and Marilyn Fain, *Nonsense Literature for Children: Aesop to Seuss* (Hamden, CT: Library Professional Publications, 1989), 171–72.

22 Edward Leo Gorey, letter to Corinna Mura, July 31, 1962, 2.

23 Anna Kisselgoff, "The City Ballet Fan Extraordinaire," in *Ascending Peculiarity*, 9.

CHAPTER 10. WORSHIPPING IN BALANCHINE'S TEMPLE: 1964–67

1 Toni Bentley, e-mail message to the author, November 7, 2012.

2 Peter Anastos, e-mail message to the author, August 16, 2012.

3 Ibid.

4 Anna Kisselgoff, "The City Ballet Fan Extraordinaire," in *Ascending Peculiarity: Edward Gorey on Edward Gorey*, ed. Karen Wilkin (New York: Harcourt, 2001), 7.

5 Tobi Tobias, "Balletgorey," in *Ascending Peculiarity*, 16.

6 Edward Gorey, "The Doubtful Interview," in *Gorey Posters* (New York: Harry N. Abrams, 1979), 6.

7 Edmund White, "The Man Who Understood Balanchine," *New York Times*, November 8, 1998, https://www.nytimes.com/books/98/11/08/bookend/bookend.html.

8 Tobias, "Balletgorey," 15–16.

9 Quoted in Alex Behr, "On *The Dream World of Dion McGregor*," *Tin House*, Summer 2011, archived on Behr's *Writing in the Ether* blog, https://alexbehr.wordpress.com/essay-on-the-dream-world-of-dion-mcgregor/.

10 Edward Gorey, letter to Peter Neumeyer, in *Floating Worlds: The Letters of Edward Gorey & Peter F. Neumeyer*, ed. Peter F. Neumeyer (Petaluma, CA: Pomegranate Communications, 2011), 55.

11 Robert Dahlin, "Conversations with Writers: Edward Gorey," in *Ascending Peculiarity*, 42.

12 Alexander Theroux, *The Strange Case of Edward Gorey* (Seattle: Fantagraphics Books, 2000), 43.

13 Kisselgoff, "The City Ballet Fan," 6.

14 Entry for "opera hat (in British)," online version of *Collins English Dictionary*, http://www.collinsdictionary.com/dictionary/english/opera-hat #opera-hat_1.

15 Entry for "velleity," *Dictionary.com* website, http://www.dictionary.com/ browse/velleity.

16 Although *The Sinking Spell* says "copyright 1964 by Edward Gorey" on its copyright page, it wasn't published until 1965, according to Gorey bibliographer Henry Toledano. See Toledano, *Goreyography* (San Francisco: Word Play Publications, 1996), 32.

17 Charles Fort, *The Book of the Damned: The Collected Works of Charles Fort* (New York: Jeremy P. Tarcher / Penguin, 2008), 19.

18 Gorey, letter to Neumeyer, *Floating Worlds*, 74.

19 Ibid.

20 Edward Gorey, *SVA CE Bulletin*, Fall 1967, School of Visual Arts Archives, New York.

21 Edward Gorey, illustration-class archived in "Freelancing," *G Is for Gorey—C Is for Chicago*, http://www.lib.luc.edu/specialcollections /exhibits/show/gorey/freelancing.

22 Richard Dyer, "The Poison Penman," in *Ascending Peculiarity*, 124.

23 Jane Merrill Filstrup, "An Interview with Edward St. John Gorey at the Gotham Book Mart," in *Ascending Peculiarity*, 76.

24 Gorey, letter to Neumeyer, *Floating Worlds*, 177.

25 Cynthia Rose, "The Gorey Details," *Harpers & Queen*, November 1978, 308.

26 Peter Neumeyer, letter to Edward Gorey, *Floating Worlds*, 29.

27 Peter Schwenger, "The Dream Narratives of Debris," *SubStance* 32, no. 1 (2003), 80.

28 Ibid.

29 Ibid., 79.

30 Selma G. Lanes, *Through the Looking Glass: Further Adventures and Misadventures in the Realm of Children's Literature* (Boston: David R. Godine, 2004), 111.

31 Quoted in Alexander Doty, *Flaming Classics: Queering the Film Canon* (New York: Routledge, 2000), 119.

32 Theroux, *Strange Case*, 53.

33 Ibid., 29.

34 Tobias, "Balletgorey," 18.

35 Peter Stoneley, *A Queer History of the Ballet* (New York: Routledge, 2007), 127.

36 Ibid., 90.

37 Clifford Ross, "Interview with Edward Gorey," in *The World of Edward Gorey*, by Clifford Ross and Karen Wilkin (New York: Harry N. Abrams, 1996), 33.

38 D. T. Siebert, *Mortality's Muse: The Fine Art of Dying* (Newark: University of Delaware Press), 39.

39 "Warhol & Collecting Books," Andreas Brown interviewed by Kathryn Price, curator of collections at Williams College Museum of Art, August 6, 2015, archived on the Williams College YouTube channel, https://www.youtube.com/watch?v=JL6TBUl8MGM.

40 Ibid.

41 Thomas Curwen, "Light from a Dark Star: Before the Current Rise of Graphic Novels, There Was Edward Gorey, Whose Tales and Drawings Still Baffle—and Attract—New Fans," *Los Angeles Times*, July 18, 2004, http://articles.latimes.com/2004/jul/18/entertainment/ca-curwen18.

42 Theroux, *Strange Case*, 2.

43 Gotham Book Mart and Gallery leaflet announcing "annual Edward Gorey Holiday Exhibit," 2004, private collection of the author.

44 Carol Stevens, "An American Original," in *Ascending Peculiarity*, 131.

45 Edward Gorey interviewed by Marion Vuilleumier for the Cape Cod public-access program *Books and the World*, 1982. Audiotape recording and transcript provided to the author by Christopher Seufert.

CHAPTER 11. MAIL BONDING—COLLABORATIONS: 1967–72

1 Elizabeth Janeway, review of *Amphigorey*, by Edward Gorey, *New York Times Book Review*, October 29, 1972, 6.

2 Edward Gorey, "The Real Zoo Story," review of *Animal Gardens*, by Emily Hahn, *Chicago Tribune*, November 5, 1967, 17.

3 Ibid., 18.

4 Jane Merrill Filstrup, "An Interview with Edward St. John Gorey at the Gotham Book Mart," in *Ascending Peculiarity: Edward Gorey on Edward Gorey*, ed. Karen Wilkin (New York: Harcourt, 2001), 26, 28.

5 Victoria Chess and Edward Gorey, *Fletcher and Zenobia* (New York: New York Review Children's Collection, 2016), n.p.

6 Filstrup, "An Interview with Edward St. John Gorey," 28.

7 *Floating Worlds: The Letters of Edward Gorey & Peter F. Neumeyer*, ed. Peter
 F. Neumeyer (Petaluma, CA: Pomegranate Communications, 2011), 9.

8 Ibid.

9 Ibid., 11.

10 Quoted ibid., 7.

11 *Floating Worlds,* 8.

12 Ibid., 134.

13 Ibid., 147.

14 Ibid., 210

15 Ibid., 130.

16 Ibid., 16.

17 Ibid., 186.

18 Ibid., 84.

19 Ibid., 134.

20 Ibid., 158, 124.

21 Ibid., 39.

22 Ibid., 39, 42.

23 Ibid., 39.

24 Ibid., 201.

25 Ibid., 18.

26 Ibid., 73–74.

27 Ibid., 60.

28 Ibid., 187.

29 Ibid., 37.

30 Ibid., 105, 111.

31 Ibid., 115, 151.

32 Peter Neumeyer interviewed by Susan Resnik for San Diego State Uni-
 versity Oral Histories, April 12–14, 2010, 133, https://library.sdsu.edu/
 sites/default/files/NeumeyerTranscript.pdf.

33 See William S. Burroughs and Brion Gysin, *The Third Mind* (New York:
 Grove Press, 1982).

34 *Floating Worlds*, 85.

35 Ibid.

36 Ibid., 7.

37 Ibid., 20.

38 Peter F. Neumeyer, e-mail message to the author, March 4, 2012.

39 *Floating Worlds*, 8.

40 Peter F. Neumeyer, e-mail message to the author, March 23, 2012.

41 Kevin Shortsleeve, "Interview with Peter Neumeyer on Edward Gorey," February 5–11, 2002, 1. Unpublished manuscript provided to the author by e-mail.

42 Neumeyer, Resnik interview, 126.

43 Ibid., 128–30.

44 *Floating Worlds*, 19.

45 Ibid., 16–17.

46 Robert Dahlin, "Conversations with Writers: Edward Gorey," in *Ascending Peculiarity*, 44.

47 Karen Wilkin, "Mr. Earbrass Jots Down a Few Visual Notes: The World of Edward Gorey," in *The World of Edward Gorey*, by Clifford Ross and Karen Wilkin (New York: Harry N. Abrams, 1996), 51.

48 Joseph Stanton, *Looking for Edward Gorey* (Honolulu: University of Hawaii Art Gallery, 2011), 90.

49 Stephen Schiff, "Edward Gorey and the Tao of Nonsense," in *Ascending Peculiarity*, 147.

50 Ibid., 147–48.

51 Simon Henwood, "Edward Gorey," in *Ascending Peculiarity*, 160.

52 Clifford Ross, "Interview with Edward Gorey," in *The World of Edward Gorey*, 11.

53 Dick Cavett, "The Dick Cavett Show with Edward Gorey," in *Ascending Peculiarity*, 59.

54 Quoted in Edward Butscher, *Sylvia Plath: Method and Madness* (Tucson, AZ: Schaffner Press, 2003), 243.

55 Selma G. Lanes, *Through the Looking Glass: Further Adventures and Misadventures in the Realm of Children's Literature* (Boston: David R. Godine, 2004), 110.

56 Karen Wilkin, *Elegant Enigmas: The Art of Edward Gorey* (Petaluma, CA: Pomegranate Communications, 2009), 80.

57 Dahlin, "Conversations with Writers," 42.

58 Lanes, *Through the Looking Glass*, 111.

59 Irwin Terry, "Three Books from Fantod Press III," *Goreyana*, April 10, 2009, http://goreyana.blogspot.com/2009/04/three-books-from-fantod-press-iii.html.

60 Richard Dyer, "The Poison Penman," in *Ascending Peculiarity*, 124.

61 Dahlin, "Conversations with Writers," 40.

62 Amy Benfer, "Edward Gorey: No One Sheds Light on Darkness from

Quite the Same Perspective as This Cape Cod Specialist in Morbid, Fine-Lined Jocularity," *Salon*, February 15, 2000, http://www.salon .com/2000/02/15/gorey.

63 Henwood, "Edward Gorey," 164.

64 Dahlin, "Conversations with Writers," 40.

65 Filstrup, "An Interview with Edward St. John Gorey," 25.

66 Dahlin, "Conversations with Writers," 41.

67 Edmund White, *City Boy: My Life in New York During the 1960s and '70s* (New York: Bloomsbury, 2009), 210.

68 "The black and Latino culture all around him in New York": This is as good a time as any to acknowledge the whiteness of Gorey's art, a reflection of the whiteness of his world. Raised in a segregated America, in a city divided by what was (and still is) a de facto apartheid regime, growing up Irish Catholic on one side and country-club WASP on the other, sustained by a cultural diet that consisted almost entirely of art, literature, movies, and music produced by whites for whites, Gorey lived in a world without a single black face (unless I missed it). He seems to have had little if any interaction with people of color, moving in all-white circles: at Harvard, among the gay literati; in New York, among the Balanchinian cultists at the State Theater and the cinephiles at Everson's screenings; on Cape Cod, among his Yarmouth Port coterie.

Like all of us, Gorey was a product of a time, a place, and his parents. Speaking of whom, his mother was too bourgeois to be crudely racist, but she wasn't exactly progressive in her attitude toward persons of a dusky hue, either. An offhanded remark in one of her letters to Ted at Harvard speaks volumes: "Have you ever noticed the ads in *Ebony* magazine? I was hysterical over them—Ed had a copy out here and I was looking at it—they have all the same ads that the other magazines do, only they put in colored people. The colored elevator operator in Ed's building asked him if when he was through with Ee-bōny he would let her have it." (See Helen Garvey Gorey, letter to Edward Gorey, n.d., circa fall 1949), Edward Gorey Collection, Harry Ransom Center, University of Texas at Austin.) Helen's mockery of a looking-glass reality where "colored people" mimic the white world—to her a kind of reverse minstrelsy that is clownishly funny on its face—drips with amused condescension.

How much of this half conscious, lightheartedly "benign" racism rubbed off on Gorey we don't know. Ken Morton told me in an e-mail

dated November 21, 2017, that he "never witnessed [Ted] speaking about race at all, in any context, positively, negatively, or neutrally. I think his views on race boil[ed] down to a kind of lack of awareness or obliviousness." Of course that blind spot, equal parts obliviousness and insensitivity, is a distinguishing characteristic of white privilege, as it's come to be called. Seen in a contemporary light, at a moment when Trumpism has emboldened white supremacists and activist voices like Black Lives Matter are demanding a racial justice long deferred, the whiteness of Gorey's worldview—a truism evinced not only by his art but also by his literary and musical tastes—is striking.

69 D. Keith Mano, "Edward Gorey Inhabits an Odd World of Tiny Draw-ings, Fussy Cats, and 'Doomed Enterprises,'" *People* 10, no. 1 (July 3, 1978), 72.

70 Edmund White, "*The Story of Harold* by Terry Andrews," in "My Private Passion," *The Guardian*, February 17, 2001, http://www.theguardian.com /books/2001/feb/17/classics.features.

71 Terry Andrews, *The Story of Harold* (New York: Equinox Books / Avon, 1975), 254.

72 M. G. Lord, e-mail message to the author, May 3, 2018. I'm entirely in Lord's debt for her phallus-spotting abilities; somehow, Gorey's in-joke snuck right by me.

73 Carol Stevens, "An American Original," in *Ascending Peculiarity*, 134.

74 Robert Cooke Goolrick, "A Gorey Story," *New Times*, March 19, 1976, 54.

75 Philip Glassborow, "A Life in Full: All the Gorey Details," *The Independent on Sunday*, March 23, 2003, 26–32.

76 "1972—A Selection of Noteworthy Titles," *New York Times*, December 3, 1972, 60.

77 "Paper Back Talk," *New York Times*, October 12, 1975, 301.

78 Andreas Brown interviewed on "Afternoon Play: The Gorey Details," BBC Radio 4 FM, March 27, 2003, http://genome.ch.bbc.co.uk/ 3dac4cad956e4d2c9572f345ad064637.

CHAPTER 12. *DRACULA*: 1973–78

1 John Wulp, "The Nantucket Stage Company," chap. 13 in *My Life*, http://media.wix.com/ugd/29b477_d0aab61ced6f4a9db8c1ebd89125a360.pdf.

2 Mel Gussow, "Gorey Goes Batty," *New York Times Magazine*, October 16, 1977, 78.

3 Stephen Fife, *Best Revenge: How the Theatre Saved My Life and Has Been Killing Me Ever Since* (Seattle: Cune Press, 2004), 184.

4 Mel Gussow, "Broadway Again Blooms on Nantucket," *New York Times*, July 9, 1973, 41.

5 Edward Gorey [Wardore Edgy], Movies, *SoHo Weekly News*, May 30, 1974, 24.

6 Edward Gorey [Wardore Edgy], Movies, *SoHo Weekly News*, March 28, 1974, 16.

7 Edward Gorey [Wardore Edgy], Movies, *SoHo Weekly News*, March 14, 1974, 16.

8 Ibid.

9 Gorey [Wardore Edgy], Movies, *SoHo Weekly News*, March 28, 1974, 16.

10 Gorey [Wardore Edgy], Movies, *SoHo Weekly News*, May 30, 1974, 24.

11 Gorey [Wardore Edgy], Movies, *SoHo Weekly News*, March 14, 1974, 16.

12 Quoted in Clifford Ross and Karen Wilkin, *The World of Edward Gorey* (New York: Harry N. Abrams, 1996), 181.

13 Glen Emil, "The Envelope Art of Edward Gorey: Gorey's Mailed Art from 1948 to 1974," *Goreyography*, September 9, 2012, https://www.goreyography.com/west/articles/egh2012.html.

14 Susan Sheehan, "Envelope Art," *New Yorker*, July 8, 2002, 60.

15 Ibid.

16 Emil, "Envelope Art of Edward Gorey."

17 Color photocopies of twenty-six of the fifty envelopes Gorey mailed to Fitzharris were included in a 2012 exhibition at the Edward Gorey House, *The Envelope Art of Edward Gorey: Gorey's Mailed Art from 1948 to 1974*. Fitzharris's name was replaced with an anagrammatic pseudonym, Hart Sifmoritz, and his address was altered, presumably to protect his privacy, though why that should have been required after nearly forty years is a mystery.

18 Ross and Wilkin, *The World of Edward Gorey*, 181.

19 Raymond Chandler, *The Raymond Chandler Papers: Selected Letters and Nonfiction 1909–1959*, ed. Tom Hiney and Frank MacShane (New York: Grove Press, 2000), 142–43.

20 Gorey's passport records his arrival in Scotland on August 28, 1975, at Glasgow's Prestwick airport and his departure from the UK via Heathrow, in London, on September 23, 1975.

21 Richard Dyer, "The Poison Penman," in *Ascending Peculiarity: Edward Gorey on Edward Gorey*, ed. Karen Wilkin (New York: Harcourt, 2001), 119.

22 Skee Morton, letter to the author, August 21, 2012.

23 Stephen Schiff, "Edward Gorey and the Tao of Nonsense," *New Yorker*, November 9, 1992, 89.

24 Paul Gardner, "A Pain in the Neck," *New York*, September 19, 1977, 68.

25 Robert Dahlin, "Conversations with Writers: Edward Gorey," in *Ascending Peculiarity*, 26.

26 Don McDonagh, "Gorey Sets Spice Eglevsky 'Swan Lake,'" *New York Times*, November 3, 1975, 49.

27 Arlene Croce, "Dissidents," *New Yorker*, May 2, 1977, 136.

28 The collaborative nature of the theater, like that of the movies, sometimes makes it difficult to assign credit—or blame—to specific individuals. Officially, *Dracula*'s scenery and costumes were by Gorey. Yet Dennis Rosa claimed, in an interview for this book, that the idea of adding a touch of blood red to each scene was his, not Gorey's. "I had already decided that not only was it going to be black and white," he told me, but also that "I wanted to add some color to it, and I thought it would be fun to add red—like, blood red." John Wulp confirmed in my interview with him that the idea was indeed Rosa's. That said, Gorey's long-standing technique of adding a single brightly colored element to an otherwise monochromatic illustration, a gimmick he'd been using since the days of his Anchor covers, in the early 1950s, suggests that he was readily receptive to the idea, at the very least, and came up with clever ways of incorporating it into each scene.

29 Carol Stevens, "An American Original," in *Ascending Peculiarity*, 132.

30 Gussow, "Gorey Goes Batty," 78.

31 Ibid., 74.

32 David Ansen, "Dracula Lives!," *Newsweek*, October 31, 1977, 75.

33 T. E. Kalem, "Kinky Count," *Time*, October 31, 1977, 93.

34 "Faggot nonsense": Quoted in David Bahr, "Bright Light of Broadway," *The Advocate*, January 22, 2002, 67. "Homosexuals in the theater!": Quoted in Harris M. Miller II, "Proper Priorities," *Los Angeles Times*, April 14, 1985, http://articles.latimes.com/1985-04-14/entertainment/ca-8612_1_critic-theater-remarks.

35 Bahr, "Bright Light of Broadway," 67.

36 John Simon, "Dingbat," *New York*, November 7, 1977, 75.

37 Ibid.

38 Dick Cavett, "The Dick Cavett Show with Edward Gorey," in *Ascending Peculiarity*, 63–64.

39 Ron Miller, "Edward Gorey, 1925–2000," *Mystery!* website, http://23
 .21.192.150/mystery/gorey.html.

40 Edward Gorey interviewed by Dick Cooke on *The Dick Cooke Show*,
 a Cape Cod–based weekly public-access cable TV program, circa
 1996. DVD copy of videotape provided to the author by Christopher
 Seufert.

41 "'Dracula' to Close Jan. 6," *New York Times*, December 13, 1979, C17.

42 Carol Stevens, "An American Original," *Print*, January–February 1988,
 61, 63.

43 D. Keith Mano, "Edward Gorey Inhabits an Odd World of Tiny Draw-
 ings, Fussy Cats, and 'Doomed Enterprises,'" *People* 10, no. 1 (July 3,
 1978), 70.

44 Cavett, "The Dick Cavett Show," 55.

45 Bill Cunningham, "Portrait of the Artist as a Furry Creature," *New York
 Times*, January 11, 1978, 13.

46 Quoted in Irwin Terry, "The Fur Designs of Edward Gorey,"
 Goreyana, October 14, 2012, http://goreyana.blogspot.com/2012/10
 /the-fur-designs-of-edward-gorey.html.

47 Angela Taylor, "From Alixandre: Big Names, Sleek Shapes," *New York
 Times*, May 20, 1979, 56.

48 Georgia Dullea, "Gorey Turns His Talent to Window Shudders," *New
 York Times*, June 3, 1978, Style section, 16.

49 Faith Elliott, e-mail message to the author, October 23, 2012.

50 Robert Cooke Goolrick, "A Gorey Story," *New Times*, March 19, 1976,
 54, 56.

51 Joan Kron, "Going Batty," *New York Times*, January 19, 1978, C3.

52 Mel Gussow, "'Gorey Stories' Are Exquisite Playlets," *New York Times*,
 December 15, 1977, C19.

53 Jane Merrill Filstrup, "An Interview with Edward St. John Gorey at the
 Gotham Book Mart," in *Ascending Peculiarity*, 33, 34, 36.

54 John Corry, "'Gorey Stories' Could Drive an Author and a Director
 Batty," *New York Times*, June 23, 1978, C2.

55 Quoted in Dan Dietz, *The Complete Book of 1970s Broadway Musicals*
 (Lanham, MD: Rowman & Littlefield, 2015), 414.

56 Carol Stevens, "An American Original," in *Ascending Peculiarity*, 134.

57 Dyer, "Poison Penman," 122.

58 Ibid.

59 Skee Morton, e-mail message to the author, March 30, 2014.

60 Stephen Schiff, "Edward Gorey and the Tao of Nonsense," in *Ascending Peculiarity*, 151.

61 Lisa Solod, "Edward Gorey," in *Ascending Peculiarity*, 95.

62 Ibid., 96.

63 Hoke Norris, "Chicago: Critic at Large," *Chicago Sun-Times*, Book Week section, September 19, 1965, 6.

CHAPTER 13. *MYSTERY!*: 1979–85

1 Derek Lamb, "The MYSTERY! of Edward Gorey," *ANIMATION-World*, July 1, 2000, http://www.awn.com/animationworld/mystery-edward-gorey.

2 Edward Gorey interviewed by Christopher Seufert for *The Last Days of Edward Gorey: A Documentary by Christopher Seufert*, August 1999. Copy of unedited video footage provided to the author by Seufert.

3 Lamb, "The MYSTERY! of Edward Gorey."

4 Gorey, Seufert interview.

5 Ron Miller, *Mystery!: A Celebration Paperback* (San Francisco: KQED Books, 1996), 6.

6 Sadly, few of Lamb's animations of Gorey's art survive in the latest redesign of the *Mystery!* title sequence. The opening now consists of a digital animation of a stylized book, its pages riffled by an invisible hand. A few snippets of the original Lamb-Gorey animations flash by at blink-and-you'll-miss-them speed; the only Gorey element that spends more than a split second on-screen is part of the *Mystery!* logo—a grinning Gorey skull on a headstone, flashing a wink at the viewer. Happily, the original animations survive, albeit in blurry form, on YouTube.

7 "Fantods: Viewer Complaints, 1984," file folder at WGBH media archives, WGBH, Boston.

8 Alastair Macaulay, "Ballet in London: NYCB and the Royal Go Toe to Toe," *New York Times*, March 17, 2008, http://artsbeat.blogs.nytimes.com/2008/03/17/ballet-in-london-nycb-and-the-royal-go-toe-to-toe/.

9 Amanda Vaill, *Somewhere: The Life of Jerome Robbins* (New York: Broadway Books, 2006), 269.

10 "Eliot's 'Cats' Enjoys Spurt of New Interest," *New York Times*, October 8, 1982, http://www.nytimes.com/1982/10/08/theater/eliot-s-cats-enjoys-spurt-of-new-interest.html.

11 Edward Gorey interviewed by Marion Vuilleumier for the Cape Cod public-access program *Books and the World*, 1982. Audiotape recording and transcript provided to the author by Christopher Seufert.

12 T. S. Eliot, *Old Possum's Book of Practical Cats* (New York: Harcourt Brace Jovanovich, 1982), 1.

13 Karen Wilkin, "Edward Gorey: An Introduction," in *Ascending Peculiarity: Edward Gorey on Edward Gorey*, ed. Karen Wilkin (New York: Harcourt, 2001), xx.

14 Paul Gardner, "A Pain in the Neck," *New York*, September 19, 1977, 68.

15 John Wulp, "John Wulp by John Wulp," in *John Wulp* (New Caanan, CT: CommonPlace Publishing, 2003), 76.

16 John Wulp, "NYU," in *My Life*, 1, http://media.wix.com/ugd/ 29b477_cd30bbdb68b14c98a6b71ce685c9ae04.pdf.

17 Robert Croan, "Updated 'Mikado' Is Found Wanting," *Pittsburgh Post-Gazette*, April 20, 1983, 15.

18 Calvin Tomkins, *Duchamp: A Biography* (New York: Henry Holt, 1996), 451.

19 Jennifer Dunning, "Performance Pays Tribute to Balanchine," *New York Times,* May 1, 1983, http://www.nytimes.com/1983/05/01/nyregion/ performance-pays-tribute-to-balanchine.html.

20 Clifford Ross, "Interview with Edward Gorey," in *The World of Edward Gorey*, by Clifford Ross and Karen Wilkin (New York: Harry N. Abrams, 1996), 33.

21 Alexander Theroux, *The Strange Case of Edward Gorey* (Seattle: Fantagraphics Books, 2000), 31–32.

22 Dick Cavett, "The Dick Cavett Show with Edward Gorey," in *Ascending Peculiarity*, 61–62.

23 Edward Gorey interviewed by Dick Cooke on *The Dick Cooke Show*, a Cape Cod–based weekly public-access cable TV program, circa 1996. DVD copy of videotape provided to the author by Christopher Seufert.

24 Robert Dahlin, "Conversations with Writers: Edward Gorey," in *Ascending Peculiarity*, 43–44.

25 Christopher Lydon, "The Connection," in *Ascending Peculiarity*, 225.

CHAPTER 14. STRAWBERRY LANE FOREVER: CAPE COD, 1985–2000

1 Tobi Tobias, "Balletgorey," in *Ascending Peculiarity: Edward Gorey on Edward Gorey*, ed. Karen Wilkin (New York: Harcourt, 2001), 16.

2 Stephen Schiff, "Edward Gorey and the Tao of Nonsense," in *Ascending Peculiarity*, 139.

3 Andreas Brown, "2012 Hall of Fame Inductee: Edward Gorey," Society of Illustrators website, https://www.societyillustrators.org/edward -gorey.

4 Kevin McDermott, "The House," in *Elephant House: or, The Home of Edward Gorey*, by Kevin McDermott (Petaluma, CA: Pomegranate Communications, 2003), n.p.

5 Elizabeth Morton, "Before It Was the Gorey House," *Yarmouth Register*, June 28, 2012, 9.

6 David Streitfeld, "The Gorey Details," in *Ascending Peculiarity*, 176.

7 Alexander Theroux, *The Strange Case of Edward Gorey* (Seattle: Fantagraphics Books, 2000), 51.

8 Mel Gussow, "At Home with Edward Gorey: A Little Blood Goes a Long Way," *New York Times*, April 21, 1994, C1.

9 Mel Gussow, "In 'Tinned Lettuce,' a New Body of Gorey Tales," *New York Times*, May 1, 1985, http://www.nytimes.com/1985/05/01 /theater/in-tinned-lettuce-a-new-body-of-gorey-tales.html?ref=edward _gorey.

10 Edward Gorey interviewed by Marian Etoile Watson for the New York–based WNEW-TV/Channel 5 program *10 O'Clock Weekend News*, 1985, archived on Mark Robinson's YouTube channel at https: //www.youtube.com/watch?v=_Rrzaif-DT4.

11 Gussow, "In 'Tinned Lettuce.' "

12 Ibid.

13 Ibid.

14 Jane MacDonald interviewed by Christopher Seufert for *The Last Days of Edward Gorey: A Documentary by Christopher Seufert*, n.d. Unedited transcript provided to the author by Seufert.

15 McDermott, preface to *Elephant House*, n.p.

16 Irwin Terry, e-mail message to the author, September 29, 2015.

17 Gussow, "In 'Tinned Lettuce.' "

18 Ron Miller, *Mystery!: A Celebration Paperback* (San Francisco: KQED Books, 1996), 7.

19 This quotation, transcribed from an article about Gorey, seems to have come unstuck from its citation. To date, an exhaustive search hasn't recovered the source of the passage quoted. Nonetheless, the substance of it—that bemused audience members sometimes left before a perfor-

mance was over and that Gorey's hearty enjoyment of his entertainments was undiminished by such defections—is corroborated by Edward's own remarks in published profiles and by comments from the Gorey players in my interviews with them.

20 Edward Gorey interviewed by Dick Cooke on *The Dick Cooke Show*, a Cape Cod–based weekly public-access cable TV program, circa 1996. DVD copy of videotape provided to the author by Christopher Seufert.

21 Ibid.

22 Clifford Ross and Karen Wilkin, *The World of Edward Gorey* (New York: Harry N. Abrams, 1996), 184.

23 Claire Golding, "Edward Gorey's Work Is No Day at the Beach," *Cape Cod Antiques & Arts*, August 1993, 21.

24 Jack Braginton-Smith interviewed by Christopher Seufert for *The Last Days of Edward Gorey: A Documentary by Christopher Seufert,* circa Summer 2002. Unedited audiotape provided to the author by Seufert.

25 Ibid.

26 Walpole, an eighteenth-century aesthete, wrote the first gothic novel, *The Castle of Otranto* (1764); it was inspired by his vision, on waking from a dream, of a giant armored fist on the staircase. Very Gorey. Also very Gorey was Walpole's manor, a fantasy castle that sparked the Gothic revival of the 1800s. From the outside, it's a Gothic wedding cake, all white stucco battlements and pinnacles; on the inside, it's a "rococo gothick" fantasia, with ornate vaulted ceilings and serpentine passageways inspired by Gothic cathedrals and medieval tombs.

27 Braginton-Smith, Seufert interview.

28 Alexander Theroux, *The Strange Case of Edward Gorey*, rev. ed. (Seattle: Fantagraphics Books, 2011), 117.

29 John Madera, "*Bookforum* talks to Alexander Theroux," *Bookforum*, December 23, 2011, http://www.bookforum.com/interview/8796.

30 Theroux, *Strange Case*, rev. ed., 20.

31 Ibid., 31–32.

32 Theroux's most glaring error is his assertion, on page 166 of the revised edition, that Gorey's ashes "were strewn over the waters at Barnstable Harbor on a day overcast and gray and hammering with rain"; in fact, it was a radiantly sunny day without a cloud in the sky. There are others: on page 135 of the same edition, Theroux cites "When in doubt, twirl" as "one of [Gorey's] more well-known and often-repeated quotes"; in

fact, that aphorism belongs to the choreographer Ted Shawn, as Gorey himself noted in the original quotation.

33 Discussing *The Strange Case*, an interviewer asked Theroux, "What kind of source material did you have?... Did you keep notes over the years?" He replied that the source material for firsthand quotes was "nothing but talking to him and my own reveries," which suggests that he relied not on tape-recorded interviews but on his recollections—an iffy proposition for anyone but a mnemonist. See Tom Spurgeon, "Alexander Theroux on Edward Gorey," *The Comics Reporter*, February 22, 2011, http://www.comicsreporter.com/index.php/index/cr_interview _alexander_theroux_on_edward_gorey/.

34 Theroux, *Strange Case*, rev. ed., 28.

35 Ibid., 32–33.

36 Ibid., 43.

37 Ibid., 97.

38 Ibid., 103.

39 Ibid., 118, 123.

40 Susan Sontag, "Notes on 'Camp,'" in *A Susan Sontag Reader* (New York: Vintage Books, 1983), 106.

41 Golding, "Edward Gorey's Work Is No Day at the Beach," 21.

42 Edward Gorey interviewed by Christopher Seufert for *The Last Days of Edward Gorey: A Documentary by Christopher Seufert*. Copy of unedited audiotape provided to the author by Seufert.

43 Johnny Ryan, e-mail message to the author, April 25, 2014.

44 Ibid.

45 Ibid.

46 Ibid.

47 Simon Henwood, "Edward Gorey," in *Ascending Peculiarity*, 161.

48 Gussow, "At Home with Edward Gorey," C4.

49 Craig Little, "Edward Gorey Finds Designs in Fantasy," *Cape Cod Times*, December 24, 1979, 15.

50 Gussow, "At Home with Edward Gorey," C4.

51 McDermott, "The Television Room," in *Elephant House*, n.p.

52 Golding, "Edward Gorey's Work Is No Day at the Beach," 21.

53 Gorey, Seufert interview.

54 Schiff, "Edward Gorey and the Tao of Nonsense," 138.

55 Edward Gorey interviewed by Martha Teichner for Out of the Inkwell segment, *CBS News Sunday Morning*, April 20, 1997. Digital copy of

VHS tape provided to the author by Christopher Seufert.

56 Leo Seligsohn, "A Merrily Sinister Life of His Own Design," *Providence Sunday Journal*, June 25, 1978, E2.

57 Ken Morton interviewed by Mindy Todd on *The Point* for the Cape Cod–based NPR affiliate WCAI, February 27, 2014, http://capeandislands.org/post/edward-gorey-livesdocumentary#stream/0.

58 Schiff, "Edward Gorey and the Tao of Nonsense," 138.

59 Golding, "Edward Gorey's Work Is No Day at the Beach," 21.

60 McDermott, "The Kitchen," in *Elephant House*, n.p.

61 McDermott, preface to *Elephant House,* n.p.

62 Jean Martin, "The Mind's Eye: Writers Who Draw," in *Ascending Peculiarity*, 89.

63 Clifford Ross, "Interview with Edward Gorey," in *The World of Edward Gorey*, by Clifford Ross and Karen Wilkin (New York: Harry N. Abrams, 1996), 29.

64 Martin, "Mind's Eye," 88.

65 Gorey, Teichner interview.

66 Gussow, "At Home with Edward Gorey," C4.

67 Martin, "Mind's Eye," 89.

68 McDermott, "The Studio," in *Elephant House*, n.p.

69 Christopher Seufert to Jack Braginton-Smith in his interview with Braginton-Smith.

70 Christine Davenne, *Cabinets of Wonder* (New York: Harry N. Abrams, 2012), 204.

71 John Forrester, *Dispatches from the Freud Wars: Psychoanalysis and Its Passions* (Cambridge, MA: Harvard University Press, 1998), 115.

72 Werner Muensterberger, *Collecting: An Unruly Passion* (Princeton, NJ: Princeton University Press, 1994), 232.

73 "'Desperate and childless' woman": April Benson, "Collecting as Pleasure and Pain," *New York Times*, December 30, 2011, http://www.nytimes.com/roomfordebate/2011/12/29/why-wecollect-stuff/collecting-as-pleasure-and-pain. "Invests in objects": Jean Baudrillard, "The System of Collecting," in *The Cultures of Collecting*, ed. John Elsner and Roger Cardinal (Cambridge, MA: Harvard University Press, 1994), 10.

74 I asked the developmental psychologist Uta Frith, a pioneering researcher of autism (specifically, Asperger's syndrome), if Gorey's flattened affect and peculiar social style—his cool, aloof air in crowds; his lack of physical demonstrativeness; his avoidance of the sort of how's-the-

family chitchat most people use to establish rapport—placed him on the autism spectrum. Her answer was "a resounding no." Noting, as a disclaimer, the difficulties of posthumous diagnosis, she enumerated the reasons she felt confident saying that Gorey was in all likelihood not autistic: "1. Gorey's hallmark irony is incompatible with autism. 2. A keen eye for subtle cues is incompatible with autism." As for his "cool, aloof style, uninterested in chitchat," this could, in theory, be a consequence of autism, she allowed, "but there can be more than one reason for aloofness. Some personalities are more introverted and hence seem aloof. Some don't show emotions as much as others, perhaps [because of] their upbringing . . . or being cagey and wishing to avoid invasion of their privacy." See Uta Frith, e-mail message to the author, March 6, 2012.

Steve Silberman, the author of *NeuroTribes: The Legacy of Autism and the Future of Neurodiversity*, had an interesting take on why Gorey might be *perceived* as autistic, even if he wasn't. "There's no clear boundary to the spectrum," he told me. "As Lorna Wing, the cognitive psychologist who coined the term [Asperger's syndrome], says, the spectrum shades imperceptibly into eccentric normality"—a description that fits Gorey to a T. See Steve Silberman, e-mail message to the author, March 23, 2012.

75 Carol Verburg interviewed by Christopher Seufert for *The Last Days of Edward Gorey*, September 2001. Transcript provided to the author by Seufert.

76 Muensterberger, *Collecting: An Unruly Passion*, 233.

77 Ed Pinsent, "A Gorey Encounter," *Speak*, Fall 1997, 47.

78 Ibid.

79 Gorey, Teichner interview.

80 McDermott, "The Entrance Room," in *Elephant House*, n.p.

81 Gorey, Teichner interview.

82 McDermott, "The Entrance Room," n.p.

83 Leonard Koren, *Wabi-Sabi for Artists, Designers, Poets & Philosophers* (Point Reyes, CA: Imperfect Publishing, 2008), 7.

84 Leonard Koren, "The Beauty of Wabi Sabi," *Daily Good*, April 23, 2013, http://www.dailygood.org/story/418/the-beauty-of-wabi-sabi -leonard-koren/.

85 McDermott, "The Living Room," in *Elephant House*, n.p.

86 Edward Gorey, "Edward Gorey: Proust Questionnaire," in *Ascending Peculiarity*, 187.

87 Schiff, "Edward Gorey and the Tao of Nonsense," 149.

88 Edward Gorey, "Miscellaneous Quotes," in *Ascending Peculiarity*, 240.

89 Quoted in S[arane] Alexandrian, *Surrealist Art* (Westport, CT: Praeger, 1970), 141.

90 Marcel Jean, *History of Surrealist Painting* (New York: Grove Press, 1967), 251.

91 Gorey, Teichner interview.

92 Ibid.

93 Julien Levy, *Surrealism* (Cambridge, MA: Da Capo Press, 1995), 102.

94 McDermott, "The Alcove," in *Elephant House*, n.p.

95 Gorey, Teichner interview.

96 Tom Haines, "E Is for Edward Who Died on the Cape," *Boston Globe*, June 9, 2002, M5.

97 Fascinatingly, the Black Doll turns out to have been based on a home-made figurine Gorey once owned. "A friend of mine made the original Black Doll—which, I believe, I left in a hotel room somewhere," he said in a 1998 interview. (See *Ascending Peculiarity*, 205.) According to the Edward Gorey House website, Gorey learned in '42 that a friend—Connie Joerns—was making a doll for him; when he saw it in its half finished state, he insisted that she leave it faceless and armless. (See "The Black Doll Doll," The Gorey Store, http://www.goreystore.com/shop/accessories/edward-gorey-black-doll-doll.) "It disappeared in the '40s and it's never been seen again," he said. Yet it clearly left such an indelible imprint on his imagination that it lived on in his art for the rest of his life.

98 John Updike, foreword to *Elephant House*, n.p.

99 Edward Gorey, letter to Peter Neumeyer, in *Floating Worlds: The Letters of Edward Gorey & Peter F. Neumeyer*, ed. Peter F. Neumeyer (Petaluma, CA: Pomegranate Communications, 2011), 187.

100 Ibid., 188.

101 Theroux, *Strange Case*, 2000 ed., 20.

102 Richard Dyer, "The Poison Penman," in *Ascending Peculiarity*, 112.

CHAPTER 15. *FLAPPING ANKLES, CRAZED TEACUPS,* AND OTHER ENTERTAINMENTS

1 Christopher Lydon, "The Connection," in *Ascending Peculiarity: Edward Gorey on Edward Gorey*, ed. Karen Wilkin (New York: Harcourt, 2001), 220.

2 Ed Pinsent, "A Gorey Encounter," in *Ascending Peculiarity*, 189.

3 Robert Dahlin, "Conversations with Writers: Edward Gorey," in *Ascending Peculiarity*, 48.

4 Annie Nocenti, "Writing *The Black Doll*: A Talk with Edward Gorey," in *Ascending Peculiarity*, 206.

5 Eric Edwards interviewed by Christopher Seufert for *The Last Days of Edward Gorey: A Documentary by Christopher Seufert*, September 2001. Unedited transcript provided to the author by Seufert.

6 Nocenti, "Writing *The Black Doll*," 207.

7 Ibid., 206.

8 Carol Verburg, *Edward Gorey Plays Cape Cod* ([San Francisco?]: Boom Books, 2011), 13.

9 Nocenti, "Writing *The Black Doll*," 206.

10 Edward Gorey interviewed by the Boston-based TV and radio interviewer Christopher Lydon, circa 1992. Unedited audiotape. Copy of tape provided to the author by Christopher Seufert.

11 Ibid.

12 Edward Gorey, "A Design for Staging the 'Horace' of Corneille in the Spirit of the Play," December 6, 1947, 3, Edward Gorey Collection, Harry Ransom Center, University of Texas at Austin.

13 Ibid., 4.

14 Verburg, *Edward Gorey Plays Cape Cod*, 26.

15 Ibid., 27.

16 Patti Hartigan, "As Gorey as Ever: Macabre Artist Delights in Sending Shivers Down People's Spines," *Boston Globe,* September 3, 1990, Living section, 37.

17 Verburg, *Edward Gorey Plays Cape Cod*, 23.

18 Edwards, Seufert interview.

19 Jane MacDonald interviewed by Christopher Seufert for *The Last Days of Edward Gorey: A Documentary by Christopher Seufert*, n.d. Unedited audiotape provided to the author by Seufert.

20 Jane MacDonald interview with the author in Chatham, Massachusetts, circa 2010.

21 George Liles, "Quirky Language Fills 'Elephants,'" *Sunday Cape Cod Times*, August 19, 1990, 52.

22 George Liles, "Gorey's *Salome* Takes Wrong Turn," *Cape Cod Times*, February 6, 1995, B6.

23 Pinsent, "A Gorey Encounter," 190.

24 Lydon, "The Connection," 221.

25 Ibid., 222.

26 Gorey, Lydon interview.

27 Carol Verburg interviewed by Christopher Seufert for *The Last Days of Edward Gorey: A Documentary by Christopher Seufert*, September 2001. Transcript provided to the author by Seufert.

28 MacDonald, Seufert interview.

29 Verburg, Seufert interview.

30 Carol Verburg, phone interview with the author, April 29, 2011.

31 Verburg, *Edward Gorey Plays Cape Cod*, 19.

32 Verburg, Seufert interview.

33 Verburg, interview with the author.

34 Verburg, Seufert interview.

35 This is Gorey at his most hopelessly, hilariously obscure. "Poopies Dallying" refers to Hamlet's observation, in the so-called First Quarto edition of the play (an early pirated copy, judged spurious by scholars), "I could interpret the love you beare, if I saw the poopies dallying." (See William Shakespeare, *The Tragicall Historie of Hamlet Prince of Denmarke*, ed. Graham Holderness and Bryan Loughrey [New York: Routledge, 1992], 75.) "Hamlet means to say that Ophelia's love is no better than a puppet show," writes the Shakespearean scholar Friedrich Karl Elze, "and that he should be able to act as its interpreter if he could see the puppets, i.e., Ophelia and her lover, dallying or making love.... [I]t is to be gathered that there must be some indecent double entendre in the expression 'the puppets dallying,' which is still unexplained..." Also see *Shakespeare's Tragedy of Hamlet*, ed. Karl Elze (Halle, Germany: Max Niemeyer, 1882), 192.

36 Verburg, *Edward Gorey Plays Cape Cod*, 17.

37 Verburg, Seufert interview.

CHAPTER 16. "AWAKE IN THE DARK OF NIGHT THINKING GOREY THOUGHTS"

1 Edward Gorey interviewed by Christopher Lydon for *The Connection*, November 26, 1998, WBUR (Boston's National Public Radio affiliate). Audio recording provided to the author by Christopher Seufert.

2 David Streitfeld, "The Gorey Details," in *Ascending Peculiarity: Edward Gorey on Edward Gorey*, ed. Karen Wilkin (New York: Harcourt, 2001), 181.

3 Simon Henwood, "Edward Gorey," in *Ascending Peculiarity*, 170.

4 Irwin Terry, "Les Échanges Malandreux," *Goreyana*, March 12, 2010, http://goreyana.blogspot.com/2010/03/les-echanges-malandreux.html.

5 Was E. D. Ward's "mercurial" nature an allusion to another Edward's sense of gender and sexuality as fluid? Clearly Gorey was in touch with his feminine side, from his campy affectations—the flapping hands, the swooping vocal style—to his remark, in a letter to Peter Neumeyer, that Herbert Read's novel *The Green Child* didn't grab him because "it is so exclusively masculine/active/positive/whatever in tone and concept, etc. that I am a- (as opposed to un-) sympathetic towards it temperamentally." See *Floating Worlds: The Letters of Edward Gorey & Peter F. Neumeyer*, ed. Peter F. Neumeyer (Petaluma, CA: Pomegranate Communications, 2011), 203.

 And then there's his frequent use of female pseudonyms: Mrs. Regera Dowdy, author of *The Pious Infant* and translator of *The Evil Garden*; Madame Groeda Weyrd, the fortune-teller famed for her Fantod Pack of oracular cards; Miss D. Awdrey-Gore, the Agatha Christie–esque mystery novelist; Addée Gorrwy, the Postcard Poetess, whose epigraphs enhance *The Raging Tide* and *The Broken Spoke*; and Dora Greydew, Girl Detective, the Nancy Drewish heroine of a series by Edgar E. Wordy.

 In that last regard, Gorey is part of a well-established tradition of male artists playing with gender and identity by adopting female alter egos, of which Marcel Duchamp, all dolled up and lipsticked as Rrose Sélavy in photos by Man Ray, and Andy Warhol, bewigged and heavily made-up in self-portraits in drag, are only the best-known examples.

 It's interesting to note, too, that Gorey often cast male members of his Cape Cod troupe in female roles: Vincent Myette played Salomé in Gorey's production of the Oscar Wilde play, and the heavily bearded, broad-in-the-beam Joe Richards was called on to play female characters on several occasions. Apparently Gorey got a kick out of Richards's performances: "To my favorite female impersonator," he wrote in a book he signed for the actor.

6 Irwin Terry, "The Pointless Book," *Goreyana*, October 16, 2010, http://goreyana.blogspot.com/2010/10/pointless-book.html.

7 Tom Spurgeon, "Alexander Theroux on Edward Gorey," *Comics Reporter*, February 22, 2011, http://www.comicsreporter.com/index.php/index/cr_interview_alexander_theroux_on_edward_gorey/.

8 Irwin Terry, "The Just Dessert," *Goreyana*, June 11, 2011, http://goreyana.blogspot.com/2011/06/just-dessert.html.

9 Annie Bourneuf, "Gorey Loses His Touch," *Harvard Crimson*, October 15, 1999, http://www.thecrimson.com/article/1999/10/15/gorey-loses -his-touch-pthe-headless/?page=2.

10 Stephen Schiff, "Edward Gorey and the Tao of Nonsense," in *Ascending Peculiarity*, 140.

11 Ibid., 142.

12 Paul A. Woods, *Tim Burton: A Child's Garden of Nightmares* (London: Plexus Publishing, 2002), 105.

13 Henry Selick interviewed in *The Making of Tim Burton's* The Nightmare Before Christmas, a behind-the-scenes TV special that aired on CBS in October of 1993, archived on YouTube at https://www.youtube.com/ watch?v=kLw-Fo8uhis.

14 Eden Lee Lackner, "A Monstrous Childhood: Edward Gorey's Influence on Tim Burton's *The Melancholy Death of Oyster Boy*," in *The Works of Tim Burton: Margins to Mainstream*, ed. Jeffrey Andrew Weinstock (New York: Palgrave Macmillan, 2013), 115.

15 Daniel Handler, e-mail message to the author, August 22, 2016.

16 Michael Dirda, "The World of Edward Gorey," *Smithsonian*, June 1997, http://www.smithsonianmag.com/arts-culture/review-of-the-world- of-edward-gorey-138218026/#HQYc2sO3lFK0fh4e.99.

17 Daniel Handler interviewed by Christopher Seufert for *The Last Days of Edward Gorey: A Documentary by Christopher Seufert*, archived on Seufert's YouTube channel at https://www.youtube.com/watch?v=flOut8ZWgPA.

18 Martyn Jacques interviewed on the NPR program *Day to Day*, October 28, 2003, http://www.npr.org/templates/story/story.php?storyId=1481865.

19 Edward Gorey, *Q.R.V. Hikuptah* and *Q.R.V. Unwmkd.* Imperf., in *The Betrayed Confidence Revisited* (Portland, OR: Pomegranate, 2014), 95, 85.

20 Alan Henderson Gardiner, *Egypt of the Pharaohs: An Introduction* (New York: Oxford University Press, 1964), 2.

21 Gorey, *Q.R.V. Unwmkd.* Imperf., 78.

22 Ibid., 83.

23 Thomas Curwen, "Light from a Dark Star: Before the Current Rise of Graphic Novels, There was Edward Gorey, Whose Tales and Drawings Still Baffle—and Attract—New Fans," *Los Angeles Times*, July 18, 2004, http://articles.latimes.com/2004/jul/18/entertainment/ca-curwen18/4.

24 Gorey, *Q.R.V. Unwmkd.* Imperf., 79.

25 Mel Gussow, "Edward Gorey, Artist and Author Who Turned the Macabre into a Career, Dies at 75," *New York Times*, April 17, 2000, http://www.ny-

times.com/2000/04/17/arts/edward-gorey-artist-and-author-who-turned
-the-macabre-into-a-career-dies-at-75.html.

26 Ron Miller, "Edward Gorey, 1925–2000," *Mystery!* website, http://23
.21.192.150/mystery/gorey.html.

CHAPTER 17. THE CURTAIN FALLS

1 Kevin Kelly, "Edward Gorey: An Artist in 'the Nonsense Tradition,'"
Boston Globe, August 16, 1992, B28.

2 Mel Gussow, "At Home with Edward Gorey: A Little Blood Goes a
Long Way," *New York Times*, April 21, 1994, C4.

3 Ron Miller, "Edward Gorey, 1925–2000," *Mystery!* website, http://23
.21.192.150/mystery/gorey.html.

4 My speculations about Gorey's heart condition, here and throughout
this chapter, are based on an extensive conversation with Dr. David
A. Brogno, a cardiovascular-disease physician who has taught clinical
medicine at Columbia University and been an attending physician in in-
terventional cardiology at the Columbia-Presbyterian Medical Center.

5 Skee Morton, e-mail message to the author, February 7, 2012.

6 Kevin McDermott, "The Bathroom," in *Elephant House: or, The Home
of Edward Gorey* (Petaluma, CA: Pomegranate Communications,
2003), n.p.

7 Morton, e-mail message, February 7, 2012.

8 Alexander Theroux, *The Strange Case of Edward Gorey* (Seattle: Fanta-
graphics Books, 2000), 45.

9 Skee Morton, e-mail message to the author, August 26, 2016.

10 Again, this assertion is based directly on my conversation with the car-
diovascular surgeon Dr. David A. Brogno. Briefed on Gorey's medical
history and provided with a copy of his death certificate, Dr. Brogno was
unequivocal about the life-prolonging benefits, in Gorey's case, of an im-
plantable defibrillator.

11 Miller, "Edward Gorey, 1925–2000."

12 Henry Allen, "For Years, G Was for Gorey," *Washington Post*, April 19,
2000, C1.

13 Ibid.

14 Quoted in David Langford, "Obituary: Edward Gorey," *The Guardian*,
April 20, 2000, https://www.theguardian.com/news/2000/apr/20/
guardianobituaries.books.

15 Probate of Will for Edward Gorey, docket number 00P0672EP-1, Commonwealth of Massachusetts, Trial Court, Probate, and Family Court Department, Barnstable Division, May 24, 2000, n.p.

16 Petition to Amend Charitable Trust Under Will, docket number 00P-672EP1, Commonwealth of Massachusetts, Trial Court, Probate, and Family Court Department, Barnstable Division, May 11, 2005, 3.

17 McDermott, preface to *Elephant House*, n.p.

18 Ibid.

19 Ibid.

20 "Ever-increasing pile of debris": Mary McNamara, "Dead Letter Writer: Edward Gorey's Macabre Wit Comes to Life in a Westside Stage Show and Exhibition," *Los Angeles Times*, October 29, 1998, http://articles.latimes.com/1998/oct/29/entertainment/ca-37314.

21 Mel Gussow, "Master of the Macabre, Both Prolific and Dead," *New York Times*, October 16, 2000, http://www.nytimes.com/2000/10/16/arts/16GORE.html.

22 Affidavit in Support of Approval of the First Intermediate Account of Trustees, docket number COP-0672-EP1, NYC 138813v3 62778-4, May 11, 2005, 3.

23 Richard Dyer, "The Poison Penman," in *Ascending Peculiarity: Edward Gorey on Edward Gorey*, ed. Karen Wilkin (New York: Harcourt, 2001), 125.

24 "A lovely sunny warm day": Skee Morton, e-mail message to the author, August 16, 2016. "Overcast and gray": Theroux, *Strange Case*, 67.

25 Morton, e-mail message, August 16, 2016.

26 Edward Gorey, letter to Peter Neumeyer, in *Floating Worlds: The Letters of Edward Gorey & Peter F. Neumeyer*, ed. Peter F. Neumeyer (Petaluma, CA: Pomegranate Communications, 2011), 7.

27 Skee Morton, e-mail message to the author, October 31, 2016.

28 Stephen Schiff, "Edward Gorey and the Tao of Nonsense," *New Yorker*, November 9, 1992, 89.

29 Gorey, letter to Neumeyer, *Floating Worlds*, 7.

30 Edward Gorey, "Edward Gorey: Proust Questionnaire," in *Ascending Peculiarity*, 182.

31 Annie Nocenti, "Writing *The Black Doll*: A Talk with Edward Gorey," in *Ascending Peculiarity*, 199.

32 Lisa Solod, "Edward Gorey," in *Ascending Peculiarity*, 102.

33 Ibid., 105.

34 Ibid., 101.

35 Lisa Solod, "The *Boston Magazine* Interview: Edward Gorey," *Boston*, September 1980, 90.

36 Ibid., 91.

37 Ibid.

38 Edmund White, *City Boy: My Life in New York During the 1960s and '70s* (New York: Bloomsbury, 2009), 1.

39 Solod, "The *Boston Magazine* Interview," 91.

40 White, *City Boy*, 119.

41 Guy Trebay, e-mail message to the author, February 8, 2011.

42 Oscar Wilde, *The Wit and Humor of Oscar Wilde*, ed. Alvin Redman (Mineola, NY: Dover Publications, 1959), 54.

43 Dick Cavett, "The Dick Cavett Show with Edward Gorey," in *Ascending Peculiarity*, 59–60.

44 Christopher Seufert interviewed by Mindy Todd on *The Point* for the Cape Cod–based NPR affiliate WCAI, February 27, 2014, http://capeandislands.org/post/edward-gorey-lives-documentary#stream/0.

INDEX